Invisible Colors

Invisible Colors

A VISUAL HISTORY OF TITLES

John C. Welchman

YALE UNIVERSITY PRESS
NEW HAVEN AND LONDON

Designed by Gillian Malpass
Printed in Hong Kong

Library of Congress Cataloging-in-Publication Data
Welchman, John C.
 Invisible colors: a visual history of titles / John C. Welchman.
 p. cm.
 Includes bibliographical references and index.
 ISBN 0-300-06530-2 (cloth: alk. paper)
 1. Titles of works of art. 2. Art, Modern – 19th century. 3. Art.
Modern – 20th century. I. Title.
 N7560.W45 1997
 701′.4 – dc20
 96-36616
 CIP

A catalogue record for this book is available from The British Library

Illustrations: medium is oil on canvas, unless otherwise indicated;
dimensions are in centimeters, height before width

Contents

Acknowledgements

Invisible Colors developed from initial research for the first chapter of my Ph.D. thesis, *Word, Image and Modernism: An analysis of the orders of relation between visuality and textuality in the modern period* (Courtauld Institute, London University, 1991). Christopher Green at the Courtauld and Stephen Bann at the University of Kent made a number of useful comments and suggestions before and after my submission. Sir Ernst Gombrich generously shared the script of his then-unpublished study of titles in modern art; and Norman Bryson at Harvard University was a helpful reader of an early outline.

A British Academy research award, an Irwin Grant from the Central Research Fund at London University, and a Fulbright Fellowship, awarded to pursue research in New York, were essential to the first stages of this project. Grants from the Academic Senate and the Committee on Publications, at the University of California, San Diego; Monash University, Melbourne, Australia; and the Australian Academy of the Humanities, assisted with later research on the inter-war and post-war periods.

Librarians and staff at the Museum of Modern Art, New York; the Solomon R. Guggenheim Museum; the New York Public Library; the Avery Library at Columbia University, New York; the British Library; and the Art and Architecture Library of the University of California, San Diego, were extremely helpful in the provision of the multiple requests and other burdens a survey of this kind necessitates. I would also like to thank the education directors or visiting committees at the following institutions for the opportunity to share material developed in *Invisible Colors* with public and professional audiences: the Tate Gallery, London; the Metropolitan Museum, New York; the National Gallery, Washington, D.C.; the Courtauld Institute of Art; and the California Center for the Arts, Valencia, California.

None of the chapters of *Invisible Colors* has been previously published, but ideas and examples are discussed in: "Image and Language: Syllables and Charisma," in *Individuals: A Selected History of Contemporary Art,*

1945–86 (exhibition catalogue; Los Angeles: Los Angeles Museum of Contemporary Art/New York: Abbeville Press, 1986); "After the Wagnerian Bouillabaisse: Critical Theory and the Dada and Surrealist Word-Image" in Judi Freeman and John Welchman *The Dada and Surrealist Word-Image* (exhibition catalogue; Los Angeles: Los Angeles County Museum of Art/Cambridge, MA: MIT Press, 1989); "Bordering On," a historical introduction to the catalogue for the *9th Biennale of Sydney* (1992–93); "Parametrology: From the White Cube to the Rainbow Net," *Art & Text* no. 54, January/February 1996; and "In and Around the 'Second Frame,'" chapter 11 of *The Rhetoric of the Frame: Articulating Distinction in the Visual Arts* ed. Paul Duro (New York: Cambridge University Press, 1996).

Thanks also to John Farmer at Columbia University for his thorough editing and comments (and to Russell Ferguson at the Museum of Contemporary Art, Los Angeles, for the recommendation), and to Allison Wiese at the University of California, San Diego, for her help with the index. Marcel Hénaff at UCSD and Yvonne Shafir and Catherine Texier in New York assisted with several translations. Phillip Denis Cate at the Jane Voorhees Zimmerli Art Museum, Rutgers, the State University of New Jersey, kindly furnished a copy of the catalogue for the first *Arts Incohérents* exhibition from *Le Chat noir* (October 1882). And Joseph Kosuth and Barbara Kruger generously provided photographs of their works for inclusion as illustrations.

At Yale University Press, London, my editor, Gillian Malpass has been enormously responsive concerning every aspect of the book's production (and aspects besides); and constructively understanding as it changed shape and dimensions after my first draft. Laura Church and Sheila Lee have been most helpful with proof-reading and illustrations.

Colorful though this book may have been, invisible it wasn't. Special thanks, finally, to Anya von Bremzen for putting up with the obsessions and miscellaneous forfeitures it occasioned during our sojourns in New York, London, Melbourne, and San Diego.

Introduction

> [The writer should] use the fantasies that a name generates as
> the background for a description that represents it as it really
> is.
>
> – Walter Benjamin, *Moscow Diary* (1926–27)[1]

I Titles and the History of Art: Beginnings

Invisible Colors aims to reread some of the history and theory of visual
modernism by examining a key aspect of the evasively determining
interrelation of textuality and visuality. Focusing on the preliminary
relation between words and images staged in the provision of titles, it
hopes to offer a detailed challenge to the still-dominant theory of mod-
ernism that insists on the autonomy and material discreteness of its visual
practices.

 Enmeshed in a complex rapport with the surface or volume to which
it relates, the title of a painting or sculpture can be considered as the *name*
of that object. It is demonstrably implicated in the signifying capacity of
the work, providing a lead term in its descriptive articulation and contex-
tual history. State, private, and commercial machineries for the exhibition
of art intervened decisively in the construction of this first verbal cor-
relative of the object, and are key to its understanding. But before the
development of discourses of exhibition – which gave rise to the twin
adjuncts of the titular activity, the catalogue and the label – fresco
painting communicated under a canopy of discrete, slightly fluid icono-
graphical signs ascribed by convention and held by memory. Located on
an architectural surface, a work such as Masaccio's *Trinità* (*The Holy
Trinity*, 1425) in the church of Santa Maria Novella in Florence, was
positioned through recognition and identification within a textual field,
notably the Bible, and within a system of known and mostly accepted
deviations (the Apocrypha, for example). The image was, in a real sense,

pre-posed by writing.² However, after the work of the sign as an exemplar, model, or illustration there is always a residue, or excess – something that is beyond mere recognition. With the rise of art history and criticism, this "extra" has been understood in many ways – as style, or color, or some aspect of the productive context of the work.³ But, as we will see, it also includes the title.

The detachment of the image from an architectural environment, the discovery of oil paint, and the use of canvas, together with the secularization of image-production and the aestheticization of taste, were essential stimuli for generating titles contemporary with the making of the work. In the eighteenth and nineteenth centuries the re-labeling of antique, Medieval, Renaissance, and later works with simple descriptive titles was achieved as a function of art-historical study and the commercial disseminations of the market place.

Until about 1860 titles maintained an almost exclusively unequivocal relation to the images they governed. Through the traditional hierarchy of types rehearsed by the European academies, titles positioned works of art with respect to literary, historical, religious, or mythical texts, which were elevated as history painting – for Joshua Reynolds, as for other academicians, the pre-eminent genre, governed by "Poetical" "grandeur of thought" and "dignity" of expression.⁴ Titles also positioned works by identifying an individual or group, in portraiture; by locating a place, real or imaginary, in landscape images; and, finally, by noting a mood and a setting – usually colloquial, working-class, and contemporary – in genre painting. With few exceptions the titles that accompanied works from across the range of these generic kinds were deployed as basic labels. They were denotative signs seldom permitted to exceed their own terms of reference, or to call attention to their status as textual supplements to the image. Ideally, they were as unallusive as the numbers that accompanied them in the exhibition catalogues of the Salons.

The normative enterprise of passive, transparent titling should not obscure a number of important exceptions. For, even in the earlier nineteenth century, and, not unexceptionally, before 1800, certain practices of titling clearly disrupted, or subverted any expectations of neutral designation. Providing a useful reminder that the title had already become a site of conflict in the production of visual signification by the mid-nineteenth century, Stephen Bann identifies a "polysemic" counter tradition to conventionally subordinated academic denomination in the poeticizing appendages to J.M.W. Turner's paintings, the inscribed and frame-carved titles of the Pre-Raphaelites, and the indexical refusals of Edouard Manet. By around 1850 the process of titling had given rise to a kind of crisis of meaning staged between the predicates of emergent

modernism and an already complex field of traditional, academic denominations. The criticism of Charles Baudelaire points emphatically to the key issues in what became a dispute over meaning, interpretation, and visuality itself.

According to Baudelaire in his "Salon of 1846," the "lowest" category of painting, what he calls the "tableaux de sentiment" of genre painting,[5] reveals the most dissent from titling norms. In section XIII Baudelaire elaborately censures the dependence of some practitioners of genre painting – whom he designates the "apes of sentiment" ("les singes du sentiment")[6] – on the textual effects of the "catalogue." This discussion exemplifies Baudelaire's critique of the contamination of visual material by poetic or literary pretensions: it is one of the fullest and most telling references to the relation between the title, the image, the catalogue, and the viewer written in the nineteenth century. The systematic debunking of genre painting to which section XIII is devoted arrives after Baudelaire's passionate defense of criticism, Romanticism, the value of pictorial color, and the work of Eugène Delacroix – in whom all these defenses are epitomized. It is part of what the critic nicely terms "the hospital of painting,"[7] that place where the ostentatious de-merits of contemporary art are given their critical due. Baudelaire takes issue with the proliferation of "the chic and the poncif" – the "neglect of the model and of nature" and "abuse of the memory"[8] – and of "eclecticism and doubt." These improprieties undermine the values and passions proper to painting. Contrasting the "health" of art, and its necessary "sacrifices," to the "sicknesses" and degeneracies of artists who trade in travesty, Baudelaire employs a curious feudal metaphor. "[F]ollowing the fatal law of propensities," he writes:

> [s]ome gather an easy and abundant harvest in the golden, autumnal vineyards of colour; others toil patiently and laboriously to drive the deep furrow of drawing. Each of these men knows quite well that his monarchy involves a sacrifice, and that it is on this condition alone that he can reign securely up to his limiting frontiers. Each of them has a banner to his crown, and the words inscribed upon that banner are clear for all the world to read. Not one of their number has doubts of his monarchy.[9]

Baudelaire's plea for the clarity of kings, the knowledge of an artist's talents and limitations, and the dedicated pursuit of pictorial practice within the territory of those borders, but not further, is explicitly linked to the proper textual signing of the bounded space. The banner, or title, must accurately and appropriately stand for the kingdom, or painted canvas, it designates and governs.

Now, this parable of sanctioned delimitation and loyal titling – loaded as it is with cautionary tales of titular transgression and malfeasance – is the approbationary recto of section XII of the "Salon." Written on the fold that separates the good names and the bad are "doubt" and "eclecticism," a special pair of linked deviations that have "led certain artists to beg the aid of all the other arts. Experiment with contradictory means, the encroachment of one art upon another, the importation of poetry, wit and sentiment into painting – all these modern miseries are vices peculiar to the eclectics."[10]

Only now does Baudelaire let the curtain rise on his ringing outline of "different orders" of defection from the predicates of painting summed up in Ary Scheffer's "blundering" recourse to the "protection" of poetry. The first of these is a false reliance on the *livret*:

> The ape of sentiment relies above all on the catalogue. It should be noted, however, that the picture's title never tells its subject – and this is particularly true with those artists who, by an engaging fusion of horrors, mix sentiment with wit. In this way, by extending the method, it will be possible to achieve the *sentimental rebus*.[11]

He cites two examples:

> For example, you find in the catalogue something called *Pauvre Fileuse*! Well, it is quite possible that the picture may represent a female silkworm, or a caterpillar, squashed by a child. This is an age without pity!
> *Aujourd'hui* and *Demain*. What can that be? Perhaps a white flag – and a tricolour? or perhaps a deputy in his moment of triumph – and the same deputy after being sent packing? But no; it is a young maiden, promoted to the status of street-walker, playing with roses and jewels; and then the same girl, crippled and emaciated, suffering the consequences of her indiscretions in the gutter.[12]

Conjugating the catalogue and the imagination, Baudelaire offers an important glimpse of the wanton seduction, frivolous obliquity, and bravado indiscretion of the genre-driven title.[13] The citations above clearly reveal the absurdities of the solicitation in genre painting of ideas and sentiments imposed across the grain of the image. The "sentimental rebus" that results from this mismatch can stand as a symbolic designation for all the perversions and non sequiturs loaded into the image-text ensemble by artists and critics who exploit the title as a moral, allegorical, or poetic detour around the image. Baudelaire's catalogue of the sentimental orders of titular excess is deliberate – and withering:

In general, sentimental genre-pictures are taken from the latest poems of some blue-stocking or other − that is the melancholy and misty kind; or else they are a pictorial translation of the outcries of the poor against the rich − the protesting kind; or else they are borrowed from the wisdom of the nations − the witty kind; and sometimes from the works of M. Bouilly or of Bernardin de Saint-Pierre − the moralizing kind. . . . Books, pictures, drawing-room ballads, nothing is without its use, no means is neglected by this charming people [the French] when it is a question of throwing dust in their eyes.[14]

Baudelaire offers a tirade against the infections of the text, finally contending that the unnecessary word is the cause of self-inflicted blindness − an especially French disease. Titles are both the testing ground and the point of issuance for all that is dangerous and supplementary to the true speech of vision.

The manufacture of such critical calumny was not the only means by which Baudelaire and his contemporaries reckoned with the title. There are numerous other mid-nineteenth century testimonies to the undue impingement of the catalogue, with its accumulation of words and titles, on the particular materiality of the visual sign. Outstanding among these are the caricatures of Honoré Daumier, representing *Le Public du Salon* and other scenes of atelier production and exhibition spectatorship in the art world of the 1850s and 1860s. A lithograph of 1865, for example, depicts a family visit to the Salon. The father clutches the *livret* and, having matched the listed number with the tag on the painting, attempts to match the title of Manet's *Olympia* (1863) with the protagonists represented in the painting. The family's comic dialogue − which first applies the name "Olympia" to the "red" woman in a shirt and then to the "cat" − parodies the system of reference circulating between image, title, and catalogue, as well as offering an effective (if deliberately absurdist) retort to Ernst Gombrich's theories of psychological "match" and "fit."

Baudelaire considers the matter of the title from several, sometimes contradictory, points of view. Writing of Daumier's caricatures in 1846, he insists on the splendid particularity of his print series and proceeds to offer a list of its textual descriptors. This is one of the first instances of what will become a more general response to the collective, serial, or cumulative work of the modern title − as we will see later from the lists of real and speculative titles compiled by Max Ernst, Frank Stella, and others:

To make a complete analysis of Daumier's *oeuvre* would be an impossibility; instead, I am going to give the titles of his principal series

of prints, without too much in the way of appreciation and commentary. Every one of them contains marvelous fragments.

Robert Macaire, Moeurs conjugales, Types parisiens, Profils et silhouettes, les Baigneurs, les Baigneuses, les Canotiers parisiens, les Bas-bleus, Pastorales, Histoire ancienne, les Bons Bourgeois, les Gens de Justice, la Journée de M. Coquelet, les Philanthropes du jour, Actualités, Tout ce qu'on voudra, les Représentants representés. . . .

[Daumier] goes straight to the point. The central idea immediately leaps out at you. You have only to look to have understood. The legends which are written at the foot of his drawings have no great value, and could generally be dispensed with★ [see endnote]. His humour is, so to speak, involuntary.[15]

As often in his writings, the site of the title precipitates Baudelaire – as it will Clement Greenberg a century later – into a conflict with his formalist predispositions. For having censured the pseudo-titles of the genre painters of the 1846 Salon, in the course of the half-a-dozen or so paragraphs that make up his discussion of Daumier, Baudelaire offers an affirmative account of the title as a provider of "marvelous fragments" and a negative account of its role as an explanatory legend. The discrepancy can be explained with reference to the double critical context within which he has constructed Daumier. On the one hand, the caricaturist is claimed as an artist who "draws as the great masters draw," with abundance, ease and "sustained improvisation." Despite the fact that his works are lithographs and wood engravings, they are held to "evoke colour" in the same way that they also "evoke thought."

At the same time Daumier is also a "moralist" concerned to point up the follies and absurdities of contemporary society. But he is truly an artist-moralist rather than a social commentator, for his social vision is predicated on immediacy – "the central idea immediately leaps out at you," notes Baudelaire. Understanding, then, is a function not of reading and reflecting, but of looking and intuiting: Daumier's "humour is, so to speak, involuntary." Ideas are not "searched for," they just "slip out." Negotiating finely between "violence," "rancour," and human "comedy," the visual immediacy of these works disavows the function of the title-caption. The "legend" is both contra-visual – an unnecessary supplement that stands in a tautological relationship to the image – and hyper-moral – in that it brokers an overcoded and under-finessed purchase on the morality of the subject.

We can glimpse in Baudelaire's discussion of Daumier two important axes of the titular activity as it was developed in the mid and later nineteenth century. The first returns the title as a suggestive poetic

shorthand that concentrates the work and reverberates in it. The second perceives the title-text as a kind of denotative repetition that undermines the visual immediacy of the image. Baudelaire's attention to the conflictual site of the title-caption is the first of three important moments when this configuration of word and image is brought forward by a major critic as a symptom of social and cultural change in the development of modernism. The second is found in Walter Benjamin's discussion of the "exhibition value" that emerges in the works of the photographer Eugène Atget. Benjamin notes that in the process of "photographs [becoming] standard evidence for historical occurrences," they "acquire a hidden political significance": "For the first time, captions have become obligatory. And it is clear that they have an altogether different character than the title of a painting. The directives which the captions give to those looking at pictures in illustrated magazines soon become even more explicit and more imperative in the film where the meaning of each single picture appears to be prescribed by the sequence of all preceding ones."[16] Roland Barthes develops this thought twenty years later, when he discusses the necessary intertextuality mobilized between the press photograph and "the text – title, caption or article" – that accompanies it.[17] The public mediation of the press photograph, the development of film technologies in the first half of the twentieth century, and the site of both the public exhibition, and of Benjamin's critical *exhibition value*, stand for three forms of social outreach for the image, each attended by inflections in the theory and the practice of titling.

As one of the great originators of the mythology of modernism, Baudelaire courted and problematized in equal measure the inheritances of Romanticism and the remainders of Neo-Classicism entrenched in the art discourse of the nineteenth century. His contradictory positions across the range of his visual criticism, and between this and his proto-Symbolist theory, inform or anticipate much that is relevant to the signification of titles in the later nineteenth and twentieth centuries. On the one hand, he persistently maintained that painting should jettison poisonous textual/verbal relationships. On the other, he championed notions of correspondence and synaesthesia where access between various materials and sentiments is valued at times in proportion to their elevation and promiscuity. This paradox and some of its implications for titling were reflected and in part resolved by a number of Symbolist artists.

As Baudelaire suggests, the new work of the modern title is organized around the various strategies by which its normal (descriptive) function is either exceeded or denied. These excesses and denials are related to a number of determinations reaching between the work and the site of its production, including the place and circumstances of its exhibitions.

Three non-distinct categories of titular activity can be identified in the modern period. First, the continuation of broadly denotative titles, where the words are presumed to stand in direct and untroubled relation to that which is represented. Second, the set of titles that can be said to provoke connotative, allusive, or even, in Dada and Surrealism, absurd and non-consequential references to an image. And third, the conclusively modernist practice of advertising the absence of a title through the description "Untitled" or through numbering or other systematic, non-referential designations. The threads of descriptive neutrality, connotative excess, and serial restraint encoded in titling practices from the mid-nineteenth century, make up an invisible coat of many colors worn by the artworks of the modernist period. Marcel Duchamp christened the modern title as an "invisible color," offering it a name that was simultaneously precise, paradoxical, ironic, and impossible.

The histories and arguments that follow weave in and out of the trajectory of modernist history and theory. The development of *Invisible Colors* is both chronological and thematic. I begin with early modernism, move to Impressionism (often regarded as the first unambiguously modernist movement), and then to Symbolism, where the key coordinates and defining order of the titular activity are established. I propose a consideration of the consequences and defaults of the title as it was produced and interpreted by Cézanne and Picasso, and in Cubism. The second section of the book begins with an analysis of the two modes of compositional titling developed by the pioneer abstractionists, Mondrian and Kandinsky. I then attend to the multi-functionality of the title in Dada and Surrealism; concluding with an extended discussion of the ramifications in mid- and later twentieth-century art of the titling dynamics thus established. The final chapter, on the destiny of the "compositional," examines the paradoxical repression and recrudescence of both titles and textuality in the high formalist theory and practice of the 1960s, and looks over to some of the titular endgames associated with postmodernist art.

Built into this sequence is a thematic triangulation that insists on the interplay of what I bring forward as the three most significant relations between the image/object and the title: denotation, connotation, and untitling. In putting forward the terms "denotation" and "connotation," it is necessary to point out that these critical designations have particular histories related to the development of cultural semiotics in the 1950s and 1960s and have also been subject to important critiques in recent work. Steve Baker offers an overview of the development of the terms in relation to an analysis of the signification of graphic design imagery.[18] He locates "the first extensive application of the denotation:connotation

opposition to visual imagery"[19] in Barthes' essay "Rhetoric of the Image" (1964),[20] although their use was implicit in his well-known analysis of a *Paris-Match* cover in "Myth Today" (1957).[21]

In one of his most extended discussions, the commentary on Honoré de Balzac's *Sarrasine* in *S/Z* (1970), Barthes identifies five connotative principles that correspond to the five major critical languages of our time – narrative, theme, psychology, sociology, psychoanalysis, – noting that "connotation is a correlation immanent in the text, in the texts; or again, one may say that it is an association made by the text-as-subject within its own system."[22] Moving beyond Barthes, Baker also discusses the use to which the term denotation is put in Norman Bryson's *Vision and Painting: The Logic of the Gaze* (1983), where it is related to the "government" of Renaissance imagery by "iconographic codes,"[23] and its eclipse in some accounts of literary semiotics – especially in Jean Baudrillard's "hell of *connotation*," where it is displaced by the sheer instability of meaning: "residue, superfluity, excrescence, eccentricity, ornamentation, uselessness."[24]

Baker proposes that the denotation/connotation opposition is neither absolute, nor always a useful or appropriate analytic polarization. In particular, any idea of pure denotation is untenable: *no sign is purely denotative*. As he suggests, it is necessary to go outside semiology to produce the conditions under which these terms may usefully be employed. The terms "denotation" and "connotation" have been retained in this book, especially in relation to the development of titling procedures in the late nineteenth and early twentieth centuries, only because they bear a useful, if always approximate, relation to an identifiable opposition and debate in the formation of visual modernism. At all points their negotiation is discussed in relation to institutional (exhibition) frames and to the closely-read arguments of contemporary textual exchanges on titling in criticism and in artists' correspondence and statements. Furthermore, the term denotation is useful only when allied to properly theorized understandings of ideological control and the formation of symbolic orders. Thus, while there is never any pure denotation as such, there is always a *denotative pressure* in signifying systems, always a certain recoil or impress of meanings – whether in the reflex of the glance which can only take in a sudden dose of signification; or whether it is the product of an elaborate and iterated social coding, as in, say, the Stalinist field of vision.

The thematic orientation of *Invisible Colors* gives rise to a rather intricate structure, and it is important to explain my historical emphases. While titling did not cease to be a significant issue following the development of non-iconic abstraction in the 1910s and 1920s (the point at

which my analysis changes direction), almost without exception the three tendencies introduced here return as strategies in the practices of later modernism. Thus the nine chapters of the study will shift ground sequentially as well as theoretically across the historical terrain of modernism and postmodernism. In effect, I shall simulate the effects of the chronological sequence of canonical modernism, even as I attempt to propose a break-up of its syntagmatic progression and formal logic.

It will be apparent from the start that my focus on titling, apparently the most simple and immediate relational mode between word and image, necessarily interacts with other conjunctions between visual and textual discourse: the physical presence of words in art objects, the specific discourse of artists' own words, and the structures of criticality that stitch the work of art into systems of meaning. While each of these domains will be discussed only insofar as they impinge directly on the problematic of titling, the precise points at which these references are made are meant as invitations for further study, as windows built into the structure of this text so that its relatively restricted parameter of the title can be opened up to other historical and theoretical discussions.

The predominant method employed is that of close textual analysis, focusing on discussions of titles in the published letters and other writings of the artists considered; on debates over titling in contemporary criticism; and, occasionally, where it is of special relevance, on art historical/critical writings, including recent monographs and catalogues raisonnés, as they touch upon the issue of naming. Assembling and intensively rereading these accounts of titling produces the first extended revelation of its strategic importance in the formative history of visual modernism.

This ambition raises the question of the relation between the present undertaking and other negotiations between textuality and visuality. The reinscription of writing into the historical frame of the modern reveals two modes of dependency between texts and images. The first is exclusionary; the second, symbiotic. The exclusionary domain embraces the totality of practices constituting the formal method – all the tendencies that combine to disengage the artwork from its productivity, to promote opticality and other kinds of self-reference. I want to insist, however, that this apparent unbonding of image from word, is, in fact, doubly predicated on textuality: first, through the elaborate criticism that manufactures the separation; and second, through what I call the articulation of silence, a characteristically modernist mythos we can trace through the taciturnity of some of the most celebrated protagonists of the modern movement, from Picasso and Braque to Samuel Beckett, John Cage, and Susan Sontag.[25] The injunction, of course, to fall silent, the call for verbal and textual restraint, and the capitulation to pessimism, absurd-

ity, and rhetorical nullity sometimes associated with it, is always already produced through the difference it marks from textual fullness. It takes its very meaning from the non-signified material that constitutes its repression. The discourse of silence, then, is another aspect of the "zero-economy" discussed in Chapter 1. It is also related to the various strategies of untitling, or minimal titling, developed by an important, though disparate, genealogy of artists, including Piet Mondrian, Clyfford Still, Ad Reinhardt, and Barbara Kruger.

Sontag's essay on "The Aesthetics of Silence" (1967) is in many ways the most considerable effort of the several alluded to above. In the course of identifying the constituent moments that make up the discourse of

1 Joseph Kosuth, *Titled* (Art as Idea as Idea), [silence], 1967. Black and white photograph mounted on board. © Paolo Mussat Sartor, Courtesy Leo Castelli and Sean Kelly

Silen-ce; silènzo *m*. Dead —, silenzio mortale. To —, far tacere; spegner il fuoco di. Keep —, tacére. Keep — about, tacere. Pass over in —, passare sotto silenzio. — gives consent, chi tace acconsente. —! zitti! **-cer**; bariletto di scaricamento, camera di scarico, marmitta *f*. **-t**; tácito, taciturno. **-tly**; tacitaménte, pian piano.

formal restraint and non-utterance (Rimbaud in Abyssinia, Wittgenstein as a "hospital orderly," the "serious" silences of Valéry and Rilke, the "exemplary suicides" of Kleist and Lautréamont, the madness-as-self-punishment of Hölderlin and Artaud, Duchamp's surrender to chess, Cage's noises and nothings, the "lifeless subjects" of Pop, Beckett's gaping voids, etc.), she parcels silence with "allied ideas (like emptiness, reduction, the 'degree zero')" and describes them all as "boundary notions" subject to specific "cultural rhetorics" and terms of deployment.[26] These are useful leads, but they are also too generalized and expansive in reference to be followed up in detail. However, Sontag does identify a crucial intersection between art and objects, language and (un)naming. Proposing "attention" as the antithesis of "silence," she claims that:

> the history of the arts is tantamount to the discovery and formulation of a repertory of objects on which to lavish attention. One could trace exactly and in order how the eye of art has panned over our environment, "naming," making its limited selection of things which people then become aware of as significant, pleasurable, complex entities.[27]

One aspect of Sontag's silentium is predicated on the withdrawal of names. It is a nominal relinquishment that participates in many of the effects and strategies of silence she outlines – including the retooling of authenticity or integrity, the cultivation of minimalist austerity, auratic magic, expressionist "ineffability," mystery, or the sublime, and the "mythic project of total liberation." Many of these strategies can be located in the discourse of untitling, a platform of namelessness that goes beyond the threshold of "brutal nominalism," the anti-humanist reduction of language to "bare physical description and location" or the "minimal narrative principle of the catalogue or inventory" associated with Raymond Roussel, Andy Warhol, and Alain Robbe-Grillet.[28]

The symbiotic dependency between visuality and textuality, on the other hand, knowingly calls attention to itself through the foregrounding of incessant intertextual exchange. This is most visible and compelling where text and image partake of the same material substance through the inscription of text in the image – though there are many other forms of relay and overlap. Titles will be brought forward as a crucial instance of these interactions. They both promote and emblematize the intertextuality of the word-image, and we will find that important inflections and renegotiations in the title accompany almost every other economy of visual-textual exchange.

In the end, however, my discussion of the titular activity of visual modernism is only introductory to a larger project of accounting in some measure for the full interdependence of visual and textual discourses in

the late nineteenth and twentieth centuries. The horizon for this enquiry is, in theoretical terms, the whole problematic of the interaction of textual and image-making capacities in the way we experience the world. While some of these larger questions are raised throughout *Invisible Colors*, I want to reflect here on a number of preliminary issues concerning the theory of the name and the critical status of the title. These I organize around the extremes of titular signification, leaving that which constitutes their inbetween to make up the analytic body of the text to come. At one remove is the capitalized Name – a name that purportedly offers a precise textual shorthand for the singular image, object, or protagonist in front of which it stands. This is the name in its function as an equivalent or surrogate. At the other extreme are the non-name and the un-title, which carry with them various forms of refusal to identify or otherwise describe.

II Theories of Titling and Naming

While it can reasonably be claimed that the most immediate relation posed in the art world between words and images is that in process between an art object and its title, there have been few detailed considerations of either the historical development, or the theoretical implications, of the title in the modern period. I want here to sketch an outline of three contributions that speak directly – though in each case provisionally and insufficiently – to the issue of titles. The first discussion comes from an extensive body of philosophical writing on the theory of names and the related practice of entitling. The second is drawn from the first wave of revisionist art history, associated with the work of Gombrich. And the third arises from renewed academic interest in the relation between words and images (or textuality and visuality) and the partial absorption of post-structuralist ideas, including those of Jacques Derrida, into art-historical studies in the later 1970s and 1980s, which spawned the first attention to the title or caption as an important component in the signification of the exhibited, catalogued, or reproduced image or object. The disciplines represented in these discussions – analytic philosophy, art history and visual psychology, and semiotics – offer quite particular emphases on the question of titles. But, with the possible exception of the third, each makes propositions about titles that are usually neither raised nor accounted for in the others.[29]

Perhaps the most cited and debated theory of names offered by philosophers is that put forward by Saul Kripke in his article "Naming

and Necessity" (1972).[30] Referred to collectively by their author not as a theory but as a "picture," his ideas are concerned with several aspects of naming: "baptism," "ostension," and "description." Baptism stands for the bestowal of names, the situation in which a name is "initially" given. Ostension and description are forms of designatory "fixing," with ostension referring extra-linguistically and description having an intra-linguistic function. The point of convergence for each of these aspects is the general condition of names as "rigid designators"[31] – that is, as signs closed down by their identity with a particular, singular referent: *this* person, *that* object, etc. The precise mechanisms attaching to this "intuitive" concept of nominal fixity have, however, been challenged by several commentators, including Jean-François Lyotard[32] and Paul Ziff, who feel that denominative processes and the reception and interpretation of names are seldom as rigid or systematic as Kripke appears to suggest.

Ziff argues, for example, that neither baptism, ostension, nor description is sufficient to account for the production and social circulation of many kinds, and instances, of names. Exposing some of the contradictions and limitations of Kripke's system, the expansive, "exceptional" analyses he offers stress the "modulatory" effects of natural language rather than the "modal logic" of formal propositions. Such exceptions are significant for *Invisible Colors* as they underline the kinds of ironic, allegorical, or deliberately perplexed significations cultivated in the title by many avant-garde artists, critics, and dealers.[33] The revisionism of Ziff and others allows us to suggest that the very enterprise of proscribing semantic rule-conditions for name-production may be compromised by the modern (post-Enlightenment) abstractions associated with the systematization of knowledge. The problematic certainty of logical, systematic reference – whether between objects and titles, or persons, places, and names – was deliberately pilloried by the avant-garde movements, notably Symbolism, Dada, and Surrealism, whose titular productions were most excessive. The names and titles invented by these groups acted more like permeable membranes brokering different kinds of semantic exchange between their sites of production, reception, and circulation, than rigid barriers circumscribing definite forms of identity.

There are important shortcomings in the tendency of analytic philosophers to use particular nominal examples as instances of a generalized logic in the discussions of names and titles. Even Ziff, who attempts to point up precisely this form of over-systematization in Kripke's picture-theory of names, indulges in these reductionisms. Discussing Duchamp's addition of a moustache to a print of Leonardo's *Mona Lisa*, he ponders the implications of Leonardo himself having added a moustache to his work, stranding his argument in a string of speculative conditionals. Such

speculation supports Ziff's useful defense of the historical relativity of certain gestures in the art world, the conditions of possibility that make Duchamp's addition avant-garde, and Leonardo's unimaginable. But important though it is, this line of argument is less significant for the question of naming than the relation staged in Duchamp's work between the Readymade, the supplement, and the title. Ziff quite ignores the fact that the second of Duchamp's supplementary additions to his reproduction of the *Mona Lisa* was the scatological title *L.H.O.O.Q.* (1919, fig. 57).

Similar refusals and further problematic delimitations characterize one of the few focused critical-philosophical discussions of the title, John Fisher's "Entitling" (1984).[34] Looking over to books and music, as well as to paintings and other works of visual art, Fisher begins his discussion by ruling out three crucial classes of title which he claims are of only modest "theoretical interest":

> [s]elf-referring inscriptions, titles chosen exclusively for economic reasons [or "merchandising purposes"], and humorous labels ["frivolous titles, puns or jokes"] constitute a very small class of titles. They are the exceptions; to consider them as standard would distort the serious investigation of the conceptual problems.[35]

The acceptance only of titular examples that fit the author's predetermined notion of relevance reduces the field of titles for modern artworks to virtual meaninglessness. Fisher's closures could almost be inverted: for it is those titles that subvert the ordered function of designation that reveal the real shape of the titling enterprises of visual modernism.

In searching for titles in the "strict sense" Fisher partly recants, and partly redoubles, his earlier stringencies. "A title in the weak sense of identifying, is," he claims, "a distinctively designative name (not merely a number or any indexical tag) which relates to the work itself – rather than to the circumstances of its creation . . . or to the circumstances of its display or performance . . . – which does not consist only of category terms specific to the medium itself . . . , and which need not in itself constitute adequate basis for distinguishing this work from every other."[36]

On the one hand, Fisher points to the hermeneutic role of the title, its function as a kind of super-name whose signifying domain extends considerably beyond "identification and designation." For him, a work with a legitimate title has already been invested with interpretative possibilities. The title stands, in effect, as a key to the understanding of an artwork. Fisher usefully points to several moments in the history of art where a change of title indicates an important shift of social and/or aesthetic value. Such was the case with the various denominations of

Velázquez's *Las Meninas* (1656), described in its first recorded mention in
1666 as *La señora Emperatriz con sus damas y una enana* (*Her Royal Highness
the Empress with Her Ladies and a Dwarf*) and *La Familia del Señor Phelipe
4°* (*The Family of King Philip IV*) in an inventory from 1734. It acquired
the name by which we know it today only around 1843. A somewhat
similar renomination was achieved by Veronese when, responding to
pressure from the Catholic Church, which objected to his sensuous
interpretation of *The Last Supper*, he simply changed the title of the
painting to *Feast in the House of Levi* (1573).

On the other hand, Fisher's concern for authentic interpretational titles
leads him specifically to relegate from consideration all numbered or serial
titles, such as Jackson Pollock's *Number One* (1948), which does "not
function as a title,"[37] and Claude Monet's *Nymphéas* (*Water Lilies*), which
is simply one instance of a putatively non-specific group designation. As
we will see later, the development, defense, and implications of numerical
and serial titles is a crucial aspect of the titular discourse of visual
modernism. Any historical and theoretical study of modern titling prac-
tices must account for this form of naming, paying special attention to the
very elements of titular production Fisher proposes to bracket or elimi-
nate: the "circumstances of creation and display."

Where Fisher falls short – and he shares this with most if not all of the
philosophies of naming or titling – is in the matter of historical specificity
and explanation. While he points to the crucial changes of title that
accompany *Las Meninas*, and notices the important historical break
marked by the titles of Whistler, he offers only the briefest speculations
about the reasons or implications of these shifts, which are, in turn, only
fleetingly described. Less convincing still are his comments on the titles of
two major works of the historical avant-garde – Duchamp's *Nu descendant ·
un escalier n°. 2* (*Nude Descending a Staircase No. 2*, 1912) and Picasso's *Les
Demoiselles d'Avignon* (1907, fig. 35). In the first instance, Fisher indulges
in a bout of the conditional speculation we encountered in Ziff, which he
compounds by generalizing the "goodness" and "badness" of particular
titles: "One cannot say that *Nude Descending a Staircase* is a true title, while
Staircase Descending a Nude would be a false title for that Duchamp
painting." It happens (as I discuss in chapter 7) that critics responding to
the exhibition of this work at the Armory Show in New York in 1913
specifically attacked its formal disruption and time-lapse seriality by satiri-
cally dislocating, rearranging, and rearticulating its title. In this very
particular sense Duchamp's controversial work *was* actually named in just
the way that Fisher puts forward as manifestly absurd, "misleading," or
"false." In a real historical sense the work *was* viewed and interpreted as
(something like) *Staircase Descending a Nude*.

As we again saw in Ziff's discussion, Fisher also neglects to mention the title itself (in this case its original name) when he brings forward Picasso's *Les Demoiselles d'Avignon*. Not only is the crucial first title of the painting (*Le Bordel philosophique* or *The Philosophical Brothel*) forgotten here, but Fisher misstates that the work refers to a street in Madrid. Most of the Picasso literature identifies the street as one frequented by prostitutes in Barcelona; while William Rubin, in the most recent study of the *Demoiselles*, suggests that reference to the French city of Avignon is more likely.[38] The sum of the insights and relegations caught up in the linguistic and philosophical discussion of titling helps suggest a location for the present project at the intersection of the exclusionary, regulatory discourse of philosophy and the contextualizations of art history: there is much to be learned from both.

Within art-historical studies, the two most extended discussions of titling in the modern period, by Gombrich and Bann, were published in the journal *Word & Image: A Journal of Verbal/Visual Enquiry*.[39] Gombrich's "Image and Word in Twentieth-Century Art" (1985) is structured around the contention that modern art has developed a dialogue with "the ideal of purity,"[40] particularly as it relates to the interaction and separation of words and images. Gombrich consistently conflates the issues of titling and the physical presence of text in the modernist image; but he offers, nevertheless, the grounds for an analysis of the titular activity by noticing that "the title is a by-product of the [market] mobility of images," that it is crucially related to the development of the "catalogue," which is claimed as the "authentic source" of the title, and that there was a notable departure in titling procedures manifested in what he terms the titular "code names" used by high modernist artists such as Wassily Kandinsky and László Moholy-Nagy.[41]

Yet Gombrich resists the production of a *history* for these developments, a close textual analysis of his particular and highly diverse examples, and in the end resists the fuller implications of the various exchanges between text and image taken on in the modernist title. In part this is because he retains a simplistic paradigm of the relation between written language and visual images: "Let me say in a rough and ready way that language can specify, images cannot."[42] The modernist title is thus interpreted as an instructional "footnote"[43] producing an informational field that can be simply mapped onto the image it governs. This mapping is constructed in a scenario of psychological interactions, according to which the title transmits a signal to the perceptual apparatus of the viewer/reader, thus altering his/her *Einstellung* or "mental set."[44] The illustration of this plea for perceptualist transmission is Whistler's *Arrangement in Grey and Black: Portrait of the Painter's Mother* (1871); but as I

discuss in chapter 4, the mentalist model established here, following the perceptualist scheme adumbrated in *Art and Illusion*,[45] can by no means account for the complexities in the economy of exchange between title and image revealed in Whistler's paintings, the range of their exhibition contexts, and the critical and personal commentaries that focused on (and beyond) this issue. In the terms of the scientistic metaphor Gombrich himself employs (the "flow of electric current from the positive pole [to] the negative pole," from title to image), we could claim that this kind of mechanistic and *a priori* logic is always subverted by feedbacks, short-circuits, and overloads. Thus, Gombrich constantly invokes "prior knowledge and experience,"[46] though only in the abstract terms of the "mental set"; for him the loss of efficiency in this positivistic model is also the loss of signification. For modernism, whether plausibly or not, this recoil, as it were, represented the onset of a new order of meaning.

As with the portrait of Whistler's mother, so Gauguin's *D'où venons-nous? Que sommes-nous? Où allons-nous? (Where Do We Come From? What Are We? Where Are We Going?,* 1897, fig. 24) is also cited to exemplify a generalized titular category − in this case the "mood-setter."[47] In chapter 3, I analyze this image and the debate around its naming partly to take issue with the drift of Gombrich's ideas, but also to suggest a number of complexities in the signification of the name that his account neglects. The grounds for Gombrich's reductionism are usually those of the "psychological experiment"; and this is as true for his study of titles as for his wider accounts of perception. Thus Gombrich proposes an experiment in relation to William Turnbull's *Head* (1957) which compares the physiognomic movements of two test groups, one of which is confronted by the sculpture titled as *Head*, the other by the same sculpture, this time called *Untitled*.

This test, of course, can have few meaningful results even in Gombrich's terms. The most it can achieve is a simple demonstration that a tested subject might read the text "head" and transfer aspects of its signification to the object it purports to label.[48] The precise nature of the processes of "matching" and "fitting" that Gombrich has elsewhere described as the mechanism of this procedure is not so much demonstrated as assumed or asserted. The title, in his view, actually takes the place of the "schema" or set of "instructions" that Bryson argues he derives from the scientific empiricism of Karl Popper: "Without the instructions that indicate *what* is to be observed, observation cannot begin, and it is just this needed set of instructions that the schema supplies."[49] The predicates of Gombrich's psychologism, the origins and the grounds of the schema itself, are always unknowable or given; there is no accounting here for the social *production* of meaning, only a cycle of

mental events. This particular bout of empiricism, then, becomes a parody of the entire pretention of psychologistic experimentalism: here the head is measured to find a meaningful measure for the *Head*.

This experiment, the electrical metaphor cited above, further metaphors invoking the molecular composition of water and the formation of "indissoluble compounds,"[50] and the detailing of a second psychological experiment (from the Gestalt school of psychology) combine to produce a kind of pseudo-scientific fortification in the text to combat the disorderly and unempirical signification of modernist images and their titles. It is in the search for system and rigor that Gombrich's perceptual art history meets the analytic concerns of linguistic philosophy. His drive for "science" evidences the inadequacy of his methodology when confronted with the apparent signifying contradictions of the modern movement. The uncharacteristic tepidness of Gombrich's summary formulations in the essay on titles – which can be gathered under a simple rubric such as "a title produces a mental evocation which combines with the image to produce a mixed, but logical and related third meaning" – is itself symptomatic of a certain failure in a method always striving for the achievement of a "new and fairly stable compound" between idea (title) and image.[51]

On the other hand, the constricted parameters of Gombrich's theory of perception give rise to a model of communication that does, in fact, challenge weak notions of psychological correspondence. Thus, when the title of a non-iconic abstract painting by Kandinsky is apparently set up to relay between a formal and coloristic assemblage and a given "state of mind" encapsulated in the title, Gombrich actively questions the sufficiency of such an exchange. The circuitry of this associative flow of ideas is for him at best faulty, at worst incapable of proper function (connection). Yet while he raises the question of broken communication in modernist abstraction, he refuses its implications by resorting to the example of a figurative *Blaue Reiter* image – Franz Marc's *Bos Orbis Mundi (Die Weltenkuh)* (1913) – whose coloristic symbolism is purportedly decoded in a letter the artist wrote to Auguste Macke in December 1910. Thus almost the only resort to documentary material in this article is ventured as something of an excuse not to prosecute the implications of the central critique[52] Gombrich is proposing.

Having laid out some questionable premises and located them in a rather vague historical context, the middle section of Gombrich's essay proceeds to extol the "uniquely poetic and imaginary quality" of Paul Klee's titles, attributing to them the kind of "magical evocation" that he has elsewhere unsystematically denied. Klee is thus allocated a sort of connotative space between the title and the image – a concession granted

because he exploited "the humorous potentialities of play."[53] Yet this brief flirtation with the free play of modernist wit is quickly foreclosed in the contention that "even the most puzzling titles in this collection [the Solomon R. Guggenheim Museum, New York] will finally fuse with the image." Where there is not recognition, affirmation, and "fit" – Gombrich invokes the psychologist once more in his positing of a category of "aha titles," those in which the impact of recognition is sudden, spontaneous, and vocal – the word-image compound is held as literally degenerate: it simply cannot bear the weight of any meaningful meaning.

Thus, while Gombrich makes a special case for Klee, going so far as to rationalize the found or group-designated title as adding "another dimension," the domain *beyond* simple rationality where "controls are abandoned"[54] is for him a domain of signifying perversion. Dreamwork, the unconscious, and sexuality (as revealed, for example, in the work of Picabia, de Chirico, and Duchamp): these coordinates fall largely outside of the Gombrichian *schema*. Accordingly, he puts to work his only major citation from recent art-historical research to demonstrate the logical travesty or "conceptual void"[55] between Picabia's titles and images (see fig. 59), stranding them outside the legitimate (i.e., verifiable, testable) flow of meaning. With the title-assisted dissolutions of Dada, the circuit is finally broken. Gombrich provides, therefore, a coda to his remarks in the course of which certain Surrealist titles are rescued into the beatitude of "reference" and "description" under the special designation "'oho' titles." In this rather extraordinary manoeuvre "the text of Freud" is offered as one stable ground of reference (although why is not explained); and Miró's *Photo: Ceci est la couleur de mes rêves* (*Photo: This Is the Color of My Dreams*, 1925, fig. 64) is described as communicating "a private experience . . . in a perfectly rational way"[56] (though how it is "perfectly rational" is likewise unconsidered). The essay concludes with a one-paragraph summary of some later twentieth-century art movements in which Gombrich cites titular examples from Abstract Expressionism to Saul Steinberg.

Bann's "The Mythical Conception Is the Name: Titles and Names in Modern and Post-Modern Painting" (1985) sets out by challenging (implicitly at least) Gombrich's perceptualist account of modern titles and his anxious drive for "connectivity." Bann underlines the relativism that potentially obtains between an image and a title, even in the pre-modern period: the title cannot always be assumed to reveal the "identity" of a painting. He proposes two "disparate" methodologies as possible modes of enquiry about the title: these are "*historical*" and "*semiotic*."[57] The former approach would be archival, dealing with "wills, inventories,

auction catalogues, salon lists . . . critical reviews, journalistic notices and personal papers of artists"; the semiotic approach would operate "outside the diachronic flux," concerning itself with "the specific character of the title as sign."[58] Observing that an adequate methodology should, in fact, take on a "convergence of history and semiotics," Bann announces his own project as a demonstration of the passage of the modern title from its condition as a "replica" or "label" to its function as a "sinsign," that is, as the work's "being as a sign." According to Bann, this passage fulfills "a certain logic of development which is inscribed in the history of Western painting."[59]

The theoretical effort here to accommodate both historical and semiotic analyses in any understanding of the title is a useful corrective to Gombrich's evacuation of both context and detailed analysis in favor of the reported (and, we might add, interpolated and imagined) experience of the perceiving subject. It also introduces an analytic vocabulary, occasional, focused discussion, and an awareness of the signifying positionality of the image in relation to a range of supplements and frames.[60] Bann develops a semi-chronological account which privileges his identification (following C.S. Peirce's semiotics) of the triumph of the "sinsign" over the "indexical legisign." This promotes a teleological reading in which so-called "post-modernist" titles fulfill their modernist predecessors as well as being anticipated by the literary nomenclature of Marcel Proust in the early twentieth century. Yet, even a history of titles that attends only to the products of the certified avant-garde at any given historical moment will not reveal a sequential or developmental strategy. I would contend that the nomination of artworks after the later nineteenth century proceeds in a series of spirals, loops, and cross-overs based on the three dominant titling modalities discussed below. These strategies are not, therefore, *arborescent* (they do not unfold like a tree-diagram);[61] rather, they always bear traces of the history and the debates in which they were formed as strategies.

Despite his deference to the smoothness of its trajectory, Bann's identification of a "polysemic" counter tradition to conventional (indexical) academic denomination reveals that the signification of titles was a matter of critical investment and dispute before the mid-nineteenth century. However, the point at which *Invisible Colors* commences, the Impressionism of Monet, appears as a weak link in Bann's semiotic narrative. Claiming that Monet overloaded the "title as legisign," Bann concludes that "what emerges from inspection of this influential work [*Impression, soleil levant (Impression, Sunrise*, 1872, fig. 15)], perhaps, is the recognition that it is a sunrise because Monsieur Monet says it is." It is precisely through the crucial space between Monet and the Cubists (the point at

which Bann next picks up his sequence of examples, following a glance
at the 1883 Salon [sic] des Arts Incohérents), that the present study
attempts to anchor its own theoretical and documentary history.

Moving from Cubism to Kandinsky to Dada and Surrealism, Bann's
overview of high modernist titling appears at times to make recourse to
"model and match" theories not dissimilar to Gombrich's. He writes of
Kandinsky's titular "initiations" of the viewer, and of Duchamp's titles as
both "vehicles" or "handy lifebuoy[s] with which to haul ourselves out"
of a "hermeneutic circle" and as "ridiculing" the indexical capacity of the
title.[62] Like Gombrich, Bann centers his essay on the titular "resourceful-
ness" and "intelligence" of Klee, though in citing Hubert Damisch's
elaborate article on Klee's *Gleich unendlich* (*Equals Infinity*, 1932),[63] he
signals his distance from the suggestive yet simple "poetic mapping"
between title and image attempted by Gombrich. Bann hints – again like
Gombrich – at the necessity for a more detailed study of the phenom-
enon of the untitled work. Yet instead of attempting this, he concludes
by producing a theory of postmodern nomenclature based on an under-
standing of the name as "a mythical conception" that issues in a return to
its "psychological functions."[64] This conclusion is accompanied by only
three examples. It also somewhat confounds the condition of the title
with that of the content of the image. Thus, while it might be said to
point to a particular aspect of recent visual-textual practice, it is certainly
inadequate to designate any general activity of postmodernism. It is also
unclear whether the proposed titular psychologism of recent visual prac-
tice is pre-occupied with self-representation or with the representation of
a mythic figure. If the latter is the case, as Bann's final paragraph seems
to suggest, then it remains unclear how any such mythic figure could be
(re)-psychologized.

Neither the philosophical quest for a nominal or titular rule-system,
Gombrich's preoccupation with psychology, nor Bann's semiotic theory
provide adequate paradigms for a full understanding of the modern title.
Nor, again, is their synoptic scope conducive to the kind of detailed
historical or theoretical analysis specifically called for by Bann – though it
is uncertain whether such a dual agenda can ever be satisfactorily fulfilled.
Responding to the suggestions and gaps in these accounts, and supple-
menting them with the insights of contemporary critics, *Invisible Colors*
will concern itself with the decisive moments in the history of titling
from the 1870s to the 1920s, and then examine their development and
deformation in the mid- and later twentieth century.

Reckoning with the Title and Its Sites

What happens when one entitles a "work of art"? What is
the *topos* of the title? Does it take place (and where) in
relation to the work? On the edge? Over the edge? On the
internal border? In an overboard that is re-marked and
reapplied, by invagination, within, between the presumed
center and the circumference? Or between that which is
framed and that which is framing in the frame? Does the
topos of the title, like that of a *cartouche*, command the
"work" from the discursive and juridical instance of an
hors-d'oeuvre, a place outside the work, from the exergue of a
more or less directly definitional statement, and even if the
definition operates in the manner of a performative? Or else
does the title play *inside* the space of the "work," inscribing
the legend, with its definitional pretension, in an ensemble
that it no longer commands and which constitutes it – the
title – as a localized effect?

> – Jacques Derrida, *The Truth in Painting* (1978)[1]

I Poetic Intensity and Social Extension: Expanded Fields for the Title

The philosophy of the name and the history of the title provide an
important set of vantage points and commencements. The "identical
character of the proper name,"[2] associated with the narrow, edifying
nominalism of Plato's Cratylus, has been challenged many times, and in
many ways, in the Western philosophical, literary, and critical traditions.
I want to introduce here a number of *intensive* and *extensive*
understandings of names. These are ideas about their dislocating effects as
prismatic fragments of language which bear profound implications as
names mark, delimit, take over, underscore, or destabilize social, geo-
graphical, political, and ethnic environments. I want, in other words, to

underline various formations of power as they are caught up in the signification of names and titles.

In "Proust and Names" (1967), one of the most suggestive refutations of the name as an *identity*, Barthes reminds us that "the proper name is also a sign."[3] For Proust the Name-sign is a special word, invested with a powerful "semantic density" or "hypersemanticity," whose laminar depths enclose a "monstrous" extension: "the name . . . immediately covers everything that memory, usage, culture can put into it; it knows no selective restriction."[4] Barthes finds sanction in his reading from Proust's own identification of figures in the Name, and goes on to uncover the "semic specter" of each Name, how it is "in effect, *catalyzable*; it can be filled, dilated, the interstices of its semic armature can be infinitely added to."[5] Part of the "armature" thus articulated includes the generation of "scenes" and "little narrative[s]"; another encompasses the detection of "phonetic symbolism" as the Name's sounds are opened up to elaborately tropic associations. Finally, the structure of the Name is held to:

> coincide with that of the work [Proust's] itself to advance gradually into the Name's significations (as the narrator keeps doing) is to be initiated into the world, to learn to decipher its essences: the signs of the world (of love, of worldliness) consist of the same stages as its names; between the thing and its appearance develops the dream, just as between the referent and its signifier is interposed the signified: the Name is nothing, if we should be so unfortunate to articulate it directly on its referent . . . i.e., if we miss in it its nature as *sign*.[6]

As often with Barthes, the concept of the sign is operative here in its most extensive sense. Within a literary context, at least, his essay offers a useful way of thinking the density of the name, how its shape and texture precipitates from the textual narrative an iconic surplus colored with memorial, and other subjective, particularities. The Name-sign weaves a gauze of supplementary meanings over the indexical conditions of the proper name. It does not just stand for, it also *stands in* for. The name is thus a highly mediated sign, carrying with it, even in its most apparently denotative instances, a flourish of differently layered associations that cannot be channeled into a unitary referent.

Benjamin also thought through the "reality [that] oscillates between name and image." Peter Szondi notes that for him "[t]he tension between name and reality, which is the origin of poetry, is only experienced painfully, as the distance separating man from things." For "[t]he name . . . creates its own reality. . . . Many pages of Proust's novel are devoted to this same theme, which already appears in the Romantic

writers and which is revived by Benjamin."[7] So when Benjamin put forward several "golden rules" of journalism in his *Moscow Diary* (1926–27), he appears to have anticipated, and even extended, the disruptive logic of the proper name attended to in literature by Barthes. Two of these rules focus on the special cultivation of meaning gathered from the name. "An article," he claimed, "should contain as many names as possible"; and the writer should "[u]se the fantasies that a name generates as the background for a description that represents it as it really is."[8] For Benjamin the name was a point of light in a universe of "magic encyclopedias." Both Barthes and Benjamin concede the function of the name as a concentrate or punctum, but both are rather more concerned with the ways in which its densities are unraveled and recirculated. The name is like a coiled spring, packed with sudden latent energies that can emerge in unsuspected vectors. This is one of the many premiums of the name that carries into the title. Brevity, concision, taut energy, latency, genealogies, "desire, perhaps even . . . bliss"[9] – we will find all these loops of the spring coiled around the name. Any encounter with the titled image begins with the release of these powerful, sometimes unstable, titular energies. Even in the denotatively captioned work, the name of the image is not just a buffer that stands in the way of second-order meanings and allusions; it is, in fact, its first detour into signification.

So, while the prismatic nature of the literary Name-sign is very differently situated than its pictorial equivalent – especially because its vibrational depth is grounded in a field of words, letters, and sounds that also constitute its own signifying materials – we will find that the brilliant scattering of semes from the concentrated stratum of the name that Barthes describes as consciously operative in Proust is no less complexly encoded, and often no less knowingly deployed, in the titles of modern paintings and sculptures.[10] In this expanded field, however, we will be addressing not just the Name, but the title-as-Name, the hyper-semanticity of titles, their little narratives, their connotative excess, and their zero conditions. We will even find the means to enlarge and dispute the *poetic* function of the name, which Barthes several times asserts as taking literary, mythic precedence over the appearance of words in "dictionaries" or in "common usage."[11]

There is other useful evidence of the critical possibilities suggested for nominal signification by Barthes and Benjamin. I want to bring forward two examples: Craig Owens's discussion of the "improper names" of the German artist Lothar Baumgarten (see fig. 2) and Paul Carter's *The Road to Botany Bay* (1987), a cultural geography of the "discovery" of Australia whose opening pages develop counter-methodology based on the social and cartographic discourses of the name. Carter writes of the "*cultural*

2 Lothar Baumgarten, *America Invention*, 1985 [1988–93], detail. Solomon R. Guggenheim Museum, New York, 28 January–7 March 1993

place where spatial history begins: not in a particular year, nor in a particular place, but in *the act of naming*. For by the act of place-naming, space is transformed symbolically into a place, that is, a space with a history. And, by the same token, the namer inscribes his passage permanently on the world, making a metaphorical word-place which others may one day inhabit and by which, in the meantime, he asserts his own place in history. It is not, then, at Botany Bay, or anywhere else, that this history begins, but in the name."[12]

For Owens the nominal inscriptions focusing the work of Baumgarten – which include the names of South American indigenous peoples, flora, fauna, and rivers – take part in "what Jacques Derrida calls the *anthropological war* . . . a war that begins with 'the battle of proper names.'"[13] As in Carter's account of the discovery of Australia, Owens suggestively contends that "linguistic" and "semiotic warfare" is as important to the articulation of the New World as armed conflict and material despoilation. "Thus 'Venezuela' [little Venice, so named in 1499 by Amerigo Vespucci, whose own name is now borne by the entire continent] is inscribed within a system of cultural associations and values – mercantilism, cosmopolitanism, Christianity – that is entirely foreign to it,

and henceforth its name will testify to, but also cover over the traces of, the violence implicit in this – or any – historical act of denomination."[14] Referring to Tzvetan Todorov's *The Conquest of America* (1982),[15] which offers an account of what Owens describes as the "nominophilia" and "baptismal frenzy" of Christopher Columbus, he goes on to dispute Todorov's relegation of the *violence* of colonialist naming, and the active, catastrophic erasure of indigenous history it brought about. Within this scene of nullification and replacement Baumgarten's names are "restorative" gestures and "memorials" to acts of genocide and cultural obliteration. Importantly, the native name is not the only titling inscription made by Baumgarten. In his counter-ethnographic "documentary" photographs the defiant, non-Western signification of these local terms is associated with another practice of naming that stands as the necessary opposite of single-word, indigenous proper names. This is located in Baumgarten's provision of "narrative captions designed to counteract the ethnographic tendency to deny both subjectivity and historicity to the Other."[16] Such textualization of the photograph is a gesture of de-isolation that reinscribes the image with contextual information – much as Barthes determined for the press photograph.[17]

Baumgarten's provision of unitary, indigenous names, and lengthy explanatory captions, meets yet another destiny of titling practice that will be of concern in the pages that follow. This is the explicit reckoning of his small and large names – and their denotative and connotative fields of signification – with institutional and cartographic *locations*, and the means by which they were constituted. The power of Baumgarten's names, and the social criticality of his visual-textual field work, are such that when the Museo de Bellas Artes in Caracas, Venezuela, commissioned their inscription on the museum, in the courtyard, and on the façade of nearby public buildings, the catalogue and the installations were subject to censorship. This collective project, Baumgarten's "imaginative geography of proper names," deployed the name, the caption, the inscription, the catalogue, and the para-institutional installation to contest the "discovery, conquest, colonization, exploitation, indoctrination, study, and representation – in short the *invention* of 'Venezuela' by and for the European imagination."[18] Looking back from Baumgarten's layering of nominal and social spaces, and forward to my conclusion, we will find several other crucial instances of the disruptive power of the name and the irritations of the title, as they work to undermine the institutional, catalogic, and public spaces of the nineteenth- and twentieth-century art worlds.

Conjugating the name with social and colonial history, and with the inscription of military and institutional power, opens up a signifying space for nomination at once vastly different from, but also complementary to,

Barthes' subtle communings with poetic and phonetic connotation. Owens's otherwise stringent essay takes brief note of such an overlap when he concludes that Baumgarten "is also offering an alternative (poetic, mythic) experience of the landscape as invested with significance."[19] Following a movement that Barthes himself negotiated, this study will insist that the poetics of the name be read across a social history of titles. While I do not pursue the counter-colonialist implications of the restitution of erased or transformed names beyond this brief discussion of Baumgarten and European expansionism, it is in such critical practices and in works like the Names Project quilt – which commemorates named individuals who have died of AIDS – that the most immediate and powerful contemporary discourses of the name are played out. It is not a coincidence that these and other projects of social visualization have returned to the site of the name, in order to reinvest it with the kind of identities, empowerments, and memorial values spurned by the dominant counter-nominal discourse of modernism. Baumgarten and the Names Project remind us that there is much more at stake than aesthetic proclivity in the choice to eliminate names and refuse titles.

If Barthes, Owens, and others have renovated the theory and practice of the name with reference to language and sociality, helping us to identify the spirals and folds of this special moment of abbreviated textuality, we must also pay attention to what might be termed the diminishment and relegation of the name, and the consequences that attend it. Many artists, critics, and historians have responded to the question of the title, not by acknowledging it as a privileged linguistic zone, or as a powerful negotiant filling in the space between the image, institutions, and the public, but by ignoring it, or actively counting it out in the contra-Barthesean belief that the title is preliminary, unitary, and semiotically impoverished. Typical of this suspicion is the de-dramatization of the title that characterizes even those monographs, catalogues raisonnés, and historical surveys that touch on the movements and issues collected in the present study. An example of the conceptual suspicion fueling such relegations is the citation from (the skeptical) Wittgenstein in Donald Kuspit's discussion of what he terms the "Wittgensteinean Aspects of Minimal Art":

> For, naming and describing do not stand on the same level: naming is a preparation for description. Naming is so far not a move in the language-game – any more than putting a piece in its place on the board is a move in chess.[20]

With Duchamp as a key witness – for both chess and language – *Invisible Colors* contends against this kind of disparagement of the title and the name, which we have already encountered in Fisher's essay on

"Entitling." But it is not written to suggest a kind of positivist substitute that simply accumulates evidence to counter Kuspit's Wittgenstein-assisted dismissal of naming. The destinies of the title are rather more critically – and historically – subtle than this. I will claim that the exercise of ignoring or debunking the title is actually incorporated as a strategy of naming. For there is no neutral name; there is only the assumption of or desire for neutrality, which, in turn, gives rise to a discourse of nominal withdrawal.

Once more Barthes can help us to recognize the peculiar imperatives of the name. For, in addition to his attention to the engorged, poetic signification of the Proustian name, he also examines the more general production of "writing degree zero," a categorically modern condition of textuality in which the word is suspended between transparency and autonomy, encyclopedic fullness and silence, depravation and reduction. According to Barthes, the site of the name meets the degree zero in a conjunction with important implications for the title: "[U]nder each Word in modern poetry," he writes, "there lies a sort of existential geology, in which is gathered the total content of the Name." The consumer of such writing, he continues, "encounters the Word frontally, and receives it as an absolute quantity, accompanied by all its possible associations."[21] Barthes' reflections not only imagine a relay between the two extremes of titular signification I want to bring forward here, but also enable the contradictory profile of the title to emerge in its double condition as the simultaneous absence and fullness of *writing*. The title, like the Name, is a special text subject both to the immediacies of a frontal encounter and the delays of cultural tradition, which weave it into unique, multi-dimensional webs of signification.

II Zero Names: "Absences and Over-Nourishing Signs"

Abstraction is everybody's zero but nobody's nought.

 – Robert Smithson, "Some Thoughts on Museums" (1967)[22]

. . . a discourse full of gaps and full of lights, filled with absences and over-nourishing signs, without foresight or stability of intention . . .

 – Roland Barthes, *Writing Degree Zero* (1953)[23]

Barthes' degree zero can introduce a leading titular extreme that frames this study: the phenomenon of the non-name, of untitling and the "zero economy." I will return several times in the chapters that follow to the

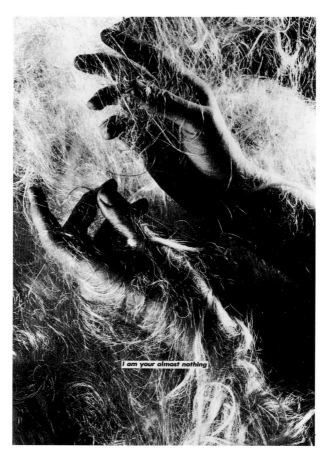

I am your almost nothing

3 Barbara Kruger, *"Untitled"*
(I am your almost nothing), 1982.
Photograph, 182.9 × 121.9

elaborate de-specificities proposed under the withdrawals suggested in the
zero (see figs. 3,4,6). While not primarily concerned with the problem of
titling, there is at least one extended account of the zero economy, Brian
Rotman's *Signifying Nothing: The Semiotics of Zero* (1987),[24] which can
serve as a point of departure. Rotman attempts a quasi–Foucauldian
"inquiry into the nature of zero in terms of its semiotic character and the
systemic, structural, paradigmatic relations it enjoys as a *sign* among other
signs and signifying patterns." His claim is that "the introduction of *zero*
in the practice of arithmetic, the *vanishing point* in perspective art, and
imaginary money in economic exchange . . . are three isomorphic
manifestations . . . of the same signifying crisis." For "[i]n all three codes
the sign introduced is a sign about signs, a *meta-sign*, whose meaning is to

indicate, via a syntax which arrives with it, the absence of certain other signs." Meta-signification is predicated on the historical emergence of a "radically different, self-conscious form of subjectivity" which Rotman terms "the *meta-subject*." The writing of this theory-history of zero across received accounts of the formation of modernity (including Foucault's) suggests that while the origin of the production of zero-economies might have been proto-modern, the three discursive "closures" to the "meta-sign of zero" identified by Rotman are located within the paradigm of modernity developed by Foucault. These closures are found in "the invention of algebra by Vieta; in painting, the self-conscious image created by Vermeer and Velázquez; in the text, the invention of the autobiographical written self by Montaigne; in economics, the creation of paper money by gold merchants in London."[25]

The disparateness of the historical articulation of both the moments of production and closure in the meta-sign of zero is such that the structural conformity of these culturally divergent signifying nothings is extremely difficult to defend – outside of exhaustive comparative research. Yet Rotman's identification of how zero economies may be crucially caught up in the discursive formation of modernity points to the usefulness of more focused projects which would attempt to make good the critical and historical densities he necessarily suspends. There are several important propositions that we can build on here: that the zero economy was fundamental to aspects of the development of modern financial, mathematical, and pictorial systems; that such systems underwent a form of crisis and modification during the post-Renaissance period; and that they contributed to the production of "meta-subjectivity."

What Rotman identifies as the systematicity of the zero is encountered from another position by Stephen Kern, whose discussion of the culture of time and space in the years around 1900 includes a discourse of "positive negative space, the notion that what was formerly regarded as a void now has a constituent function."[26] Kern links this new spatial understanding to a set of geopolitical and social correlates, beginning with the perception of an end to the finite geographical space of the world in the colonialist and frontier imaginations of the West. But his breathless conjunction of "constituent negativities" in "physical fields, architectural spaces, and town squares; Archipenko's voids, Cubist interspaces, and Futurist force-lines; theories about the stage, the frontier, and national parks; Conrad's darkness, James's nothing, and Maeterlinck's silence; Proust's lost past, Mallarmé's blanks, and Webern's pauses" – are also associated with the "progress of political democracy, the breakdown of aristocratic privilege, and the secularization of life."[27]

Within these broad theoretical, social, and pan-cultural horizons I will

be concerned only with the destiny of one small, but significant, aspect of the zero economy in the naming of visual art objects in the later nineteenth and twentieth centuries. While predicated on withdrawal and attenuation, this economy is certainly constituent and not merely absent or void. That it participates in a much wider historical negotiation of similar questions is a useful possibility to which this study will on occasion return. It is also the case that the gestures of denotative, and eventually nominal, refusal I discuss below are at the same time refusals of an old order of discourse and the values of transparency and classical referentiality associated with it. Otherwise this study will not be concerned with the kind of macro-history that subtends a particular practice in a list of a dozen or more structurally congruent tendencies operative in one supposedly homologous moment. Instead I want to investigate the problematic of the non-title in relation to the super-title, and to a quasi-chronological weave of theories and practices that reveal the contradictory historical development of visual nominalism.

The relation between zero and the name is occasionally addressed by Rotman, but would appear to have a significance beyond these asides and subsidiary arguments. Indeed, the site of the crisis engendered by the appearance of the meta-sign is really a crisis in naming. For what commences with the onset of the "secondary manufactured description" predicated on different forms of re-presentation is the end of a regime of knowledge bound to "naming, pointing, ostending, or referring relation[s]." In this sense "zero is a sign about names." Furthermore, when Rotman addresses the "secondary meta-sign" system of Velázquez and Vermeer, claiming it as a site of the production of signs about picture signs, or, in Foucault's terms, a place where "representation undertakes to represent itself," he does so by pointing to the "understandabl[e], but incorrect" translation of "Vermeer's title, *Di Schilderkonst*," as *The Artist in his Studio*. What Rotman claims as an acceleration in conceptual abstraction and an accompanying reduction in denotative names is managed by "a new self-conscious subject, the meta-subject, able to *explicitly signify* this loss in the discourses of number, vision, and money."[28] We, too, will look over to titling as linguistic explanation (and obfuscation), and to its calculated absence – where its surrogates are zeros, "number," "vision," and the "market."

In his introduction Rotman points to evidence from titles as a kind of proof of the relevance of his project. In answer to the question whether "outside of elementary arithmetic and computer binarisms," the zero carries any "contemporary intellectual or cultural charge," he responds that "[i]f titles of artefacts, intentional and proclamatory as they are, are anything to go by the answer seems to be yes."[29] *Invisible Colors* is

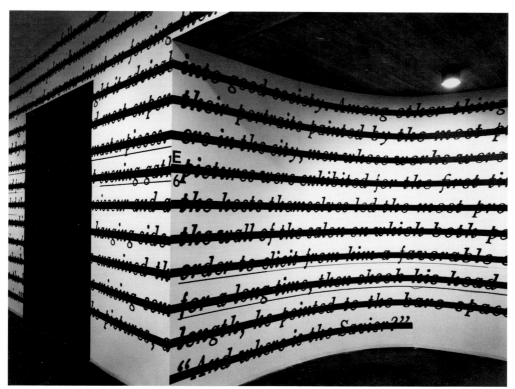

4 Joseph Kosuth, *Zero and Not*, 1987. Whitney Biennial installation view. Offset print on paper with colored tape. Photo: Dorothy Zeidman Courtesy Leo Castelli and Sean Kelly

concerned with the wide range of implications brought forward by this "yes." For the zero-title represents a carrying-over into the protected pictorial domain of some of the implications of meta-subjectivity. But it also represents one of the extremes of counter-nominalism, the claim that the world is not made up of nameable objects, but of visual perceptions opaque to names and language alike. In relation to the historical series proposed by Rotman, the present enquiry would be the endgame of the meta-condition of the zero he identifies as bracketing the discourses of economy, mathematics, and visual representation from the thirteenth to the seventeenth centuries. As with the production of meaning from proper names and rigid designators, which has been so effectively problematized by Barthes and Benjamin, so the "semiotics of zero" also enfolds strategies and meaning systems far more complex than our conventional understandings of absence and nullity can contain.

Rotman's then will be another methodological point that marks the theoretical development of this book. But I want to insist that these are only partial inscriptions, for the wide-angled historical imagination of Rotman, the intermittently de-socialized poetic metaphoricity of Barthes,[30] and the textualist stringency of Derrida are each insufficient to underwrite a project that to art history might appear too broadly based, to critical theory too historical, and to poetics too unindulgent in the sign itself.

Let me briefly follow the destinies of the zero economy of untitling as they are folded around several moments in twentieth-century art. Just as the theory and practice of the Symbolists issued in two seemingly contradictory responses to the cultivation of symbolic mystery – silence and reduction on the one hand, and the allusive, poetic hyper-reference of elaborate titles and obscure connotation on the other – so the afterlife of these responses were reinflected along similar lines first by the avant-gardes of the early twentieth century and then by the post-World War II neo-avant-gardes.

One of the earliest and most sustained articulations of the "negative intensity"[31] of the zero-economy is associated with the theory and practice of Kasimir Malevich (see fig. 5). Here, it is caught up in what might be described as the emotive transcendence of formal nihilism. At the beginning of his tract "From Cubism and Futurism to Suprematism: The New Painterly Realism" (1915), Malevich writes: "I have transformed myself *in the zero of form* and fished myself out of the *rubbishy slough of academic art.*"[32] Malevich establishes his anti-academic zero-form with reference to a version of the pictorial past that disputes the traditional notion of composition. Thus, he rails against classical artists such as Michelangelo, claiming that "their composition should not be considered a creation," and that "composition rests on the purely aesthetic basis of niceness of arrangement":

> For art is the ability to create a construction that derives not from the interrelation of form and color and not on the basis of aesthetic taste in a construction's compositional beauty, *but on the basis of weight, speed, and direction of movement.*[33]

Malevich has aligned an insistence on counter-institutional space, and a refutation of received notions of composition, as the key negatives behind his positive terms, which are located in "the zero of form." The new Suprematist values were predicated on "the creation of painterly forms as ends in themselves." Yet, mysteriously, the zero-form becomes an expression of total form, while counter-composing is imagined as a function of hyper-compositionality. The zero-form will be made up of

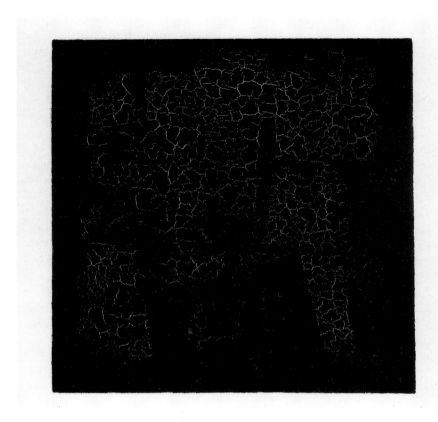

5 Kasimir Malevich, *Quadrilateral (The Black Square)*, 1915(?). 80.01 × 80.01 (given as 79.6 × 79.5). State Tretiakov Gallery, Moscow

new "forms [that] will not be repetitions of living things in life, but will themselves be a living thing," forms that will be constructed "out of nothing, discovered by intuitive reason."[34] For Malevich, previous art forms, such as Cubism and Futurism, provided for so many "distortions," even "to the point of disappearance"; but such distortion "did not go outside the bounds of zero":

> I have transformed myself in the zero of form and through zero have reached creation, that is, suprematism, the new painterly realism − nonobjective creation.[35]

The chief symbol of the Suprematist zero is the square, which Malevich understands simultaneously as "the face of the new art" and its new figure

for the cipher. The face-square-circle is the matrix of symbolizations that stand for the year zero of form he proclaimed.

This promulgation of a transdimensional "zero of form" is just one of several manifestations of reductive nominalism associated with the historical avant-garde. We can find another, very differently predicated, example in the parodic nihilism of the Dada anti-artists. Thus, in his account of the founding mythology of the naming of the movement, Richard Huelsenbeck describes the random selection of the name "dada" from a German-French dictionary: "'Let's take the word dada,' I said. 'It's just made for our purpose. The child's first sound expresses the primitiveness, the beginning at zero, the new in our art. We could not find a better word.'"[36]

In the same vein, Duchamp refers to "the 'blank' force of Dada,"[37] while Tristan Tzara noted in his "Lecture on Dada" (1922) that "[e]verybody knows that Dada is nothing," a trope he repeated in various disguises throughout his lectures, poems, and agitations.[38] Duchamp also remarked on the strategies of decomposition invested in Dada, a notion that serves as another of several important antitheses to the theories of composition discussed in the following chapters on Mondrian and Kandinsky, and on the strategies of neo-composition and de-composition in the post-World War II period.

In both recent and contemporary attempts to understand the signification of the Abstract Expressionists, a version of the zero economy returns as a critical strategy which offers a transcendent reckoning with the content-level of Abstract Expressionist images. One of the best known of these strategies, initiated by Barnett Newman and Mark Rothko, is underwritten by a rehabilitation of the sublime. Newman's association of the sublime with "the exalted" and with what he terms "the absolute emotions" bears a superficial resemblance to Malevich's earlier emotive absolutism. Certainly, both artists articulated their zero-economies in relation to a string of reductions and denials that blank out the traditional iconographic and compositional "devices of Western European painting." Newman lists these "props and crutches" as follows: "We are freeing ourselves of the impediments of memory, association, nostalgia, legend, myth, or what have you."[39] As we will see in chapter 8, many of the key interpretations of Abstract Expressionism turn on the oppositional visual-textual semantics of two key discourses. These are, first, a theory that proposes the image as the home for a kind of sublime "self-evidence" of "revelation" (these are, again, Newman's terms), which is associated – though not exclusively or unproblematically – with titular restraint and non-nomination. At stake here is a practice of image-making associated with the creation of a pictorial world *ex nihilo*. The artist "is handling the

chaos of a blank picture plane."[40] Second, and in contrast, is the perpetuation, particularly in the work of Willem de Kooning, Adolph Gottlieb, Pollock, and the early Rothko, of a meaning system still deeply invested in the types of mythological and memorial association denounced by Newman. Many, though by no means all, paintings accounted for under this theory are endowed with titles suggestively "colored" in ways similar to the multidimensionality of the Proustian Name (full of "memory, usage, culture") argued for by Barthes.

In the generation following Abstract Expressionism, the zero-form and the "metaphysics of nothing" are first ironized by the parodic negativity of Reinhardt or the "anti-form" gestures of the Neo-Dadaists and then formalized in the reductive conjugations of the Minimalist object. Reinhardt's status as the "black monk" of abstract reductivism is a kind of neo-avant-garde recto to the historical avant-garde verso represented by Malevich's magnification of absence and blankness. Robert Smithson made the connection explicit, claiming that the "nullification" of Robert Morris (see fig. 82) and other Minimalist artists "has re-created Kasimir Malevich's 'non-objective world,' where there are no more 'likenesses of reality, no idealistic images, nothing but a desert!'"[41]

Another switch in the experimental art of the 1950s between Malevich's emotive zeroing and Reinhardt's iterated negativity is found in Piero Manzoni's troping of the non-color white in his "Achromes" (fig. 6), a collective title inaugurated in 1957, which signified his interest in:

> rendering a surface completely white (integrally colourless and neutral) far beyond any pictorial phenomenon or any intervention extraneous to the value of the surface. A white that is not a polar landscape, not a material in evolution or a beautiful material, not a sensation or a symbol or anything else: just a white surface that is simply a white surface and nothing else (a colourless surface that is just a colourless surface). Better than that: a surface that simply is: to be (to be complete and become pure).[42]

Less insistent versions of such concerns are returned in many of the standard accounts of Minimalism, including Barbara Rose's article "A B C Art" (1965). Such texts emphasize Minimalism's "blank, neutral, mechanical impersonality . . . stripped of incident, accident, or anything that might distract from the subtlety, the efficiency, or the clarity of the all-over effect."[43] Rose also writes of conditions of "emptiness, repetition, and uninflection," and of Minimalist arrays of "big, blank, empty things." Apparently proposed as early as 1960, in a manifesto intended for publi-

6 Piero Manzoni, *Achrome*,
1959. Gesso on canvas, 65 ×
65. Courtesy Hirschl & Adler
Modern, New York

cation in La Monte Young's *An Anthology*, Robert Morris referred to his
scalar objects as "Blank Form sculpture."[44]

It might be said that Reinhardt and the Minimalists prosecuted the
fantasy of Clement Greenberg's formalist evacuationism, that they know-
ingly staged the muted spectacle of the implosion of form he mordantly
dreaded.[45] Less cocooned in unknowable irony than Reinhardt, zero
definitionality, and its concomitant erasure of form, was a common
gesture among the post-formalists of the mid and later 1960s. Agnes
Martin, for example, writes of her grid paintings that they "have neither
objects, nor space, not time, not anything – no forms. They are light,
lightness, about merging, about formlessness breaking down form."[46] Mel
Bochner, reviewing the "Primary Structures" exhibition at the Jewish
Museum in New York in 1966, concludes his own mini-series of
definitional negatives with the claim: "Art no longer need pretend to be
about Life. . . . Art is, after all, Nothing," and "Invisibility is an object."[47]

Lawrence Alloway explores the implications of these claims in a 1973
essay, where he explains Martin's project as negotiating the image of "an
image dissolving":

From about 1964, however, the area of the grids extends to the edges of the canvas, making a single undifferentiated tremor of form, or a plateau of non-form, across the whole surface. By removing the internal boundaries of the grid, by which it was seen to stop and start, Martin emphasizes not the succession of the modular bits from, say, left to right, but the wholeness of the module, its occupancy of space rather than its duration in time. Accepting the format of the painting (that is, the shape of the ground) as an absolute, as we must be prepared to do in interpreting painters' ideas of space, it is possible to say that Martin's seamless surface signifies, for all its linear precision, an image dissolving.[48]

7 Joseph Kosuth, *Titled* (Art as Idea as Idea), [nothing], 1966. Black and white photograph mounted on board. © Paolo Mussat Sartor Courtesy Leo Castelli and Sean Kelly

Nothing [nuth'-ing], *s.* 1. Nada, ninguna cosa. 2. Nadería, cosa de poca entidad, friolera. 3. Estado de lo que no tiene existencia ; la nada. 4. La cifra 0 ; cero. *That is nothing to me,* Eso nada me importa. *It is good for nothing,* Para nada sirve. *He had nothing to live upon,* No tenía nada con que mantenerse. *It signifies nothing,* Eso no significa nada, nada quiere decir. *He made nothing of his labour,* Nada sacó de su trabajo.

Martin's illusive precision and rectitude of form are corraled into the service of a zero-economy that relays the center of the work to its edge in a single sweeping gesture refusing any anchorage in formal value. This center-becoming-frame in the iterated grid is the obverse to the frame-becoming-center of the shaped-canvas school. Both were unimaginable hallucinations to the formalists, as monstrous in their silent deformities as the unconscionable extrapolations and "real-world" novelties of combine paintings, Happenings, Earth art, Hyper-Realism, and, later, Conceptual art (see fig. 7). Thus, while Alloway notes that "there is all the difference in the world between a compact zone, such as a painting establishes, and a boundless field, the continuous space of the world," Martin's work also reveals an intimation of "endlessness" and provides a perceptual moment on the site of the perpetual frame in which the exteriority of the art-as-lifers meets the trans-formal evacuations of the Minimalists.[49]

Minimalism thus takes its place as one of the most defined instances of a general shift towards reduction that characterized many Western art and critical gestures in the 1960s, including Post-Painterly Abstraction, the Nouveau Roman, the critical gains of the structuralist methodology, and the much-touted death of the author. Many of the renovations of the name and the title characterizing art practice from the later 1970s, including Baumgarten's, are achieved in tacit opposition to the evacuated zero-economies summed up in Minimalism, and against the contra-visualist predicates of the Conceptual art that followed.

We have already discussed attempts by Gombrich and Bann to outline a critical history of the titular activity in the modern period. But these more general efforts are supplemented by a growing number of specific sites of research and revision – by curators, cataloguers, monographers, and in the archival work of art historians.[50] William Rubin, for example, foregrounds the convoluted history of Pollock's titles to dispute with the theory that the artist might be a kind of "Jungian Illustrator."[51]

Rather differently, Carol Armstrong's deconstruction of the Aperture monograph on the work of the photographer Diane Arbus[52] focuses on the editorial de-contexualization of her photographs of "mental retard-ates" into an untitled, numbered series. According to Armstrong this strategy assists in the dilution of the images and maps their reference back onto the artist herself. She opposes the process of untitling to the "straightforward 'documentary' title" inscribed "on the blank verso of the preceding page, each informing the reader as to physiognomic type, location (sometimes replete with address), and date," that makes up what Armstrong terms the "'Chinese Encyclopedia' principle of organization" of the monograph up to its "ending series."[53] The crucial absence of titles

for a series that concludes the publication leads Armstrong to produce a speculative title for these images — "the series might have been entitled something like *Middle-Aged Retardates, Vineland, N.J., 1970–71*" — and to interpret them as emblematic of Arbus's "*id* theory of photography" predicated on "an uncanny sort of biology."[54] Armstrong's is just one of a number of imaginary titles proposed by artists, critics, and historians to re-name works whose significations are especially complex or obtuse. As we will see, the titular re-imaginations and surrogate renominations by (or on behalf of) Gauguin, Whistler, Pollock, and others offer clues about the immense pressures that build around the name and the title in the modern period.

III Titular Transformations: "Beyond Recognition"

The history of the visual avant-garde from the 1870s has been conventionally interpreted as a cumulative series of *formal* innovations. Yet, inscribed into this lineage is a "minor" history[55] of the referential disruptions achieved by the avant-garde title. During the half century between the first Impressionist exhibition (1874) and the dissolution of the Dada movement in the early 1920s, the traditional theory and practice of the title was interrogated and reconfigured by almost every movement or tendency, and by the institutions of exhibition and criticism. Threatening the name (the title) was also to threaten the passivity and non-connectivity assumed, until the later nineteenth century, to govern and secure the relation between visuality and textuality.

While this period witnessed the most decisive contestations of the signifying territory of the title, I expand the parameters of my debate into the mid- and later twentieth century. In so doing I discuss the ways in which a history of the title is always a study of that which supplements. It is in this sense that titles face onto the wider field of other complements to the visual image. The titular supplement works with and against other forms of textual incursion and proxy operative in and around the signification of modern images. Disturbances of the name had notable consequences at the level of institutions, and for questions of gender and ethnicity. Each of the following chapters takes up one or more of these issues. In the process the supplement is returned to other positions and other questions of power and desire.

The miniature textual system of the title is complexly bound into and exceeded by other regimes of signification. This is why close attention to a "minor" system can be so useful. The restricted parameters and close focus required to locate the discourses of the name permit a glimpse of

the operationality of greater systems. It sees them from another side and offers insight into their closures and assumptions. A recurrent move of the present study is a deconstructive reading of the governing discourse of modernism itself. To some of the key propositions of this discourse, the title's supplementarity, like that of so many extras and adjacencies, was truly dangerous. At the same time it was almost perversely solicited and courted, if only to be subject to calculated refutation in the formation of in-house critical accounts, as most notably in the "new abstractions" of the 1960s.

If one of the linings of the present study is a critique of the assumptions of modernism, another, to which it inevitably relates, is a sketch of the tangled encounter of visuality and textuality as they were filtered through the art world in manifestoes, statements, reviews, and other criticism. On its own such a project would be massive and unwieldy, but using the "little text" of the title as a focus returns an outline of this encounter that I would argue is a similar reduction of the larger picture. Their attitudes to the title and its relation to the framed world of the image were crucial to the thinking of artists such as Kandinsky, Mondrian, some of the Abstract Expressionists, and to many artists working in the 1960s and later. I have threaded this discussion through two chapters organized around the titular designation *Composition*. As often in visual modernism and postmodernism, the title looks onto a key debate about the constitution of the visual field and provides a useful taking-off point for wider study. In respect of the compositional I offer a preliminary glimpse of this broader arena.

Elsewhere, I can only suggest the possibilities for further research. Most chapters use the title to raise questions of the institutionality of visual modernism. Such an inquiry runs as a sub-text from the first Impressionist exhibition of 1874 (where the title furnishes the grounds for one of the most innovative and trenchant early accounts of modernist transgression) to the self-conscious institutional critique of artists from the 1960s through the 1980s. Included in this loose genealogy of institutional disputes funded by the name are Whistler's calculated extrapolation of his musically connotative titles into the decorative parameters of the exhibition space; Duchamp's Readymade renomination of *Fountain*, which was excluded from exhibition in 1917; and the institutional vibrations of the blank (uninflected, untitled) "white cube" filled with discrepantly connotative objects, and obliged by its denotation and reduction to ignore them. I take up these questions of nominalism and institutional space in a separate, and somewhat provisional, epilogue. This is one of several concluding gestures, which, considered together, offer less a set of final arguments and instances, and more a way to understand the issue of the

title as it merges with other questions: of visuality and textuality, of the public circulation of visual knowledge, and of the representation of national-cultural interests.

The project taken on in *Invisible Colors* is part of what Craig Owens identified as the necessary transformation of "the object, the work of art, beyond recognition."[56] The *parergon* was proposed by Immanuel Kant in his third *Critique* as a name for the inessential in art (he offers as examples the pictorial frame, the costuming of a statue, and the colonnades fronting a palace).[57] While the title is not equivalent to the *parergon*, it appears as one of its symptoms and another of its causes. Thus, I attempt here not a "renovation of aesthetics," but a means of mapping a field of parergonistic knowledge which art history and criticism have for the most part ignored, suppressed, or otherwise overlooked.

The logic and functionality of the title is similar to the logic of the supplement, which Derrida addresses in his discussion of Jean-Jacques Rousseau and elsewhere, but it is not reducible to this operationality. Certainly the title functions as a supplement in the sense that it acts "[b]oth [as] an increment and a substitute, [and] it plays a compensatory role." Certainly, too, we will find that the title "comports within itself" a strategic danger, that it encodes "the possibility of perversion," and that its "vicarious nature" is often repressed.[58]

Then, again, the title takes on a relation to the image or the object in ways that resemble the supplementarity differently argued by Rousseau and Derrida for writing in its relation to speech, or of color in relation to design. But the title also crosses the grain of the supplement; and this in several ways. First, it often has an annunciatory priority or firstness that reverses the possible passivity, or secondness, of the supplement. Second, the title is the administrative interpreter of a heterogeneous agency that sometimes doubles the image, sometimes blanks it, and sometimes offers it a transgressive, connotative spin. Any of these individual functions might be described as supplementary, but together they form the horizon of a hyper-supplement.

The title is thus a code for the hyperspace of the image. It is a plateau that opens up a thousand interactive possibilities of reading, viewing, and socializing. We find the title as an identity or as an absence, as a poetic supplement and an institutional critique, and as a memorial or a detour into absurdity and non-referentiality. These possibilities are some of the branches on the critical tree that follows; but they are also little trees in their own right, grafted onto the immense forest of signs negotiated by the title.

Though Derrida's deconstructive methodology will be deployed only as is warranted in approaching particular documentary, critical, and artist-

written texts, as he notes in the citation that heads this chapter, any encounter with the question of the title raises a series of important considerations. Derrida is not alone among contemporary critical theorists in his desire to speak to the problem of the title, the name-of-the-object. Michel Foucault, for example, usefully posits a historical frame for this concern in his contention that the whole equilibrium of the Classical Order (the regimes of power and knowledge that were institutionally developed through the eighteenth century and beyond) is dependent on what he terms "the sovereign act of nomination": "One might say that it is the Name that organizes all Classical discourse."[59] Revisiting the development of visual modernism from the point of view of the title allows us to glimpse some important contestations of the Classical Order played out between visual and textual discourse.

With these theoretical provisions in mind, we must find a historical point of beginning. As Foucault notes, the problem of the name is inscribed in the development of academic order in the eighteenth century. Svetlana Alpers anticipates this order as part of her challenge to the conceptual hegemony of Italian Renaissance space in *The Art of Describing: Dutch Art in the Seventeenth Century* (1983), and points to a counter-narrative tradition of pictoriality not predicated on the window-like apertures and distantiated viewer posited by Albertian perspective theory. In her opening discussion Alpers takes on what she describes as the "stilled or arrested character" of key works in this non-narrative tradition: Caravaggio's *Crucifixion of St. Peter*, Velázquez's *Water-Seller*, Vermeer's *Woman with Scales*, and Manet's *Déjeuner sur l'herbe*.[60] While the narrative contestations of these works are quite different, Alpers has identified a proto-modern lineage of painting that elevates the sensuous immediacy of the surface over the depth of narrativized space.

Loosely governed by the model of the camera obscura, the proto-photographic descriptive imaging of the world replaces the textual predication of Italian Renaissance narrative painting with the conjugation of surfaces. In his review of Alpers's book, Louis Marin brings out a corollary of this mode of describing the world – one that has significant implications for the history of names and titling:

> As Alpers notes . . . , one remark is frequently made in critical and art-historical discourse with regard to Dutch painting, and that is that there is nothing to be said about such pictures: the picture shows exactly all that can be named; it brings all the names to its surface and its whole "substance" seems to consist in that showy and always nameable articulation of its surface or, more precisely, of the level of representation. The picture is thus a surface of description that is exactly coex-

tensive with and perfectly transparent to the descriptive discourse that
utters it and which it exhausts in a "smooth" tautology between image
and language.[61]

Marin provides two reasons – operative in two European contexts – as
to why the discourse of the title, or name, of the image was relatively
undeveloped until the later eighteenth and nineteenth centuries. In both
contexts the title was essentially redundant, a tautology that simply iden-
tified or repeated what was manifest in the image. In the Italian tradition
its signification was eclipsed by the narrative pre-condition of the biblical
text, or of the religious or secular protagonist ("a tale from antique
mythology or Christian tradition whose reference is basically a literary
text, sacred or profane").[62] In the Northern tradition discussed by Alpers
the title stood in another relation of redundancy to the image. Here, as
Marin points out by looking to Erwin Panofsky's theory of spectatorship,
the viewer "keeps his distance, draws back, and speaks the picture's title,
which is its exact description."[63]

Yet the descriptive, empirical recapturing of nature, "the act of record-
ing" is dependent on what Marin terms "the philosophical paradigm of
conventionality: each thing has its name, each thing its appearance, each
thing, *in its name and appearance*, is at once proper to itself." He challenges
the stability of the descriptive world of Dutch painting, and the philo-
sophical viability of the "figurative and nominal lexicon" it assembles, by
raising the question of changes in point of view and spectatorial approach.
If Italian paintings tended to fix the viewer at an ideal distance from the
implied narrative action, Dutch paintings refuse such stable posture, and
demand to be seen by coming closer. Moving towards the image dissi-
pates the "*nomination* of figurative 'contents,'" substituting for description
a process of "*conceptualization*." Such an approach is a metaphorical pas-
sage (from Caravaggio to Manet) to the modernism of the surface, at
which point a third regime of titular tautology is inaugurated – the silence
of the specifically "untitled" image whose materiality, form, or expressive
content is claimed as self-evident. The move against conventions of
narrativity and their replacement by a regime of describing-signs, as
discussed by Alpers and Marin, is similar to the displacement of
discursivity by the figural argued for by Bryson as the historical drift of
French painting in the eighteenth century. As Marin hints, it may also
relate to the distinction drawn by Emile Benvéniste between the larger
categories of discourse and history themselves.

We can find a more literal visibility for the issues of naming, order, and
description in the recent appearance on the art market of a pair of works
by the little-known artist E. Hiernault (or Yernault): *Still Life of a Back of*

a Painting with a Plaster Medallion of Charity and *Still Life of a Back of a Painting with a Hebrew Bookplate* (figs. 8a and b). The former is signed and dated on the lower stretcher bar "E. Hiernault 1766," the latter similarly signed and dated "E. Yernault 1766." Both paintings are "further extensively inscribed on the two labels fictively attached to the frames."[64] These images confront us with a scrupulous and astonishing absence: that of painting itself, understood as para-generic. Both simulate the behind of an unknown, unseen painting, dwelling lavishly on the materiality of the reverse. We are compelled to linger over the details of what we are never normally invited to confront: corner struts securing the stretcher; nails, tacks, and mortises; the grains and blemishes, knots and cracks, of different woods; tufts of peripheral canvas, indications of wear, tear, and exhibition – a crater's-eye-view, in short, of the tradesman verso of the commodity-image. Their various frames, supports, fixings, and canvas backs aside, both paintings are also supplied with three material and symbolic forms of supplementation, items extra to the paintings' *trompe-l'oeil* constitution and self-presentation. These are, first, a rectangle of paper calligraphically inscribed with a number (in both cases "32") and affixed at its corners with four differently sized touches of a red wax seal; second, a symbolic appendage (the plaster medallion of Charity, and a bookplate with a print of Noah and a Hebrew subscript – this last functioning as a kind of second-order title, a supplement to the supplement); and third, a label closely filled with handwritten information suggesting the unseen contents of the paintings. The labels take on a double function. They are posed both as titular surrogates and descriptive catalogue entries, offering tantalizing details about the images' religious and narrative contents, and also about their exotic ownership histories and lineages:

> One painting is said to represent the creation of the universe and the animals (possibly Noah and the Ark) and the other, the fall of Adam with Cain and Abel in a continuous narrative. The label states, in addition, that the two paintings were found in the deep forest at the foot of Mount Ararat; they may have been hung by the Turkish emperor in a spacious gallery in the Seraglio at Constantinople (along with various and sundry other objects including a box of matches used by Abraham to light the wood to sacrifice his son Isaac!). The label on the frame with the plaster medallion of Charity recounts a story of a sultana taken to a Seraglio with a guardian designated by Mohamed. A young captain then attempted to escape with her but for a chariot accident. The story's relationship with the medallion of Charity remains to be explained.[65]

8a E. Hiernault, *Still Life of a Back of a Painting with a Plaster Medallion of Charity*, 1766.
54.9 × 71.1. Private Collection

8b E. Hiernault, *Still Life of a Back of a Painting with a Hebrew Bookplate*, 1766. 54.9 ×
71.1. Private Collection

The playful conceit structuring these images folds together an assemblage of material conditions that reassert the historical and referential parameters of painting practice. An account is rendered of the hitherto invisible verso of painting. In this sense the pictorial gesture is predicated on the catalogic ordering invested in the Neo-Classical moment, which it at the same time undermines through its ineffable systematicity.

Notwithstanding the mischievous, exoticizing, parodic illusionism of Hiernault, and the titular nonconformities of artists such as Turner, it may fairly be claimed that the three modes of titling briefly identified and described above (denotative, connotative, and untitled) are historically conjoined for the first time in the practices and criticism of Symbolism. Such a conjunction, however, was anticipated by the Impressionists. For while they usually produced titles anchored according to a particular *descriptive* logic to the place from where the "impression" was taken and registered by the painter, artists such as Pierre-Auguste Renoir, Camille Pissarro, Berthe Morisot, Alfred Sisley, and, above all, Monet, experimented with the register and syntax of the title in ways that offer as emphatic a signal of the commencement of modernist visuality as the traditional emphasis on their formal and technical innovations. A discussion of the Impressionist nomenclature of Monet, will begin this critical history of modernist titling.

Monet and the Development of a Nominative Effectualism

> The Lapin Agile (also known as the Lapin à Gill or Là peint A. Gill), the Montmartre cabaret that succeeded the Chat Noir around the turn of the century, housed many celebrations, which always included Frédé, the bushy-bearded proprietor, and his unhouse-broken donkey, Lolo. A group of young artists, inspired by the author Dorgelès, there concocted the celebrated hoax of a canvas brushed entirely by Lolo's twitching tail. The resulting work, distinctly "impressionist" in style, was hung at the Salon des Indépendants with the title "And the Sun Went Down over the Adriatic."
>
> — Roger Shattuck, *The Banquet Years* (1955)[1]

> Pharmacy = snow effect, dark sky, dusk, and 2 lights on the horizon (pink and green).
>
> — Marcel Duchamp[2]

I "Explanations," Poems, and "Real Allegory"

One of the key propositions of this study is that attention to the strategies of titling and nomination reveals a subtextual history that in part parallels and in almost equal measure disputes with received, formalist-driven accounts of the origins and development of visual modernism. In this sense the practices and contexts of nomination take their place among the many kinds of revisionist art history attempted during the past two decades. These studies have had to address the question of where to begin, of what chronology (if any) to follow, and of how to mark their new grids of reference over the maps that have already been laid down. For the present project, too, there are many potential points of origin.

The work of Francisco Goya y Lucientes, for example, has often been pointed to for its decisively modern characteristics, its darkness and ambiguity, its formal and technical innovation, and its allusive conjugation of popular iconography, social comment, and satirical irreverence. As witnessed by the eighty aquatint plates of his *Los Caprichos* (1799), Goya was also the author of (or, better, the point of origin for) a startling and complex renegotiation between the image, the title, the caption, and the explanatory legend. With the exception of the first plate – a portrait of the artist – each of the eighty *Caprichos* is accompanied by a brief, quasi-allegorical title, followed by a longer "explanation" purporting to focus the nature of the satirical commentary allusively visualized in the illustration. As the explanations exist in "half a dozen or more contemporary manuscript" versions, no one of which "is clearly authoritative,"[3] any interpretation of this image-text series would depend on comparative, intertextual readings played out between the social context, the graphic image, the short title, and these alternatives.

Goya's titles for *Los Caprichos* are cited by Fisher as key examples of literal, "inscriptive" titles, often, as in *El sueño de la razón produce monstruos* (*The Sleep of Reason Produces Monsters*, fig. 9), "occupying more than 10 percent" of the surface area of the print. "In such cases," Fisher states, "titles are not given: they are elements of works, not by inference or subtle metaphor but in a most literal way. No other title fits in that way."[4] The brief titles themselves operate across a gradient of reference that encompasses several types: one-word designations – which can be nominal denotations, such as *Duendecitos* (*Hobgoblins*) or *Los Chinchillas*; general descriptors, such as *Ensayos* (*Trials*); abstractly indicative statements, as in *Volaverunt* (*They Have Flown*); suspended phrases, as in *Por que fue sensible* (*Because She Was Susceptible*); interjections, as in *Lo que puede un Sastre!* (*What a Tailor Can Do!*); interrogatives, as in *Si sabrà mas el discipulo?* (*Might Not the Pupil Know More?*); and general maxims, as in *El sueño de la razón produce monstruos*. Negotiating between the social critique that erupted in the French Revolution and the pressures of religious, courtly, and social conservatism at home, between the superstitions and common sense of Spanish folklore, and between the dream world and the real world, Goya opened up a panorama of titular spaces. The meanings that circulated within them were both passionate and intricate: they joined proverbial wisdom, popular fantasy, social allegory, political caricature, anticlerical satire, contemporary anecdote, poetic mystery, and nightmare revelation.

Goya's gestures were foundational for many later manipulations of the title, though seldom were the title and the caption subject to such a range of discursive interventions. Perhaps only the Dada and Surrealist artists

9 Francisco Goya y
Lucientes, *The Sleep of Reason
Produces Monsters* from *Los
Caprichos*, 1799. Aquatint.
Avery Collection, Miriam and
Ira D. Wallach, Division of
Arts, Prints and Photographs,
The New York Public
Library, Astor, Lenox and
Tilden Foundations

put the title to work with such bravado. Several of the artists I discuss in
the following pages take on the particular instances of naming anticipated
by Goya, including the "poetic mystery" of Odilon Redon and the
"social allegory" and "political caricature" of Honoré Daumier. Others
invent new regimes of their own: the "impressionist" titles of Monet, the
musical titles of Whistler, and the disjunct metaphoric titles of many
abstractionists working in the 1960s. Such specificity, and the elaborate
serial development in which it is staged, is one of the chief characteristics
of modernist titling. As such it stands apart from the genealogy of avant-
garde nominations, which are far more disparate and occasional. The first
tendency functions predominantly in an intertextual space, the second in
one that is more usefully termed "interdiscursive."

Looking to the origins of visual modernism, a case could be made for the importance of naming in almost every movement that retreated from history, narrative, and academic realism in the second half of the nineteenth century. Some of these moments have been anticipated by other historians. Griselda Pollock, for example, locates a crucial break in the work of the English Pre-Raphaelite Dante Gabriel Rossetti in the late 1850s:

> The paintings which mark the turning-point from 1858 onwards were increasingly devoid of narrative, relying instead on linguistic messages in the form of titles and poetry inscribed often on the canvas or frame. These word-signs serve as relays not to complete narratives elsewhere, but to sonnets, a form which establishes particular positions from which the object in the poem or painting is obliquely viewed, like Medusa's head in a mirror.[5]

According to this account, the concentration and de-narrativization espoused by Rossetti from the late 1850s resembles, in miniature, several of the central turns in the titular activity that structure my discussion as a whole (see fig. 10). The most consequential of these are contra-narrative reduction and the deliberate cultivation in the visual sign of poetic obliquity. The poetry of the title and various other forms of the para-writing it takes on will be central to the arguments that follow, especially to Symbolism, Dada, and Surrealism.

Rossetti's unsystematic commitment to the "double work of art" attempts to translate the adjacencies between textuality and visuality in several ways: by writing poems in response to paintings by other artists; by painting images that respond to poems by other writers; and, most distinctively, by writing poems appended to or inscribed in his own paintings. In a letter of 1864, he relates how he has "been thinking of some concise mottos to inscribe on the stonework round the pictures, and so suggest their purport."[6] The mutual exchange between title, motto, or poem and the associated image appeals both to the Romantic notion of a common syntax shared by painting and text, and to the idea that the text will channel or otherwise govern the meaning of the image (rather than just identifying or naming it). Elaborating on the dialogue established between picture and poem, Rossetti claims that they "bear the same relation to each other as beauty does in man and woman: the point of meeting where the two are most identical is the supreme perfection."[7] The androgynous perfection of visual-textual identity aspired to by Rossetti was a striking idea whose aestheticism was, we could say, deferred by, or delayed until, the transparent interaction between bride and bachelors in Duchamp's *Large Glass* and its attendant notes.

10 Dante Gabriel
Rossetti, *Proserpine*,
1874. 119.5 × 57.8.
Tate Gallery, London

Respecting other turns and redirections that art historians have identi-
fied in the later nineteenth century, we should look to academic painting
to establish a sense of the titular rubrics and nominal investments sanc-
tioned by the official status quo. As I have already alluded to academic
painting in France, in relation to the Salon criticism of Baudelaire and the
caricatures of Daumier, I want here to establish some coordinates for the
title as it was developed in Victorian painting.

While a preponderance of Victorian paintings are labeled and cata-
logued with brief, predictable, descriptive epithets, whose object is little
more than the identification of the subject, there is a notable counter-
current to the flow of denotations in a variety of hyper-scripted titles.
These more elaborate titles function according to several regimes of
signification. The first of these might be termed "empirical specificity":
the title, or catalogue caption, acts to underline the exactness of the
pictorial observation, and to link it with the natural appearance of
observed climatological events. As an important exception that may prove
the rule, I will consider one example in some detail. Following his tour
of Norway, Francis Danby exhibited a work in the Royal Academy
exhibition of 1841 with the title *Liensfiord Lake, in Norway* (fig. 11). The
catalogue entry supplied what seems like a quasi-scientific justification for
the accuracy of the record: *A sudden storm, called a flanger, passing off – an
effect which on their lonely lakes occurs nearly every day in autumn.*[8] This
supplement to the title can serve as a measure of the apparent similarities
and final differences that separate Impressionist from academic landscapes.
For while Danby's title contains elements of the system of nomination
that would later be developed by the Impressionists, it also carries a
number of significations excessive to the syntax and focus of Monet's
image-titles. And it also encodes a surprising reversal of the "scientific"
precision of the artist's description of his pictorial locale.

It is clear, first of all, that a Romantic subtext animates the title's
restatement of the scene. The storm is "sudden," and in motion ("passing
off" over a "lonely" lake). It also marks the atmosphere with "effects"
that can be caught up into representation by the painter. Impressionism
will strip the title of both its Romanticism and its scientism. It will also
refuse the suggestion of extended temporality encoded in such titles, the
sense of "passing" and the notion that this might be seen (or have been
seen) on another of the sequence of "every days." On the other hand, the
Impressionists will surrender their scenes and their titles to a deliberate
investment in the sumptuous, momentary sensation of a particular *effect*.
Like Danby, they will also locate this effect in terms of place. But unlike
him they will often supply a marker of temporal or atmospheric precision
that is much more powerfully focused than the seasonal "autumn" which

11　Francis Danby, *Liensfiord Lake, in Norway*. (A Royal Academy catalogue of 1841 supplies the following explanatory note: *A sudden storm, called a flanger, passing off — an effect which on their lonely lakes occurs nearly every day in autumn*.) c. 1841. 82.6 × 116.8. The Board of Trustees of the Victoria and Albert Museum, London

sounds the last note in the academic sub-caption. Finally, the Impressionists will bring the catalogue-title up against the image, in the sense that its brief text and two- or three-part syntax is constituted as an efficient titular summary not predicated on the more elaborate academic reference-system of the catalogue. The Impressionists act to capture or enclose the supplementarity of the title within the bounds of the space it labels. As we will see, while thriving on the title's deliberation, they refuse its excess.

Residual in Danby's images, and often manifest in his titles, are a number of other characteristics that separate his work from the Impressionism to come. While Danby painted many images of sunrises and sunsets, moments that in fact predominate in his landscape representations, they are often caught up in explicit reference to classical mythology, contemporary genre painting, or the Romantic sublime. These additions and emphases finally subtract the image from an Impressionist-type obsession with the temporal moment and its intense effects. One

Sunrise of 1851 is subtitled *The Fisherman's Home*; another painted six years earlier is called *The Wood-Nymph's Hymn to the Rising Sun*; while a work of 1860, later called *The Birth of Venus*, is named and narrativized in an extravagant flurry of mythological references: *Phoebus, Rising from the Sea, by the lustre of his first vivifying rays, through the drifting foam of a rolling wave, calls into wordly existence "The Queen of Beauty"*. Another of the Norway works, which Danby aptly described as "of Norway or poetical," was exhibited at the Musée Rath in Geneva in 1835 with the title *Vue d'un lac en Norvège, avant que le soleil ait dissipé les vapeurs du matin* (*View of a Lake in Norway, before the Sun Had Dissipated the Morning Mists*). Here Danby focuses his titular attention on the "vaporous" effects of the pre-solar moment. While each of these elaborations of the title serves as a kind of veil or diversion put up in front of the sun, there was at least one occasion when the intensity of Danby's Romantic vision seemed to venture beyond (rather than vacillate before) the Impressionist image. Even though the title of his oil sketch *Sunset through Trees* (c. 1855), described by one commentator as a record of "exciting landscape effects,"[9] points again to the veiled diffusion of sunlight through foliage, Danby has here painted an image of astonishing expressionist-like facture and "close-up" enlargement.

Yet there is an even more persuasive measure of the difference marked between Danby's darker paintings (such as *Liensfiord Lake*) and the Impressionist painting of light and reflections. For, despite the apparent topographical specificity of the caption-title, Liensfiord Lake did not exist. While the locale of the title might be a confused reference to "Lifjord, an arm of the Sognefijord north of Rutledal on the west coast" of Norway, the painting is an example of what Danby's contemporary, George Cumberland, described as the artist's "embellished views," which were, "like Turner's," quite distinct from the "facts" of the place. Cumberland adds a succinct explanatory note to the effect that "none else will sell."[10] Joining with imagination and memory, the title is clearly an active agent in the market-driven "embellishment" of Danby's paintings. The naming that embellishes, for the academic Danby, will soon be more completely allied with decoration to the demands of the market place, by the aesthete Whistler.

Other academic title-types can be itemized more briefly, as the images they name operate, for the most part, in decisively different representational spaces from Impressionist paintings. There was a sub-genre of Victorian image-making that established its own relation to the poetic through the cultivation of sentimental effects that were almost the opposite of the inscriptive counter-narratives of Rossetti, though these could certainly embrace their own form of sentimentality. When Sir David

Wilkie, for example, exhibited his *Grace before Meat* at the Royal Academy of 1839, the catalogue supplied a poetic adjunct in the form of an unremarkable quatrain penned by the "Countess of Blessington."[11]

A third form of nineteenth-century academic exchange between painting and title appears to have been the most extensive and probably the most popular. According to the idiom of "citational illustration," a work illustrates a passage (often an obscure one) from the Bible, from literature, or even social criticism, and the title takes the form of a keynote quotation. Sometimes this was quite brief, with the consequence that a full reading of the image – often edifying or admonitory – might only proceed with reference to the complete sentence or narrative from which it was abstracted. An example is furnished by William Mulready's *Train Up a Child*, exhibited at the Royal Academy in 1841, whose title is constituted by the first four words of the Book of Proverbs, chapter 22: "Train up a child the way he should go, and when he is old he will not depart from it."

This type sometimes functioned as a descriptive realization of an incident from a play, as in Augustus Leopold Egg's *Launce's Substitute for Proteus's Dog* (1849), which illustrates a moment from Act IV of Shakespeare's *Two Gentlemen of Verona*; or William Holman Hunt's *Valentine Rescuing Sylvia from Proteus* (1851), which depicts the climax of the same play. Sometimes the citation was more indirectly – though still clearly – referenced, as in Henry Wallis's *The Stonebreaker* (1857), whose catalogue quotation on the question of labor is taken from Thomas Carlyle's *Sartor Resartus*.

Another expansive category of titles, which we can term "genre comments," was attached to genre paintings. The title-as-comment took as many forms as the commentary it enclosed. It could be facetious or trivializing, as in Henry Le Jeune's *Tickled with a Straw* (exhibited at the Royal Academy, 1868); it could point up a morality or common wisdom; or it could simply gloss one of the rural or working-class scenes that govern the genre.

Artists associated with visual modernism and the avant-garde did not invent the offbeat, allusive, multiple, or deeply metaphoric titles we will be considering in detail in the following chapters. In addition to its descriptive title, Tom Graham's *The Landing Stage*, for example, is supplied with a "genre comment" title (*Adieu*), and an action or process title (*Going to Sea*). Henry Stacy Marks exhibited his *A Select Committee* (fig. 12) at the Royal Academy in 1891 (by which time, admittedly, such liberties of reference even had modest academic sanction). The painting of parrots swinging on their perches represented a satirical indulgence in the pathetic fallacy that also took a side-swipe at the contemporary glut

12 Henry Stacy Marks, *A
Select Committee*, c. 1891.
111.7 × 86.7. Board of
Trustees of the National
Museums and Galleries on
Merseyside (Walker Art
Gallery, Liverpool)

of genre paintings. The layering of meanings between title, caption, and
image could be multiple in other ways – beyond the invention of two-
or three-part titles.

In the work of Sir William Quiller Orchardson titles may be said to
resupply some of the pictorial evacuation staged in what contemporary
critics described as the artist's "empty spaces." Works such as *Mariage
de covenance – after!* (1886), *An Enigma* (1891), *Trouble* (1897), and late
works left unfinished, including *Solitude* and *The Widow*, were all suscep-
tible to the charge that their formal spareness was unsatisfactorily at odds
with their insistence on a generic immediacy that was at once moralizing
and anecdotal. The paintings were vulnerable to "the emptiness into
which those painters inevitably tumble who think only of the moment."[12]
The First Cloud (1887) is another work of this type, though it manages its
social commentary with a slightly more elaborate metaphor. Depicting a

husband and wife in a domestic interior, in the subdued throes of the first
blemish in their marital tranquility, its tropic title is further embellished
by two lines from Tennyson:

> It is the little rift within the lute
> That by and by will make the music mute.[13]

Two forms of metaphoric reference are thus imposed over the quiet
pictorial statement of looming schism. The first, in the title, is
climatological. The second, deriving from Tennyson, is organized as a
musical metaphor. Without these two types of tropic indicators, a viewer
would scarcely be able to interpret the social implications of the
unanimated couple in the picture. Orchardson's work is a useful example
of how two forms of titular referentiality (the atmospheric and the
musical), which were also key elements in the development of Impres-
sionist and Symbolist titling, are organized and understood by means
antithetical to the formalism, sensationalism, and evocation of the later
nineteenth-century avant-gardes. With their superficially similar struc-
tures of nomination, Victorian moralizing encounters modernist equivo-
cation on the site of the title.

The work of other nineteenth-century artists further attests to the
importance attributed to titles. Gustave Courbet, for example, took spe-
cial care with the designation of his monumental realist images, especially
his *L'Atelier du peintre* (*The Painter's Studio*, 1855), famously subtitled
allégorie réelle determinant une phase de sept années de ma vie artistique (*A Real
Allegory Summing Up Seven Years of My Artistic Life*, fig. 13) when exhib-
ited privately following its rejection by the jury of the World Exhibition
of 1855. Thirty years later, in a letter of 1885, Courbet also observed
that:

> The title of realist was imposed upon me as the title of romanticist was
> imposed upon the men of 1830. Titles have never (at any time) given
> an accurate idea of objects; if it were otherwise, works would be
> superfluous.[14]

Courbet's is one of the first of what will be a chorus of artistic
disapprobations aimed at the accelerating critical tendency to name, label,
and otherwise demarcate the practitioners of the avant-garde, inventing
titles and group-descriptions that conveniently bracket what are often
disparate interests, styles, and subject matters.[15] This form of struggle with
the name is one of the most consistent attributes of the practice and
reception of experimental art from Courbet's "Realism" to the disputed
art labels of the 1980s. Yet, even as he contended with the title on the
grounds that it had little accuracy in relation to its objects, Courbet was

13 Gustave Courbet, *The Painter's Studio, A Real Allegory Summing Up Seven Years of My Artistic Life*, 1855. 359 × 598. Musée d'Orsay, Paris

also willing, in one of his best-known statements, to develop an extended analogy between the image and the word: "[P]ainting is an essentially *concrete* art and can only consist of the presentation of *real and existing things*. It is a completely physical language, the words of which consist of all visible objects; an object which is *abstract*, not visible, non-existent, is not within the realm of painting."[16]

ii Claude Monet: "A Succession of Astonishing Effects"[17]

This section will introduce the first sequential development of a modernist nominal *style* in the work of the Impressionist, Claude Monet. For it is here, in the relatively restrained, generically focused titles of Monet, that the titling regimes of the modern movement find their most sustained inaugural gesture. Using Daniel Wildenstein's *Biographie et catalogue raisonné*, alongside more recent critical studies, we can offer a fairly accurate account of the formation and implications of Monet's titling procedures. Wildenstein himself maintains a conservative attitude to the attribution of titles in the Monet oeuvre. He confines his citations to "the

original title as furnished by the painter's account books ['carnets de compte'] or by the records of the Durand-Ruel gallery, or even by an exhibition long past" and refuses to subscribe to the allures of later popular titles or nicknames.[18]

The critical reception of Monet's *Impression, soleil levant* (*Impression, Sunrise*, dated 1873 by Wildenstein, though signed and dated 1872 by the artist), was responsible in major part for the naming of the Impressionist movement. But it was not, in fact, his first painting attended by temporal or atmospheric qualifiers. These additions were already present in works from the late 1860s, including *La Jetée du Havre par mauvais temps* (*The Jetty at Le Havre in Bad Weather*, 1867), *Marine, Orage* (*Seascape, Storm*, 1867) and *Bateaux de Pêche, temps calme* (*Fishing Boats, Calm Weather*, 1868). Such textual supplements reach further than the mere specification of place: they qualify the literal location of the work by indicating the time, place, season, or nature of any action or event in process. They are emphatic environmental indicators, never used so consistently before in Western painting. The most decisive early manifestation of these subordinate indicators is revealed in a "series" of paintings (certainly this group of images reveals Monet's earliest nuanced treatment of a single motif) from 1867 representing "the road by the Saint-Siméon farm," a route connecting the Normandy ports of Trouville and Honfleur, which Monet had painted in the summer and autumn of 1864 – though he had not then seen fit to signal these conditions in his titles:

79 *La Route devant la ferme Saint-Siméon, l'hiver*
80 *La Route de la ferme Saint-Siméon, effet de neige*
81 *La Route de la ferme Saint-Siméon en hiver*
82 *La Route sous la neige à Honfleur*[19]

One consequence of these designations is that the operations of process and temporality are inscribed alongside the image, forcing a new assessment of the visual sign in relation to the physical *activity* of representation. *La Route à la ferme, Saint-Siméon, Honfleur, effet de neige* (*The Road Toward the Farm, Saint-Siméon, Honfleur, Snow Effect*, fig. 14) is an early example of the use of the sub-title "effet" ("effect"). But the very first work to carry this qualifier appears to be the 1866 *Marine, effet de nuit* (*Seascape, Nighttime Effect*, 1866) – a relatively rare indication in the Monet oeuvre of nighttime conditions. The term "effect" and the critical rhetoric that constructs it are continuously attested to in the literature surrounding Monet's production at this time – in his correspondence, in the correspondence of his friends, as well as in contemporary critical discourse. A letter sent from Honfleur by A. Dubourg to E. Boudin on 2 February 1867, for example, twice uses the term as something like a test of

14 Claude Monet, *Road Toward the Farm, Saint-Siméon, Honfleur*, c. 1867. 54.6 × 79.4.
Courtesy of the Fogg Art Museum, Harvard University Art Museums, Cambridge, Mass.
Bequest of Grenville L. Winthrop

approbation. Writing of Monet's "famous" *Robe*, almost certainly the *Camille* or *La Femme à la robe verte* (*Woman in a Green Dress*, 1866), Dubourg notes that due to a perceived "lack of opposition" and despite its "vigorous" color, "l'effet me semble un peu effacé" ("the effect seems to me a little obscured") – though he later concedes that Monet "fait aussi des effets de neige assez heureux" ("also makes rather satisfying snow effects.")[20]

Proper and place names aside, the "effect" that Dubourg complimented was the chief mediating term put forward by the artist. The repeated use of this, and a number of other new nouns, made it abundantly clear that Monet was not offering simply to represent a motif, but rather painted a specific interpretation of it according to the definite and determining impingement of contextual conditions. Brought into appositional association with the effect were a whole range of seasonal, temporal, atmospheric, locative, and coloristic qualifications. The colors included "rose," "blue," and "white," and were very occasionally doubled, as in "effet blanc et jaune" ("white and yellow effect.") Each of the four seasons – winter, spring, summer, and autumn – gave rise to works titled after their effects. Monet also paired the term effect with the evening, the morning, and with snow, the sun, fog, and the wind. In his

serial works, particularly the *Meules* (*Wheatstacks*) series of the early 1890s, and again in the paintings made in London in the early 1900s, Monet offered titles which notated double effects, as in *Effet de neige, soleil* (*Snow Effect, Sun*, W. 1287), *Effet de neige, temps couvert* (*Snow Effect, Overcast Weather*, W. 1281), *Effet de neige, le matin* (*Snow Effect, Morning*, W. 1280), *Effet de gelée blanche* (*Effect of White Ice*, W. 1215 and 1277), *Effet de neige, soleil couchant* (*Snow Effect, Sunset*, W. 1278), *Fin de l'été, effet du soir* (*End of Summer, Night Effect*, W. 1269), and *Fin de l'été, effet du matin* (*End of Summer, Morning Effect*, W. 1266). In London these effectual doubles included *Waterloo Bridge, effet de soleil avec fumées* (*Waterloo Bridge, Effect of the Sun with Smoke*, W. 1566).

Most of the seasonal, temporal, and atmospheric indicators, as well as a small number not associated with "effect," were also used on their own, or in combination with other modifiers, such as "temps," "plein," "déclin," "milieu," "fin," "grand," as well as the famous, though rare, "impression." Thus: *Dans la brume* (*In the Fog*, W. 1382), *Temps clair* (*Good Weather*, W. 1375), *Temps gris* (*Gray Weather*, W. 1345), *Temps de neige* (*Snowy Weather*, W. 1332), *Temps sombre* (*Gloomy Weather*, W. 1224), *Temps nets* (*Clear Weather*, W. 1482), *Temps couvert* (*Overcast Weather*, W. 1299), *Matinée sur la Seine, temps de pluie* (*Morning on the Seine, Rainy Weather*, W. 1473), *Plein soleil* (*Bright Sunshine*, W. 1360), *Plein midi* (*High Noon*, W. 1358), *Crépuscule* (*Twilight*, W. 1296), *Grand soleil* (*Very Sunny*, W. 1267), etc.

Of all the noun-objects foregrounded in Monet's titles, the sun itself was attended by the greatest number of adjectival and other associations. The cluster of effects around the actions of the sun includes: *Derniers rayons de soleil* (*Last Rays of the Sun*, W. 1272), *Grand soleil* (W. 1267), *Au soleil, milieu du jour* (*In the Sun, Midday*, W. 1271), *Coucher de soleil, hiver* (*Sunset, Winter*, W. 1282), and *Soleil d'après-midi* (*Afternoon Sun*, W. 1223). The portrait of Suzanne, daughter of Alice Hoschedé, painted in 1890, *Portrait de Suzanne aux soleils*, gives rise to a unique usage, as the "suns" here refer to the three sunflowers that surround the head of the subject. In the London works we encounter a renewed specificity of solar effects, including *Effet de soleil avec fumées* (*Sun Effect with Smoke*, W. 1566), *Le soleil dans le brouillard* (*Sun in the Fog*, W. 1572), *Soleil voilé* (*Veiled Sun*, W. 1591), and *Trouvé de soleil dans le brouillard* (*Sun Appearing Through the Fog*, W. 1610). In several works where access to the sun is blocked (or "stolen") by the weather, various conditions of the sky are remarked in Monet's titles: *Ciel nuageux* (*Cloudy Sky*, W. 1246), *Ciel gris* (*Gray Sky*, W. 1221), and *Ciel orageux* (*Stormy Sky*, W. 1605). Monet also painted the complete absence of the sun in occasional night pieces, including *Marine, effet de nuit* of 1866, and the later *Leicester Square, la nuit* (W. 1616).

In addition to this range of conditions and effects, Monet occasionally used more abstract designations, usually paired with a color, such as "harmony" (*Harmonie bleue*, W. 1373, and *Harmonie verte*, W. 1515), "reflection" (*Reflets roses*, W. 1415, and *Reflets sur la mer*, W. 1469), and "symphony" (*Symphonie en rose*, W. 1599, and *Symphonie en bleu*, W. 1601). With similar infrequency, the artist called attention to more extreme (or artificial) weather events and sensations – storms, gales, floods, and industrial pollution. Such references are mostly confined to his representations of the Mistral in southern France – e.g., *La Méditerranée par vent de Mistral* (*The Mediterranean in a Mistral wind*, W. 1181; also W. 1174 and 1176); to his sojourn in Norway in the mid-1890s – *Tempête de neige* (*Snow Tempest*, W. 1417); to smoke-filled or stormy vistas of London seen from Charing Cross and Waterloo Bridges – *Effet de soleil avec fumées* (W. 1566), *Fumée dans le brouillard* (*Smoke in the Fog*, W. 1535), and *Ciel orageux* (*Stormy Sky*, W. 1605); and to occasional representations of the flooded river Seine – *L'inondation* (*The Flood*, W. 1439) – and to the stormy seas of the north of France – *Mer agitée* (*Rough Sea*, W. 1443), though Monet painted a number of wind effects in the early 1880s, including *Coup de vent* (*Gust of Wind*, W. 688), *Le Coup de vent* (W. 1264), and *Effet de vent, série des peupliers* (*Wind Effect, Series of Poplars*, W. 1302).

In the *Nymphéas* (*Waterlilies*) and other paintings made after the London works, Monet dispenses with most of his titular epithets. A few works are given color specifications: *Nymphéas blancs et jaunes* (*White and Yellow Waterlilies*, W. 1801) and *Nymphéas jaunes et lilas* (*Yellow and Lilac Waterlilies*, W. 1804); and occasionally the reflective impingement of trees or other vegetation is noted, as in *Reflets de saule* (*Reflections of Willows*, W. 1858). Otherwise Monet's titles return to the particularity of the motif: *Le Pont japonais* (*The Japanese Bridge*, W. 1932), *Coin de l'étang à Giverny* (*Corner of the Pond at Giverny*, W. 1878), *L'Allée de rosiers* (*The Rose Bush Path*, W. 1938), and *La Maison dans les roses* (*The House Among the Roses*, W. 1954).

The general shape of these usages, especially the clustering of qualified effects around the serial works of the 1890s and 1900s, partly confirms recent suggestions that the titular specificity of the term effect acts as a kind of substitute for – and eventually a displacement of – the "specifics of the modern scene:"[21] those people, places, and events that Baudelaire had observed to fall under the purview of the "painter of modern life," including strollers, bathers, river frontages, trains, and parks.[22] Apparent from the early 1870s, Monet's attention to atmospheric ambience and the *enveloppe* of environmental effects (which were antithetic to the conditions of Baudelairian modernity), was suddenly resolved, according to this

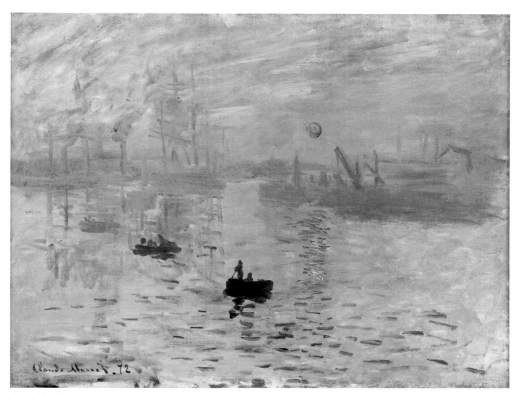

15 Claude Monet, *Impression, Sunrise*, 1872. 48 × 63. Musée Marmottan, Paris

account "at a stroke,"[23] by his move to Vétheuil in 1878. Thenceforward Monet's emphatically depopulated Impressionism was free to concentrate almost entirely upon the pictorial predicates of the artist's technical vocabulary – "effets," "impressions," "temps," "harmonie," etc.

While used quite sparingly by Monet himself, the debate around the key term "impression" has been especially well developed in art-historical research – though it was also attended to with vigor by contemporary critics. Wildenstein's note on the naming of *Impression, Sunrise* (fig. 15) insists that while the artist almost certainly sanctioned the term, there is an unfortunate absence of first-hand evidence concerning the precise circumstances of the designation: "The title *Impression, Sunrise* in the catalogue of the exhibition of April 1874 was certainly approved by Monet, [although] he never offered the slightest critical comment on this matter."[24]

John Rewald contradicts this assertion of critical silence, citing the

"unpublished recollections of Edmond Renoir," brother of Auguste and editor of the catalogue for the first Impressionist exhibition. Rewald notes the compiler's dissatisfaction with "the monotony of [Monet's] titles":

> *Entrance of a Village, Leaving the Village, Morning in a Village* . . . When Edmond Renoir objected, the painter calmly told him: "Why don't you just put *Impression!*"
> Monet later explained that he had selected for the exhibition a painting done in Le Havre from his window: the sun appearing in damp vapors, in the foreground a few shipmasts pointing. "I was asked to give a title for the catalogue; I couldn't very well call it a view of Le Havre. So I said: 'Put *Impression.*'" Indeed the painting was catalogued as *Impression, Sunrise* (it was one of two views which Monet painted in 1872).[25]

Responding to the lack of circumstantial discussion noted by Wildenstein and partly resupplied by Rewald, Steven Levine, John House, and Stephen Eisenman, among others, have offered accounts of the contextual signification of the term "impression," revealing it as a production that is "instinctively grasped and left at the state of the *ébauche* [sketch]" rather than resolved into a finished "tableau" (painting).[26] House also notes the use to which "impression" was put in the 1850s and 1860s, and Eisenman writes a detailed account of the social and cultural importance of the struggle in the years 1874–77 between the terms "Impressionist" and "Intransigent" for the publicly accepted denomination of the group.[27]

Several contemporary critics responding to Monet's paintings at this time – especially to *Impression, Sunrise* – contended at length against what they perceived as the technical shortcomings of the impressionistic manner. Jules-Antoine Castagnary, for example, described such work as relentlessly "superficial," motived by an "unbridled Romanticism, where nature is no more than a pretext for reveries, and where the imagination becomes powerless to formulate anything but personal, subjective, fantasies, without any reverberation in general reason ["raison générale"]."[28] Castagnary's invocation of the dictates of "general reason" against the "reveries" and dissolutions of "Romanticism" is a throwback to the conditions of academic Neo-Classicism developed in the seventeenth and eighteenth centuries and adumbrated virtually as a formulaic desideratum for artistic practice – whether for poetry, or for both the grand style and subordinate genres of painting by academicians such as Sir Joshua Reynolds. Concluding his Fourth Discourse "delivered to the students of The Royal Academy on the Distribution of Prizes, December 10, 1771," Reynolds admonishes:

the works, whether of poets, painters, moralists, or historians, which are built upon general nature, live for ever; while those which depend for their existence on particular customs and habits, a partial view of nature, or the fluctuation of fashion, can only be coeval with that which first raised them from obscurity. Present time and future time may be considered as rivals, and he who solicits the one must expect to be discountenanced by the other.[29]

As Castagnary implies, the foregrounding of the instantaneous, improvised nature of the impression signals, in Reynold's terms, the triumph of present time over future time (i.e., universality and generality). The images and titles of Monet witness a collapse of the Neo-Classical regime of time, the fall of the "pregnant moment" ordained for the plastic arts by Gotthold Ephraim Lessing in his *Laocöon* (1766). The artist's titles also transgress the apparatus engendered by the academy to secure the division and appropriateness of genres. Monet's momentary impression, we might say, is a "significant moment" in that it has been selected to represent the natural conditions of a brief instant of time; yet its significance refuses to go beyond the moment and to take on the symbolic weight of a notable action and its attendant morality, as arbitrated by Lessing, Reynolds, and others. Stranded resolutely outside the regulated constraints of the academic understanding of time, the "impression" is a moment-for-the-moment untouched by the gravity of the past.

The implications of the term "impression" obsessed writers and critics for more than a decade after it was first coined. In 1883 Joris-Karl Huysmans — elsewhere by turns generous and capricious to the protagonists of the visual avant-garde — pronounced that Monet was "certainly the person who, more than any other, persuaded the public that the word 'impressionism' only designated a manner of painting reduced to a state of rudimentary confusion, vague sketches ["ébauche"]."[30] The immense symbolic investments made in the "impression" are also revealed in the humorous deprecations launched against the designation in the review press.

The most notable of these textual caricatures was the facetious dialogue concocted by Louis Leroy between himself and a fictitious, geriatric academic named M. Vincent, published in *Le Charivari* (25 April 1874).[31] Touring the first Impressionist exhibition held in 1874 in the photographer Nadar's studio, the critic and the academician (and, in a later, choric addition, one of the custodians of the exhibition, a "municipal guard") stage their simulated incredulity toward the exhibited works around the names of the paintings as they are read from the *livret*. As noted for the "Salons" of Baudelaire, the relation between catalogue, image, and title

was crucial for what Norman Bryson describes as the "textual control of the image" by the livret — one of the many means by which discursive logic kept figural signification in thrall.[32] The "impression" is the special butt of the humor and connivance of Leroy's text. It is also the chief term in a subordination radically undermined by both the stylistic and textual excesses of the paintings.

At stake here is a new question in the "territorialization"[33] of visual practice — an important and recurrent trope operating in the critical texts of contemporary writers and reviewers of the nineteenth-century avant-garde.[34] The refusal of early avant-garde painting, in the work of the Realists, Manet, the Impressionists, and the Post-Impressionists, to conform to officially sanctioned parameters of visual practice found one of its most notable and sustained expressions through a complex array of literary devices — parody, litotes, satire, irony, etc. — that can be convened under the controlling metaphor of the "border."

The implications and operationality of the transgressive metaphor that dominates Leroy's review must be understood in relation to what is discussed in chapter 3 as a "flood of alternative exhibition bodies" that grew up in the later nineteenth century. This history was explicitly staged as a succession of secessions from establishment space, from the territory of the status quo. The Salon des Refusés (1863), the Salon des Indépendants (1884), the eight Impressionist exhibitions (1874–86), and many other shifts of the territories of display, are all wilful gestures of manoeuvre beyond the bounds and out of the confines of academically regulated space. The criticism that attends these moves out of bounds is itself written through with a sustained commentary on the conditions of the margin and the consequences of transgression (literally, of "walking beyond").

Leroy's parody offers one of the most powerful instances of this commentary. While the text is usually interpreted in relation to its emphasis on the formal and technical excesses of the works on view that first astonish and finally derange Vincent, the academician, the *grounds* of the formal disruptions notated by Vincent and funded by Leroy are just as significant as the amorphous and abstract pictorial tendencies themselves. The subtext of the review, then, concerns the territories of practice, how these are named and by what means exchanges are managed between the image, the viewer, the institution, and the title. It is possibly for this reason that Vincent is deliberately characterized at the beginning of the piece as a painter of traditional "landscape" — that is, as one who has co-defined, given appropriate borders to, the whole enterprise of the generic representation of place.

The mise en scène of the critical dialogue between Leroy and Vincent in a conversational passage through the exhibition finds its way into the metaphorical structure of the text as a commentary on the deterritorialized spatial qualities of Impressionist landscape. The "astounding landscape" of Camille Pissarro (*Ploughed Field*), which is held to wreak havoc with the very foundations of perspective ("It has neither head nor tail, top nor bottom, front nor back."); the "mud-splashes" of Henri Rouart's *View of Melun*; the "people walking along" that Leroy elucidates from Vincent's description of "innumerable black tongue-lickings in the lower part" of Monet's *Boulevard des Capucines*; the "proper path" that Vincent in his delusion attributes to Pierre-Auguste Renoir's *Harvesters*; the territorial denouement that concludes the review: all these insistent messages of spatial sequence and the conduct proper to it are assembled as an elaborate counter-discourse of transgression ("walking beyond").

The extraordinary finale of Leroy's parody-satire completes and displaces the figures that have structured the text – body/territory/technique/sequence – by staging the ultimate deterritorialization of painting: its transference outside the frame of the pictorial. The deranged Vincent mistakes the "municipal guard" for an Impressionist "portrait." The guard/portrait, however, insists on the continuation of the walk/transgression ("'keep moving, will you!' said the 'portrait'"). And Vincent concludes with a "scalp dance" in which he transfers the attributes of the Impressionist image onto *himself*, before perpetuating the transgressive motility of the territorial metaphor with a final invocation: "Hi-ho! I am impression on the march."

Leroy's parody of the reception of the first Impressionist exhibition anticipates one of the crucial negotiations between visual practice and its outsides (everything that lies beyond it) that Peter Bürger, and others following him, claim as central to the activities of the historical avant-garde. Indeed, there are few more compelling testimonies to the split in the modern period between modernist formalism and avant-garde "interdiscursivity"[35] than the different attitudes manifested by these partly opposing (though always somehow *bound*) tendencies to the visualization of the border. The metaphor of avant-gardist trespass and transgression, so elaborately noted here, is a recurrent, though often tamed and chastened, trope in the non-formalist discourse that sustains visual practice in the modern.

With these suggestions in place concerning the transgressive possibilities of the Impressionist image as founded by its name, we must return to the "primal scene" of the review – to Vincent's first encounter with the image-title that will precipitate his derangement:

Vincent: "'What does that canvas depict? Look at the catalogue.'
"'*Impression, Sunrise.*'
"'*Impression* I was sure of it. I was just telling myself that, since I was impressed, there had to be some impression in it.'[36]

The satirical exchange convenes several of the attitudes to the Impressionist title that we have discussed so far. First, the dependence of the interpretation of the painting on the textual supplementation of the catalogue is parodied here, as it was earlier, though in a different context, by Baudelaire: the title at this time takes on a signifying burden greater than that of an aid to identification and description. Second, the multiple valency of the key term "impression" is indulged-in by Vincent to the extent that its etymology and its double-entendres are exercised in the cause of interpretation: the title begins to take on a role that will eventually puncture and in part redeem the narrative, situational, or autonomous frame-bounded image – an intervention taken on even as the practice of painting was historically preoccupied with its own definition and autonomy. Third, the Leroy exchange clarifies the contention that Monet's title offers the first glimpse of what may be termed the tautological impulse of visual modernism. Much modernist practice was concerned not simply with self-reference, but with self-*definition* through self-reference, a kind of epistemological enquiry that begins and ends with its own first terms. Something of this circularity was noted above with respect to the insistent temporality of the Impressionist image (its "moment-for-moment"); but the tracing of a hermeneutic circle by Leroy/Vincent is even more emphatic. The interpretative movement runs as follows:

Incomprehension	Catalogue	Name/Title
Confirmation	Recall/Return	Remodel

As the dialogue proceeds, the interpretation and reception of the painting is simultaneously remodeled and reconfirmed so that the name of the image becomes identified with the experience of its reception. The loop of meaning is, of course, ironized and reduced by Leroy/Vincent into little more than a simple paradox: the painting impresses, therefore it is an impression; the painting is an impression, therefore it impresses. But the implications of this definitional exchange, abetted by the textual intervention of the title, ramified throughout the history of visual modernism, before receiving its *coup de grâce* at the hands (and in the mouths) of the pioneer Conceptual artists in the late 1960s.[37]

The Leroy review was not the only contemporary caricatural practice that assists us in locating the nominal space of Monet's innovative paint-

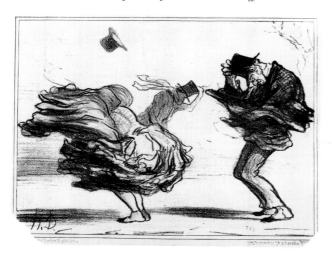

16 Honoré Daumier, *A Light Zephyr Announcing the Arrival of Spring*, 30 March 1855. Lithograph. General Research Division, New York Public Library, Astor, Lenox and Tilden Foundations

ings. From its inception, *Le Charivari* had been home to a comic-satirical discourse on the effects of the weather and its locations that anticipated, inverted, and upstaged the social-climatological beatitudes of the Impressionist image. Indeed, virtually all the iconographic appurtenances of Monet's visual repertoire had already been converted into humorous, disapprobationary image-texts by Daumier and his colleagues. Various *intemperies* ("*pluie-neige-froid-vent*")[38] were some of Daumier's favored scenes for social comment. For him the weather and its vicissitudes are occasions for profound metropolitan, or — when the city-dweller ventures into the countryside — rural, distress. The "effects" of rain, snow, cold, ice, wind, water, and even sun, are sudden, unpredictable, annoying, and sometimes dangerous. Their immediate impingement into daily life is a source of frustration and discomfort, which Daumier renders as ridiculous, troubling, or absurd. In an early series, "Les Plaisirs de l'hiver" ("The Pleasures of Winter," published in *Le Charivari* in 1836), for example, *La Glace* (*Ice*) features two besuited foreground figures — one bandaged, the other dripping wet — after their respective tumbles on the ice, against a background of loosely sketched skaters, half of whom lie prostrate on the slippery ground. *La Pluie. Jour de visites* (*Rain. Visiting Day*) offers a family of three caught in pouring rain under a single umbrella as they go about their social rounds. In *La Neige* (*Snow*), the snow of the title is not the flawless, placid blanket that usually drapes the Impressionist image, but an occasion of social abandon or mishap, as a woman is pelted with snowballs by frolicsome youths. *Le Vent* (*Wind*) represents hats, a shawl, an umbrella, even a flower pot flying in the

wind. This, and related Daumier lithographs – such as *Un Léger Zéphir annonçant l'arrivé du printemps* (*A Light Zephyr Announcing the Arrival of Spring*, 1855, fig. 16) – remind us that, in contrast to the Romantic sublimity cultivated in Turner's paintings of storms, the Impressionists only rarely represented conditions whose inclemency was registered by the painting's protagonists, and seldom offered titular indicators to match the disturbing temporal effects of winds, gales, or even breezes.[39]

Though no less vivid in conception, Daumier's relation to the weather was very much the inverse of Monet's. His characters were intractably urban, his point of view was the metropolitan everyday, and the climatological moments he privileges are those in which extreme weather conditions wreak modest havoc with social routine or expectations. In a series devoted to "La Chasse" ("The Hunt"), "Pastorales" ("Pastorals"), and various "Croquis Aquatiques" ("Aquatic Sketches"), he satirizes the drawbacks and follies of rural promenades, river bathing, outdoor picnics, the quest for picturesque views, and the artists representing them – associated *plein-air* activities that constitute the iconographic heart of Impressionist painting. The effects of Daumier's weather are always those that interfere with typical social normality or interrupt banal routine; they give rise to no experiences that are benign, neutral, or pleasing. The consequences of the weather are registered as effects that strike at their human subjects just like the distresses and impediments of the cultural world. Indeed, according to my review of his captions, the only time he uses the term "effect" with any deliberation is in a lithograph that highlights the dysfunctional innovation of the turnstile at the Universal Exhibition in 1853, *Effets du tourniquet sur les jupons en crinoline* (*Effects of the Turnstile on Crinoline Petticoats*).

Yet the parallel meteorological universes of Daumier and Monet intersect at one point in time: they converge on the climatic "moment." Two forms of immediacy meet and then diverge in the representational space between the wilful distortion of the caricature and the perceptual essentialism of the impression. As discussed in the introduction, Baudelaire contends that Daumier's images are fueled by a moral or social immediacy ("the central idea immediately leaps out at you"): his image-situations are "intuitively" grasped for what they are, leaving the caption text – in a position of relative redundancy – to drive the point home. Monet replaces a moment of social irruption with an absorptive surrender to the aesthetic particularity of the captured instant. In both cases the title or caption serves to explicate and reinforce the effects of a meteorological event – though the referents of Daumier are as ineffably social and dystopian as those of Monet are indissolubly natural and utopian. In the end Daumier's specific generality meets Monet's general specificity on the

site of the title. The dialogue, description, miniature narrative, or social commentary inscribed by Daumier around the momentary scene of the weather highlights the intense contra-sociality of Monet's abstract titular signs – the impression and the effect. Monet paints perceptual masks worn by nature after the recoil of the weather. Daumier offers human masks that catch the impressions and effects of more pointed recoils, but which can only be known according to their social contexts.

One of the most important implications of the appositional structuring of the title developed by Monet after the late 1860s, and consistently after *Impression, Sunrise*, is the development of serial painting, in which the motif remains constant, but the atmospheric conditions are varied, with appropriate titular gestures. While several precedents for Monet's seriality have been discerned (in the writings of P. H. Valenciennes, and in the paintings of Turner, Jongkind, and Courbet),[40] Monet's scrupulously elaborated serial work represents the first consolidated effort of this type, described by Levine as the "comparative-sequential modality."[41] The "Meules" ("Wheatstacks") series, begun after the harvest of 1890, continued into 1891 and exhibited in May 1891, is listed as follows in Wildenstein:[42]

1266	Meules, fin de l'été, effet du matin
1267	Meules, grand soleil
1268	Les Meules au soleil, effet du matin
1269	Meules, fin de l'été, effet du soir
1270	Deux meules, déclin du jour, automne
1271	Meules au soleil, milieu du jour
1272	Meules, derniers rayons de soleil
1273	Meules
1274	Meules, effet de neige
1275	Les Meules, hiver
1276	Meules, effet de neige, le matin
1277	Meules, effet de gelée blanche
1278	Meules, effet de neige, soleil couchant
1279	Meules, effet d'hiver
1280	Meule, effet de neige, le matin
1281	Meule, effet de neige, temps couvert
1282	Meule, coucher de soleil, hiver
1283	La Meule
1284	Meule, dégel, soleil couchant
1285	La Meule
1286	Meule, soleil dans la brume
1287	Meule, effet de neige, soleil

1288 Meule au soleil
1289 Meule, soleil couchant
1290 Meule

These twenty-five paintings and their titles form an almost incantatory diorama of seasonal effects played out on human-made collection-stacks of a basic, cultivated food product. Natural, cultural, and necessary by turns, these little towers of wheat are points of focus for the governing theater of the seasons which first produces and then decorates them – before finally taking them away, as the cycle begins again. The series is the most complete and concentrated in Monet's oeuvre. All the seasons are present: the summer is marked by its "end"; the fall is the very agent, or maker, of the stacks; winter bestows its ornaments of snow and ice; while the beginning of spring is signaled by their melting and disappearance. The cyclicality of the series is underlined by its beginning and ending with paintings made in, and named after, the sun, the chief magician behind the conjuring trick of the weather. While the majority of the eleven "effects" specified in the titles attend to the winter conditions which dominated its time span, the titles of four paintings from the sequence are left without qualifications – somewhat in the manner of placebos. We do not know whether Monet, or his gallery and cataloguers, made this subtractive gesture deliberately; but when the series is viewed as an ensemble, these *Wheatstack[s]* remind us of the animating *difference* between the motifs themselves – as enduring symbols of sustenance – and the envelope of weather effects which both created them, and will take them away. They also remind us that while there may be moments of relative climatological neutrality without the definite effects of rain, snow, fog, ice, wind, etc., all representation out-of-doors is a representation of the weather.

The early 1890s was the heyday of Monet's seriality. In the "Peupliers" ("Poplars") series, painted from his boat in the summer and autumn of 1891, and exhibited at Durand-Ruel in March 1892, he added the following qualifiers to the general types included above: *crépuscule*; *effet blanc et jaune*; *temps gris*; *Trois arbres roses, automne* (*Three Pink Trees, Autumn*). And in the "Rouen Cathedral" series (painted between February and April 1892 and exhibited at Durand-Ruel in May 1895 [see figs. 17 and 18]) several titles suggest a more emphatic cultivation of Symbolist effects, including *Le Portail vu de face, harmonie brune* (*Frontal View of the Portal, Brown Harmony*), and the Whistleresque *Symphonie en gris et rose* (*Symphony in Gray and Pink*, fig. 18). In the course of several sojourns in London between 1900 and 1904, Monet painted his "Série de vues de la Tamise à Londres" ("Series of Views of the Thames in

17 Claude Monet, *Rouen Cathedral: Facade and the Tour d'Albane (Morning Effect)*, 1894. 109.9 × 73. Beyeler Collection, Basel

18 Claude Monet, *Rouen Cathedral: Setting Sun Effect (Symphony in Gray and Pink)*, 1892(?). National Museum and Gallery, Cardiff

London"), of which thirty-seven were exhibited at Durand-Ruel in May 1904. Assisted by a greater volume of detailed correspondence exchanged during these visits, we are better positioned to speculate on the implications and the consequences of the intense scrutiny and variation of Monet's serial work and the fugal disposition of his titular epithets.

Levine has pointed to the peculiarly punctuated syntax of Octave Mirbeau's two-part essay, "Claude Monet: Vues de la Tamise à Londres," written in response to the Durand-Ruel show. Mirbeau's clipped encapsulations of the effects of Monet's series – he writes of their "multiple drama, infinitely shifting and nuanced"[43] – appear to respond to the serial subordination of Monet's titles. As Levine notes, however, the critic reacts ambiguously to the *concept* of seriality, recognizing the impact of multiplicity in his textual tropes, but ignoring it in the works themselves: "There were three subdivisions in the series, eight paintings of

Charing Cross Bridge, eighteen of Waterloo Bridge, eleven of the [H]ouses of Parliament. Mirbeau discussed the paintings of each group collectively, as though there were only one of each."[44] Mirbeau's reflections on the infinite change and nuance of the London works suggest that the serial project of Monet, worked out in images and title-texts, can be related to the methods and procedures of the Symbolists. Such a suggestion is not new. Robert Goldwater, for example, holds that Monet's series pictures "exemplif[y] the emergence of a new attitude."[45]

Goldwater goes on to describe this new tendency as the beginnings of Symbolism. The addition of the musical qualifiers to the "Rouen Cathedral" series, possibly after the model of Whistler, whose "10 O'Clock" lecture was translated by Stéphane Mallarmé in 1888, and the use of "effet" to describe the signification of *color* ("effet blanc et jaune") rather than, as hitherto in Monet's career, of a season, a part of the day, or of sun and snow, all attest to the absorption by Monet between 1890 and 1892 of what were to become basic Symbolist ideas.

But Goldwater's characterization of the serial imagery of Monet as "a further elaboration of the impressionist programme in the direction of 'scientific objectivity' – a parallel to the neo-impressionist goal" is more contentious.[46] Monet's work unquestionably lacked the well-developed recourse to scientific or quasi-scientific studies of color and the disposition of form that underwrote the Neo-Impressionist practices of Georges Seurat, Paul Signac, and others. But the complete absorption of Monet in the differentiation of his motifs according to the visible impingement of atmospheric effects was a project of unique retinal and technical solipsism. Indeed, even as Monet sought to recapitulate the predicates of Symbolist nomination in his musical and crepuscular titles, what he achieved was in fact a kind of Symbolism without a referent; or to put it another way, a Symbolism of self-reference. It was a practice that resisted in equal measure the Realist call for the depiction of contemporary modern life, the Naturalist call for the simulation of appearance, and the Symbolist call for evocative external reference.

Within the painting practices of the earlier nineteenth century there were several anticipations of Monet's meteorological vision. But perhaps no comparison is more suggestive than that between Monet and the work in the 1820s of the English landscape painter John Constable. In a letter from his friend John Fisher, Constable is advised to "diversify your subject this year as to *time of day*. Thompson [sic] you know wrote, not four Summers, but *four Seasons*. People are tired of mutton on top of mutton at bottom mutton at the side dishes, though of the best flavour & smallest size." Constable responds: "I regard all you say but I do not enter into that notion of varying ones [sic] plans to keep the Public in good

humour – subject and change of weather & effect will afford variety in landscape."[47] Ann Bermingham notes of Constable's paintings during the period of this exchange that "the 'change of weather & effect' became no less important to the work than its subject; and storms, clouds, rainbows, and other transitory aerial effects came to carry as much meaning as the familiar sites over which they played, transforming Constable's sun-filled naturalism into a meteorological expressionism."[48]

Monet's work did not so much reach this point, as take off from it. If Constable can be seen as courting "ahistoricism," "scientism," and "formalism" – especially when his work is measured against the heartfelt "personal historical significance"[49] of his landscapes – Monet's drew on these coordinates almost from the beginning, and developed from there. The intensity, quiddity, and introspective determination of Monet's painterly regimen is revealed most clearly in the correspondence exchanged with his wife Alice between January and March 1901, long sections of which are devoted to detailed reports that combine prevailing financial and weather conditions. Monet makes repeated reference to the barometer and to the regulating activities of the sun and the fog: "It is 6 o'clock, and for 1 hour it has been gloriously sunny."[50] Writing on 6 February 1901, Monet observes:

> There was, indeed, a little too much fog this morning, but it wasn't long before the pretty red ball appeared, and with it a succession of remarkable effects.[51]

And on 14 February:

> Alas! The fog persists and from dark brown it turns olive green, yet still just as gloomy and impenetrable ... Beginning at 10 o'clock, the sun emerged, hidden from time to time, but [creating] brilliant effects on the wonderful water.[52]

Two days later Monet makes the simple, yet precise, observation that "it is the weather alone that will decide, marking all my efforts."[53] This attribution of the creative effort to the forces of the weather itself, and the abandonment of even a subjective volitional response to the vagaries, theatricality, and evanescence of the solicited atmospheric conditions, combine to reduce the signification of Monet's images to the limpid registration of the concatenated "effects" of brilliancy, astonishment, and admiration. The making of the itemized serial painting is, for Monet, like putting one's eye to the kaleidoscope of nature, which is twisted by the random contingencies of a "deciding, enabling" weather. Intense, repetitive, and elementally preoccupied as these reports are, their accumulated weight is less that of a profound existential experience, than it is of an

almost obsessive perceptualism. The labor of waiting on, writing (letters and titles), and registering the sensational effect are even, on occasion, collapsed together, so that Monet actually describes the conditions of 18 February 1901 in his correspondence with the same kind of brief deliberation that characterizes the titles: it was, he noted, "gray weather, foggy, without sun" ("[t]emps gris, brumeux, sans soleil").[54]

Monet's reliance on the *performance* of nature to begin before he could make his own beginning inevitably tested his patience and challenged his passivity. In at least one recorded instance he reported that he became "furious" because the outside conditions had offered him merely the same effect ("le même effet") as he had experienced on the previous day. Such continual reliance on the orchestration of elemental effects that were beyond all artistic control save viewpoint, scrutiny, and technical rendition engendered a practice that was radically reductive – a painting entirely dependent on the static reception and transmission of a sudden short-lived visual sensation. Monet's remark about the "pretty red ball" is revealed, then, as a somewhat cliched and extenuating metaphoric usage. For the later paintings of the artist are purged of almost every system of reference that might inform visual practice, both academic and avant-garde, including any, even vestigial, symbolism or tropism. What concerned Monet was simply the atmospheric veil, the web of weather, backlit by the efficacious luminosity of the sun. The motif thus interfered with by the elemental texture was literally a kind of ground supplying the preliminary materials (shape, color, surface) on which the overcoded gauze of lights and fogs could be worked.

In Monet's serial work the individual impression or effect takes its place in the sequence of versions. This in part relieves the emphasis on instantaneous transmission and suggests the construction of a pictorial grid of shifts and transformations: "There was sun, but what changes, what transformations."[55] Such mutations cannot be demonstrated in the unitary image; they can only be read from image to image in a reconvened series of parts. The analysis of the sequential totality of a day's or a season's weather is as "evident," yet evasive, as the contemporary photographic recording of the serial instants of the body in movement undertaken by Eadweard Muybridge, who invented the zoopraxiscope in 1881 and published his *Animals in Motion* in 1899.

In stopping the weather a thousand times, Monet is attempting to recombine a series of effectual definitions of signal seasonal or diurnal instants, whose combination offers a kind of abstract meteorological diorama. The contribution of the title is to negotiate between the crucial polarities introduced above: between unitary and sequential exposition, and between the presence and absence of metaphoricity in Monet's work.

First, the longer titles themselves offer up a sequence of relational modes to be read into the image. The typical tripartite structure would be: motif (place name, as in a traditional title); quasi-metaphorical marker (impression, effect, symphony, etc.) emphasizing the quality, density, and process of the image; and a final temporal, seasonal, or instrumental qualifier (morning, winter, sun, snow, etc.). Second, the terms effect and impression are thus suspended between a function that we might call the "demonstrative simile" (the atmosphere was "like this") and an "indexical marker,"[56] that is, an affirmation of the presence and contiguity of the graphic notation in relation to a present (but now past) event or condition. Resisting the Romantic dramatization of natural forces (or the subjective response to them) bestowed on his paintings in the form of poetic textual appendices by Turner; and resisting equally the post-Romantic (Symbolist) interpolation of the image through explicit metaphoricity, deliberate evocation, or psychic correlates, Monet's visual and written effectualism occupies a space that is neither quite wholly modernist (in the sense elaborated by the Fry-to-Greenberg axis) nor narrative (in any sense understood by the nineteenth century), nor again either decorative or residually allegorical. Instead, the *mood* of the weather is elided in pigment in much the same way that mood might govern the verbs that are always absent from the painting's titles. Monet's pictures are particular *names* for the weather.

While the function of Monet's titles has been curiously neglected by art historians, the effectualist theory they underwrite was appreciated, exegized, parodied, and annexed by Duchamp in a set of jottings, now collected in the "Speculations" section of his *Manuscript Notes 1912–20*: "Do not forget the painting of Doumouche: Pharmacy = snow effect, dark sky, dusk, and 2 lights on the horizon (pink and green)."[57] This text is jotted above a swirling sketch for the *Large Glass* showing "gaz avec cones" ("gas with cones") and "Aspiration de la pompe" ("the exhaust of the pump"), and the words "chercher à discuter sur la durée *plastique*" ("try to argue on the *plastic* duration"). Duchamp annotated the last sentence (in English) in 1965: "I mean space into time."[58] The note and the diagram seem to ironize (through the literal emission of exhaust and fumes, a *brouillard* and a smoke-screen at the same time, both the Impressionists' scrupulous designation of temporal effects and Whistler's "pink and green" musico-pictorial luminescence (discussed in chapter 4).

But they do more than this. That the Impressionist jargon was as available and immediate in Duchamp's formation as, say, the mottos of Pop art are to the generation of the 1990s, is attested by what was probably the first work the artist made in which a calculated, punning tension is set up between the title, the image, and the caption. This is

Duchamp's *Flirt* (1907), which bears the following caption: "Flirtation/
She – Would you like me to play 'On the Blue Waters'? You'll see how
well this piano renders the impression suggested by the title./He (witty)
– There is nothing strange about that, it's a grand piano./(In French *piano
à queue*, grand piano, sounds like *piano aqueux*, watery piano.)."[59] The
work of "rendering the impression suggested by the title" would be
radically reformulated by Duchamp during the 1910s. But in 1907 he was
already (ironically) aware of the received relations set in motion between
the impression, the title, and musicality. And already he has mixed these
up with erotic desire and double entendre.

In his later "Speculations" Duchamp deployed the atmospheric impres-
sionism of Monet and company as a kind of measure for the development
of his own more radical meditations on (as he himself put it) "space into
time." Duchamp recognized the potential complexity (as well as the
obsessional and repetitive nature) of the Impressionists' registration of
effects. Having raised the question of the place of the temporal within the
spatial coordinates of visual practice, he meditated on contemporary
Bergsonian theories of time ("duration") with a view to extrapolating the
logic of the Impressionist enquiry into a non-retinal, not solely spatial,
visual activity. We are led to a final, curious, imagination: of an Impres-
sionist machine blowing an effectualist fog over the sharply edged details
of the *Large Glass*.

19 Art and Language, *Impression Returning Sometime in the Future*, 1984.
Three panels each 234 × 112 (overall size 234 × 336).
Courtesy Lisson Gallery, London

Chapter 3

Symbolism 1: Redon, Gauguin, Signac

1 Introduction: Titles, Institutions, and Analogues

During the last two decades of the nineteenth century, the theory and practice of the title underwent one of its most significant developments. In the work of Odilon Redon, Paul Gauguin, Paul Signac, and other artists who enjoyed extensive contact with the Symbolist poets and theorists, we will find that the three titular types I have proposed – denotative, connotative, and untitled – were conjoined and disseminated with a concentration hitherto unprecedented. Further, the titling strategies developed in and around the Symbolist milieu established paradigms that would be carried forward as predicates for many of the naming strategies operative in the twentieth century.

This, and the following, chapter will propose a critical history of Symbolist titling. I will discuss three of the practices that engaged and shaped the relation between title and image most significantly. In Redon the title takes on a key role in the elaboration of poetic mystification and calculated ambiguity. For Gauguin, it negotiates between the artist's mark of self-identification (his "signature"), and the non-Western contexts and languages with which he was obliged to contend for much of his later life. While for Signac, the title was produced, probably for the very first time, in an overlapping system drawing on all three of the conditions that underwrite the naming of art in visual modernity. Some of them named and identified, though often flamboyantly (and in this sense participate in the following category); others offered suggestive, connotative detours; others still were subject to a calculated numerical ordering system that imagined them as a serial sequence of forms and surfaces.

In chapter 4, I underline the importance of the name as a focal device for the development of what I term the "environmental formalism" of James McNeill Whistler. The title clearly functions for Whistler as an arbiter between the material, form, and subject matter of his images, and their total context (including the frame, wall, gallery, room, and any

other objects – or even persons – that might share the same environment, institution, or musical metaphoricity). Because of the powerful centrality of Whistler's titles to almost every aspect of his work, context, and daily routines, this chapter will offer the most extended discussion of a single artist's titling strategies.

I want to insist, however, that the importance of Symbolist titling is not confined to a number of individual artistic decisions. Instead it is linked to two decisive contexts: the institutions that made Symbolism visible and the theoretical debate on which it was predicated. While no examination of the titling of images can be undertaken without reference to histories of their production and reception, especially their public display, such contexts must be underlined with respect to developments in France and Northern Europe around the 1880s. For the period within which the most consequential reinventions of the titular activity take place is also one characterized by what has been termed a "flood of alternative exhibiting bodies."[1] There is clearly a crucial correlation between various forms of institutional dissent and reformation and the stakes of the title. As we saw with Courbet, who set up his "Pavilion of Realism" in 1855; with the critical reaction to the Salon des Réfusés, established in 1863; and with the series of Impressionist exhibitions beginning in 1874, there was already an established history of yoking titular innovation to alternative sites of exhibition. At the beginning of the 1880s a still more decisive separation was enacted between official and less official exhibition spaces. This was the designation of the Salon des Indépendants. As the contemporary critic Théodore Duret noted, "[a] radical transformation had been effected in the constitution of the Salons and the award of prizes. In 1881 the State divested itself of its traditional rights over the Salons and handed them over to the artists themselves, who formed a legally recognized society [renamed the Société des Artistes Français]."[2]

Signac was a founding member of the Salon des Indépendants, along with Georges Seurat and Redon. The Indépendants was just one of an increasing number of exhibiting bodies that had succeeded from the official Salon des Artistes Français – others include the Salon de la Nationale, founded as the Société Nationale des Beaux-Arts by Pierre Puvis de Chavannes, Eugène Carrière, and Auguste Rodin in 1890; the Salon de la Rose + Croix, founded by Josephin [Sar] Péladan in 1891; and the Salon d'Automne, founded by Pierre Bonnard, Georges Rouault, Henri Matisse, and Albert Marquet, among others, in 1903, which reacted in turn to the Salon de la Nationale. In addition, the Belgian exhibiting society Les XX had established itself as the "foremost international exhibiting body of avant-garde art by the end of the 1880s."[3]

The original constitution of the Indépendants proposed the right of an artist to exhibit his or her work, on payment of a fee, without going

through a selection committee. Thus, in the name of a democratization of the exhibition process (though in practice its effect was to privatize or subjectivize the image), the vaunted ideals of the Salon – official notions of subject matter, scale, and technique – were subverted by the new body. Significant changes in the making of titles both demonstrate and witness these changes in the exhibition arena. An understanding of this conjunction supplements traditional accounts of the period that discuss technical, formal, and, more recently, iconographic change.

In addition to the titular inscription of the movement in these institutional contexts, it is important to note that an animating premise of Symbolist activity was an acceptance of the legitimacy of the analogue in the production of meaning. Much excitement was centered on notions of *correspondence* and synaesthesia, derived from Baudelaire and others, and drawing on theories of expression through the potency of suggestion and calculated ambiguity. Within the debate concerning the exchange of meanings between signifying economies, one of the most sustained preoccupations of the visual Symbolists was with the nature and extent of the relation between painting and writing. In his *Théories* written between 1890 and 1910, Maurice Denis affirmed that "[t]his age is literary to the marrow. . . . In all periods of decadence, the plastic arts fall apart into literary and naturalistic affectations."[4] The very commutivity between visuality and textuality that marks many of the practices convened under the aegis of Symbolism, and which also supported the art criticism and the poetry of Baudelaire, underlines the complex intertextuality which is written across the Symbolist moment. Such imbrications cannot be subsumed under the discursive regime of categorical separateness, deriving in major part from Lessing, which formalist criticism associates with the origins of modernism. In fact, the founding and in many ways the consummating formations of visual modernity – Symbolism, Dada, and Surrealism – are radically unavailable for appropriation under any species of formalist methodology: their practices are for the most part compound signs characterized by a plurality of materials and animated by a polyvalent reference system that refuses to apportion signification through the closures of opticality.

This is the case, even though a painter/critic such as Denis consistently flaunts the term "literary" as a derogatory designation attached to academic painting that employs literary techniques. Symbolism is thus revealed both as the place of theoretical formation and consolidation of the formalist aesthetic, and *at the same time*, the place where many of the predicates and assumptions about color, form, text, and reference were also invested in a *counter-formalist* project – a project that emphasized the transfer of meaning, the cultivation of mystery, and a constant equivocation with autonomy. The convergence of the titular activity of the

Symbolist artists on a complex amalgam of centripetal (eventually to be termed autonomous) and centrifugal (suggestive, eventually non-material) significations reveals the title and its three coordinates to be an especially telling index of Symbolist practice and a key gesture in the formation of modernism at large. The Symbolist moment, then, witnessed the extremes of hyper-referentiality and of signifying closure. Beginning with the expansion of reference, I will consider both sides of this crucial polarity as it was played out in various patterns of denomination. The Symbolists often sought a kind of semantic collateral for the image through what we can call a rhetoric of indeterminacy, whose strategies were exemplified in (and dependent on) the work of their titles.

ii Odilon Redon: "Vagueness, Indeterminacy, Equivocation"

Recent research on Redon's *Noirs* allows us to encounter the critical and historical importance of a figure who, somewhat marginalized at the beginning of his career, and celebrated at its end, has if anything become less, rather than better, known. Redon's work in transfer lithography and charcoal drawings from the later 1870s to the 1890s occupies a special place in this consideration of the title. No other artist active in these years was as thoroughly absorbed in the mechanisms of exchange conceived between visual and textual sign systems.

Emerging from a provincial middle-class background near Bordeaux, Redon's first drawings, oils, and sketches took on themes drawn from "fecund nature" and returned an idealized, Romantic image repertoire, which included trees, forests, and "illustration[s] of epic literature."[5] The artist's early preoccupation with the tree as motif, symbol, and technical exercise might be linked to Mondrian's *Trees*, whose outgrowths into geometric tessellations occasioned his first deployment of the titular parenthesis "composition" – a word and a theory that would come to dominate his practice. Trees were as formative in Redon's early image-making as they were in the development of Mondrian's transitional post-Cubist style after 1911–12. For both artists the conversion of the tree (or plant) motif from an organic symbol into the armature for "uncanny, homomorphic relationship[s]"[6] (Redon) or an abstract-utopian configuration (Mondrian) was accompanied by notable expansions and reinflections of the title–caption.

Revisionary accounts of Redon's work reveal the degree to which his thinking emerged in contradiction to the established modes of art-making in Paris during the later 1860s and early 1870s. Unable to identify with

Academicism, Realism, Naturalism, or the new school of "Intransigents" or Impressionists, Redon searched for a visual-textual modernity that looked beyond the surfaces of things, taking on a relation to history that was not merely illustrative, and to the future that was not positivist, though it might be "evolutionary." He was looking above all for an original and suggestive mode of realizing the social imagination. Reviewing the Salon of 1868, Redon insists, against the realism of Manet, on what he terms the "right of fantasy and of the free interpretation of history": "the future," as he suggests a few years later, "belongs to the subjective world." Soon after this moment his particular negotiation with modernity will be staged in the form of what Stephen Eisenman calls an "allegorical syncretism," in a series of "tragicomic allegories" loaded with the politics of imaginary utopianism.[7] "Born in imitation, but nurtured in allegory, popular art and the grotesque,"[8] Redon's *Noirs* were achieved through a democratization of both audience and materials, a transcoding of peasant and folk-art sources, and the caricature, and what might be termed a sublimation, of the traditions of visual-political commentary. Eisenman locates in these interests "a radical embrace of nonelite cultural practices as a challenge to bourgeois ideological dominance" as well as a residual "reactionary populism." The "examination of the caricatural grotesque in Redon's *noirs*" which he carefully outlines, with reference to Bakhtin, Baudelaire, and Ruskin, as well as to the history of the French caricature (and its censorships) "reveals both a romantic anticapitalist nostalgia and an extraordinary concern for semantic innovation and modernity . . . a unifying of modern metropolitan and traditional popular cultures."[9]

The "semantic innovation" pointed to in this account has an important location in Redon's conjugation of words and images and a special site in the title. While Redon's literary, critical, and other writings were not as extensive as those of some other artists, considered together they clearly mark the emergence of a new moment of intertextual activity in the Symbolist milieu. Beginning in the later eighteenth century, we can locate several horizons in the development of textual commentary by artists. The Neo-Classical formation of the discourse of artists' writings is linked to the elaboration of official or quasi-official academic pronouncements on style, subject matter, and form – a genre epitomized, though also somewhat undermined, in the *Discourses* of Sir Joshua Reynolds. Romantic artists such as Delacroix, or even Van Gogh, tended to reveal their opinions "informally," through journals, notes, and letters – a transition, as Clement Greenberg once noted, from "principles to personality."[10]

As evidenced – though reinflected – in his journal *A Soi-Même (To Oneself*, translated as *To Myself*, 1922), Redon was heir to this Romantic

tradition. But he took it much further. He converted the discourse of the diary into an instrument of revisionary self-definition; and he augmented it with several other modes of textual production that had rarely, if ever, been assembled in one synthetic enterprise. In addition to his journals, Redon wrote Salon criticism (for *La Gironde* of Bordeaux), stored his letters for possible future publication, penned literary sketches of his mentor Rodolphe Bresdin, indulged in what we might term "counter-illustration," and made elaborate title-captions. Together these fields of visual-textual encounter are constitutive of Redon's new role as a contra-narrative, contra-Realist, "poet-artist."[11]

Redon was compelled and seduced by the effects of textuality. This is attested not only by his admiration of and friendship with Mallarmé, and by his frequent recourse to literary texts (by Poe, Baudelaire, Flaubert, and others) as points of thematic origination for his images, but also by a number of emphatic declarations. On one occasion he wrote that "writing and publishing is the most noble work. . . . [W]riting is the greatest art. [I]t crosses time and space, manifests superiority over the others [arts] as over music."[12] On another he noted his profound intimacy with "the savory writings of our authors, the turn of their thoughts, the rhythm of their style, the breath of their effusion, the spurt, concise or unconstrained, of their mind, their nuances?"[13] He was also given to the theorization of the system of differences and *rapprochements*, the contiguities and territorial limits, of the relation between literature and painting:

> What are the limits of the literary idea in painting?
> It is well understood. There is a literary notion as long as there is no plastic invention.
> This does not exclude invention, but any idea which could be expressed in words is subordinated to the impression produced by purely pictorial touches, and in this case appears only as accessory, and finally as superfluous. A picture thus conceived will leave in the mind a lasting impression that words could not translate, with the only exception of words in the form of art, a poem for example.[14]

Until the concluding phrases of this journal entry, Redon develops an understanding of the literary idea similar to Denis's derogatory formulation. Yet before reversing this subordination of the literary to the visual through the introduction of the preferred transferable model of poetry, Redon works out an apparently formalist definition of the purely pictorial painterly touch or mark ("tâche") precisely articulated as an autonomous "impression." Here the notion of "impression" has been diverted from its Monetesque temporality and reinterpreted as a sign of pictorial self-reference. Kandinsky would later inflect the term further so that an

"impression" became the specific name for a particular field of psycho-
logical notation.

The textual investments of Redon took still other forms. Anticipating
the point of departure (though not the conclusion) of Benjamin's 1936
essay, "The Work of Art in the Age of Mechanical Reproduction,"[15] he
marveled at the possible destiny of "painting" if it became caught up in
the unfolding drama released by the rapid development of reproductive
technologies:

> Imagine museums reproduced in this way. The mind refuses to calcu-
> late the importance painting would suddenly assume if it were thus
> placed in the sphere of literary power (the power of multiplication) and
> of its new security assured in time.[16]

The guarantee of temporality ("assurée dans le temps") solicited here by
Redon offers a contrast to Monet's cult of the instantaneous effect and
momentary sensation. Although both the act of fixing the impression and
the exhibition of series of multiple moments had already broached a new
complexity for the understanding of pictorial time, Redon's thought
about the literary power of reproducibility raises another innovative set of
questions.

One aspect of the impact of literary power for Redon was its capacity
to reproduce images, and whole image repertoires ("museums"), on a
large scale. But he was also deeply fascinated by the specific texture and
form of writing (and print). He noted the pleasures and necessities of
chiaroscuro, and was himself a great celebrant of black and grisaille. Many
of his lithographs offer a compelling play of sinuous scriptoral graphisms
that stand out in an era given over so completely to the indulgence of
color and the particularity of brushstrokes – whether impressionist, point-
illist, or expressive.

But we can go further than this. Redon once cited an aphorism from
Corot in his diary: " 'Next to an unknown, place a known,' Corot said
to me. And he made me see pen and ink studies."[17] There is a movement
in this recalled episode from an admonishment to juxtapose a certainty
with an uncertainty, a form with an un-form, a semantic presence with
a non-signifying absence (and from the visual display of these calculated
oppositions), to "études à la plume." These transitions suggest that Redon
was aware of, and indulging in, a kind of Mallarméan play with the
materiality of visual-textual sign systems – black against white, space
against fullness, ink against paper, sign against non-sign. One critic noted
that his "subtle gradations of black and white" return a "savagery" of
composition.[18] Such formal violence amounts to a kind of compositional
relinquishment, based on the radical new aesthetic of Symbolism, which

we will later trace (again after the theory and practice of Mallarmé) to a lineage of counter-compositional gestures that includes collage, montage, assemblage, and even, according to Louis Aragon, the first principles of Surrealism.

It is not surprising that Redon's *Noirs* were assailed by contemporary critics for their conspicuous lack of *compositional* value. Writing in *Le Chat noir* in 1886, George Auriol castigated his "schoolboy doodles" and "*compositions* which resemble nothing at all." "[L]et him write down his thoughts," he continues, "let him scribble them on the sidewalks, but don't let him smear any more paper!"[19] The position rehearsed here appears as the utter inverse of Mallarméan theory. No communicative or formal value is allowed for the putative abstraction of Redon's graphic marks. The possibility of any visual signification based on connotative signs is ruled out of bounds. The critic allows only that Redon might *write* his thoughts (in alphabetic script). Even then the visibility of Redon's thought-script is satirized as a kind of graffiti, whose public display on the street is the parodic inverse of the artist's imaginative internality. The designation of these marks as infantilized, non-signifying doodles and scribbles, or even as excremental smears, is a recurrent trope in the conservative critique of title-assisted reformulations of visual composition. We will see in the following chapter that such accusations reached something of a crescendo in the critical assault on the text-assisted visual-musical paintings and etchings of Whistler.

It is, however, at the interface suggested by this hostile critic between compositionality (traditional and avant-garde), public display, and Mallarméan connotation and textual-material practice that we must engage what I termed above the "special site" of the title in Redon's work – an intersection that funds the "violent trouble" of the *Noirs*.[20] This juncture is best brought forward in the course of a critical tour of Redon's titles. Redon invested powerfully in his nominative decisions, for not only are the titles of his drawings, lithographs, and later paintings elaborately thought out and complexly referential, but the names he proposed for his journal and for particular aspects of his oeuvre are similarly suggestive. Eisenman notes at the beginning of his study that "[t]he very name he eventually gave to his drawings and lithographs – the *noirs* – indicates the frequent bitterness and irony of Redon's vision."[21] Ted Gott makes a similar claim about Redon's first album *Dans le Rêve* (*Dreaming* or *In the Dream*, 1879): "His choice of the title *Dreaming* was a deliberate act of defiance, a statement of direct opposition to the work of the Impressionist school of painting. . . . [B]y stressing the supremacy of fantasy and the imagination over realist documentation, Redon was also consciously attacking the pragmatic principles of Zola and his 'scientific' coterie."[22] Further evidence is supplied in the title of his journal,

which he kept for some forty-eight years and which was first published as *A Soi-Même* in 1922. The formula "To Oneself" is composed as an indirect, even evasive, third-person reference to the self. It evinces a kind of calculated masquerade in which the author takes knowing refuge behind the literary confection of a self-image and the construction of a sanctioned self-history. As with Signac, who, as we will see, christened his sailing boats with alluringly oblique names, the work of the Symbolist title spills over into the affairs of the everyday world, carrying wider implications than simple (or even difficult) pictorial reference.

Insofar as Redon's work might be linked to either a conscious or unconscious transposition of the social signification of the censored caricatural image – an idea suggested but not pursued by Eisenman – we might infer a point of historical reference for his titles in the captions that accompanied contemporary caricatures. As with the visual-textual reference system of later nineteenth-century painting, a clear gradient of relational possibilities was set in place between the caricature and its caption. At the de-textualized extreme of this hierarchy were numerous caricatures that thrived on the visual immediacy of their denotative deformations: works of counter-portraiture that exaggerated a particular feature, or combination of features, of a well-known personality, or métier-type, either for satiric or comic effect. Such works were assumed to be instantly recognizable, or were merely supplied, as in conventional portraiture, with a proper name or brief identificatory tag. At the other extreme of the gradient were several forms of caricature that required much more elaborate textual supplementation. Many of these, indeed, would have been "illegible" without it. Such productions include "narrative caricatures" invested in an episode (say in a court of law, or at the Salon) which required sub-image, "cartoon bubble" dialogue or other forms of descriptive or story-line notation.

While the development of such graphic extensions and elisions (what Gombrich terms "purely conventional symbolism," "elliptic expressions," and the "supplementation" by "the beholder" of what is omitted in "an abbreviatory style"[23]) is clearly of importance for the elaboration of visual Symbolism, there is another variant of text-rich caricature that was probably of more moment for Redon's title-captions. These were the "comic/grotesque texts and images" of Grandville made for *La Caricature*, founded in 1830 by Charles Philipon, whose "rebus-like allegories" Eisenman joins with the work of Bresdin and Baudelaire by virtue of a shared "arbitrary grafting of meaning onto form."[24] Critics of a different persuasion, however, took issue with the disjunction and portentousness of such work. Champfleury criticized "Grandville's often grotesque late works," which he held were "burdened by long captions in which the reader can only 'painfully follow the thread of ideas.'"[25]

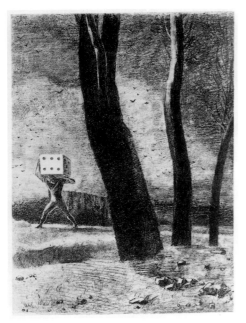 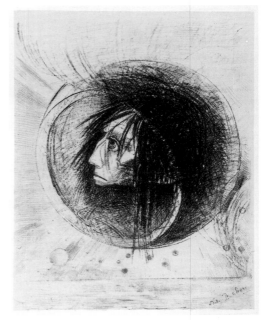

20 and 21 Odilon Redon, *The Gambler*, plate v, and *Blossoming*, plate ɪ, from *Dans le rêve*, Mellerio 27 and 31, 1879. Lithographs on mounted ivory China paper, 27.3 × 19.3 and 33.4 × 25.8, respectively. The Art Insitute of Chicago. Charles Stickney Collection

This coupling of obscurely allegorical form with extended, allusive titles constitutes a preliminary definition of Redon's title-images. With this in mind we should turn to the artist's first effort in the lithographic medium, *Dreaming* (1879). An album of ten plates printed in a small edition of twenty-five, it was composed as a series of fantasy images based on found and invented crypto-mythological and biological forms accompanied by short, suggestive, abstract titles. These included: *Eclosion* (*Blossoming*, fig. 21), *Germination*, *La Roue* (*The Wheel*), *Limbes* (*Limbo*), *Le Joueur* (*The Gambler*, fig. 20), *Gnome*, *Triste Montée* (*Sad Ascent*), and *Sur la Coupe* (*On the Dish*). In each case a simple, though generalized, title meets an image which sanctions a flicker of motif-driven orientation, before diverting its excess signification into allusive visual allegory. Thus in *The Gambler* (fig. 20) a single element in the composition signals the presence of the titular subvention. This is a gigantic die, whose six-dot face fronts the viewer, borne on the shoulders of a muscular, spread-footed man, who may be striding out of the image or struggling to secure his enormous burden. The die-bearing figure occupies only a small fraction of the image, the rest of whose tenebral dimensions are given

over to a barren, rock-strewn landscape, three black-barked leafless trees, and a sweep of sky – filling three-quarters of the picture – loaded with wheeling birds that barely emerge from its graphic markings. Apart from an intimation of cliffs or a ravine behind the man, these are the entire contents of the image. The viewer is confronted by a nightmarish environment, the scalar disruption of dreams, and the enigmatic passage of the titular figure, whose iconography seems ironically suspended between the Atlantid and the striding Worker-Sower.[26]

Other lithographs from the album offer even less by way of iconographic orientation. *Blossoming* (fig. 21) confronts us with a hollow, sectioned sphere cut open to reveal the profile of a hook-nosed figure with a bulbous eye and scored with hairy, husk-like emanations. This apparition hovers above a faint low horizon and a shower of meteor-like fellow spheres. Precisely what is blossoming in this representation is left pervasively obscure. It could be a dark allegory of the germinal ascent of the soul or the disembodied levitation of the intellect or finer mind, or it could encapsulate a metaphor for human evolution. The indirectness of what is already a deeply metaphoric relation between the title and the image invests the lithograph with a necessary, ever-speculative referentiality that spins it in its own universe of connotations. The viewer is simultaneously implicated in and alienated from the social vice (gambling) or faint euphoria of progress, blossoming, through a combination of allusive visual disinvestment and textual over-suggestion. The result is a lithographic sequence that almost perversely captures the seen and read, dreamed and imagined interiority of modern life.

Dreaming was followed by *A Edgar Poe* (*To Edgar Poe*, 1882); *Les Origines* (*The Origins*, 1883); *A Gustave Flaubert* (*To Gustave Flaubert*, 1889), and other series. For each of these productions Redon developed a specific titling procedure, though in all of them he moved away from the juxtaposition of attenuated textual abstraction with obscure visual reference, which characterized his first album. The decisive break from his earlier practice is signaled in the six plates of the Poe edition. Here each lithograph is accompanied by "strange poetical captions which Redon composed, in the style of Poe."[27] The technique of poetic simulation engenders a decisively new re-orientation of the visual-textual ensemble. The invented compounds Redon drew into the visual dimension of his image offer a virtually unprecedented displacement of its signifying parameters. What is invented here is a link-system that deploys and re-allocates each of the conventional modalities of the title and secures them in a relation of semi-controlled polyvalence with the image. Thus, denotative reference, calling up relations of near equivalence from the title to the motif, is not simply relegated in the album (as it was not

in *Dreaming*). Instead, the comfortable invisibility of its immediacies are thickened and made over as semi–legibilities. We are granted access to a portion of the referentiality of the work, but denied any real understanding of the disconnected logic of its spiritual or social meanings.

In titling many of these lithographs Redon took his own advice seriously, producing allusive, poetic sentences and invocations such as *Il y eut peut-être une vision première essayé dans la fleur* (*There Was Perhaps a First Vision Attempted in the Flower*, no. 2 of *Origins*) or *La Mort: Mon Ironie dépasse toutes les autres* (*Death: My Irony Surpasses All Others*, no. 3 of *To Gustave Flaubert*). In his journal Redon left an extended note on his titular activity:

> The designation by a title given to my drawings is sometimes superfluous, so to speak. The title is not justified unless it is vague, indeterminate and aspiring, even confusedly equivocal. My drawings *inspire* and do not define themselves. They determine nothing. They place us just as music does in the ambiguous world of the indeterminate.
>
> They are a sort of *metaphor* Rémy de Gourmont said, in placing them apart, far from all geometric art.[28]

Redon's blandishments mobilize many of the key terms active in his rhetoric of "indeterminacy." He writes of the quest for vagueness, equivocation, and ambiguity; he celebrates the Romantic-inspired potential of music for the cultivation of these effects; and he likens the whole process of equivocation to the tropic action of metaphoricity.

These reflections on the title offer important evidence of his drive for connotative signification. But they also function within the revisionary self-history put forward in his diary. Such as it can be established, the ascription and material history of Redon's titles is in many ways no less dispersed and mysterious than their ambiguous semantic values. Thus, in their first publication by Lemercier in 1883, the plates of *The Origins* were not accompanied by the title-captions they later bore. Redon's correspondence with André Mellerio, who published a catalogue of his work for the Société pour l'Etude de la Gravure Française in 1913, suggests that he had deliberately suppressed his captions "because the cover title was already so loaded."[29] This was in 1898. Yet a decade later, in 1909, as Dario Gamboni notes, Redon claimed to André Bonger that it was "afterwards, for a collector who asked for them" that he "drafted some captions which supported the great hypothesis of evolution."[30] The rival histories of the generation of these titles is matched by the different histories of the arrangement and labeling of the lithographs in different publications and editions. If they were "neither numbered nor titled" by Lemercier, "permitting an open-ended interpretation," and if their absence was deemed regrettable by Jules Destrée in his *L'Oeuvre*

lithographique de Odilon Redon: Catalogue descriptif (1891), by 1913 Mellerio stated in his catalogue that the reordered sequence to which they were subject was fixed by the artist himself, "who attaches a real importance to it," and, further, that the new, more developed captions were also sanctioned by the artist, forming "a kind of continuous poem." There was yet another, intermediary, stage between the non-titled and hyper-titled sequences, as Redon inscribed abbreviated captions onto at least two other editions of the album, including that owned by Mellerio.

In thinking through the implications of this shifting territory of refer-ence, Eisenman offers another useful point of departure:

> Redon's texts seem at first glance to provide an "additional element" [the phrase is borrowed from Yves Bonnefoy's discussion of Mallarmé's poetics] that elucidates the image; in a moment, however, that deno-tative foundation is revealed to be chimerical. Thrown back on the image alone, sight is suddenly revealed to possess extraordinary cognitive power. Yet as the riddle of the image gradually reappears – a flower with a human face – we fall again (and this time with greater velocity) into the abyss of the impossible. That fall is the experience of the grotesque.[31]

The supplementarity of the additional element of Redon's title-texts, and their relation to the ideas of Mallarmé, are well noted. But I would want to resist the suggestion that Redon's titles are set up to elucidate the image, even in a momentary or preliminary sense as well as the claim that we are "thrown back on the image alone." On the contrary, what is new in Redon's titles, and what is equally radical in Mallarmé, is the notion that the meaning of the image/text is caught in a continual play of superimpositions. The supplement of the title is assembled with and layered over the "invisible speech" of the image.

Redon's somewhat introverted *oppositional* play with the material of language took a more socially extroverted form by way of his participa-tion in many of the alternative exhibitions organized in the last quarter of the nineteenth century. In 1867, early in his career, Redon actively questioned both the values and the vocabulary of official art:

> The official painting juries officiously recommend that you present *important* works to the Salon. What do they mean by that word? A work of art is important according to its dimensions, execution, choice of subject or thought.[32]

While it may anticipate some of the future formalist tendencies of the Symbolist movement, the listing here of dimension, execution, subject, and sentiment as the officially important attributes of a painting practice has not yet developed a mature comprehension of the bases of Symbolist opposition – except, that is, for the elevation and syntactical separation of

"thought" ("*la pensée*") as the final touchstone for any measurement of difference with official concepts of painting.[33] The desire to represent abstract thought (and allied concepts such as idea, inspiration, vision – i.e., not particular ideas) unencumbered by traditional allegorization or by genre sentimentalism and literary affectation, and in particular the representation of mysterious or enigmatic thought, was anticipated or at least hinted at by Redon at the beginning of his career. The attitude glimpsed here would become a crucial indicator of Symbolist alternativism in the 1880s and beyond.

Redon played the role of outsider, or alternative artist as thoroughly (and whimsically) as anyone in these years. He was elected vice-president of the Société des Artistes Indépendants in 1884, and exhibited in the Salon des Indépendants in its inaugural show, and in 1886 and 1887; he was in the first Venice Biennale in 1895; an entire room at the first annual show of the Salon d'Automne in 1904 was devoted to his work; and he was even represented – by some forty works – at the Armory Show in New York in 1913. When he exhibited at Les XX in Brussels in 1886, his work was featured in a satirical para-review, organized as a conversation staged on a street near the exhibition hall – a trope with loose similarities to Leroy's play with the technical, nominal, and institutional parameters of the first Impressionist exhibition published in *Le Charivari* thirteen years earlier. Commenting on its comical effects, one interlocutor noted the presence of "[s]ome blue landscapes, some red interiors, some hair without heads, and some portraits without eyes." The other riposts: "And some eyes without portraits. Look at Odilon Redon, for example."[34]

The titular gestures of Redon depart from premises that we can describe as virtually the antithesis of the titling concerns of Monet and the Impressionists. While the Impressionists actively sought to *report* their negotiation between the environment and time (or season), maintaining direct contact with the natural world, Redon's first mentor in the art world, Rodolphe Bresdin, a Bordeaux printmaker he met in 1863, specifically advised him not even to look at "nature."[35] This contra-natural internalization lies at the heart of Redon's Symbolism and is crucial for the signification of Symbolist images and texts at large.

Redon's titles can be related to the heterogeneous poetic disruption staged in the poetic texts of Mallarmé and Lautréamont. Like the disruptive poetic formations of avant-garde language, the title stands for another practice that might give rise to what Kristeva has termed the "laughter" of practice.[36] This laughter would be exchanged between the image and the text. For the title always negotiates a *passage* from one material signifying practice to another. Just as the Symbolist moment witnessed the revolutionary emergence of a new poetic force in the transrational

deployment of language, the Symbolist title interrupts the signifying economy of the image and binds itself to poetic language in a relational field that exceeds the descriptive subordination of the pre-modernist title as consciously as the poetic simultaneously exceeds and denies narrativity or denotation. The title doubles up the poetic with its laughter, jouissance, boundlessness, and emptiness. The nothingness, whiteness, and self-articulation of the Symbolist poem, as interpreted by Kristeva, is met by the extremes of the signifying relay of the Symbolist title – its reduction, zeroing, and relay into *form*, on the one hand; and its hyper-referentiality, mysticism, or absurdities, on the other.

The alternative exhibition; the cultivation of "thought-painting"; the separation, interchange, and eventual sublimation of textuality and visuality in a complex economy of difference predicated on the literal poeticization of his titles: all these signatures of Symbolist painting reveal Redon as a decisive figure in the reorientation of visual modernism towards its double destiny of formalist autonomy and textualist equivocation.

III Paul Gauguin: "Not a Title, but a Signature"

Until the late 1880s, Gauguin's paintings were for the most part supplied with Impressionist-aligned titles subtending Impressionist-like subject matter (such as *Landscape with Skaters in the Snow*, 1883). Like most of the Symbolists, though with an agenda uniquely his own, Gauguin subsequently elaborated a calculated disparity of register between the image and its name. Two self-portraits, usually the most verbally uncircumscribed of images, attest to this new obliqueness of reference: *Bonjour M. Gauguin* (*Good Morning Mr. Gauguin*, 1889) and *Les Misérables* (1888, fig. 22). Soon after these works were painted, Gauguin responded to his immersion in the so-called primitive cultures of Martinique and Tahiti by appending a further series of opaque names to new subjects and different objects. He gave titles to his works drawn from local vernaculars, which, even when translated, resist any easy descriptive reference to what is represented: *Hina Te fatou* (*La Lune et la terre*) (*Hina Te fatou* [*The Moon and the Earth*], 1893, fig. 23), or *Nave nave fenua* (which has been translated as *Land of Sensuous Pleasure* and *Delightful Land*). Sharing with many of the Symbolists both a suspicion of illustration, naturalism, and Impressionism, and their not occasional contempt for literary affectation, Gauguin, like Redon, found the material and signifying differences between title and visual image to be one of the most appropriate sites for the cultivation of obliqueness and connotation, and the suggestion of a new kind of musical referentiality.

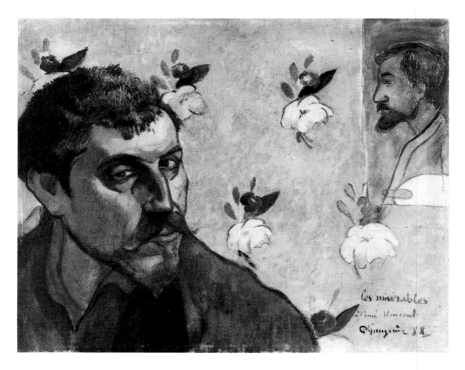

Gauguin struggles most notably with these differences in relation to one of his most elusively titled works, *D'où venons-nous? Que sommes-nous? Où allons-nous? (Where do we come from? What are we? Where are we going?*, 1897, fig. 24):

> Awakening with my work finished, I ask myself, "Where do we come from? What are we? Where are we going?" A thought which no longer has anything to do with the canvas, expressed in words quite apart on the wall which surrounds it. Not a title, but a signature. You see, although I understand very well the value of words – abstract and concrete – in the dictionary, I no longer grasp them in painting. I have tried to interpret my vision in an appropriate decor, without recourse to literary means and with all the simplicity the medium permits: a difficult job.[37]

For Gauguin, the painting came first and was executed in a direct and privileged relation to his visionary experience. His account implicitly supposes that both the material and the visionary images take their places in simple, untroubled relation to the abstraction and complexity of Western writing. The title of the work, however, was the product of a

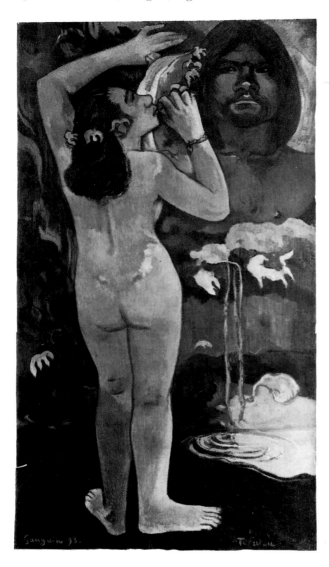

22 (*facing page*) Paul Gauguin, *Self-Portrait with Portrait of Bernard "Les Miserables"*, 1888. 45 × 55. Van Gogh Museum (Vincent Van Gogh Foundation), Amsterdam

23 Paul Gauguin, *The Moon and the Earth (Hina Te fatou)*, 1893. Oil on burlap, 114.3 × 62.2. The Museum of Modern Art, New York. Lillie P. Bliss Collection

different – although perhaps also visionary or oneiric – state, as the artist has purportedly just "awoken." But its status as title – in the sense of a potentially objective description of the content of the work – is explicitly denied. Instead, Gauguin realigns the title with its earlier meaning in both English and French ("personal appellation," *Oxford English Dictionary*), when he likens it to a signature. For Gauguin, the work of the title is both modified and expanded on the analogy of the signature. It becomes

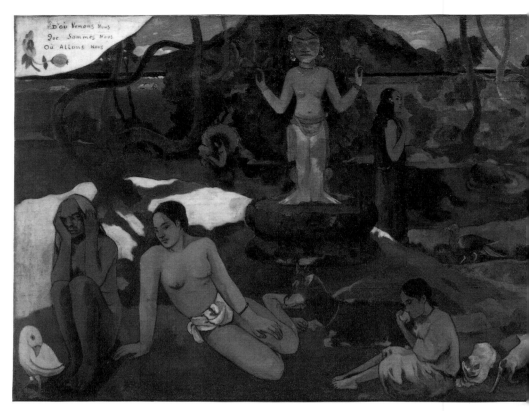

24 Paul Gauguin, *Where do we come from? What are we? Where are we going?*, 1897. 139.1 × 374.6. Museum of Fine Arts, Boston. Tompkins Collection

a strictly personal act of naming, a mark of psychic commentary on the work by its maker, and, like a signature, comes after the completion of the painting, rather than before it or with it, necessarily interfering with the signifying capacity of the image by virtue of its material, contextual, and temporal differences from it. Meaning may be glimpsed as in process between these several modes, rather than given, or denoted, by a titular tyranny of encapsulation or description.

The conjugation of signature and title is attested to not only in Gauguin's writings, but also in the painting itself, and in the wider context of the artist's Polynesian experience. Looking first to the painting, we can observe that two yellow curve-edged bubbles intrude into its top corners, the left one bearing the title in handwritten script, accompanied by a floral emblem, the right one carrying the artist's signature and date,

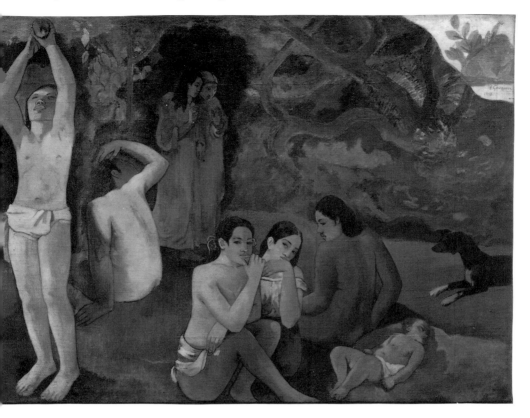

written in small letters and numbers all but crowded out by another emblem. This format clearly signals the symbolic intrusion of these associated scripts. However, the implications of the forced entry of Gauguin's title and name into the unsystematically allegorical pictorial space are not confined to unfurling, or superimposition, of the two legend-bearing devices. Having committed the corners or extreme margins of his composition to a counter-realist form of textual and decorative scrolling, Gauguin carefully places a symbolic white bird in the bottom left corner of the painting, at the feet of the crouching figure – a position symmetrical with the title bubble. Both the color and the shape of the bird attest to the care with which he organized this opposition, for its body and tucked-down head make up a sinuous "L" form that answers quite directly to the "L" shape of the emblem in the bubble above it. In a letter to Daniel de Monfreid, Gauguin explains the significance of his "strange white bird, holding in its claws a lizard": it "represents the vanity

of useless words."[38] The bird, then, is a kind of symbolic anti-title that quietly, stubbornly, and opaquely assails the signifying pretensions of Western language. It is a coded visual response, from ground level, to the elevated, philosophical interrogations invested in the title hanging above it. In the same letter Gauguin insists that his painting is "a philosophical work on a theme comparable to that of the Gospel."[39] This is the first in a title-driven mini-series of large-scale "signature" works that take on ambitious questions of life, death, sexuality, and the representation of "others" – the first culminating gesture of which will be Picasso's *Le Bordel philosophique* (*The Philosophical Brothel*, 1907, fig. 35), later called *Les Demoiselles d'Avignon*.

On the right side of the painting, nothing in the bottom corner answers to the signature and date in the corner above. Given the clear deliberation over symbols, scripts, and forms lodged in the other margins, it is difficult to assume that this empty space, clearly bounded by a dog lying on its front and a baby on its back (themselves symbols of loyalty and innocence), lacks significance. It is surely a knowing evacuation: for while the signatory name itself could be reduced in scale and signifying power, while it could be subordinated to the emblematic or decorative motif with which it cohabits in the bubble, Gauguin did not allow himself to attack his signature with some form of symbolic antithesis, as he had the title. He could satirize speculative abstraction, but he was too insecure (financially, socially, colonially) to ironize the signing of his selfhood, or to erase his name. He described exactly this dilemma in a letter to Dr. Gouzer, soon after the painting was completed, complaining of the impossible profusion of "schools, academics, and above all else by mediocrities" in the European art world – "a whole constellation of names. My own [name] may disappear," he continued, "what does it matter?"[40] *Where Do We Come From?* may be the last time that Gauguin resisted this capitulation. As he suggested to Charles Morice – with the melancholy exaggeration of his later years – Gauguin associated the precipitous finalization of his painting, and the appending of his signature, with pain, suicide, and death: "I hastened to sign it, and then took a formidable dose of arsenic."

In *Where Do We Come From?* Gauguin gathered up his strengths and fears, commitments and doubts, answering the impossible questions of his title with a flourish of symbolic figures, animals, and natural forms that competed with and deconstructed his Western-style speculative anxieties. While he gave his signature double-billing with the title, necessarily associating himself with the introspective abstractions of the West, its cramped miniaturization and the empty space below it were as far as he could go (on the right side) to answer his symbolized fantasies of the naked, primordial, and unrefined languages of the South Seas on the left.

Gauguin could allow language to be symbolic, and thus a territory of dispute and difference, as well as of domination, but his imagination of the self needed to be protected as if it were real.

Gauguin's wider understanding of the term "title," suggested in his likening it to a signature, is further attested in an aside he recounts in his *Avant et après* (*Intimate Journals*): "In Oceania a woman says: 'I don't know whether I love him, for I haven't slept with him yet.' Possession gives title."[41] In this recollection, the indulgence in sensuous experience gives rise to passion, thus conferring (and confirming) a "title" – the justness of the relationship. In the process, the Western courtly ritual of love is reversed in the name of a kind of pragmatic immediacy, a figure of the kind of role reversal between title and image that Gauguin envisaged for his painting practice. Not only is the title a "mark of personal commentary," thus displacing its condition as a descriptive prompt, but it could be entirely removed from the exigencies of a particular canvas: "I should like to write as I paint my pictures, – that is to say, following my fancy, following the moon, and finding the title long afterwards."[42] Gauguin sets the conditions, then, for the predetermined separation of the title and image, as well as for their imaginative re-coordination, their mental mixing (to use a metaphor from the contemporary theories of color separation) in an imagined domain beyond the scope of denotation, recognition, and labelling.

Almost the only critical coherence that can be inferred from Gauguin's miscellaneous writings and correspondence, written mainly from Tahiti and Martinique during the 1890s, is his commitment to a renegade form of Mallarméan connotation. In the same letter to the critic Fontainas cited above he invokes Mallarmé to claim his devotion "to precisely that which is not expressed" ("précisément dans 'ce qui est n'est pas exprimé'") – that which is implicit and mysterious, and cannot even be expressed either through "colors or words" ("couleurs ou paroles").[43] Two years later (in a letter to Charles Morice of July 1901) Gauguin is apparently still preoccupied by what he regarded as Fontainas's inability to interpret either the monumental painting itself or his own response to the critic's original article. He reports Fontainas's disappointment that his "abstract title" is "by no means reflected in concrete forms on the canvas, etc."

There follows an extended comparison between Puvis's literary Symbolism and his own "savage . . . artfulness":

> Puvis explains his ideas, that is very true, but he does not paint them. He is a Greek, whereas I am a savage, a wolf without a collar in the forest [this was Degas' expression]. Puvis will entitle a work 'Purity,' and to explain it will paint a young virgin with a lily in her hand, a well-known symbol, which everybody can understand. Gauguin, faced

with the same title of 'Purity,' will paint a landscape with limpid streams, no sign of pollution by man, perhaps one human being.

Without going into details, Puvis and I are divided by a whole world. Puvis, as a painter, is a wordsmith, not a man of letters, whilst I am not a wordsmith, but perhaps a man of letters. . . .

Where are we going?
Close to the death of an old woman. A strange and stupid bird brings everything to an end.

What are we?
Daily life. The man of instinct asks himself what all that means.

Where do we come from?
The source. The child. Communal life.

The bird concludes the poem by comparing the inferior being to the intelligent in the grand order of things propounded in the title. Behind a tree, two sinister figures dressed in robes of a melancholy hue introduce, close to the tree of science, their note of sorrow, caused by science itself, in contrast with the simple human beings in uncontaminated nature, which could be a paradise of human conception leading on to the happiness of living.

Other explanatory attributes – familiar symbols – would endow the canvas with a melancholic realism, and the problem announced [in the title] could no longer be a poem.

In these few words I explain the picture.[44]

If we attend closely to this extended discussion, we will find that the contrast spelled out by Gauguin between the textually transparent and traditionally motivated Symbolism of Puvis and his own symbolic obliquity, is simultaneously affirmed and denied. Gauguin, in other words, develops a rather ambiguous counter-system which he opposes to Puvis's rational, legible Symbolism. According to its logic, Puvis's "idea" is formalized by terms (images) that are "known" ("connu"), received, and explicable in relation to concrete forms. Yet despite its comprehensibility, this idea can only be explained and not *painted*. Gauguin's idea, on the other hand, is discussed only by implication, as he does not produce positive terms of his own that answer to the explanatory discourse constructed for Puvis, preferring to characterize his ("savage") personality instead. Yet when Gauguin describes a putative painting of his own making, he stresses the limpidity of its form, precisely its *clarity*, as much as he contrasts its figural occupation by personages as opposed to civilized people. Finally – and with more than a touch of irony – Gauguin proceeds to offer the kind of synoptic ("peu de mots") explanation whose

very possibility his theories and musings elsewhere would appear to challenge and deny.

This whole (imagined) debate, of course, has been staged between two painters (Puvis and Gauguin) and between two titles, one single and real (Gauguin's *Where Do We Come From?*); the other, double and imaginary (*Pureté* as it might be treated by both artists). In Gauguin's refusal to go as far as Redon in the cultivation of sheer enigma and conundrum, in his apparent compromise with an initial insistence that the "abstract title is never manifested in a painting by concrete forms" ("le titre abstrait ne se manifestent nullement dans la toile en formes concrètes"), he equivocates with the loss and the return of his own Western history: its system of signs, symbols, and language. There was, he notes "a world" of difference between Puvis and himself, as indeed there was both literally and figuratively. In the context of Polynesia he comes to realize that he is willing to risk suggestiveness and oppose denotation, but he will not openly court dissolution.

Gauguin's titles are tokens of this dialogical symbolism. Physically inscribed on the canvas, they take their place in a drama of senses (linguistic connotations and material sensations) spun in the web of a strange and fascinating language.[45] They are, by turns, personal signatures (subjective investments and responses to the image); abstract, musical reveries ("This language is fantastic and has several meanings"); playful teases ("Many of the pictures, of course, will be incomprehensible and you will have something to amuse you");[46] and even explanations (the image in some sense enacts "the problem announced by the title.")[47] Seldom was the signifying range of the title permitted this kind of latitude and contradiction. Fearful of its literature, other Symbolists and most subsequent modernist painters – as we will see – preferred to close down the title, or to explode it into wild, provocative reference, or to retreat behind its utter mystification.

IV Paul Signac and Alphonse Allais: Exhibitions, Numbers, and "Incoherents"

Signac chose all three of these Symbolist options – closure, extreme connotation, and mystification – and his work provides some of the earliest evidence of two of the paradigmatic modernist nomenclatures: the apparently overscripted, offbeat, or allusive title on the one hand, and the untitled or merely numbered work on the other. In 1890 Signac painted a remarkable portrait of the Symbolist critic, Félix Fénéon. The title he bestowed on it is one of the most elaborate nineteenth-century

designations: *Sur l'émail d'un fond rhythmique de mesures et d'angles, de tons et de teintes, portrait de M. Félix Fénéon en 1890, Opus 217 (Against the Enamel of a Background Rhythmic with Beats and Angles, Tones, and Colors, Portrait of M. Félix Fénéon in 1890, Opus 217*, fig. 25). While somewhat atypical as an example of Neo-Impressionism, this painting clearly demonstrates the processes of exchange between title and image that signal displacements of humor, irony, and esoterica to the viewer. A commentary on the portrait in the catalogue to the 1979 Post-Impressionist exhibition at the Royal Academy in London emphasizes a probably unrecoverable network of "private references" that center on the relationship between Signac and the theories and personalities of Fénéon and Charles Henry, particularly their ideas on the psychological effects of colors and linear directions, and of the correlations between them. The work is situated as a "key example" of "private, attributive portraiture, pioneered in the 1860s by Manet (in his *Portrait of Zola*, 1868 . . .) and by Degas . . . , and developed by Van Gogh . . . and Gauguin, among others, in the 1880s."[48]

The correspondence between Signac and Fénéon on the subject of this "stylized effigy" reveals another, equally important, frame of reference for the portrait and its title. It also gives rise to another in the sequence of imaginary titles that I present as a subtext throughout this study. For when the "idea of a portrait" was broached by the artist, Fénéon wrote to Signac with an ironic approval:

> I would rather like for it [my performance] to be immortalized for the cymae of future art galleries, whose catalogue would say:
> Paul Signac (1863–1963):
> Portrait of a Young Man.
> H. 2.30 m. – L. 1.15 m.
> Have you already thought of the pose, the costume and the décor?[49]

Even though Fénéon was a critic, this brief, partly frivolous, riposte is remarkable for its encapsulation of institutional and other parameters for the production and reception of a painting. It embraces the gallery, the future reception of the work, the catalogue, the artist (here rewarded with a century-long life-span), the title, the (life-like) dimensions, as well as questions of pose, costume, and décor – the very adjuncts of the frame-bound representation that Whistler had already integrated as a compositional context.

Signac's response – both in his return letter and in the eventual work – was to actualize, accentuate, and legitimize each of these attributes of the image, conceiving the product as a special effort of composition: "It would not be a commonplace portrait at all, but a carefully composed picture, with very carefully arranged colors and lines . . . [with a] well-

25 Paul Signac, *Against the Enamel of a Background Rhythmic with Beats and Angles, Tones, and Colors, Portrait of M. Félix Fénéon in 1890, Opus 217*. Private Collection, New York

defined background composed of two complementary colors."[50] The portrait thus develops as a kind of title-assisted parody-composition that sought to conjugate all the aspects of synaesthetic sensation – rhythm, angles, tones, colors, design, light, scent, motility, and music. Combining pedantic formal specificity with offbeat allusion, this is a work that could hardly imagine the ingrained seriousness with which the more settled and less ambitious versions of compositional order would be negotiated in the century to come. Nor that they would be simultaneously most fulfilled and exhausted almost exactly in the year of the anticipated centenary of Signac's birth. By 1963, the "measures and angles" that Signac cites from Henry, in his "flamboyant application" of the writer's "theories on the dynamogeny of lines and colours," have become wedded to the abstract processes they somehow represent. Thus, for Clement Greenberg there is no trace of irony in his review of "Three New American Painters: Louis, Noland, Olitski": "Louis is not interested in veils or stripes as such, but in verticality and color. Noland is not interested in circles as such, but in concentricity and color. Olitski is not interested in openings and spots as such, but in interlocking and color."[51] Greenberg's commentary reveals

how the elements of composition (circles, stripes, etc.) have been subordinated to a discourse on the compositional, eliminating all reference to subjects or selves. It is significant that Signac, like Whistler and Gauguin (and later Picabia and Miró), chose portraiture as the vehicle for his most audacious experiment in synaesthetic composition. Linking visual-formal values to musicality, merging the foreground subject with the background environment, the resulting composition is encrypted with the visual theorization of the protagonist (Fénéon) and the moment (Symbolism). A century later there are still residual traces of this struggle over the referentiality of the abstract composition. For while its Greenbergian incarnation announces the abstract exteriority of purely formal values in the works of Louis, Noland, and Co., other artists, including Stella and Twombly, use the title to reinvest the image with personal, historical, and contextual knowledge.

More outrageous than Signac's portrait, and more antagonistic still to the residual academic standards of the late nineteenth century, were the efforts of the wit and humorist, Alphonse Allais (1855–1905), who produced works headed by titles such as *Première communion de jeunes filles chlorotiques par un temps de neige* (*First Communion of Chlorotic Young Girls in Snowy Weather*, 1883, fig. 26a). Exhibited at the second Exposition des Arts Incohérents, where its "suave title" ("titre suave")[52] was noted by the ubiquitous Fénéon,[53] the piece consisted of a sheet of blank Bristol paper and four drawing pins. Other burlesque productions by Allais include *Les grandes douleurs sont muettes. – Marche funèbre incohérente* (*Great Sorrows Are Silent – Incoherent Funeral March*), the constitution of which is uncertain; while another ironic monochrome, *Combat de nègres dans une cave pendant la nuit* (*Negroes Fighting in a Cellar at Night*, fig. 26b) is attributed to Paul BILHAUD in the catalogue of the first Arts Incohérents exhibition (1882). Two works in the same show by the "poet" Auguste ERHAUD offer related commentaries on liberty, licence and infinite smallness: *Liberty chasing licence* (no. 54), and *The Smallest of the Small, Visible Only to the Eyes of Science* (no. 55).

These early text-assisted monochromes culminate in Allais' extraordinary *Album Primo Avrilesque* (*April fool-ish Album*), published by Paul Ollendorf in 1897, which collects five single-color works (red, yellow, blue, green, and brown) in addition to the black and white pieces mentioned above: *Récolte de la tomate par des cardinaux apoplectiques au bord de la mer rouge (Effet d'aurore boréale)* (*Tomato Harvest by Apoplectic Cardinals on the Shore of the Red Sea [Aurora Borealis Effect]*, reproduced on the back cover); *Manipulation de l'ocre par des cocus ictériques* (*Manipulation of Ocher by Jaundiced Cuckolds*); *Stupeur de jeunes recrues apercevant pour la première fois ton azur, O Méditerrané!* (*Astonishment of Young Recruits Seeing for the First Time*

PREMIÈRE COMMUNION DE JEUNES FILLES CHLOROTIQUES
PAR UN TEMPS DE NEIGE

26a and b Alphonse Allais, monochromatic images from *Album primo-avrilesque* (*April fool-ish Album*) (Paris: Paul Ollendorff, 1897). *Above: First Communion of Chlorotic Young Girls in Snowy Weather; below: Negroes Fighting in a Cellar at Night*, based on Paul Bilhaud's entry in the 1882 *Exposition des arts incohérents*. Jane Voorhees Zimmerli Art Museum, Rutgers, The State University of New Jersey. The Herbert D. and Ruth Schimmel Museum Library Fund. Photo by: Jack Abraham

COMBAT DE NÈGRES DANS UNE CAVE, PENDANT LA NUIT
(Reproduction du célèbre tableau.)

Your Azure Expanse, O Mediterranean!); *Des souteneurs, encore dans la force de l'âge et le ventre dans l'herbe, boivent de l'absinthe* (*Some Pimps, Still in the Prime of Life, Lying on Their Stomachs in the Grass, Drinking Absinthe*); *Ronde de Pochards dans le brouillard* (*Round of Drunks in the Fog*).)

This sequence represents an especially important moment in the development of the parodic title as well as a remarkable anticipation of the non-iconic abstract art that emerged as the signature style of high modernism on the eve of World War I. It cleary suggests that the crisis of reference engendered by the opaque constitution of the non-iconic sign had already been exposed and debunked – albeit with one-dimensional irreverence – some thirty years *before* the serious claims made in its behalf by the pioneer abstractionists of the 1910s.[54]

The Incohérent was founded in 1882 as an occasional exhibiting body by Jules Lévy, and continued until 1893. Its seven Parisian exhibitions (and several regional variants) probed further, however, than the blank, one-color or invisible image: they provided an anarchistic "parody of the whole apparatus surrounding the Salon exhibitions of the period, complete with illustrated catalogue, modelled on the *Salon illustré* volumes."[55] The association of the Incohérents with the most outrageous titling practices in the nineteenth century is consistent with its staging of an explicit, extreme, and ephemeral critique of official art practice. Fénéon described the iconoclasm of this alternative Salon as follows:

> At the Galerie Vivienne Mr. Jules Lévy has just brought together all that the most audacious wordplays and the most extreme methods of execution could do to give birth – from the dazed [body of] painting and sculpture – to madly hybrid works.[56]

Amidst the exuberant disruptiveness of the exhibition – its "exhilarating and epileptic rantings" – Fénéon specifically noted the mockery it wrought with respect to the conventional role of the catalogue: "As for the tricks that pepper the exhibition catalogue – too often cribbed from joke books sold by foreign clowns – they are beached on constant harping."[57]

The catalogue of the first *Arts Incohérents* exhibition, printed as a non-illustrated supplement to *Le Chat noir* on 1 October 1882, offers a line by line item veto of the official parameters of exhibition. The catalogue (im)proper commences under a headtext proclaiming that Lévy, the "spiritual organizer" of the exhibition, will throw a "grand masked ball" to celebrate the anniversary of Le Chat Noir cabaret, at which "the most intense 'bizarrerie'" is promised. Replete with insider jokes, topical allusions, and schoolboy puns, there follow 159 numbered works, listed by artist, beginning with ALBIN-ALABRÈGUE's *Memories of the Great Manoeuvrers* and ending with *The Amorous Chicken/Love Letter* of Jules THIN, a "drawing made by foot in 2 seconds." As Fénéon suggests, each

aspect of *Salon illustré* propriety is mercilessly impugned: the artist's entry, with surname, first names, profession and/or rank, birthplace, pupillage, and address; the titles, subtitles, genre, and/or poetic addenda of the exhibited works; their collection, prize-winning, or saleable status; and their material constitution.[58]

The artists' biographies – fictional, literal, or composite – are, by turns, cutting, redundant, and absurdist. François-Joseph-Albert DEBELLY is described as a "thief by day, poetaster by night, the rest of the time a sculptor of dreams, born in Moux (Aude), brought up [the French "élève" puns on "pupil [of]" and "raised" or "brought up"] a numerous family; 43, Boulevard St.-Germain, week days and holidays excepted." Berthe-Antoinette LHEUREUX is six years old, professionless, was born in Paris, and is a pupil of her honored father. The painter, Luigi LOIR, is the offspring of "three-colored parents" from Bory-sur-Loire (Loiret), and a student of the beasts of Puteaux. While Réné d'ALISY is the "former president of a Society being formed, [was] born and reborn in Paris, and raised the baby's bottle to the level of art;" and Jules RAINAUD, creator of *Moon Street*, (no. 129) painted on a pastry ("polonais"), and *Soft Smiles, Flowers and Perfume* (no. 128, whose medium is not recorded), had the good fortune to come into the world "93 centimeters from the rectal orifice."

Itemized materials and supports include terracotta (no. 6); "uncooked clay" ("terre pas cuite," no. 19); "clay not cooked but painted" ("terre non cuite mais peinte," no. 98); "'painting in relief" (no. 57); "instantaneous photography" (no. 120), "sculpture in cheese" (no. 71); "painting on 4 pounds of bread" (no. 101); an eleventh-century "sculpture in chestnuts" (no. 82); a "washed drawing in invisible ink" (no. 94), and "garlic sausage" (no. 152). Sending up the contemporary fad for *japonaiserie*, there are also two "fans" by Henri SOMM (François Sommier, the illustrator and Chat Noirist), one, belonging to a Mr. M. R. Salis (probably Rodolphe Salis, founder of the Chat Noir cabaret), titled *Mr., Missus, Baby and the Kids* (no. 143).

Nothing, it seems, was exempt from the satirical impulses of the Incohérents exhibitors. If Allais impugned the pretensions of visual narrative representation, others offered witty literalizations of everyday language. In the 1883 Incohérents, for example, Raoul Colonna de Cesari exhibited a double portrait titled *Lapin* (*Rabbit*) which used a rabbit to "reproduce" the French slang formula for a hoax or stand-up ("poser un lapin"). "Out of the man's mouth," wrote Fénéon, "extends a rope attached to the neck of a live rabbit that is chewing on carrots in a cage installed in front of the painting. This allegorical use of a rabbit was a great success."[59] "With these gentlemen," noted Fénéon on another occasion, "the cliché doesn't miss a beat."

In the un-illustrated catalogues of the first exhibitions, and to a great extent thereafter, it was the endless manipulation of the title that gave rise to the most polemical finesse from this irreverent anti-Salon.[60] Titles held center stage in the theater of wit, profanity and allusion. In the 1882 catalogue-supplement each is picked out with a number and italicized; and virtually every type of title, every genre and artistic style — whether academic or avant-garde — gets its satirical comeuppance.

The pretensions and obscurities of history painting are sent up in numerous entries, including as Charles LAURENTS's *The Gauls Discovering the Caspian Sea* (no. 83); the "poet" Émile GOUDEAU's "historical drawing" called *Henry IV, annoyed by the Revolution, seeks to recover his crown, he is prevented by the radiant apparition of the Republic, denizens and omnibuses continue to live and to love* (no. 60); and Henri SOMM's *The Republic and the Rabbit* (no. 145), among others. Two kinds of work are attributed to Eugène LEVY-DORVILLE, of Bethlehem and Bagdad. His series of over-literal or pseudo-allegorical pastels — *The Sea, The Cow, The Cock, The Duck, The Orient, The Current, Snow, Hope, The Drowned* (no. 87) — is followed by a work whose title summarizes the irony reserved at the Incohérents for historical representations: *The Revenge of History* (no. 88).

Mythological subjects include Rodolphe SALIS's *The Judgement of Paris* (no. 140), a "peinture léchée" (a "licked" or "belabored painting"); *The Death of Lucretia* (no. 36) by DEBELLY, winner of the "35th. 8th. second grand prize of Rome" and "belonging to the École des Beaux-Arts;" and the *Fable express illustrée* (no. 12) of Paul BILHAUD (creator of the Institute of Total Black Painting in 1882). There are fewer examples of religious titles, though GOUDEAU gives us a *Modern Saint-Mary-Magdalen* (no. 61); Charles CLAIREVILLE's *The Finger of Providence* (no. 29) is described as a "Painting!!!"; and Henri GRAY ("designer, costumier, fantasist, with a straight nose," as the catalogue puts it) painted a *Creation* bearing the subtitle, "How many fewer worries [we would have had] on this earth if God had not been so far away."

The portrait genre, by contrast, is represented in numerous entries. Bilhaud's *The widow, Madame X* (no. 13) is not a "still life" or "nature-morte," but rather a "nature demi-morte." Albert ARTUS mischievously joins portraiture with history and religion in his *Portrait of Pope Erisme, Principle Agent of Nihilism in Russia* (no. 8). While among Luigi LOIR's several portrait contributions, which include pictures of Jules Lévy, Paul Bilhaud and a policeman, is a self-portrait (no. 104) done in "soft wax, cloth, hair, button, enamel, leather, wood, cardboard."

Abstract, sentimental, vapid, banal, emblematic and exclamatory titles, mostly associated with various kinds of genre painting, are fulsomely

pilloried. The Warsaw-born "tourist," Gabriel-César-Alexandre LUBIENSKI presents *Death is no Joker* (no. 112), and *Long-live the Galette* [a plain, round, flat cake] (no. 113). Henri GRAY is represented by *The Fiancé of Death, Philosophy, The Microcosm,* and *One of the Noblest Sentiments of the Heart: Reconnaissance* (nos. 63–66) – this last "bought by the Museum of Anatomy." Next to *Indigence and Honor* (no. 100) by Guillaume-Antony-François, "etc." LIVET – a name only one letter short of the "livret" – we are advised to "see [elsewhere] the caption [which is] too long for the catalogue."

The exhibition also takes aim at avant-garde tendencies that preceded the 1880s, including Realism. A. FERDINANDUS (a contributor to *Le Chat noir*), born in Flanders, and a noted student of his geese, contributes a "relief painting" of *The Rural Postman* (no. 57), while the former "Hydropath," Henri DETOUCHE paints *Dispute Between Coachmen* (no. 44) and *The Tenants* (no. 45). It is not surprising that a prominent place was found in the repertory of velitation for a skirmish with the recently touted temporal immediacy and representational seriousness of the Impressionist title, whose nomenclature is repeatedly parodied. DEBELLY offers a Dutch lunar effect whose duration is just three-quarters of a minute: *Effet de lune* (minuit 3/4) *Pays-Bas* (no. 38). From Ernest DÉPRÉ comes a dubious *Rural Landscape* with the subtitle "nocturnal snow effect." While a "collective painting by a group of incohérents" (no. 114) who have not – "despite their perfect union" – been able "to agree on the composition of their subject" is ironically weighted with Impressionist temporalities and motifs (notably the locomotive and the sea):

Albert Ruef	a peint	*L'Arbre et le chat* (*The Tree and the Cat*)
G. Ruef	id.	*La Locomotive* (*The Locomotive*)
Grenet-Daucourt	id.	*La Nuit et la lune* (*The Night and the Moon*)
Albouy	id.	*La Mer de nuit* (*The Sea at Night*)
Duard	id.	*La Mer de jour* (*The Sea, Daylight*)
Tell	id.	*L'Azur, le soleil et la gondole* (*Azure, Sun, and Gondola*)

The parodic conjunction of the Impressionist past and the Incohérent future is explicitly attested in what is almost certainly the first public notice of the 1882 Incohérents exhibition, written under the pseudonym Constantin Chanouard a week after the opening of 1 October 1882: "What the Impressionists had attempted earlier – the precise vision rendered in the impossible tenuousness of values and color touches – the Incohérents were to furnish to a crowd eager to study this essentially innovative form."[61]

Later Incohérent productions included a work discussed by Fénéon in the 1883 Incohérents exhibition: *Nez d'Hyacinthe par un temps de brouillards* (*Nose of Hyacinth in Foggy Weather*). There are no details about its media or form; but judging by the image-titles of Allais and the others, it may have been configured as a fogged-out monochrome, possibly with the addition of an outline or model of a nose, thus parodying the preoccupation of the Impressionist group with the representation of an obscurely inclement moment of everyday life. The beloved of Apollo (the epigone of classical order and lucidity) is reduced to a singular metonymic attribute (his nose), picked out against a meteorological background of natural effacement.

This end of the titling spectrum is concerned less with certain forms of *exchange* between title and image than with a swiftly exhausted verbal-visual pun in which most of the energy and inventiveness of the artist's labor is invested in word and not in image production. Its humorous evaporations can usefully be contrasted with the more complex visual-and-object related word/image plays of the Dadaists and Surrealists, explored in chapter 7. Like other items associated with the Incohérents, the extraordinary fun-fair of jokes, put-downs and scatologies selectively reviewed above, amounts, in the end, to a catalogue of insider one-liners. But as those lines are more often than not the titles of artworks, one of the most persuasive satirical effects achieved at the Incohérents was to explode the regimes of academic and generic nomenclature and strategically shake-down the new burden of signification borne by the modernist title following the Impressionist movement.

Signac did not venture as far as Whistler in the matter of musico-abstract reduction, nor was his gamesmanship and exhibitionism as scandalous as the artists who assembled at the Incohérents. In fact his nonformal interests, particularly in anarchism, would at times confound the implications of his musical abstractness. However, the range of titular strategies he employed during the 1880s and 1890s embraces virtually the entire repertoire of Symbolist-inspired nominations. These title-types include: musical-abstract, connotative-metaphoric, political-allegorical, and serial-numerical. Unlike Whistler's, or Monet's, insistent preoccupation with a *particular* titling format scrupulously developed and defended over the major part of a working career, Signac invented and deployed each of these several titular types.

In 1891 he painted a series of five works under the general title *La Mer, les barques, Concarneau* (*Sea, Boats, Concarneau*) which were individually designated by opus numbers and the expressive musical signatures "Scherzo," "Larghetto," "Allegro Maestoso," "Adagio," and "Presto (Finale)" or "Brise, Concarneau" (fig. 27) when exhibited at Les XX in Brussels in 1892. These musical attributions "were replaced by descriptive

titles when the paintings were shown at the Indépendants in Paris."
Transforming the series into a sequence of symphonic movements, the
original titles offered the most elaborate musical analogy Signac invented
for his paintings. As John House notes, he may have felt that they were
more appropriate for an exhibition of Les XX – an arena of calculated
avant-gardism, which sought to select and represent particular trends, and
was accompanied every year by musical performances – than they might
have been in the jury-free mixed bag of the Indépendants.[62]

Signac's offbeat, connotative exercises, revealed most emphatically in his
Portrait of Fénéon, have already been noted. But he also applied his
whimsical titular imagination to the naming of a series of sailing boats,
eventually totaling thirty-two, inaugurated in 1883 with a vessel called
Manet-Zola-Wagner. Others included *Le Hareng-saur épileptique (The Epi-
leptic Red Herring)*, *The Magus*, *The Olympia*, *Valkyrie*, and *Faux-Col (The
Detachable Collar)* – the latter apparently named by Mallarmé.[63] The wit and
playfulness of these nominations were more pragmatically tempered in the
course of Signac's extended involvement with the anarchist movement, so
that some of his titles took on a kind of prognostic or epigraphic quality.

27 Paul Signac, *Brise, Concarneau (Op. 222)*, 1891. 66.7 × 81.9. Sotheby's, 3 December
1985.

Such is the case with the subtitle for his only large mural, *Au Temps d'harmonie: L'Age d'or n'est pas dans le passé, il est dans l'avenir* (*In the Time of Harmony: The Golden Age Is Not in the Past, It Is in the Future*), the study for which, made in 1895, he at first intended to entitle *Au Temps d'anarchie* (*In the Time of Anarchy*).[64] Fénéon summarized this movement from allusive experiment to more settled formal values, noting that by 1889 Signac had sacrificed "anecdote to the arabesque, nomenclature to synthesis."[65]

At the same time, Signac was also one of the first artists to delegate (or at least to defer) the titling procedure to another imagination; just as Mallarmé was left to name one of his sailing boats, so the Symbolist poet and critic Paul Adam, parodying the specificities of the Impressionist name, came up with the "light-hearted title" *Le Pont d'Asnières (L'Arrière du Tub, Soleil)* (*The Bridge at Asnières [The Stern of the Tub in the Sun]*) when he was presented with the work in 1888.[66] In addition to his musical designations, descriptive over-elaboration, co-nominations and imaginary names, and anarchistic allegorization, Signac began systematically to number his works in 1887, going so far as to inscribe the opus number on the canvas, and even to add back-numbers to particular images – such as *L'Embranchement à Bois-Colombes, Opus 130* (*The Railway Junction at Bois-Colombes, Opus 130*, 1886).[67]

Like Baudelaire, Fénéon was consistently aware of the shifting functions of the title in nineteenth-century art. He commented several times, for example, on Signac's new mode of numerical designation. Like Baudelaire, too, he was scathing about the appending of "ridiculous poems" and absurdly over-specific titles in exhibition catalogues. Attempting to review an exhibition of amateur, Meissonier-influenced pastels and "tableautins" made by a certain General Clauseret in Turkey following the war of 1878, Fénéon can barely bring forth a critical comment. Instead he turns to the catalogue and ironically recites its contents:

> From the catalogue of the exhibition – printed in red and invaded by a ridiculous poem from Mr. Paul Roinard – I'll copy the text of several titles of the paintings: "*Faith is Vanquished! A Dervish harangues the common people, who laugh.*" – "*Northern Girl after bathing. The contraction of the muscles and flushing of the extremities indicate the sensation of cold.*" – "*The Bull and the Dog. Allegory of France and Prussia.*" – "*War Engenders Idiots, the Mutilated, Fourteen Year-Old Mothers and Beggars.*" On painting by a philanthropist of Saint-Cyr [a French military Academy]! . . ."[68]

Elsewhere, reviewing the fifth international exhibition at Georges Petit for *La Vogue* in 1886, Fénéon remarks on the "serial title," *Deuxième été à Jersey* (*Second Summer in Jersey*), that groups nine of Jean-François Raffaëlli's paintings.[69] The following season he offered a capsule account

of the "painting entitled *Impression*" (1874), "qui prit cours le mot impressionnistes, qui supplanta ceux de plein-airistes, de tachistes, etc." ("which gave rise to the term, 'Impressionist,' replacing "Open-Air Painters,' 'Tachistes,' etc.")[70] In the context of these remarks, it is not surprising that Fénéon pays careful attention to Signac's practice of numbering, locating it in relation to the artist's fastidious preparation for the display of his work. Commenting on Signac's participation in the Salon des Indépendants in 1888, he notes the artist's utter "faith" and dedication to "the realization of his artistic project":

> While the other rooms at the Indépendants are done-up in red, the one in which he [Signac] exhibits is completely draped in grey paper; but Mr. Signac thinks this measure insufficient: judging them trouble-some, he therefore removes the cardboard numbers which the exhibi-tion organizers insert between the canvas and the frame; his signature assumes the dominant tint of the place where he writes it; and, like Mr. Alma-Tadema, he numbers each of his paintings with the brush (Alma-Tadema in Roman numerals, Signac in Arabic).[71]

The special, grey-papered room, the removal of the official "index de carton," the conscious color and placement of his signature, and the addition to each work of painted numbers attest to a profound concern for the environmental form of the painting-in-presentation. Two years later, writing of Signac as an optical painter, Fénéon underlines the harmonious decorative effect of anti-literary images:

> Even though he knew how to give then pleasant titles (*A Little Sun on Austerlitz Bridge* or *Brisk Breeze "de N 1/4 NO"*), Mr. Signac refuses to put literature under his paintings. He numbers them. Signature, date and number are harmonized with the background – similar hues for a light ground, and contrary for a dark one. For decoration: white frames with four straight, golden bands on the exterior border.[72]

Of all the artists active in the mid- and later nineteenth century, only Whistler pursued the rhythmic unity between these elements with similar, or greater, vigor.

With the partial exception of the conjugation of musicality and deco-rative abstraction, the profoundly various titling techniques laid out by Fénéon seem at odds with Signac's later theoretical insistence on the intensely *optical* character of visual experience and painting practice. His treatise *D'Eugène Delacroix au Néo-Impressionisme*, published serially in three numbers of *La Revue blanche* in May–July 1898, offers an extended, genealogical defense of a pictorial technique that issued in the optical mixture of colors in the eye of the beholder. This procedure was

inaugurated – or at least anticipated – by Delacroix, developed by the Impressionists, and perfected by the Neo-Impressionists, including Signac himself. The artist's somewhat prosaic hymn to the juxtaposition of divided color represents the early apogee of a technical-formal approach to visual representation which Duchamp was later to abjure as a "retinal" compulsion. It was against the critical monopoly of such optical obsessions in avant-garde circles in the 1910s that Duchamp conceived of his negative theory of color – one that turned on the deployment of words rather than pigments. This was, as we will see, a theory that privileged the special properties of "invisible color" represented in the supplementation of a title.

Fénéon's reference to Sir Lawrence Alma-Tadema as the possible originator or co-originator of the numerical title demands a moment of consideration, which will form a coda to this chapter. Apparently Alma-Tadema's custom of ascribing sequential Roman numerals to his finished paintings began in 1872, and according to his catalogue raisonné may be attributed to several factors. These include the need to keep an ordered record for a contemporary commission and a precaution against copying and forgery occasioned by his growing financial success following his remove to England in 1870. It also, of course, provided another, more literal, anchor for the paintings in the Roman world consistently privileged by the artist. The numbering technique avoided the need to date work, afforded a secure form of identification, and made paintings "seem older and therefore" more "desirable."[73] The inscription of the work's opus number on the pictorial surface itself was inaugurated with *Greek Wine (Opus 106)*, the only work to bear Arabic numerals; was backlisted to *Portrait of My Sister, Artje (Opus I)* (1850); developed as a physical inscription next to the signature from November 1872 onwards; and was continued in this form until the artist's final works.

Vern Swanson suggests that the numbering "may have been borrowed from James Whistler": "Although Whistler did not number his work in this way for catalogue purposes, merely calling a painting an opus as part of its title, Alma-Tadema would have appreciated the practical application of the method."[74] Little evidence is suggested for any exchange between Whistler and Alma-Tadema on this matter, beyond the fact that they were acquainted, and that Whistler, who teased and baited his more establishment colleague, once referred to Alma-Tadema's paintings as "symphonies and harmonies."[75] The following chapter suggests that Whistler's catalogue citations and the relation they bear to his life and work are considerably more complex and resourceful than Swanson seems to suggest. But a deliberate attention to titles and their contexts offers several grounds for thinking a connection – which runs rather against the grain – between Alma-Tadema's Romanizing Victoriana and Whistler's polemical aestheticism.

Sketching in this connection will introduce key aspects of Whistler's contribution to the modern title. It will also offer another relay between the interests of the Academy and the avant-garde, between formalism and moralism, and between the site of the title and art-historical revisionism. Like Whistler, though with different emphases and commitments, Alma-Tadema was a devotee of Japanese art. One of his early commentators noted its "visible influence upon his methods of disposing his composition," going so far as to claim that he worked to "dismember" his figures "to the detriment of composition as classically understood."[76] The decomposition of form associated with Eastern art may also be linked to the decorative extrapolation of pictorial logic and its contextual arrangements which Whistler was to practice in his home, on his body, and in his exhibiting venues, including – like Alma-Tadema – the Grosvenor Gallery; and which Alma-Tadema carried on in his homes in London. In October 1874 Townshend House, which he had bought in 1871, was destroyed by fire, occasioning the following remarks by a critic for the *London Illustrated News*:

> [An artist] invariably . . . furnishes his home and painting-room with references more or less to his professional pursuits. The observation applies with very unusual force in the case of Mr. Tadema, for it is well known that he had made it a hobby for years to surround himself with such objects, and to decorate his residence and studio in such a way as to aid in and associate with those archaeological studies which are turned to so good an account in his works.[77]

Alma-Tadema's domestic orchestrations were just one manifestation of a general "turning to good account" that also includes his visible placement of an abbreviated numerical alphabet of "Is," "Xs," "Vs," "Ms," and "Cs" – signs that are simultaneously letters, numbers, and, like the capital orders, concrete tokens of the antique – into the surface of his paintings. The domestic syntax that linked the objects in Townshend House included the inscription of the initials "L.A.T." in all the rooms.[78] Such inscriptions were a similar model of the ordering sequence that connected and serialized his paintings. Commenting on the house on Grove End Road in St. John's Wood that Alma-Tadema bought in 1885, a visitor observed that it "is a glimpse of his work, it is his soul seen from the interior. Whoever understands his house learns to cherish his art."[79] Another symptom of the artist's public assertion "that the decorative and fine arts were but part of a single whole,"[80] Alma-Tadema's house-and-painting order system also hints at the concatenation of forms, the ceaseless exchange between sign types and materials, that would characterize Symbolist aestheticism.

Clearly, such resemblances remain hints and suggestions and are all but

crowded out by the antique illustrationism of Alma-Tadema's dominant idiom. But I want to conclude by examining two final forms of connection between Alma-Tadema and modernist titular innovation. The first is found in *Improvisatore (Opus C)* (1872, fig. 28), his "only nocturne." The work was apparently "painted to prove to some of his colleagues that colour was a product of light. Many of his friends felt that colours could be distinguished at night. As an experiment he tied brightly coloured ribbons to various trees in his London garden and asked friends to identify them in the dark, which they were unable to do."[81] Using a classic referent (the "improvisatore" is the lyre player featured in the nighttime painting) for a title term that was to be measured against the "impression" and turned to very different account by Kandinsky forty years later, Alma-Tadema produced his version of a "noir" image that conjugates musicality, darkness, the suburban garden, and the interrogation of light.

Such concerns, especially the last, also form a relegated subtext in Alma-Tadema's oeuvre. It is only through attention to his titles that we can reconstitute an iconographic strand that has been shouted down by the academic approbation, social probity, and sheer physical scale of his more sanctioned classical and mythological images. Yet, in the mid- and later 1870s – precisely the years when he may have felt the pressures of avant-garde innovation from Monet and the Impressionists, on the one hand, and from Whistler, on the other – Alma-Tadema painted a series of landscapes that contain little or no narrative, anecdotal, or historical content. In 1875 alone the following works were produced: *Haystacks (Opus CLVI)*, *Study of Haystacks*, *A Breezy Day in August (Opus CLIX)*, and *Study of Blue Sea and Sky*. As many as half of these and related works (including the first and last listed here) have been lost, and are thus known only though their titles and the occasional contemporary description; some, in addition, do not bear the customary opus numbers, indicating their casual, counter-classical status. Paintings from the later 1870s continue this exploration. *From the Firehills of Fairlight, Hastings* (1877) – another lost work which has no opus number – offers an unusually sparse and painterly view over empty gorse fields to the English Channel. *A Landscape (Near Haslemere, Surrey) (Opus CXCI)* (1878) images an uninhabited passage of countryside which partakes of neither classical, genre, nor Impressionist conventions. *Study of a Birch Wood* (1875–79), yet another lost work, had its unusual texture furrowed into the wet paint with a "brush handle."[82] In 1882 he produced *Reflections (Still Life)*, one of only two still lifes in his oeuvre, and *The Oleander (Opus CCXLV)*, an image "playing with foreground and background contrasts of light, detail and colour."[83] Once more both works are lost. These, and

28 A. Gloss after Sir
Lawrence Alma-Tadema,
Improvisatore (Opus C),
1872. Engraving

a very few other exceptions, aside, after 1879 Alma-Tadema reverts to his
antique subject matter and compositional formats, relinquishing his hesi-
tant flirtation with painterly landscapes and the aesthetic disposition.

Numerical inscriptions, Japoniste compositionality, occasional commit-
ment to non-academic exhibition fora, and his decorative, inter-artistic
propensities join with perhaps twenty works from the middle of Alma-
Tadema's career to form a cautionary tale. Innovations in titling, no less
than novelties in form or technique, were not the exclusive domain of
avant-garde or modernist artists. Indeed, in order to understand both their
social and stylistic implications, such innovations should be retrieved from
the spaces between the academy and the avant-garde. Yet, concerns that
remained muted and occasional in the studio-house of Alma-Tadema
were emerging as pictorial obsessions, titular slogans, and socio-aesthetic
strategies in the work of Whistler.

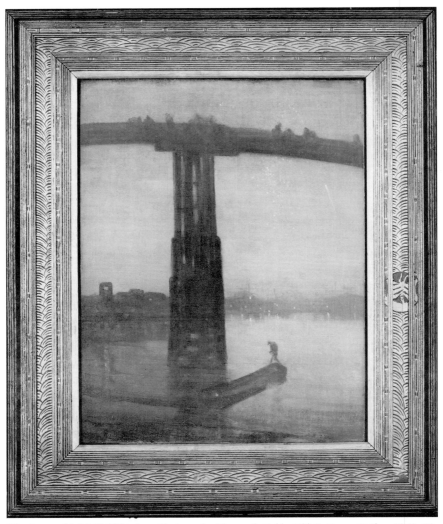

29 James McNeill Whistler, *Nocturne in Blue and Gold: Old Battersea Bridge*, 1872–73.
67.9 × 50.8. Tate Gallery, London

Symbolism II: James McNeill Whistler: The Elaboration and Contraction of the Title

While Allais and Signac produced some of the most humorously and provocatively excessive titles in the nineteenth century, James McNeill Whistler and Signac (wearing another nominal hat) were among the first artists to signify through the names of their paintings that the viewer should look past or through the motif in order to prioritize the formal, especially the musical and rhythmical, elements of the composition. Whistler's statements of this apprehension were perhaps the earliest, fullest, and most rhetorically persuasive. In the course of his litigation against John Ruskin in 1878, he states:

> I have perhaps meant rather to indicate an artistic interest alone in the work, divesting the picture of any outside anecdotal sort of interest which might have been otherwise attached to it. It is an arrangement of line, form and color first, and I make use of any incident of it which shall bring about a symmetrical result.[1]

Seven years later, in his celebrated *10 O'Clock*, a lecture delivered at the Prince's Hall in London on 20 February 1885, Whistler offered an even more unmitigated defense of visual values, a powerfully rhapsodic *apologia pro artis*. He attacked the whole intervention of the writer-critic ("the middle-man in this matter of art") as predicated upon an understanding of the picture as a mere "hieroglyph or symbol of a story."[2] He railed against the same writer-critic's lack of appreciation for "the painter's poetry"; he eulogized the "sharp, bright gaiety of [visual] beauty,"[3] and, as he put it elsewhere, vigorously dismissed the entire non-visual content of an image as the fondest "clap-trap."[4] Whistler's bravado defence of pictorial values, summarized here from the *10 O'Clock*, but recurrent throughout his career, was one of the most public, and most controversial of such protestations in the nineteenth-century European art world. It is crucial for this discussion of the place of the title in the formation of visual

modernism that Whistler's theory and practice (as well as those of his most influential critics) were constantly supplied, indeed were never without, the sustaining presence of an elaborate understanding of the titular activity. The sum of his attentions to the naming and assisted reception of his work offers us an insight into the expanded field of the title that is unparalleled in the nineteenth century. Whistler's titular inventions were not always the first of their kind (though they do include several important historical innovations), nor were they necessarily the most extravagant. But they were developed in an extraordinarily *total system of naming* that reached out to embrace the gallery, private and occasionally public space – and even the body of the artist himself. I will outline this system by attending closely to Whistler's writings and to the mostly contemporary or near-contemporary biographical and critical literature that has described and alluded to his titling methods.

Whistler offered repeated (and repetitive) commentaries on the making and reception of his titles, but no account surpasses the suggestiveness of that published in *The World* on 22 May 1878:

> Why should I not call my works "symphonies," "arrangements," "harmonies" and "nocturnes"? I know that many good people think my nomenclature funny and myself "eccentric." Yes "eccentric" is the adjective they find for me.
>
> The vast majority of English folk cannot and will not consider a picture as a picture, apart from any story which it may be supposed to tell.
>
> My picture of a "Harmony in Grey and Gold" is an illustration of my meaning – a snow scene with a single black figure and a lighted tavern. I care nothing for the past, present, or future of the black figure, placed there because the black was wanted at that spot. All I know is that my combination of grey and gold is the basis of the picture. Now this is what my friends cannot grasp.
>
> They say, "Why not call it 'Trotty Veck,' and sell it for a round harmony of golden guineas?" – naively acknowledging that, without baptism, there is no . . . market! . . . the picture should have its own merit, and not depend upon dramatic, or legendary or local interest.
>
> As music is the poetry of sound, so is painting the poetry of sight.[5]

The aesthetic that informs this and other of Whistler's contestations poses as little more than a kind of work-a-day synaesthesia animated by an unrigorous adoption of the poetic primacy of painterly form and materials. For this reason much of the historical interest these images hold is best revealed by attending to the strategies that underlie their naming and exhibition. The dissimulation and banter of statements such as the

above notwithstanding, Whistler took on a highly visible, tactical, and polemical role in relation to the controversy engendered by his titling methods. He authored a steady stream of articles, squibs, and rejoinders in a number of newspapers and journals; he offered chicly timed public lectures; he took on the chairmanship of a floundering London arts society (the Society of British Artists); he exploited the mystique of his occasional successes in Paris; and, most memorable of all, he all but choreographed the famous art trial which pitted him against the writer and educator John Ruskin, whose deprecation of his work appeared in *Fors Clavigera* (2 July 1877). Indeed, Whistler's virtuoso performance on the instruments of public taste was so thoroughgoing that he appears to have anticipated the propagandistic agitations of high modernist avant-gardes such as Futurism, which were also managed through newspaper publications, lectures, and other public events, and a general, though in the case of the Futurists, heightened, management of scandal.

If Whistler's 1878 description of his titling method and its implications is not remarkable for its sustained intellectual rigor, it is valuable, never-theless, for its outline of what were to become (and, to an extent, had already become by the late 1870s) the commonplace assumptions concerning Symbolist signification. Reading directly from Whistler's article in *The World*, we can summarize these as follows. First, there is a rejection of the narrativity of picture-making: the visual sign is not dependent on a literary, religious, or historical text or event. Second, the image signifies *despite* its apparent representational, iconic content. Its formal disposition is (mysteriously — for "all I know . . .") self-regulating. Third, the relation of the image to temporality is independent of "real time" — the imputed time frame of the represented figures, objects, or landscape — and, in effect, stands outside time altogether in a condition of formalist trans-temporal beatitude. This atemporality is emphasized by Whistler ("I care nothing for the past, present or future of the black figure.") and thus contrasts starkly with the Impressionist sensationalization of the effects of the moment. Whistler goes beyond the momentary into a decorative abstraction that transfixes time.

Fourth, Whistler, like Gauguin later on, stages a mock re-nomination of his image(s) for the sake of demonstrating the validity of his own titling procedure.[6] On the way to this demonstration, however, he makes an important remark concerning the relation between the image, the title, and the market place: "without baptism, there is no . . . market." This is an explicit recognition of the general and progressively important bond drawn between the art object and its market valency; and, in particular, of the deliberation that Whistler consistently invested in his nominative decisions and in his formulaic consistency. Simply put, a Whistler title

was emphatically part of the image's value, and was recognized as such. Fifth, reminding us that one of the preferred procedures of formalist reduction from its very beginnings was a negative critique, Whistler rejects for a second time the interference of subject matter, whether of "dramatic, legendary, or local interest." One could gloss this as a relegation of Romantic history painting, traditional mythological or religious subjects, and the particularities of Realism.

Finally, at the beginning and end of this quotation, Whistler relies on metaphoric references to his pictorial activity that privilege its poetic and, above all, musical effects. As in many late nineteenth-century passages between word and image, the relay of meaning imagined here was most effectively handled through the directed intervention of music as analogue. The taking up of the musical analogy in such titular gestures as "symphony" or "nocturne" was a specific extension of the metaphoric conflation of the two arts associated with the reaction of the Romantic movement against Enlightenment clarity, hierarchy, and order. Such tropic musicality was of profound significance. It dominated the innovative titular regimes of the later nineteenth century and was consistently influential in formalist image-making up to the 1960s. Little by little direct references to music were subordinated to the aesthetic generality of the term "composition," around which each of the arts could specifically imagine its formal and subjective values.

Scholarship, however, has failed to find system or method in the myriad examples it has adduced of this crucial metaphoric activity.[7] Recourse was made to the musical analogy frequently (if decorously) before the mid- and late eighteenth century, even by those whose views we would not describe as characteristically Romantic. Reynolds twice deploys musical references in his "Discourse IV." On both occasions he attempts to communicate his views on the nature and significance of color – an effort that originates as digression and ends up taking over the discourse. He allows "that elaborate harmony of colouring, a brilliancy of tints, a soft and gradual transition from one to another, present to the eye, what an harmonious concert of musick does to the ear"; although, of course, "it must be remembered, that painting is not merely a gratification of the sight."[8] Against this, Baudelaire, in the full tilt of his passionate defense of the powerfully Romantic coloristic values of Delacroix in his "Salon of 1846," offers the following caution in relation to what he perceives as the over-zealous tendency of the reading public to seek out a representative Romantic painter to answer to the definitive literary Romanticism of Victor Hugo: "This necessity of going to any length to find counterparts and analogues in the different arts often results in strange blunders."[9] This is a curious offer of analogic restraint from the

author of *Correspondances*! Whistler himself seldom participated in such modesties. At the end of his contribution to *The World*, he surrenders his discussion to the boundary-less generalities of referential exchange taken on in the centrifuge of Symbolist signification, which produces music as the "poetry of sound" and painting as "the poetry of sight."

Whistler was not alone in foregrounding the activity of titling. The French writer Théodore Duret, the most supportive and prolific critic of Whistler's work throughout his career, addressed the subject of titles with a regularity that approached a refrain. Like Whistler himself, though with a less mystifying agenda, Duret realized that the introduction, explanation, and defense of the artist's titling system was a key to the success of his critical enterprise. Accordingly, he begins his major study of the artist by outlining what he understands as the chief characteristics of Whistler's titles and their effects:

> His works then could well carry two titles. In a portrait, for example, he naturally had to name the model painted, and so the picture was called: *Portrait of Carlyle, Portrait of Miss Alexander*, but as Carlyle and Miss Alexander had been painted by the aid of a combination of colours which was precious in itself and itself intended to charm, he added to the name of the model a title describing the combination realised, and said: *Portrait of Carlyle, Arrangement in Grey and Black*; *Portrait of Miss Alexander, Harmony in Grey and Green*. In a picture by Whistler, beside the subject properly so-called, there was also an arrangement or harmony of colour that one might call decorative, using the word in its highest sense and as it was understood by the artists of the Far East.[10]

Lacking entirely the torrential overstatement indulged in by Whistler in his own commentary, Duret sets forth a relatively expository account that appears rational and unthreatening. Unlike Whistler, he does not emphasize the "combination of colours" to the exclusion of "the subject properly so called." Instead the two coexist as natural consequences of the dual nature of painting as representational and formal. Duret gets into trouble only when he feels obliged to supply a term that adequately articulates the purpose or final effect of the "arrangements" and "harmonies." He evidently conceived that the adjective "decorative" bore sufficient derogatory connotations for him to qualify it with reference to the "highest sense" of its apprehension "by the artists of the Far East."

With similar matter-of-fact restraint, Duret went on to outline the numerical system that came into play when Whistler repeated certain dominant combinations of color both in his paintings and in their names: "when several [decorative combinations of color] repeated, with different

motifs, the same combination, he called them by the same title, derived from this, and distinguished one from another simply by numerals, calling them *Symphony in White, No. 1, No. 2, No. 3* (fig. 30). He was to take the final step on the path to decoration."[11] This final step was, interestingly, not taken in the image itself, but arose as a consequence of Whistler's scrupulous attention to the context of his exhibitions. Thus, says Duret, "when he held private exhibitions the decorative arrangement of the rooms formed a part of his preoccupation."[12] The key term here is "private"; for the charade (the acting, writing, and performance) of decorative and titular reduction was only possible in the closed – though expanding – circuit of private, commercial, or non-official spaces. Whistler's listless alternativism was, I will argue, a necessary corollary of his simulated abstraction.

Duret and others have noted Whistler's unceasing antagonism to the Royal Academy and its annual exhibition. But Whistler went much further in the management of his exhibition career than espousing a mere antagonism toward officialdom. The exhibition history of one of the first of his purportedly "abstract" works, *The White Girl*, offers important evidence of his self-location on the margins of institutional space. This was a work, we should remember, described as being "without subject, according to Victorian standards, and the arrangement of white upon white was more bewildering even than the minute detail of the Pre-Raphaelites."[13]

As the Pennells record, following its completion, *Symphony in White, No. 1: The White Girl* was shown in London at the Berners Street Gallery in summer 1862, an exhibition space "with the avowed purpose of placing before the public the works of young artists who may not have access to the ordinary galleries."[14] At this time, "[o]ne gallery after another took up the cause of outsiders, or was established to take it up. After the Berners Street Gallery came the Dudley[;] . . . in 1868, the Corinthian Gallery in Argyll Street; in 1869, the Select Supplementary Exhibition in Bond Street. . . . Dealers also came to the rescue."[15]

In 1863 Whistler was part of a crowd of young artists "including Fantin, Jongkind and Manet" whose rejection from the official Salon that year prompted the issuance of a proclamation from Emperor Napoleon III that a Salon des Refusés be held in the Palais de l'Industrie, the same building that housed the official Salon. Whistler's *White Girl* aroused particular mirth and incredulity in what critics dubbed the "Exposition des Comiques." The Pennells claim that "it eclipsed even Manet's big *Déjeuner sur l'herbe*, then called *Le Bain*."[16]

The origin of the musical titles can also be understood in relation to the parameters of institutional exhibition. Following his somewhat mysterious trip to Valparaiso, Chile, Whistler exhibited a Valparaiso piece in

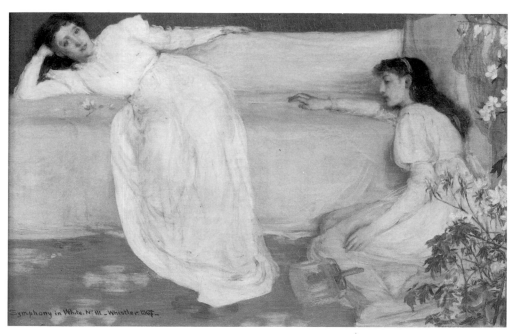

30 James McNeill Whistler, *Symphony in White, No. 3: The Two Little White Girls*, 1865–67. 51.1 × 76.8. University of Birmingham, Barber Insititute of Fine Arts

1867, *Crepuscule in Flesh Colour and Green: Valparaiso* (it may have been titled later). Although it was originally titled *Twilight on the Ocean*, this painting has been claimed as "the first of the Nocturnes."[17] One of the first documented instances of a musical title was among Whistler's submissions to the Royal Academy in 1867. This was the *Symphony in White, No. 3* ("heretofore named *The Two Little White Girls*" [fig. 30]). The biographical record on this image – whose "offence was in the title" – states that it represented "the first time one of his pictures was catalogued as a Symphony, [and] his first use of a title borrowed from musical terms to explain his pictorial intentions."[18] The cue for the name of his third study of women in white against white may have derived from a variety of sources – including Baudelaire, Gautier, and the critic Paul Mantz, who described *The White Girl* as a "Symphony in White."

Within a couple of years Whistler's titular technique was finally in place:

> His use of titles to explain his pictorial intentions was now so well established that this same year (1872), when *The White Girl* and the *Princesse* were in the International Exhibition at South Kensington,

they were catalogued respectively as *Symphony in White, No. I*, and *Variations in Flesh-colour, Blue and Grey*, later changed to *Grey and Rose*; and he supplied the explanation, printed in the Programme of Reception, that they were "the complete results of harmonies obtained by employing the infinite tones and variations of a limited number of colours."

His portrait of his mother was sent to the Academy of 1872 with the title, *Arrangement in Grey and Black: Portrait of the Painter's Mother*.[19]

1872, then, marks the first time that a portrait is called an "arrangement" and an "impression of night" a "nocturne." It was also the last year that Whistler showed at the Academy. From this moment on his institutional rejection was as definite and uncompromising as his titles were extravagant. In 1874 Whistler leased the premises of 48 Pall Mall for a private exhibition of thirteen oils, fifty etchings, and thirty-six drawings. It elicited a sympathetic review by Henry Blackburn, who extrapolated the symphonic metaphor of Whistler's titles into one of their most developed contextual extensions:

> The visitor is struck, on entering the gallery, with a curious sense of harmony and fitness pervading it, and is more interested perhaps, in the general effect than in any one work. The gallery and its contents are altogether in harmony – a *symphony in colour*, carried out in every detail, even in the colour of the matted floor, the blue pots and flowering plants, the delicate tints of the walls, and, above all, in the juxtaposition of the pictures.[20]

Making explicit the transference of terms and "effects" from the works through their titles to the framing context, Blackburn goes on to offer the reader "an idea of the effect and arrangement, in a sketch of the little gallery, with its graceful lines and delicate tints." He notes, further, that a proper feeling for the harmonious ensemble will only be induced "in secure shelter from, the glare of the guardsman's scarlet tunic in the busy window of the club opposite."[21] The private, but overflowing, aesthetic of early modernist display appears far removed from the would-be purity and signifying restraint of the white cube of the 1960s. Yet in both cases, the gallery environment functions not just as a cultural location, but, to use Blackburn's phrase, as a "congenial home" for an aesthetic experience that arrives as a function of the entire viewing arena, or perceptual field. Anything that clashes with this privileged, continuous space becomes an irritant, or contaminant, that must be blocked out of vision.

In Blackburn's review we encounter the centripetal inverse of Leroy's mock internalization of the "municipal guard" in his account of the first Impressionist exhibition in the same year, 1874. Both writings attest to

the novel, beguiling, powers of the images they confront; but while Monet's works are dizzying and discomforting, Whistler's are seen as precious, harmonious, and symphonic. In the former case, Impressionist canvases seem to suck in the institutional environment, allowing the critic the conceit of having his companion confuse the municipal guard with an avant-garde landscape. In the latter, the guard is alien and other, symbolizing not only a chromatic but also a social clash with the pictorial values enshrined in the place of "harmony and fitness." The shrilly clad establishment figure in the high society Club on the other side of the road is another symbol of Whistler's forced separation from the traditional elite.

Whistler's disparagement by the institutional managers of the art world prospered even after the artist's death. One of his long-term adversaries even attempted publicly to humiliate him on the very site he had so successfully used to launch his own "eccentric" dissent – the title (and the label): "Sir Edward Poynter, when he hung *Old Battersea Bridge* (fig. 29), first in the National Gallery, affixed to it, or allowed to be affixed, a label on which Whistler's name was misspelt, Whistler himself was described as of the British School, and the title of the picture was incorrectly given."[22]

In terms of both image-making and titling, painting the night in the "Nocturnes" of the 1870s was the veritable inverse of Monet's daylight impressions.[23] Whistler would paint on a grey or other colored ground, and his friends observed the finished products "set along the garden wall to bake in the sun." The name "Nocturne," however, was not Whistler's invention, but was suggested to him by his patron, Leyland. Whistler had called the works "Moonlights," but he wrote to Leyland ebulliently: "I can't thank you too much for the name 'Nocturne' as the title for my moonlights. You have no idea what an irritation it proves to the critics, and consequent pleasure to me; besides it is really so charming, and does so poetically say all I want to say and *no more* than I wish."[24]

When London's Grosvenor Gallery opened in May 1877 as an exhibition space for "dissenters," Whistler was present in force with seven paintings, including four "nocturnes." It was Ruskin's review of this show that occasioned his famous denunciation of Whistler on the grounds of "Cockney impudence," "willful imposture," and "flinging a pot of paint in the public's face." Duret's reaction to the same exhibition, however, was to consummate the second of the controlling tropes that structure his critique of Whistler – a continual assertion that the work signified at the threshold of meaning, that it teetered on the brink of dissolution ("absolute indefiniteness"): "He [Whistler] attained to that extreme region where painting, having become vague, in taking one more step would fall into absolute indefiniteness and would no longer say

anything to the eyes."[25] Always ventured, always about to be taken (in the critical rhetoric as in the visual practice), the "final step" is, in fact, suspended in a state of infinite potential. The joint enterprises of image production, exhibition, and criticality had the effect of fixing the visual sign and its textual appurtenances in a zone of signifying indeterminacy.

The litigation with Ruskin (heard on 25 and 26 November 1878) forced a kind of disequilibrium between material, name, and site. As the financial, aesthetic, and social *value* of Whistler's practice was challenged and impugned, the fragile equipoise between its constituents was disrupted, and their collaboration momentarily gave way to a struggle with outside forces: "[T]he prosperity which he had enjoyed ceased from the moment he had engaged upon his struggle with the public and critics in wishing to impose his musical nomenclature and make his nocturnes accepted."[26] As subsequent avant-gardes learned somewhat faster, the peculiar balance achieved by simultaneously flirting with and lampooning the values of the liberal status quo produces evident risks. There is some inevitable loss in the efficiency of the recuperative process that ensures the validation of the avant-garde product.

The way Whistler staged his comeback from near financial ruin by taking on Ruskin in his own holy-of-holies, his medieval dream-city of Venice, was little short of remarkable. He did it by acting out a calculated schizophrenia between conservative and radical aesthetic values whose terrain was the title. Having been dispatched to Venice by the Fine Art Society of London in September 1879 on a commission to produce a series of etchings of the city, Whistler exhibited his work at the Society in 1881, supplying it, for the most part, with conventional titles (see fig. 31). But though traditionally named, the etchings were stylistically diffuse and ill-received by the critics. The partial compromise with official values, the deliberate slackening of one of his "joint enterprises," gave Whistler something amounting to a permission for the gesture he attempted in a second exhibition of fifty-one of the Venice etchings, again at the Fine Art Society, in February 1883. On this occasion, the titles made up a kind of ransom for the critical release of the images.

The circumstances of this second exhibition of the Venetian etchings and drypoints carry Whistler's conjugation of the constituent parts of his painting-titling-exhibiting regime to one of its most sustained encounters with avant-garde activism (despite — in part because of — its semi-official location). Whistler made two thoroughgoing extra-pictorial gestures. First, he had the exhibition environment scrupulously "arranged" in yellow and white; and, second, he "prepared an extraordinary catalogue."[27] The decoration of the gallery was one of the most elaborate efforts Whistler made towards the consolidated interrelation between his titles, images, signatures, and contexts:

31 Sketch for the selection and arrangement of Whistler's first Venice set, c. 1880. Pencil drawing, 113 × 177. Davison Art Centre, Wesleyan University, Middletown, Conn. Photo: Blomstrann

The gallery itself was to be transformed into a work of art entitled "Arrangement in Yellow." To this end it was decorated in white and yellow: the mouldings, skirting board, carpet, and fireplace were to be yellow; the walls were to be covered with white felt to a height of ten feet; and the etchings were to be hung in white frames. In addition, Whistler began making little yellow butterflies to give to his friends and supporters "to wear defiantly with the brave and beautiful on the great day."[28]

As for the importance he attached to this exhibition space, Whistler described his commitment to the context of public display in a letter of December 1886, written to, but rejected by, the London *Times*. It responded, as was often the case with his journalistic efforts, to a spate of adverse criticism:

Permit me, therefore, to rectify inconsequent impressions, and tell your readers that there is nothing "tentative" in the "arrangement" of colour, walls, or drapery – that the battens should *not* be removed – that they are meant to remain, not only for their use, but as bringing

parallel lines into play that subdivide charmingly the lower portion of the walls and add to their light appearance – that the whole "combination" is complete – and that the "plain man' is, as usual, "out of it."[29]

Here, Whistler considers the artwork and its environment as contiguous in their collaborative effect on the viewer.[30] He deliberately employs the same formal language in his description of the gallery interior that he attaches to the individual images themselves: the space is a "complete 'combination'" of "parallel lines" and other "arrangements."[31] We should also note that a not inconsequential product of this decorative environmentalism is the deliberate relegation of the "plain man" – that is, the simple and unpretentious "general public," precisely the kind of public solicited by Ruskin during the second phase of his writing career (after c. 1857).

The catalogue itself – which was distributed by "a 'yellow man' whose canary and white livery led him to be nicknamed 'the poached egg' "[32] – featured not only the offensive musical titles of the individual works, but also boldly reprinted selections of adverse, often polemical, criticism alongside the particular work discussed. This material was culled from across the whole range of contemporary wits and reviewers. As in Whistler's own writings, and as in the approbationary criticism of Duret, the critique centered on the images' titles. These *adversaria* recurrently cited the outlandishness of the titles, and the defeat of the proper conditions of vision, as the predominant irregularities of the "work" on view. Under catalogue entry no. 19, *Upright Venice*, for example, the damning praise was offered that there was "[l]ittle to recommend [the images] save the eccentricity of their titles."[33] F. Wedmore, writing in *The Academy* (24 February 1883), described the ensemble of etchings as "literary efforts with the scissors and the paste-pot," "[the application of] snippets of published sentences to works of art."[34] Other critics reported the failure of Whistler's "impressionism" – here understood as the attempt to convey a convincing visual impression of a scene. Apropos catalogue no. 20, *Little Venice*, the *Daily News* noted that "Whistler has attempted to convey impressions by lines far too few for his purposes." The reviewer added, acerbically, that, "[o]ur river is naturally full of effects in *black and white and bistre*." Another reviewer simply reported that the works "produce a disappointing impression."[35]

Monet had been content to manipulate the adjacency of image and title in order to promote the proper registration of his "effects" and "impressions." As attested to here and elsewhere in the newspaper criticism of the 1880s, the language of such effects and impressions had a legitimate currency both outside France and outside the alternative exhi-

bition bodies. But Whistler evidently strove, in theory at least, to exceed the representational and titular conditions of Impressionism, even in its serial manifestations, and (rhetorically if not pictorially) to separate the signification of the image from both the content and the time of the *scene* of representation.

When Whistler made the same gesture of appending a litany of antagonistic criticism to the catalogue of a later exhibition, "Nocturnes, Marines, and Chevalet Pieces," the press reception of his work appeared to consolidate and greatly to develop the dual critique of titling and the quality of vision/registration orchestrated in 1883. The critics, indeed, began to play the game and to indulge in its terms. The transition between these events thus marks one of the fullest moments of development of one of the most significant gambits in the history of avant-garde bravado: the solicitation and cultivation of outrage, and its return as (market) validation.

The reception of the later exhibition is worth reviewing. A critic for *Life* proposed that "[h]is Nocturne in Blue and Gold, No. 3, might have been called, with a similar confusion of terms: A Farce in Moonshine, with half-a-dozen dots."[36] The critic for *Punch* also offered a parody of a Whistler title: by no. 23 in the catalogue, *Harmony in Grey and Green – Portrait of Miss Alexander* (1872), is recorded the titular retort, "A 'gruesomeness in grey.'"[37] Beyond the simple debunking of Whistler's formal preoccupations, it is apparent that by repeating (consciously or not) the device earlier employed by the artist himself of proposing an alternative name for a particular work, such critical commentary is susceptible to just the kind of partial interpretation that Whistler models for the reception of his artworks. That is, the reader notes the emphasis on titles, but ignores (or at least does not fully apprehend) the satirical content of the utterance.

The critics themselves were aware of the enigma and "occultation" that potentially attended the exhibited images, and Whistler knew of their awareness. He willingly cited the *Daily Telegraph* on the subject, apropos catalogue no. 7, *Nocturne in Black and Gold – The Fire Wheel* (1872/77): "These weird productions – enigmas sometimes so occult that Oedipus might be puzzled to solve them – need much subtle explanation."[38] In the end, the catalogue citations set up a strange echo system as the values and mannerisms of the artist are assaulted, satirized, parodied, repeated and eventually (albeit implicitly) reinforced. Another comment from the *Daily Telegraph* thus (negatively) collates what we have established as the two crucial valencies of Whistler's work at this time – the title and the gallery environment: "If he did not exhibit these as pictures under peculiar and, what seems to most people, pretentious titles, they would be entitled to their due meed of admiration [*sic!*]. But they only come

one step nearer pictures than delicately graduated tints on a wall-paper do."[39]

Even the small details of usage in this quotation relate to the language and the thematics of the obverse and approbationary critique. The attribution to the images of a place in a kind of representational no-man's-land, one "step" between wallpaper and painting, is a twisted rehearsal of the avant-gardist language of Duret, who, as we have seen, repeatedly positioned Whistler's practice a "step" away from pure non-iconicity. All that has happened is that the *direction* of the step has been reversed: the *Daily Telegraph* critic insists that a Whistler is a step *from* wallpaper *towards* painting; whereas Duret maintains that the work can be defined as stepping away from pictorialism towards decorative abstraction. Whistler, of course, went to great lengths to accentuate the relation between his paintings and the walls of the exhibition space through his insistence on a personally decorated interior. But the telltale sign of Whistler's consciousness of the tactical complicity he was engineering among a purportedly hostile critical crowd is the sly interpolation of the "[sic!]" at the point where the *Telegraph* critic has apparently tripped himself up with an unconscious pun between "title" and "entitle" (the same terms confronted by Gauguin). The very process of punning, the production of a double or second meaning from a single term, is a model for the tropic reversals that seem to be everywhere effected in Whistler's parody catalogue.

In addition to his dispersal of the implications of his musical titles into the adjacent institutional domains of the gallery, the exhibition, the market, and the catalogue, Whistler also (and quite remarkably) contrived to have them inscribed on his own body, in his immediate proximity, and in his domestic space. We can find instances of each of these trans-titular writings in the critical and biographical literature on the artist. Whistler cleverly manipulated his social appearance and sartorial persona by reinventing his own artist-body. He shifted its signification from an eccentric, bohemian dandyism to return the *image* he wanted to project for the receptive context of his work. It is in these terms that we can understand the "shock of curly black hair, amid which shone his celebrated white lock," which was carefully noted by Val Prinsep, and vividly represented in a portrait etching by McCulloch, *Whistler with the White Lock* (1879). As the writer further observes, "[m]any, seeing him for the first time, mistook it for a floating feather," but "[w]hatever its origin, Whistler always cherished it with the greatest care."[40] This cultivation of a self-identity confected out of black and white answers to the many contemporary instances of dark and light that were both literally and metaphorically visible in the British art world. These include such

institutional designations as the "dark cell," the name given by critics at the time to the east end of the National Gallery in the late 1850s, which was "reserved for black-and-white."[41]

This reading seems considerably less far-fetched when we locate it in the context of other postures got up by the artist to mimic, supplement, or extend his "art" into his "life." We might recall the brown paper and black-and-white chalk of Whistler's boating sketches made at night on the Thames in the vicinity of his house in Cheyne Walk, where he was rowed by the Greaves brothers (sons of J. M. W. Turner's boatman), who apparently imitated his dress. The night, the paper, the chalk, the "costumery," the enveloping noir of the gaslit evening, are as perfectly composed as the eventual images whose materials and conditions they constitute. The mimetic Greaves brothers even smoked in unison with Whistler and copied his figure drawings as he, in turn, sketched from the life model.[42] Whistler has literally *drawn* these willing assistants *in*, letting them copy him, take on his attributes, his clothes and his look, rendering them in their rightful places as he worked out the unfolding of his art-life tableau.

The brothers also helped him decorate the drawing room of his new house in Cheyne Walk, where he had moved in 1867, on the occasion of his first dinner party. The designer-dinners that ensued, of which this was a prototype, were fastidiously organized and visually concurrent with the taste that informed all of Whistler's social exercises. His scrupulousness extended everywhere, as a detail from the Pennells' biography make clear: "[H]is eloquent 'H'm! H'm!' were placed as carefully as the Butterfly on his card of invitation, the blue and white on the table."[43] This was Whistler the social Butterfly, seeing, being seen, and causing to be seen.

The blue and white chinoiseries and japoneries that Whistler introduced from Paris, and with which he decorated his house, were key elements in a carefully managed quasi-social domestic space that formed the envelope of the artist's decorative *Gesamtkunstwerk*: "The only decorations, except the simple harmony of colour everywhere, were the prints on the walls, a flight of Japanese fans in one place, in another shelves of blue and white. People, afterwards, copying him unintelligently, stuck up fans anywhere, and hung plates from wires as ornaments. Whistler's fans were arranged for a beautiful effect of colour and line."[44]

Two of the many more parts of the compositional canopy from under which Whistler conducted his world are closely associated with the title: the signature and the frame. The first, introduced above, is Whistler's famous monographic signature, which developed into the Butterfly:

He signed his name to the earliest pictures, even to some of the Japanese. But with the Nocturnes and the large portraits the Butterfly

begins, made from working the letters J. M. W. into a design, which became more fantastic until it finally evolved into the Butterfly in silhouette, and continued, in various forms. In the *Carlyle*, the Butterfly appears in a round frame, like a cut-out silhouette, behind the figure, and repeats the prints on the wall. In the *Miss Alexander* it is in a large semicircle and is far more distinctly a butterfly. In time, however, it grew like a stencil, though in no sense was it one, as may be seen in M. Duret's portrait, where the Butterfly is made simply in silhouette, on the background, by a few touches of the rose of the opera cloak and the fan. It was introduced as a note of colour, as important in the picture as anything else, and at times it was put in almost at the first painting to judge the effect, scraped out with the whole thing, put in again somewhere else, this repeated again and again until he got it right. We have seen many an unfinished picture with the most won-derfully finished Butterfly, because it was just where Whistler wanted it.[45]

This "signature" functioned as an element of Whistler's pictorial compo-sitions, as a design in its own right, and as a mark of possession (and thus a title). It was both a decorative adjunct and a compositional unit. Whistler also used the Butterfly monogram for signing letters and dedica-tions. Eventually it was put to work in all his routine correspondence, and "was elaborated in the most ingenious manner in *The Gentle Art of Making Enemies*, the Butterfly not only decorating, but actually punctuat-ing the pages."[46]

The matter of Whistler's frames merely extends and completes the field of compositional identity that he had so lavishly worked up all around him. Whistler's gold frames were often painted with Japanese patterns, in red and blue "and [had] a Butterfly placed on them, always in relation to the picture." Later he designed special frames – "a simple gold frame, with parallel reeded lines on the outer edge . . . now universally known as the 'Whistler frame.'"[47] Yet, from the very beginning of his exhibiting career, he had transgressed the limits of the frame in its functional deployment as a decorative borderline between art and its outside. His painting *The Little White Girl*, for example, had a subtitle by Swinburne in the form of his poem "Before the Mirror: Verses under a Picture" that is said to have been "printed on gold paper, pasted on to the frame, which has disappeared, and two verses were inserted in the catalogue as sub-title."[48] Here are conjoined a title, the poetic sub-titular appendage – printed in the color of the frame and fastened to it – and the (partial) secondary inscription of the sub-title in the catalogue.

Shortly after his election to the presidency of the Society of British Artists in June 1886, Whistler took it upon himself to pursue what was

simultaneously the most literal and the most ambitious of his titular adventures. Using the occasion of Queen Victoria's Jubilee the following year, he prepared an "address" to the Queen in the form of a "dozen folio sheets of my old Dutch etching paper":

> First, came the beautiful binding in yellow morocco and the inscription to Her Majesty, every word just in the right place, – most wonderful. You opened it, and on the first page you found a beautiful little drawing of the royal arms that I had made myself; the second page, with an etching of Windsor, as though – "there's where you live!" On the third page, the address began. I made decorations all round the text in water-colour, at the top the towers of Windsor, down one side a great battleship plunging through the waves, and below, the sun that never sets on the British Empire, – What? – The following pages were not decorated, just the most wonderful address, explaining the age and dignity of the Society, its devotion to Her Glorious, Gracious Majesty, and suggesting the honour it would be if this could be recognised by a title that would show the Society to belong specially to Her. Then, the last page; you turned, and there was a little etching of my house at Chelsea – "And now, here's where I live!" And then you closed it, and at the back of the cover was the Butterfly.[49]

Whistler's titular artwork-petition, the only piece he made that went in search of a title, was rewarded with the bestowal of royal patronage, and the Society was henceforth named the Royal Society of British Artists.

With this entourage of para-pictorial "effects" in place, we are in a better position to witness the most elaborate of the titular critiques offered (and re-offered) in Whistler's catalogue for the exhibition "Nocturnes, Marines, and Chevalet Pieces." The critic of the *Echo* constructs a whole "parable" based on the imputed value system of Whistler's titles:

> With regard to Mr. Whistler's Symphonies, Harmonies, and so on, we will relate a parable. Here it is: – A lively young donkey sang a sweet love song to the dawn, and so disturbed all the neighbourhood, that the neighbours went to the donkey and begged him to desist. He continued his braying for some time, and then ended with what appeared, to his own ears, a flourish of surpassing brilliancy.
>
> "Will you be good enough to give over that hideous noise?" said the neighbours.
>
> "Good Olympus!" said the donkey, "did you say hideous noise? Why that is a 'Symphony,' which means a concord of sweet sounds, as you may see by referring to any dictionary."
>
> "But," said the neighbours, "we do *not* think that 'Symphony' is the

word to describe your performance. 'Cacophony' would be more correct, and that means 'a bad set of sounds.'"

"How absurdly you talk," said the donkey. "I will refer it to my fellow-asses, and let them decide."

The donkeys decided that the young donkey's song was a most symphonious and harmonious, sweet song; so he continues to bray as melodiously as ever. There is, we believe, a moral to this parable, if we only knew what it was. Perhaps the piercing eye of the '*Nocturnal Whistler*' may find it out.[50]

This self-confessed parable works itself out according to an ironic logic based on the exchange between musicality and "cacophony," mediated by a relay of misrecognitions that flow from the subject (and interest group), i.e. the donkey and the other donkeys, to the (wider) community. At stake here are certain classic dilemmas concerning the nature of subjective experience that issue in (rather than are resolved by) either a relativist position or an absolutist (empiricist) determination. The parable is ventured in order to establish and then clinch what it wishes to construct as the obvious fraud, the patent absurdity, of a supposedly objective quality ("x," say, formless noise) masquerading as a supposedly ordered quality ("y," say, a symphony or a painting). Yet the crux of this socio-interpretative dilemma rests on the historical activity of definition – the regulation and codification of words and concepts in the dictionary.

The dictionary is the preliminary meeting place of names and meanings; the locus of the assignment of consensual signification to the units of language.[51] Yet what the parable must elide as it works itself out is that it has put the call to definitional order (even if this is discovered as a false call) in the wrong mouth – that is, in the mouth of the donkey. It is the use-value of the dictionary, the circulation of designs and definitions, which produces actual (mobile) language; the musicality/cacophony, image/abstraction collisions are disjunctive clashes between materially discrete codes. They can only exchange an *imprecise* referentiality. Despite, therefore, the bravura final pun on whistling (producing an unfathomable noise) in the dark ("nocturnally")[52] the parable can be seen to recoil upon itself as it insists on the transparency and efficiency of exchange between a word (a name) and an object (or "effect").

The parable is an elaborate attempt to home-in on what the critic construes as the manifest absurdity of the referential claims invested by Whistler in his title-image compounds. It evidences his desire to explode Whistler's apparent logical travesty – to pin and fix the butterfly, his monogram, in the legible vitrine of common meanings. But the fable reveals that a kind of revenge has been taken by the non-denotative

conditions of language and of names – their arbitrariness, inexactitude and sheer materiality – against the vaunted definitional closure of the dictionary. In other words, the critic could say that if he did not *like* the musical pictorialism of Whistler, he could assert his derision in a value judgement; but it is at a certain cost (the ultimate failure of this kind of tactical closure) that the critic tries to assert, model, and parody the inferiority of the connotative to the denotative sign.

If this "parable" represents the most extended critical commentary on the conditions of the Whistlerian title, then an indirect exchange mediated by the letters sections of two London newspapers between the artist and Wyke Bayliss (who had recently replaced Whistler as the President of the Society of British Artists) amounts to a kind of titular meta-commentary, a commentary-about-the-commentary. It caused the already complex discussion of Whistler's nomenclature to spill over into a public, social debate that quite dismantled its confinement to the pictorial image. Bayliss wrote as follows to the editor of the *Morning Post* on 1 April 1889:

> The notice board of the Royal Society of British Artists bears on a red ground, in letters of gold, the title of the Society. To this Mr. Whistler, during his presidency, added with his own hand a decorative device of a lion and a butterfly. On the eve of our private view it was found out that, while the title of the Society, being in pure gold, remained untarnished, Mr. Whistler's designs, being executed in spurious metals, had nearly disappeared, and what little remained of them was of a dirty brown.[53]

This letter represents both a concentrated reprise of the major issues identified in this discussion of Whistler's titles, and an unfolding of these points into the social configuration of the institutional space of the late nineteenth-century art world. First, the term "title" itself is put forward here in one of its many *extensive* usages (others relate to the discourses of law, property, etc.): it is a description of the symbolic apparatus that (naturally) appertains to a particular social "Society." The "notice board" thus offers a public display of the titular insignia of the Royal Society of British Artists, its gold letters standing out on a red ground.

The precise identification of this bold color scheme recalls the decorative efforts made by Whistler for the environments of his exhibitions. But whether this is significant or not, we learn that Whistler augmented ("with his own hand") the Society's title by painting on a kind of signature, amalgamating, as did Gauguin, the notice of titular possession with that of a personal mark; making, in effect, a symbolic claim on an item of public signage. Bayliss proceeds to distinguish between the true

elements of the title (rendered in "pure gold") and Whistler's "spurious metals." This can be read as a drive to purge the title of foreign material, to render it denotative ("pure") and unencumbered by extraneous signifying elements – whether a monogram signature or a musical signature.

The description of the literal residue of Whistler's supra-title, as "of a dirty brown," is a scarcely concealed reduction of the color-specificity of the artist's paintings to the condition of excrement, the ultimate *impurity*: "the soiled butterfly" ("his well-known signature") was "therefore effaced."[54] The visiting of this hostile "cacagraphics" onto his somber-toned musical *titulae* evidences the symbolic fear Whistler's practice elicited among the powerful arbiters of taste and the critical status quo. It also represents the meeting place of the repressed logics of the socially and aesthetically critical disparagement of the artist; the surface implications of the parable (what is vaunted as musicality is self-evidently a "*caca*-phony" – just what you would expect from a donkey) is restated in the literal relegation of the "soiled butterfly" from the institutional space of the art world. The appearance, then of Whistler's brownish works in the gallery could be answered by broadsides and parodies; but their insinuation *outside* the gallery space, and into the public domain, had to be quashed and effaced. The abstract, formalist, musical demonstrativeness of a "Nocturne" had to be described for the waste material it was held to be, and then flushed out of the visual system, relegated into the signifying void.

While this reading of Whistler's position in the late 1880s underlines the complexity, the polemic, and the sublimated critical violence that surrounded his practice, these years did not witness the final terminus of "formulated painting," as Duret rather quaintly put it, and as the latterday adventures of formula modernism have demonstrated. But it is important that the first gestures towards extreme formalist reduction were made in and through a moment that also accommodated aspects at least of practices antithetical to the telos of pictorial self-reference.

Whistler was clearly the inventor of one of the most powerful originary formalisms. Yet his was a kind of environmental formalism that played itself out in the exhibition space and also embraced the cultural self-presentation of the artist. Its parameters were considerably broader, and its instances far more specifically designed, than the attenuated discourse of critical formalism which was to follow. In the case of Whistler, the title was the key agent that negotiated between the formal organization of a surface and the panoply of institutional, domestic, and somatic inscriptions that offered it further grounds and other dimensions. When we turn to retrospective formalist readings of work by Cézanne and Picasso, and to the prescriptive criticism that attended the high modernist painting and sculpture of the 1960s, we will find that the title still plays

a crucial role; only now, it forms a site of resistance to the refusal of formalist readings to transgress the limits of the frame-bound surface (or its sculptural equivalent). Negotiating between the image and the text, between metaphoric extension and descriptive identity, the title in this destiny is caught in the contradictions of its interdiscursive location. We will follow the traces of its embattled future in the singular titular epithet that became the preferred designation for the textual unconscious of visual modernism: *composition*. Encoded in this, probably the most powerful word in the visualization of modernity, is an elaborate debate over the very predicates of pictorial order and the mighty challenges mounted against it by avant–garde dissolution.

Nominalist Order and Disorder:
Form, Violence, and Revisionism

> Nomination is important, but it is constantly caught up in a process that it does not control.
>
> – Jacques Derrida, "Living On: BORDER LINES" (1979)[1]

The most radical and disruptive titling strategies, such as those of the Symbolists, are associated with works that negotiate emphatic, strident relations to their conditions of production and to the outside world. They reveal the energy of the title as an important component of avant-gardist signification – how it joins in with, or competes against, the clamor of statements, manifestoes, institutional secessions, and other assaults on prevailing standards of public taste. The titular activity thrives on the publicity and scandal provoked by the social circulation of dissident names. While Monet made much of his struggles with the weather and its designations in his personal correspondence, the entry of his non-standard title-captions into the public domain was, as we have seen, attended by bemusement, ridicule, and polemic incredulity. With the Symbolists and with Dada and Surrealism the title is explicitly cultivated as a site of resistance to traditional values, becoming one of the chief instruments of avant-garde contestation.

Yet the problematic of the title is not reduced to insignificance in its encounter with artworks and movements that have been aligned with the development of visual formalism, or what might be termed "paradigmatic modernism." In this and following chapters I attend to the critical economy of the modernist-formalist axis of visual-art practice in the later nineteenth and twentieth centuries, looking here to Paul Cézanne, Cubism, and, briefly, to the Soviet avant-garde, and (in chapter 6) to what can be termed the "compositional" non-iconic abstraction of Mondrian and Kandinsky. In chapter 8 I discuss the fate of the title at the

culmination of visual-formalist discourse in the 1960s. My aim will be to show how the nominative structures deployed in visual modernism, and the institutional parameters that govern them, are, in effect, braided with those of the avant-garde. I will suggest, further, that their signifying histories cannot be grasped outside a complex relational field which, directly and indirectly, engages or refutes the nomenclatures of counter-formalist developments.

I will first offer a critical outline of the titling strategies of "definitively modernist" work by Cézanne, Pablo Picasso, and Georges Braque, which are read through and against the expectation solicited by modernist formalism that any connotative excess, especially that encouraged in the title, be reduced or eliminated. I begin and end the discussion with two moments – one of formation and the other of summation – within which the development and consequences of visual modernism according to the formalist logic reserved for it are clearly revealed as provisional. Joining the beginning and the end is a third moment (a "high" or "middle" point) of reckoning with nomination, located around the original name of Picasso's *Les Demoiselles d'Avignon* (1907, fig. 35). Together, these three sites of crisis in formalist semantics offer to dislocate the topology of modernist critical space. In one sense they can be described as "switches" to the avant-garde. But they are also sites that clearly mark the struggle and *repressive* effort caught up in the will-to-reduce-to-form.

I Paul Cézanne: "Do Not Remain a Creature without a Name"

In contrast to the subordinated temporal poesis of Monet's titles, Cézanne's nominations – after about 1880 at least – produced some of the most simply and descriptively titled paintings of all the works made by the so-called Post-Impressionists. Large groups of paintings are assembled under little modified generic headings such as *Mont Sainte-Victoire*, *Baigneuses* and *Baigneurs* (*Bathers*), or qualified *Nature Morte* (*Still Life*) arrangements, such as *Nature Morte avec l'Amour en plâtre* (*Still Life with Plaster Cupid*), c. 1895).[2] Alongside Cézanne's powerful engagement with the analytic scrutiny of the motif, the repeated, collective nature of these nominations and re-nominations has itself assisted in the critical and historical reception of his oeuvre as a play of structural differences predicated on the formal analysis of rearticulated spaces. Cézanne is returned here in his well-rehearsed role as the founding father of the closely focused envisioning championed by the new criticism of the early twen-

tieth century – associated above all, in the English-language critical
tradition, with the writings of Roger Fry and Clive Bell.

It is significant, however, that longer and often more opaque,
semi-allegorical, or symbolic titles are attached to many works from the
first twenty years of Cézanne's career, especially from the late 1860s to
the late 1870s. These extended and discomforting titles appear to reveal
a crisis (what some historians and critics, including Meyer Schapiro, have
noted as Cézanne's anxiety) in his representation of figures, especially the
female nude.[3] The names of these paintings offer an engagement with
several specific areas of real or imaginary trauma. They include, first,
mythological or religious figure-subjects such as *Le Jugement de Paris* (*The
Judgement of Paris*, 1862–64); *Nymph and Tritons* (c. 1867); *La Tentation de
Saint Antoine* (*The Temptation of Saint Anthony*, versions from c. 1870 and
c. 1873–75); *Bethsheeba* (*Bathsheba*, 1875–77); and *The Battle of Love*
(c. 1880). Second, there are a number of disparately suggestive portraits,
including the masquerading image *Portrait de moine* (*L'oncle Dominique*)
(*Portrait of a Monk [Uncle Dominic]*, c. 1866), *Portrait du Nègre Scipion*
(*Portrait of The Negro Scipion*, c. 1867), and the *Portrait de Achille Empéraire*
(*Portrait of Achille Empéraire*, c. 1868), which was rejected by the jury of
the 1870 Salon and caricatured by Stock. And, third, there are scenes of
violence, mayhem, orgy, alcoholic dissipation, and erotic seduction, as in
L'Enlèvement (*The Abduction*, 1867); *Le Meurtre* (*The Murder*, c. 1870); *The
Orgy* (c. 1870) and *L'Après-Midi à Naples* (*Afternoon in Naples*), also
known as *Le Punch au rhum* (*The Wine Grog*, 1876–77). While Cézanne
painted a number of more tranquil images during this period (including
several versions of the *Déjeuner sur l'herbe* (*Luncheon on the Grass*) and
Pastorale) all of these generic reinflections are associated, in their different
ways, with the extremities of representation. The religious and mytho-
logical figures stand for moments of moral passion, erotic charge, and
sensual seduction. Many of the early portraits offer formal, iconographic,
contextual, and titular resistances to the denotative closure that tradition-
ally attended the genre. And, most of all, Cézanne seems to have worked
up a particular investment in scenes of primal violence and raw sexuality,
which (had they been shown) would clearly have transgressed prevailing
standards of public visual morality.

A full account of this nominative excess, measuring its friction against
the controls of the following thirty years of work, is beyond the scope of
the present study. But it seems clear from the available research, particu-
larly from John Rewald's pioneering study of the early Cézanne and the
young Zola,[4] that repressive anxiety and sexual frustration, trauma, or
dysfunction accounts, to some extent, for the production and sublimation
of this imagery. Zola's epistolary commentaries on his friend's irascible,

moody youth offer compelling evidence of a colossal struggle over the predicates of representation. He pointed to "the evil demon" that "becloud[ed]" Cézanne's "thought" and to his poetic fits and provincial dissidence; he censured his "ignorance of reality" and "impulsive and unreasonable changes of behavior," his "fits of discouragement" and despair; and noted the artist's retreat to the surrogate world of the Jas de Bouffan, which was the Cézanne family home for forty years between 1859 and 1899. Cézanne, himself, joined in with this condemnatory spree when he admitted his own inertia, laziness, and alcoholic proclivities in the failed love-story letter discussed below.[5]

The correspondence exchanged in their formative years between Zola and Cézanne (and to a lesser extent between them and Baptisin Baille) affords access to one material form in which Cézanne's anxiety could be deposited. His letters were often fitful, depressive, and fragmentary; their tone, allusions, and visual-textual formats unusually disparate. These broken writings were also unevenly supplied with disjunct sketches, doodles, and other marginalia. Viewed in relation to his other textual gestures, Cézanne's titles carry an intense, digressive impulse into a curiously sustained relation with the early painting. Zola once upbraided his friend for his unending "uncertainty" in terms that specifically turn upon designation: "do not," he cautioned, "remain a creature without a name."[6] The fullness and turmoil of the early images and their titles acted as a counterweight to the sexual evacuation and sublimation of the artist-subject. Naming and representing powerful actions deflected the inner doubts of an artist stranded outside the action world. They provided a form of "speech" that Zola constantly urged his correspondent to utter.

They also substituted for a "silence" that Zola could neither endure, nor comprehend. In one of his more colorful railings the young writer prickled at Cézanne's percussive restraint: "[N]ote that it is not the one who makes the most noise who is right; speak softly and wisely, but by the horns, the feet, the tail and the navel of the Devil, speak, go ahead and speak!" The pro-vocative demands of Zola were funded by the dream of linking his "name" with that of his friend in the form of a shared frontispiece to a collaborative publication. It was the dream of a joint signature: "Both our names shone in letters of gold on the first page and, inseparable in this fraternity of genius, passed on to posterity."[7] Action, writing, and name are conjoined in Zola's personal commentary on the representational conditions that beset his friend. Cézanne's response to this nagging and entreaty was to encode his sublimated actions in a partly coerced transference onto canvas. It is in this sense that he writes to Zola, using a formula the writer was to cite back at him: "I am going to talk without saying anything, for my behavior contradicts my

words." Cézanne's early titles were special words excepted from his "contradictory" retreat from speech – a removal that became almost congenital. For in the later Cézanne, as Derrida has discussed so provocatively, "truth" was held to be lodged in the visual scrutiny of nature and passed over into paint without the intermediary disruption of theory, text, or speech.[8]

Within the catalogue of possible dysfunctions signaled by Zola, special attention is reserved for Cézanne's relation to women, whether actual, imaginary, or painted.[9] A certain Justine might stand as the recurrent figure for the artist's imaginative retreat from the carnal real to the sexually repressed. He writes a lengthy description to Zola of his love, his disappointment, and his fantasies about this young dressmaker from Aix. In its course he negotiates a rather explicit passage from fixation to sublimation. He writes (not without self-irony) of the genie-like dispersion she undergoes when he smokes one of the "caramel and barley sugar" tasting cigars that were a gift from his addressee:

> But oh! look, look, here she is, she, how she glides and sways. Yes, it is my little one; how she laughs at me; she floats on the clouds of smoke; there, there, she rises, she descends, she frolics, she turns over, but she is laughing at me. O Justine, at least tell me that you do not hate me. She laughs. Cruel one, you enjoy making me suffer. Justine, listen to me! But she is disappearing, ascending, ascending, ever ascending until at last she fades away. The cigar drops from my mouth.[10]

Its ironies notwithstanding, the production and recall of this quasi-oneiric image of the tormenting, mocking, cruel, etherial, and finally transcendent woman is a clearly castrating experience ("the cigar drops from my mouth"). For Cézanne the phallic loss is double, in that it has been induced not only by the repetitive return and disappearance of the object of desire, but also by the removal of the "pen," of Zola himself, the self-identified-writer-(br)other. The cigar-phallus is also a synecdoche for Zola. Dispatched from him, and deeply associated with him, it functions as a kind of *aide-mémoire* extension of Zola's person and milieu.

Several historians and critics of Cézanne, including Rewald, who described it as a "strange and violent book . . . full of unassimilated romanticism,"[11] contend that the cluster of potentially violent attitudes towards women manifest in the Cézanne-Zola circle found one of its most vigorous expressions in Zola's first novel, *La Confession de Claude*, written, in part, during the summer of 1862 while Zola was with Cézanne in Aix, and published in October 1865. Zola made a casual

description of this project. It took on, he wrote, "the mad idea of bringing back to decent life an unfortunate woman, by loving her, by raising her up from the gutter."[12] His formulation, especially with respect to the rising woman, has a loose similarity to the imagery of Cézanne's castrative fantasy.

It is from Zola's commentary on the repressed sexuality of Cézanne that we are best able to reimagine the artist's relation to women. There can be no dispute that Cézanne had what amounted to a pathology in this respect. We have already noted Zola's observation of the artist's despair, continual distraction, and manic work routines. He also observed his friend's social retreats into violent and abusive language. And on women he was emphatic: "[H]e treated them all like a boy who ignored them." Zola reported a statement by Cézanne: "'I do not need any women,' he said, – that would disturb me too much. I don't even know what they are good for – I have always been afraid to try!'"[13] Fear, frustration, anger, and disdain can all be established, but a key question remains: how did these demonstrable attitudes carry themselves over into the paintings and their titles? For his part, Zola is explicit. Judging from his novel *L'Oeuvre*, he is clearly of the opinion that his painted women played a fulfillment role in Cézanne's fantasy and an object role in his abuse. Rewald offers the following as evidence of Zola's views on the artist's eroticism:

> It was a chaste man's passion for the flesh of women, a mad love of nudity desired and never possessed, an impossibility of satisfying himself, of creating as much of this flesh as he dreamed to hold in his frantic arms. Those girls whom he chased out of his studio he adored in his paintings; he caressed or attacked them, in tears of despair at not being able to make them sufficiently beautiful, sufficiently alive.[14]

There are two forms of evidence that provide yet stronger links between the castrating, elevated woman, the Cézanne–Zola circle, and the titles of Cézanne's paintings. First, it appears that Cézanne acquiesced in the collective or surrogate nomination of certain of his works from the mid- and later 1860s. Rewald notes that "Guillemet is credited with having supplied many a canvas by Cézanne with more or less fancy titles. Thus he christened one of his paintings: *The Wine Grog*, or *Afternoon in Naples*, and another: *The Woman with the Flea*."[15] The surrender to intimate creative exchange suggested in this collaborative naming is further underlined by the contention that Cézanne may have been virtually the co-author of the pamphlet of Salon criticism that Zola published in 1866 – with an elaborate dedication to his artist friend. The arena of the title, then, was one in which Cézanne was prepared to admit a form of

creative co-authorship over forms whose physical production he jealously guarded. The title was a kind of escape-valve, enabling the hard-won realization of the image to be sublimated into collective, generalizable words. Generic, religious, or mythological texts, and the captions of abstract violence or desire, translate the dark, blurred, knifed-in confines of the brooding image into a language whose publicness is mediated by the solidarities of the group.

Second, Rewald's detailed account of the relation between Cézanne and Zola provides the first of three moments of revisionism predicated on the title. In order to contest what he terms the "gravedigger attitude" to contemporary history and the patent trivialization of figure and genre paintings licensed by the academy, Rewald's biography turns to the Nietzschean censure of the "commemorative" past and, like Baudelaire's and Fénéon's earlier criticism, to the convoluted titles ranged in the official Salon catalogues:

> They contain titles such as *The Little Bird's Nester, First Caresses, The Sugar-Plums of the Baptism, A Good Mouthful, Grandmother's Friends, First Shave*, etc. Some paintings have a long caption such as the following:
> *Woman Tied to the Tree from Which Her Husband Had Been Hanged by Order of the Bastard of Vanves, Governor of Meaux in the XVth Century, Devoured by Wolves.*[16]

These titular surpluses symbolized the decadent mediocrity of the Salon, its promotion of over-elaborate, pseudo-narrative incident and fitfully heightened coloration. By contrast, the catalogues of the Salon des Refusés are brief and incomplete, so that the precise names and even the number of paintings shown by Cézanne are unknown. Rewald concludes his attempt to separate the early work of Cézanne from official notions of history, style, and naming with an aside concerning Manet's *Luncheon on the Grass*, which he describes as the "focal point of the Salon des Refusés": "If Manet had surrounded the woman with nude men, calling it *A Scene of Fauns with a Nymph*, the public would doubtless have been less shocked."[17]

Rewald is not the only art historian to have speculated on the re-nomination of key works from the 1860s and 1870s. When considered together, the sum of these occasional attentions emphasizes the strategic role of the title in the institutional reconfigurations of art-world exhibition space from the 1860s. It underlines the importance of the caption in the accelerating provision of supplemental text in relation to the image: information (catalogues); caricature and satire (in a range of journals, some dominated by this mode of commentary); and criticism (Salons and review journalism). It shows how the title becomes a key element in the public reception of paintings. And it also begins to map the "modern"

reinflection of the title onto a new attitude to history, past and contemporary.

Looking over only to its place in the development of critical discourse in the later nineteenth century, we see that the title, even when it is a simple description, increasingly becomes a take-off point for discussion – especially for ridicule and put-downs. In addition to the works mentioned above, one of Cézanne's submissions to the Salon of 1870, *Reclining Nude* (now lost) was retitled by the critic Guillemet as *The Wife of the Sewage Collector* and caricatured by Stock. His *Portrait of Victor Choquet*, exhibited at the Third Impressionist Exhibition in 1877, gave rise to a defensive comment by the critic Georges Rivière that began by recalling some of the disapprobation leveled at the artist in the press: "There is no outrageous epithet that has not been attached to his name; his works have had a success in ridicule and continue to have it. A newspaper called the portrait of a man exhibited this year *Billoir en chocolat* [Billoir was a notorious murderer]."[18] This device of launching a polemic by seizing on, or distorting, the title, or writing a mock re-nomination of the work, would be standard recourse for the expression of critical hostility against the avant-garde. We have already seen how Monet's *Impression, Sunrise* was subject to this kind of titular satire at the first Impressionist exhibition of April 1874. At the Armory Show in New York forty years later, Duchamp's *Nude Descending a Staircase, No. 2* likewise occasioned several kinds of facetious re-nomination. It is in this context that Whistler's powerful counter-attack against the critical dislocations of his musical titles can be seen as a peculiarly prescient gesture.

Of all the paintings from Cézanne's first phase of work, there is one canvas that conjugates the problematic of the representation of women, the recoding of the title, and the negotiation of generic and institutional space more emphatically than any other. This is the quadruply entitled *L'Eternel Féminin (Le Veau d'or; Le Triomphe de la femme; La Belle Impéria)* (*The Eternal Feminine [The Golden Calf; The Triumph of Woman; The Beautiful Imperia*], 1875–77, fig. 32).[19] Usually known either as *The Eternal Feminine* with or without the subtitle *The Triumph of Woman*, according to Lionello Venturi's catalogue raisonné there are two other "aka" names that make up its total titling field. Three of these designations ape vaunted Salon categories that might have been convened under the general rubric of history painting. *The Eternal Feminine* offers an idealizing abstraction, *The Golden Calf* is a biblical type, and *The Triumph of Woman* a kind of renegade apotheosis.[20] The fourth title appears to relate to a story by Balzac titled "La Belle Impéria." In contrast to Monet's resolutely empirical perceptualism, Cézanne (and/or his surrogate titlers) has articulated a dialogic relation to the notations of official culture as represented by the Salon.

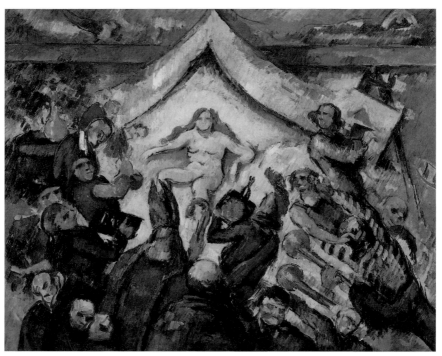

32 Paul Cézanne, *The Eternal Feminine*, 1875–77. 43.2 × 53.3. Collection of the J. Paul
Getty Museum, Los Angeles, California

In order to think through the sexual or gender anxieties of Cézanne in
more general terms (against the specificities pointed to by Zola), it might
be useful to refer to what Harold Bloom describes as the "anxiety of
influence." This idea may help us to account for the *différend*(s)[21] staged
between the province and the capital city, between the museum and the
imagination, between (violent) action, and (passive) representation, and
how they are figured in the relation between early Cézannist style and
subject matter. Bloom notes that the Western poetic tradition since
the Renaissance has been produced from a history marked by "anxiety
and self-saving caricature, . . . distortion, . . . [and] perverse, wilful revi-
sionism."[22] These effects have a visible residue in the traumatic scenarios
and their split (schizophrenic) titles that characterize Cézanne's painting
in the 1860s and 1870s. Titles such as *The Eternal Feminine* precisely *return*
the image to its ambiguous and contested relation with authority (Salon,
genre, high style, patriarchy).

The sublimation of Cézanne's anxiety with respect to the re-

presentation of women through the triple articulation of pseudo-allegorizing idealisms highlights and summarizes the difficulties of his confrontation with the unclothed female. Several Cézanne scholars have suggested that these anxieties may be continued in his extended sequence of exercises in the *Bathers* sub-genre. Schapiro, for example, claims that the complex and disquieting implications of the early work are "carried-over" into the repetitive structural experiments of Cézanne's last twenty or so years. There is, he states, "a continuity in Cézanne's career, from the early often erotically charged works with their strong if naive forms and distinctive sense of color, to the last paintings such as the three *Grandes Baigneuses* (1898–1905)." Schapiro's development of a quasianti-formalist social iconography for Cézanne is partly motivated by his attention to (and even critical re-naming of) individual works whose titles explicitly signal their difference from Cézanne's iterated still-life and landscape themes – thus providing us with a second moment of title-driven historical revisionism.

Schapiro confronts the *perceptual* interpretation of Cézanne deriving from Maurice Merleau-Ponty ("he [Cézanne] gradually learned that expression is the language of the thing itself and springs from its configuration")[23] and related formalist/modernist evaluations, with the beginnings of a social and contextual analysis predicated on the disruptive signification of specific Cézannist titles. On one occasion he actually re-nominates Cézanne's *The Judgement of Paris* on the grounds that it does not conform to the literary legend referred to in the title. He prefers to call it *The Amorous Shepherd*. Elsewhere, Schapiro again uses the title of a painting – *La Maison du pendu à Auvers* (*The Suicide's House at Auvers*, 1874, fig. 33) in order to introject his contextualist project into an analysis otherwise dominated by formalist readings. While his discussion of this image is suffused with stylistic descriptions – "seriousness of colour," "strong composition," "the aesthetic of light," "diagonal elements," "diagonal axis," etc., it is interrupted by a conjecture whose only origin is the title of the work: "The title of the picture – *The Suicide's House* – suggests that the conception might have something to do with Cézanne's response to the story of the house; but this is uncertain."[24] Cézanne's offhand comment on the work in a letter of June 1889 does nothing more than to coax Schapiro's suggestion onto the edge of relevance: "*The Suicide's House* is the name given to a landscape I did at Auvers" ("*La Maison du Pendu*, c'est le nom qu'on a donné à un paysage que j'ai fait à Auvers").[25]

At this level of speculation, then, the usefulness of such revisionism is limited. But whether with Cézanne, or with the early work of Picasso (in particular *Les Demoiselles d'Avignon*), sustained attention to the titles of

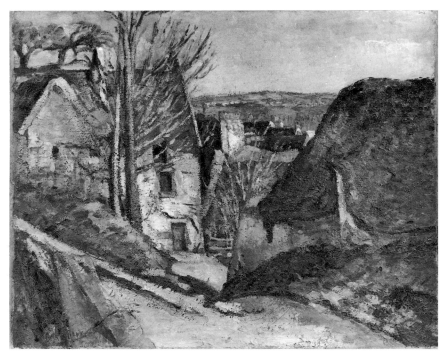

33 Paul Cézanne, *The Suicide's House at Auvers*, 1874. Musée du Louvre, Paris

modernist artworks is important for the elaboration of alternative critique or revisionary art *history*. One by one the titular decisions and modifications of key late nineteenth- and twentieth-century artists have been either ignored, or discarded, into footnotes and asides. At most they have been discussed in the context of a momentary historical or analytic argument, or in the course of a catalogue entry. Yet the sum of these instances and the syntax that articulates them reveals a significant counter-narrative about the visual, textual, institutional, and critical investments of visual modernity.

II Cubic Language and the Philosophical Brothel

Largely passed over by historical reconstructions of the period, the relays between art object, title, exhibition, and critical context engendered at the outset of the modernist period provide a matrix for the productivity of naming in the twentieth century. In part, however, the *work* of titling

after the early 1890s was modified and reduced by virtue of the accelera-
tion and redeployment of other textual supplements to the image/object.
These include fastening the specific discourse of artists' writings into the
distinctively modernist categories of "Statements" and "Manifestoes,"
which reinvigorated more casual, epistolary modes of textual enunciation
practiced by painters such as Pissarro, Van Gogh, and Cézanne, and the
full-scale admission of text into the material space of the image, first in
Cubist collage and more emphatically in Dada and Surrealism.[26]

Fauvism and Cubism relied predominantly on short, conventional
descriptions for their titles – of landscape and portraits in the main for
Fauvism and of still life and portraits for Cubism. These names tend
merely to enumerate the places, persons, and objects under painterly
consideration. As briefly discussed in the following chapter, Matisse is
revealed as the most distinctive of the Fauves in titling, as he was with
respect to technique and iconography. It is no surprise that Cubist titles
should be clustered, virtually without exception, in the domain of the
simple unadorned, denotative description. Picasso, in particular, seems to
have been almost wilfully careless in the bestowal of names upon his
works. In consequence, many of his titles are the product of the first and
sometimes of subsequent encounters of the work with the dealer system,
and with the necessity of labeling the product prior to a possible sale.
Because of the notorious circumspection of both Picasso and Georges
Braque concerning the public exhibition of their work, before 1914 at
least, some titles may not have been given until several, and in some cases
many, years after the works had been completed. This is one of the most
compelling instances of the historical importance of titular accident.
Various forms of non-nomination, mis-nomination, and re-nomination
participate in launching work into the increasingly complex (and progres-
sively mercantile) systems of exhibition and commodity exchange.

There are several important stakes in the titular activity of the Cubists.
Most immediate is the fact that as the motif or subject came under
complex planar and volumetric scrutiny from multiple viewpoints – a
technique that culminated in 1911 and 1912 in what has become known
as "Hermetic Cubism" – the title took on a potential less to describe than
to *identify* (as in works such as Braque's *Clarinet et bouteille de rhum sur une
cheminée* [*Clarinet and Bottle of Rum on a Mantlepiece*, 1910/11, fig. 34]).
Cubism thus achieves some of its particular effects through the strategic
non-correspondences between our realism-saturated representational
expectations, epitomized here in the unallusive titles, and the abnormal
referential structures of the canvas surface. These twin components of
(necessary) identification and strategic non-correspondence achieve a sig-
nificant polarity in many other types of twentieth-century titles.

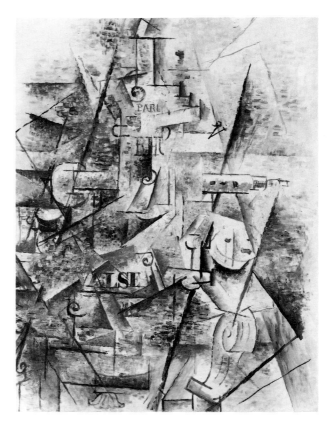

Second, and almost inversely, the critically accepted moment of origin
of Cubism was anticipated by a crisis of visual-textual adjacency not
unrelated to the problematic inscribed around Cézanne's *Eternal Feminine*.
Indeed, the site of the title for a key work by Picasso focused an
important debate that turned on the renovation of contextual (psycho-
logical, iconographic, sexual) analysis, and the corresponding retreat of
formalist interpretation. This discussion was developed from the late
1970s, precisely through the recovery and subsequent elaboration of what
appears to have been the "lost" (or suppressed) initial title of Picasso's *Les
Demoiselles d'Avignon* (fig. 35). In his pioneering analysis of 1936, Alfred
H. Barr cites some seventeen compositional sketches for the work,
describes its late Cézannism, "primitivism," spatial ambiguities, and asserts
its status as "the first Cubist picture."[27]
 While subsequent research by John Golding, Pierre Daix, Tim Hilton,

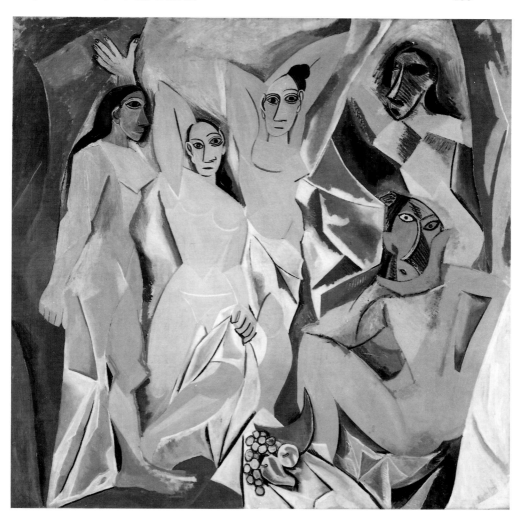

Robert Rosenblum, and, most recently and notably by William Rubin, has modified many of the details of Barr's account (and fabulously embellished the formal genealogy of the work) almost nowhere is adequate attention paid to its remarkable first title – *Le Bordel philosophique* (*The Philosophical Brothel*). Here, once more, the various layerings of the title are associated with quite formidable manifestations of repression. After nearly half a century of trenchant campaigning amidst a barrage of textual debate whose canon must constitute an unparalleled formalist

fantasia, Leo Steinberg puts it most succinctly when he notes: "[that] the most important consideration suppressed by the prevailing views of the *Demoiselles* is the picture's specific erotic content." Steinberg goes on to point out, somewhat tartly, that he "hate[s] to get the credit for merely pointing out that a picture of naked whores in a brothel may have somewhat to do with sex. (Far more remarkable, surely is the feat of repression which enabled critics for fifty years to think otherwise)."[28] To continue Steinberg's metaphor, if not his language, we might consider the title here, as with the earlier examples from Cézanne to which it bears an important relation, as a kind of linguistic slip into the textual unconscious of the image, a lapsus which has been effaced by the purely optical aesthetics of the formalist master discourse.

John Golding also relates the "erotic implications of the subject" of the *Demoiselles* to the earlier work of Cézanne, including his *The Eternal Feminine.*[29] He observes that the first title, *The Philosophical Brothel*, was "suggested in a spirit of humour by [André] Salmon, Max Jacob and [Guillaume] Apollinaire"; and that "[t]he painting seems to have acquired its present name after the war [World War I], when it entered the collection of M. Jacques Doucet. Even so it is only a more oblique reference to the same theme, since the *Avignon* in the title refers to a street in the prostitutes' quarter of Barcelona."[30] As with the early Cézanne, the provocative, consensual title was suggested by an intimate of the circle. Golding's footnote explains, further, that "Salmon refers to it by this name [the *Demoiselles*] in *La Jeune peinture française*. In *Propos d'Atelier*, Paris 1922, he writes of the *Demoiselles*: 'On a peu oublié le titre premier, suggéré, revu et adopté par les familiers de Picasso: Guillaume Apollinaire, Max Jacob et moi-même: Le B . . . Philosophique' ['The first title, *The Philosophical B . . .* — suggested, reviewed, and adopted by intimates of Picasso, Guillaume Apollinaire, Max Jacob, and myself — has almost been forgotten']."[31] Golding's analysis continues, however, by relating the "primitive" and "Iberian" sources of the painting, claiming that Picasso "became more interested in the purely pictorial problems . . . [and began] to look with greater concentration at Cézanne's later figure work."[32] Steinberg (and a few other scholars) excepted, this formal emphasis has prevailed in the interpretation of the *Demoiselles*. Even Pierre Daix in his *Catalogue raisonné* keeps the "traditional title" (following the Kahnweiler archives and Zervos) and prefers an extended summary of the stylistic and thematic influences on the work, including Picasso's competitive interest in Ingres, to any account (or mention) of *The Philosophical Brothel*.

In a recent essay that combines exemplary thoroughness with psychosexual speculation, Rubin has offered what is to date the definitive study

of the *Demoiselles*. His three-part account attends to virtually the entire documentary history of the painting through discussion of its "critical heritage"; its pictorial "gestation"; and the actual "execution of the large canvas."[33] While Rubin's text includes a newly detailed account of the formal, stylistic, and iconographic development of the painting through close readings of the unprecedented volume of preparatory works, he intimates his opposition to the predominantly formalist, poetic, or literary interpretations sponsored, in particular, by Kahnweiler and Barr, developed by Golding, and repeated by most critics and historians thereafter. Rubin is an enthusiastic supporter of Steinberg's "epochal essay";[34] though he, in turn, revises its revisionary thesis that the *Demoiselles* is a summa of orgiastic libidinal investments by claiming that Picasso painted a darker and more conflicted image reflecting the psychosexual ambivalence he staged between "sexuality and artistic creativity," Eros and Thanatos.[35]

Following Steinberg's lead, Rubin uses the title of the work – and other titular practices – as leading indicators for his interpretation. Indeed, it is with the title that Rubin begins, the opening section of the first part of his study being devoted to "The Name of the Picture." These pages offer the fullest yet account of the history summarized above, which it corrects and extends in several respects. First, Rubin notes Picasso's "studious avoidance" of giving titles for his work, and his stated "annoyance" at the title *Les Demoiselles d'Avignon*. Second, he returns to Salmon's 1912 *La Jeune peinture française* with its account of the "spontaneous baptism" of the work as a "studio prank" by friends – later specified as Guillaume Apollinaire, whom Rubin claims devised the title, Max Jacob, and "myself." The scene of this crucial "baptism" takes its place between Whistler's association of baptismal naming with market valency, and Matta's elaborate "baptism" of *The Earth is a Man* (1942, fig. 66), which gave rise to André Breton's theory of Surrealist nomination (see chapter 7).

Third, he elaborates on the possibility that the writings of the Marquis de Sade may have influenced the work and its nominal scene. For not only was Sade the author of *La Philosophie dans le boudoir*, a copy of which was owned by Apollinaire (also a "pornographic" author), but his family came from Avignon. Fourth, Rubin traces the evolution of the title through several nuanced stages, from the original *Le Bordel philosophique* or, possibly, *Le Bordel d'Avignon*, to *Les Filles d'Avignon* and, eventually, to *Les Demoiselles d'Avignon* in 1916. "Salmon's finessing of brothel whores into anodyne maidens," he writes, "probably accounts for Picasso's having been 'annoyed' by the title in 1933." The journey of this title is a "sidestepping" of its "scandal," which Rubin interprets as a conscious

repression of the image's profound violence and sexual intensity. Fifth, Rubin corrects the contention, accepted following an ambiguous report by Kahnweiler, and its incorporation by Zervos (1942) and Barr (1946), that the Avignon in the work's second and subsequent titles referred to "a cabaret or brothel on the Carrer d'Avinyó" in Barcelona. He suggests that there is no need to discount Picasso's own statement that the Avignon in question was the city in the Midi: for "Avignon was synonymous with vice, and was the familial home of the de Sades (which also links this later title to 'Le Bordel Philosophique')." This account of the title of the painting, and his concluding comments on the "frightening," "hideous," "abominable" face of the crouching demoiselle, are the leading components of Rubin's psychosexual interpretation.[36] But there are several further suggestions in his essay concerning the role of the titles in the production, signification, and reception of the *Demoiselles*. Considered together these make up an expanded concept of titling and the revisionisms to which it may contribute that relates to the arguments I am advancing. Lamenting the overly literary nature of Breton's remarks on the *Demoiselles* – one of the earliest significant discussions of the work – Rubin notes, but overlooks the importance of, Breton's remarkable contention that the *Demoiselles* "is a work which to my mind transcends [or "goes beyond"] painting; it is the theater of everything that has happened in the last fifty years; it is the wall before which have passed Rimbaud, Lautréamont, Jarry, Apollinaire and all those we still love."[37] The "beyond" of painting, which as we will see is identified by Louis Aragon with the invention of collage, especially with the image-title collages of Max Ernst, is here anticipated by Picasso's key work. Breton's metaphors for the extra–pictorial expansion of the *Demoiselles* are significant. By likening it to a theatrical summary of the development of modernism, and to a wall channeling a procession of avant-garde writers, he has seized on a number of contextual parameters – enclosed and divided space, performance and textuality – that can be aligned (though they are obviously subject to different motivations) with Whistler's title-assisted "environmentalism." Breton does not directly allude to the title as one of these contexts, but he clears an important space for its extra-pictorial signification. His realization that what distinguished the *Demoiselles* was its capacity to break through its own pictorial borders, and to speak historically, theatrically, or poetically, is carried forward and inflected by the demands of the original title with its insistent reference to philosophy and sexuality.

If Breton allows us an important, but allusive, glimpse of the para-pictoriality of the *Demoiselles*, in the course of elucidating the context of the painting Rubin himself twice refers to the production and reception

of multiple titles for works that are not Picasso's. At the conclusion of the first reference, to El Greco, he suggests that "one may doubt that he [Picasso] was any more interested in this particular picture's title than he was in any other." Following the second (to tribal objects in the Trocadéro), he makes almost the opposite claim, thinking that Picasso may have been more affected by the information on the label-captions than in the aesthetic properties of the images and objects on display.

Discussing the influence of El Greco on the composition and symbolism of the *Demoiselles*, Rubin compares the accounts of John Richardson and Rolf Laessøe, which turn on two alternative titles, giving rise to two interpretational emphases. El Greco's *Apocalyptic Vision (The Vision of Saint John)* (1604–14) was exhibited in Madrid in 1902 under the title *Sacred and Profane Love*, "by which it was certainly known to Picasso" and the Zuloaga circle. The representation of split experiences of love in the El Greco fits well with Rubin's claim that the *Demoiselles* is organized around an opposition between libidinal sexuality and the darker instincts of fear and death. Richardson reveals that another title for the El Greco, *The Opening of the Fifth Seal*, was suggested in an article published in 1908 and might have been known to Picasso earlier through contacts with the same and overlapping Barcelona circles. Picasso's knowledge of this title would thus support Richardson's interpretation of the *Demoiselles* as an "Apocalyptic Whorehouse." Rubin demurs from this notion, however, suggesting instead that the El Greco was more important to Picasso by virtue of its "blunted vertical" format and compressed space than for "the particulars of its subject." Rubin contends that the "passionate and painterly approach" of El Greco better communicated Picasso's desire for spatial and expressive ambiguities than did Cézanne's later style with its "meditative mosaic of architectonic accents."[38]

The governing opposition in Rubin's critical scholarship is between the centrifugal and centripetal interests of the *Demoiselles* – between forms, styles, preparatory evolution, and pictorial logic, on the one hand and a range of non- or para-pictorial concerns on the other, which converge on the psychology, biography, sexuality, and personality of the artist, and which find some of their leading referents in titles, not forms. The influence of Cézanne on the *Demoiselles* is an important juncture in the opposition between style and naming (and what may lie behind them). In the discussion of El Greco and elsewhere, Rubin makes clear that the formal impact of Cézanne's later work on the painting has been overstated or too easily assumed. He widens the polarity between formal intensity and the contextual field, claiming that if "we parse the *Demoiselles* purely in the light of its many studies . . . the pivotal role traditionally attributed to Picasso's diverse 'sources' seems diminished."[39]

In stressing the autogenesis of the work, reducing the impact of Cézanne's formal innovations, Rubin opens the aperture of anxious, emotive, non-formal exchange. Thus, Cézanne's "overall conception of the picture as a simulacrum of a bas-relief: an indivisible, interlocking, and integral low-relief structure, characterized by *passage* between the planes" is much "less coherent and integral" than it would become in 1908, the real beginning of Cubism. On the other hand, Rubin finds that it is "more in the mood than in the formal aspects of Cézanne's bathers and nudes" that Picasso's affinity with his predecessor might be found. Rubin locates this influence in Cézanne's early work (he cites *The Temptation of Saint Anthony* and *Luncheon on the Grass*), with its "sexual" "distress," "rumbling anxiety," and "gloomy *Stimmung*." In this view the titular decisions and dilemmas that faced Cézanne in the earlier part of his career meet analogous conflicts at a crucial moment in Picasso's development. Rubin adds an important emphasis to the discussion of Cézanne's nominal anxiety developed above by noting Picasso's insistence that Cézanne's anxiety "forces our interest" and that Salmon's identification of a similar anxiety informed the making of the *Demoiselles*. It is my claim that titles are important precipitates of these repeated anxieties, forcing us to attend to the complex network of relations between Picasso's sexuality, contexts, and forms.

There is another important instance of Rubin's discussion of the power of titles and captions in relation to the more disturbing aspects of the painting. Playing down the possibility of Picasso's having been directly influenced by African masks and fetishes, though still insisting on the "epiphany" that resulted from his visit to the Musée d'Ethnographie du Trocadéro, Rubin substitutes the power of the captions that accompanied display items there for the impact of any particular – speculative and unlocatable – "work." He claims that the "aesthetic side of the tribal objects mattered less to the deeply superstitious Picasso than did their ritual and psychological function,"[40] and conjectures that Picasso "no doubt":

> read some of the lapidary phrases regarding practical function on the labels of the objects. Among those we know to have been visible in 1907 were "Cures the insane," "Cures ailments caused by the deceased," and "Protects against the sorcerer." For anxieties perhaps closer to home, there was a gourd neck in phallic shape provided with mirrors on each end; it was succinctly labelled, "Cures gonorrhea."[41]

The possibility that these "magical" works – talismanic masks and fetishes – entered Picasso's pictorial imagination through their museological description is met by Rubin's conclusion that the image into which they

somehow finally issued was itself a kind of psychological abreaction, an instance of "solving problems by 'speaking them out.' "

Whether or not one accedes to Rubin's interpretation, it is clear that the painting's original title constitutes the clearest grounds (in Rubin's terms) of its "speaking out" and also offers the first instance (in Breton's terms) of its "going beyond" painting. In the (original) desire to name, and through naming both to control and to suggest, we glimpse a momentary access to the conflicts of the founding moment that produced the image. In Cézanne this was staged in the suggested violence of categories visited upon the threatening body of women through a string of abstract, non-corporeal idealizations. For Picasso the semi-absurdist conjunction of the disciplinary name of high mental activity ("philosophy") with the locus of bodily expenditure exchanged as a commodity (the "brothel") sets in motion the fundamental opposition between embodiment and abstraction, which in various disguises informed his practice throughout his career. The origin of Cubism is thus marked by an explicit titular reorientation that stands for the de-allegorization and counter-symbolism of the avant-garde, and the beginnings of its makeover into formal enquiry. The new, "anodyne," title of *The Philosophical Brothel* is a public, market-driven nomination that pre-neutralizes the critical and iconographic controversies that future display of the image might engender.

Half a decade after the *Demoiselles* was painted, a second fundamental reorganization of the visual-textual signifying economy is set in process following the first full-scale inscription of text in the image in 1911 and the invention of collage during the next year. With the Cubist revolution, first stenciled text, and then collaged text fragments from newspapers and other printed sources, were admitted into the bounds of the image. From this moment the work of the title was necessarily subject to radical new forms of imagination and specificity. The displacement of text from an extra-pictorial relation to the image to a form of conflictual consubstantiality with (and against) it is one of the key developments in the history of the title. Indeed, the new signifying economy of the name cannot be thought without attending to the rejection of the traditional subtextual adjacency of the title. The Cubist model would serve as the site for a reinscription of the entire visual-textual economy.

Tracing the evolutionary development of collage, Clement Greenberg outlines a specific role for the text and numerals that made their appearance inside the pictorial frame in 1911. It is a role whose development and function he will repeat in similar terms throughout his several discussions of the Cubists and their contemporaries:

In the same year [1911] Braque introduced capital letters and numbers stencilled in *trompe-l'oeil* in paintings whose motifs offered no realistic excuse for their presence. These intrusions, by their self-evident, extraneous and abrupt flatness, stopped the eye at the literal, physical surface of the canvas in the same way that the artist's signature did; here it was no longer a question of interposing a more vivid illusion of depth between surface and Cubist space, but one of specifying the very real flatness of the picture plane so that everything else shown on it would be pushed into illusioned space by force of contrast.[42]

In this account the supplemental textuality of stencilled lettering is annexed to serve the purposes of formalist overdetermination. Although he doesn't test its implications, Greenberg notes that some of Braque's painted text establishes itself within the picture frame in a mode of appearance that has little or no precedent in the Western pictorial tradition. That is, it is not predicated on what he terms the "realistic excuse" of the motif. Such text is unlike the representation of text from posters, hoardings, street signs, tombstones, and even books and newspapers, following the realist logic of the observed scene. Even in a work such as Gustave Caillebotte's *Intérieur, femme à la fenêtre* (*Interior, Woman at the Window*, 1880), where fragmentary letters "NT—RBU" (the right stem of the "U" is cut off halfway up by lace curtains) are visible on a sign across the street through a domestic window, the text has an inferred place in the observed ensemble of the street.[43]

Greenberg rightly notes the vigorous counter-coding of the Cubist image that sees it not as a dimensional wedge of vision but as a flat surface that holds writing. He fails, however, to admit that written signs will also signify in ways that traduce their material flatness.

[T]rompe-l'oeil lettering, simply because it was inconceivable on anything but a flat plane, continued to suggest and return to it. And its tendency to do so was further encouraged by the placing of the letters in terms of the illusion, and by the fact that the artist had inserted the wallpaper strips themselves partly inside the illusion of depth by drawing upon and shading them.[44]

Greenberg's insistence notwithstanding, it would be wrong to conclude that with the high Cubism of 1911 and 1912 the problematic of the title and the space of name are reduced to inscriptive flatness. Instead a counterpoint is developed between the text of the title and other, often multiple, forms of inscription. Historically it was only the signature that was allowed to puncture the illusionistic space of the image. Yet the self-written identification represented by the signed name was also a form of

transparency; it afforded a modest, bracketed appearance of text to be looked on and through according to an economy of vision quite different from that invested in the image "behind" it.

Several contemporary receptions of Cubism actively refused the formal consumption of the image (and the text) later ritualized by Greenberg. A string of reviews of the Armory Show in New York in 1913, including notices in the *Times*, the Chicago *Tribune*, and the Philadelphia *Inquirer* of 23 February, all criticized the "literary" character of the Cubist titles. One critic put it in these terms:

> In short, so far as Post-Impressionism and Cubism are not mere sham they seem to me an insidious rebirth of the literary picture. Only the models have changed. The mid-Victorian literary picture was nourished on harmless anecdote. The Post-Impressionist or Cubist picture is spawned from the morbid intimations of symbolist poetry and distorted Bergsonian philosophy. In fact the unwholesomeness of the new pictures is their most striking and immediate condemnation. . . . The critic notes a forced and hectic mixing of pictorial and literary values.[45]

The early American reception of avant-garde European art puts forward a reading of the "symbolic," "morbid," "unwholesome," and "hectically mixed" nature of Cubism, rather differently stated and predicated than the Anglo-American formalism that would soon dominate its interpretation. There are several reasons for refraining from too subtle an explanation of the implications of these opinions. First, few of the critics of the Armory Show were willing or able to develop their observations in any sustained encounter with the works or their contexts. Second, the majority of notices were hostile and disparaging. And third, it would seem, especially from the final phrase of Frank Jewett Mather's account, cited above, that one of the contradictory motivations for his remarks was that the Cubist paintings on view were not restrained, ordered, and formal *enough* for his taste. Yet there is something important remaindered in these contemporary reviews. This is the sense that Cubist works were avant-garde not merely by virtue of their radical invention in forms and materials, but also by virtue of their disturbing emotive, theoretical, social, or sexual references. For Picasso, in particular, the collaged text took on the function of a para-symbolism that reintroduced precisely the elements of sexual innuendo, scatology, and semi-opaque self-reference that Cézanne had expressed outside the bounds of the image. Text in this sense was knowingly, and wittily, deployed as compensation for the over-compensation of the image as sublimation.

III Suprematism, Unovis, and "5 × 5 = 25"

> [T]he word is a unit of building, material is a unit of
> organised volume.[46]
>
> – Vladimir Tatlin, "O Zangezi" (1923)

I can offer only a few preliminary pointers to the enormous contribution
made by the naming and inscribing of artworks to wider social and
cultural developments in Russia and the Soviet Union in the years
immediately before and after the 1917 Revolution. As they relate to
several types of titling and inscription crucial to this study, I will summa-
rize three practices. These are, first, the intense experiment with written,
stencilled, and painted letters, book art, and linguistic theory, prominent
in the Soviet development of collage and associated techniques; second,
the titular battle waged between the rival discourses of *composition* and
construction between 1918 and 1922; and, third, the innovative nomencla-
ture invented for avant-garde exhibitions. These nominal innovations
were clearly related to the profound material and conceptual interroga-
tion of the elements of visual practice that took place in Moscow and St.
Petersburg/Petrograd/Leningrad in the later 1910s and early 1920s.
Indeed Soviet visual experimentation provides probably the most
provocative historical example of the conjunction and overlay of formal
and textual material – first in the artwork itself, and then in its radical
re-envisioning.

While the destinies of Cubist textual inscription are numerous,
nowhere were the grounds of the new signifying economy it brokered
opened up to more far-reaching investigation than in the Russian and
Soviet avant-gardes. The new irruption of text in the picture or image-
frame produced a massive increase in the signification of words. Such
visible text not only identified and described, but offered formal texture,
marginal commentary, and complex allusion. The text of the image
might be informational, suggesting referents in the social, political, or
commodity worlds. It might offer propagandistic exhortation, moral
incitement, or (as with many of Picasso's collages), scatological allusion.
As with the space and motifs of Cubist and post-Cubist compositions,
text was also subject to various forms of cropping and dispersal, whether
in the *zdvig* displacements of Kasimir Malevich's *An Englishman in Mos-
cow*, and Larionov's paintings around 1911, or in the free-word, typo-
graphical experiments of Marinetti and others. As one historian observed,
"Larionov's painting of this period [around 1911] is related to many of
the literary devices of Russian Futurist poetry: letters out of context,

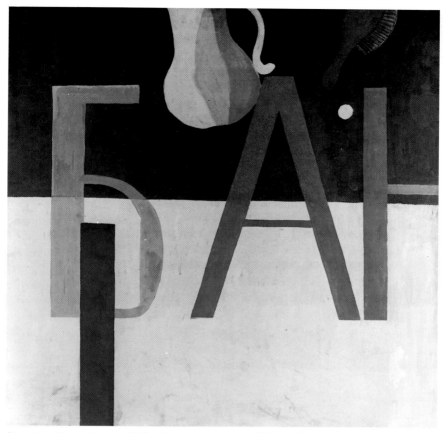

36 Ivan Puni, *Letters*, 1919. Gouche on paper, 88.9 × 88.9. Musée Nationale d'Art Moderne, Paris

jumbled words, deliberate misprints, erratic spacing, crude and inexpensive printing processes."[47]

Such expansive innovation could not fail to embrace the title. Among the many functions of inscribed text and pictorial names, Ivan Puni's *Baths* (1915), consisting of the single Russian word for "Baths" painted on canvas, offers a point of origin for the word-only picture, whose development represents one of the final stages in the pictorialization of the title. The first two-and-a-half letters reappear in a gouache on paper of 1919 called *Letters* (fig. 36), along with a jug, hairbrush, and a dot. All are laid out on a ground divided horizontally into two light and dark sectors and marked with one thick vertical line that runs parallel to the

Russian "B" of "Bath," confusing a pictorial notation with the shaft of a letter.

Some of the most extreme reformulations of the visual-textual economy in the Soviet Union are associated with the transrationality of Kruchenykh, who divorced sound from meaning, rerouting the field of the signified away from the logic of the signifier. Kruchenykh collaborated with Ol'ga Rozanova in 1916, producing *A Duck's Nest of Bad Words* (1913), and *Transrational "Book"* (1916) – whose title incorporated a deliberate misspelling of "kniga" (book) as "gniga." Rozanova's handwritten text formed illustrations that attempted to fuse visuality and textuality in still more intimate ways. Other variants of this solicited confusion include Kruchenykh's *Universal War* (1916), in which he "wrote twelve titles with poems consisting of columns of words."[48] Vavara Stepanova's *Gaust Tschaba* (1919) was a transrational handmade book with handwritten, asignifying phrases written on a newspaper support. In 1922 Liubov' Popova wrote a piece for the first number of the Moscow journal *Zrelishcha* called "On Exact Criteria, Ballet Numbers, Deck Equipment on Battleships, Picasso's Latest Portraits, and the Observation Tower at the School of Military Camouflage in Kuntsevo." The opening sentence of her text offers to rearticulate the rhetorical structure of the title: "It's clear, surely, from the title itself what I'll be talking about?" Her list, embracing scientific description, dance, Cubist portraits, and two references to warfare offers a parodic questioning of the investments made by the Soviet avant-garde in their nominal decisions. It stands as an emblem for the radical potential, the infolding and pluralization, of the title as it was variously deployed in the early 1920s.[49]

Rodchenko and Maiakovsky disrupted the economy of the visual sign rather differently, producing advertising images that operated at the intersection between art, propaganda, and capitalism. In their series of about fifty posters and one hundred signboards Rodchenko used "diagonal superimposition of text on image" in an enterprise whose "agitational importance" a contemporary critic described as consisting "not only in the two-line captions, but also in the replacement of those old [candy] names and designs by ones which show distinctly the Revolutionary, industrial orientation of the Soviet Republic."[50] Finally, all these developments in visual-textual conjunction were staged amidst a blizzard of competitive logos, signs, and affiliations: titles, acronyms, names, tags, clubs, abbreviations, and labels.

These are only some of the signposts in a crowded field of textual and titular redirections in Soviet visual practice during the 1910s and 1920s. They allow us to understand that the Soviet deployment of collage and related word-image combinations produced a field of names, inscriptions,

signatures, filiations, sounds, and visual-textual events considerably more varied and provocative than many of the developments of collage in the West, especially those produced or interpreted under the aegis of formalism.

Many artists working in the period immediately before, during, and after the 1917 Revolution signal an awareness of the intense pictorial, textual, and social experiments in the inventing and copying of titles. Around 1915 the new abstract vocabularies developed in theoretical discussion and studio experiment begin to displace the familiar references to art-world or domestic life and make a sustained appearance in a new titling regime. In 1915 Nadezhda Udal'tsova painted a Cubist-influenced work titled *Kitchen*, built up in overlapping planes with references to samovars, guitar parts, and domestic implements. The following year she adopted the style and the titular regime of the more radical avant-garde, producing works such as *Painterly Construction* (1916). In 1915 Rozanova painted works titled *Room* and *Cupboard with Dishes*, but later in the same year made a number of works called *Non-Objective Composition*, a few bearing subtitles such as *Flight of an Airplane*. In a similar vein Aleksandra Ekster called works *Dynamic Composition* (1916), *Non-Objective* (1916), *Movement of Planes* (1916–17), and *Constructive Still Life* (1917). By 1922 Ekster's preferred designation becomes *Construction* – whether *Color Construction*, *Construction of Lines*, or other versions.

As we will see with the development of Mondrian's compositional abstraction, the pressures of the new abstraction often intrude in the form of subtitles before they finally displace the literal, or iconographic, title. Thus, Popova's *Jug on a Table* (1915) bears the parenthetical *Plastic Painting*. Beginning in the following year, however, she used titles with variants on *Painterly Architectonic* for a series of works that explored the formal, material, and painterly elements of pictoriality. By 1920–21, reacting, at first somewhat ambiguously, to the debate between composition and construction, she titles works in oil on board or plywood *Constructivist Composition*, *Abstract Composition*, and *Space-Force Construction*. Vladimir Tatlin named his mixed-media, wall-based sculptures begun in 1914 for their position in the gallery or viewing environment: they were termed *Corner Relief* or *Counter-Relief*. In the early 1920s a number of artists working with metal, wood, and other materials, including Rodchenko, Vladimir Stenberg, and Konstantin Medunetskii took up the terms *Spatial Construction*. The Stenberg brothers, Georgii and Vladimir, made a sequence of constructions between 1919 and 1921, including *Construction of a Spatial Structure, No. 11* (1921), titled with their Russian-language acronym, "KPS," and a number.

Rodchenko's experiments between 1918 and 1920 with color,

non-color, texture, and linearity are supplied with titles that underline the enquiry at hand. For the most part such names are descriptive, as in *Points: Composition No. 119* (1920), *Black on Black* (1918), or *Non-Objective Painting (Lines)* (1919). But occasionally they are more elaborate, as with *Dissipation of Plane* (1921), and *Composition No. 64/84 (Abstraction of Color; Elimination of the Density of Color)* (1918), this last directing the viewer emphatically to the theoretical debate within which the work was conceived.

In addition, a succession of artists associated with the Suprematism of Malevich, the laboratory experiments of Popova and Ekster, or the new Constructivism developed after 1920–21, signaled their allegiance to specific, increasingly nuanced, visual discourses through their titles. In 1921 Valentin Iustitskii made a number of diagrammatic paintings and works in oil and wood on board that bore the title *Painterly Easel Construction*. Another work from the early 1920s is called *Painterly Construction with Wire*. Their forms, materials, and titles all testify to an uneasy, split affiliation between the proponents of radical painterly values and post-painterly construction. During the same period Vasilii Ermilov made several numbered pieces using such materials as wood, brass, sandpaper, knives, etc., arranged in "pictorial" configurations, which he titled not as constructions but as *Compositions*. Conversely, sketches by Vera Ermolaeva for the festive decoration of the city of Vitebsk are termed *Suprematist Construction*, as are suspended metal pieces by Katarzyna Kobro, such as *Suprematist Construction (Suspended)* (1921).

Malevich and his followers used a full repertoire of denominations to title their works. The key-words "Suprematist" or "Suprematism," often feature in these names, but with many variants and inflections. At the very beginnings of Suprematism in 1915, Malevich himself apparently used titular emphases that described, theorized, and even identified the image. His *Red Square* (1915) is supplied with two parenthetical subtitles, *Painterly Realism; Peasant Woman in Two Dimensions*. Many subsequent works are simply known as *Suprematist Painting* (1915), *Suprematism: Non-Objective Composition*, or *Suprematist Composition* (1917), with or without qualifiers (which may or may not be attributable to the artist) indicating their formal disposition: *Suprematism: Yellow and Black* (1916); *Suprematist Painting: Eight Red Rectangles* (1915). Other works are more specifically named or numbered. These include *Dynamic Suprematism (Supremus No. 57)* (1916), whose title seems to allude to the work's position within a detailed scheme of theoretical preparations.

In 1915 Ivan Puni made a number of works that bear the title *Suprematist Relief* or *Suprematist Relief Sculpture*. Later Ilya Chashnik made a work in 1926 called *Circles in a Suprematist Cross* and another dating

from the previous year titled *The Seventh Dimension: Suprematist Stripe Relief.* But he also offered a less terrestrial nomenclature in another work from 1925, *Cosmos – Red Circle on Black Surface,* and a drawing in India ink on paper, *Supremolet (Suprematist Planit)* (1927–28), which collides Suprematism with cosmological extension in the neologistic title-term "Supremolet."

I want, now, to turn to a struggle between designations that partly informs, partly anticipates, and finally denounces the longer discussion, outlined in chapter 6, of the Western discourse of composition. The separation of the compositional from the constructive undertaken by Rodchenko and others in the late 1910s and early 1920s is the governing nominal reorientation of avant-garde Soviet art (see figs. 37 and 38).[51] In her essay "The Transition to Constructivism," Christina Lodder links the emergence of a complexly negotiated discourse of construction with the expressive titular choices of Rodchenko in the crucial years between 1918 and 1921.[52] Rodchenko's decision in the late 1910s to join the title *Konstruktsiia,* accompanied by a number, to "paintings in which a machine-like precision in the articulation of the surface and the linear construction emphasizes the impersonal and analytic quality of the painting process," signals his clear allegiance to a new set of counter-compositional predicates. According to Lodder, Rodchenko exhibited sixteen works with the title *Konstruktsiia* (mostly dated to 1919) at the Nineteenth State Exhibition in Moscow in the autumn of 1920, as well as a number of others that bore the title *Kompozitsiia* (Composition). The pieces titled "Composition" may be distinguished as "more planar and spatial, and more modulated in texture and tone."

The opposition between these two terms is a reprise at the level of the name and the label of the artistic debates associated with the General Working Group of Objective Analysis at Inkhuk, which were conceived around the opposition between the decorative, subjectivist, self-consciously aesthetic mode of image production and analysis favored by the founder and first director of the General Working Group of Objective Analysis at Inkhuk, Wassily Kandinsky, and the more objective, economical, precise analyses of a Working Group whose members referred to themselves as Constructivists. In a gesture that recalls Rodchenko's contributions ·to the Nineteenth State Exhibition, participants in this debate "also produced pairs of drawings illustrating their personal understanding of what composition and construction entailed."[53]

Rodchenko's titular regime of *Constructions* is thus a direct retort to the investment by Kandinsky and others in the effects and intensities of *Compositions.* As Kandinsky had aligned himself so thoroughly with the spiritual, subjective, and aesthetic significations of composition, we might

37 Vladimir Stenberg, *Composition*, 1920.
Colored pencil on paper, 21 × 13.9.
George Costakis Collection, Cologne

38 Vladimir Stenberg, *Construction*, 1920. Ink on
paper, 25.4 × 19.3. George Costakis Collection,
Cologne

expect him specifically to have resisted the mechanistic connotations of
the term that was in the process of becoming its antithesis. In his
"Program for the Institute of Artistic Culture," written in 1920, this is
precisely his contention. He writes of what he viewed as the erroneous
insufficiency of "the engineer's answer" to the "problems of construc-
tion."[54] The "errors" of construction were soon pressed even further by
the most radical of the Constructivists. The title "Construction" was
converted into a form of diagrammatic designation, complete with letters
and numbers which did not so much name or otherwise order the image-
title, but instead served to label its properties and functions as in a
blueprint or mechanical drawing. Ioganson's *Construction* (7 April 1921),
for example, bears the subtitle, "A graphic representation of a cold
structure in space," and is supplied with the elucidatory symbols "a′, a″,
a‴, and a⁗." The Constructivist title would be dissolved into the pure
denotation of the Productivist diagram, just as surely as its formal antith-
esis, the simple, identificatory name of the Socialist Realist painting,

would issue in the ideological clarity of sanctioned designation. "Pure" function, "pure" politics, and all the antitheses of "art" converge on the renovated site of the denotative title.

Finally, I want to suggest that visual experimentation in Russia and then the Soviet Union between around 1911 and the early 1920s also went hand in hand with the invention of new audiences and formats for display. This proliferation of exhibitional avant-gardism is clearly associated with a new horizon of titles that named the collective presentation of images, objects, schools, and art-life collectives. The exhibition titles generated by the pre-Revolutionary avant-garde operate in semantic spaces that parallel the dislocations materialized in the works themselves. Examples include the first "Jack of Diamonds" exhibition of December 1910; Larionov's "Donkey's Tail" of 1912; the "First Futurist Exhibition of Pictures: Tramway V" of 1915 in Petrograd; and "The Last Futurist Exhibition of Pictures: 0,10," also in Petrograd in the winter 1915–16, where Malevich's *Black Square* made its first appearance in a high corner of one room, in "the place reserved for the icon."

It is clear that Malevich, in particular, went to great lengths to surround the creation and naming of the new movement, Suprematism, with dramatic effect. In autumn 1915, the term "Suprematism," along with notes on its theorization, was deliberately released in the form of a brochure titled "From Cubism to Suprematism" before the paintings themselves made their first public appearance. Fearing that colleagues or rivals might get wind of his innovations, Malevich wrote: "Now, no matter what, I must publish the brochure on my work and christen it and in so doing protect my rights as author."[55] Malevich also made it clear that the name of his movement was meant to be taken at face value. "I think," he wrote, "that Suprematism is the most appropriate [name], since it signifies supremacy [or dominion – *gospodstvo*]."[56] He underlined this "blasphemous" "dominion" by taking literally the religious metaphors of naming (christening, baptism) that inaugurated his movement. While Whistler, the Cubist circle, and others had merely appropriated and secularized the religious terminology of naming, for Malevich the name of his first "icon," and the niche it occupied, take on the authority of a new counter-religion. At the same time the designation Suprematism was issued as the identifying, signatory, correlative of its author. Writing of the fierce competition among avant-garde artists in Petrograd at the time of the "0,10" exhibition, Mikhail Matiushin, a friend and correspondent of Malevich, succinctly noted that "Whoever says the last word is king!"[57]

The Malevich axis of the Soviet avant-garde did indeed produce a royal last word, one intended to have even more social and cultural

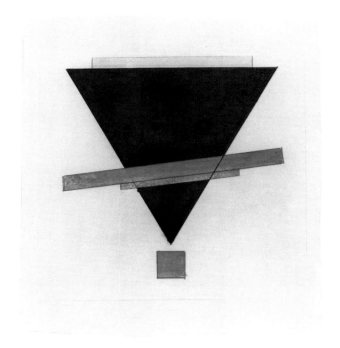

39 Ilya Grigorevich
Chashnik, *Red Square
(UNOVIS)*, 1921. Watercolor
and india ink on paper, 21.4
× 19.5. Leonard Hutton
Galleries, New York

impact than Suprematism. Moving to Vitebsk in 1919, where he wrote
and organized at a furious pace, Malevich was the founding figure of
"Unovis" (another acronym, which translates as "Affirmers of the New
Art," see fig. 39). Alexandra Shatskikh summarizes the diverse definitional
parameters signaled by the name of Malevich's enterprise as follows: "[A]
phenomenon without parallel in the history of early Soviet art [and
which] defies classification," "it has been variously labeled a group, a
collective, a school, a commune, an organization, and a program." To
which she adds that it also "betrayed many features of a sui–generis
religious fraternity or variety of Masonic lodge," and that it was referred
to by the Unovisniks themselves as "a party in art."[58] It was under the
auspices of the emerging Unovis that El Lissitzky adopted the "El" (and
"El!") for his name, and that his own movement derived its title "Proun"
("project of Unovis" or "project of the affirmation of the new"). Unovis
represented perhaps the furthest reach of the organizing power of titular
definition as it operated in the spaces between revolutionary life and
transrational mysticism:

 The name [Unovis], an acronym in keeping with the verbal shorthand
 and coining of the times, was greatly to Malevich's liking – he named

his daughter Una in Unovis' honor. And the new word spawned others: *unovisets* (Unovist), *unovisskii* (Unovistic), and *unovizm* (Unovism). The ease with which "Unovis" entered the Russian language was an acknowledgement of the reality and vitality of a phenomenon for which no other word existed.[59]

Unovis is revealed as a title that invades all aspects of social life: the family, the self, and the collective artist, as well as the party and a form of religiosity, or spirituality. In addition, it summarizes and betokens a liberatory affirmation of the new, and gives rise to numerous forms of designatory allegiance. In the revolutionary fervor of the early 1920s the production of profoundly compacted new titles, such as Unovis, speaks to the production of a whole new order. The making and circulation of these names was just as important as the production of new forms, new materials, new ontologies, and new environments. Such titles were as significant for the avant-garde as were slogans for the political diffusion of the revolutionary message, with whose significations they often merged. But when the agitational slogan finally displaced the radical title, when life, art, politics, and names were finally superimposed one on top of the other, the Soviet avant-garde was both eclipsed and – it has been claimed – paradoxically completed.[60]

In the later phases of exhibition nomenclature, even the kind of numerical designations later associated with non-iconic abstraction are literally multiplied and carried over into the naming of the exhibition. The "5 × 5 = 25" exhibition in Moscow (September 1921) is important in several respects here (see fig. 40). The perfunctory mathematics of the title refers to the five works from each of five contributing artists (Vesnin, Popova, Rodchenko, Stepanova, and Ekster) displayed at the All-Russian Federation Writers Club. The sum of twenty-five also – perhaps not coincidentally – tallies with the twenty-five Inkhuk artists who were co-signatories of what was probably the founding declaration of Constructivism, in the winter of 1921–22. These artists were committed to "the scientific and theoretical working out of all the questions connected with the idea of production art."[61]

The exhibition was accompanied by twenty-five unusual hand-made catalogues, containing an original cover, and a work and typescript page by each artist. In this arrangement, it is the catalogue that becomes an "original work" – whose "title" is borne by the exhibition itself. While Stepanova's abstractly named "figures," represent a partial exception, most of the listed works carried generic names such as Vesnin's *Construction of Colored Space Along Lines of Force* and Rodchenko's *Line* (1920), *Square, Pure Red, Pure Yellow, and Pure Blue* (all 1921). Popova's *Painterly-*

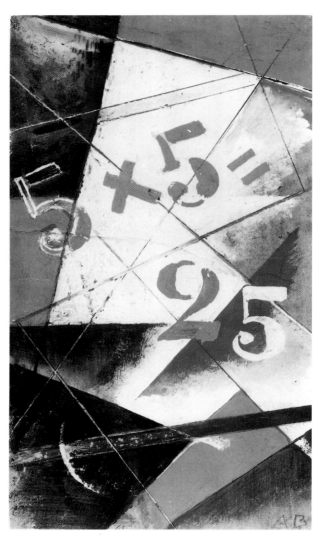

40 Alexandr Vesnin,
5 × 5 = 25, 1921. Pencil, oil
and whiting on cardboard, 22
× 12.6. State Shchusev
Museum, Moscow. By
courtesy John Milner

Force Construction[s] and Ekster's *Plane and Color Construction*[s] were each
supplied with a qualifying subtitle. Accompanied by what has been
described as "an artists' bookwork, and also an anti-artists' bookwork,"[62]
the show presaged the end of easel painting and the beginning of a new
era of construction. Modernist compositionality was to be eclipsed by
material construction with a social agenda. And at the same time titles
were to be eclipsed by the ultimate denotation: that of self-evident

function. Neither of the two cultural projects that were the final legacy of the Soviet twenties – the utilitarian object and the Socialist Realist image – needed to be named. No one needed to call a spade a spade, and no one needed an interpretational subtext to identify the face of the Leader. All titular innovation, all reference to form or theory, all poetic ellipsis or Suprematist opacity, was demolished by the double triumph of Use and Power.

Returning, by way of a conclusion, to the Western avant-garde, we have seen that the works of the Fauvists and Cubists are accompanied by an interrupted, and in the case of Cubism, a displaced, discourse of what we can now only hesitantly call the descriptive or denotative title. In the years that followed the Cubist experiment, the development of geometric abstraction, on the one hand, and of Dada and Surrealism, on the other, witness, respectively, the full prosecution of restrained titles (or untitling), and *excessive* titles which set up complex denominating relations to the image. The following chapter will address the first of these post-Cubist titling procedures – the retreat of the title into a compositional or numerical formula in the non-iconic abstraction of Mondrian and Kandinsky. Chapter 7 takes on the larger problem of Dada and Surrealist nomination, attempting to locate it within the wider implications of the whole nexus of relations negotiated by Dada and Surrealist "word-images."

Chapter 6

Composition 1: Naming the Non-Iconic in the Work of Piet Mondrian and Wassily Kandinsky

> Our picture has . . . progressed gradually through dimensions so numerous and of such importance, that it would be unjust to refer to it any longer as a "Construction". From now on we will give it the resounding title of "Composition".
>
> − Paul Klee, *On Modern Art* (1924)[1]

In chapter 7 of the *Poetics* Aristotle notes that "a picture, or any other composite object, if it is to be beautiful, must . . . have its parts properly arranged."[2] Aristotle's is perhaps the founding articulation of the theory of aesthetic composition that dominated Western cultural practice until the twentieth century. The correlation between beauty and the coordinated arrangement of parts was vigorously reinforced in the eighteenth-century Neo-Classicism associated with the development of modernity. Here it was identified with the dominant theory of the aesthetic unity of the individual work proposed by German art historians from Johann Joachim Winckelmann to Erwin Panofsky − a lineage that culminated in the Gestalt perception of the image as an organized visual whole. I want to propose here that certain powerful tendencies within visual modernism actively struggled with the inheritance and reinflection of this compositional tradition and that they signaled the intensity of their intervention in a complex discourse of compositionality that was refracted through the titular designation "composition" itself. I will argue in chapter 8 that the implications of this debate were still highly significant for the late modernist and postmodern practices of the post-1945 period.

The most crucial development for the practice of titling during the early years of the twentieth century was the production of non-iconic abstract images − paintings that did not refer to the "real" world through systems of recognition and identification. Once more, it is my claim that

the making and reception of titles intervened decisively in this new formation. We are offered a glimpse of the conjunction between abstraction and names in one of the first contemporary meditations on this newly referential painting, Guillaume Apollinaire's *Les Peintres cubistes* (*The Cubist Painters*, 1913): "Many new painters limit themselves to pictures which have no real subjects. And the titles which we find in the catalogues are like proper names, which designate men without characterizing them."[3] The situation in which the title offers a *designation*, a kind of signature of effect, and not a descriptive characterization, takes place in a peculiarly modernist scenario, and serves to reinforce the semantic wedge driven between the image and its name. The title becomes another form of mark, supplementing the marks within the frame. It is suspended between the signifying conditions of written language and pictorial signs. The theory and practice of Mondrian and Kandinsky, two of the most significant pioneer abstract artists, reveal that the titling history of the non-iconic abstract sign from the 1910s on is complexly bound up in the drive for supplemental connotation suggested by Apollinaire.

1 Piet Mondrian: "It Is Above All Composition That Must Suppress the Individual"

The Dutch artist Piet Mondrian is held to exemplify the most rigorous development of hard-edged, straight-lined visual abstraction in a mature career of some thirty-five years whose sequence of works constitutes the most scrupulous "evolutionary" progression, accommodated within the tightest margins of trial and error. 1921 has traditionally been seen as the great threshold in this career, the year in which Mondrian's elementary triad of colors was first organized with confidence and deliberateness, and his lattice-work of lines became thicker and more certain. The basic relational units of his "composition," finally established as the straight line, the right angle, and the three primary colors, red, yellow, and blue, and the non-colors, white, black, and grey, are signaled as formally dominant in the reiteration of the title "Composition" for the majority of his productions during the 1920s and 1930s.[4]

Within the stringent coherence and sequentiality of Mondrian's pictorial development it was at the precise point between 1912 and 1915 – when his motif finally dissolved, or rather straightened and formalized, under the pressure of a crusading and abstract idealism – that his paintings began to take on the designated abstractness of the "Composition." The development and the implications of this apparently neutral titling proce-

dure bear scrutiny, however. For it can be demonstrated that the term "composition" itself functions for Mondrian, and others, not simply as a non-referential title or handy tag, but as a sort of philosophical envelope for the social high seriousness of his whole pictorial enterprise. The brevity and reduction of the title are somewhat illusory. For the term "composition" is set up with a philosophical weight that devolves upon the shifting context of Mondrian's theoretical pronouncements, and, as the artist would have it, transcends even these in its allusion to the fundamental condition of the new modernist spirit.

From about 1908, with works such as *Avond* (*Evening* or *Red Tree*, 1908), Mondrian painted a series of views of trees that became progressively schematized. Up until 1912 the works in this "series" were explicitly titled after the motif in question – as in *Boom* (*Tree*) or *Appelboom* (*Appletree*), also known in English as *Gray Tree* (1912); *Bloeiende Appelboom* (*Flowering Appletree*, 1912); or *"The Trees"* (1912). But towards the end of 1912, and more emphatically in early 1913, Mondrian begins to signal both the heightened non-naturalism of these works and his developing ideas on the nature of visual representation, by interrupting the descriptive title in several ways. Most emphatic is the renomination of his paintings as "compositions," with the motif subordinated as a sub-title, as in *Composition: Trees 1* (1912, fig. 41), or in parentheses, as in *Tableau No. 4; Composition No. VIII; Compositie 3* (1913) to which "op boomen" ("with trees") was added when the work was exhibited in Amsterdam in 1922. Occasionally the term "composition" and the nature of the motif would be combined and parenthetically relegated together. Discussing one of the works in the trees series, *Tableau No. 2; Composition VII* (1913), Angelica Zander Rudenstine outlines the circumstances behind this renomination:

> Mondrian's use of numerical designations as titles for his paintings was usually directly related to exhibitions of his work. He numbered his entries to a given exhibition consecutively, irrespective of any titles they may have carried previously. Thus, the present work [*Composition VII*] was entitled *Tableau N: 2* when it appeared in the Nov. 1913 *Kunstkring*. Half a year later when he sent 16 paintings from Paris to The Hague for the Walrecht exhibition he numbered them I–XVI (inscribed in roman numerals on the stretchers), and it was at this time that he deleted the *Tableau N: 2* on the reverse of the present work, substituting the *Composition VII* on the stretcher.[5]

Following J. M. Joosten, Rudenstine notes that *Composition VII*, in turn, had its title changed to *Composition E* "to fit in with the sequence of entries for [a subsequent] exhibition [in Rotterdam]."[6] Mondrian's proce-

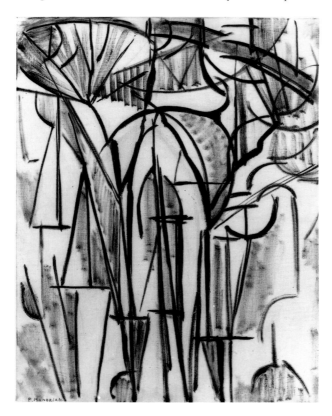

41 Piet Mondrian, *Composition: Trees I*, 1912. 81 × 62. Haags Gemeentemuseum, The Hague

dure here gives rise to several preliminary conclusions. First, the term composition has become a privileged designation standing in for the progressive eclipse of the naturalistic visual sign. While Mondrian (in this respect, like Miró) continued on occasion to use the word "tableau" as a titular epithet (the Guggenheim's *Composition 2* of 1922 is inscribed *tableau 2* on the reverse),[7] it is already clear by 1913 that a special force of signification is invested in the compositional painting. Second, the *composition* is directly associated with the display and social circulation of the work – indeed, during this transitional phase of Mondrian's career, the term functions (whether exclusively or not can be debated) as a form of serial itemization. As we saw with Monet's "Impressions" and Whistler's "Nocturnes," and as we will also find with Kandinsky's more elaborate compositional nomenclature, an important innovation in titling routines is explicitly related to the circumstances, control systems, and defaults of the exhibition.

Mondrian's subordination of motif to composition was also practiced in paintings whose subject matter was not confined to trees, as in *Composition no. 11; Composition in Line and Color (Windmill)* (1913) and *Composition with Pink, Blue, Yellow, and White (Church Facade)* (1913/14). In the "Pier and Ocean" series (1913/14–1916/17), residual referential connotations are still offered; and the mass, density, and intersection of lines is cited as bearing an indexical relation (of sorts) to the projection of a pier in the sea. These references to the "real" world were almost completely suppressed in the 1920s and 1930s in titles which, with few exceptions,[8] merely repeated the deliberate abstract patterns of the work, specifying the particular color equilibrium foregrounded in the painting.[9] Once more, however, at the precise moment of a key development, in 1918, that leads to what some historians have seen as the first Neo-Plastic work, Mondrian (and those in his immediate milieu) reinforced his innovation with a shift of titular emphasis. While some of the key paintings from this year have been lost, a record of their titles, made for the Kröller-Müller collection in 1921, survives. Reflecting a decisive new inflection, in particular the bounding of color rectangles with a lattice-work of lines, it contains one of the fullest quasi-titular descriptions of any works in the artist's oeuvre, including no. 420, which is listed as "*Composition. Rectangles in tones of grey, yellow, greenish grey, grey and mat white, separated by grey bands.*"[10]

The course of Mondrian's struggle for titular sovereignty, and the eventual triumph of the term "composition," is attested to in several of his written statements produced during the critical years 1918–21 when his visual style took on its characteristic abstract morphology. It was immediately after the adoption of the title "composition," in October 1917 according to Carel Blotkamp, that the artist first "presented himself" as an "art theorist."[11] Mondrian wrote a piece called "Natural Reality and Abstract Reality: A Trialogue (While Strolling from the Country to the City)," which appeared in twelve installments of *De Stijl* from June 1919 to July 1920. It takes the form of a discussion between three interlocutors: "Y" is "a layman," "X," "a naturalistic painter," and "Z" "an abstract-real painter," clearly identified with Mondrian himself. As the debate develops one of the participants notes that he has "called . . . [Z's] *compositions 'symphonies'*; I can see music in them . . . but not nature."[12] The naturalistic painter denies the presence in the abstract–real painter's works of any "form" clearly signaled in the title "Composition" that Mondrian gave to the majority of his works from the late 1910s on. In this context "Composition" is revealed as a calculated retort to the putative formlessness, musicality, and decorative tendencies advertized in the Whistlerian title "Symphony." The title "Composition" offers more than a simple

abstract designation: it is a term redolent of the goals and achievements of Mondrian's work in its heyday. It is a governing term, a titular motif, that suggests and perhaps finally embraces the whole range of sometimes contradictory abstract pictorial effects actively sought out by Mondrian and italicized in his writings. It is the point of conjunction of a whole lexicon of "New Plastic" attributes – relationship, repose, rhythm, equilibrium.

In a position paper on the theory of Neo-Plasticism, Mondrian notes the centrality of the notion of composition to his whole undertaking: "[J]ust as in painting [so also in architecture], it is above all *composition* that must suppress the individual."[13] This is underlined in a manifesto of 1921: "It is through *composition* that the 'universal plastic means' must be expressed in continuously self-neutralizing plurality (and not by repetition 'in the manner of nature')."[14] The achievement of *compositional* order was the crucial goal of a theory and practice that sought to produce what Mondrian termed a radical "otherness" in respect of traditional artistic (or architectural) practice. Composition – the semi-mechanical disposition of plastic units into a "universal" order – had as its antithesis the inherited (Romantic) conception of artistic "individuality."[15] At its extreme it approached the condition of "logic": "Is not art," asked the artist, "the *exteriorization* of logic?"[16]

The discourse of the "composition" developed by Mondrian was influential for several other artists associated with *De Stijl* in the years around 1917. Bart Van der Leck's encounter with Mondrian, for example, was decisive in his development of a new titling strategy: "After his visit to Laren in the spring of 1916 and his meeting with Mondrian, he changed his style and started to number his paintings, naming them 'Compositions' without a further descriptive title."[17] More significant, perhaps, is what developed into the reverse situation, following Mondrian's association with Theo Van Doesburg. The circumstances of their meeting are significant, for it was occasioned by a Van Doesburg review that offered a respectful notice of Mondrian's *Composition* (1915), one of the first works that bore this designation without subtitle or qualification. As their relationship developed, and as the two artists offered each other criticism and commentary, it became clear that their potential for disagreement was situated on the same compositional territory as their mutual admiration. In 1917 Van Doesburg made the transition from descriptive to compositional titles, sometimes appending a subtitle, as in *Composition IX, The Cardplayers* (1917) or *Composition VIII, The Cow* (1917). Within a year he was subjecting the compositional designation to the restless, often provisional, scrutiny that characterized so much of his work in painting, architecture, writing, design, and pub-

lishing. In 1918 he titled a work *Composition in Discords*, and in 1920 experimented with compositional combinations in such works as *Composition with Three Paintings, XVIII*. From these beginnings the theory and practice of composition became a key site of definitional debate between Mondrian and Van Doesburg. Soon after Mondrian developed his "Checkerboard" compositions in 1919, Van Doesburg wrote to J. J. Oud complaining in no uncertain terms that "his [Mondrian's] most recent work" was too modular, and still unnecessarily invested in "position and dimension"; it was − and this was his harshest disapprobation − "without composition."[18] The compositional crisis represented by the "Checkerboards," and spelled out in no uncertain terms by Van Doesburg, has also been noted by Mondrian scholars. Yve-Alain Bois claims that with the abolition of figure/ground relationships in *Compositie in Lijn* (*Composition in Line*, 1916–17) the artist "enters definitively into abstraction." The ensuing sequence of "modular *all-over*" grid works (1918–19) culminates in two paintings of 1919, *Composition with Grid 8: Checkerboard with Dark Colors* and *Composition with Grid 9: Checkerboard with Light Colors*, the former described as "one of the least compositional works in Mondrian's entire output. It is ostensibly even anticompositional."[19] For Bois, the Neo-Plastic works that followed, beginning with *Composition with Yellow, Red, Black, Blue, and Gray* (1920), represent a "negation" of the anticompositionality suggested in the "Checkerboards," as Mondrian drew back from the more extreme implications of the grid. The discourse of Neo-Plasticism thus stages an emphatic, though stringently managed, return of compositional order and experiment, inflected in the early 1930s by the theory of "dynamic equilibrium" and the release of lines, and again, in the later 1930s and 1940s, in Mondrian's stated desire to "destroy" line, and once more (though differently), to relinquish composition.

That the unfolding of Mondrian's career was oriented around the possibilities and defaults of composition is underlined in the discussions and theories that followed the compositional reversions of Neo-Plasticism from 1920 on. Abetted by the closer proximity resulting from Van Doesburg's extended stay in Paris from 1923, compositional debate turned into a profound dispute. Nowhere is the rivalry, exchange, mutual influence, and final antagonism that characterized their relation in the mid-1920s better attested than in Van Doesburg's decision to compete with Mondrian not just in the disposition of lines, planes, colors, and compositional formats, but in the provision of titles and their attendant theorization. Beginning in 1924 he made a loose series of numbered works, many foregrounding the diagonal element, and endowed them with the provocative collective title *Counter-Composition* (see fig. 42).

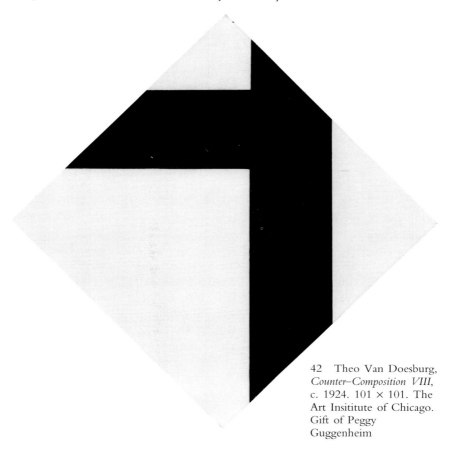

42 Theo Van Doesburg,
Counter–Composition VIII,
c. 1924. 101 × 101. The
Art Insititute of Chicago.
Gift of Peggy
Guggenheim

Significantly the term *Counter-Composition* was used to distinguish pictorial counter-compositionality from the *Counter-Constructions* which Van Doesburg had already proposed as point seven in his architectural program. Both "counters" were the titular signs associated with a new movement, called Elementarism, which Van Doesburg believed would surpass Mondrian's "Neo-Plasticism":

> The feature that distinguishes Elementarism from Van Doesburg's ear-lier work is that the compositions are turned at a forty-five degree angle. Accordingly they make a contrast with (that is, an oblique counter-movement against) the horizontal-vertical structure found in nature as well as architecture.[20]

Van Doesburg conceived the *Counter-Composition* as a retort to the frontality and binarism of Mondrian's settled compositional formats after

1921, and to the residual intuitivism of his visual theory. He claimed that the oblique made a connection with the fourth dimension and that it "stood for the new application of the element of time."[21] Kandinsky, as we will see, made a related claim for the additive importance of temporal consolidation, though it was predicated not on a single unit of formal articulation but on the sustained action of reflective compositional time on the final form of what amounted to a super-composition.

Like Mondrian (and Kandinsky) Van Doesburg was continually aware at this time of the social and semantic importance of the term composition. Like them he participated in an active search for keywords that would signal a linguistic response to the desire for a "newly shaped world." The positive signifying burdens of such words might be opposed (with not altogether negative consequences from Van Doesburg's shifting points of view) to terms such as Dada: "Dada – the word does not mean anything, as Hausmann remarked, 'Bébé, Sisi or Lollo' could have served just as well – did not stem from any *a priori* or other theory. It was born from a general resistance to our entire way of thinking. Dada expanded more or less from 'nothing.' "[22] In a text of 1918 "composition" was clearly a role-model word: it was the destination of the journey from "naturalistic to plastic composition."[23] By 1926 Van Doesburg had revised the signposts on his pictorial journey by extending the length of the road. At the beginning of an essay written in that year, "Painting: From Composition to Counter-Composition," he meditates on the importance of the "title of the present article," interpreting it as a continuation of his previous text. His new direction is supplied with a founding moment: "With the *Composition in White, Black and Grey* of 1924 . . . I terminated the period which in my view represents that of classical-abstract composition."[24] And it is invested with an alternative theory of time-based, "anti-static," counter-composition. Another essay written in 1926 offers a textual diagram of the entire compositional history of world art, in five stages. "Classic, Symmetrical Composition" is deemed to have lasted from antiquity to the beginning of the twentieth century, at which time it was replaced by the "vertical," "centred" arrangements of "Cubist Concentric Composition" ("Christ, Mary and the Cross were replaced by Guitar, Bottle and Newspaper").[25] "Neo-Plastic, Eccentric Composition," deemed "[a] very important, genuine renovation of compositional methods" holds the middle ground of compositional evolution. Here "*Composition gravitates towards the extreme boundaries of the canvas, instead of towards the centre*, and indeed, implies continuation beyond these limits."[26] Stage four is "Elementary (Anti-Static) Counter-Composition," which "adds a new, oblique dimension to orthogonal, eccentric composition. *Thus it eliminates the tension of*

the horizontal and the vertical in a realistic manner." Van Doesburg's compositional history culminates with a grandly assertive manifesto of "Elementarism," whose acknowledgment of "Time as an element in modern plastic expression" is hailed as "the equivalent of relativity."[27] In line with this final moment, counter-compositions were displaced and interrogated by what Van Doesburg refers to as "*unbalanced counter-composition[s]*,"[28] and what he paints under such titles as *Simultaneous Counter-composition XXI* (1929). The compositional quest continued – and for Van Doesburg it never really came to rest.

First deeply embedded and then profoundly questioned in the theory and practice of Van Doesburg, the title "composition" must also be situated within Mondrian's wider understanding of visual-textual discourse. That we are not misreading the theoretical centrality of the term composition in Mondrian's practice, and that it has not been overburdened here with symbolic weight, is attested in the artist's intense struggle with the whole signifying domain of textuality, as well as with the sign-function of individual words. Discussing the relation between "verbal art" and Neo-Plasticism, Mondrian notes that "[a]t present the word alone is vague,"[29] and (citing André Gide on Dada) that it is "[not] possible to free words from thought by stringing them together without any connection."[30] Having attacked the general imprecision of words and impugned the modernist device of uncoordinated syntagmatic juxtaposition, Mondrian elsewhere attacks the vagaries of individual words and usages:

> The meaning of words has become so blurred by past usage that "abstract" is identified with "vague" and "unreal," and "inwardness" with a sort of traditional beatitude. . . . The conception of the word "plastic" has also been limited by individual interpretations.[31]

Usage (history), the circulation of meanings, and textual individuality are all sources of potential infringement upon the universal (plastic) order that should be the proper goal of "the new man." Textual discourse itself can overcome these limiting factors only by means of careful discretion and deliberate attentiveness to the actual conditions of language. Thus while words are often "vague," "[t]his vagueness is somewhat clarified by *composition* and proportion but nevertheless remains veiled by form. The word, as form, is a *limitation*."[32] The term composition, then, is put forward by Mondrian as a "formless" word, uncontaminated by inappropriate past usages. Unsuited to individualist reduction, it is, therefore, precisely capable of subsuming the Neo-Plastic drift toward a universal discourse. It is one of the exceptional units of language that Mondrian expressly separated from the flux of words by virtue of their high expressive order: "There nevertheless exist *a few, perhaps even a number of*

words, which by their inherent strength and their mutual relationships, can express the principle of being."[33] Furthermore, this privileged vocabulary would actually gain strength and purpose through *repetition*:

> We need words to name and designate things. But we have only a *static language* with which to express ourselves. The most advanced minds as well as the least advanced are obliged to *use the same words*. If we adopt new words it will be even more difficult − if not impossible − to make ourselves understood. The new man must therefore express himself in conventional language.[34]

What we might term the conservative modernist restraint manifested by Mondrian here with respect to the function of language demonstrates that for him the appropriate choice of words was a crucial element in the steady and resolute adventure toward the grail of a newly designed utopian environment. The ripping apart of words, whether the product of the Futurist *soirée* or of Soviet textual experimentalism (Khlebnikov), was deemed counterproductive if measured against the *compositional* (rather than "constructive" − or "deconstructive") enterprise of Mondrian and *De Stijl*.

After 1921 the most frequent collocation of colors subordinated to the Composition were the three primaries (see fig. 43); but many other combinations were also used: *Gray, Blue, and Yellow* (1921), *Large Blue Plane* (1921), *Composition with Blue* (1926), *Composition with Red and Black* (1927), and *Composition in Black and White* (1930). During the period of his concentrated elaboration of a relatively "static" visual paradigm, Mondrian revealed himself as scrupulous a grammarian of naming and theoretical vocabulary as he was an exacting magus of form and color. As he put it in 1931, "[e]xactness is one of the most urgently needed means for realizing the new life."[35] We are offered a glimpse of Mondrian's fastidious exactitude on an issue that explicitly turns on the problem of the title. In April and March 1926 there occurred an exchange between Mondrian and Félix Del Marle, the editor of the magazine *Vouloir*, concerning the specification of the title for an article Mondrian had contributed to the publication. Del Marle had used the following formulation:

<div align="center">

ART

Pureté + Abstraction

</div>

But in a letter of 2 April 1926 Mondrian offered a resolute defense of his own title, "L'Art purement abstrait," citing just the reasons of precise usage and appropriateness discussed above: "I do not like the title. Purity

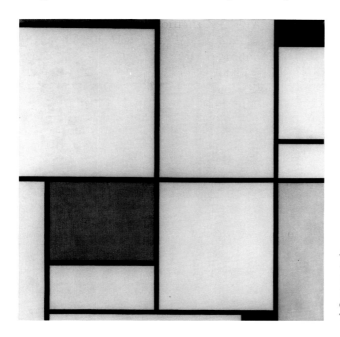

43 Piet Mondrian,
Composition with Red,
Yellow and Blue, 1921.
103 × 100. Haags
Gemeentemuseum,
The Hague

is for the Purists and 'abstraction' is not 'abstract art.'"[36] The cute
aesthetic algebra of the editor's title had in fact turned both of Mondrian's
original adjectives – qualifying "art" – ("purely" and "abstract") into
nouns accompanied by unwanted fiefdoms of meaning – with the result
that the surrogate title was misarticulated with non-sensical associations
and imprecisions. The capitalized term "Purity" could thus be read to
signify allegiance with the Paris-based "Purisme" of Amédée Ozenfant
and Charles-Edouard Jeanneret, who adopted the name "Le Corbusier"
in 1921, which Mondrian (as well as subsequent scholars) viewed as
distinct in its theory and practice from the precepts of Neo-Plasticism.[37]
We recall that it was on the site of the imaginary title "*Pureté*" that
Gauguin staged his elaborately specified separation from the "unsavage"
visual-textual allegorizations of Puvis de Chavannes. Similarly, the confla-
tion of "abstraction" with "abstract art" is a further example of the
linguistic (and other) "imprecisions" against which Mondrian wrote con-
sistently during the 1920s.

Theories and practices of alleged "purity," then, had a privileged
relation to the nominal scene of modern painting. Indeed, it was in the
activities of the Purist movement itself that the symbolic mediation of the
compositional, its production as a rational, material, and technical adjunct

to the realization of the pictorial (and social) projects, reached probably to its furthest, and in many senses its most reductive, point in the history of Western modernism. In their signature text, "Le Purisme," published in the fourth issue of *L'Esprit nouveau* (1920), Ozenfant and Jeanneret devoted one of the two longest sections of their seven-part discussion to "La Composition." For them, composition is an assemblage of "choices" ("choix") of "technical means" ("la composition étant un moyen de métier") "involving tasks of an exclusively physical order" ("elle comporte des besognes d'ordre exclusivement physique"). The work of composition is a labor of material and spatial organization, involving questions of "format," "surface," and an appropriately cautious and moderate deployment of the "perilous agency" ("agent périlleux") of color. The restraining order of composition is antithetical to "the caprices of an effervescent imagination" ("les caprices d'une imagination effervescente"). It should promote "discipline," "resonance," "firm geometry" ("ferme géométrie"), general "order" ("ordre"), and "unity" ("l'unité"). Even the complex and dis-orderly signification of color itself is allotted its "hierarchical place" – "we have the certitude of confining color to its hierarchical place" ("nous avons la certitude de cantonner la couleur à sa place hiérarchique") in a system of "purely rational investigations" ("investigations purement rationnelles").[38] In this account composition becomes the policing agent of formal restraint. The work is the precinct and the title, the Law.

For Mondrian the rise and fall of compositional theory and its attendant designations were more studied. As early as 1930, less than a decade after its purified introduction, Mondrian began to loosen the reins on his titling formula, first by directing attention to compositional elements other than colors, as in *Composition en blanc et noir II* (*Composition in White and Black II*, 1930), and then by dispensing entirely with the governing term "composition," as in *Composition IV; Fox Trot A; Lozenge Composition with Three Black Lines* and *Fox Trot B* (1929); or, later, as in *Red Corner* (1938). The *Fox Trot* titles are significant, for they form a kind of retort to the Symbolist evocation of musical reference we have traced in the works of Whistler, Signac, and others. Mondrian's gesture towards the modern dance hall, to which he referred as early as 1921 in his first article discussing music, manifested a commitment to modern musical forms that were neither traditional (like symphonies or nocturnes) nor self-consciously avant-gardist (like Luigi Russolo's *bruiteurs*). Mondrian was not interested in music's capacity for suggestion, formal abstraction, or disorganized clamor. Instead, it was the capacity of modern musical compositions to "break off" from "the old harmony" that appealed to him most. Such commitment found its final resting-place in Mondrian's

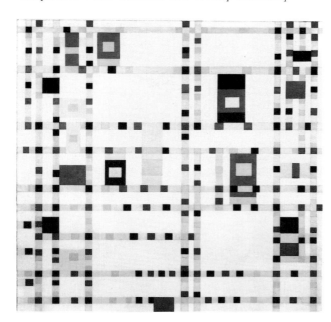

44 Piet Mondrian, *Broadway Boogie Woogie*, 1942–43. 127 × 127. The Museum of Modern Art, New York. Given anonymously

affirmatory passion for jazz, in homage to which his final two paintings were titled.

At the end of his career, following his remove to London in September 1938 and thence to New York in October 1940, Mondrian allowed connotative enthusiasms in the form of musical and topographical references to re-enter his paintings and to take the ground of his titles. These works include *Trafalgar Square* (1939–43), *Place de la Concorde* (1939–43), *New York* (1941–42), *New York – New York City* (1941–42), *New York City; New York City I* (1942), *Broadway Boogie Woogie* (1942–43, fig. 44), and his unfinished *Victory Boogie Woogie* (1942–44).

This notable shift of attention and apparent relinquishment of the scrupulous format and nomenclature of the 1920s is directly attested to in Mondrian's writings. In an article for the journal *Transition* in 1937, the very moment of the final release of his heyday geometries and the capitulation of the title "composition," Mondrian begins to speak for the first time of "*de*composition" [my emphasis] as being "essential" to the purposes of his art: "Finally, the decomposition of neutral form – complete separation – leads to the complete liberation of line and color."[39] For Mondrian, the title was not a mere indicator signaling the *effectiveness* of the work (as for Monet), nor was it a connotative supple-

ment offering another position on the image, or threatening its stability through its signifying vagaries (as for Whistler and other Symbolists). Instead the title was conceived as *consubstantial* with the work of the image as a social sign. The title was a rearticulation in its proper material (language) of the drive for a new order of environmental relationships. More than a supplement and beyond a mark of possession, the *Composition* was itself a fraction of the total enterprise of Mondrian, and when it fell away we can surmise that more than a scaffolding collapsed with it. The desire for clarity and preciseness, inherited, as Sixten Ringbom has pointed out, from the theosophical system of M. H. J. Schoenmaekers,[40] though never abandoned, was finally subordinated to the particularities of modern experience: syncopation, we might say, won out over the interval.

The final coordinates of Mondrian's compositionality, like the outreach of Whistler's decorative musicality, must be located in the extra-pictorial environment. Unlike Whistler, however, Mondrian's most consolidated investment of "extensive" Neo-Plasticism was not in his domestic space or in the gallery or exhibition hall, but rather in his own studio – at first the famous working space on the second floor of 5, rue de Coulmiers in

45 Mondrian in his studio, 26 rue du Départ, Paris, 1933

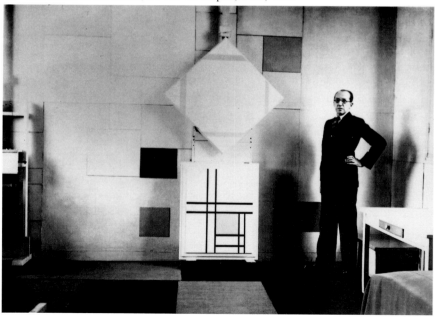

Paris, which he rented in 1919, and then the studio at 26, rue du Départ (fig. 45). Mondrian "composed" these interiors by disposing colored planes on the walls and organizing his few objects and studio necessities, including chairs, working table, stool, and easel. Several commentators have pointed out that the "trialogue" discussion between Y (the art-lover) and Z (the modern painter) probably informed the layout of the first studio.[41] The arrangement of the second was subject to continual modification, as evidenced by a series of photographs taken in the mid and late 1920s. Mondrian was also involved in the composition of interior space for Ida Bienert, who lived in Dresden, and designed "three inter-changeable decors for Michel Seuphor's play *L'Ephémère est éternel*," devoting "a great deal of time and effort to getting the composition exactly as he envisioned it."[42] Mondrian's theory of composition was always a spatial or otherwise "extensive" practice. It was a theory-practice dedicated to the organization of newly heightened moments of cultural life, whether in the materials of words, music, paintings, local spaces, or city-scaled environments.

II Life and Death Sentences: Compositional Theory in Matisse, Malevich, and the United States

Mondrian, of course, was not the only painter in the first decades of the twentieth century for whom the theory and practice of composition was of great strategic importance. While there could scarcely be an artist more antithetical to Mondrian in terms of visual style, written theory, and habits of everyday life, there is a form of modernist continuity between the reliance of both Mondrian and Henri Matisse on the structural governance of the pictorial by means of composition. In what has been described as his "thoroughly phenomenological"[43] "Notes d'un peintre" ("Notes of a Painter," 1908), Matisse consistently invokes the subordina-tion of all pictorial practice to "composition." "Thought," "expression," and "pictorial means" are for Matisse subject to the final resolution of their aesthetic order through the subtle operations of the art of composition:

> Composition is the art of arranging in a decorative manner the diverse elements at the painter's command to express his feelings. . . . Compo-sition, the aim of which should be expression, is modified according to the surface to be covered.[44]

Elsewhere, Matisse is even more emphatic:

> When I see the Giotto frescoes at Padua I do not trouble myself to recognize which scene of the life of Christ I have before me, but I immediately understand the feeling that emerges from it, for it is in the lines, the composition, the color. The title will only serve to confirm my impression.[45]

This citation reconvenes three critical terms around which the present study is organized – *title*, *impression*, and *composition*.[46] Differences in his subject matter and technique notwithstanding, Matisse submits to the same modernist conformity in the relegation of all non-compositional effects from visual practice as would be negotiated slightly later by Mondrian and Kandinsky. The title for Matisse is a mere "confirmation" of the pictorial "impression"; and the content of an image (its iconography) is likewise subordinate to color, line, and compositional design. Composition for Matisse stands as the most effective term for the synergetic product of all modern pictorialism. It offers an almost transcendent co-extension between the interactive elements of painting practice: nature, (dynamic) equilibrium, pictorial means, expression, color, sensation, intuition – all of which are briefly attended to in this key Matissian text.

Yet there are important distinctions to be drawn between the theory and practice of Matisse and that of the pioneer abstractionists. Matisse appears to occupy the middle-ground between Symbolist theory (which was itself complex and contradictory in its discussion of "composition")[47] and that of the writer-abstractionists Mondrian and Kandinsky. In particular, the fluid, interactive, and in the end always under-specified compositional system of Matisse was never able to dispense with the figure as the assumed central component of the pictorial experience. Figural and situational recognition are central devices in Matisse's humanist symbolism and the iterated drive for "pleasure" in his pictorial texts is predicated on the dispersal of reference from human (and we might say from other, surrogate biological) forms. As the figural or biomorphic sign is always partly *residual* in its signification – that is, its tendency is to signify before as well as after "composition" (perhaps in an analogous if more mediated way than has been suggested for the signification of color)[48] – Matisse can be said to have knowingly resisted the fuller implications of a more complete governance of painting by the rather absolutist theories of *composition* common to abstractionists who worked outside the ever more experimentally cautious School of Paris. Thus while Matisse contested the notion of "fixed form"[49] that he felt underlay art practices as diverse as those of Greek classicism and his contemporaries, the Cubists, he fell short of the post-Cubist drive for the

elaboration of an abstract compositional system that would bypass the "object" while at the same time signifying the emotional "effect." The term "composition" itself can stand in "Notes of a Painter" (and elsewhere in Matisse's occasional writings and interviews)[50] both as a governing label for the constellation of pictorial elements and mental effects that construct the painting, and for one "component" among many.[51]

We find clear confirmation of the significance for Matisse of title-assisted composition among a small number of works, painted at strategic moments during his career, which are governed by titles that deliberately sidestep the descriptive neutrality characteristic of the vast majority of his works. Two of these paintings, *Luxe, calme et volupté* (1904–05, fig. 46) – whose title is the product of an almost untranslatable cadence from Baudelaire's poem "L'Invitation au Voyage" – and *Le Bonheur de vivre* (1906), later renamed *La Joie de vivre*, form the basis of a extended revisionary account of the artist. According to Pierre Schneider, the works and their symbolically suggestive titles represent elaborately pre-

46 Henri Matisse, *Luxe, calme et volupté*, 1904–05. 98 × 118. Musée d'Orsay, Paris

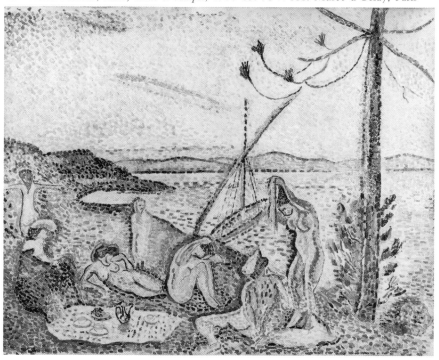

pared, "compositional" responses to a stylistically modernized and figurally renovated "pastoral-bacchanalian tradition." They are the key sources for the protagonists who inhabit the future pictorial world of Matisse — satyrs, nymphs, musicians, "celebrants of idleness and love." Their unique "literary" titles and formal innovations offer dramatic refreshment for a profound, long-severed, relation "between European art and the sacred."[52] For the "Golden Age" alluded to in both these paintings "supplies the founding myth of [Matisse's] 'religion,' its doctrinal body, its repertoire of themes."[53]

Schneider underlines the compositional deliberation invested in the works, stating that Matisse "conceived *Luxe, calme et volupté* as a *composition*, a work not painted from life but deliberately constructed"; and that in *La Joie de vivre* "instinctive observation of the subject is replaced by deliberate 'composition.'" Looking back in 1941 Matisse concurred in his own words, remembering, in a statement that resembles Kandinsky's definition of the extended composition, that "[t]his picture was painted through the juxtaposition of things conceived independently, but arranged together."[54] Overwhelming the insipid allegorization of Puvis de Chavannes, and the formulaic Divisionism of Signac (who made his own gesture to the Golden Age, *In the Time of Harmony*, and was the first owner of *Luxe, calme et volupté*), Matisse fuses Mediterranean mythology with the delayed realism of the Impressionist outdoors and links the dream time of rhythm, dance, and music to the succinctly expressive forms of the enraptured body. *La Joie de vivre*, the only work exhibited by Matisse at the 1906 Salon des Indépendants, thus takes its place with Gauguin's *Where Do We Come From? What Are We? Where Are We Going?* (1897, fig. 24) and Picasso's *Les Demoiselles d'Avignon* (1907, fig. 35), begun a few months later (in part, perhaps, as a response) in the series of complex, powerfully titled compositions that organize many of the key social and pictorial issues in the "banquet years" of visual modernism.

No other works by Matisse bear titles with ramifications as significant as these. During moments of compositional experiment or intensity, however, Matisse was occasionally willing to release various types of titular suggestion. Most of these — and they are not especially numerous — are references to a dominant color or form, as in the awkward, Cubist-inspired *Tête blanche et rose* (*White and Pink Head*, 1914) or *Harmonie rouge/La desserte (Panneau décoratif pour salle à manger; La chambre rouge)* (*Harmony in Red/La desserte [Decorative panel for a dining-room; The Red Room]*, 1908). At the height of his commitment to Fauvist brushwork and colorism, the famous portrait of *Madame Matisse; La raie verte* (1905, fig. 47) carries the colloquial subtitle "The Green Stripe," referring to the astonishing carriageway of

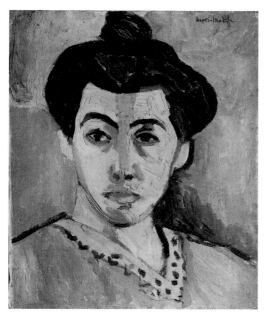

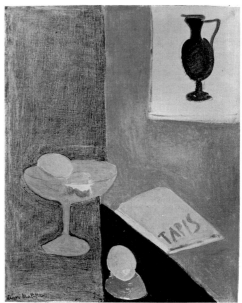

47 Henri Matisse, *Madame Matisse, The Green Stripe*, 1905. 40 × 32.4. Statens Museum for Kunst, Copenhagen. J. Rump Collection

48 Henri Matisse, *Still Life with Lemons Which Correspond to Their Forms in the Drawing of a Black Vase upon the Wall*, 1914. 39.7 × 53.8. Museum of Art, Rhode Island School of Design, Providence, R.I. Gift of Miss Edith Wetmore

green paint that divides the shaded and lit halves of the sitter's face. Such allowances reach a unique crescendo with another work made during Matisse's most incautiously experimental phase. This is *Nature morte aux citrons dont les formes correspondent . . . (Still Life with Lemons Which Correspond to Their Forms in the Drawing of a Black Vase upon the Wall*, 1914, fig. 48) – referred to as "a virtual pedagogical demonstration of his [Matisse's] method."[55] Finally, the title-compositions made between 1904 and 1906 spawned a lineage of abstract or thematic titles that answers to the sequence of figures and motifs to which they also gave rise. These include *La Danse (The Dance)*, *La Musique (Music)*, *Luxe I*, *Luxe II*, and *Pastoral*.

If Matisse's theory-practice offers an emotion-driven, modernist renovation of composition, eight years later Kasimir Malevich will unveil a movement grounded in an evasive set of rhetorical arguments that seemingly broach just the opposite. Malevich raises the stakes of the debate on composition traced here by predicating the "organization" of his new paintings on the hyper-emotivity of post-formal intuition. In introducing

the question of untitling, the non–name, and the "zero–economy" I have already discussed Malevich's distrust of form and formal composition. If Matisse defends his compositional pictoriality on the residual grounds of the figure, Malevich uses the same grounds to issue a withering attack on the attributes of body-form. He rails against the "allusive" "parody of life" that appears in "a face painted in a picture," asserting, near the conclusion of his essay on Suprematism that, "You go into raptures over a picture's composition, but in fact, composition is the death sentence for a figure condemned by the artist to an eternal pose."[56]

In this essay, "From Cubism and Futurism to Suprematism: The New Painterly Realism" (1915), Malevich offers one of the first of what will be a wave of radical disaffections for the modernist notion of "composition" issued from the progressively militant and polarized ranks of the Russian and then Soviet avant-gardes. Malevich makes a double move in this text against the predicates of composition. First he inveighs against the "classical painters" (he has in mind Michelangelo, whose *David* he has just denounced): "[Their] composition should not be considered a creation." Then he takes on the theoretical generality of composition, claiming that "composition rests on the purely aesthetic basis of niceness of arrangement."[57] Later in the same text, Malevich brings his discussion closer to contemporary concerns, announcing that "art is the ability to create a construction that derives not from the interrelation of form and color and not on the basis of aesthetic taste in a construction's compositional beauty, *but on the basis of weight, speed, and direction of movement.*"[58]

The opposition between the virtues of "construction" and the decadence and futility of (bourgeois) "composition" will become one of the centerpieces of the elaborate art debates staged in Moscow and elsewhere in the late 1910s and early 1920s. Here, however, Malevich seems to imagine that constructive values are a greater and privileged set, containing and controlling a range of other "formal/technical" attributes, including what he terms "compositional beauty." Following the demise of the "laboratory art" experiments of Liubov Popova, Alexandr Rodchenko, and others around 1918–21, all hints of composition will be banished from the theory and practice of Constructivist-Productivist practice. "Composition" becomes a predicate of the "art" function, while constructed work is given solely to the design and production of things that are named only by their function.

It is important that the death of composition and the outer limits of form are proclaimed at the same moment by one of the three pioneer abstractionists, the other two of whom chose to articulate their entire theory-practice on different but equally foundational understandings of composition. What Mondrian and Kandinsky developed from outside the

immediate orbit of the Paris art scene is met, then, by powerful counter-
compositional impulses from the Russo-Soviet margins of the Western art
world. In both Britain and the United States the opposite tendency can
be observed. For in the formalist theories of Clive Bell and Roger Fry,
and in the lesser-known, but institutionally powerful, ideas circulated in
"progressive" art circles in New York and elsewhere in the United States,
a dominant discourse of composition emerges that returns an insistent,
though more generalized and mild-mannered, version of the
compositionality defended by Matisse.

Barbara Rose outlines a brief introduction to the formal-compositional
theories current in the United States in the first half of the twentieth
century. She points in particular to the ideas formulated by Arthur
Wesley Dow, a teacher of Georgia O'Keeffe, and Denman Ross, a
Harvard professor, whose *A Theory of Pure Design*, published in 1907, a
year before Willem Worringer's *Abstraction and Empathy*, "stressed pattern,
abstract design, rhythm based on architectural measure, and movement"[59]
and was a demonstrable influence on Fry. The most notorious issuance of
these ideas would be in the monological, diagrammatic, hyper-formalism
of Albert Barnes, who eventually ran his precious collection as an insti-
tutional fortress for the detention of compositional virtue – in the process
offering another key moment in the controversial coordination of nam-
ing, composition, and institutional space woven into the present study.

The return of straightened precepts of compositional reduction are
commonplace in the critical and artist-authored literature that discusses
American visual modernism. In a note on "The Forum Exhibition" at the
Anderson Gallery in New York in 1916, for example, Stanton
Macdonald-Wright, architect of the Synchromist aesthetic (see fig. 49),
outlines a formulaic response to the de-textualization of art and its
concomitant emotio-aesthetic purity and compositional probity:

> I strive to divest my art of all anecdote and illustration, and to purify
> it to the point where the emotions of the spectator will be wholly
> aesthetic, as when listening to good music. . . . However, I still adhered
> to the fundamental laws of composition (placements and displacements
> of mass as in the human body in movement), and created my pictures
> by means of color-form which, by its organization in three dimensions,
> resulted in rhythm.[60]

This, and similar accounts, have little of the technical and conceptual
specificity that was attempted by Kandinsky and Mondrian at much the
same time. Indeed, contrary to what I identify as a deliberate separation
of composition and construction in several key European avant-gardes,
Macdonald-Wright uses the terms "composition" and "construction"

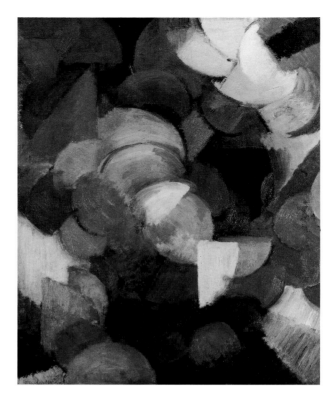

49 Stanton Macdonald-
Wright, *"Conception."
Synchromy*, 1915. 76.2 × 61.
Collection of the Whitney
Museum of American Art,
New York. Gift of George
F. Of

almost interchangeably – as in a continuation of his remarks cited above
where he writes of his "visualization of abstract forces" as a "goal of
finality which perfectly accorded with my felt need in picture
construction."[61]

III Wassily Kandinsky: "Reason, the Conscious, the Deliberate, and the Purposeful"

> I was searching half consciously, half unconsciously, for the
> compositional. I was inwardly moved by the word
> composition and later made it my aim in life to paint a
> "composition." This word itself affected me like a prayer. It
> filled me with reverence.
>
> –Wassily Kandinsky ("Reminiscences/Three Pictures," 1913)[62]

Both the practice of composition, and the signification of the word "composition," were of central importance to the development of Kandinsky's abstraction. In his "Rückblicke" ("Reminiscences," 1913), Kandinsky insists on compositional ordering as a crucial regulating device in respect of the procession of his unconscious pictorial drives. He writes of the need to discover through the resolution of "compositional element[s]" ("das Kompositionelle") a matrix of "responsibility" ("verantvortlich") in which to fix the "half-conscious, half-unconscious" ("halb bewußt, halb unbewußt") materials of his practice. Composition, here, is afforded something like a religious status. It becomes a "holy word" activating Kandinsky's quest for the spiritual and emotional communicability of abstract form, the very grail of his theory of pictorial expression.

Kandinsky theorized his own distinct relation to the domain of textuality, yet at points his conclusions (and reported experiences) seem to resemble those of Mondrian. Writing of the preparatory history of his *Komposition 6* (*Composition 6*, 1923), which included a series of attempts at the representation of the deluge, he notes:

> In a number of sketches, I dissolved the corporeal forms; in others I sought to achieve the impression by purely abstract means. But it didn't work. This happened because I was still obedient to the expression of the Deluge, instead of heeding the expression of the word "Deluge." I was ruled not by the inner sound, but by the external expression.[63]

Even more than for Mondrian, the very theoretical predicates of Kandinsky's practices, including the production of his titles, are bound up with a particular understanding of the function of language, and of its complementarity and incomensurability with the imputed psychological effects of a visual field. Kandinsky's abstraction is in many respects constitutionally different from that of Mondrian in its maintenance of an expressive system of emotional and spiritual cross-references set in process between the picture surface, the viewer, and, importantly, the title. Throughout his whole career Kandinsky was a scrupulous titler and cataloguer of his paintings. He maintained a "meticulously kept House Catalogue"[64] and exploited to the full the three languages of which he had command: Russian, German, and French.

Until about 1910, Kandinsky offered titles for his works which merely designated the place where the image was painted – in Rapallo, Murnau, or Munich (e.g., *Strasse in Murnau* [*Street in Murnau*, 1909]). During his period in Munich, however, from around 1910–14, Kandinsky devised a unique personal classification system which he outlined in *On the Spiritual*

in Art (*Über das Geistige in der Kunst*, 1912), and which has been summarized by his major monographer, Will Grohmann. In the concluding section of his text Kandinsky lists the three principal titular categories to which he made recourse:

> These reproductions are examples of three different sources:
> 1. The direct impression of "external Nature," expressed in linear-painterly form. I call these pictures "Impressions."
> 2. Chiefly unconscious, for the most part suddenly arising expressions of events of an inner character, hence impressions of "internal Nature." I call this type "Improvisations."
> 3. The expressions of feelings that have been forming within me in a similar way (but over a very long period of time), which, after the first preliminary sketches, I have slowly and almost pedantically examined and worked out. This kind of picture I call a "Composition." Here, reason, the conscious, the deliberate, and the purposeful play a preponderant role. Except that I always decide in favor of feeling rather than calculation.[65]

Kandinsky painted six "Impressions," all of them in 1911; the series of "Improvisations" he began in 1909, and by 1914 had produced thirty-five, which he numbered (see fig. 50). As for "Compositions," he painted seven between 1910 and 1914 – three in 1910 (which are no longer extant), two in 1911, two in 1914 – and another three during the last thirty years of his working career (one each in 1923 [fig. 51], 1936, and 1939). As Grohmann remarks, the other works from these years have transitional titles, though it is not always clear why he did not call some of these, which suggest natural objects, "Impressions," or others less suggestive of natural appearance, "Improvisations."

Grohmann's account of these titles recapitulates the main tendencies of Symbolist discourse on the process of nomination and the function of words in relation to the images they govern. Notable in his view is Kandinsky's prioritizing of musical connotation and his elaboration of a kind of *summa* of untitled designations. The Symbolist-derived emphasis on the musicality of form and color is early on given a poignant cosmological inflection – one rendered all the more relevant to the mooted "universality" of the musical analogy when we recall the history of its development by Whistler, and in particular the would-be ironic parable visited against him by the hostile critic from the *Echo*: "Each work," noted Kandinsky, "originates just as does the cosmos – through catastrophes which out of the chaotic din of instruments ultimately bring forth a symphony, the music of the spheres."[66]

Looking from Whistler to Kandinsky we find an overlay between two

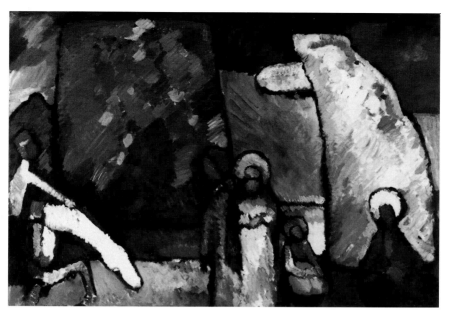

50 Wassily Kandinsky, *Improvisation 2 (Funeral March)*, 1909. Oil on linen, 94 × 130, Moderna Museet, Estocolmo

51 Wassily Kandinsky, *Composition 8*, July 1923. 140 × 201, Solomon R. Guggenheim Museum, New York, Gift, Solomon R. Guggenheim, 1937

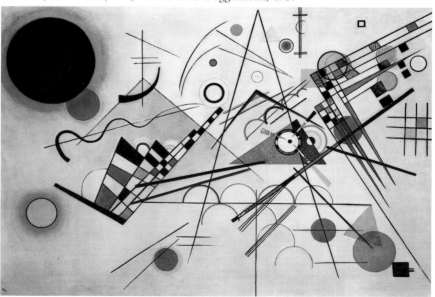

accounts that privilege the *symphonic* (as a conflation of music, title, and image). They meet across the threshold of modernism, and match each other term for term. Kandinsky's "chaotic din" is a version of the critic's "cacophony" and "hideous noise"; "symphony" is the model word for, Kandinsky, the delusionary term for Whistler's critic ("we do *not* think that 'Symphony' is the word to describe your performance"); the symphonic effect is for Kandinsky like the "music of the spheres," just as for the donkey in the parable it is "melodious . . . sweet sounds." The distance between the two accounts, however, amounts to something like the virtual space of modernism. Between the late 1880s and World War I the purportedly self-evident ludicrousness of Whistler's musical signatures had been transformed into the earnest tokens of a new transcendent visuality that, unlike Whistler's paintings, actually appeared formless, but which were still attached to a system of religio-expressive signs.

I want to claim, however, that Kandinsky's uniquely detailed consideration of title types finally left behind the legacy of Symbolist musical reference. Under the titular auspices of the "Impression," the "Improvisation," and the "Composition," Kandinsky organized his allegiance to three distinct dimensions of pictorial production. "Impressions" were made in response to observed motifs and natural forms. They were external notations, quasi-diagrammatic sketches of perceived reality. "Improvisations," conversely, offered visual organization for internal sensations. These may have been driven by observation, but they gave rise to forms and formats Kandinsky claims as "unconscious" and interior. In contrast to the idea of somehow fixing, or "impressing," a system of marks which approximated the forms, colors, and atmosphere of a visual scene, the term "Improvisation" is much more provisional. It promises, in fact, the opposite of that which is fixed and notated: a visual space that is simultaneously marked, but in process – one that is not rendered from observation, but recast through sensation, perception, spiritual apprehension, or other psychic dispositions of the artist-subject. The idea of the "Improvisation" could not be more antithetical to what we have described as Monet's devotion to the cult of the meteorological instant. In a sense it is the most radical of the titular types proposed by Kandinsky. On the one hand, it meets other avant-garde resistances to the static, spatial construct of the unitary image proscribed for painting practice by Lessing. Like Cubism's bid for dimensionality and material surplus, or the Futurists' desire to reckon with temporality and sequence, the "Improvisation" offered to shift outside the parameters of the frame-bounded image by recording a moment in the shifting visual consciousness of the mind. But representing an improvisation is also to improvise in representation. Mark-making is rendered contingent, tentative, and always unfin-

ished under the designation "Improvisation." To improvise is not, then, merely to evoke: it is also in some sense to evoke from what is already an evocation. It is not a means of cultivating mystery: it is an insistence that visual forms are already, innately mysterious – or rather deeply subjective and emotionally profound. To improvise is thus an effort to render what is already mysterious somehow accessible to a receiving consciousness. The "Improvisation" traduces the Symbolist image by proposing that representation is anchored to the mentalist production and reception of visual forms. The ordered form, decorative patterns, and mysterious evocation of Symbolism are not cultivated as refuges from signification or mere allegories of thought. Instead the image is proposed as a register of psychic events. So, finally – and paradoxically – the "Improvisation" impresses unconscious thought into visual form, while the "Impression" improvises the shape of external nature.

It would be tempting to describe the "Composition" as the synthesis of the two types of image production that are its determining thesis and antithesis. Such a proposition is not completely wide of the mark, and even appears to be given limited sanction in Kandinsky's "reminiscence" of the relay of two parts, "half conscious, half unconscious," that made up the "Composition." But it also simplifies the pressures, contradictions, and supplements that informed Kandinsky's privileged nominal and pic-torial type. For a "Composition" is not simply the result of an overlay of Impressionist and Improvisational marks. It is, rather, a fusion of these possibilities with a third term or process incorporated in neither the "Impression" nor the "Improvisation." This third term is itself a complex function of temporality, reflection, and order. Such extras are the binding agents that convert external appearance and "internal nature" into the fundamental pictoriality signed as "Composition." For if both "Impres-sions" and "Improvisations" accede to the registration of effects, the "Composition" seeks for another dimension of form, which is won by revision and concentration. In his definition of "Composition," Kandinsky lays almost his entire emphasis on the effects of sequential time, on accumulating investments and excruciating revision. He stresses that a "Composition" is the result of the formation of feelings "over a very long period of time" and that its forms are "slowly and almost pedantically examined and worked out." Unlike the Futurists he is not concerned to represent sequential time or simultaneously serial instants. Instead a "Composition" arises as a *combination* of sequences, sketches, and preliminary ideas whose totality might be compared to a dimensional map of a complex psychological state. A "Composition" rectifies the superfi-cial apprehension of the "Impression" and the provisionality of the "Improvisation" by offering a powerful, summary *representation of revision*.

 The consolidation of forms that results from this revisionary screening
is made of many parts. Art-historical research has demonstrated that a
relatively coherent mass of mainly biblical and apocalyptic imagery moti-
vates the signifying structure of works from across each of the titular
categories rehearsed above. Kandinsky's effort seems to have been par-
tially to obscure and efface his motifs, employing what Rose-Carol
Washton Long terms techniques of "veiling" and "stripping."[67] In her
study of the development of Kandinsky's abstract style, she recognizes the
crucial function of the title in Kandinsky's work by organizing the central
section of her book around three titular types. These types are not,
however, those set out by Kandinsky: Washton Long proposes to "step
beyond these categories and group the paintings by motif, pattern, and
size."[68] Thus her chapter 7 analyzes "Paintings with Thematic Titles"
(thematizing, and mostly titled after, "the Last Judgement, Deluge, battle
scenes (Armageddon?), Garden of Love and/or Paradise");[69] chapter 8
discusses "Paintings in the Composition Series" (*Composition*[s] 1–7,
1910–14); and chapter 9, "Paintings with Titles Emphasizing Form and
Color" (see fig. 52), such as *Im schwarzem Viereck* (*In the Black Square*,
1923), *Durchgehender Strich* (*Traversing Line*, 1923), and *Auf Weiss* (*On

52 Wassily Kandinsky, *Painting with White Border*, May 1913. 140.3 × 200.3. Solomon
R. Guggenheim Museum, New York, Gift, Solomon R. Guggenheim, 1937

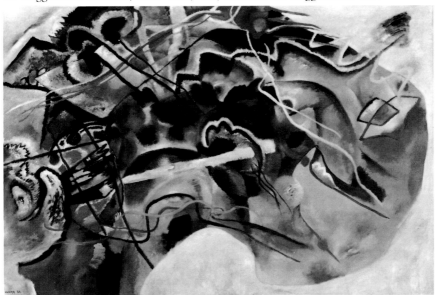

White, 1923). While this recategorization facilitates the historian's icono-graphic enquiry, it risks effacing the crucial summary position that Kandinsky's titular activity achieves at the interface of the titling regimes detailed here. The three key terms, "Impression," "Improvisation," and "Composition," and the "symphonic" organization to which they (ideally) tended, represent the nominal coordinates of the visual practices of early modernism.

Like Mondrian (though unlike other early twentieth-century abstractionists), Kandinsky was not afraid that the written word, formu-lated as title or elaborated as pedagogical or visionary text, would com-promise the visual integrity of the canvas surface. His contacts with the Belgian Symbolist Maeterlinck and with the Theosophical ideas of Madame Blavatsky and Rudolf Steiner, among others, reinforced the notion that material reality, and in particular, form, color, and music, could be construed as a vast and potentially available set of signs whose ultimate spiritual referents would be released through the specific and privileged intervention of the artist. Written language was no exception to this, although its deep codification through systems of traditional usage militated for Kandinsky against any easy, if potent, psychic relation to this ultimate reality. In any case, perhaps on the model of Maeterlinck[70] (who argued for an appropriately allusive use of language as, in his view, ordinary language was too rooted in its external context to stretch the limits of consciousness) Kandinsky envisaged his role as an artist, particu-larly from 1910–14, as one of interference in the denotative relay between religious image and spiritual signification – something of which we noted briefly of the Masaccio. He manifested an abundant willingness to display these modes of intervention in his titular activity: particularly in those works mentioned above, where form and color, the central defining characteristics of painting itself, are deliberately specified as constituting the very axes within which any transubstantiation from material signifier to spiritual signified must be achieved.

Like Mondrian, then (although the consequences of this belief were differently formulated), he indicated in *On the Spiritual in Art* and else-where his belief that words themselves had a non-material potency directly analogous to the spiritual expressiveness of plastic form: "Just as every word spoken (tree, sky, man) awakens an inner vibration, so too does every pictorially represented object."[71] According to Kandinsky, words possessed "spiritual qualities" or "effects" and produced "inner sounds."[72] In another observation which recalls Mondrian, he suggested that through repetition "the sense of the word as an abstract indication of the object is forgotten, and only the pure sound of the word remains."[73] But Kandinsky also indicated an awareness of the dangers of a situation in

which "Inner necessity is disguised as external fashion," where "a new Classification emerges, new names are invented, new labels are produced."[74]

Kandinsky left Germany for his native Russia in 1914 and remained there for the most part until 1921; he produced only a modest number of paintings during this time, but when he returned to Germany and joined the staff of the Bauhaus, he began making works titled with non-specific phrases such as *Oben und links* (*Above and Left*, 1925), *Spitz und Rund* (*Pointed and Round*, 1925), or *In the Black Square*, 1923. He was apparently petitioned on several occasions by both dealers and collectors to modify or re-conceive his titles; but he always refused, writing in 1928 that:

> My titles are supposed to make my paintings uninteresting, boring. But I have an aversion for pompous titles. No title is anything but an unavoidable evil, for it always has a limiting rather than a broadening effect − just like "the object."[75]

This statement marks something of a shift in Kandinsky's attitude − surprising, perhaps, in view of the kind of works he was to produce in the later 1920s and 1930s, which consistently bear titles apparently devised to stand in psychologically direct but perceptually complex, relation to the non-iconic abstraction of the images. Sometimes humor and self-irony are interposed between the image and the title, as in works such as *Scherzklänge* (*Jocular Sounds*, 1929, fig. 53), *Ernst-Spaß* (*Serious-Joke*, 1930), or *Bunt aber Still* (*Variegated but Quiet*, 1929).

The most important question raised by examples such as these is one that has been posed, in different ways, by Gombrich and Bann, whose account of modernist titling began this study. It concerns the status of title-assisted abstraction as a mode of communication.[76] There would appear to be grounds for doubt that it can ever be more than a wilfully subjective conundrum, a language without a code, a kind of idiolect, even the decorative satisfaction of which is disputed by Gombrich. If these doubts are sustained, then the issue of titles becomes a roguish operation designed to furnish a semantic legitimacy for the image under the cover of misplaced notions of artistic intentions and psychological correspondence.

The great pictorial compositionists, Kandinsky and Mondrian, devised two elaborate visual-textual systems for the articulation, respectively, of spiritual and utopian world orders. For both artists the composition was a sanctified space, designated by a powerful word, whose co-significations traduced the more restricted logics of earlier compositional orders. They took on some of the aestheticist/formalist insistence of compositional self-

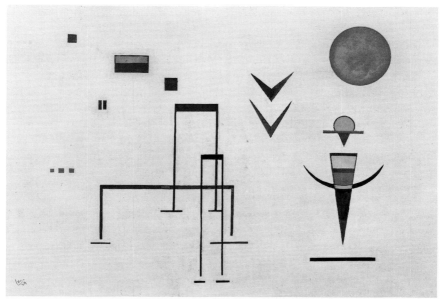

53 Wassily Kandinsky, *Jocular Sounds*, 1929. Oil on cardboard, 34.9 × 48.9. Courtesy of the Busch-Reisinger Museum, Harvard University Art Museums, Cambridge, Mass. In memory of Eda K. Loeb and Association Fund

reference, "arrangement," and decoration, but such emphases were for them, merely points of departure. Visual forms, they claimed, must be intense and arranged, but they are always signs and not just patterns. For Kandinsky they were modernist allegories for communicable psychological states. For Mondrian they were the environmental barcodes laid down for a visual adjudication of the future.

Whether or not one accedes to the pragmatic pessimism of Gombrich and Claude Lévi-Strauss in the matter of naming and communication, by the mid- and late 1920s, the discourse of visual modernism had reached what can be described as a plateau of signifying possibilities. As far as the naming and titling of art works is concerned, the typology of kinds identified and deployed in later nineteenth-century art practices (denotative, connotative, and untitled) attests to the existence of this "threshold." Certain *extremes* of titular reference had already been approached during the twenty or so years on either side of 1900. In particular, the elaborate connotations of Allais or Signac were clinched by several of the Dada and Surrealist artists (though we cannot argue that they were necessarily *surpassed*). But the function of titles in these movements is so inextricably bound up with general problems of interpretation and approach, particu-

larly in respect of the Dada and Surrealist "word-image," that a different approach seems necessary here – one that does not "privilege" the title as in the present project; at a certain historical point in the "progress" of the avant-garde, it is no longer useful to develop an attention to titling alone.

Though raised to a flashpoint and finally incinerated by Kandinsky and Mondrian, compositionality did not cease to be a preoccupation for visual artists after the mid-century. In many ways it remained the key point of investment and antagonism for all modernist art. It was also the most important point of calibration for avant-garde and neo-avant-garde disavowals of formal order. The late modernist and neo-avant-garde destinies of *composition* will be discussed in chapter 8.

Chapter 7

Dada and Surrealism: Alchemies of the Word

> By sticking labels on to things, the battle of the philosophers
> was let loose (money-grubbing, mean and meticulous weights
> and measures).
>
> − Tristan Tzara, "Dada Manifesto" (1918)[1]

> Anarchy?
> He simply found that object, gave it his name. What then
> did he do? He found that object, gave it his name.
> Identification. What then shall we do? Shall we call it by his
> name or by its name? It's not a question of names.
>
> − John Cage, "26 Statements re Duchamp" (1964)[2]

Anarchy, identification, finding objects, and the calling of names: Cage's
reflections on Duchamp introduce the prolix coordinates of the title as it
was obsessively developed, mauled, and flouted by the Dada artists, and
then inflected − both poetically and philosophically − by the Surrealists
from the later 1910s to the end of the 1930s. In no other avant-garde
configuration were the signifying spaces of the title so radically opened up
and so fervently disputed. In addition to subjecting the title to three
decades of astonishing reinvention, many of the titling strategies taken on
by the Dadaists and Surrealists were formed in loose continuity with the
typology already established by the early years of the twentieth century.
This chapter will offer a general map for both of these spaces, of the
"anarchy" and the "identification."

 Each of the major developments of visual practice in the early twen-
tieth century − the beginnings of non-iconic abstraction, the invention of
collage, and the various-avant-garde equivocations of the art object with
mass-production, popular culture, dreams and the unconscious, political
action, and the everyday − were associated with important rearticulations
of the titular function. Titles took on roles and agendas, which, though

often predicated on the nominal developments of the later nineteenth century, gave rise to a striking new field of signifying possibilities. For the pioneer abstractionists the title became a key psychologistic tag (Kandinsky) or an iterative function of formal–utopian design (Mondrian). For the Dada collagists – though, significantly, not for Picasso and Braque, who invented the technique – it was developed as a primary space through which the visual image-ensemble staged its encounter with the outside world, whether in political messages (John Heartfield, George Grosz), or in allusive, poetic appendages (as for Max Ernst and other Surrealists).

If we switch our historical gaze to look *first* across the horizon of titles during the furiously innovative years between 1900 and the 1920s – rather than looking to developments in form, style or iconography – we will find a signifying territory parallel to, but by no means a mirror image of, the familiar landscape etched by the received narratives of visual modernism. As already discussed, the invention of collage, and the rupture of traditional signification associated with it, introduces a new moment of emergence for the practice of the title. But the title also takes on a special relation to post-collage activities (including Duchamp's Readymades, the Berlin Dadaists' photo-collages, Ernst's dream-collages, Ernst's pictorial pseudo-collages, and the neo-avant-garde assemblages, combines, and environments produced in the post-war U.S. art world). There is a sense in which the title played an avant-garde role "before" collage – one that was, I will claim, modeled on an anticipation of its material disruptions. For in the challenge it offered to the constitutionality of the art object, the title became the very agent of avant-garde parergonism. Its disposition in relation to the work it named, described, supplemented, or otherwise interfered with, is the relay-station for the interdiscursivity of the artwork, the place where the image or the object stages its encounter with the world. It is the virtual space of its production into meaning. Thus, the reinflections of the avant-garde title can legitimately be termed the first collages. And, as with the pasted papers of Braque and Picasso, they negotiated a new signifying space that was, by turns, informational, decorative, "poetic," or absurdist.

I Max Ernst: Titles and the "No Longer" of Painting

> In his new texts and captions Ernst confronted the rare word,
> the exquisite poetic image, the purple passage, with the
> insurmountably alien barbarism of one-dimensional objective
> naming.
>
> – Werner Spies, *Max Ernst: A Retrospective* (1991)[3]

I want to begin by considering the essay by Louis Aragon, written for an exhibition of Ernst's collages in March 1930, "La Peinture au défi" ("The Challenge to Painting"). While Aragon often changed his critical colors, the propositions and examples he offers here form a link with the reformulation of visual practice by the early twentieth century avant-garde.[4] He argues that the ends of painting are already glimpsed in an assemblage of ideas that turns on the collage revolution inaugurated by Picasso and Braque in 1911–12. Crucial to the understanding of these "ends" are a number of "significant moments" which put "personality on trial": "Duchamp adorning the *Mona Lisa* with a mustache and signing it; Cravan [sic] signing a urinal; Picabia signing an inkblot and titling it the *Sainte Vierge* (*Blessed Virgin*). To me these are the logical consequences of the initial gesture of collage."[5]

This conjunction of the title and the signature represents an important restaging of a complex relation already investigated by Gauguin. Two "breaks" measure the space between these disquisitions on the title, one geo-cultural, the other, material. For Gauguin, it was the often over-whelming Romantic-colonial context of non-Western notions of property, possession (title), and signing that precipitated an inquiry into the conflictual overlap of rights and names in his pictorial documents. For Aragon the technical breakthrough of collage offers a radically new productive mode for visual practice that reorders its signification from a unitary, enframed surface (in the case of painting) to a layering of materials and discourses. The title and the signature represent important horizons in the new, multiple articulation of the artwork. Implicit here is the suggestion, ventured above, that named artworks were already col-lages by virtue of the additive dimension of their titles.

While his essay discusses the work of Braque, Picasso, Picabia, Jacques Vaché (he cites "lost" "collages with scraps of cloth on postcards" made in Nantes in 1916), Miró, Magritte (for whom, he conjectures, the addition of inscribed words was an extension of the collage technique), Dalí, Masson, and Man Ray, Aragon leaves us in no doubt that it is Ernst's collage-experiments, culminating in the three collage novels – *La Femme 100 têtes* (*The Hundred Headless Woman*, 1929), *Rêve d'une petite fille qui voulut entrer au Carmel* (*A Little Girl Dreams of Taking the Veil*, 1930), and *Une Semaine de bonté*, (*A Week of Goodness*, 1934) – that lie at the center of the technical and other dissolutions issuing the "challenge to painting." Even though Aragon conducts his inquiry from a footnote, prominent among these dissolutions and renegotiations is the multifunctionality of the title. Of all the elements in the "inventory of procedures used by Max Ernst to understand the state of collage," "the written component" alone is privileged with an entire paragraph of discussion:

> The title, elevated beyond the descriptive for the first time by Chirico and becoming in Picabia's hands the distant term of a metaphor, with Ernst takes on the proportions of a poem. "Proportions" is to be understood literally: from the word to the paragraph. No one as much as Max Ernst has caused it to be said of his pictures, "This is no longer painting." Doubtless it is because painting knows now how to avoid being painting, with all that is disconcerting about this: to be painting and then to cease to be. I will quote a few examples of title poems. The first two are to be read with the collage, if you approach it; they are written on the collage or in its margin. The third is written on the back; you don't see it with the collage. I am not pointing out this difference from love of detail. I think it pertains to considerations we would like Ernst to explain.[6]

While de Chirico's titles (see fig. 55) were clearly not the first to transgress the parameters of visual description, and Picabia's were not the first to metaphorize the space from image to denomination, Aragon has made a striking claim here: that Ernst's titles are caught up in the very end of painting, that they are in fact measures of its literal and symbolic death. With Ernst the non-descriptive, tropic title has finally got "out of hand." It has been gigantically enlarged, from the "space" of the "word" (or the phrase) to the "paragraph," a magnification in the domain of textuality that answers to a succession of modernist expansions of the image – from Monet's late lily-pond "environments" to the "sheer physical size"[7] noted by Clement Greenberg as a defining characteristic of Abstract Expressionism.

Yet scale is only the most literal of the senses in which the title-text takes on – and eventually over – the function of painting. Aragon carefully specifies the dimensional palpability of Ernst's title-poems, which are inscribed in three different ways in and around the collages they subtend – within the work itself, at its margins, and on the back of the support. The visual image is thus interred by a barrage of textual increments. The titular supplement has absconded with the logic and dimensions of the image, leaving it only with the knowledge of what has been lost, the "no longer" of painting.

Aragon concentrates on Ernst's collage-work around 1929–30 (closer, that is, to the moment in which he was writing). But many, if not quite all, of the tendencies he draws out had already been attempted in Ernst's first collage experiments made between 1919–21 (see fig. 54). Ernst left a well-known description of his founding encounter with "the catalogue of a teaching-aids company" in Cologne in 1919, whose "diversity" and "absurdity" gave rise to "rapidly changing" "confusion" and "hallucina-

tions." He writes of "capturing" the sensations of "newly emerged objects" by means of "a little paint or a few lines" which would "fix" the hallucinatory impression. But as with the later collages, the artist did not leave the matter there. It was, he maintained, crucial that the "hallucination" be "interpreted" "in a few words or sentences," three examples of which he cites.[8]

Critical discussion of Ernst bears out some of what Aragon so perspicaciously noted in his pioneering study, but often resists the radical implications of the title-assisted move to painting's "beyond." Werner Spies, for example, claims that the artist produced "[a]n open-ended oeuvre." Just as significant, I would argue, is that Ernst's work was also "open-begun," supplied as it was with title captions, collaborative pre-texts, and prefaces that traverse the entire signifying range of the titular activity. The critical literature on Ernst stages a median interpretation of

54 Max Ernst, *Stratified rocks, nature's gift of gneiss lava iceland moss 2 kinds of lungwort 2 kinds of ruptures of the perineum growths of the heart (b) the same thing in a well-polished box somewhat more expensive*, 1920. Anatomical engraving altered with gouache and pencil, 15.2 × 20.6. The Museum of Modern Art, New York. Purchase

his innovations as a titler,[9] and outlines a strategy that stands as the paradigm for almost all Surrealist nomination: Ernst's titles are understood as a 'little poetry' that is variously added to and diffused in the image. Not quite part of the picture, yet never separate from its signifying possibil- ities, the title is a connotative supplement that defers the image into a mysterious intensity. Most of the historians and critics who have discussed the relation between the visual and the textual in Dada and Surrealism offer a version of this position. Spies is no exception. For him "[s]uch poetic titles [as *La Puberté proche . . .* (*Approaching Puberty . . .* , 1921) and *Au Dessus des Nuages marche la nuit* (*Above the Clouds Midnight Passes*, 1920)], miniature prose-poems in their own right, evoke a mood in perfect harmony with the metamorphosis of mythical themes found here and in other works of the period."[10]

Dada and Surrealist titles often functioned as one of the crucial means by which the "mysteriousness" and "poetry" solicited by the major protagonists of the movements were conjured up and allocated their ambiguous signifying spaces. The cultivation of ambiguity, by the Surre- alists in particular, was superficially similar to the connotative indulgences of the Symbolists and others in the 1880s and 1890s. But there was a clear difference in the degree of irresolution and opacity between the two movements. Thus, while Redon titled one of his major works *Silence*, the Dada and Surrealist artists took their compulsion for strangeness and dislocation one step further by making literal insistences on the secrecy and mystery they perpetrated. Ernst, Duchamp and de Chirico, working in the "pre-Surrealist" phase, provide some of the most obvious examples of this tendency. De Chirico, in particular, drew fastidious attention to his cultivation of enigma by posting titles such as *L'Enigma di un pomeriggio d'autunno* (*The Enigma of an Afternoon*, 1910); *L'Enigma di una giornata* (*The Enigma of Day*, 1914, fig. 55); or the many versions of *Le muse inquietani* (*The Disquieting Muses*, first version 1917). Duchamp titled an assisted Readymade *A Bruit secret* (*With Hidden Noise*, 1916, fig. 56). Ernst used many titles that flirted with mystery, including *Dans une Ville pleine de mystères et . . .* (*In a Town Full of Mystery and . . .*), 1923/24. Spies argues that "[o]ne might interpret a painting title such as *People Won't Know a Thing About It* (1923, Tate Gallery) as expressing Max Ernst's demiurgic pride in creating unknown and unseen."[11]

In *Au-delà de la Peinture* (*Beyond Painting*, 1936) Ernst insisted that the "nomenclature" of his collages ought to be committed to memory by "every child worthy of the name." Rote memorization of the collage titles is facilitated by the provision of a long list of his favored names, a device he used several times,[12] which promotes the serial or collective apprehension of the names:

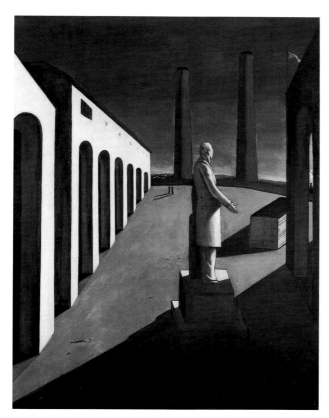

55 Giorgio de Chirico, *The Enigma of Day*, 1914. 185.5 × 139.7. The Museum of Modern Art, New York. James Thrall Soby Bequest

The Phallustrade. Great Dadaists Cast their Shadows Forwards. Bonemill of Non-violent Barbers. Flowing Relief, Taken from the Lung of a 47-year-old Smoker. Bitterness of a Mattress. The Preparation of Glue from Bones. Hypertrophic Trophy. Noli me derigere. Fluidoskeptic of Rotzwitha von Gandersheim. A Dirty Old Man, Armed, Protecting Museum Spring Fashions from Dadaist Attack. The Little Tear Gland that Says Tic-Tac. Approaching Puberty Has Not Yet Blurred the Delicate Grace of our Pleiades. Our Umbrous Eyes Watching the Falling Paving Stone. The Gravitation of Light Waves is Still Up in the Air.

Winter Landscape: Gasification of the Vulcanized Iron Bride to Produce the Necessary Bed Warmth. A Little Machine Built by Minimax-Dadamax for the Fearless Pollenation of Female Suction Cups in Early Menopause and Similar Fruitless Efforts. Everything is

Still Up in the Air Here. The Master's Bedroom – It's Worth Spending
a Night There. Dada Degas, Dada Gauguin. The Volume of the Man
Can Be Calculated from the Accessories of the Woman. Erectio sine
qua non. In the Midst of their Growth Women are Carefully Poisoned
and Bottled. The Little American Girl We're Promoting This Year
Gleefully Offers her Breast to Seals. Katharina Ondulata, i.e., Mine
Hostess on the Lahn, Appears as a German Angel and Mother of Pearl
on Cork Soles in the Sign of Cancer Katharina Ondulata.

Above the Clouds Midnight Passes. Above Midnight Glides the
Invisible Bird of Day. A Little Higher than the Bird, the Ether Spreads
and the Walls and Roofs Float.[13]

As a means to resist the temptation either to narrativize or poeticize this
list, I want to suggest that Ernst's remarks about the use of the title for a
kind of children's "Dada-education" is not fortuitous. Several of the titles,
beginning of course with *The Phallustrade*, refer directly to the various
stages of life: birth, the primal scene of *Das Schlafzimmer des Meisters/La
Chambre à coucher de Max Ernst* (*The Master's Bedroom*); childhood and
adolescence, *The Little American Girl . . .* , *La Puberté proche n'a pas encore
enlevé la grâce tenue de nos pléiades* (*Approaching Puberty Has Not Yet Blurred
the Delicate Grace of our Pleiades*), *In the Midst of Their Growth Women
Are . . .*; maturity, . . . *Female Suction Cups in Early Menopause, Flowing
Relief, Taken from the Lung of a 47 year-old Smoker;* old age, *A Dirty Old
Man, Armed.* Interspersed with these Dada variants on "The Ages of
Man" is a clear subtext on reproduction and growth – a Dada "Birds and
the Bees," also launched by the delicious ambiguity of *The Phallustrade*,
complete with anatomical and sexual references to bones, breasts, erec-
tion, a tear gland, and warm beds – and underlined by a more consciously
poetic sense of violence, menace, or the unknown, which might be
summed up in "The Bitterness of the Mattress."

There are also references to a number of names – including *Dada Degas*
(c. 1920/21) and *Dada Gauguin* (1920), *Rotzwitha von Gandersheim*, and
Katharina Ondulata (1920) – as well as to other unspecified protagonists
who fill in for the nominal identities of the "Ages" and the "Birds."
Finally, Ernst locates his titular biology lesson and its dramatis personae in
a decisively indefinite atmosphere. One title is key here, for it breaks up
the sequence of the nominal pedagogy and is the only one accorded a
paragraph of its own: *Winterlandschaft: Vergasung der vulcanisierten Eisenbraut
zur Erzeugung der nötigen Bettwärme* (*Winter Landscape: Gasification of the
Vulcanized Iron Bride to Produce the Necessary Bed Warmth*, 1921). The
Duchampian mechano-sexual subtitle offers an impression or effect gov-
erning the "winter landscape," that looks back to Duchamp's imagination

of the "snow effects" jotted above his sketch for the "gas with cones" for the *Large Glass*.[14] If "Great Dadaists Cast their Shadows Forwards," as Ernst suggests, this means that the sun is behind them, and thus, if we look at them face on, "out of the picture." In Ernst's world what replaces the solar impression is a domain of gasification, darkness, clouds, shadows, blurs, and ether. It is quite literally a counter-Impressionist space, a scene in which "The Gravitation of Light Waves is Still Up in the Air." The clear light of day, with its Impressionist names, is replaced by the opaque darkness of night (allegorized in ever less transparent layers in the three-title finale of Ernst's catalogue) and supplied with a fantastic pseudo-pedagogy of bodies, organs and sensations.

The tension I am suggesting in this list between instruction and poetry, science and literature, biology and the erotic, marks one of several forms of interpretational dialogue that usefully dispute with what we can term the "poetic priority" of Ernst's titles. Spies, in the most consolidated recent account of Ernst's collages, and Aragon, in the most suggestive contemporary one, both offer and refuse the poetic as a measure for the effect of this work. Ernst himself also seemed ambiguously uncomfortable with the designation, noting that the "art criticism" that attended his 1921 exhibition thought his collages "[w]ithout sculptural value, but poetic."[15]

Spies outlines the role of the title in Ernst's earliest collages in the following terms:

> They tend merely to describe or echo the visual material, and they bristle with technical jargon. Most of them are paratactic, catalogue-style titles full of compound words and nonsense neologisms. And they are more than titles – they belong intrinsically to the composition, and this in a new sense: the titles plus the pictorial elements constitute the works. Sometimes an image is framed in lines of text at the top and bottom, which create a functional link between two means of expression comparable to that of medieval illuminated manuscripts. These titles were secularly inspired, however, their configuration and composition resembling the mixtures of text and illustration typical of technical and scientific publications.[16]

He concurs with Aragon's emphasis on "the expanded significance of titles," noting their transgeneric dislocation of the traditional categories of painting and drawing. Such layering and overlap between visuality and textuality was different in kind from the relatively separate visual and textual practices of Hans Arp and must be distinguished again from the relative literary disparagement of visual Surrealism by Breton and the *Littérature* group. According to Spies, Ernst's early collages "involved a

subjective reinterpretation of existing forms, [and] depended on illustrative material that was always functionally related to its accompanying text." This illustrative image-text *ensemble* formed the basis of Ernst's unique exchange between "two semiotic levels."[17]

Spies further specifies the range of technical language deployed, or re-used, by Ernst:

> In the titles to collages made up of various kinds of technical illustrations, such terms and phrases appear as hydrometric demonstration, temperature, gasification, vulcanized, for the production of, 5 items, sheet copper, sheet zinc, rubberized cloth, rock strata, gneis, lava, Icelandic moss, models, lungwort, icicles, mineral varieties, holohedral, sulfate, silicate, industry, anatomy, paleontology, spindles, turnbuckles, fuselage, corolla, capillary tubes, tissue, detail, pollenation, suction cups, and equipment.[18]

The titular disposition of these words might involve straight description or enumeration, "false etymologies," diminutives, neologism, alliteration, onomatopoeia, and "poetic persiflages of other languages." Spies determines that many of these usages are not specifically automatic, and, further, that Ernst's dependence on scientific and technical knowledge revealed a non- or para–aesthetic attitude towards the appropriation and redisposition of material: "Deprived of their function, torn from their utilitarian context, these words and visual elements now began to destabilize an *écriture automatique* which was still heavily reliant on the hermetic tradition of Symbolism."[19] In Spies's account then, "the crux of Max Ernst's approach," conditioned by his preference for visual and textual "quotations and techniques which were foreign to fine art," was not just "the destruction of the poetic image," but a contestation of the post-Romantic, Surrealist "poetization of the world."[20]

Having raised the question of the poetic signification of the visual-textual sign, Aragon also took issue with the poetic designation of Ernst's titles – even before it had become the preferred interpretational shorthand of a rising generation of historians and critics of Surrealism. Noting that "[p]eople have tried in the past to reduce Max Ernst's collages to plastic poems,"[21] he claims that what is specific to collage is not, in fact, a vague sense of "poetic unity," but a fundamental "incoherence" – a mode of signification that is always doubled, transient, and in the process of supplementation. This loop of plural meanings no doubt appealed to Aragon's sense of "dialectic." It also stands as another example of the refusal of the most committed critics of Dada and Surrealism to bracket their meanings into closed semantic systems. The process of discursive exchange between visuality and textuality envisaged by Aragon during

the transitional moment between the two movements, and in Ernst's work as a whole until the early 1930s, gives rise to a whole range of renegotiations. Thus, in discussing the eclipse of "personality," and the annexation of the "manufactured object" (such that "[a]n electric lamp becomes for Picabia a young girl") Aragon poses the possibility that "painters are truly beginning to use objects as words."[22]

Once again the title is the privileged, nodal point in a complex system of visual-textual switches. It mediates between the manufactured object and its metaphoric redesignation. It participates in the reallocation of the work of the signature from a mark of identification to a gestural sign. It abets the transfiguration of the image into an object or a name. And it presides over the eventual replacement of painting through its own scaled expansion on the disputed model of the "poem." The broken, plastic "poem"; the machinic-diagrammatic "portrait"; the de-personalized signature; the Duchampian designations underwritten in the Readymade; the dream-split image-title; and the founding strategy of collage: these indices of visual-textual splicing that Aragon brings together in his discussion of the Surrealist extrapolation of the logic of Cubism into the "beyond" of painting will be used to structure what follows in this chapter.

ii Marcel Duchamp: "Prime Words" and Inscriptions

> [Dalí] – "You would have been a perfect man to be a king, a king crowned in the town of Rouen, there where you found the marvelous *Chocolate Grinder*.
> [Duchamp] – Why?
> [Dalí] – Because all your titles are based on kings and queens. And the most ingenious of all is *The King and Queen Traversed by Swift Nudes*. This represents the entire genetic program of the movement discovered by Leibnitz, which took off from certain passages from Malebranche. The genetic speed which traverses the King and Queen!"
> Because of this title alone, Duchamp has become one of the most important painters and poets of our time.
>
> – Salvador Dalí, "The King and Queen Traversed by Swift Nudes"[23]

The space between the title and the image had been opened up by the hyper-connotations of the Symbolists and reinvented by the Cubist inscription and superimposition of text. Duchamp not only raises the

stakes of these titular inventions to their (il)logical extremes, but also stands as the first avant-garde artist actively to dislocate the syntax of the title and to fold its signification so radically into the conceptual-visual signification of the *work* that the dissemination of the text becomes the key agent in the post-collage "beyond" of the image. Despite the wit and inventiveness of Ernst's titles and their material formats, it was Duchamp above all who anticipated the destiny of the super-text of the title described by Aragon.

The signifying range of Duchamp's titles and the variousness of their orders of interaction with the images, objects, and exhibitions around which they circulate represent probably the fullest and most diverse repertoire of titular activities in the history of visual representation. As suggestions for the interpretation of the visual and textual field of Duchampian signification are legion, my comments here will be limited to a brief survey that foregrounds the new work of his titles. I will outline what appear to be the chief *modalities* of the Duchampian title – the major orders of signification which, considered together, open up the titular activity to an astonishing conjugation of functions.

Perhaps the governing order of the Duchampian title is that of *inscription*. From his early works in India ink, Conté crayon, watercolor, or pencil, made around 1908, Duchamp practiced the inscription of text on or within the work, handwriting pointed captions or dialogue into the image. One of the first of his inscribed works was *Flirt* (1907), whose caption-text joining the "impression," the title, and musical reference was discussed at the end of chapter 2. From this moment on, inscribed text is a crucial adjunct of the Duchampian visual sign. In addition to captions and snatches of dialogue, Duchamp inscribed his titles, his signature – sometimes doubled, as in the superimposed names on *Landscape* (1911) – dates, places, comments, notes, "explanations," and various other puns, phrases, and asides. Sometimes these were limited to the restatement of an image's subject matter. Sometimes they were extensive, running to several lines of notes and commentary – as in the pencilled text in the upper right margin of *Cimetière des uniformes et livrées* (*Cemetery of Uniforms and Liveries, No. 2*, 1914), and numerous other works.

Following the drawings and paintings produced between 1907 and around 1912, this practice was continued with the Readymades after 1913. Designated by a phrase generated in 1915, which referred to a preliminary piece of 1913, and extending as a series until around 1921, the Readymades are denominated in a vividly full repertoire of titular functions. The earliest of the series, *Roue de bicyclette* (*Bicycle Wheel*, 1913) still bears a traditional identificatory title that labels and describes the object Duchamp appropriated from the "real world." However, as Ulf

Linde points out, the similarly titled *Egouttoir (Porte-bouteilles; Hérisson)* (*Bottle Drainer; Bottle Dryer*, 1914) might "[i]n the last resort . . . be defined as a kind of torso since its title has been lost. The original title disappeared with the composition and Duchamp does not remember it anymore."[24] As the irregular sequence of the Readymades continues, a spectrum of nominal types and inscribed "proximal" text accompanies the found, re-presented, and occasionally assisted objects.

Duchamp's *Fountain*, signed R. Mutt, was rejected from the Society of Independent Artists' "open" exhibition in 1917. That year he wrote a brief article for the short-lived magazine *The Blind Man*, financed by Walter Arensberg, who had also contributed to *291*, "The Richard Mutt Case":

> They say any artist paying six dollars may exhibit. Mr. Richard Mutt sent in a fountain. Without discussion this article disappeared and never was exhibited. What were the grounds for refusing Mr. Mutt's fountain: − 1. Some contended it was immoral, vulgar. 2. Others, it was plagiarism, a plain piece of plumbing.
> Now Mr. Mutt's fountain is not immoral, that is absurd, no more than a bathtub is immoral. It is a fixture that you see every day in plumbers' show windows. Whether Mr. Mutt with his own hands made the fountain or not has no importance. He CHOSE it. He took an ordinary article of life, placed it so that its useful significance disappeared under the new title and point of view − created a new thought for that object. As for plumbing, that is absurd. The only works of art America has given are her plumbing and her bridges.[25]

The work of the "new title and point of view" in *Fountain* is summarized by William Camfield according to three gestures: "He rotated it 90° from its normal functional position, inscribed it 'R. MUTT 1917' and named it *Fountain*. To date, there is no record that he ever explained the name or the 90° rotation of the urinal, but he did comment on the signature of the fictitious artist, R. Mutt . . . in a 1966 interview."[26] Linde, whose discussion of Duchamp is one of several that privilege the linguistic (textual–verbal–phonetic) axis of the work, finds that "the word *fonte* (= *moulase* = moulding) can also be heard in this title − at least a feeble echo of it can, and this is stressing the allusion to the illuminating gas once again."[27]

There are many forms and significations of the inscribed Readymades. *In Advance of the Broken Arm*, for example, is an inscribed snow shovel, originally presented in November 1915, in New York. The inscription reads "In Advance of the broken Arm/ [from] Marcel Duchamp." Arturo Schwarz explains that "the square brackets which enclose the word 'from'

56 Marcel Duchamp, *A Bruit
secret (With Hidden Noise)*,
1916. Metal and twine,
12.7 cm high. Philadelphia
Museum of Art. Louise and
Walter Arensberg Collection

were used to emphasize the meaning 'coming from,' equivalent to the
French expression *venant de*, in order to make it clear that this item was
not *made* by Duchamp but was *coming from* him."[28] *With Hidden Noise* (fig.
56) has been defined as the first "assisted Readymade." It has inscriptions
engraved on the top of the upper and on the bottom of the lower plate:
"Duchamp intentionally made them unintelligible by omitting letters
from each of the words according to a system he had already used in a
poem written in English and dedicated to Arensberg in which the article
'the' was left out each time."[29]

 Apolinère Enameled (1916–17) takes the form of a painted tin advertise-
ment for Sapolin Enamel with modified wording. It is cited, along with
L.H.O.O.Q. (1919, fig. 57) – whose inscribed title reads in French as
"elle a chaud au cul" ("she has a hot ass") – and *Fresh Widow* (1920) – a
semi-Readymade in the form of a miniature French window inscribed on
its base in black paper-tape letters with the phrase "FRESH WIDOW COPY-
RIGHT ROSE SELAVY 1920" – as one of a number of Readymades made as
"the plastic identification of a pun . . . or the projection into the future of
its realization."[30] Such plastic identifications of word-play were extended
in Duchamp's occasional later works, such as *Objet-Dard* (*Dart-Object/Art
Object*, 1951), a galvanized plaster sculpture with inlaid lead rib, which

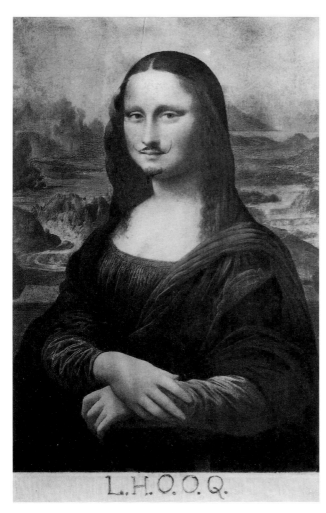

57 Marcel Duchamp,
L.H.O.O.Q., 1919.
Readymade, 19.7 × 12.4.
Pierre Matisse Gallery, New
York

Schwarz describes as a "'three-dimensional pun': the word *dard* is a
homophone of *d'art*."[31] Writing of his "inscription" on *Pharmacie* (*Phar-
macy*, 1914) in the "Specifications for 'Readymades'" – notes included in
the *Boîte verte* (*Green Box*, 1934) – Duchamp notes that title, date, and
signature become "information" concerning its transformation into a
Readymade. Planned in advance according to a gesture of inscription, the
title-inscription becomes Duchamp's preferred mode of designation for
the Readymade. He writes a memo: "Find inscription for Woolworth
Building as Readymade."

For Robert Lebel, the permanent residues left by the word blur any clear separation between the various acts of punning, inscription, and retrieving objects: "Duchamp's objects and puns are cast," he writes, "with the same material. . . . The *Sculpture for Travelling* and the *Unhappy Ready-made*, which have been destroyed, are as immediate, thanks to their titles, as such recently realized objects as the *Female Fig Leaf, Object-Dart,* or *Wedge of Chastity*. For Duchamp, the loftily humorous act of naming them constitutes the creative process *par excellence*."[32] There are, of course, several exceptions and reversals, to Lebel's logic, including the "lost" inscription on the first Readymade. But his is a clear manifesto of the priority of humor and naming as the joint agents of Duchampian re-creation.

As with the drawn and painted images, many of the Readymades carry extra sentences that shift the object into a different order of signification. Duchamp wrote of them as follows:

> One important characteristic was the short sentence which I occasion-ally inscribed on the "readymade." That sentence instead of describing the object like a title was meant to carry the mind of the spectator towards other regions more verbal.[33]

In his view the "short sentence" inscription was an explicit counter-title that "carried" the object into an associative dimension beyond description and denotation. For the so-called "unassisted" Readymades, such as *Bottle Drainer*, the physical inscription of Duchamp's name, the date, and in this case a text that has been "forgotten" with the loss of the "original," represents almost the entirety of the labor invested in the piece. Even though he details the loss, and with it the text that was engraved "on the bottom ring," Schwarz overlooks these modifications when he notes that *Bottle Drainer* was Duchamp's "first Ready-made in the full sense of the word, since it was not modified in any way."[34]

Whether drawings, paintings, found objects, optical disks, diagrams, jottings, notes, or ensembles, there is virtually nothing in the Duchamp oeuvre that was not interfered with or otherwise "assisted" by the inscription of text. This insistent textualization of image-objects thus becomes the foundational gesture of the Duchampian sign. Returning to Aragon's proposition, we can say that it completes the journey of the collage-supplement into the written "beyond" of painting.

We have already encountered one significant exception to the inscrip-tive repertoire of Duchamp's works — his first Readymade, *Bicycle Wheel*. While the "original" work was lost, its "history" and subsequent market retrieval offers further evidence of the commercial valency and exhibition value of the title. According to Schwarz, the 1913 version of the "bicycle

fork with its wheel screwed upside down onto a kitchen stool painted white" had "[n]o inscription" and "no signature." However, at least two of the subsequent reproductions – those of 1951, which was "signed and dated at a second stage," and the eight "first-full scale replicas issued [on the occasion of the fiftieth anniversary of the first Readymade] under the direct supervision of Duchamp on the basis of a blueprint derived from photos of the lost original" in June 1964 – decisively made up for the absence of the signature and inscription.[35] In this last case the sanctioned re-inscription of the work is particularly elaborate, including at least three modes of writing over the textless original:

> Under the seat of the stool, in black ink: *Marcel Duchamp, 1964/ 1/8 to 8/8.* Below the autograph signature, a small copperplate has been screwed, on which Duchamp etched signature, date and number of the example; at the bottom of the plate, title, original date, and publisher's name are etched in printed capital letters.[36]

To this litany of solicitous confirmations of the museological and commercial value of the object – the autographic signature, the scrupulously numbered limited edition, the exhibition-worthy copperplate, the date, the "publisher's name," the capital letters – yet another exception to the non-inscription of the lost original is made in the form of an "extra copy" "inscribed to the Philadelphia Museum of Art."[37] These recapitulations of the lost inscription testify first to the attributed power that their substitution attempts to reconvene. Second, the non-supplemental parameters of the inscription, its iterated, bare-bones listing of official attributes, are assembled for and by the gallery-salesroom, and the museum display. Duchamp himself (the "original" Duchamp) once gamed with the space of the name and had a "long-avowed reluctance to exhibit."[38] Yet here, much later, the (absent) name (for neither the title, nor any of the non-descriptive "information" Duchamp aligned in the inscriptions on his other Readymades are present) is supplanted by the redemptive institutionality of the re-made-Readymade. The Schwarz-assisted recalibration of the *Bicycle Wheel* offers to convert the conceptual aura of the Readymade into commercial and institutional exchange value at the height of Duchamp's postwar celebrity. This is yet another reminder that the long fuse of commerciality is carefully threaded through the nominal space of the neo-avant-garde.

If inscription, and its "seductive obscurity,"[39] constitutes the main ground of Duchamp's titular significations, then their principal mode of elaboration is bound up in a complex attitude towards textual-verbal signification which privileged allusion, puns, anagrams, cryptograms, and suggestive brevity. Duchamp took on a form of condensation of the title

that resembled the dream-like reductions and superimpositions described by Freud in the *Interpretation of Dreams*.[40] Yet, as with many of the practices considered here, an account of the function of these titles depends on a wider understanding of the artist's conception of textuality. In an interview with James Johnson Sweeney in 1946, Duchamp emphasized that "Dada was an extreme protest against the physical side of painting. It was a metaphysical attitude. It was intimately and consciously involved with literature." Within the "literary metaphysics" alluded to here, Duchamp leaves no doubt concerning the significance of naming: "For me the title was very important."[41]

Like Kandinsky and Mondrian, Duchamp was seduced by the possibility of reinventing the social and visual conventions of painting and sculpture. And like them – only with much more speculative precision – he reserved a special place in his reckoning for language. A key section of his "Notes" (from approximately no. 19 to 29) reflects on the possibility of reformulating the organizational matrix for languages, whether in the form of a new "alphabet" or in a modified "dictionary." An important condition of this restructuring was Duchamp's desire to mobilize the exchange-value of words (and letters). In one thought the unitary letters of the alphabet would be replaced by "films that would convey the significance of groups of sentences or words."[42] In another, he searched "for words that could be the equivalents of the non-visible colors."[43] And, like many artists and writers in the 1910s and 1920s he pursued the dream of integrating visual and textual languages on the basis of "the ideogram of the Chinese language"[44] or another form of "schematic sign" that would designate "abstract words" copied from "a Larousse dictionary." Duchamp proposed the compilation of several of these type-specific lists within the ordered field of language represented by the dictionary. These piles of associated words, which he termed "prime words," would function as reservoirs for the generation of new modalities of linguistic exchange. They would be subject to an elaborate and elusive connectivity in the form of a new grammar that traduced traditional "pedagogical sentence construction."

Duchamp once noted that the governing principles of his working method for the *Large Glass* (fig. 58) might be found in Roussel; and it is from Roussel himself that one of the most convincing outlines of Duchampian textuality can be found: In *Comment j'ai écrit certain de mes livres* Roussel writes:

Creative work [is] based on the coupling of two words which are taken in two different senses. . . . This procedure, in fact, is related to the use of rhyme. In the two cases, the creative act is an unexpected one

58 Marcel Duchamp, *The Large Glass: The Bride Stripped Bare by Her Bachelors, Even*, 1915–23. Oil and lead wire on glass, 277.5 × 175.6. Philadelphia Museum of Art. Bequest of Katherine S. Dreier

resulting from coincidences in the sounds of words. Such an approach is essentially poetic.[45]

The interpretation of Duchamp's Rousellian management of the title has been varied. Lawrence Steefel writes that "wherever Duchamp assigns a title or a punning syntax to an abstract image or unconventional form, a sensation of expansion of the form in question occurs insofar as the viewer superimposes a phantom or associative image on the material at hand." In this understanding the title takes its place as one of a number of "movements" within and between the work and its referentiality which engender "a sense of transformation" and "expansion."[46]

While Duchamp apparently published his first pun only in 1921 (in Picabia's *391*), the titles of his Readymades had already created a whole repertoire of both textual and visual word-plays. The most obvious of Duchamp title-puns are *Fresh Widow* and *L.H.O.O.Q.* (fig. 57). The anagrammatic and other dislocations of Duchamp's titular texts were part of a broader field of verbal plays that occasioned commentary from André Breton in a 1922 article "Words Without Wrinkles," later anthologized in *Rrose Sélavy* (1939). Breton writes of how:

> The "alchemy of the word" was followed by a veritable "chemistry" that first of all went about the task of discovering the properties of the word — only one of which, "meaning," is specified in the dictionary. The need was, first, to consider the word in itself, and second, to study the reactions of words one upon another as exhaustively as possible.[47]

Breton opposes the "dead weight" of "etymology" and the "mediocrity" of "utilitarian syntax" and embraces a "domain of poetry" that puts paid to "the innocence of words" and deals above all in "images." "It was," claims Breton, "by assigning colors to the vowels that the word, for the first time, consciously and in acceptance of all the consequences, was released from the duty of having a meaning."[48]

The encrypted title, the name that can be decoded or split into two — or more — punning fractions, was sometimes defeated by names and inscriptions that implode meaning into deliberate dissociation. *Peigne* (*Comb*, 1916) is supplied with pedantically definite date and time — perhaps in ironic reference to the Impressionist vogue for geographical and climatological specificity: "FEB. 17 1916 11 A.M." It is also accompanied by a French inscription: 3 OU 4 GOUTTES DE HAUTEUR N'ONT RIEN A FAIRE AVEC LA SAUVAGERIES," which can be translated as "three or four drops of loftiness have nothing to do with savagery." Such grammatically correct, but seemingly nonsensical, statements are yet another of the Dada and Surrealist productions that commentators have sought to bracket under the rubric of the "poetic." In his entry on *Comb*, Schwarz states

that "Duchamp's frequent practice of associating elements which have nothing to do with each other ... is a practice which, when applied to language, has the poetic image as its end product."[49] But the non-sequitur is not the same as the "poetic image." *"Why Not Sneeze Rose Sélavy"* (1921) is defined as a "semi-Ready-Made: 152 marble cubes in the shape of sugar lumps with thermometer and cuttle bone in a small birdcage fitted with four wooden bars."[50] Its title is inscribed in black paper-tape letters on the underside of the cage. Discussing the work on French television with Jean-Marie Drot in 1963, Duchamp explicitly noted the "dissociational gap" he sought to open up between the title and the object:

> [O]f course, the title seems weird to you since there's really no connection between the sugar cubes and a sneeze. . . . [T]here's the dissociational gap. . . . [T]he answer to the question, Why not sneeze? is simply that you can't sneeze *at will!* . . . And then there's the literary side, if I may call it that . . . but "literary" is such a stupid word. . . . [I]t doesn't mean anything . . . but at any rate there's the marble with its coldness, and this meant that you can even say you're cold because of the marble, and all the associations are permissible.[51]

Some pieces, such as *Rendez-vous du dimanche 6 février 1916* (*Rendezvous of Sunday 6 February 1916*), four postcards covered with typewritten texts and addressed to the Arensbergs in New York City, take the translogic of the text to an extreme. The spin of such inscriptions out of the domain of public cogency imbues the text-object with a non-decodable "mysteriousness" not as over-calculated as that deliberately lodged in the signifying field by mystery-seeking titles such as those discussed above. But, according to Schwarz, even in cases such as this, the text is always partly legible.[52]

The non-sense inscription is one extreme of a titular field whose other dimension Duchamp has also thought and redeemed. For some of his smaller titles operate as one (or two) of those "prime words divisible only by themselves and by unity," which Duchamp considered one of the essential "conditions" for the elaboration of a new "language."[53] Such empowered words are his answer to the formal and psychological investments gathered up by Mondrian and Kandinsky in *composition* – the most powerful title-word in the development of visual modernism.

Duchamp also used later restagings of the title to revise the signification of some of his earlier work. Thus an oil on hardboard painting from about 1909, originally titled *Nude with Green Hair* was renamed by the artist *Nude on Nude*, when, according to Schwarz, "he noticed that the nude is overpainted vertically on the buttocks of a larger nude lying horizontally"[54] Conversely, he at least once avoided titular revisionism

when the printer of a pamphlet he co-edited from New York in 1917 transformed it into *Rongwrong* (as opposed to *Wrongwrong*).

Few discussions of the Readymades refer them back to the history of the nineteenth-century industrial design and production of commercial objects. Molly Nesbit, however, argues that Duchamp's Readymades are models "taken out of circulation, often given an absurd title, hung in a limbo, and effectively silenced."[55] In this interpretation, Duchamp's project is held to reconvert the energy of the name from its inscription in industrial production and instructional pedagogy in nineteenth-century France:

> At the heart of the program sat the object of everyday life, or better, objects, which were named and prescribed in the certification for drawing teachers and repeated, without being specified individually, in the manuals used in the schools.[56]

While the notion that Duchamp's seizing of objects was an escape from "the tyranny of the shop window"[57] is provocative, the claim that the Readymades are regulated by a kind of capitulation to silence does not square well with the complexly folded nominative energies they enclose. It might be that Duchamp quieted the functional, received name of the common, mass-produced utility, but far from silencing the object-commodity, he clamorously realigned its signification in the counter-space between production, the art world, the market, and the name.

Against these larger understandings of the title, it must be noted that the stakes of the name, the inscription, and the signature have also provided grounds for the debunking of Duchamp. Donald Kuspit, for example, associates the artist with "The End of Creative Imagination." In comparison (both explicit and implicit) with Matisse, he claims that Duchamp's withdrawal from the fabrication of work amounts not to a triumph of the conceptual imagination, but rather to a nihilistic declaration of artistic bankruptcy, predicated on "disgust with the body." For Kuspit, "the readymade is the residue of self-castration," and its signature is a "swindle":

> But who was "Duchamp"? Only another name. Dressed in the name, as in the emperor's (artist's) new clothes – or rather dressed in the old clothing of the artist's signature – the readymade remained the same, that is, ordinary. And so did the artist, that is, he remained an ordinary man with an ordinary signature."[58]

Duchamp's refusals are mis-understood only as reversions to sameness. They give rise to nothing more than the residues of commonality and averageness, to things and to titles already there or minimally altered. The

name is naked and transparent because it is already *given*. In a series of gestures including the use of glass and the clever calculation of miniature modifications, Duchamp, of course, had already thought through the implications of transparency, of things already assumed and said. Indeed the relation between the cliché and the Readymade is one of the crucial negotiations he offers between the cultural and industrial histories of modern France.[59]

What Kuspit fails to understand here are the re-creative possibilities of a *field* of nuanced interventions in the signifying economy or system of exchange between visual and textual signs. He refuses to admit that the name participates not just in the act of repetitive self-designation, but in a project that refutes precisely the normativities and reductions he attributes to Duchamp. For the Duchampian title is the locus of a radical attempt to unfasten traditional linguistic systems – alphabets, dictionaries, letters, grammars, and so on – and to problematize, sexualize, ironize and humorize the agencies of referentiality. In addition to the various modes of titling in play among the Readymades, Lebel has identified a further set of "verbal ready-mades" which Duchamp "let fall in the accidents of conversation" "in which meanings overlap and interpenetrate in lapidary expressions." Such efforts are interlingual, operating in both English and French, and in "the 'contamination' of the two languages":

> Proceeding as he did by the sudden flash of assonance, all he needed were ingenious substitutions of syllables in order to explode the logical framework of the phrase. He disclosed in the very depths of the most commonplace speech the lightening-like brilliance of "primary" words which conventional usage disfigures.[60]

Later, in the second version of his rotary demisphere (*Rotative Demisphère [Optique de Précision]*, 1925), one of the copper discs that frames and turns with the sphere is engraved with an alliterative sentence: "Rrose Sélavy et moi esquivons les ecchymoses des esquimaux aux mots exquis." ("Rrose Sélavy and I dodge the bruises of golden-tongued Eskimoes").

By using an endless series of puns, anagrams, alliterations, broken syntax, split phrases, neologisms, "prime words," random associations, ideograms, word-colors, "schematic signs," and yet other forms of found, "discovered," and "altered" text, Duchamp has raised the stakes of the equivocation between the image and the title, the visual and the textual, to one of the most powerful "beyonds" of painting. Only in the Conceptual art movement of the late 1960s and 1970s will the visual valency of writing be explored with such finesse – though the exquisite control that Duchamp invested in the adjacencies of the title are surrendered in the later movement to the more reductively expansive allures of critical and informational self-reflection.

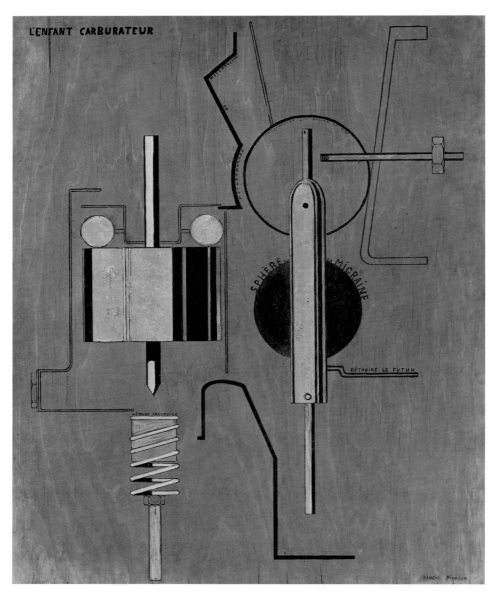

59 Francis Picabia, *The Child Carburetor*, 1919. Oil, enamel, metallic paint, gold leaf, pencil, and crayon on stained plywood, 126.3 × 101.3. Solomon R. Guggenheim Museum, New York, Gift, Solomon R. Guggenheim, 1937

III Francis Picabia: Names, Bodies, Diagrams, and Counter-Identities

If Duchamp's "pictorial nominalism"[61] is forged through the crisis and cross-identification of words and objects, Picabia's work during the 1910s contends with a long history of dispute between the subject and the name – a conflict that would in some sense be clinched in Magritte's radical nominative disjunctions. In 1913 Picabia gave an interview with Henry Tyrrell for *World Magazine* just before the opening of the Armory Show in New York, in which he proposed a theory of image-naming and -reading that summed up his newly developed theories of pictorial association and non-iconic reference. The moment of this interview marks the finale, or plateau, of his long dalliance with the theories and styles first of Impressionism and Post-Impressionism, and then of Symbolism and Cubism. It marks the threshold of a new tendency Picabia named "Amorphism." In the course of the discussion Tyrrell poses the question: "One of your pictures, which we heard was a storm centre at the last Autumn Salon in Paris, was entitled *Danse à la source* or 'Dance at the Spring'[62] – wasn't that a figure composition in a recognisable scene or place?" Picabia's reply makes reference to a form of late-Symbolist pictorial associationism – what he calls "equilibriumizing" later in the same interview:

> No, my dear Sir, it was nothing of the sort. There are no dancers, no spring, no sky, no sunlight, no perspective, nothing whatever in the way of a visible clue to the feelings I am trying to express. You don't find any of these things in Beethoven's Pastoral Symphony, either. There is the title, indicating the motif, that is sufficient. I invite your attention to a song of colors, which without imitation and without commemoration shall make others feel the joyous sensation and sentiments which inspired me on those summer days when I was stopping at a country place on the frontier of Italy, where there was a natural spring of crystalline water in a lovely garden.[63]

Picabia alludes to a Symbolist-supplied, post-Cubist theory of visual expression that denies even a vestigial grounding of recognition or identification in the "visible clues" of the "motif." It is interesting, however, that he is still willing to cite the title as the only ("sufficient") anchorage "indicating the motif." The title will remain a privileged site of 'indication' even in the most radical of his machine-images of the following years – though it will be caught up on the way with a new theory of the *name*. For now, the non-mimetic, and non-"commemorative" musical play of colors is sufficient to provoke in the viewer an experience of the

recollected inspiration that funded the image.[64] We might recall that
Kandinsky and, to a lesser extent, Mondrian, had retooled their own
versions of this post-Symbolist theory of psychological reading in, at first
forcing the image to make a detour past the title, which simply named
the image-as-image, *Composition*, then elaborately redeploying it as a
leading indicator of mood, sensation, and spatial orientation. Here Picabia
has made his own intervention in the nominal scene of the image, closing
it off from the color sensationism of the abstractionists and forcing a crisis
in the naming of the body as its signification was reallocated between
text, diagram, and machine.

Picabia's revolution in the representation of persons was achieved in an
important series of machinic-portrait-diagrams made in the mid-to-late
1910s which shatter the denotative, identificatory assumptions of the
portrait genre[65] – assumptions operative in Baudelaire's early art criticism.
In contrast to the citations of allegorical, religious, topographic, anecdotal,
and historical titles in his "Salon of 1845," Baudelaire makes no effort to
relate the names of the portraits he discusses. Despite the fact that his
writing almost exclusively identifies such painterly effects as "modeling,"
"tonal scale," "magical color," etc., he assumes an easy equivalence
between the painting and the name of the sitter – though he does pause
to admonish what he considers noteworthy failures of likeness, especially
in the case of public figures such as Louis-Philippe.[66] From this moment
on the portrait and its name were to experience a significant history of
experimental modification. It was the parodic transference of the titular
attributes of the "impression" onto the real-life "portrait" of the
"municipal guard" that formed the denouement of LeRoy's commentary
on the First Impressionist Exhibition in 1874. Portrait figures were
subject to some of the first of Whistler's new musical titles, and because
of the disparity between their formal nominations and their ostensible
contents, were deemed more shocking and risible than the artist's darker,
evening-set river- and townscapes. Among the Symbolist-affiliated artists
Signac, notably in his portrait of Fénéon, and Gauguin, in his self-
portraits, also disputed with the normative logic of the transparently
labeled portrait subject. And for Cézanne, and again with Picasso, we
noted that the portrait or figure group was the focus of both conscious
and unconscious forms of sublimated violence and pictorial revisionism.

Picabia subjected the new counter-identities of this revisionary lineage
to another series of shocks. These are anticipated in two key works
painted in the summer of 1913, *Udnie* and *Edtaonisl*, in relation to which
Picabia wrote: "I am thinking more and more of a purer sort of painting,
in a single dimension and without a title. Each picture will have its own
name, created just for it."[67] These single-word "special names" were

condensations of two word phrases, *Udnie* of "une dimension," and *Edtaonisl* of "danseuse étoile."[68] Picabia has rearticulated the site of the title, posing a difference between an identificatory "title" and an original, purposely created, "name." The new name-works exalt in the contracted unidimensionality of both their forms and their names, taking on a relation to the "real world" somewhat like the patterned condensations and ellipses of the unconscious dream- or joke-work (Picabia sent works to the Amsterdam International Exhibition of May-June 1914 called *Comical Force* and *Joking*).

The ironic machinic-portraits made in pen and ink in 1915 are often given pseudo-identificatory titles that offer to divulge the "subject," only to have their nominal linkage severed by the refractory associations of the text-assisted diagram that makes up the "image." Such works include *Voilà Haviland* (*Here's Haviland*, 1915), *Portrait d'une jeune fille américaine dans l'état de nudité* (*Portrait of a Young American Girl in a State of Nudity*, 1915), *Ici, c'est ici Stieglitz* (*Here, This Is Stieglitz Here*, 1915), *Portrait of Max Jacob* (1915), and *De Zayas! De Zayas!* (1915). Other machinic images do not appear to offer the image as a portrait, suggesting, instead, the anonymous, dissociational, or memorial aspects of the dysfunctional diagrams they constitute: *Machine sans nom* (*Machine without Name*, 1915), *Très Rare Tableau sur la terre* (*A Very Rare Picture on Earth*, 1915), and *Cette Chose est faite pour perpétuer mon souvenir* (*This Thing Is Made to Perpetuate My Memory*, 1915).

These works, the counter-"portraits" in particular, have been understood in several ways. Iconographically they cap the hermetic tradition of what has been termed "private, attributive portraiture" pioneered by Manet in his *Portrait of Zola* (1867) and eccentrically developed by Signac in his *Portrait of Fénéon*.[69] They accentuate the deconstruction of the traditional portraitures of art history, recasting more radically what the Symbolists had already begun to defer: identification and particularization – offering the attributes of, and visually idealizing, a social sitter.

In their broadest context Picabia's portraits participate in the general retreat of visual modernism from the shared social codes of public signification, especially the rejection of historical reference and the cultivation of various forms of remoteness from the dominant values of the bourgeois social world. They answer to the anti-materialist removals of the turn-of-the-century – mysticism, symbolism, and abstraction – with a dysfunctional satire of the blueprints of progress.

Picabia's counter-portraiture follows from the generic disruptions already wrought by Signac's portrait of Fénéon, Matisse's explicit relegation of the particulars of a portrait, notably the face, to the decorative effect of the whole composition,[70] and Picasso's text-bearing portraits,

such as *Ma Jolie* (1911–12). In each of these instances we confront a retreat into the private experiences and symbol systems of the representer and the represented, who collude in the production of an image suffused with their private language, many of whose references may only be available and decoded among themselves and within a small group of initiates.

The intimate origin and privately coded circulation of names is typical of the avant-gardist work of art. Discussing the collaboration between Jean Crotti and Suzanne Duchamp, which they designated with their own special name, "Tabu," Camfield notes that the elaboration of a system of "private symbolism . . . [was] a standard feature of much dadaist art" and that Crotti explicitly sought to obscure the references between the forms of his images and their allusive, punning, and anagrammatic titles.[71] In choosing to make a special kind of portraiture composed of text − a title, label and addendum − and *diagram*, Picabia explores the limit-terms of hermetic portraiture.[72] At the same time Picabia's machine-portraits do not merely subtend a Symbolist gesture, or finally displace the hermeticism of anti-portraiture to a degree zero of reference. Instead, they open up another space of representation that seems to have taken on the larger burden of confronting the modern construction and specification of humanness with the two governing instruments of representation − text and image − as well as with perhaps the greatest metaphor and model of postindustrial knowledge: that of the machinic diagram.[73]

Within the development of his private symbolism and his challenges to the notations of visual identity, Picabia, as we have seen, reserves a special place for the title: "In my work the subjective expression is the title, the painting is the object . . . the pantomime . . . the appearance of the title."[74] The "pantomime" and the "object" are in fact, made over into the machine, so that Picabia writes of his conjunction of image and text in these works as "[les] schémas que nous traçons, [les] mots que nous alignons" (The diagrams we draw, the words we align).[75] The "we" here is not fortuitous. For as in Symbolist circles, and as with Cézanne and Picasso in their early careers, the *act* of naming itself was often deferred to group decision and to acts of random or digressive designation. Like Magritte later, and as with other Dadaists and Surrealists, Picabia turned to the dictionary for titular inspiration.

The French Larousse dictionary was recast, by artists and groups antagonistic to modernist reductionism, in a discontinuous series of allusions and in a spate of imitations and borrowings. The *Petit Larousse* − "un ouvrage explicitement destiné aux enfants, recommandé dans les écoles"[76] − was first exploited by Picabia as a particularly useful resource for the generation of "found" phrases, titles, captions and textual ephemera.

Several of his machine-portraits, including his *Fille née sans mère* (*Daughter Born without a Mother*, c. 1915), which was reproduced in *291*, no. 4 (1916) and five further portraits reproduced in *291*, nos. 5–6, were titled after such discoveries.[77] Picabia's foraging for Readymade phrases in the *Larousse* and the related Readymade objects of Duchamp were both identified with what Gabrielle Buffet called

> an identical extreme point of logical decomposition: the decomposition of the immediate, routine logic of the senses. . . . [T]hey were as one in their extraordinary adhesion to paradoxical principles and destructive reflexes, in the blasphemies and condemnations they directed not only against the ancient myths of art but also against all the foundations of life in general.[78]

The object Readymades of Duchamp and the texted and diagramed Readymades of Picabia represent the two most extreme gestures of counter-compositionality in the historical avant-garde. Both were associated with new regimes of the name and title that did not so much undermine as explode the traditional categories of reference taken on by the identificatory name or the descriptive caption. The title takes its place in an amalgam of devices which are not distinguished in any generic hierarchy: Latin phrases, everyday objects, symbolic notations, hand-written calligraphy and print, Nietzschean phrases, dictionary entries, personal allusions, "cryptic inscriptions," diagrams (one "used by Mme. Curie for explaining in graphic form the action of a particle of radium";[79] some enhanced with gold and silver), and *dessins trouvés*. One of the culminations of this tendency was in the "eighteen drawings, all of them with provocative captions" published in *Poèmes et dessins de la fille née sans mère* (*Poems and Drawings of the Daughter Born without a Mother*, 1918), which for Borràs "effectively destroys the barrier between painting and poetry . . . between the visual art and the text."[80] It is in this sense that Picabia has been held to open the way for the "collaborative" "subconscious" writing of the Surrealists and the development of "thought-poetry," especially in his *Pensées sans langage* (*Thoughts without Language*, 1919).

At the exhibition at the Cirque d'Hiver in 1918, the organizers collaged-out the "obscene inscriptions" of Picabia's *Vagin brillant* (*Shining vagina*, 1918) – retitled *Muscles brillants* (*Shining muscles*) – with "gummed papers." As Picabia reports, he was at first requested to change the "titles," but after a general withdrawal was threatened, and the organizers appeared to back down, the offending parts were still covered over with "strips of paper."[81] This gesture of titular erasure, ironically using the methods of the collage revolution that had taken place only six years

earlier, marks an end to a brief regime of titling, and to a moment of the avant-garde. One measure of this end might be found in Picabia's exhibition at the Galeries Dalmau in Barcelona in November 1922. In his contribution to the catalogue, Breton describes the "elemental" geometric configurations of the watercolors as "compositions with a plastic value devoid of any representative or symbolic intention and representing nothing but the signature and the title."[82] More recent interpretations of these images have rightly aligned them with the beginnings of international Constructivism – to which we should also add the later geometric style of Kandinsky. For just as Picabia had insisted in 1913 that his new images would be governed not by a title but by a *name*, Breton's commentary marks a reversal from the name back to the title. Picabia has not reverted to the nomination of states of mind (as did Kandinsky), for many of his titles are still related to machine-objects – *Pompe* (*Pump*), *Magnéto* (*Magneto*), *Resonateur* (*Resonator*), *Presse hydraulique* (*Hydraulic Press*, all 1921–22). Instead the beginnings of this reversion are suggested in titles such as *Vertical* (1922) and *Bobinage* (*Winding*) and *Fixe* (*Fixed*, both 1921–22) though there is also a continuity with the Dada mischief of the 1910s in works such as *Thermomètre pour aveugles* (*Thermometer for the Blind*, 1921–22), *Culotte tournante* (*Revolving Leg*, 1921–22), and *Sphinx* (1922).

At the Cirque d'Hiver four years earlier, however, the collage technique that Aragon had defined as launching the break with painting returns (even before it has been reinflected by the painters of Surrealism) in the form of a fig leaf with which exhibition officials could blank out the provocative textuality of an image. Picabia made the title over into a new kind of "name," and merged the image with the machine. But we should note what was "lost" in the folded logic of the most intense reaches of this work: the notion that there might be "thought without language," or image-texts that existed almost wholly outside of the traditional syntax of illustrational subordination, or forms of "identification" that knew nothing of the label and which reimagined the "proper name." Such losses would be repaired by the Surrealists. Thought would find its home in "poetry," misidentification would become formulaic, and the connotative, Readymade titular sign would find its ultimate destiny in the cultivation of enigma and the para-normal.

IV Notes on Surrealist Titling: Magritte, Miró, Tanguy, Matta

> The painted image and the word
> are the circle and the circus
> of all the contradictions of creation
> What a word digs out of the under-
> ground of the spirit is a magic fruit.
> It is rendered by
> the image, which helps consciousness to grow.
>
> — Roberto Matta, "The Earth is a Man"[83]

I offer here a summary of some of the chief coordinates of Surrealist titling — a naming enterprise which, while it resists or reverses several of the Dada challenges discussed above, is still among the most considerable and suggestive of any modern art movement. The rhetorics of the Surrealist title include theories of "poetic" signification (put forward by René Magritte, Joan Miró, and others); cults of mysteriousness and indeterminacy (including the mediumistic titles of Yves Tanguy, and the "pataphysical" image-texts of Roberto Matta); mislabeling and nominal disjunction, associated above all with Magritte; a range of title-texts purportedly delivered by the unconscious, whether provoked by the hallucinogenic dream-imagery of Miró, the "critical-paranoia" of Salvador Dalí, or the automatic transcriptions of André Masson; and the word-shapes invented by Matta and signaled as the definitive gesture of ritual namelessness by Breton, which accompanied the "psychological morphology" of his paintings.

In outlining these developments I will have to defer discussion of other important sites of Surrealist naming, in particular the titles of the non-pictorial practices of Surrealism. These include the elaborate caption-like titles produced by Man Ray for his photographs of found objects — e.g., *A Highly Evolved Descendent of the Helmet* (1934) and *From a Little Show That Was Part of It* (1937) — and the trauma-driven sculptures of Alberto Giacometti. Giacometti's *Femme egorgée* (*Woman with Her Throat Cut*, 1932) and *Le Palais à quatre heures de l'après midi* (*The Palace at 4 a.m.*, 1932–33) gloss the structure of traumatic events whose narrative lineaments are suggested in the configuration of the work. In this sense they offer one of the extremes of the titular *surplus* worked up by the twentieth-century avant-garde. Reaching for much more than evocation, or sensation, they layer description and suggestion with identification and projected anxiety, which has led some critics to identify the work as playing out a castration anxiety.[84]

One of the governing assumptions that underwrites the titular activity in Surrealism – and the Surrealist visual-textual economy at large – is founded on the important configuration in the movement of "pensée" (thought) and "poésie" (poetry). Already suggested by some of the Dada provocateurs, this association functions as the obverse to the drive for compositional order dispersed through the visual language of psychological abstraction, discussed in chapter 5. I have examined the formation of the Surrealist desire for engagement with metaphysical reference and poetic dissolution in another study,[85] suggesting that there is a common effort among Surrealist artists to accommodate the signifying activity of the image or the word-image in a transcendent synthesis which unites the formative components of a work – consciousness, unconsciousness, materials (letters, words, images, colors), even its context – into a unified sign embodying a *thought*. In this understanding, the Surrealists often constructed "thought" as a replacement for the *unity* of disparate pictorial and subjective elements that was frequently conceived of by the pioneer abstractionists (and even by Matisse) as resolved into the universalizing sign-machine of *compositional* order.

The bracketing of the "plastic statement" – without distinguishing between images and words – into a *poetic* whole was one of the most substantive of the myths of generality invoked by the Surrealists. Like so many of the impulses we now understand to have defined modernism, the first sustained allocation of "artistic creativity" to a materially indifferent category named "the poetic" was developed by the Symbolists. Baudelaire concluded his "Salon of 1845" with a eulogy to those artists able to celebrate "the life of today" as both "great and poetic."[86] But "the poetic" was not embraced as a governing metaphor by the visual avant-garde until the 1910s and 1920s. The Dadaists were only inconsistently reliant on the indulgence and tropic evaporation later to be associated with poetic metaphor. In the name of an irregularly defended anti-aestheticism, Tristan Tzara censured "all the etceterisms that mix music and poetry" ("tous les etcéterismes qui mélangent musique et poésie") and jibed against "the Wagnerian bouillabaisse" ("la bouillabaisse wagnérienne").[87] When he did make recourse to poetic generalities, such ideas were deflected from the avant-garde culture where they would find their most comfortable home, towards an ironic identity with the commercial world and the world of public affairs: "la réclame et les affaires sont aussi des éléments poétiques."[88] Other artists made no such distinctions. Hans Bellmer, carrying what remained of Dada provocation into the 1930s, wrote of the overarching "psychophysiological" unity to which all expressive gestures were subject: "the various modes of expression, pose, gesture, act, sound, word, handwriting, creation of an object,

all result from the same assemblage of psychophysiological mechanisms, that they all obey the same generative law."[89] Finally, a more chaste, "purer" version of the poetic metaphor was associated with the call to order of the 1920s. In one of the first numbers of the journal *L'Esprit Nouveau* Paul Dermée wrote an article under the heading "Poésie = Lyricisme + Art," in which he expanded on the aesthetic algebra of his title and charted some of the loose coordinates of the grand poetic metaphor.

Following the lead of these avant-garde artists, critics and historians have fixed on the resolution of the work of art into an ineffable signifying unity bracketed by the poetic. Some have pronounced consideration of material or generic distinctions as irrelevant to the making or reception of Surrealist works. What results is the pervasive commitment to a Surrealist mode of signifying that equates the original signifier (the material, the work) with the final signified (its message or meaning). This theory assumes that "thoughts" refer directly to "thoughts," in the process keeping their own substance as pure as a catalyst. According to J. H. Matthews, for example, "[t]here are no radical, insurmountable differences between pictorial surrealist image-making and creating surrealist word-images."[90] In this account the title is an active agent assumed to secure the poetic whole. Thus connotatively titled Surrealist works are ordered into a "poetic" unity that binds material, form and name: "[W]hile the title may be composed of a single word or a single locution, some collages may be accompanied by phrases or groups of phrases, the 'ensemble' of which forms a poem."[91]

Magritte inherited and then cultivated this lineage of ideas about the poetic, although they did not become a dominant recourse until late in his career.[92] With Miró such theories are present, but less insistent.[93] In his trade with the poetic Magritte is definite, concerted, and equivocal all at once: "les images, idées et paroles sont déterminations *différentes* d'une *seule* chose: la pensée" ("images, ideas and words are *different* determinations of a *single* thing: thought."[94] Above all, however, he believed that the co-production of artistic "thoughts" and visual poetry was the best means to promote Surrealist mystery. The invocation of "mystery" is one of the most frequent strategies he used in his published writings and correspondence to describe the effects of his paintings. He even defined "the surreal" as "reality which has not been separated from its mystery" ("le surréal est la réalité qui n'a pas été séparée de son mystère").[95] In the course of discussing the subordination of image to text in illustration, he further underlines the mysterious specificity of the image: "There is nothing, without mystery. . . ." ("Sans le mystère, il n'y a rien . . .").[96] Eventually mystery becomes a condition for the very

possibility of thought: "[T]he mysterious doesn't conform to any law; no world, and no thought is possible without it" ("[L]e mystère qui ne correspond à aucune doctrine, le mystère sans lequel aucun monde ni aucune pensée ne sont possibles").[97]

The "mysterious" thought sought for by Magritte arises in the frisson of difference between various systems of signs. It is produced in that clash of significations at the interface of different codes – especially between the image code and the more defined code of language. Mysteriousness can also arise from different expectations within a single code, as in many of Magritte's paintings where there is a collision between the expectation of narrative realism – prompted by his scrupulous pictorial verism – and the glaring defections from any predictable or legible scene. Such defections are built into both the foundations and the details of his images and function much like *non sequitur* in speech. The viewer is seduced by the realistic technique of the painting into believing that it will offer an understandable narrative or message. But this simple coding of the image is knowingly subverted by puns of the surface, strange illusionisms and iconographic ambiguities. Magritte deliberately uses these devices as channels for the inrush of mysteriousness.

Magritte's titles play a key role in his training of the signification of an image toward the metaphysics of "thought." Encouraging a continuous interchange of parts between the materials and devices of his paintings, "thought," for Magritte, becomes something of a ringmaster in this circus of exchange. He speaks of his titles as word-images superimposed upon picture-images: "The title *Stabbed* [or *Transfixed*] *Time* [fig. 60] is itself an image (in words) joined to a painted image" ("Le titre 'La Durée Poignardée' est lui-même une image (avec des mots) réunie à une image peinte").[98] In several lectures and texts he repeated his call for an evocative Symbolist-derived indeterminacy in titling: "The poetic title has nothing to teach us; instead it should surprise and enchant us" ("Le titre poétique n'a rien à nous apprendre, mais il doit nous surprendre et nous enchanter").[99] In an interview with Jan Walravens, he outlines a theory of titling modeled on the "mysterious rapport" set in motion between the figures and objects in his paintings. Just as these motifs are relationally suspended in an uncertain, evocative syntax, so the title is made and received in another spiral of the same dislocated logic. The sum of these disjunctions gives rise to a titular theory similar to that advanced by Breton in relation to Matta. It asserts the relative autonomy of both title and image, refusing in particular the "illustrational" subordination of the image to the title caption, but allowing at the same time that they produce a collocation, or ensemble, that signifies as a function of their disparate associations:

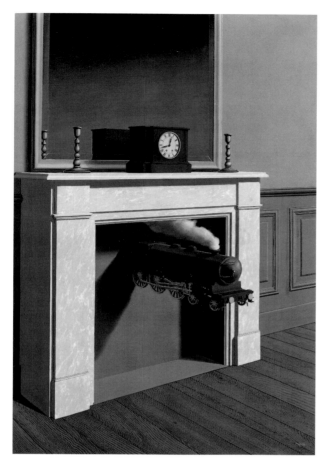

60 René Magritte, *Time Transfixed*, 1938. 147 × 98.7. Art Insititute of Chicago, Joseph Winterbotham Collection

The title maintains the same *rapport* with the painted forms as the forms maintain among themselves. The forms are assembled in an order that evokes mystery. The title is associated with the painted figure according to the same order. For example, the painting *Memory* shows a plaster figure on which a drop of blood is displayed. When I gave this title to the painting, I felt that the two went well together. One can speak of a painting and its title. . . . The painting is not an illustration of the ideas that follow.[100]

During the later part of his career at least, Magritte, like Picabia, solicited the effects of chance for his titles, paging through the dictionary (with the assistance of friends) for enigmatic titles to append to his elusive pictorial

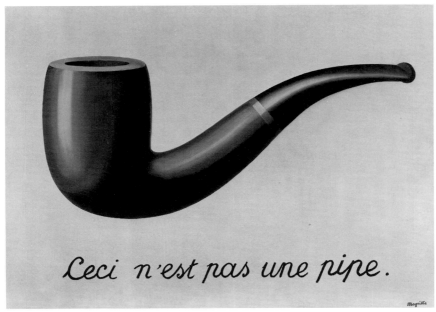

61 René Magritte, *The Treason of Images (This Is Not a Pipe)*, 1926. 60 × 81.3. Los
Angeles Museum of Art. Purchased with Funds Provided by the Mr. and Mrs. William
Preston Harrison Collection

configurations.[101] Like Jackson Pollock in the 1940s, he was also not
averse to scratching or renaming his paintings after they had been pro-
duced and titled. Ronald Alley notes of *L'Esprit de la géometrie* (*The Spirit
of Geometry*, c. 1936) that "Mme Magritte confirms (letter of 19
November 1976) that her husband did not like the original title 'Mater-
nity' and decided to change it to 'The Spirit of Geometry.' "[102] Others of
his titles are more elaborate than meets the eye: his famous image *Ceci
n'est pas une pipe* (*This Is Not a Pipe*, first version 1926, fig. 61), for
example, actually bears four other titles: *La Trahison des images* (*The
Treason of Images*), *The Faithful Image*, *The Use of Speech*, *The Air and the
Song*.[103]

It is this painting, of course, that occasioned one of the most sustained
reflections on the economy of visual-textual and poetic signification –
Michel Foucault's essay on Magritte, titled after the artist's inscription,
This is Not a Pipe.[104] Magritte's work is an icon of the perpetual deferral
and non-identity of visual and textual discourse; for in the collision of
text and image neither material nor its mode of signification is separable
from a supplementary trace of the other. The word–image underlines the

difference between plastic and textual signs by never fully fusing them together or eclipsing one behind the other – "[d]esignation and design do not overlap."[105]

Magritte's representation of a pipe is staged with a deceptively simple logic which Foucault compares with the tradition of illustrative diagraming, in particular to "a botanical manual: a figure and a text that names it".[106] But while he doesn't explicitly describe *This Is Not a Pipe* in these terms, Foucault also suggests the model of the calligram, with its doubling of text and image, as an anchor for his discussion. The somewhat digressive analogy that ensues concludes that a step-by-step itemization of the plural messages of the image. The break marked by Magritte's ambiguous images and word–images is described by Foucault as a "disassociation" of "resemblance" (epitomized by *trompe l'oeil*) from "similitude." The order of resemblance is one in which a form of "rigid designation" takes place such that an object and image, on the model of persons and their proper names, are related by identity. Magritte's gaming with the title of a work of art offers an explicit critique of the dependency of the classical order on "the sovereign act of nomination": "[O]ne might say that it is the Name that organizes all Classical discourse."[107] Threatening the name (the title) also threatens the passivity of the relation between words and images that regulated painting and sculpture until the late nineteenth century. And, as Foucault suggests, this annexation by text of a potentially unsettling role in the naming of an artwork can be related to the overthrow of the theory of words as simple names, one of the key strategies by which classical, or pre-modern, discourses were assembled and understood.

This Is Not a Pipe stands as the terminus and antithesis to the tradition of the descriptive title inherited by modernism. The subversion of the denotative label by the insertion of a negative one introduces a semiotic layering in the reception of the image which insists on its status as a *representation*, and on representation as separate from "reality." The image is now positioned as a sign. But this is a compound sign joining visual and textual regimes through the inscription of the title within the bounds of the image. The countermanding of the image by the word is a statement against appearances and a bid for multiplicity in the reception of the image. This dissociation offers a preface to the wide range of dislocations that Magritte stages in his images – poetic juxtapositions, mislabeling, referential disjunction, and dream texts.

With Miró the case is more complex. This is in part because his statements are less formulaic and more occasional than Magritte's, and partly because the most thoughtful critical scholarship on the artist – by Rosalind Krauss, Margit Rowell, and Sidra Stich[108] – has made assump-

tions congruent with the assertions of "poetic unity" in artists' discourse in the 1920s and 1930s (Stich) and with the structural predicates of the "visual poetics" emerging in European critical theory (Krauss).

As with all the Surrealists, the signifying field of Miró's titles is caught up in a wide spectrum of visual-textual encounters and rendered yet more elusive by another general tendency – the artist's blurring of sign types and materials – whether written, pictorial, or subjective. Miró was succinctly emphatic about this perpetual relay: "I make no distinction," he asserted, "between painting and poetry."[109] While contributing to the contextual detail of such claims, commentators often collude with the artist's metaphysics. Stich reduces Miró's signage to a "universal character" originating in his concern for exploring the unknown, and in "mystical unity . . . the primordial . . . his distinctive adaptation of a primitivist impulse" – all of which are eventually (and mysteriously) resolved into "compositional unity and poetic harmony."[110]

If we follow the course of Miró's career, paying careful attention to his choice of titles, it becomes clear that changes at the level of his chosen names correlate closely with three major "crises" or shifts in his pictorial style. Until around 1924 Miró worked within a traditional framework of generic constraints, which were unemphatically signaled in his titles. His still lifes, portraits, and landscapes frequently used these genre designations as the first term of the title, which was then expanded with a conventional denotative description. Around 1922–23, in line with changes in his compositional style, Miró began to open up his titular formats. A series of three lyrically spare still lifes painted in these years are inscribed on the reverse *Nature-Morte I, II, III* (*Still Life I, II, III*). At about the same time, Miró makes use of the more metaphorically suggestive term "pastorale" in a number of "landscape-type" paintings which exceed or escape the coordinates of a particular location. During the following two years, a major inflection in his images is accompanied by a newly expanded (and knowingly contracted) regime of names. Miró's illustrative style gives way to a more abstract and oblique system of signs: the schematic body and its appurtenances; notations for a kind of anecdotal narrative; zones of activity such as horizon, sky, and land forms; marks of action; and the assertive interruption of letters, words, and numbers – all of which seem to be jockeying for position and ceaselessly reversing their order of appearance, as he actively questioned the conditions of representation. The nominal field that governs these pictorial innovations can be summarized as follows.

First, landscape paintings are labeled simply as "landscapes," and their leading motifs or protagonists appear (often years later) in parentheses supplied by dealers, curators, and occasionally by sanction of the artist

himself. Such works include *Landscape (Grasshopper)* (1926) and *Landscape (Hare)* (1927). Second, a new class of metaphorical or poetic titles makes its first appearance. Even when these names appear most "abstract" and govern images supplied with few legible signs – *Birth of the World* (1925) is the most obvious example – an identificatory role is still reserved for the title. Thus some "poetic" titles, such as *Chien aboyant la lune* (*Dog Barking at the Moon*, 1926, fig. 62) also function as simple descriptions of the content of the image. With the partial exception of the titles discussed in the following category, Miró never abandoned the descriptive label. Third, between 1925 and 1927, he makes recourse to two forms of restrained, quasi-untitled, designations. He inscribes several works *Peinture* (*Painting*), again usually leaving the parenthetical specification of their subject matter to other hands; examples include *Painting (Blue)* (1925 and 1927); *Painting (Lasso; Circus Horse)* (1927); and *Painting (Untitled; The Bullfighter)* (1927). The last images are supplied with two variant supplementary titles in the 1993 Museum of Modern Art catalogue, the most complete and accurate record of Miró's work to date. Six works titled

62 Joan Miró, *Dog Barking at the Moon*, 1926. 73.3 × 92.7. Philadelphia Museum of Art. A. E. Gallatin Collection

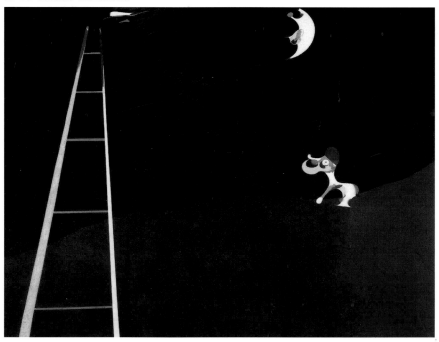

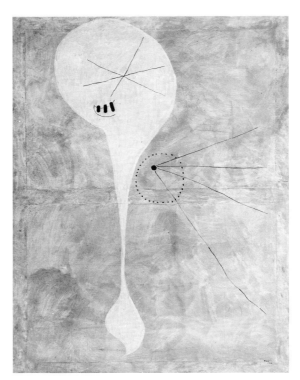

63 Joan Miró, *Personage*,
Summer 1925. Oil and egg
tempera (?) on canvas, 130
× 96.2. Solomon R.
Guggenheim Museum, New
York, Gift, Solomon R.
Guggenheim, 1937

Painting and dating from his second moment of crisis in the early 1930s
were explicitly associated with the artist's "farewell to painting," or as
he put it more famously – and stringently – his desire to "assassinate"
painting. According to a recent account, their under-specification joins
with other gestures of over-elaboration as a general symptom of represen-
tational anxiety: "[H]e had tried, he said, to compensate for the fact that
'the subjects of the paintings weren't clear enough' by 'giving them
realistic titles.'"[111]

Other works representing unspecified protagonists, their actions and
contexts, are titled *Personage*. The Guggenheim's *Personage* (fig. 63),
painted in the summer of 1925 (which is listed in the museum's catalogue
with a total of three "abstract" titles – "*Personage; Composition; Abstraction*
– in parentheses), appears to be the earliest of these, though its title, while
certified by Miró, may have been given (much) later.[112]

Miró first made recourse to the designation "personage" in the mid-
1920s, and used it recurrently throughout his career (notably in the
mid-1930s). As a strategy it can be said to answer in the domain of

the human-animal figure to the function of "untitled" for a landscape, or "composition" for a still life. It was a notation for the abstracted figure, stripped to its diagrammatic base, yet still carrying out the conscious, reduced actions of a subject. One of Miró's well-known resistances to the "empty house" of abstraction is thus underlined in his refusal to name paintings in which human actions transpire as "compositions" or "paintings." These titles were permissible for works that explored hallucinatory mark-making or the suggestive interplay of non-figuratively coded shapes, or the locative requirements of calligraphy, numbers, or other text, but they were out of bounds in any confrontation with the abstracted armature of human figures themselves. *Personage* is thus an explicit anthropological retort to the figuratively irredeemable abstraction of the *Composition*.

The precise origin of the making and naming of "personages," which, from the 1920s on, came to stand in for the confused hinterland between general human conditions and generalizable (abstract) human actions, needs further investigation. But let me offer a tentative beginning and a possible outcome for this crucial designation. With his interest in persons, machines, and identities already established – and possibly played out – it is not surprising that Picabia offers an iconoclastic view about the implications and possible future of the term. This is advanced in the form of a skeptical reaction to a proposed Dada excursion to St. Julien-le-Pauvre in 1921: "All I hope," he noted, "is that it will not represent any political, clerical, or nonclerical character, for I will always abstain from participation in a manifestation of that kind, considering 'Dada' a personage having nothing to do with beliefs – whatever they may be."[113] This association of the personage with the anarchic collective body of Dada sets itself against all religious or political belief systems. In 1921 such "abstention" might be said to equivocate between passive, or subjectivist, restraint and something "transactivist" (more radical than simple, binary opposition). But during the 1920s, and more emphatically thereafter, the "personage" becomes an interhuman cover-sign for residual figuration and the imagination of anthropomorphic conditions. It is the final destiny of the modern portrait genre, abstracting the protagonist against an exotic flux of contextual actions, but at the same time delivering a poetic message about the general human condition. Thirty-five years later, in the mid-1950s, Matta throws out another revealing aside that seems to understand the implications and shortcomings of the Surrealist discourse of the "personage"; and to offer a terminus for its signifying reach. If there were to be "new worlds" occupied by a new dimension of collective subjects, then they would have to intervene decisively in the imagination of "others".[114]

The two early forms of quasi-untitled names, *Painting* and *Personage*, are joined – during Miró's second "crisis" of representation – by the self-identifying, material-generic terms, *Collage* (1929), *Construction* (1930), *Relief Construction* (1930), *Object* (1931), and *Drawing-Collage* (1933). While, again, these titles are usually the product of the contingencies of exhibition or sale, they reveal the artist's equivocation with the social and aesthetic debates of the time, especially with the demand to supersede, or go "beyond" painting.

Finally, it is in 1923–24 that Miró first deploys his signature cursive calligraphy across swathes of the painting surface. The resultant word-images, such as *Photo: Ceci est la couleur de mes rêves* (*Photo: This Is the Color of My Dreams*, 1925, fig. 64), are poetically self-titling configurations that merge the textual sign with the material condition of pictorial representation. The title is forced into a position of appositional redundancy or tautological repetition, as the image takes over the space of the label. *48*, painted in early 1927, extends – and also ironizes or deflates – this allusively inclusive signifying logic, by creating a textless "number-

64 Joan Miró, *Photo: Ceci est la couleur de mes rêves*, 1925. 96.5 × 129.5. Pierre Matisse Gallery, New York

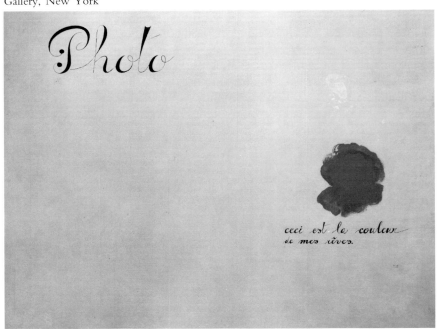

image." The composite personal sign-system of Miró's word-images of the 1920s gave rise, then, to hybrids searching for a language in the very clash of languages.

The invasion of text into pictorial space is the most discontinuous and disruptive of all the oppositions between "languages," despite its admission in the same material – paint – as that of the other pictorial elements. Conventional sanctions for the appearance of text with image in visual practice were fourfold: first, its neutral presence in the depicted environment (from tombstones to billboards); second, its identification and explanation of parts and processes in labeling (diagrams); third, the posting of narrative details, imputed morals or titles in scrolls across the picture surface; and fourth, the post-Romantic practice of the artist's signature. Miró toyed with all these modes but always distorted them, whether in the deployment of ragged, architecture-sized lettering for his own name, or of deliberately slicing a word (such as "sard" in *The Hunter*, 1923/24) which we would expect to function as a kind of label.

As with Duchamp's Readymade names, Picabia's mecanomorphic personae, and Ernst's fatagaga collages, it was also Miró's earlier work – the complexly layered textual-pictorial innovations of the mid-1920s – that were attended (sometimes co-produced) by his most telling and experimental titles. His later work is governed by a titular field that for the most part repeats or reinflects the typology already established before 1930. While he continues to make "painting-poems" such as *Une Étoile caresse le sein d'une négresse (Peinture-Poème)* (*A Star Caresses the Breast of a Negress [Painting-Poem]*, 1938), other works are called after the abstract-tending names developed around 1925, including a series of ceramics made in the 1950s and 1960s that recapitulates the three major denominative types achieved in the 1920s: quasi-human, generic, and coloristic – *Personage* (1956); *Monument* (1956); and *Blue Vase* (1962). Miró continued to deploy the title-term "personage" throughout the 1970s.

In a series of revealing letters to his New York dealer, Pierre Matisse, written during the mid-1930s, Miró offered his most extended comment on the nature and function of his titles. As artist and gallerist were rarely able to meet during these years, Miró made a special effort in this correspondence to discuss the exhibitional parameters of his works – catalogues; media, materials and techniques; framing suggestions; gallery display conditions; and, powerfully conjugated with these variables as we have seen from Monet and Whistler to Mondrian and Kandinsky, the question of the provision and implications of titles.

On 7 February 1934, writing from Barcelona, Miró mildly upbraids Matisse for having used the title *Composition* for works in his recent exhibition: "If I may make one small criticism, instead of the title

Composition (which evokes abstract things in a dogmatic or superficial sense), I would have preferred that you had simply put *Painting*, along with the date of the picture."[115] Eight months later Miró underlines this preference in the course of a substantial meditation on his current and previous title choices:

> I have thought a lot about the question of titles. I must confess that I can't find any for the works that take off from an arbitrary starting point and end with something real. In the past I have given titles to my works, but they always seemed like a joke. However, I give you permission to choose titles based on the *real things* my works might suggest to you, provided these titles do not evoke some tendency or other, something I want to avoid completely: "composition," for example (which evokes the Abstraction-Création group), or literary titles in the Surrealist manner. For the pastels that I am now doing, I will give titles, since they are based on reality – but the titles will be unpretentious and very ordinary: figure, personage, figures, personages.[116]

At the center of Miró's thought here is the disavowal and deferral of the titling process, precipitated, perhaps, by a certain loss of nominal energy ("I must confess that I can't find any [titles] . . ."), and by his life-long resitance to avant-garde affiliation or art-group pressure ("some tendency or other"). Of the two types of image-making he identifies – works that are commenced "arbitrarily" but "end with something real," and those that supposedly begin and end in the real – it is the first at which his titular reserve is finally directed. In line with his general reservation about "abstraction," doubled on fear about its cooptation by hard-core abstract-rationalists such as Abstraction-Création, Miró identifies the work of the title with the naming of the real. It is on this basis (the "suggestion" of "*real things*") that, in a gesture multiply reinvented in the artist-critic-dealer nexus of the postwar U.S. art scene, he relinquishes control and delivery of the title to his New York gallery.

The corollary of Miró's preference for "reality," "unpretentiousness," and the "ordinary" (in other words for a form of unintrusive titular denotation) is an explicit disparagement of the two polar title-types that organize the nominal structures of visual modernism. These are the titles he wishes "to avoid completely." "Literary titles in the Surrealist manner" are deemed too speculative and textually abstract, and Miró even condemns his own earlier attempts in this idiom as "a joke." They are rejected because their reference is not "suggested" directly – even imaginatively – by the "real" content of the image, as he optimistically hopes will be the case when Matisse exercises his "permission" to issue "titles

based on . . . *real things*." Along with poetic, metaphoric indulgence, Miró also censures the key title-type, *Composition* for its dogmatic and superficial evocation of "abstract things."

This signifying nadir for the title during the middle stage of Miró's career clearly contradicts many of his interests and convictions in the mid-1920s, and will be further contested by a remarkable body of work, headed by poem-titles, made from 1939–41. The creative paradox that drove Miró's titular resignation in the mid-1930s is founded on his desire to "transport" the viewer into the wilful impossibility of what he provocatively termed "*real unreality*."[117] For a brief moment the immeasurable space of this para-reality merged with the assumptions of modernist discourse, joining (as it would again among abstract artists in the 1960s) the production of restrained, but still imagined, projected, *and* "real," titles, with the formal environments of modernist display. Thus Miró's stripped-down titles are reinforced by his call for spare frames and minimal gallery embellishment: "As for the framing, the more *simple* and *less elaborate* it is, the more perfect and successful it will be":

> The walls of my studio are white-washed, and it is in this kind of atmosphere – of maximum serenity and simplicity – that I imagine my paintings, as far away from Parisian refinement as possible. For the large exhibition at Georges Bernheim's I had the large paintings framed with a single strip of *natural wood*, untouched *even by a plane*, which allowed the paintings to stand out and did not rob them in any way of their power and strength.[118]

Miró's fear that the abstract geometries of the frame might "rob" his work of its "power," parallels his rejection of the dogmatic, strength-sapping, abstraction of the title *Composition*. While the italicization of his preference for frames of "*natural wood*" restages his underlined drive for titles governed by "*real things*," Miró was apparently aware of the equivocal nature of his negotiation between the real and abstract, and of their co-dependency on the title, for in the same letter to Matisse, he offers the following paradox that sums up the dilemmas of this period: "You see that I have given titles, very simple ones, however, since I wanted to remain within pure painting, at the same time going beyond it of course."[119] The fuller consequences of being simultaneously "inside" and "outside" of pure painting, and the pressure of this condition on the title, will only be revealed in categoric abandonment of the artwork to the dictates of modernism among the group of artists favored by formalist criticism in 1960s.

Miró, however, turned away from closures of his paradox in the *Constellations* (1940–41) series, the third moment of intensity in his career.

In Stich's view, the word-images of the 1920s are precursors of the truly "autonomous sign images" and "primordial alphabet" of the 1930s, which culminate in the "pure magic" of Miró's Constellations.[120] But the impact of the later works is very different. The titles for these compelling gouches alternate between concisely resonant single words or small phrases (such as the Whistleresque *Nocturne*, 2 November 1940) and highly associative poetic sentences, including *Personages dans la nuit guidés par les traces phosphorescentes des escargots* (*People at Night, Guided by the Phosphorescent Traces of Snails*, 12 February 1940) and *Femmes au bord du lac à la surface irisée par le passage d'un cigne* (*Women at the Border of a Lake Irradiated by the Passage of a Swan*, 5 March 1940). In a striking reversion to the logic of Impressionist specificity – though with imagined dream substituting for effectual daylight – Miró insisted (again to Pierre Matisse) that "it is very important to date them exactly, in each case mentioning the place where they were made." All the Constellations were inscribed on the reverse with the day, month, year, and place of execution, as well as with a diagrammatic sketch. The artist insisted that all this supplementary information be reproduced along with the works themselves in a proposed facsimile edition of the serial ensemble.

In 1968, when Miró makes a final summation of his titular investments, it is, quite naturally, in the form of a title: *Lettres et chiffres attirés par une étincelle* (*Letters and Numbers Attracted by a Spark*, 1968). Here, his ecstatic deliberation, his tantalizingly specific inscriptions, names, dates, numbers, letters, words, poems, signatures (front and back), thickening lines – and even, by extension, the sketches, diagrams, and captions kept in his many notebooks – are suggested only to be desired, ignited, or enflamed in the magic carburetor of the image.

Consideration of the discourse of the poetic in the images and titles of Magritte and Miró has already touched on a major strategy of Surrealist nomination: the cultivation of enigma. The few specific accounts we have of the production of Surrealist titles reveal the connivances set up by several artists between expression, visuality, and language. In a study entitled "Tanguy, Titles, and Mediums," Jennifer Mundy outlines the "premium" laid by Tanguy "upon the much vaunted mystery of his work" and describes some of the consequences of his taciturnity (his "cult of instinctive, automatic expression") and its attendant rejection "on principle [of] the supplementing of visual imagery with verbal explanation": "[C]ircumventing the world of nameable reality, the biomorphic dramas of his paintings challenge the eye to recognise more than the mind can fully identify."[121] As the site of the title is a major exception to Tanguy's calculated textual reticence and withdrawal, Mundy discusses the titling circumstances of many of the twenty-three paintings exhibited

by the artist on the occasion of his first one-person exhibition at the Galerie Surréaliste in 1927. She reveals a number of titular strategies, including several we have already encountered, which constitute – though also threaten to lift – the "veil of mystification shrouding the life and work of Tanguy."[122]

The semi-legendary point of origin for this nominal field takes place in an afternoon quest that Tanguy later reports having conducted with Breton – "searching through books on psychiatry for statements of patients which we could use as titles for the paintings."[123] Mundy identifies the main source among these books as Dr. Charles Richet's *Traité de métapsychique* (1922), a compendium of hundreds of examples and discussions of "paranormal phenomena" – telepathy, levitation, premonitions, "ecto-plasmic materialisations," etc. – showing how various titles are derived from the different informational and expository levels of the treatise. Some of these are names, such as *Elberfeld*, a German town that was home to a number of "calculating" horses; others are drawn from descriptions or explanations of monitions and para-normal prescience, including premonitions of death and injury, such as *Maman, Papa est blessé* (*Mama, Papa is Wounded*, 1927, fig. 65); or from manifestations of physical paranormality, including "spirit materialisation," such as *Vite! Vite! . . .*; others still are based on "messages from the beyond," or "dream-apparitions." Some Tanguy titles were drawn from sources other than the Richet, including a film caption from *Nosferatu*, and popular ghostlore. But all of these elaborately pre-nominated works share a common subtitle: *Quand on me fusillera*, a phrase, lifted once again from Richet, from a larger sentence that suggests the "immortality of the soul."

Mundy sets the parable of titling offered in the 1927 exhibition in a context also important for Miró, that of the primitivist anthropology of Lucien Lévy-Bruhl. For the Tanguy show and its "pendant exhibition," *Objets d'Amérique*, establish a relay between the opaque image, the found title, and the "primitive object" that suggests the signifying co-production of physical and noumenal realities. The configuration of work, name, and ritual object refuses the division between the phenomenal world and the world of dreams and para-normal experience. Even more than with Duchamp's Readymade phrases and the title-searches of Picabia, Magritte, and others in the Larousse dictionary, the production by Tanguy (and Bretòn) of this litany of metaphysical titles insists on the solicitation of the para-normal for mysterious effects from yet another of the many "beyonds" of painting.

I want to conclude this sketch of Surrealist titling by examining the nominal field achieved in the work of Roberto Matta Echaurren, during and after World War II. Offering a reprise of the Dada obsession with

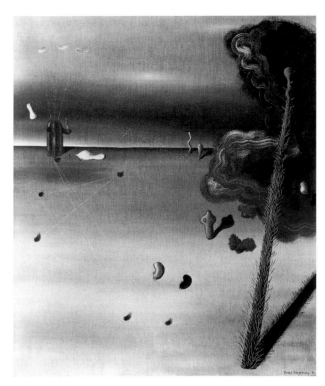

65 Yves Tanguy, *Mama,
Papa is Wounded*, 1927. 92.1 ×
73. The Museum of Modern
Art, New York. Purchase.

puns, inscriptions, cross-identities, and nominal absurdities, Matta also
discovered a renovated space, an "other side," for the Surrealist cultiva-
tion of enigma and titular poetry. In this sense he "completes" Surreal-
ism's destiny as outlined by Breton in *Le Surréalisme et la peinture*
(*Surrealism and Painting*, 1944). Writing of the crystalline, gem-like scin-
tillation of Matta's earlier paintings, with their "corraline vegetation,"
Breton connects the founding premises of the movement with the work
of its last major protagonist (at the same time anticipating the correlation
of text and geology by Robert Smithson): "Surrealism's first gesture was
to confront the creeping fog of thought-out and 'constructed' works of
art with images and verbal structures absolutely comparable to these
agates."[124] He makes a striking forecast of the crystalline suggestiveness of
the Surrealist work, as measured against the murky weather conditions of
the preconceived ("thought-out") or "constructed" work. The para-
doxical calculation, willed-for utility, and illegibility of the construction,
even the observational blur of Impressionism, veiled as they are by a kind

of rational seepage, are simply out-shone, out-patterned, and out-"structured" by the agate-like image-texts of Surrealism. Unlike Aragon's discussion of Ernst a decade and a half earlier, Breton does not dwell on the specific interplay between the painted "image" and the title as a "verbal structure." But he was clearly aware of the leading role assumed by this conjunction, as revealed in his discussion with Lionel Abel, and (somewhat laconically) three years later in another text on the artist: Matta's "arrangements are further underlined by titles which are revealing in themselves: *The Heart Players*, *Wound-Interrogation*, *Remorse for the Impossible*, *L'Octrui* (a neologism compounded of the word *octroi*, local tax, and *autrui*, other people), etc."[125]

I want to suggest that titles, textuality in general, and word-play in particular are related instances of what Matta in 1938 called the "umbilical cords" needed to "connect us with different suns, objects in full freedom which would be like plastic psychoanalytic mirrors."[126] In the late 1930s, however, when Matta was first developing his theory-practice of "psychological morphologies" in works that imploded the logic of compositionality and cubic space, he was not specifically preoccupied with naming and language. "At that time [autumn 1938]," writes Gordon Onslow-Ford of Breton's request that the artist set down some aspects of his theory on paper, "words were too slow to catch the fireworks of Matta's imagination."[127] But Julien Levy did encounter something of the ambivalence of Matta's profuse verbalization and textual retreat during these years, when, in *Memoir of an Art Gallery*, he wrote of his virtual transformation into an amanuensis as he struggled to encapsulate the artist's 'habitual verbal flights' into notes that might elucidate and promote the paintings:

> He was an inventive talker, and I decided to draw up his footnotes as appendages to his paintings. Condensed from his habitual verbal flights, his rationalizations, "[T]hese will be *pseudo*-explanations of what I mean," he said. They would, I reasoned, help publicize his ideas and create handles for those art lovers (unfortunately a majority of the public) who prefer the adornment of explanation to the naked image.[128]

Though he probably never forgot his own suspicion of the "pseudo-explanatory" nature of abbreviated language, the "condensed," interpretational texts proposed by Levy that "publicized" the image, while working against its "decorative" or formal consumption, were soon proffered – in some respects had already been put forward – in the style of titles, supplementary diagrams, catalogue aphorisms, and notebook jottings by the artist himself. Matta's adoption of a vigorous titular

strategy is clearly signaled in Abel's recollection of the "public" nomina-
tion of a key work in 1942:

> Some weeks after our first meeting, Matta invited me to a party at
> which he was to exhibit a new painting of his, and publicly name it.
> It was to be something like a baptism but not too much like one.
> Among those present were the painters Chagall, Masson, Tanguy,
> Seligmann, Motherwell, the composer John Cage, the dealer Pierre
> Matisse, and of course, André Breton. At one point in the evening
> Matta produced his painting and gave it a name, which was *The Earth
> is a Man.*[129]

As we saw in chapter 4, Whistler was one of the first artists explicitly
to link the naming of an image to its market valency. Like Levy, he
clearly associated the production of textual appendages to the market
promotion of the work, and like Abel he emphasized that the circum-
stances of such a nomination were a kind of ritual "baptism." But if there
is a certain symmetry, there is also a clear inversion looking across from
Whistler to late Surrealism. For while Whistler sought to use the title as
a semantic ribbon with which to tie up the decorative totality of the
painting, frame, wall, room, and wider productive context, for Matta the
title has a declamatory force specifically "designed" to release the drifting,
dreaming poetic imagination. This kind of "de-designation" works
against the grain of its visual structure and compositional coordinates.

In the mercantile conditions emerging in the New York scene in the
mid-1940s, in front of an "inside" audience of dealers and artists who
formed a symbolic link to the School of Paris and the experimental avant-
garde, and in the context of an "outside" viewing and buying public
who might find the work devalued in proportion to its mystificatory
textlessness, the nominal scene of the historical avant-garde reaches a
denouement with the christening of *The Earth is a Man* (1942, fig. 66).
Abel registered this significance, for following his description of the
baptismal scene at Matta's party, he pressed the matter of naming further,
questioning Breton about the nature and larger implications of the Sur-
realist title. In the process he elicits one of the fullest accounts of titling
in the Surrealist literature:

> It might have had any number of names, and I remember asking
> Breton: "Is there a definite Surrealist theory about how a picture
> should be named?" "Oh yes", he said. "We have such a theory." What
> was it? I can't remember the words he used exactly, but the purport
> was that the name given to a Surrealist painting would have to be such
> that the picture would remain forever nameless. "Well", I asked him,

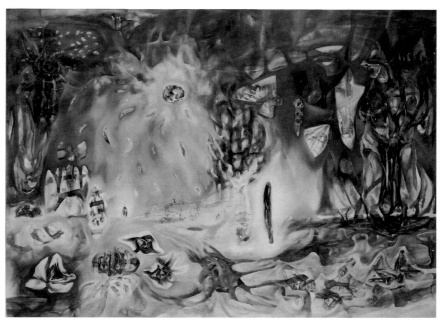

66 Roberto Matta Echaurren, *The Earth is a Man*, 1942. 182.9 × 238.8. The Art
Institute of Chicago. Gift of Mr. and Mrs. Joseph Randall Shapiro

"take Matta's painting, *The Earth is a Man*. Is it nameless, now that he's
named it?" "Yes", said Breton. "It is now nameless, because the title,
The Earth is a Man, is completely independent of that painting." (It
most certainly was.) "You can think about it without looking at the
picture at all. You could type out that title, *The Earth is a Man*, and
hang the typed letters up by themselves on the wall and they would
have the same effect on you." "And I suppose", I replied, "you could
hang the painting up without the title." "That's just what I mean", said
Breton. "But couldn't that have been done before he invited us here
to give the painting a title and called it *The Earth is a Man*? "That
would have been more difficult", said Breton, unsmiling – he was
always grave.

"Because, had he shown it to us without having named it, we would
have thought it lacked a title."[130]

The Surrealist paradox cultivated here by Breton forms a coda at the
end of the charged and ambiguous titling regimes of the experimental,
European avant-garde. It does so by conjoining the two key titling types
that make up the nominal antitheses of visual modernism: the untitled or

nameless work, on the one hand, and the production of elaborate, coded, or ritualized titles on the other. These antitheses merge on the site of hyperconnotation. In a manner whose rhetoric outpaces its logic (as Abel suggests by jibing at his interlocutor's habitual "gravity"), Breton proposes that the nominal scene of the image functions independently of the painting, even though the work is still somehow bound to its circumstance and suggestions. Speaking to the general condition of Surrealist nomination, Breton privileges the *activity* of naming – which must arise to satisfy the shared *need* for a nominal process and decision – above the particularity of the resulting title. Surrealist images are nameless because their titles are fundamentally non-descriptive. They are para-relational appendages, which signify autonomously, yet co-produce associational meaning in and across the word-image compound. They are "nameless" because Breton (abetted by Matta) has resisted every vestige of the Western nominalist tradition that privileges "proper" names or any form of "rigid designation."

Breton makes the remarkable claim that the title could be "typed out" and "the typed letters" hung "by themselves on the wall" where they "would have the same effect" on the viewer as if they were encountered under the painting. Yet, despite his emphasis on this autonomy in the discussion with Abel, in neither Breton's, nor Matta's, theory of naming is the title completely severed from the image. Neither fully countenance the wholesale abandonment of the name to absurdity or chance. Instead it creates a signifying field that still maintains some kind of "umbilical" tie to the visual field with which it comes into contact. Put in the terms outlined earlier by his great antagonist, Aragon, Breton has proposed a theory of the title that envisages it as a materially dislocated collage, as a kind of meta-collage, an association perhaps only imaginable in the domain of pataphysics. The collaged material (the titular text) need not abut, edge onto, or otherwise formally interfere with the image. It need not refer to or in any way describe the image. But it will signify *nevertheless*. It will mean as a text in its own right, and it will mean as it is read across and between the possibilities of the image. The image remains "forever nameless," as Abel's remembered formula has it, because the possibilities of its reference are never foreclosed or dictated. The name is radically "cut-off" from the form, iconography, space, identities, and materials of the enframed work. The parergonism of the title is thus complete only when it is simultaneously suggestive but nameless.

If Miró offered a typically succinct commentary on his naming proclivities in the titles of several works, Matta released an avalanche of speculation on the theory of names in his titles and associated commentaries. What results is a vertiginous envelope of meaning possibilities as

Matta deliberately disorientated the ordered separation between titles, perceptions, and the canvas surface. While describing his picture-making as a "colossal," "phenomenal experience" supplied by volleys of "insistent perception" that issue directly into the work, Matta claimed that "[t]here are titles for each square inch running up and down the canvas like a fever."[131] This Medusa's head of "feverish" multiple titles should be set with the theory of nameless connotation described above. For Matta, the quiet severence of the title text, its hanging on the wall, alone (its destiny in some Conceptual art) is simply the other side (and the equivalent) of its frenzied inscription over every inch of the canvas. It follows that when titles are marked thus, even by association, on the entire space of the canvas, all the titles gather together as the constitution of the work. Titles would thus be stained into the canvas every bit as insistently as Greenberg and Company claimed form was definitionally stained into the works of the Post-Painterly Abstractionists of the next generation.

By 1942 Matta was obsessed with the signification of words and writing as they staged their baffled encounter with the visual field (and with each other). His speculations oscillated between the ecstasy returned in his parable of the "Total Title" inscribed over every inch of the canvas, and his old suspicion of "pseudo-explanation." His notebooks are full of speculations on the interactive functions of words. Matta's desire for "a morphology that does not stop at the outline, at the epidermis of people and things" led him to think the "image of a tree," for example, not as an object, or, as with Mondrian, as a relational abstraction, but as "the sum total of all we know of seed and germination." "Rather more," he continues, "it is everything the word 'tree' can bring into our field of consciousness as emotive images, many of which have nothing to do with the image of a tree, but nevertheless require the presence of this image in order to exist."[132] If Mondrian gathered up the abstract universality of "treeness" in the magic word "composition," Matta's "graphics of ideas," driven as it is by the force of words, seems to follow Breton's model of a title which is separate from, but always crucial to the painting. Thus, while "many" associations conjured by the word tree have "nothing do with the image of a tree," they still "require" its "presence" just to exist.

Words are key threads in the "strange mucous webs" out of which Matta spins his visionary world. They are a non-binding element that switches between architectures, bodies, geometries, music, cosmologies, and selves. Sometimes Matta rehearses the oneiric orthodoxies of interwar Surrealism: "We must think painted poetry." Sometimes he pitches in with the world of old-order nominalism: "Thanks to mathematics and language, it may be possible to dissociate all these [incredibly effervescent mental] energies and to identify and name them." Sometimes he even

professes belief in the "transparency" of language: "The word is glass, and language is transparent like crystal."[133] But these traditional stratas of meaning were fused with a much more interactive sense of the mutual becoming of language and images. In "Matta Physics" he wrote:

> To open the sign and see
> the elements of images.
> Letters of the verb in our imagination
> to find the real form of the world.
> To feel before the words,
> to feel the earth as one's own body.[134]

In another place he thinks through the disjunction between names and events:

> Events have no name, no noun.
> An event is not identified as if it were an object, the word Austerlitz does not render the real image.
> The "other side" of the word Austerlitz could, for instance, be imagined as "emancipated metal," creating, through the suggestion of the image, the same existing density.[135]

Matta was always turning problems over and looking at their other sides: "On one side all is fire," he wrote in a note called "The Disaster of Mysticism," "on the other, all is earth."[136] But his formulation of the "'other side' of the word" brings up a relational strategy that focused the continual warfare of overlays and modifications he envisaged between the visual and textual domains. Closely following the lead of Duchamp – and in the process forming one of the more significant commentaries on his work – Matta went on to split, pun, and blur in the space between words and images.[137] Punning on "being" (*être*) and writing (*lettres*), he made a Duchampian list of "Prime words from the physics side of the ETTRES already found in language." He established a category of "Names Interrogation" in which he chastised the Western subordination of orality, sexuality, touch, and aurality "to the eye." Here he delivers to names an obligation to answer for the blindness of what is merely seen. And in a letter to "Charles" of 15 January 1943 he writes of the need to "find a metalanguage in place of the Babel-language" to find "whirlwind words (of what we know and what we see)" as "[o]ur language of Babel does not express the conflict represented by the object."[138] With typical bravado Matta turns, a few lines later, on the potential insufficiency of the metalanguage he has just invoked: for "several Metas need to be torn up before finding the metalanguage able to denounce the speed of the object, or its relativities to the senses." Matta's titles may be viewed as

tangible traces of these torn metalanguages as they chase after the effects of velocity, displacement, vertigo, in the artist's found and assembled world of psychological object-spaces.

Inside all the folded horizons of his titles (think of *The Intra-rrogator (Temptete)*, or how *The Disnamer Tress-Names into the Phenomenon's Heart*),[139] it is the artist's own name, his adopted title, that presides over the last great enterprise of Surrealist naming. We have seen how the title has become fully autonomous, inexplicably multiple, and simultaneously other. Now we can see how it also merges with the signature-self, as the artist is punned with his own teeming visual-textual world. In "Matta-Scope" he searched for "a series of words with such a grip." In the same vein, Matta once invoked, his reader/viewer: "trans-nome toi."[140] This was advice he took very seriously. For, as the artist put it in one of his most suggestive titles, he was himself – in his many disguises and voices – *The Un-Nominator Renominated* (fig. 67):[141] Matta/matter/Matta Physics.

67 Roberto Matta Echaurren,
The Un-Nominator Renominated,
1952–53. 120.4 × 175.
Peggy Guggenheim Collection, Venice.
Photo: David Heald

68 Honoré Daumier, *Oh! pour le coup voilà une composition qui est réellement insensée!*, from *Le Charivari*, 1865. Lithograph. Print Collection, Miriam and Ira D. Wallach Division of Art, Prints and Photographs, The New York Public Library, Astor, Lenox and Tilden Foundations

69 Roy Lichtenstein, *Compositions*, 1964. Magna on canvas, 141 × 121. Private Collection

Composition II: Sounds, Silences, and "Cognitive Naming"

> The intellectual armature of the poem conceals itself, is
> present – and acts – in the blank space which separates the
> stanzas and in the white of the paper: a pregnant silence no
> less wonderful to compose than the verse itself.
>
> – Stéphane Mallarmé, *Oeuvres Complètes*[1]

I Towards a Genealogy of the Counter-Composition

Composing with silence, spaces, blankness: the Symbolists had already
raised the possibility of compositional gestures that were minimal, form-
less, and unendowed – but which were still somehow *composed*, even in
the process of their "decomposition." Such thoughts are more demanding
than the tranquil compositionality imagined by Matisse. They are equally,
and oppositely, less invested in subjective expression and quasi-sociality
than the works of Kandinsky and Mondrian. Mallarmé is writing of a
composition somehow beyond form, a production articulated as a play of
differences. But this kind of composition would not be stitched together
as a "mystery," or congealed into subjectivity, or coerced into some
desired effect of the social world. It would instead be built up, assembled,
constructed. To compose in this way is to reveal the "intellectual arma-
ture," the conceptual organization, at work within the materials of
practice – even if they are the visible spaces between words or the
whiteness of a sheet of paper.

 A description of Gustave Flaubert's writing method in his *Temptation of
Saint Anthony* offered by the contemporary critic Emile Hennequin in the
Revue contemporaine in 1885 makes a similar claim against the received,
and future, history of composing. Flaubert's "fragmentary art," he writes,
took on the "final decomposition" of form, issuing it "into a succession

of independent phrases endowed with identical characters; thus its descriptions, analysis of general effects and souls . . . are reduced to an enumeration of facts . . . placed side by side without any recapitulation which would condense them into a totalized effect."[2] Neither Mallarmé's thought, nor Flaubert's method, can, of course, simply be aligned with an aesthetics (let alone a politics) of construction. But they alert us to some of the earliest manifestations (others we have glimpsed in the *Noirs* of Redon, whose captions, titles, and compositional discretion are aligned in a series of additive rather than unificatory gestures) of a counter-compositional system crucial to the development of the European avant-garde.

We can identify the formation of several important horizons of counter-compositionality in early twentieth-century art, including the practices of collage, montage, construction, and assemblage. All entered into various forms of dispute with the key predicates of composition – a debate, as we saw in chapter 5, often made explicit by artists and theorists, though nowhere with more vigor than in the cultural-political debates in the Soviet Union during the 1920s. While there were innumerable compositional retrenchments, each of these tendencies is predicated on the development of the visual sign through a sequence of additive functions, in which materials were layered, superimposed, or juxtaposed. What resulted were image-objects that could be read as an aggregate of supplements, rather than as – the case with most *compositions* – a variant of a Gestalt whole.

The inauguration of a fully developed anti-compositional discourse may be located at almost the same historical moment in the 1910s in which Kandinsky and Mondrian launched their title-assisted fetishizations of compositional effects. But as Yve-Alain Bois notes, this launch was not without its false starts, especially for Mondrian. For the "power of the modular grid," variously deployed by Mondrian, Vilmos Huszar, Georges Vantongerloo, Josef Albers, and Theo Van Doesburg, "is that it is at once a deductive (centripetal) structure and an all-over (centrifugal) system." As a place where formal unity was "eliminated," the grid was, for Rodchenko and Mondrian, "a way out of the 'truing and fairing' associated with Cubism, the *com*-posing, the putting together, the adjusting of heterogeneous fragments into a reconstituted formal and organic unity."[3] With Mondrian's compositional consolidations in the 1920s, and Rodchenko's abandonment of painting, two sides of the logic of decomposition were clearly laid down: art had to be artfully recomposed or knowingly relinquished. The anti-art of the Dadaists represented another response – for the composition/anti-composition split can also be understood as a replay of the division between materially discrete, frame-

bounded painting practices and the materially heterogeneous practices of the avant-garde that took off from the pasted papers and collages of Picasso and Braque, and again from the Readymades of Duchamp.

The refutation of composition and all (or most) of what it stood for, is also attested in art-historical discourse. Meyer Schapiro, for example, offered several interventions against the elaborate edifice of compositional decorum, suggesting in essays such as his 1966 paper, "On Perfection, Coherence, and Unity of Form and Content," that contrary to the celebration of perfect achieved Form (modeled on a nineteenth-century reading of the Renaissance aesthetic), many periods of art production — including the Romanesque and the modern, his own major interests — were characterized by various kinds of "incoherence." "Critical seeing," he wrote, "aware of the incompleteness of perception, is explorative and dwells on details as well as on the large aspects that we call the whole."[4] In "Recent Abstract Painting," a 1957 article on Abstract Expressionism, Schapiro writes of "the mastery of the formless and accidental," and of the power of "non-communication." His essay on "Style" likewise disputed with attempts to make of this concept an indissoluble signature of social, national, and/or intentional reality. While Schapiro's references were almost always to abstract painting, the terms of his discussion are powerfully symptomatic of a desire to rethink the parameters of the formally composed unity of the artwork. His revisionism suggests that the work of the compositional abstractionists is a last refuge for the perceptual order defended in the Western visual tradition since the Renaissance.

While noting its origins in the second and third decades of the twentieth century, I want to move this discussion of counter-compositionality into the postwar American art scene. For the neo-avant-garde disavowal of composition, while not as radical or "original" as the onslaught against Western modernist aesthetics staged by the Productivists and others, nevertheless opens up a moment of complex renegotiation between the title, the work, and the parameters of social visibility. Schapiro has already pointed to a place of departure, in Abstract Expressionism. Pausing to consider the conjunction of the movement's investment in nomenclature, and the views of some of the artists caught up in it on "composition," will reveal another index of the avant-garde's counter-formalist commitments. But we will also find that the destiny of counter-compositional discourse cannot be aligned unproblematically with avant-garde anti-formalism; and, further, that the high modernist foregrounding of composition is also attended by debates, explicit and implicit, during which the theory and practice of composition is paradoxically assailed. These twists and inversions underline, once more, the uneasy imbrication of the avant-garde and modernist projects.

They also interfere with Peter Bürger's historical separation of an authentic avant-garde from a simulated neo-avant-garde. For I trace in this chapter the final moment in a three-part sequence that departs from, but somewhat re-triangulates, Bürger's polarity, finding it, in the end, insufficiently folded in the contradictory codevelopment of modernist and avant-garde theory and practice. We have already discussed the first moment – the formative importance of Symbolist ideas for the development of visual modernism. As we will see in relation to the abstract tendencies of the 1960s, the meta-discursive possibilities of avant-garde composition (as named and developed by Kandinsky and Mondrian) are subject to a further spiral of reference by the critics of the new abstraction such that the historical emphasis on composition is inflected as meta-compositional. At this point, the dangerous supplementarity of titles is courted in proportion as the works they govern are variously purged of symbolic, iconographic, emotive, or psychological meaning. Names become the double agents of contextual interference, the ghostly remnants of places, dreams, sounds, sensations – and both formal and market values – trapped under the surface of the visual sign.

This important horizon in the titling regimes of postwar art was preceded by the development in the United States in the 1940s and 1950s of a counter-compositional discourse that both annexed and partly answered to the counter-compositional rhetoric of the Dadaists and Constructivists. The high-water mark of institutional certification for this opposition to composition is clearly evidenced in the Museum of Modern Art's 1961 exhibition, "The Art of Assemblage," organized by William Seitz. With this show, and its attendant symposium, the term "assemblage" became the most powerful designation set up to counter what were now viewed as the profound limitations of the compositional tradition.

This and the following chapter offer a dialogue between the late modernist defense of composition and various strategies of neo-avant-garde and postmodern resistance to it. I will attempt to read in the nominative spaces between formalism and non-formalist critical discourses to reveal something of the shape and destiny of the titular activity after World War II. It must be underlined, however, that the deployment of titles was just one of several textual supplements through which the signifying economy of visual practice was expanded during and after the 1940s. Others include the expansion of critical discourse, a profound increase in the sheer number and means of circulation of artists' writings (statements, reviews, manifestoes, debates, broadcasts, etc.), and a corresponding acceleration of the denomination and verbal packaging of movements, tendencies, and avant-garde configurations and thematics.

While such developments have been surveyed, and while they have been attended by a skeptical or ironic counter-critique (in Susan Sontag's admonition of experiential "silence," or in Tom Wolfe's disquisitions on *The Painted Word*, for example), the particular significations of titling for high modernist and the neo-avant-garde have not been well observed. I will discuss three moves in the mid-century history of the title, beginning with a commentary on the titling practices of the Abstract Expressionists. I will then examine two oppositional sites of naming: in the heterogeneous activities of the neo-avant-garde (concentrating on the "environments," "events," and "happenings" of Allan Kaprow); and in the discourse of high modernism, where I focus on the destiny of the title in the writings of Clement Greenberg and other formalists in the 1960s. In the course of these discussions, I will track the various destinies of the compositional: since the values associated with composition form an important subtext, repressed or explicit, engaged or disputed, in each of these movements.

II Abstract Expressionism: "Something[s] Extra"

It is of special significance that when discussed from the point of view of the title, there is a switch, or inversion, between the names proposed by the Abstract Expressionists for their images in the late 1940s and 1950s, and those concocted by the Post-Painterly Abstractionists and high modernist sculptors in the 1960s. With certain notable exceptions, including Clyfford Still, who maintained throughout his career a staunch unwillingness to supply any textual material whatsoever with his images, the earlier work of the Abstract Expressionists was titled with resonant, often mythologically inspired, captions, such as Jackson Pollock's *Search for a Symbol* or Mark Rothko's *Slow Swirl at the Edge of the Sea* (both 1943), that mimed or otherwise reinforced their quest for a new system of marks, notations, symbols, and hieroglyphs. Yet during the later 1940s and early 1950s, as their distinct visual idioms were formed (Pollock's all-over drip paintings, Rothko's floating color rectangles, Newman's "zipped up" color fields), there was a progressive, if not scrupulously observed, reluctance among these same artists to augment their painted images with any sort of metaphorical title – a refusal of the titular *surplus*.

This tendency is clearly observable in the work of Pollock and the scrupulous account of his titles rendered in his catalogue raisonné. As many of Pollock's paintings had no "official" titles, the compilers of the catalogue propose a protocol according to which six observations give rise to five titling possibilities. Least problematic are titles accepted as

Pollock's and published in his lifetime. These constitute a filament of authoritative names. Then there are a number of titles that have become standard through usage, but which are not Pollock's; a set of titles bestowed on works by their owners subsequent to viewing or purchasing; descriptive and non-interpretative titles given by the editors of the catalogue for the purposes of identification; and numbered titles that have verbal subtitles or titular additions of various kinds. The compilers also add a sixth "observation" that does not generate a set of sanctioned titles: "Terms such as 'Untitled,' 'Painting,' 'Drawing,' and 'Composition' have not been accepted by us as titles even though these nontitles have been published and are cited in the Exhibitions and References."[5] The refusal of the "nontitle" is as significant as the adumbration of legitimate nominal types, for implicitly caught up in this sequence of evacuated names is a theory of signification that refuses the equation between formalism, non-iconic abstract expression, and the empty title. The Pollock brought into being by this editorial decision is the Pollock of action painting, rather than the Pollock of optical reduction elaborately argued for by the post-Greenbergian formalist, Michael Fried.

But there is more to it than this, for the horizon of titling types arrived at in this catalogue of work crucial to the trans-Atlantic redirection of painting in the mid-twentieth century is closely articulated with the phases of Pollock's career. In the early period, from the mid- to the late 1930s, many works are left untitled by the artist; but around 1938–41, a high incidence of descriptive titles is offered by the editors. The change in Pollock's approach to painting around 1942–43 is signaled by a move to larger canvases and by evidence of greater interest from the artist in titling his own work. By the mid-1940s something of a premium has been placed on the title, and the name becomes a site of debate and critical investment. Some works are retitled for their various exhibitional appearances: for example, *Male and Female in Search of a Symbol* (1943) was renamed *Search for a Symbol* when it was shown at the Arts Club of Chicago in 1945; *Croaking Movement* was titled *Sounds in the Grass* in a Guggenheim catalogue; other works are named by, or in deference to, critics, dealers, or members of the Pollock circle (Clement Greenberg, for example, contributed the title *Gothic*). As the drip technique is finalized, around 1947, almost all the titles for the works are given by Pollock himself. The chosen names are simply, but deeply, metaphorical. They include *Phosphorescence*, *Cathedral*, and *Full Fathom Five*, another painting renamed following its encounter with a critic. Works from the later phase of Pollock's career are usually numbered by the artist in the sequence of their production, followed by the year, a practice scrupulously embraced by Still. But there were also works, such as *Lavender Mist: Number 1,*

1950, that earned their metaphorical title from critics (in the case of *Lavender Mist* it was, once more, Greenberg) after they had already been numbered by Pollock.

The waxing and waning of the title, and the production of substitute and surrogate names, has figured quite centrally in the interpretation of Pollock's works. For some critics, the nominal indeterminacy of Abstract Expressionism, especially of Rothko and Still from the mid-1940s, is bound up with the evaporations of a failed visual metaphysics. Donald Kuspit, whose hostility to textual discourse and the inscription of the title we have noted several times, claims that "[t]he abstract irradiations of Rothko and Still evoke but do not name visions, incite but do not clarify thought, and illuminate and exalt but to no clear purpose."[6] The failure of Abstract Expressionist "evocation" is linked by Kuspit to the absence or denial of the name: what cannot be named must be suspended outside of communicative rationality. Elsewhere, however, the question of naming is brought forward as a key form of evidence in the historical interpretation of the movement. In another of his contributions to the relatively rare discussion of titling in the history of modernism, William Rubin thinks through problems around the naming of Pollock's earlier paintings in order to refute the interpretation of these works as a form of what he terms "Jungian illustration."[7] Rubin contends that the historically accurate retrieval of the names for particular works reveals the large signifying range of Pollock's titles, and his relative inconsistency in their use. He points to Pollock's practice of titling work "only long after making the image" and notes that while some of them are apparently elliptical, "evocative," or "memorial," others seem to contain unclear and unspecified personal connotations, such as *Portrait of H. M.* (c. 1945), while others still are "'associational' − in the manner of Surrealist titles," or "roughly descriptive of the images to which they are attached."[8] Given the variance and discrepancies in his titling regimen it is difficult to accept some "literal," unequivocal, reading of the relation between the title and the image, especially that form of interpretation, or "overreading," which insists on the close coordination of Pollock's paintings with specific mythological content. Rubin cites a cautionary tale: Pollock's decision to change the name of his *Moby Dick* to *Pasiphaë* (c. 1943, fig. 70) was apparently made on no better grounds than that Peggy Guggenheim didn't like the original title and James Johnson Sweeney was on hand with a substitute mythological name − one drawn, furthermore, from a story the details of which Pollock might not even have known. These and other examples reveal Pollock's titular mythologization of his paintings more as a set of loose associative gestures than as the product of a programmatic symbol-system.

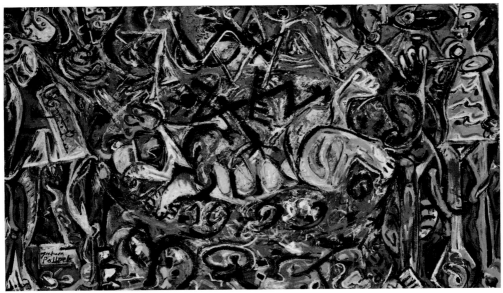

70 Jackson Pollock, *Pasiphaë*, c. 1943. 142.6 × 243.8. The Metropolitan Museum of Art, New York.
Purchase, Rogers, Fletcher and Harris Brisbane Dick Funds and Joseph Pulitzer Bequest

The casual designatory field of Pollock supplies only one of the titular
indices of Abstract Expressionism. With de Kooning, the role of the title
as supplement and the encounter of the movement with the discourse of
composition, are made explicit. In his discussion "What Abstract Art
Means to Me," de Kooning writes of the title as a "something extra" that
marks an important moment of difference between practices of form and
formalist practice. It is the conscious mobilization of the supplementary
function of the title in the meta-discourse of *composition* that clarifies the
more disparate Symbolist gestures of musical titling, untitling, numeric
titling, and hyper-connotative titling, discussed earlier.

As soon as it − I mean the "abstract" − comes into painting, it ceases
to be what it is as it is written. It changes into a feeling which could
be explained by some other words, probably. But one day, some
painter used "Abstraction" as a title for one of his paintings. It was a
still life. And it was a very tricky title. And it wasn't really a very good
one. From then on the idea of abstraction became something extra.
Immediately it gave some people the idea that they could free art from
itself. Until then, Art meant everything that was in it − not what you
could take out of it sometime.[9]

This meditation by de Kooning, in which he attempts to situate a new understanding of abstraction in the United States in the 1940s and 1950s in relation to European precedents, takes its place in the line of speculative artist-titles we have traced to Gauguin's elaborate comparison of an imaginary work differently named by Puvis de Chavannes and himself. Only here the title "Abstraction" − a specification, we should recall, left out of the list of "nontitles" put forward in the Pollock catalogue raisonné − is situated midway between our earlier categories of "denotative" and "untitled." It is reductively descriptive in that it names the content of the image simply for what it is. But it is also empty in the sense that the "abstraction" specified here can have no referent other than itself. De Kooning is reaching for a crucial break in the development of modernist discourse − that necessarily unspecifiable point at which "abstraction" becomes not only a critical desideratum, but also a self-conscious inscription. Again, this is the moment not of abstraction itself, but of meta-abstraction, of the production of abstract work about the means of abstraction. Abstraction here is not a purpose or a set of equivalents or a meaning system, but a surplus, "something extra," as de Kooning puts it, that can be subtracted from the "everything that was in it."

Now, de Kooning has identified this moment of meta-abstraction as a form of decadence in which art practice is hopelessly *predicated* on − literally "said before" − the painting in written explanations and theoretical tracts which the work merely illustrates and the title faithfully labels. These ideas contain a version of the "visualist" paradigm and its attendant disparagement of textuality differently championed, as we will see, by Sontag and the formalist critics of the 1960s. The pre-texts of theoretical exposition, especially in the case of Kandinsky, are understood as "philosophical barricades": "[Kandinsky's] own writing has become a philosophical barricade, even if it is a barricade full of holes."[10] The de Kooning essay complains about earlier twentieth-century avant-garde group solidarity and theorization which it pits against both individual absorption and expression, and the cultivation of "poetic frames" for the practice of "intuition." In addition to his rejection of pictorial prescription and negativity, de Kooning also dismisses the mediation and social complexity reached for by "that famous turn of the century," the avant-garde legacy which issued only "into politics or strange forms of spiritualism."[11]

For de Kooning, then, the supplementary, subtractive nature of the turn to abstraction is understood as a deviation from "free," intuitive fullness − that artistic face onto the world that refuses pre-textuality, conceptual mediation, and the sociality of art-world formations in favor

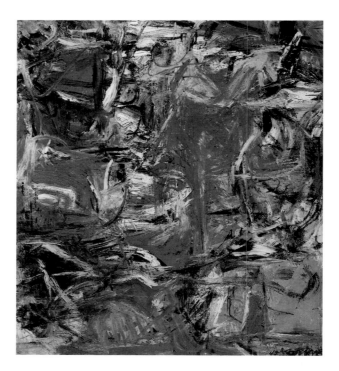

71 Willem de Kooning,
Composition, 1955. Oil,
enamel, and charcoal on
canvas, 201 × 175.6.
Solomon R. Guggenheim
Museum, New York, Gift.
Solomon R. Guggenheim,
1937

of the incarnate freshness of instinctive vision defended by Harold
Rosenberg and others. In this sense the supplementarity of the abstract
functions in de Kooning's account rather like the supplementary function
of language in Derrida's reading of the counter-cultural idealism of Jean-
Jacques Rousseau.

In an interview with David Sylvester, de Kooning elaborates on how
these disavowals are registered in his "Women" series. Finding himself
"stuck to a certain extent" on the visual prolixity of the historical
traditions of visual idols and whores, the artist notes of his preoccupation
that: "It did one thing for me: it eliminated composition, arrangement,
relationships, light – all this silly talk about line, color, and form – because
that was the thing I wanted to get hold of."[12] The series, then, took on
the decomposition of the "woman-thing," whose representation becomes
the pretext for a new order of transcompositional immediacy. De
Kooning uses the flesh of the woman-thing-Other as a dissolve for the
tradition of decorous sensuality (Matisse), or abstract–expressive formalism
(late Kandinsky). Another of his works, the Guggenheim's *Composition*
(1955, fig. 71) plays out the ambiguity of his front onto "composition" as

it is associated with formal "reading-in." A catalogue entry states: "Completed by March 1955, *Composition* belongs to the period of transition from figure to landscape to abstraction. . . . By early 1955 the figure gradually dissolved into an abstraction which retained compositional elements of the paintings of women."[13] As with Cézanne and Picasso, the site of the encounter of the male artist with the female model gives rise to a double crisis: of compositional form and of the nomenclature that articulates it. De Kooning has produced a representation of the body (and its after-effects) that aspires to a non-verbalized, non-compositional, somatic "thingness." It was the unsettling, "outspokenly representational" nature of his "'Women' pictures of 1952–1955" that led Greenberg to describe de Kooning's "manner" in this phase as a form of "homeless representation."[14] They were "homeless" because of their drive to connect paint and the "thing" without being diverted through compositional order, without the necessary organization of form central to the vigorous critical system defended by Greenberg after Abstract Expressionism.

If we turn to statements made by other artists associated with the Abstract Expressionist movement, we will find that the textual resistances and counter-compositionality established by Pollock and de Kooning are further inflected. Discussing the critical obsession to "read-into" his paintings, Franz Kline noted that: "If someone says, 'That looks like a bridge,' it doesn't bother me really. Naturally, if you title them something associated with that, then when someone looks at it in the literary sense, he says, 'He's a bridge painter.'"[15] This distinction between figurative identification and titular recognition and confirmation merges in Kline's thought with the notion of painting as a "question of destroying – of destroying the planned form." The assault on pre-pictorial forethought, literary association, and iconographic reduction resembles the criticism leveled at the "subtractive" by de Kooning, for whom any admission of pre-conception stood for a clear failure of address towards the "thing" itself.

For Barnett Newman, similarly, while the Impressionists "destroy[ed] the established rhetoric of beauty," modern art failed persuasively to carry through this "impulse." The modern tradition fell short by virtue of its "effort and energy to escape the pattern rather than [attempting] the realization of a new experience." Such art was "caught [with] a sublime content" yet foundered in its "empty world of geometric formalisms." It revealed an unfortunate refusal "to live in the abstract" and "to admit any exaltation in pure relations." Newman's stand is "revelational" and properly subtractive: "We are freeing ourselves of the impediments of memory, association, nostalgia, legend, myth."[16]

These same obstacles – "memory, history or geometry, which are

swamps of generalization from which one might pull out parodies of ideas (which are ghosts) but never an idea in itself"[17] – are taken up by Rothko. His is an elaborate plea for an abstraction that forgets the allures of formal decorum and compositional finesse, resists the collective memory of forms lodged in the modernist imagination – which are capable of eliciting only "parodies" of received ideas – and advocates the transcompositional enactment of an uncontaminated sublime. We encounter here a willed "exaltation" that knows nothing of the ordered effects of a surface, or of the descriptive banalities of the name.

Still gathers such sentiments and returns them against the site of the name even more emphatically (see fig. 72). In a letter of 24 January 1972 he wrote that "[m]y paintings have no titles because I do not wish them to be considered illustrations or pictorial puzzles. If made properly visible they speak for themselves."[18] His statement for an earlier exhibition pressed the matter of nomination further:

To supplement the reproductions of paintings shown in this catalogue with written comment by the painter represents not only the extreme

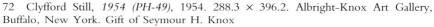

72 Clyfford Still, *1954 (PH-49)*, 1954. 288.3 × 396.2. Albright-Knox Art Gallery, Buffalo, New York. Gift of Seymour H. Knox

of temerity on my part – it is patently presumptuous. At least that is what I have been told by some of those who write about pictures. In a culture where the written word is commonly regarded as synonymous with God, the gesture suggests an arrogance pregnant with blasphemy.[19]

Still's is an extreme version of the refusal of the "dangerous supplement" of textuality espoused by de Kooning. Only here the Logos itself is the incarnation of the supplement, and its disavowal is a blasphemy. His "blasphemy" is the very opposite of Malevich's deliberate drive for the iconic status of the *Black Square*, for elaborate theorization that supplements and completes it, and for a whole institution of speculative discourse that fronts onto the social and spiritual worlds. Instead, Still's religiosity is the pretext for one of the most rigorous denouncements of the titular activity in the twentieth century. Railing against "literary frustrates" and the "collectivist denominators of this time," Still is ferociously committed to the belief that in the matter of the making-present of the image, "[n]either verbalizings nor aesthetic accretions would suffice."[20]

III Neo-Dada, Assemblage, Happenings: Making "In Spite of Composition"

The silent, ecstatic, punctual, modern sublime sought by several of the Abstract Expressionists is articulated in opposition to "composition" in ways that meet the counter-compositional rhetoric of the neo-avant-garde at ninety degrees. For the Abstract Expressionists composition was a superfluous veil that masked out the impact of an immediate, experiential encounter with the visual sign. For the generation that succeeded them, composition was an ambiguously contested sign of the false order and fastidious control of European modernism. Robert Rauschenberg is one of an accumulating number of artists working in the United States in the later 1950s and 1960s who commence a fundamental rejection of the precepts of ordered form, especially as they had been worked out by the School of Paris. Rauschenberg claims to work "in spite of composition," substituting a theory and practice of collaboration, accumulation, and contingency whose operations are specifically mobilized against the deliberation, control, and order of the composition. His titles, such as *Almanac* (1962) and *Bed* (1955), attest to this new emphasis: "Painting is always strongest," he asserts, "when in spite of composition, color, etc., it appears as a fact, or an inevitability, as opposed to a souvenir or arrangement"[21] – a citation that immediately precedes his most famous statement:

"Painting relates to both art and life. Neither can be made. I try to act in the gap between the two." Like de Kooning and Still, Rauschenberg opposes "the whole idea of conception – execution – of getting an idea for a picture and then carrying it out"; though unlike them his concern is for "*collaboration* with the materials," for a kind of spontaneous, chance-assisted interaction of fact-like parts "combined" rather than "composed."[22]

In order to open up the consequences of the counter-compositionality suggested by Rauschenberg, I will look first to some of the stakes of the debate he has raised as they have been discussed by contemporary critics. Then I will turn to one of the most sustained attentions to the reinvention of composition, in the work of Allan Kaprow. My aim is to show how, even in the later 1950s and 1960s, artists, including Kaprow, who were radically opposed to the constraints of notational form, staged an important struggle between order and dissolution, eventually between art and life, whose key symbolic terms are still "composition" and "decomposition."

Several recent discussions touch on the hinge between visual modernism and the avant-garde, between modern and postmodern, including studies by Rosalind Krauss and Peter Wollen, who problematize the focal antithesis between form and structure, on the one hand, and dissolution, entropy, and annihilation, on the other. The shift in much Dada work from a modernist notion of making form to a more avant-garde idea of "deforming" has long been a preoccupation of Krauss's writings. In contrast to her residually formalist discussion of Cubism and collage practice, Krauss's later essays attend to what she terms a "counterhistory" articulated against "the optical logic of mainstream modernism."[23] This counterhistory brings forward the compositional disfigurations of avant-garde practice. Krauss examines the desecration of form and the implications of "structure *en abyme*," glimpsed in the "anamorph," the "heteromorph," and the "informe." Such anti-formalisms are related to the "convulsive aesthetic" discussed by Breton, which promotes "deliquescence . . . entropifaction . . . a resistance to form" and results in the "the shattering of signifying boundaries, [and] the undoing of categories."[24]

What Krauss traces here is a formalism in the process of interring its own ethos – but which still confronts its self-image through the conscious generation of a negative. Krauss might *diagram* this in a quadrilateral based on the mapping of Form-AntiForm. For diagraming and its structural logic, like form and formal logic, is another of the supervised encounters she sutures as pros and cons in a conflictual elaboration that finally comes full circle. The residues of this conflict are clearly manifest in the formal

reversions and uncertainties that structure the diffuse practices achieved in the United States after Abstract Expressionism, but against the logic of Post-Painterly Abstraction and the later formations of Pop.

We can follow the implications and the paradoxes of the anti-compositional debates of the postwar neo-avant-garde by examining Kaprow's ideas as they developed in the decade following his key 1958 essay, "The Legacy of Jackson Pollock." In this essay, he surveys the inherited history of visual modernism, claiming that the idea of compositional "order" was explicit in the "last seventy-five years" of the act of painting, and that "even Dada, which purported to be free of such considerations as 'composition,' obeyed the Cubist esthetic." "[P]art-to-whole or part-to-part relationships, no matter how strained," he continues, "were a good 50 percent of the making of a picture (most of the time they were a lot more, maybe 90 percent)."[25] The practices of Assemblage and Environments, on the other hand, which Kaprow was instrumental in developing shortly after the publication of this essay, were predicated on a counter-compositional impulse that, as he put it in a later discussion, "may be named simply *extension*":

> Molecule-like, the materials (including paint) at one's disposal grow in any desired direction and take on any shape whatsoever. In the freest of these works the field, therefore, is created as one goes along, rather than being there *a priori*, as in the case of a canvas of certain dimensions. It is a process, and one that works from the inside out, though this should be considered merely metaphorical, rather than descriptive, since there actually exists no inside, a bounded area being necessary to establish a field. There are only a few elements one begins with, and these at best are located with respect to one's body and the room itself.[26]

All the attributes of the composition are here assailed: its unity, boundedness, dimensionality, conceptual planning, field-like articulation, even the notion of "beginning." The new work of "assemblage, environments, and happenings" emerges as a free-form function of the body, its adjacent space and the process of material extension: "There is no apparent theoretical limit to what may be used."[27] Yet Kaprow also notes that "in practice" this extensionality is not limitless. As if to explain the necessary compromises at stake in the making of assemblage-type work, he deliberately reverts to the language of the composition: "the very great majority of works which are composed of such stuff . . . have a fairly limited iconography."[28] Their "charm" and "cuteness," are bound up in the kind of "nostalgia," "reverie and gentle humor or irony" characteristic of early Cubism.

Much of Kaprow's theory, and many of his Environments and Happenings, establish a dialogue between the centripetal drive for compositional order (the "home-likeness" identified by Greenberg) and the centrifugal forces of dissolution. Thus, even the most heterogenous accumulations of material, from which the "last vestiges of picture making have fallen away," are imagined, in one striking passage, as reverting to composed order:

> The work begins to actively engulf the air around it, giving it shape, dividing it into parts, weighing it, allowing it to interact with the solids at such a rate or in such a strange manner that one now cannot help noticing the shape and feel of the gallery which, like some radar signal, sends back its shape to contend with the work of art.[29]

The "strange manner" of this dream-like recuperation of formless shape into managed form, and its reinscription in an imaginary museum, are reminders that the vivid destiny of collage in the "dream spaces of science fiction, rooms of madness, and junk-filled attics of the mind" is always subject to institutional recall and some vestige, at least, of the "will-to-form." Indeed, Kaprow proposes that change itself "suggests a form-principle for an art which is never finished, whose parts are detachable, alterable, and rearrangeable in theoretically large numbers of ways without in the least hurting the work."[30] Perhaps this is why Kaprow continues to refer to the making of work as a "compositional activity." Even imaginary non-works are defined in this way: "[I]t is not hard to imagine a rain storm making a marvelously soggy shapeliness of blotters, rags, and papers composed within an apple grove laden with ripe fruit." Furthermore, the third of Kaprow's "four areas [of Chance] comparable to Aristotle's 'four causes'" is specifically reserved for a description of formal effects and titled "COMPOSITION."[31] Here, the artist invents a kind of semi-absurdist permutational scheme for the quasi-infinite combination of materials and forms. It offers dissident formulae for the determination of "automatic decisions," and a non-precise system for the "execution" of an Environment "according to plan." Kaprow allows for various orders of artistic discipline, different listing techniques, and categorical imperatives. He even suggests that the cultivation of chance can be reduced to "another confining academicism."[32]

The Happenings, his writings, and much of the critical commentary on his work make it clear that Kaprow holds on to a fundamentally renegotiated idea of composition as perhaps the central sustaining principle of his oeuvre. As several writers have noted, the matrixal constraints of his elaborately staged and titled *18 Happenings in 6 Parts* (1959) suggest the location of the piece within the limits of ordered, enframed art discourse.

Reading from this work, Michael Kirby, for example, defines Happenings as *"a purposefully composed form of theater in which diverse alogical elements, including nonmatrixed performing, are organized in a compartmented structure."*[33] Here the language of compositional order ("purposely composed," "organized," "compartmented structure") is clearly asserted over the two types of heterogeneity brought forward by the critic: "diverse allegorical elements" and "non-matrixed performing." It is also by virtue of an implicit, subtextual attachment to *composition* that Kaprow himself resists the nominal, avant-garde newness of the designation "Happenings." The text from Kaprow's book, cited above, has a footnote explaining the origin and consequences of the term:

> I doubt that this is a term acceptable to all artists. It was part of the title of a score included in the body of an article written in early 1959 for the Rutgers University *Anthologist* (vol. 30, no. 4). This was apparently circulated in New York City. In October of the same year, I presented *18 Happenings in Six Parts* at the Reuben Gallery, a loft on New York's lower Fourth Avenue (now an artist's studio). A number of artists picked up the word informally and the press then popularized it. I had no intention of naming an art form and for a while tried, unsuccessfully, to prevent its use.[34]

Kaprow's reluctance to take responsibility for the public circulation of his casual label "Happenings" as the preferred designation for his work in this idiom may be accounted for in two ways. First, he is aware of the social power of the title, and, as evidenced from his discussion of the theoretical underpinnings of the post-assemblage work of the later 1950s, appears to favor a name less explicitly identified with spontaneity and dissolution. It is for this reason, as we will see, that he introduces an extended account of the rehabilitation of composition. Second, his distrust of the connotations of "Happening" is met by a general distrust of textuality – for words both as theory, and as particular elements (among others) in his environmental works. Indeed, despite the fact that one of his "Rearrangeable Environments," *Words* (1961, fig. 73), was organized as a combination of words with "light and sound," the textual is caught up in the Environments and Happenings in ways that are quite particular – and somewhat reduced. Kaprow was insistent, for example, in his description of the Environment, that temporality and vocality were subordinate to space and "tangible objects." He notes that the "chief accents" of the Environment "to date have been visual, tactile, and manipulative." In the "kaleidoscope" of a Happening, however, words take on a variety of often minor functions. They "rumble past, whispering dee-daaa, ba-ROOM, lovely, love me." They come in the form of the shouts from janitors,

7.3 Allan Kaprow, *Words*, 1961. Rearrangeable environment with lights and sounds.
Courtesy the artist

"from different passageways, *but their words are backwards.*" Kaprow even
uses a metaphor from language to separate out the "hackneyed" "struc-
ture" or "grammar" of the night club from the "experimentation and
change" of the Happening.[35]

In the conclusion to his essay for *Assemblage, Environments, and Happen-
ings*, Kaprow develops a number of "rules-of-thumb" for the Happening.
These include the necessity to keep the "line between art and life" "as
fluid and perhaps indistinct as possible"; the rejection of "themes, mate-
rials, actions," etc., that derive from the "arts, their derivatives, and their
milieu"; the use of multiple, shifting locales; "variable and discontinuous"
time; the non-repeatability of Happenings, which "should be performed
once only"; and the elimination of audiences. Kaprow's final category
reads as follows: "*The composition of a Happening proceeds exactly as in
Assemblage and Environments, that is, it is evolved as a collage of events in
certain spans of time and in certain spaces.*"[36] This section develops both as a
"discussion of composition" and as "a summary of all the rules-of-
thumb raised respecting Happenings." The concluding pages of his fullest

meditation on the art revolution of the later 1950s and 1960s thus take
the form of a debate over the historical semantics of compositionality:

> When we think of "composition," it is important not to think of it as
> a self-sufficient "form," as an arrangement as such, as an organizing
> activity in which the materials are taken for granted as a means toward
> an end that is greater than they are. This is much too Christian in the
> sense of the body being inferior to the soul. Rather, composition is
> understood as an operation dependent upon the materials (including
> people and nature) and phenomenally indistinct from them. Such
> materials and their associations and meanings, as I have pointed out,
> generate the relationships and the movements of the Happening,
> instead of the reverse. The adage that "form follows function" is still
> useful advice.[37]

Kaprow resists the two extremes of the composition, the formalist sur-
render to "a self-sufficient 'form,'" and what he terms the "artistic
schizophrenia" that would result from the merely random or anarchic
conjunction of "*any* subject matter and material" with "*any* interesting
formal technique." Accordingly, the rest of the article is devoted to an
outline of the "spacing" and "durations" of his events, noting for example
that "[t]here are related ways of setting off rearrangements of fixed
numbers of actions such as by *cueing*." The deployment of "chance
methods" does not issue in non-relationality or formlessness. Instead,
their "advantage" "is that they free one from *customary* relationships rather
than from any relationships." Kaprow also suggests examples to demon-
strate that "in making a Happening, it is better to approach composition
without borrowed form theories, and instead to let the form emerge from
what the materials can do."[38] Of one "score for an unperformed Hap-
pening," he notes, somewhat in the manner of Mondrian's compositional
theory, that,

> in composing it, I played around with the images on paper, shifting
> them this way and that, letting one thing suggest another, without the
> slightest thought about "meanings" per se. At the time I was only
> interested in a certain vividness.[39]

Part of the "vividness" revealed by these detailed "conditions" of the
Happening is found in the lengths to which Kaprow will go to negotiate
a space for his avant-garde that is simultaneously radical and "deeply
traditional"; that produces not "iron-clad rules but fruitful limits" which
can and should be transgressed. This manifesto is bound up in a theory
that explicitly renounces the categorical limits and fractured structure of

"analytic writing" – especially when measured against the "pervasive process" sought in the Happening. In the end Kaprow has clung on to the outer limits of possibility for the traditional notion of composition, identifying it as a necessary name for even the most minimal and tentative sorting of visual order from the flux of the world. Within the pressures of this flow, the term "composition" is vigorously defended over the name "Happening." Kaprow's composition may be just one step from pure extension but it is a step that can only be taken in the name of the art-form.[40]

IV Tropic Writing: Rethinking the Titular Metaphors of Late Modernism

Between Abstract Expressionism and the neo-avant-garde, between Pollock and Pop, between the final staging-post of abstract pictorialism and work in the "expanded field," a space opens up in visual practice and its contexts that has been held to separate modern and postmodern. Without dwelling on the history or theory of this divide, I want to claim that while the discourse of nomination is a symptom of these shifts, it also plays a role in their articulation. For, as we have already seen, the stakes of the textuality associated with the title, and with the compositionality that governs European modernism, are raised yet again in the postwar period. They are driven on the one hand by the constitutional anxieties of modernism, and on the other by the textual and other expansions of postmodernism.

In her essay "Non-Writing and the Art Scene," Susan Sontag establishes a key position that will inform one half of the "great divide" of the postwar art world. Unleashing something of a diatribe against the reductive, chauvinist, critical tokenism and "nativist boasting" that attended the reception of Pop art by the popular press in the mid-1960s, Sontag fixes on the derogatory effects of the "label" – which would later constitute the focus of Louise Lawler's critique of the institutional context of the artwork.[41] Sontag, however, contests the "substitutive," "cut-off" logic of the label as a verbal token that only gratuitously stands in for "genuine thinking, feeling and acting." The brevity, attenuation, and purported disingenuity of the label reveals it as a signage that is as equally and oppositely false as the overproduction of critical verbiage. Both kinds of textual supplement to the visual image are adjudged superfluous; both are regarded as contaminating the purity of exchange imagined between the image and a receiving human consciousness replete with its exquisite powers of non-verbal apprehension.[42]

For Sontag, then, all textual production that subtends the image – the label, the title, and most of the available, ambient criticality – is for the most part simply insufficient to speak for the image.[43] She views the sum of these textual extras as an invasive surrogate contending against the discursive (self)-presence of the visual sign. The premium placed by Sontag and others on the self-evidentness and revelatory presence of visual discourse is predicated on a contra-social theory of the sign that, at the extremes of its formulation, merges with the kind of contextual blindness and irresponsibility that led the ACT UP coalition to adopt the graphic emblem SILENCE = DEATH in its "direct action" struggle "to end the AIDS crisis."[44]

It is on the site of the title and other additive texts that Sontag's phenomenological disparagement of textuality meets Greenberg's formalist foreclosure. For playing opposite the textual disapprobations of Sontag in the later 1950s and 1960s – in the heyday of the formalist elevation of Post-Painterly Abstraction as the culminating gesture of visual modernism – is an extraordinary exfoliation of the connotative, tropic title. It is almost as if the vigorous metaphoricity of the title is vaunted by late modernist artists in proportion as the formalist rhetoric of the critics reaches in a crescendo towards its historical destiny of announcing the final triumph of "ineluctable flatness" and "Kantian self-criticism."[45] The astonishing propensity of the denominative gestures of the most touted modernist artists of the 1960s to juxtapose their spare, self-preoccupied paintings and sculptures with oblique, flamboyant, even mischievous titles, has rarely been remarked. Yet this singular exercise in the cultivation of extra-pictorial signification is strikingly at odds with the anti-theatrical, anti-referential purism of the formalist critical coterie.

Indeed, the calculated titular polyvalence of works by Noland, Stella, Caro, and others reaches across a strategic site of crisis in the whole enterprise of late-modernist critical accountancy. And the semantic imbroglio to which it gives rise reveals as profound a rupture in the bastion of critical formalism as the more famous and iterated debate over Minimalism and the conditions of "theater." The history of this rupture in the signifying conditions of the title casts a long shadow over the field of contemporary art. In order to understand the implications of the text-assisted metaphoricity of 1960s abstraction, it is useful to look over to the (non)place reserved for the title – and for textuality in general – in the development of formalist criticism.

I have insisted throughout this study – in relation to the development of the "untitled" work, to Cézanne, Picasso, and to the marking of modernist institutional space – that a critical history of the modern title must engage with the refutation of titular (and other) textualities, equally

as it looks onto various scenes of connotative fullness and extremism. In each of these moments of textual minimization we encounter different formations of a crucial repression whose *actions of silence* may occasionally be glimpsed as one or another defenses of visual self-sufficiency are acted out.

Despite the resistances staged by the European avant-garde, and aspects of the postwar neo-avant-garde, the market, intellectual, and institutional domination of formalist discourse lasted well into the 1970s, and still lingers on. An important task for any historical account of this domination would be a properly deconstructive reading of formalist discourse that attends to the strategies by which all the traces and effects of textuality are overtly reduced and covertly refuted. This is a task too extensive for the present discussion, but some gesture towards a reading of the textual "behind" or "underneath" of the visuality of art-world formalism is necessary. For the sum of the returns of the discourse's repression of text (returns at the level of titles, criticality, literary reference, the physical presence of words, symbolism, and metaphoricity) together constitute what is ultimately the most "dangerous supplement" for the formal method. Similarly, the strategies by which these textualities are recoded, disputed, ignored, and suggested reveal an ultimate dependency on the word which appears necessary for its own theoretical definition, as well as for any historical understanding.

What follows is limited to a discussion of Greenberg and other formalists writing for the most part in the 1950s and 1960s. It is immediately apparent that consideration of textuality in all its conditions, including the title, is stringently foreclosed in this criticism. On those few occasions where there is some compulsion to take on text, it is invariably folded back into the visual field *as if it were itself exclusively visual.* The most notorious instances of this reversion are found in Greenberg's discussion of Cubist collage and papiers-collés, which we have already encountered in the discussion of Picasso. For Greenberg the appearance of stenciled text is not an invitation to read, but to look. The form of the letters added to the surface is an insistent token of the work's radical and defiant *flatness.*

Greenberg deployed his unyielding "Laocoönism" in the face of any intrusion of textuality he could see or imagine. He was powerfully suspicious of Miró's poetic metaphoricity and Kandinsky's subjective theorizations; of Minimalism's textual academicism and Rosenberg's "rhetorical," existentially-driven, reading-in; and of virtually all other imbrications of text with the purity of the visual field he was so anxious to defend. In my reading of his oeuvre I have encountered only one place where he allows himself to dwell on the title; somewhat predictably, this represents an exceptional moment in his writings. The occasion was his

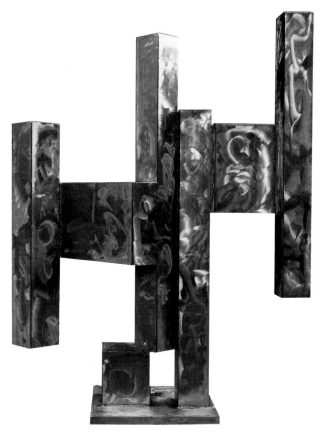

74 David Smith, *Cubi XXII*, 1964. Stainless steel, 263.5 × 196.2. Yale University Art Gallery, New Haven, Conn. Stephen Carlton Clark, B.A. 1903, Fund

contribution of annotated remarks to a selection of David Smith's work in the January–February 1966 edition of *Art in America*. The result is not so much a critical essay, as it is a form of memorial to the recently deceased artist who represented for the critic the high point of modernist sculpture. Greenberg outlines several types of title used by Smith for the works that surrounded his "house and workshop, which he called The Terminal Iron Works, in Bolton Landing, New York." Some of these are formal and generic, such as *Cubi I* (1963), which Greenberg notes is "numbered first of nearly thirty large stainless-steel sculptures" called by this name (see fig. 74). Some are formal and pseudo-descriptive, such as *Zig IV* (1961), which Greenberg glosses (in parentheses) as deriving from the word "ziggurat."[46] The "Zig" series "contains some of Smith's . . . sheerest masterpieces" by virtue of a pervasive "[a]bstract form" that "escapes entirely from the allusions to the natural world

(which includes man) that abound elsewhere in his art." Some are named
after the locations in which they were made or to which they somehow
allude. His description of *Menand III* (1963), for example, begins:
"Menand[s] is the name of a place near Albany." Two are "untitled,"
including *Untitled* (1964) – which is singled out for its unique construc-
tion "entirely of I-beams of different sizes and proportions," and its
"intimacy," and "cuteness." Some are connotative, including *Primo Piano
I* (1962), whose title Greenberg translates from the Italian (it "means 'first
floor' in Italian"). One work, *Becca* (1965) appears to be untitled, but is
in fact inscribed with the abbreviated names of Smith's daughters, carry-
ing a range of personal references that Greenberg, uniquely, allows to
stand in his memorial-text: "The signature plate of this sculpture bears
only *Becca* by way of a title, and *Becca*, like *Dida*, appears on a number of
other of Smith's late works. They are the diminutive names of his two
daughters, Rebecca and Candida, aged ten and eight." Finally, Greenberg
discusses an unusually figurative work left unfinished on the workshop
platform outside the studio, "which he did not have time to sign or
date"[47] (or, we might add, title).

The layering of these titular regimes – formal, descriptive, meta-
phorical, subjective – rehearses the title-types I have followed in this
study. It also forces a certain layering of the signification of Smith's
sculpture, an open invitation to understand the work according to each of
the field of possibilities opened up by the title. Such layering, however,
is inimical to Greenberg's methodology, which is insistently monological:
the quality of Smith's sculptural project is a function of its participation in
a unitary set of formalist predicates. Any other mode of signification is
ruled out of bounds. It would contaminate the crystalline, unitary focus
of the pieces, which are permitted complexity only in one analytic
dimension.

The present unusual instance excepted, in his many reviews and men-
tions of Smith's works Greenberg never permits himself to speculate on
the non-formal connotations of the sculptures. Writing of the sugges-
tively titled *Helmholtzian Landscape* in 1947, for example, he notes the
"richness of its suggestion and possibilities" but fastidiously avoids com-
menting on its content or its name.[48] Instead Greenberg's language is
crushingly abstract. He writes of "'classical' spareness and speed,"
"streamlining," "elegance," "clarity," "plenitude," and "economy."[49] In a
later essay Greenberg is abstractly explicit about Smith's abstraction, but
even more definite about his own (inadequate) textual description of it:

> A complex simplicity, an economic abundance, starkness made deli-
> cate, and physical fragility that supports the attributes of monumen-

tality: these are the abstract elements comprehended in the canon of Smith's art. But naming them is of little use.[50]

Why the critic should have had so much trouble with naming abstract qualities, and why he is unable to suggest less abstract "elements" in his writings is hinted at in the earlier review. Here he alludes, somewhat obliquely, to the existence of a domain of arcane signification which does not arouse his critical interest. It springs from the postwar "disillusionment" and "disenchantment of the world" that forced artists, including Smith, to "seek new myths and new obscurities inside themselves." To fetch meaning from the inwardness of the artist or from the modern mythology formulated by the Abstract Expressionists was a travesty against the panoply of visible, formal meanings that could be harvested from the surface and volume of the sculpture. To look below the surface was to risk the shocking specificity of personal reference – something that might only be ventured in an obituary, the only time that no more pessimism about the future of meaning is possible.

It is surely not fortuitous that on one of the rare occasions when Greenberg discussed the content of a Smith work – *Interior*, exhibited in the exhibition "American Sculpture of Our Time" at the Buchholz and Willard galleries in 1943 – it was to observe that "Smith shows for almost the first time that a house can be a proper subject for sculpture in the round." Remembering Greenberg's general insistence on the centered "homeliness" of visual form, and his memorial essay on the "house and workshop" pieces, it appears that when sculptural content turns on the (metaphor) of the house, discussion of the connotations of the object are suddenly permissible. It is here also that he allows himself another unique textual indulgence – a play on the name of the artist: "Smith, who, fittingly, is more smith than carver or modeler."[51]

Extensive titular collaborations with Pollock, Louis, and other artists notwithstanding, elsewhere in his writings the title and its signifying field are simply not addressed by Greenberg, except in passing. That such relegation is not fortuitous, but may instead be the product of a vision-driven repression, can be glimpsed in a polemic Greenberg wrote against his fellow art critics in 1962. When he turns his attention to Rosenberg's best-known critical statement, Greenberg pays what is almost certainly his most sustained attention to the title (with the exception of the memorial text on Smith). This attention is not based on the title of an artwork, nor is it confined to a single reference:

> . . . an article by Harold Rosenberg appeared in *Art News* in New York under the title "Action Painting." Though it named no names, it was

taken as a first attempt to throw real light, friendly or hostile, on the intentions of the new American painters . . .[52]

Greenberg's association of criticism with a kind of nominalism is announced in the very title of his essay, "How Art Writing Earns Its Bad Name." Indeed, the article explicitly attempts to separate (good) "art writing" from the promulgation of "bad names." The latter formula stands in not only for the "poor reputation" that Greenberg supposes for contemporary art criticism, but also for many other species of name-calling. The most important of these nominal badnesses is the notion of the Artist as Name, and the attendant intentionalities that this theory assumes are carried in the work, like emotional surrogates. But there are other "bad names" as well. One is the general irruption of extra-visual material into the signifying arena of the image which it lamentably occasions; another, of course, is the name as the title. Greenberg's fear – even abhorrence – of these textual interpositions is revealed by his inability correctly to identify the title of Rosenberg's key essay. Despite his deliberate citation of its title (one of the very few times he specifies such a designation) Greenberg misremembers the correct (bad) name, calling it, instead, by the simplest available shorthand for its leading concept: "Action Painting." Rosenberg's essay was in fact titled "The American Action Painters,"[53] a lead that among other things lays its emphasis on the artists rather than the process or painting technique which they are proposed to share.[54]

Greenberg's main target in this essay is the idea, seemingly defended by Rosenberg's "transposition" of "Existentialist notions," that a finished painting was the remainder of an action. He put it in these terms: "[T]he covered canvas was left over as the unmeaning aftermath of an 'event.'" What troubles him in this reading is the possibility that the painting itself is made over into a ("useless") supplement of action, that it becomes a common item of physical evidence – he uses the terms "clinical data" – or "solipsistic record." Painting, here, is considered as debased and secondary in relation to the privileged "event," just as Rousseau claimed writing had a deferred, subversive relation to the primacy of speech. Yet Greenberg's Rousseauianism is necessarily convoluted. While he clearly stands up for the purity and primacy of the finished physical product of painting, and is anxious to ward off the undue interpretative influence of the productive history of the image, his defense of the immediacy of the pictorial surface makes conspicuous recourse to its "governance" "by the norms of [the] discipline."[55] Considered from another angle, then, the disciplinarity spoken to by Greenberg looks like precisely the kind of acculturated artifice against which Rousseau was contending in his championship of "natural" values and expression.

Intentionalism, "autobiography," and "'[e]ssence,' or the identity of the painter" are precisely the investments in the painting of which Greenberg is most suspicious. For him it is these putatively "natural" reversions to origin which constitute contaminating supplements to the formal integrity of the finished work. Writing, especially the "movingly written" "eloquence," "rhetoric," and "opaque profundity"[56] of "Mr. Rosenberg's" criticism, is another of these unwanted investments. In fact, Greenberg makes a pseudo-Rousseauian appeal (against writing) which is also an anti-Rousseauian appeal against natural origins and expressive selfhood. Greenberg, here, plays the double role of Rousseau-Derrida, vaguely deconstructing the theory of "subjective" naturalness only to replace it with a theory of "objective" purity.[57] In one place he cannot prevent his fears and reservations about textuality from making an explicit appearance: "The very flavor of the words, 'action painting,' had something racy and demotic about it – like the name of a new dance step – that befitted an altogether new and very American way of making art."[58] By aligning the key words "action painting" with taste, movement, dance, power, and Americanness, Greenberg has made them stand in for the antithesis of his closed formal system, which bracketed consideration of temporality, and all art references that were not medium-specific. Further, Greenberg denounces the origins of Rosenberg's ideas, whether in "conversation" with Pollock or as a function of Rosenberg's own "literary" speculations. He cites Rosenberg's assertion "that his *literary discoveries* [were] outside his [Pollock's] range' (Mr. Rosenberg's italics)." Greenberg thus taints Rosenberg with his own (underlined) profession of literariness, which he immediately merges with the opinion, attributed back to Pollock, that the whole invention of "'Action Painting' was a big spoof." Writing, criticism, and the literary are cleverly and suggestively transformed into the after-effects of "half-drunken conversation." They are the travesties of alien theorizing in an alien material.[59]

Greenberg does not let it go at this. Pursuing the critical reception of Abstract Expressionism across the Atlantic to England, he scathingly notes the voguish confidence with which the "authorized brand name and certified label of the new abstract painting from America" "became current overnight." He attributes the success of the Rosenbergian notion of Action Painting with critics such as Lawrence Alloway to a general English resistance to the category of art, and the Eurocentric conviction that such a thing as art was simply not possible in the United States. It was, claims Greenberg, by providing a theory of action and not art that Rosenberg was able to wield such influence in London, where "muddled readings" of his article held the day. Greenberg contends against mannerisms and the loss of control, asserts Pollock's "almost completely Cubist

basis" – "the fruit of much learning and much discipline" – and finds Rosenberg to have perpetrated another "graft" of "mystification" on the first mystification of his transgression of the category of art. The denouement of this defense of (compositional) order is the equation of blindness with the "literary discoveries" that underwrite Rosenberg's theory.[60]

Finally, Greenberg takes a shot at the French critic, Michel Tapié, whose "intellectual journalism" is unable to understand the "newness" of Abstract Expressionism (and its European counterparts) for what it really is and must be – "eventually self-explanatory."[61] This excursion into criticism and catalogue writing, takes on "avant-garde critics" such as Alloway, and "an academic avant-garde critic like Robert Goldwater,"[62] in order to assail them for their failure to produce a *history*, and their impertinent suggestion that the avant-gardes of the 1950s were inventing, rather than renegotiating, a brand new range of problems. This is the second of Greenberg's switches in his essay on art writing. The first was constituted as an attack on, and simultaneous defense of, the supplement: this thought proposes the absurdity of thinking that painting can be considered a supplement to action; and, equally, though oppositely, it notes the erroneousness of the supposition that writing could ever supplement painting. The second defends the autonomy and non-productivity of the painted image by arguing for a continuity of interpretative approach that is *historical*. It is at this point that Greenberg, perhaps advisedly, introduces the notion of the "absurd" – which he cavalierly attributes to "contemporary art criticism." Such absurdities are double: they are a function of criticism's "rhetoric, its language, and its solecisms of logic"; but they are also the result of a repetition compulsion – the desire to repeat the same narrative of avant-garde reinvention in relation to each and every artist and movement "since Manet." Only Greenberg, perhaps, could argue the need for historical temperance in the face of over-vigorous critical avant-gardism – in effect, calling criticism to order for going too fast – yet predicate his call on "the speed with which modernist painting and sculpture have outrun the common categories of art criticism."[63] In the end, he falls back on an elaborate version of his own name-calling. The result of the:

> widening of the gap between art and discourse solicits, as such widenings will, perversions and abortions of discourse: pseudo-description, pseudo-narrative, pseudo-exposition, pseudo-history, pseudo-philosophy, pseudo-psychology, and – worst of all – pseudo-poetry (which last represents the abortion, not of discourse, but of intuition and imagination).[64]

What Greenberg cannot abide in critical discourse, is, also, and quite

precisely, what the discourse of the modern title actually returns. His list is as exact as any in its specification of the types of supplement offered by the title: descriptive, narrative, expository, historical, philosophical, psychological, and poetic. Just as there is a special premium – especially in Surrealism, but also in the abstract art Greenberg favored in the 1960s – reserved in avant-garde titling for the poetic or metaphorical title, so it is this category that elicits the most fulsome put-down from the critic. "Pseudo-poetry" is "worst of all" because it is held to go beyond "discourse," corrupting not only language, history, and explanation but also "intuition" and "imagination" – the cornerstones of formal understanding.

Other formalisms participate in the contestatory suppression of the title initiated by Greenberg. Indeed, one measure of the difference between what might be termed his abstract formalism and the historical formalism of William Rubin can be found in the way that supplementary, non-visual material is returned in their texts. So far as the title is concerned, there appears to be a reluctance to take them into account in Rubin's monographs on Caro and Stella superficially similar to Greenberg's passing over of textual supplementarity throughout his writings. Yet especially concerned as he is to situate formalist work within a formalist "history," Rubin allows a number of anxieties about this foreclosure to emerge in both discussions. The different formalisms of Greenberg, Rubin, Fried, and Krauss had different and progressively imbricative relations with textuality, culminating in Krauss's espousal of structural analysis in which the signification of the image was predicated on models deriving from the linguistic understanding of signs. The progression here might be from abstract formalism (Greenberg) to spectatorial formalism (Fried) to historical formalism (Rubin), to linguistic formalism (Krauss).

I have stressed the repressive structures of Greenbergian formalism in its necessary dispute with textuality. But we should also note that the formalist crusade launched by Greenberg in his art writing of the 1950s and 1960s was specifically, though intermittently, conceived against the *compositional* degeneracy of the American neo-avant-garde. Greenberg closely defines the "centrality" and "homeliness" of his critical system with reference to frequent summary sketches that seem to rehearse the compositional precepts of European modernism. This, of course is a composition more closely aligned with its Matissean incarnation, and the utopian or subjective compositions developed by the abstractionists Mondrian and Kandinsky. We should remember, too, that Greenberg's defense of the proper proportions made visible in "felt, inspired" relations, his assertion of the sheer "rightness of 'form,'"[65] is played out against the bravura disruptions and spectacular inappropriateness of the

"progressive" art of the 1950s and 1960s. This opposition comes most explicitly to the fore in a late essay, "Avant-Garde Attitudes: New Art in the Sixties" (1969), in which he assails the "artistic rocketry," "blank-looking" boxes, the "startling," "spectacular," "novelty art of the sixties: kinetic, atmospheric, light, environmental, 'earth,' 'funky,' etc., etc."[66]

The possibility that Greenberg's writings, and the formalist project at large, may be structured around the push of compositionality and pull of decomposition (somewhat in the manner of the theory-practice of Kaprow) can be defended with reference to both the critique of modernist formalism, and to its exaltation in the Post-Painterly Abstraction and new sculpture of the 1960s. Turning first to T. J. Clark, author of one of the more astute of these critiques, we will find that central to his deconstruction of Greenberg's defense of pictorial purity and self-definition is the claim that it is predicated on a kind of tautological negation, and issued in a remarkable form of cultural implosion. So anxious was Greenberg to flee from the contaminatory edge of the work of art that his defense of mediumistic "practice" became "extraordinary and desperate: it presents itself as a work of interminable and absolute decomposition, a work which is always pushing 'medium' to its limits – to its ending – to the point where it breaks or evaporates or turns back into mere unworked material." The anti-frame-bound internality so assiduously courted by the formalists is held in this account to turn inwards in a ritual display of self-consumption that gives rise to an epiphany of the "ineffable, a vacuity, a vagueness, a mere mysticism of sight."[67]

Elsewhere in the essay Clark returns to the notion of decomposition, which seems to consist in two separate, even opposite, formations. The first is specified as "the age of bourgeois decomposition so eloquently described in 'Avant-Garde and Kitsch.'"[68] This is the world of the debased simulacra of culture circulated in a world dominated by consumption, and the facile satisfactions of popular culture – all that is kitsch. "Decomposition" here is a function of "pseudoculture" and "pseudoart." The second decomposition, one of the kind described above as "absolute," is encountered where it is least expected. It is the consequence, or better the pathetic and contradictory issue, of Greenberg's own centrifugal proclivities. It is registered in the implosion of formalism itself and staged in its own most extreme instances. It is, finally, composition simultaneously fetishized and reduced to its opposite.

Though rarely discussed in this frame, the abstract art of the 1960s represents the apogee of compositional value. It is achieved at a moment when every vestige of compositional finesse is deployed for the sake of formal, plastic notation – even when there are competing meaning systems inscribed in the work, above all by the title. Almost everywhere in the contemporary criticism of abstract art of the 1960s we can see a

perplexing avoidance of reference to any effect not supposedly engendered by the emotive properties of the composition. The effects of this art could be described as meta-compositional. Its critics claim in their different yet convergent ways that it is made up of compositions that intensely meditate on the sensate conditions of composition – the emotional effects given off by shape, texture, color, arrangement, opticality, etc. These conditions are not merely present in the work: the work is held to signify through their mutual configuration, as if they were already mobilized as compositions before moving (again) into signification.

That the abstract work may conform to some type of the meta-compositional is evidenced in many ways. It can be glimpsed, for example, in the brief essay by Leo Steinberg that accompanied paintings by Paul Brach in the catalogue for the "Toward a New Abstraction" exhibition at the Jewish Museum in New York in 1963. The text is one of many from the period that take on the rhetorical articulation of a meaningful near-zero condition, rehearsing for the painting a litany of its defections from and resistances to traditional forms of visual plenitude. This rhetoric of absence and reduction will achieve both its apogee, and a curious form of disavowal, in Reinhardt's theory and practice – in which, it has been noted, "there are only so many ways to deal with non-composition."[69] Steinberg defends Brach's work for its "near invisibility," which issues in "absent objects," a "vacant geometry," "depleted voids," "empty iconicity," "opacity," and, eventually, in a kind of "unseeing indifference" which has "dispelled its physicality" in a "symbolic allusion to wholeness," the "ineffable metaphysical One."[70]

The climax of this critical language seems to speak of the monochromatic surfaces of Brach in terms that clearly recall the quasi-existential affirmations of Newman and Rothko made by counter-formalist critics such as Rosenberg. In one sense it is this recirculation of discourse that sustains my description of 1960s abstraction as "meta-compositional" – a designation that now collides compositional self-reference with traces of an implicit metaphysical discourse inherited from the previous generation. But there is more to it than this. In summing up the intensity of Brach's "romantic renunciation" Steinberg makes a list of the forms of visual fullness that the artist has rejected: "Composition, incident, movement, color, focus, style, signature, painterliness." "Composition" heads the inventory with such sufficient insistence that we can presume its renunciation is staged only to mask the intensity of its return. The critic claims, in effect, that Brach's work turns composition inside out, folds it back on itself so that what is essential (and not contingent) in it can be held over as the revitalized content of a new-age abstraction.

This essay, like so much art writing of the period, is as remarkable for its strategies of evasion and complicity as it is for the strength and

abstraction of its own texture. Thus, following Steinberg's iterated contestations of the "difficult" absence-value of Brach's pictures, his brief excursion into an explanatory mode, releasing as it does a number of notable metaphoric flurries ("like a coin and a moon at arm's length"), refuses any engagement with the first-order suggestions of metaphoric mapping inscribed by the title. This refusal is made explicit and contradictory when Steinberg notes (in the only parenthesis in the article) that the work can, in fact, only be beheld or produced into meaning "when you play the game (or read the language)." That he almost certainly has in mind "visual language" here, and thus an already metaphorical deployment of language, is interesting, but beside the point. By simultaneously naming and then bracketing the category of language Steinberg makes explicit the repression necessitated in securing work such as Brach's in critical discourse. The work is obliged to be both formal and metaphysical, to exist in semantic crisis, always to gesture towards, but never to reach, the referents pronounced in the titles.

We are left to conclude that while "composition" can deal with language – as Mondrian and Kandinsky make clear both by the abundance of their writing and by the collaborative role for writing they envisage within it – "meta-composition" cannot. This is why Reinhardt stands aside from the main drift of 1960s abstraction, in a niche of restraints all his own.

Of course, it is only in the writings of a historian-critic such as Steinberg – never a devotee of party-line formalism, as evidenced by his contribution to the debate on *Les Demoiselles d'Avignon* – that some of the contradictions and unstated assumptions of the dominant discourse around 1960s abstraction can be revealed. But the meta-compositional exertions made on behalf of many other key artists of the 1960s are readily apparent. What remains curious, even astonishing, is that the titling practices of the 1960s abstractionists are, with few exceptions, as connotatively driven as the psychological mood-charts of Kandinsky in the 1920s and 1930s, or the offbeat poetic allusions of the Surrealists. We are left with the paradox that the high point of formal compositional reduction is marked by a recrudescence of what appears to be counter-formalist connotation. An investigation of this paradox will help us to construct a brief revisionary history of non-Minimalist 1960s abstraction, from Louis to Caro.

Critical discussion of 1960s abstraction, whether the work of Louis, the paintings and relief-paintings of Stella, or the sculptures of Caro – is remarkable for the strategies of evasion by which the metaphorical or occasionally direct elaboration of such works into the non-art world, through the well-advertised connotations of their titles, meets powerful

resistance. Consideration of the colorful, expressive, and not occasionally outlandish titles of artists like Stella and Caro would seem to pose a fundamental threat to the formal and technical closures placed upon the signification of late modernist artworks by this particular mode of critical discussion. Eschewing serial or numerical designation, the very provision of these titles allows the possibility of meaningful deconstruction and permits the exposure of certain powerful frauds in the celebrated signifying pretensions of much late modernist abstract art.

Louis's titles and the debate around them stand somewhat apart from those of Stella and Caro. His dealer, André Emmerich, explained in a letter of 20 May 1969 that:

> The titling of both pictures [he is referring to Louis's *Vav* (1960) and *Alpha-Phi*] is based on the system developed posthumously under which veils are titled with Hebrew letters, unfurleds with Greek letters. The pictures are titled arbitrarily, in the order of their being stretched. Morris Louis was not especially interested himself in titling his pictures generally. He accepted the idea of titles but he was not interested in titling pictures until this became necessary, i.e. until pictures were not sent out of the studio. When titling pictures, he generally wrote the title on the back of the canvas at the very last moment.[71]

75 Morris Louis, *Dalet Vav*, 1958. Acrylic on canvas, 226 × 401.5. Graham Gund Collection, Cambridge, Mass.

This entry in the Tate Gallery catalogue further notes that "the artist's widow, Mrs Marcella Louis Brenner, added (letter of 2 March 1970) that she chose to use numbers and alphabet letters in all posthumous identification of the paintings in order to avoid imposed literary or idea overtones or titles with meaningful associations."[72] Louis, his estate and its representatives, his dealer, critics, and major monographers, are all emphatic about the circumscribed and subordinate role of titling in the artist's career. Diane Upright offers the fullest account to date: "Any attempt to gain access to Louis's personality or ideas about art by considering subjective or personal implications of his titles will prove frustrating. As William Rubin once explained, 'As with certain other modern artists, titles were of little interest to Louis, who preferred them to numbers simply for reasons of convenience. Many of the titles of his works were suggested by friends.'"[73]

However, some works from the late 1940s and early 1950s, worked out in a kind of late-Surrealist semi-abstract style, do bear what Upright describes as "personal associations." These include *Trellis* ("one of the few paintings he hung at home, . . . titled with reference to the grape arbor he maintained in his garden; the imagery suggests both the form and the color of the arbor"),[74] *Hummingbird*, *Two Heads*, *Sub-Marine*, *Water-Hyacinths*, *Cyclops*, *Topographic View of City*, and *The Ladder*. For his first one-person exhibition at the Washington Workshop Artcenter Gallery in 1953, the directors, Leon and Ida Berkowitz, collaborated with Louis in the development of sixteen "subjective" titles, some with references to the Nazi book burnings. In addition, "Ida Berkowitz claims responsibility for titling the *Tranquilities* collages [1952–53], which stemmed from her interest in Zen poetry."[75]

Before the development of the three serial sequences for which he is best known (the "Veil" paintings, 1954 and 1958–59 (see fig. 75); the "Unfurled" paintings, 1960–61; and the "Stripe" paintings, 1961–62), Louis had already experimented, or participated in experiments, with several distinct orders of title – those dealing with intimate, domestic, or local sensations, including flowers and water effects (recalling the Giverny works of Monet); those making reference to mythology (such as *Cyclops*); those that appear to be simple descriptors (including *Two Heads* and *Topographic View of City*); those designed to elicit non-Western, meditative effects (the "Tranquilities"); and the "subjective" titles of the Washington Workshop show, with their intimations of Nazi violence and censorship. The range of these referential orders, from backyard pleasures, to mythological and meditative remove, to memories of totalitarianism, suggests that before he "broke through" to his signature seriality, Louis was at least somewhat engaged with the signifying possibilities of the title.

What followed from the difficult, experimental years of the mid-1950s, however, was an extraordinary form of critical and titular co-optation, as the artist's style, technique, exhibitions, and names were subject to scrupulous surveillance and "assistance" by the critics with whom he associated – above all Greenberg and Rubin. Greenberg, in particular, was assiduously deferred to by the artist, and later the estate, in almost all matters of fronting Louis's work onto the world. *Dalet Tet* (1959), for example, has an inscription on the unstretched canvas: "1 in. of white on each side or per Clem[ent Greenberg]."[76] While the critic's eye patrolled the image for its preferred dimensions and exposure, his pen created its formal reception and historical importance, and his modernist imagination secured the signifying domain of its title.

Louis's titles were thus developed in a kind of formalist control system. They were, after all, one of the chief channels through which paintings exited the studio, were gathered-in by public and professional audiences, and sold. Thus while Rubin coined the generic term "Veil" to describe Louis's work of 1954 and from 1958–59, and named at least one work (*Saraband*), it was Greenberg who suggested the majority of titles for works exhibited during the artist's lifetime. These are mostly one- or two-word descriptors, drawing on a wide variety of mythological, natural, and abstract-emotive vocabularies: *Air Desired*, *Aurora*, *Curtain*, *Golden Age*, *Iris*, *Surge*, *Vernal*, *Zenith*. Following Louis's own practice, paintings exhibited after his death were titled by his estate in order of their release after the letters of the Hebrew alphabet, a procedure concluded only in the preparation of the catalogue raisonné.

Greenberg also influenced the naming of the "Unfurleds." In a letter of July 1962 addressed to him Louis first used the expression "big unfurling ones," and in an exhibition Greenberg organized at Bennington College in 1960 Louis named the only two of these works exhibited (and titled) during his lifetime: *Alpha* and *Delta*. The estate once more followed precedent and titled the "Unfurleds" with transliterations of the Greek alphabet. The "Stripes" series was originally designated "Pillars of Fire" by Greenberg in May 1961, and following a request by Louis for assistance in the provision of names for his exhibition at André Emmerich in October 1961, he wrote the following note:

TITLES: Parting of Waters; Pillar of Dawn; Flood End; Water-Shot; Pillar of Cloud; Pillar of Noon; Sea Gamut; Sky Gamut; Earth Gamut; Pungent Distances; Plane Beyond Plane; Color Barrier; Notes of Recession; Pillar of Hope; Pillar of Desire; Pillar of Risk (you and Marcella can go on with the Pillars; note that all titles have two or more words in them: that identifies your 1960–61 production; your

next series should have titles of a different generic character; but we'll talk about that).[77]

Greenberg's nominal investment takes the form of sixteen or so quietly referential titles. Several continue the "Pillar" metaphor, while the others conjure quasi-literal, semi-poetic descriptors that might answer to variants on Louis's vertical striped format. About half of the titles recall leading indicators of the Impressionist pictorial environment – "Dawn," "Cloud," "Noon," "Sky," etc. The rest solicit effects that relate more abstractly – and generally – to the paintings' formats and attributes. Some specify the effects of formal qualities – *Color Barrier*, *Plane beyond Plane*, or *Notes of Recession* – while others incorporate emotional states or psychological tendencies – *Pillar of Hope*, *Pillar of Desire*, *Pillar of Risk*." It is with the slightly aberrant notion of "risk" that Greenberg ends his list, deferring its continuation along the same lines to Louis and his wife.

In practice Greenberg himself rarely took textual risks with his supply of titles, and sometimes they were literal reminders of the circumstances of production or exhibition, as with *Last of a Series*, which, he wrote to Louis in 1961, "is what it is."[78] An exception may be *Quo Numine Laeso* (*What Deity Offended*, 1959), "selected by Greenberg from the first book of Virgil's *Aeneid*,"[79] which reads as a palpable effort to elevate the painting to classical status. Clearly aware of the stakes, and risks, involved in his surrogate provision of titles, Greenberg knew that the title had to make contact with the work at an angle that was as perfectly abstract as the image it unprovocatively governed. It is for this reason that the private Greenberg was an avid, almost impulsive, inventor of titles, while his public critical persona rarely alluded to their existence. What he proved in this simultaneous annexation and disavowal of names was the almost miraculous quietening of metaphorical language, and its folding back into the superior abstraction of the image. In this sense the title was always a tautology for Greenberg. Somehow necessary to foreclose the sterility of numerical series or endless untitling, and to underline the formal purport of the painting, the signification of Louis's titles was actually abandoned from the moment of origination, then suppressed in the work's critical reception. Greenberg's control over the point of origin and reception of Louis's titles secured the paradox of this semantic void.

Louis was just one of an increasing number of artists working in the loosely collective style of Post-Painterly Abstraction who titled their works *post factum*, sometimes changing their names, and at other times refusing to name them altogether. Larry Poons titled his *Out* (1967) in the course of its exhibition at the Kasmin Gallery; and Kenneth Noland reported that "the titles of his works were always given after they were finished." This provisionality extended into the institutional display of the

work. Noland, again, reported that when he viewed his *Drought* (1962) hanging in the Tate Gallery, in 1965, he "improved" the image by having it rotated ninety degrees. Similarly, the title of Robert Motherwell's "Open" series "was not arrived at until a number of versions had been painted."[80] Such caution, even abandon, in relation to the title has a long history. We might recall that Rauschenberg viewed his titles as "rarely specific in intent," leading one compiler to suggest that "[t]hey can be used in a way similar to the images in the paintings."[81]

Stella, however, turns his back on these diminishments of the title – although his titling strategies do not emerge with any more clarity. While almost all his striped and shaped paintings from the later 1950s through the early 1960s, and most of his later series, are supplied with metaphorical titles, neither the ground for this provision, nor its critical implications, have been well remarked. Robert Rosenblum's commentary is typical. His point of entry into the interpretation of Stella's earlier work is marked by an elaborate statement of the work's self-referentiality. Rosenblum claims that as "the striped geometries and the picture's framing edges were inseparable functions of each other; [and] the rectilinear notches of the borders determined the patterns they enclosed and vice-versa," so, "[t]he pictorial field was . . . redefined as the picture itself."[82] The notion of the painting as a tautology, redefining itself as a picture, leaves the title in a strange apposition where it functions only to name the self-evident. Yet this, of course, is precisely what Stella's titles fail to do.

There are two significant exceptions to the general relegation of the title in the critical discussion of Stella. The first, in monographs by Rubin published on the occasion of Stella's two retrospectives at the Museum of Modern Art in New York, furnishes another illuminating example of Rubin's productive (though here more tentative) equivocation between the formalist and contextual understandings of modern art. The second, written in dialogue with Rubin's first text, is a catalogue entry by Brenda Richardson for an exhibition of the artist's "Black Paintings" in 1976–77 that constitutes probably the most exhaustive documentary exploration of the naming of a specific group of artworks yet achieved.

Richardson takes account of the general disavowal of Stella's titles, and makes a number of suggestions about their signification. The most useful of these are her annotations to "two sheets of paper inscribed in Stella's handwriting with lists of names the artist considered for titles of paintings."[83] Her "line by line" analysis of the titles explicates the origin and geographical/cultural context of each name, and forms the basis for a more general "iconographical hypothesis" based on Stella's complexly layered, but "specific and intentional," references to "black."[84] While

clearly appropriate in many cases, reference to black does not account for all the titles of the works exhibited.

Following Richardson's entry it is apparent that several clusters of association, or titular groups, make up the nominal field of the "Black Paintings"; as well as a number of more isolated names. The clusters include, first, the names of apartment buildings in the Bedford-Stuyvesant area of Brooklyn, such as *Clinton Plaza* and *Tomlinson Court Park* (both 1959), one of which, *Arundel Castle* (1959), also the seat of the Dukes of Norfolk, carries another level of reference. These locations are held to recall the ambiance of Stella's house-painting jobs. Second, a number of titles, such as *Turkish Mambo* (1959–60), *Gavotte* (1959), *Tuxedo Junction* (1960), and *Zambezi* (1959), refer to music or musical clubs. The Zambezi Tavern, for example, was a Harlem club located at 2267 Harlem Avenue that flourished between 1957 and 1960. Third, a series of titles cultivates specific allusions to German National Socialism. These are *Die Fahne Hoch!* (1959), *Reichstag* (1958), and *Arbeit macht frei* (1958), the last named after the slogan mounted over the gates of Auschwitz. As only *Die Fahne Hoch!* was listed on the title sheets we may conclude that these references were thought appropriate for the paintings at a relatively late stage in their development. "Valle de los Caidos," intended as the name for the final work in the "Black Paintings" series, refers to a monument to the Spanish Civil War intended as Franco's tomb near Madrid. Fourth, a number of paintings bear titles that refer either specifically or more covertly to the marginal gay and lesbian underworlds of New York in the late 1950s. According to Stella, *Club Onyx* (1959) was a gay bar on Sixth Avenue near 59th Street in New York, although the name was also borne by a jazz bar in midtown in the 1930s and 1940s. *Seven Steps* (1959) was a women-only bar at 92 West Houston Street. *Delphine and Hippolyte* (1959) alludes to a lesbian liaison in one of the poems (censored in subsequent editions) in Baudelaire's *Fleurs du mal* (1857). Fifth, three titles appearing on the lists referring to Catholicism, "Our Lady of Perpetual Help" I and II, and "Sacred Heart," were finally rejected in favor of other names. Sixth, the lists offer four possible titles deriving from disasters: "Triangle Shirtwaist Fire," "Sidney Mines," *Morro Castle* (1958), and "Coconut Grove" (the last, according to Richardson, "a nightclub in Boston which burned on 28 November 1942, killing 491 people").[85] Only one of these disasters named a finished work. Seventh, the names of several individuals are listed: "Ponzi," for Charles Ponzi, a famous Boston swindler of Sicilian descent; "Marquis de Portago," a Spanish aristocrat and sports enthusiast who died in 1957 in an Italian auto race; "Ponell Johnson," a black artist who committed murder in 1959; "Louis Miquel Domingúin," a Spanish matador; "Nicolas de Staël," the French painter;

and "Daniel Poling," a conservative clergyman. In the end, only one "Black Painting" was titled after a person. This was *Jill* (1959), named, Stella claims, after a female friend because "she was around at the time." "Marquis de Portago" and "Luis Miquel Domingúin" were used to title Stella's works in the "Aluminum" series. Finally there are a number of suggested titles referring to particular places, though they do not appear to share a common theme: *Getty Tomb* (1959), by Louis Sullivan in the Graceland Cemetery, Chicago; *Yugatan* (for "Yucatan"); *Gezira* (1959), which probably refers to a pleasure island in the Nile near Cairo; *Kansas City*; and *Bethlehem's Hospital* (1959), the "Bedlam" insane asylum in London.

In addition to these clusters of specific reference to places, persons, disasters, Catholicism, gay hangouts, Nazism, contemporary music, and apartment buildings, Stella, often in collaboration with Carl Andre, came up with several more metaphorical possibilities, mostly derived from the literary and artistic worlds: *The Marriage of Reason and Squalor* (1959, fig. 76), an Andre title, originally linked to one of his own pastels, which Richardson suggests combines references to William Blake's *Marriage of Heaven and Hell* and a story by J. D. Salinger, "For Esmé – with Love and

76 Frank Stella, *The Marriage of Reason and Squalor, II*, 1959. Enamel on canvas, 230.4 × 337.2. The Museum of Modern Art, New York. Larry Aldrich Foundation Fund

Squalor"; "Diamond as big as the Ritz," after the short story by F. Scott Fitzgerald; "Master Painting," which "Andre says . . . is a reference to the suicide of Benjamin Robert Haydon,"[86] an English artist and political activist who worked in the early nineteenth century; "Happiness Exchange," for the charitable organization, the Happiness Exchange Foundation, and a late-night radio program of the same name broadcast on WABC in New York; "Corduroy Road," an apparent reference to the log roads built during the American Civil War; "Laocoön," a Trojan priest strangled with his two sons by sea serpents, and the title of a treatise by Lessing which arbitrated legitimate boundaries between visual and textual representation.

It is difficult to offer any decisive conclusion concerning this wide range of title choices. Stella's titles invoke references to sexuality and sexual preference; personal pleasures, contexts, and proclivities; literature, painters, historical figures, and events; local and "exotic" places; and modern social and political traumas. While the dominant mode of reference is to personal aspects of Stella's life, what Richardson terms "the psycho-sociology of being a young artist in New York City at that time,"[87] many, if by no means all, of the titles listed and/or used also carry a cross-reference to the formal or emotive aspects of the works. Sometimes this is staged quite casually, as in "Criss Cross" (a composition by Thelonius Monk) or "Corduroy Road" (with its suggestion of a regular, transverse arrangement of logs), or *Laocoön*, which Stella found expressive of the potential for formal expansion into "more baroque configurations." Sometimes they allude to various forms of symmetry, polarity, or reflection, as in *The Marriage of Reason and Squalor*; and sometimes they subtly reinforce repetitions and linear rhythms (Richardson suggests that the nine interstices of "Our Lady of Perpetual Help" – eventually renamed *Club Onyx* – may respond to the Catholic term for the Virgin as a recipient of the "9 Days devotion"). Other titles make direct or implicit reference to steps, ziggurats, cubes, and, more problematically, to the swastika.[88]

The main emotive referents are to music, and the neutral, or non-color, black. Richardson holds that the "Black titles are a virtual catalogue of the dictionary definition of the adjective 'black,' with its myriad, multi-layered connotations." These include references to color, race, blindness, and the absence of light, evil, calamity, disaster, and "grim, distorted, or grotesque satire."[89]

While they span almost the entire range of connotative types, Stella's titles resist the cultivation of chance or randomness invested in their works by some of the Dada and Surrealist artists, including Picabia and Magritte, who, we recall, scoured the Larousse dictionary for found

names. Richardson notes this restraint: "Stella was not scanning almanacs looking for obscure disasters after which he could name paintings."[90] At one extreme of reference his titles include highly coded, insider, or "hermetic" allusions arising from Stella's encounters with his friends and their milieu. At the other they refer to the most public, memorable, and tragic events of the century (National Socialism). Both of these titular extremes and much of what lies between them seem calculated to disturb the understated, even placid, formal arrangements of the paintings themselves. What we encounter here is a logical outcome of the crises of form we have traced from the early work of Cézanne to the denouement of formalism in the 1960s. In Cézanne multiple titular description of potentially disturbing iconographic scenes seems to precipitate a crisis of repressed heterosexual anxiety in relation to the representation of female figures. In Stella images that are systematically purged of iconographic reference and deliberately reinscribed with the referentiality of painting and its formats are governed by titles that would seem to shatter their formal determinations. The closure of reference at the level of the visual sign is answered by a corresponding amplification at the level of its textual supplement. In the process the "anxiety" of the artist is fundamentally rerouted: from pastoral temperance and arcadian allusion to modern tragedy; from the formal notation of the body to the bodily notation of form; from heterosexual libinal repression to homosexual announcements; and from a relatively explicit problematization of pictorial and extra-pictorial reference to a semantic deferral that is almost schizophrenic in its splits between image, form, and referent.

While such splits might have provided the grounds for an interrogation of the relation of the formal and extra-formal components of Stella's work, his paintings are, in fact, sanctified precisely in the refusal of any discussion in the space between title and work. Even Richardson's catalogue, which furnishes important information on the specificity of the titles, accounts for the names of the paintings in a manner that at times looks like formalist discourse turned inside out: the titles are described and expounded with the same kind of intensive logic other critics have invested in the forms. Richardson's determination that the works interrogate the various conditions of "blackness" is the symptom of this identity. For the real question that arises here is just how concepts and instances of "black" are mobilized between painting and name; and, even more challenging, how a series of formally similar images can subtend the referential range Richardson has so cogently identified. How can Nazism, gay bars, and low-income housing be conjugated? And what are the stakes, what might be lost or gained, in this elision?

These questions can be answered, in part, by examining the conse-
quences of Stella's equivocal nominations in the context of his second
retrospective at the Museum of Modern Art in 1987. Reading this show
of some thirty-five of his post-1970, florid, "maximalist" "painting-
reliefs" also allows us to glimpse the destiny of formalist discourse beyond
its apogee, and to find in the title yet another measure of its participation
in the signifying crisis of form. The catalogue makes a number of claims:
that Stella's reinvented image-objects are one of the most decisive
inflections of the American art world's great years of trauma and experi-
ment in the two decades from 1968 and that Stella's change of style is
radical, yet contiguous, innovative and exuberant, but always controlled
and purposeful. It is formalism transcended, and formalism reinvented; it
stands above all for the enormously consequential and uplifting liberation
of abstract painting beyond the ultimate in Minimalist reduction. Stella
sprouts new phoenix wings for the triumph of American art.

Rubin's catalogue essay on Stella's work between 1970 and 1987 picks
up the Stella story from the moment where it had so presciently been left
off at the end of the first survey and at the end of the 1960s. While the
new works seem volatile, convoluted, even hysterical in relation to the
earlier, understated serial elaborations, Rubin offers them a resolute
defense. He outlines a rigorous formal exegesis, and attempts, in a strange
combination of assertion, argument, and even of a brief reworking of
modernist history, to justify Stella as the savior of the modernist aesthetic
in its time of troubles.

The work is parceled up into its distinctive, related series, about ten in
this case, the most developed of which are the "Polish Village" (1972–
73), the "Brazilian" (1974–75), the "Diderot" (1974), the "Exotic Bird"
(1976–80), the "Indian Bird" (1977–79), the "Circuit" (1981–82), the
"Malta" (1983–84), "Cones and Pillars" (1984–87), and the "Wave Se-
ries." The "insistently palpable" physicality and constructedness of the
works, their "resolute and unabashed materialism," are painstakingly
adduced. Yet, the production, etching, and assembly of the metals and
mixed-media, the lapping of "day-Glo colors and epoxy enamels," the
inventory of high-brow mechanical shape-makers, from templates and
flexi-curves to pantographs and fractals – all this winning accountability –
somehow ends up stranded as fact or observation. Rubin's account is
partly woven into a chronological narrative, and partly put to work as
building rubble for the construction of Stella as a modern art star, full
of "confidence," "freedom," "expansiveness," "exuberance": a sublime
geometer.[91]

What is most notable about this *apologia pro Stella*, however, is its
half-muted striving to negotiate with history and to flirt with interpreta-

tion. If late Stella is not quite comfortable in the received history of modernism according to the museum (and he is not), then it can be tampered with a little and new understandings can be fetched from its ledger. First, Stella is held to provide (literal) relief from the "noumenal loftiness" of high modernist abstraction – Kandinsky, Mondrian, and Rothko. Second, the whole modernist/formalist emphasis on *pictorial* flatness, the familiar Manet-Monet-Cézanne-Pollock axis, which Rubin has done so much to validate with his notable "scholarly formalism," is significantly annotated in the suggestion that Stella's "particular pictoriality" derives from another reading of the "Cubist/Constructivist tradition that is itself ultimately rooted in Cézanne."[92] This reading is sketched only briefly, but has potentially far-reaching implications, opening up as it does a fissure in canonical modernist accounting. Instead of the simple opposition between old-master illusionistic sculptural roundness on the one hand, and literal flatness on the other, a mediating third term is revealed, deriving from Cézannist *passage* and its "conceptualization" in Cubism: this is termed an effect "more like *a simulacrum of a bas-relief.*"[93] Elsewhere, apropos the later "Cones and Pillars Series," another purist modernist tradition is desanctioned in favor of a genealogy of "mixed space," that other lineage of schematic perspective – Matisse, Picasso, de Chirico, Klee, Léger, Lissitzky. Not for the first time, modernism has been plausibly reanalyzed and reinvented to produce a thematic for one of its own to clinch in style.

These early signals in the text of interpretative flexibility are part of a loose counter-current in the catalogue which opposes the perfectly documented, seamless flow of its expository formalist bulk. The mere existence of these alternative suggestions at an explicit rather than a latent level is testimony in itself to some kind of institutional recognition of the crisis and possible collapse through the 1970s of mainstream high modernism as the only engine of the avant-garde. Stella can epitomize only the continuation of modernist abstraction in proportion as he is seen to redefine and extend it (by, for example, anticipating "aspects of recent graffiti-influenced painting" and "some East Village styles of the eighties," and by reclaiming the "inspirational spirit of narrative").[94] This is the most effective retort, from within the family, as it were, to the stasis and closure of Greenbergian/Friedian pictoriality.

Try though he may, however, Rubin cannot completely stitch up the loopholes in his text. Stella's continuity with modernist tradition is argued at length, but at all points where the non-autonomous signification of these works is put at stake, profound questions are raised, and the formal method reveals a death mask behind its cosmetics. Thus the celebrated versatility, profusion, and "serendipitousness" of the new Stella's are

ventured only as a kind of "self-imposed challenge to invest their extraor-
dinarily complicated structures with pictorial clarity." And the invitations
to identify figures and forms, and "free-associate" with images, are tem-
pered by a final call to see everything in the works "simply as shapes" –
a well-managed poke in the eye for reference.

But it's not always hedged so well. For almost every time Rubin's
prose ventures into such issues as "context," "origins," "intentions," or
any other reason why, it becomes less convincing. Semantic crises are
thus sprinkled throughout the catalogue. They surface several times in
relation to the titles of the works. It would appear that the pieces were
mostly named *post factum*, as with the "Cones and Pillars Series," titled
after Italo Calvino's *Italian Folktales*. The titles serve as conduits for the
reading of the work, but we should expect little more from them than a
kind of offbeat allusiveness, what Stella terms "a certain appropriateness,"
and Rubin glosses as an "echo" of "narrative implication."[95] The "fin-
ished maquettes" of the "Indian Bird" series "reminded Stella of birds in
cages, so he found a book on birds of India, from which the titles are
taken. ('It struck me as a nice idea to use them. . . . It was very casual.')"
Similarly "the titles of the Exotic Birds . . . relate directly to a new
interest [in bird-watching] encouraged by his [second] wife."[96]

There is some gratuitousness in this, and not a little tongue-in-cheek.
But when the titles are derived from more historically or politically
poignant sources than say racetracks and exotic avifauna, as in the "Polish
Village Series," named for settlements destroyed by the Nazis, or the
"South African Mines," playfulness and evasion are less acceptable. Of
course, it could be countered that the former is an homage and the latter
an irony: but this is not fully convincing, especially when "Stella recalls
that in choosing these works' titles, he very much likes the sounds of the
mine names," such as *Stilfontein*, *Western Deep*, *Blyvoors*, and *Welkom*, "but
also something in the look of the words as well – their angles and
sharpness." "The titles were not," Rubin continues, "inspired by the
political situation in South Africa, as had been the case with some 1962
titles, such as *Sharpeville* and *Cato Manor*, which Stella refers to as 'my
apartheid pictures.'"[97]

The author of the catalogue also allows a rather avuncular attitude to
Stella to surface from time to time, revealing him as a kind of "Boy's
Own" artist: aesthetically poised in a metal factory, driving fast BMWs,
playing squash with the world champion, lecturing at Harvard. It is this
generational difference, between growing up and not growing up in the
1960s, and its concomitant difference of taste that allows some of Stella's
means and effects to be labeled as hip, "disco," and streetwise. This is
another of the text's short-circuits to the outside world. It leads to the

claim that Stella manifests a type of spirited "vulgarity," especially in his "bad taste" colors. This, in turn, gives rise to the far-fetched contention that Stella is a "popular" (down to earth, street-real) artist.

The essential disingenuousness of these claims, and the general lack of conviction mustered by the non-formalist segments of the catalogue, are made explicit when the words of another critic active in these years, Philip Leider, are put to work in the service of a political quietism which Rubin seems unwilling to pronounce for himself. We have encountered the grounds of this politics before, in the battle between Constructivism and compositionality, and their names, in the Soviet Union in the early 1920s. Forty years later Constructivism has become a specter haunting the "context" of Stella's work. For Leider, and apparently for Rubin as well, there are already quite enough political "implications" in the very notion of Constructivism, or in any allusion to it, to satisfy the demand for this particular "content." Political directness is, anyway, the one "vulgarity" that neither would wish to associate with Stella. Street-wise, but apolitical, capable of using the traumas of history as a titular reference, but not of letting that moment disturb the integrity of the work, Stella's formalism, and the paradoxical contribution of his titles to it, reveal something of the moral and cultural death of the formalist tradition sponsored by the corporate-museum-sector.

Looking to the work of other artists from the later 1950s and 1960s, we will find a measure of perspective for the metaphorically assertive cutting loose of the title from history, form, and reference attempted by Stella. There appears to be a significant anticipation of his titling methods – though not of his specific decisions and categories – in another "list" of potential titles drawn up by Cy Twombly "in collaboration with Rauschenberg and Johns" in 1955. According to Kirk Varnedoe, "unusual titles," such as *The Geeks*, *Criticism*, and *Free Wheeler* (all 1965) were "derived" from this list and "assigned to the pictures more or less arbitrarily."[98] Looking from list to list, and back across their respective careers, reveals important continuities and divergences between Twombly and Stella in the matter of titles, composition, and interpretative contexts.

Twombly's "dialogue of inscription and erasure," his giving, making, feinting, alluding, soliciting, and canceling with letters, words, and quasi-alphabetic signs, makes a decisive intervention in the cluster of tendencies, discussed in previous chapters, associated with "inscription" and "compositionality." His work stands at the head of the lineage of practices that stretches from Miró's painting-poems, 'Klee's writing-like tracings, and the various interests of the future Abstract Expressionists in pictographs, hieroglyphs, visual symbols, and Eastern calligraphies. Operating at the threshold of legibility, at that place where the mark is the becoming

77 Cy Twombly, *Min-oe*, 1951. Bitumen and house paint on canvas, 86.4 × 101.6. Robert Rauschenberg Collection, New York. Photo courtesy Sperone Westwater Gallery, New York

of a written sign, Twombly developed a theory (just before Stella began work on the "Black Paintings") of "forming" that he set apart from "formalizing – or in the general sense the organizing of a 'good' painting."[99] This idea of non-composing with the materials of white and calligraphic marks is contrasted to the compositional ideal of "an abstract totality of visual perception" as "[t]he imagery is one of the private or separate indulgencies."[100] Commenting on his works of February 1959, Varnedoe underlines the "extreme of asceticism" that funds Twombly's counter-compositional impulses: "[These works] have an echoing airiness dusted over with minute motes and threads of linear energy that share absolutely nothing in the way of traditional compositional bonding."[101] Twombly's resistance to composition ("His art brings little with it in the way of set compositions") is further emphasized in relation to the reshuffled systems of visuality brought forward in the early cinema – which Paul

Virilio also discusses as offering a visual challenge to the ruling compositional order: "[Twombly's] language of flow and fracture draws directly on the early modern fascination with the cinematic decomposition of forms in motion."[102] It is this withdrawal from composition that leads Varnedoe to make a leading interpretational claim in relation to Twombly's images: "It is," he suggests, "the cognitive act of naming . . . – the direct citation of the concept in the picture – that is as important as the formal nature of words or writing in general."[103]

The meanings of Twombly's work are articulated in the space between the mark as signature, or word, and the semi-legibility of the image's nominal field. What Varnedoe terms the "the direct citation of the concept in the picture," involves a co-emergence of visual-textual signs. While certainly not drained of the referential "ironies," uncertainties, and personal allusions we have encountered in Stella and other abstract artists in the 1960s, Twombly's words, titles, and marks are not only formed in relations that are loosely formal or emotive, or even arbitrary.[104] Even though they are often difficult to read, it is, precisely, the co-production of visual-textual signs in "a cognitive act of naming" that may be said to govern their making and reception. In other words, Twombly's work has found a way to release some of the pressures of semantic obfuscation established between title and image by many of the Post-Painterly Abstractionists and their affiliates. It is important, of course, that he does so by reinventing (and renaming) in the timeless arcadian, neo-pastoral spaces already modernized by Matisse and Miró, and that he alludes more often to distant historical warriors than to the more recent horrors of twentieth-century war. Twombly's real communicative engagement with "naming, marking and painting"[105] is thus suspended between a quixotic, quasi-legible self and the non-modern past, while Stella's more baffled relays between forms and names solicit from the pleasures and hard realities of modern life. Considered together, the intermittently convergent giving and taking of meaning by these artists offers a measure for the crucial site of the name in the struggle for meaning after Abstract Expressionism.

In much of the painting that followed, the ironies and conflicts of the later 1950s between the title and the image simply wither away. Residual references to sexuality, politics, or catastrophes are subsumed by a kind of emotional formalism. While titles still broker a struggle with the theory and practice of composition, the conflict becomes self-referential and internalized. The social and technological extension of counter-compositionality (especially as predicated on the model of cinema) are mostly forgotten. Names become affects, qualities, or sensations. The titles of Leon Polk Smith's works, for example, tend to be composites of

formal and emotive reference such as *Black and White Prolong* (1962), or simply descriptive *Correspondence Red-Black* (1962), or simply connotative as in *Expanse* (1958). It is characteristic of the art discussions of the 1960s that the problematic of emotive, psychological reference carried by the textual supplementation of the titles is at once alluded to and evaded. In conversation with d'Arcy Hayman, there are two moments when these issues are broached, but then retreated from, as the conversation drifts back to formal, abstract generalities:

> D. H. I am going to try to have you put into words some of the things you put into paint.
> L. S. That's not an easy thing for me to do.
>
>
> D. H. You seem to have come by your vision, by your thought, almost metaphysically, or almost by delivery, so that it is like the word coming through you in some way.[106]

If we look over to the critical reception of Caro's metal sculptures beginning in the early 1960s, we will find that many of the issues raised by the analysis of composition and titles in relation to critical formalism re-emerge with particular clarity. As with so many of the abstract artists, criticism of Caro's work is remarkable for its almost complete avoidance of the metaphorical titles used to designate his works. Workaday accounts of Caro by critics influenced by Greenberg characteristically impose a resolutely abstract vocabulary of formal effects – "'dancing' I-beams," "frozen 'limbo,'" "weightlessness," "space producing networks."[107] What "language" there is in Caro is a pseudo-specific language of form, a "new vocabulary of sculptural support," "distillations of the essential elements of a new sculptural language."[108]

Early on in his career Caro became one of the handful of "international" (i.e., American and British) artists – along with Louis, Noland, and Stella – to receive special sanction from the king-and-queen-pins of formalist criticism, Greenberg, Fried, and, slightly later, Krauss. Around 1966–67, at the height of Caro's new celebrity, the debate around his work taken up by Fried and Krauss specifically focuses on the question of its "compositionality." The initial and most extended article in this loose critical sequence was Fried's "Notes on Not Composing," written for the *Lugano Review* in 1965. Here he argues as follows: "My basic contention is this: that there is an important sense in which it may be said that both Caro's sculpture and Noland's paintings are not composed – that the decisions that go into their making are not compositional decisions."[109] In relation to Noland, Fried is able to substitute another modality of production for the compositional. This he terms "deductive."[110] Defining

"traditional composition" as the engendering of "balance" between differential elements whose relative "pulling-powers" are resolved into "equilibrium," Fried determines that Noland's work – with its "perfect lateral-symmetry" – would look "trivial, even vacuous" when measured by these parameters.[111]

Caro, Fried claims, shares Noland's resolute retreat from the precepts of composition, but has failed to formulate a "positive alternative" that would answer to Noland's pictorial "deductions." As evidence of Caro's non-compositionality Fried cites from an article published in the *Washington Post* (21 February 1965), in which the sculptor bluntly states, "I don't compose," and from an early interview with Alloway during which he notes that his "decisions" are "not compositions."[112] With reference to the viewer, Fried makes a brief attempt to follow through the consequences of this double retreat from composition. The new methods of Caro necessitate a kind of deferment of vision and a new predication of "close-up-ness" for which a "point of no view" is substituted for the traditional "point of view."[113] The inevitability of compositional intuition is a consequence of "stepping back" to take in the wholeness of the sculpture. Caro himself censures the *Gestalt* unities involved in "stepping back." Similar is his refusal of outdoor locations interfered with by landscape, or any other aspect of the public domain. Such literal and interpretational interiority gives rise to a social abstraction formed in a metaphorical titular *Gestalt* that itself resembles the gesture of "stepping back." The resolute anti-sociality, internality, even myopia, encoded in the "point of no view" returns an abstract viewing environment that appears the internalist inverse of what Krauss will later describe as the effects of the "expanded field."

Writing two years later Krauss argues against the non-compositionality proposed by Fried, again using the modeled similarity read from an American painter back onto the sculptures of Caro. The newer works of Stella are held to mark "a withdrawal from the kind of structure which obviated the need for compositional decision within the interior of his painting, to one that now calls for relationships between parts of the paintings' fields." With reference to Caro's *Carriage* (1966, fig. 78), Krauss argues that "[i]t seems, at least to me, that the far-flung disparateness, the quality of being uncomposed, the sense in which the parts of the sculptures did not relate compositionally to one another, has been withdrawn or at least modified." Color, for example, has been prepared for "by a kind of composing that he now allows himself, and it is that kind of composition that I wish to discuss." Such "alternative composition" resembles the meta-compositional form, introduced above. Krauss traces the origin of this mode back to the historical avant-garde, claiming that

78 Anthony Caro, *Carriage*,
1966. Steel, painted blue.
195.6 × 203.2 × 396.2. Photo
courtesy Knoedler Gallery

the effects of *Carriage* resemble some of the pictorial revolutions of the
Cubist moment 1910–12: "This was not an abstraction of objects, but
the abstraction of what lay behind the presentations of objects in painting:
the abstraction of illusionism itself." In this sense, somewhat unusually,
Caro's work is described as "the first really Cubist sculpture," a sculpture
that "is almost totally diagrammatic."[114]

The diagram stands here as an image of the "meta-compositional,"
implicitly replacing the Dada diagraming of Picabia, which is its formal
adversary and its parodic inverse. For Caro this renewed compositionality
releases what are almost pure emotional effects, the new "effulgence" and
"dimensionality" of color, with its hints of the beginning of a new retinal
solecism – a new, an abstract "impressionism" (or, better, a new
interiority of vision), which is clearly picked up in the titles of the works.

Kuspit foregrounds the negative implications of connotative titling in
the 1960s in his discussion of "authoritarian abstraction." He claims that
many abstract artists during this period marched into a cul-de-sac of
reference that eventually caused them to turn back to nature or society.

Having nowhere else to go they are forced into a future of allusion. Brice Marden's signal to the *Seasons* in the title of one of his works is, he claims, a "trivial" symptom of a desire to meet again with the landscape. But, for Kuspit, such textual gestures are merely indications of the "sickliness" of abstract art. He satirizes the Minimalists' contentions that their materials need not be altered, or that they existed in a more perfect, pristine, and purified state than their rendering after subsequent "work" by the artist. Thought according to the logic implicit in the "specific object," the "work of art is a revelation of the innate goodness of matter."[115] And no title, text, or other form of surrogate referentiality can rescue the work from its revelatory solipsism – however secretly needed or desired such a release might be. While Kuspit's view is a useful, skeptical retort to the unexamined metaphoricity encoded in high modernist abstraction, it is as equally and oppositely uncompromising as the more fanciful titles invented in the 1960s are wilfully imaginary, gratuitous, or irreal. Yet a number of solutions and endgames were proposed in postmodernism that respond to the redundancies and vagaries of the title. New strategies were found, and old ones redeployed, that actively rethought, regrouped, and occasionally repoliticized the textual supplementarity of the title.

v Conclusion: Titles after Composition

Concentrating on the disjunction between formalist criticism, compositionality, and the muted rhetoric of metaphorical titles, I have omitted several important moments in the history of titling in American and European postwar art. One of these, in the works of Ellsworth Kelly during the late 1940s and 1950s, is important, as it offers a form of conclusion to the debate over composition and modernism we have traced from Mondrian and Kandinsky to Post-Painterly Abstraction. Bois helps us, once more, to identify a vigorous discourse of anti-compositionality in Kelly's relinquishment of traditional modes of picture-making. Using a method Bois terms the "transformed already-made," Kelly acts to minimize the material confection of composed space by espousing "the index as an anti-compositional procedure," and deploying "chance as a non-compositional strategy," while briefly flirting with his own version of calculus-driven "systematic composition," derived from Van Doesburg's *Composition arithmétique* (1930), and defended in his *Manifesto of Concrete Art* of the same year. As with Rodchenko, and, differently, with Reinhardt, the final destiny of the anti-compositional drive is the uninflected monochrome canvas, "the

total abstraction of the nominalist monochrome panel: the form as emblem, or *blason*, the form as word." The titles of Kelly's transitional works, made in France between 1948 and 1954, were still playful and plural. One of his chance-assisted paintings, *November Painting* (1950), for example, bears a name that "is at once a chronological indication and a metaphor: the scraps of paper fell like autumn leaves." But the relinquishment of composition necessitated the withdrawal of names, and all the (Greenbergian and other) "risks" that accompanied them:

> In order to eradicate all division, and thus all "relations," all composition, all projection of an image onto a surface, it is enough to eliminate the slightest risk of figure/ground opposition (which is only possible if the image is identical with the field, and this latter is "untitled").[116]

Tropic allusion must finally give way to the nominalist literalism of the monochromatic surface: for if titles were Duchamp's "invisible colors," the hypervisible colors of Kelly equally, and oppositely, give rise to invisible titles.

I have also paid little attention to Jasper Johns's deadpan gaming with the contextual predicates of painting practice, including the name. Johns's bluff reiteration of a descriptive title (*Flag*), in relation to the icon it names, offers a complementary ironic relay between the symbol system (say, the "flag" or "national self-identity") and the material image/object labeled and exhibited. The significance of the title for Johns is indicated in his "Sketchbook Notes," where he outlines a list of parts, or potentials, for a work: "Lead section? Bronze junk? Glove? Glass? Ruler? Brush? Title? Neg. female fig.? Dog?"[117] Tightly lodged in a sequence of materials, tools, and subjects, the title is merged with the coordinates of practice, even at the preparatory stage in a manner that recalls, and informs, Twombly's interaction between names, words, and marks.

Among the Pop artists of the next generation, both James Rosenquist and Roy Lichtenstein align their image-making with anti-modernist counter-compositionality. Rosenquist writes of the "combination" of fragments whose assemblage forms a corrosive ensemble – of which the title is an additional part:

> When I use a combination of fragments of things, the fragments or objects or real things are caustic to one another, and the title is also caustic to the fragments. . . . The images are expendable, and the images are in the painting and therefore the painting is also expendable. I only hope for a colorful shoe-horn to get the person off, to turn him on to his own feelings.[118]

Lichtenstein specifically orients his work in the mid-1960s against the Cubist theory of composition and uses this opposition to measure his

distance from conventional ground and figure relations, which he seems to suggest are an inevitable result of all compositional activity (see fig. 69):

> I think that in these objects, the golf ball, the frankfurter, and so on, there is an anti-Cubist composition. You pick an object and put it on a blank ground. I was interested in non-Cubist composition.[119]

A few years later, one of the high-water marks in the re-repudiation of the compositional is found in the work of the Minimalist object-makers and theorists, especially in Donald Judd and Robert Morris. During a conversation with the critic David Sylvester, recorded for a BBC radio broadcast, Morris links the non-compositional insistence of the Minimalists with the repudiation of the descriptive or connotative title:

> I think that the reason that I don't title them [his works] is that I don't think the work is about allusions. And I think titles always are. And I think the work is very much about *that* thing there in the space, quite literally. And titles seem to me always to have some allusion to what the thing isn't, and that's why I avoid titles.[120]

The last turn in this history of the titular activity reveals the density of the modernist unraveling of sequence and con-sequence, dialogue and appropriation, that has unfolded since the heyday of the historical avant-garde in the early years of the twentieth century. If, as I have shown, the theory and practice of *composition* were rhetorically central to the activities of the formative non-iconic abstractionists, it was precisely through the rejection of compositional precepts, conditions, and names by key artists, such as Stella and Judd, associated with American Minimalism in the 1960s that this movement played out its wished-for radical separation from Paris-based modernism. The iterated assertion by the Minimalists and their critics of the "objectness" (object-like-quality) of their works is predicated on a practice that is systematically purged of what was described at the beginning of this study as the "hell of connotation."

In "Specific Objects," his strategically important discussion of the new object-based work of the 1960s, Judd announced that his chief problem with painting was that it was unredeemably "spatial." It could never resist producing images of space; it was vestigially illusionistic; it looked like or intimated something else: in short pictorial space was always *composed*, it had "qualities especially identified with art." Only Yves Klein and Stella, in his opinion, produced painting that was nearly "unspatial."[121]

During a broadcast interview with Bruce Glaser of February 1964, Judd specifically articulates a final departure from what Glaser terms "traditional compositional effects," and what Stella calls "compositional or structural element[s]":

[T]he fact that compositional arrangement isn't important is rather
new. Composition is obviously very important to [Victor] Vasarely,
but all I'm interested in is having a work interesting to me as a whole.
I don't think there's any way you can juggle a composition that would
make it more interesting in terms of the parts.[122]

The elusive environmental utopianism of Mondrian and the
psychologistic mood-seeking connotations of Kandinsky, both of which
were explicitly signaled through the nominalist syntax of the *composition*
(composition as an assemblage of reference-bearing units [semes] and as
the titular designation of a whole visual regime), are renounced by the
1960s late-modernist vanguard as still replete with a subterranean (inten-
tional, spiritual, universal – "sentimental" is Stella's term) semantics that
parallels and outplays conventional iconographic reference, though is still
bound to certain of its traditional signifying strategies. As Derrida suggests
in his meditations on the name and the title, it is precisely through the
activity of the nominalist frame which passes below, around and through
the work that the (under)grounds for a non-formalist "history" of visual
modernism can be developed. Attention to this activity offers to under-
stand the *relay* established out of the bounds of the image between the
title as the "first supplement" and its other complexly determining con-
ditions of signification – institution, "con-text," "inter-text."

A discussion between Gerhard Richter and the critic Benjamin H. D.
Buchloh further reveals the convolutions of the postwar debate with
composition as it merges with the theory and practice of postmodernism.
Probing to find an acceptable formula for the content level of Richter's
work, Buchloh posits a range of resistances in his paintings to the formal
and "transcendent" values first of European modernism and then of the
Abstract Expressionists. As often with the neo-avant-garde, the cultiva-
tion of restraint, withdrawal, and a kind of de-captioned, deadpan deno-
tation (what Richter calls "banal objects and snapshots") is directly
associated with counter-compositionality. In reaction to Richter's desire
to "call a spade a spade" – "a picture of a dead dog shows a dead dog"
– Buchloh contends that not only can one "no longer speak about the
chords of chromatic ordering," but one can no longer speak "of compo-
sition in your work because ordered relationships just don't exist
anymore, neither in the color system nor in the compositional system."
At first Richter repudiates this possibility, asserting that "I can't see it that
way; I can't see that there are no longer any composition or chromatic
relationships." But when Buchloh points out that while "even absolute
negation is a composition," Richter's practice appears to be predicated on
the transcendence of "traditional, relational orders," the artist concedes
the possibility of his own non-compositionality.[123]

The certainties and assumptions invested in the traditional discourse of composition were rearticulated by the pioneer abstractionists, and conflictually realigned by the avant-garde and neo-avant-garde. While Buchloh usefully reminds us of the impossibility of zero-compositionality (or zero reference) even in practices that cultivate such effects, the remainders of historical composition are everywhere challenged in the conditions of postmodernity. We might remember, for example, that one of Aristotle's contentions in his understanding of aesthetic beauty is that the composite work must also be appropriately "scaled"; the object that is too large or too small will risk the kind of formless dissolution that threatens aesthetic propriety. It is in these terms that Susan Stewart discusses the threatening nature of the "gigantism" of earthworks and other "postminimalist" practices whose articulation in the landscape (one of the chief metaphors for the gigantic) shatters the compositional assumptions of the Western tradition – though it does so in a way that layers sublime dislocation with picturesque re-naturing, agonizing with the modernist tradition and negotiating with the "moralities" of 1960s ecology.[124]

It is now only a short step to Ashley Bickerton's *Le Art (Composition with Logos #1)* (1987, fig. 79), in which the decals and corporate logos of

79 Ashley Bickerton, *Le Art (Composition with Logos #1)*, 1987. Acrylic and bronzing powders and laquer, silkscreen on plywood with chrome-plated brass, anodized aluminum and anylux, 86.4 × 182.9 × 38.1. Photo courtesy Sonnabend Gallery, New York

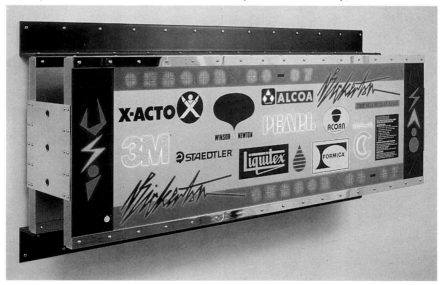

the companies which supplied the tools and materials for the construction of the piece (Liquitex, Formica, Staedtler, Windsor and Newton) eclipse all the effects of the word (the *logos*) and the composition – offering them what is now a final refuge, in the title.

Writing at the most recent end of a long tradition of counter-compositional discourse, Virilio claims that it is in cinema that we can locate the ultimate composite sign-technology that announces the final decomposition of the discrete, rule-bound, and now historical arts of painting, sculpture, etc.:

> Cinema is the end in which the dominant philosophies and arts have come to confuse and lose themselves, a sort of primordial mixing of the human soul and the languages of the motor-soul. The chronology of the arts in history already demonstrates this decomposition.[125]

Virilio takes these questions further in *Lost Dimension*, where he writes that what "we are living is a system of technological temporality, in which duration and material support have been supplanted as criteria by individual auditory and retinal instants." He continues:

> The perspectival effects of classical ornaments and the cinematic characteristics of certain styles, such as baroque, liberty or neo-liberty, is replaced by an integral cinematism, an absolute transitivity, involving the complete and thorough decomposition of realty and property. This decomposition is urban, architectural, and territorial. It is based on the deterioration of the ancient primacy of the physical separation and spatial limitation of human activities. And this very deterioration occurs so as to facilitate the interruption and commutation of time – or better, the absence of time – in instantaneous intercommunication.[126]

Much twentieth-century theory has invested its future against the order of the composition. Alphonso Lingis describes one effect of Merleau-Ponty's thought, for example, in the following terms: "Throughout his work Merleau-Ponty rejected all thinking-by-composition – being and nothingness are, he wrote, twin abstractions. All his phenomenology is anti-Kantian in that everywhere he refused the analysis into matter and form. One cannot separate the significance from the *hylé*, the grain or opacity in a sensible phenomenon. There is no contour disengaging a figure from the ground without a significance, a reference to far-off elements; it is the significance that delineates the contour."[127] Lingis also offers a way to lead this conclusion back to the exotic site of the name as understood by Proust, and forward, in opposition to the *Gestalt* speculations of the 1960s, to the allied counter-compositionality of Gilles Deleuze and Félix Guattari, whose deployment of *bricolage*, anagrams,

rhizomes, patchworks, collages, and folds exemplifies the postmodern resistance to the unification of form: "Deleuze and Guattari have taken over from Proust the idea of a noncomprehensive, non-Gestaltist whole, a whole that is added to the chain as another part."[128] Thinking well beyond the parameters of the art world, the "decomposition" envisaged by Deleuze, Guattari, and Virilio is urban, social, and political. Decomposition has become a name for the commutative, even the disappearing, action of time.

Label (lēi·bĕl), *sb.* ME. [a. OF. *label* (also *lablel*) ribbon, fillet, file (in *Her.*); etym. unkn.] 1. A narrow band of linen, cloth, etc.; the infula of a mitre. †2. A strip of paper or parchment attached to a document by way of supplement; hence, a supplementary note or clause, a codicil.

80 Joseph Kosuth, *One and Three Labels* (English and Latin), 1965. Black and white photograph mounted on board and label. Photo: Dorothy Zeidman Courtesy Leo Castelli and Sean Kelly

Chapter 9

"Labelless Labels": Notes on the Postmodern Title

> You proto and pre-critical patch of writing. . . . You footnoteless, illustrationless, iconoclastic epitome of generic advertizing. You babbling triumph of the information byte. You, labelless label, starched and washed and swinging that swift and fatal club of "education" to the head.
>
> > – Robert Morris, "Dream Journal Entry"[1]

> In this, my essay on postmodernism, I want to keep open the possibility that the label is inappropriate, that labelling itself has been rendered dumb, and that one has to hold it all at arm's length, accounting for the impulse to label as much as the label.
>
> > – Eric Michaels, "My Essay on Postmodernism"[2]

This discussion of the destiny of the title after the high point of modernist theory and practice in the 1960s will not offer a full account of the innumerable titling variants attempted in the postmodern period. As the major formations in the history and theory of the title had already been achieved by the first decades of the twentieth century, I argue that while these signifying techniques were subject to remarkable forms of extension and refutation from Surrealism to the 1980s, they were not so much radically reimagined as strategically dispersed or differently framed. These remarks join with my comments on the two discourses that intersect with the history of the title – the theory/practice of *composition* and the development of alternative institutional spaces – to offer further means of going beyond the manifest limit-terms of the title.

As we saw with the work of Baumgarten, many more discussions in the postmodern period – including feminist and post-colonialist positions – are funded by the nominal field of the image-object. From the late 1950s the signification of titles is more explicitly bound up with the larger

sphere of the politics and sociality of the visual-textual economy. One of the implications of this accelerated textuality, which includes the rise of academic-artist-theorists (in Minimalism and Conceptual art), and propositions concerning the final eclipse of the visual object and its substitution by "concepts" (in Conceptual art), is that it no longer makes sense to isolate the title as a singular textual strategy. The question of the title and postmodernism, then, cannot be discussed without reference to the larger struggle knowingly played out between visuality and textuality since the later 1960s.

One moment of critical insight offers us a point of departure – and caution – for the postmodern reinflection of the title. Writing in 1956, Guy Debord and Gil J. Wolman elevate the manipulation of titles as one of their preferred "methods of detournement." Citing Duchamp's addition of a moustache to the *Mona Lisa* (though, like several philosophers who have discussed this work, neglecting to mention the addition of a new title), they argue that the Dada cultivation of scandal and "negation of the bourgeois conception of art and artistic genius has become pretty much old hat."[3] Looking for something beyond the collaged "beyond" of painting analyzed by Aragon, they also insist that negative critiques or gestures must be replaced by negating the negation. This is the task of "détournement" (diversion, or meaning shift): to provoke the "mutual interference of two worlds of feeling," or to bring together "two independent expressions." The effect of the detourned encounter would not simply be parodic or comic, as for the historical avant-garde, but would instead precipitate "indifference toward a meaningless and forgotten original."[4]

Thus the classical novel form might be detourned (and "adroitly perverted") by the invasion of counter-illustrational images and re-titlings. George Sand's *Consuelo*, they suggest, could be "psychogeographically detourned" and "relaunched on the literary market disguised under some innocuous title like 'Life in the Suburbs,' or even under a title itself detourned, such as 'The Lost Patrol.' (It would be a good idea to reuse in this way many titles of old deteriorated films of which nothing else remains, or films which continue to stupefy young people in the film clubs.)"[5]

While "metagraphic" (poem-collage) and other heterogeneous practices or locations (especially film and the urban environment) are singled out for their susceptibility to successful detourned interference, the only *method* of detournement to which Debord and Wolman repeatedly turn is the diverted reconstitution of the title. "Titles themselves . . . are a basic element of detournement," because they are easily interchangeable, and "they have a determinant importance in several genres." Their brevity,

immediacy and capacity for imaginary relocation unleashes in Debord and Wolman – as it had, more moderately, in Gauguin, Whistler's critics and others – a series of speculative titular detournements answering to these genres. "Série Noir" detective stories, with their repetitive narratives and stock characters, are already nominally detourned, as the addition of a new title "suffices to hold a considerable audience." In music, where "a title always exerts a great influence" though "the choice of one is quite arbitrary," the "Eroica Symphony" might be corrected to "Lenin Symphony." Echoing quite precisely (whether consciously or not), some of the referential strategies of Ernst's collage-titles, further recommendations in the project of titular detournement are suggested: "one can make extensive use of specific titles taken from scientific publications ('Coastal Biology of Temperate Seas') or military ones ('Night Combat of Small Infantry Units'), or even of many phrases found in illustrated children's books ('Marvelous Landscapes Greet the Voyagers')."[6]

The most elaborate of Debord and Wolman's titular reinventions offers us a cautionary tale about the art world. For if the Soviet Productivists in the 1920s wished to subordinate all forms of artistic practice to the production of utilitarian objects, so the Situationists aimed to divorce the title from any and all modes of reference or dependency on the image, object, text, or place to which it was re-appended. Only thus would the activity of detournement be adequate or complete. Explicitly disparaging the "backward" nature of the "plastic framework" within which metagraphic writing might be situated, Debord and Wolman outline a project:

> devised in 1951 but then abandoned for lack of sufficient financial means, which envisaged a pinball machine arranged in such a way that the play of the lights and the more or less predictable trajectories of the balls would form a metagraphic-spatial composition entitled *Thermal sensations and desires of people passing by the gates of the Cluny Museum around an hour after sunset in November*. We have since, of course, come to realize that a situationist-analytic work cannot scientifically advance by way of such projects. The means nevertheless remain suitable for less ambitious goals.[7]

An important outcome of their imaginative retitling, here of a functionless popular cultural gaming machine, is the production of a new form of composition, termed "metagraphic-spatial composition." The compositional description of this project is one of several clues as to the grounds of the writers' suspicion that composed objects could not advance what they term the scientific goals of a "situationist-analytic work." Just as they desire to break up all the referential anchoring

achieved by the title, so the quasi-artistic *composition* is a seductive and ineffable arrangement of material, form, light, space, and color, whose composed material presence must be also contested.

The name they invent for their new composition is deliberately, if parodically, aligned with the outmoded traditions of the art world; for what Debord and Wolman offer their machine of lights and "predictable trajectories" is something like the last Impressionist title. The Impressionist effect is transformed into a thermal "sensation," admixed with a measure of Dada desire, and supplied with a pedantic specificity recalling the temporal and atmospheric coordinates of Monet: "around an hour after sunset in November." Further, the locale, or motif, is not the facade of a church or a wheatstack, but actually a museum. Far from establishing an abrupt, defamiliarized passage from an object to an unrelated text fragment, this title offers a final moment of coordination for three discourses central to *Invisible Colors* – the temporal-atmospheric effect, the composition, and the institutional location – which are locked in a last spasm of signifying order.

Situationist detournement thus marks both a beginning and the end for the postmodern title. On the one hand it disparages the residual avant-gardism of the parodic or allusive title, the formal order of composition, and the institutional constraints of materially discrete practices. But on the other it is already critical of the still neo-avant-gardist gesture of appropriation. For the act of merely finding, taking over, and relabeling might give rise to what Debord and Wolman censure as the "slavish preservation of 'citation.'"[8] We are forewarned that the resistance to detournement signaled in the postmodern renovation of untitling may give rise to a politics of implications and assumptions, not of actions and diversions.

I Switching from the 1960s: Smithson, Morris, and Conceptual Art

Having shaken off the influence of European culture and the "mythological content" of the Abstract Expressionists, Robert Smithson took up with "an area of abstraction that was . . . rooted in crystal structure." But before he did so in earnest he went through what he describes as "an interim period when I was doing a kind of collage-writing situation, writing paintings."[9]

With a number of artists working in the mid- and late 1960s, and with Smithson in particular, the putative separation between visual production and textual adjacency or subordination is finally broken down. Words are

not merely combined with visual material or constituted as titular cap-
tions or critical interventions; they, instead, become procedurally and
materially co-extensive with practice itself, a process that culminates in
the theory-(as)-art pronouncements of the Conceptualists. Smithson
writes of constructing his work just as he does his articles, a claim that is
developed by Craig Owens in his article "Earthwords" (1979).[10]

But this is not to say that in the practice of Smithson, Judd, or even the
Conceptual artists, there are not moments when the traditional syntax of
titular and associated textual propositions is followed. In an interview
with Paul Cummings, Smithson discusses a key work from the mid-
1960s: "[T]he title *Alogon*, the piece I showed in the 10 Show, comes
from the Greek word which refers to the unnameable and the irrational
number." *Alogon*, then, is a title that stands between his "mathematical
notation[s]" and his negotiation with "intuition," "irrationality," and
"entropy."[11] Smithson continually thought his visual practice and his
writing together. Speaking of the "Strata" series, he notes: "My writing,
I guess, proceeded that way. I thought of writing as material to put
together rather than as a kind of analytic searchlight":

> The language tended to inform my structures. If there was any nota-
> tion, it was a kind of linguistic notation. So, together with Sol LeWitt,
> I thought up the language shows at the Dwan Gallery. But I was
> interested in language as a material entity at that time, as something
> that wasn't involved in ideational values, as printed matter. The infor-
> mation has a kind of physical presence for me. I would construct my
> articles the way I would construct my work.[12]

In the context of the radical de-differentiation of the materials of practice,
the refutation of the gallery space, and the refusal of the commodity-
object, the traditional roles of the title can be said finally to dissolve. I
have shown that such a collapse did not occur in the residually object-
based iconoclasms of the Dadaists. Indeed with the Readymade and the
Surrealist object, the title undergoes a crucial reinflection, and becomes
one of the key means by which the "art"-gesture is produced and
re-routed. On the other hand, from the moment in the 1960s when the
"expanded field" of art unfolded, almost every deployment of image-
object-environment titles unleashes a more or less knowing replay of one
or more of the previous modalities described at the beginning of this
study – denotative, connotative, untitled.

Like Brian O'Doherty in his famous article on the "White Cube"
(1976), Smithson recognized that the ultimate abstraction of the 1960s
was not so much the wall-hung work of the "new abstractionists," as the
"abstractness of the gallery as a room."[13] The institutional context of the

meta-compositionality of 1960s abstraction, strangely cocooned in its titular metaphors, provided a replay of the compositional precepts of the images. In other words, the gallery space was the first composition and the paintings were fixed within it as the second in a final dissolve of the figure-ground relation. Whistler was opportunistically prescient in the 1880s when he invented a sustained collusion between painting, allusive title, and the special, contiguous arrangement of the exhibition space. While artists such as Pissarro and Seurat had extrapolated the visual conditions of their pointillist images onto the frames that contained them, Whistler's was the first gesture of a long arc of private, commodified formalisms. The new abstraction of the 1960s provided the last, focusing and refracting the compositional back against itself. Smithson and others slashed the umbilical cord of this reflective dependency: in the shadow of the 1960s, compositionality became forever historical, awaiting, perhaps, only its reconstitution in a virtual space it will never be able to frame, situate − or name. The final implications of this relegation of compositionality are, as I have suggested above, *institutional*. I will there-fore return to Smithson's contestatory museum-words in the epilogue.

My point here is that if the formation of three dominant modernist and avant-garde titular paradigms was in most respects complete before the mid-century, and if, as we have seen, they were strategically reoriented by the non-iconic abstractionists, postmodern titling practices tend, in their turn, to appropriate and recast these idioms of naming without fundamentally altering their positionality in relation to the signifying field of the image. But the title is like a catalyst. While its form, structure, and signifying economy are not fundamentally modified at the level of mate-rial or text, the postmodern title (at least in some of its formations) opens a new space onto the collapse of the "object" into critical, historical, and social contexts. In a sense the title has beaten the *work* into a form of submission to its materials (text), its placement (context, whether social or institutional), and its system of allusion (a new "philosophy" of art).

The flow of reference from the image-object to the title and vice versa is rendered characteristically turbulent in the transitional tendencies asso-ciated with Earthworks and Conceptual art in the late 1960s and early 1970s. The resulting titular revisionism is insistently revealed in the early works and statements of the Conceptualists. In his critical history of Art & Language, Charles Harrison discusses the photostat series "Title Equals Text" (1967–68, fig. 81) by Terry Atkinson and Michael Baldwin:

> In some of the early art of those who were to compose Art & Language, "artistically" bland objects and surfaces were accompanied by or were made the bearers of texts which reflected back models of

The description of syntax is obviously to be given within a syntactical descriptive range of discourse . . . Some of these ranges are essentially objectual (though not art objectual), the precise structure of which may be hinted at. Part of this description is syntactical and part of it semantical (in the sense of extensional semantics). The non analysed constants of the object theory are said to denote or designate certain objects. And these are in well knit domains. Within this context, there is no concern with 'art objects' sui generis, but only with designation denotation and similar notions. One thing is that within this not very generous context, as formulated for suitable object oriented theoretical languages, a notion of analyticity may be developed. And on the basis of this notion, it will be possible to introduce by definition a specific sort of 'art object' — and this without strengthening the underlying logic or semantical background. The objectual theories and ranges of discourse are thought to be the most suitable for the purposes of intuitionally underwritten discourse. They could be well sorted out as similar to the classical systems of first order. The underlying logic is thought to contain identity as well as the customary connectives. If something more complex is needed it can in some instances be shown that it is merely a special case of the former — or a development of it. Also, many of the art theoretical underlying languages (which are in the relation of metalanguage with the objectual ones) are also available for construction in terms of first order.

In an analysis of the type of entity or theoretical entity under consideration, it may be stipulated that in the context of a theory of art, the art object in question is not a named entity — or at least not named in the context of an object context as such (one which in some way corresponds to the traditional conception of the theory of art) — 'The art object so and so', then is not constructed as a name, neither might it be a description. The table in the corner should not be confused with that art object table in the corner. But it may be that one can't be very clear about that sort of contention until there is somewhat more clarity about existential propositions — i.e. whether they do assert the existence of an object of a certain sort. In either case, an ontology seems presupposed. Even if the ontology of objects are not to take persisters as priority, and take, e.g. events as basic, this would still perhaps not make too much of a hole in the contention above: the point is that the events of which a certain object may be said to be composed should not be confused with the conception of 'art object' here.

81 Terry Atkinson and Michael Baldwin, *Title Equals Text No. 15*, 1967. Photostat, Dimensions variable. Courtesy Lisson Gallery, London

explanation and exegesis, with the intention not so much of frustrating the beholder's activity as of displacing it with intellectual speculation or pre-empting it with irony. "Titles" became texts in themselves, while texts which resisted the application of either literary or artistic predicates were put in place of paintings.[14]

Harrison identifies a series of "ironic" switches among three terms: "objects and surfaces," explanatory or exegetical "texts," and "titles." The "Title Equals Text" pieces offer to interrupt the logic or syntax which governs these parts, making over the "bland" (i.e., Minimalist-like) surface into a bearer of text, and expanding the title from a descriptive caption or name into an argument, "explanation," or "speculation." The

reversal, exchange, or "reflecting back" envisaged here literalizes the overlay of the title as its size and materials are merged first with the condition of (extensive) text, and second, with the material condition of the image-object-support itself. While somewhat programmatic in these early works, this mirroring of the title inaugurates an attention to the signifying conditions of the label or caption that actively participates in the revisionary project of Art & Language as a whole. Harrison makes this clear in his later discussion of one of the works intended as a critique of issues at stake in the return to painting in the later 1970s:

> "A Portrait of V. I. Lenin in the Style of Jackson Pollock" is the title of a painting, or, more precisely, it is a title given to some individual paintings within a series produced by Art & Language. . . . The title is also the title of an essay published by Art & Language, and it is the title of a song with words by Art & Language and music by Mayo Thompson, which was recorded by The Red Crayola in 1980. Before it was any of these things, however, it was a linguistic description, an ironic proposal for an impossible picture, a kind of exasperated joke.

The text that follows offers a critical archeology of "the conditions under which the impossible picture was possibly painted," conditions which emerge through a tracing of "the various significations of its title."[15] The magic dimensions of Atkinson and Baldwin's engorged titles are replaced here by a range of more materially normative, yet equally "expanded," roles. Rather than simply substituting for art practice and/or critical discourse, the title now takes its place in a range of artistic and social functions. It is the literal (singular) title for an artwork, and, at the same time, the name of a series. It also names non-pictorial projects – an essay and a song. And, finally, it is held to have existed *before* the image it governs, as an "ironic proposal for an impossible picture." The field of references for the title combines to offer the image-name compound one of its last destinies. For Conceptualism gathered, rehearsed, and reinflected all the forms of coordination and mutual dispersal imagined between the image and its texts, so that the title is finally held to implode as an exasperated joke. As often in the work of Art & Language, the dissolution of forms, titles, and reference offers a commentary on the metaphorical pretensions of formalist art, such as Stella's. Art & Language recognize the futility of what the discourse on Stella could only (and willfully) imagine: that the title is forever destined to be ironic in relation to an image that can only be "impossible."

A related challenge to the title was issued by Conceptual artists working from New York (see fig. 80). In an interview broadcast on WBAI-FM, New York, on 7 April 1970, Jeanne Siegel asked Joseph

Kosuth about his works from the mid- and later 1960s: "[I]f 'Art as Idea as Idea' is the subtitle, then what's the title?" In response Kosuth states that "on the photostats I titled them all the same. It was titled already within the work, so I just titled the title." Just as formalist theories of Post-Painterly Abstraction introduced the meta-composition, so Conceptualism gives rise to the meta-title. Kosuth is working at a second-order contextual remove from the proposition that art might be rearticulated as an "idea." It is not, he proposes, the literal instantiation, or assertion, of this possibility that interests him – or that constitutes the gesture of the "artwork." Rather it is the conceptual thought (the second "idea") that art might be equated with ideas. The title here neither names the content of the work, nor is it connotatively removed from this content. Instead, the title reaches across the double space that separates "art" from "idea," and then "art-as-idea" from the conceptualization of that proposal.

George Dickie raises another conceptual extension of the space of the title in relation to Walter de Maria's *High Energy Bar*, a work exhibited with a certificate signed by the artist claiming it was produced by him. This act of certification is also a "procedure of licensing," notes Dickie, that further highlights the "significance of the act of naming works of art."[16] Licensing, authorization, recontextualization – we can find in the label and the title a site of connection between the Minimalist 1960s and the critical practices of a new generation of artists active from the late 1970s through the 1980s. Most obviously in the work of Louise Lawler, but also, as has been recently argued, for other artists, including Robert Morris, what Sontag conceived of as the textual contamination of the label has actually become the field of operation for the "image."

The line connecting these two moments of attachment to the label runs from what we might call the para-Minimalism of Morris (see fig. 82) to the institutional critique of Lawler, and allows us to trace another important destiny in the postmodern reckoning with the title, the gallery, and the "consuming" context. In his contribution to the catalogue for the Morris retrospective at the Guggenheim Museum in 1993, W. J. T. Mitchell uses the theory, practice, and "dream work" of the label as a kind of allegorical measure of the artist's negotiation between image, object, environment, avant-garde nomenclatures, and philosophical enquiry. A series of the artist's "dream journal entries" from 1990 – in which the label is nightmarishly engorged, and in which its title-bearing supplementarity "threatens" the stability of the object world – is threaded through the essay as an intertext: "Show yourself in the light, wall label. Come out of the shadows of the gallery. But this protean linguistic monster hides behind the institutional leadenness of its prose."[17]

For Mitchell the label offers an expansive metaphor that stands for a

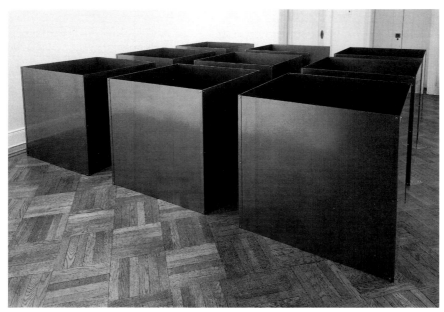

82 Robert Morris, *Untitled*, 1967. Lacquered cold rolled steel, 9 of 16 units (each unit
91.4 × 91.4 × 91.4). Photo courtesy Leo Castelli Gallery, New York

whole horizon of thresholds between visuality, textuality, and power as
they are taken on and contested in Morris's protean image, object,
installation, and text-making career. Most literally (and most deceptively),
the label is the rectangular, textual appendage associated with particular
works that "make[s] his objects intelligible."[18] But there are other "labels"
that open onto an exterior order of critical designation – "labelling,
packaging and securing" – in an attempt to position or pre-place the artist
in relation to the named styles or tendencies operative around him.
Mitchell also holds that Morris's collapse of the traditional priorities and
dependencies between the image-object and the label, and between
writing and imaging in general, exemplifies a postmodern return to
hybridity and "impurity" – which, as he carefully specifies, has its roots
in the interdiscursive practices of the historical avant-garde. Morris is,
finally, a maker of "philosophical objects" that "when successful, exceed
and explode (or incorporate) the labels that accompany them."[19] The
explosion of the label, here, offers a constitutional scene for the emer-
gence of an object that incorporates the texture of "philosophy." Mitchell
considers the "word SLAB'" [from the title "*Slab (Cloud)*", 1963], as "the
key that opens the object as a case of philosophical provocation," which

has a point of origin in the Wittgensteinian dispute with the "picture theory" of language, where words are seen as names for objects. The philosophical extrapolation of the label makes over the title as an "imperative declaration" of "work": "Morris's SLAB is an invitation to transform a curatorial label into a perceptual and intellectual form of public work."[20] Here the title embarks on its ultimate journey: dislocated from a kind of minuscule dependency on the image-object, it moves to a condition in which the interpretation of its text envelops the signifying arena, both immediate (the gallery) and contextual (the "public sphere"). This is the final gigantism of the title – its ultimate dream (though as an eventuality it must begin and end, as it does for Morris, precisely *in a dream*).

Mitchell's essay helps us to identify the label as a governing symbol for many of the orders of exchange and refusal between word and image woven together in this study. Attending to the disparity between the apparent opacity and self-enclosure of the Minimalist object and the "unprecedented intrusion by language – especially critical and theoretical language – into the traditionally silent space of the aesthetic object," he also points to the title itself:

> On the one hand, the beholder is confronted by simple, spare, elemental, usually "untitled" objects that seem deliberately "inexpres-sive," "deadpan," and "inarticulate." What can objects labeled "Slab," "Beam," and "Box" say to us? What can we possibly say about them? The labels seem to say it all, to exhaust the object and the visual experience of the object. The whole situation of minimalism seems designed to defeat the notion of the "readable" work of art, understood as an intelligible allegory, an expressive symbol, or a coherent narrative.[21]

But this is a liminal scene of restraint within which philosophical textuality lies in wait for the make-over of the image-object. Morris, of course, is an efficient broker of the prolix relationships opened up in the beyond of the "exhausted" Minimalist label, as he has deliberately (and controversially) allied his work with the "lead-styles" of art and theory from high Minimalism, Conceptual art, Process art, Performance, and Earth art to Neo-Expressionist gesturalism and Post-Conceptual image-texts. Yet Mitchell enables us to see him as a chief spinner of the vortex of visual-textual signs conflated at the end of the tradition of American high modernism. In Morris the engorgement of the label, the overween-ing signatures of the words it bears and projects, and the production of what Mitchell terms "self-devouring imagetexts"[22] offer a reprise and a finale to the hypertext of the title. For the title here begins its life in

closure and restraint, where it is caught waiting out the return of its repression in substitute criticalities, poetic and cryptic excess, and even in the traumatic narratives of simulated nightmare. Morris's dream unveils the label-title as the latent content of the artist's imaginary – the dreamwords of modernism, the contextual filigree of the postmodern.

II Naming through Institutions and Expressions

For all its profits and its losses, Morris produced himself, and has been promoted, as the paradigmatic visual postmodernist, changing his formats, materials, contexts, theories (and titles) in time with the key shifts in critical currency from the 1960s to the 1990s. The other postmodern practices I want to bring forward here – the Neo-Expressionist painting represented predominantly by male artists from Germany, Italy, and the United States, and the critically informed photo-text work of women artists including Barbara Kruger, Cindy Sherman, Sherrie Levine, and Louise Lawler – for the most part function in a much more consistent, even iterative, space, developing themes, contents, and styles and associating them with names and titles that are knowingly programmatic in the first cases, and problematically connotative in the second.

Before introducing these tendencies we should return to a different site for the label, one alluded to by Morris and Mitchell, but not pursued. The site in question has been termed "institutional critique," a set of critical practices that is part of a general reconsideration of the social and aesthetic function of the museum and exhibition context that has foregrounded aspects of the logic of display, including the title and the label, presumed innocent or absent both in the mythology of the "white cube," and in the residually colonialist assumptions of the general survey museum. The "new museology" is therefore one of three important sites in the cultural politics of the label. The first, as we have seen, is caught up in the blanket "visualist" refusal of textual or informational supplementarity. The image must be the sole arbitrator of the various contents it controls – whether formal, aesthetic, or even social. A second can be found in the general turn, commencing in the late 1960s, towards practices that test and challenge the cultural parameters of the museum and adjacent institutions. Daniel Buren, Hans Haacke, Michael Asher, and a generation of younger artists including Louise Lawler, Andrea Fraser, and others have scrutinized the repertoire of repressed functions taken on by the museum – sponsorship, cultural patronage, interior design, education, interns, docents, display routines, the architectural envelope. They substituted a history of market genealogies for formal

chronologies; they insisted on the museum as "real estate" rather than an aesthetic resting place; they disinterred the cultural and political assumptions that underwrote exhibition *policy* and motivated cultural *choice*. They variously questioned the frame, context, space, and extension of the museum.

These critical practices were joined, a little later, by the attentions of a third site, that originated in revisionary art history and criticism – first in left and feminist criticism and then within the field of post-colonial critique. Carol Duncan, Allan Wallach, and others have deconstructed the ideology of aesthetic neutrality, interrogated the origin and function of gallery itineraries, and sought to relocate the museum in a history of cultural appropriations and object fetishisms.

Revisionary attention to the title and the label is just one aspect of the larger project of institutional critique. Yet such focus is central to important work from each of the two locations, in art practice and in criticism and history, that contend against the visual poeticizing of Sontag and other formalists. Lawler and Fraser attend directly to the signifying dynamics of modernist art history by taking on the captioning of culture. Lawler's *Well Being* (1986) relocates the normally subordinate identifying label to the center of the work, where it is positioned against a double field of differently scaled geometric areas of blue and rose which stand, respectively, for the per capita spending in the United States on the military and healthcare. Adjacent is a photograph of the installation of a Fernand Léger work in the sitting room of a private collector. Similarly, Andrea Fraser's spoofs of docent tours, and the culture of para-information that circulates in larger museums, literalize what had remained at the level of imaginative reverie and critical satire in 1874 at the First Impressionist Exhibition.

In the context of the "new museology," Michael Baxandall has brought forward "the ["intellectual"] space between object and label" as a crucial adjudication between what he outlines as the "three agencies" of exhibition – the maker, the exhibitor, and the viewer:

> In invoking a space between object and label I have in mind a sort of intellectual space in which the third agent, the viewer, establishes contact between the first and second agents, the maker and the exhibitor. And I use the word *label* here to denote the elements of naming, information, and exposition the exhibitor makes available to the viewer in whatever form: a label is not just a piece of card, but includes the briefing given in the catalogue entry and even selection or lighting that aims to make a point. To attend to this space, it seems to me, is to attend not only to the scene but also to the source of the viewer's activity.[23]

In his "extended sense" of the label, Baxandall glimpses something of the signifying territory of the title – though, at the same time, his logic of the label suggests the differences, as well as the intersections, between label and title. The label, then, is "not directly descriptive of the object." It also offers a "name" and a variety of what Baxandall terms "causes" – whether "material" (as in the materials of fabrication), "final" (as in the purpose or intent of the object), or "efficient" (as in the functionality of its maker). The label is deeply interpretative, and thus aligned with the knowledge and proclivities of the exhibitor. But it is also one strategic, though not determining, zone within a field of constructs that animate the "social" activity of exhibitional experience. By placing the label at the center rather than in the margins of a viewer's encounter with the museum, Baxandall is emphasizing its pivotal role as a mediator between the productive context of the object, the curatorial management of knowledge within which it is brought forward for display, and the particularities of its reception.

Concerns such as Lawler's and Baxandall's are remote from the axis of postmodern representation associated with the return to expressive painting. In many respects they are opposite, for among the painters in Europe and the United States who joined in with the general return to figuration in the late 1970s and 1980s, there is a common desire to use the title as a minor seduction that brokers the revelatory enigma of the painted image. The gallery or museum is made over into a magic container for images and titular strategies that exploit the poetic as a market valency. Notions of political history, religion, mysticism, institutions, and the mythology of the expressive self are all subject to titular deformation in a common effort to designate pictorial *value*. Sometimes such efforts are explicit. Douglas Crimp notes, for example, that "the young American painter David Salle even took the daring step of foregoing his usual cryptic titles and labelled his tailor-made creations *Zeitgeist Painting Nr. 1*, *Zeitgeist Painting Nr. 2*, *Zeitgeist Painting Nr. 3*, *Zeitgeist Painting Nr. 4*. The prospective collectors would no doubt be very pleased to have acquired works thus stamped with the imprimatur of a prestigious international show."[24]

In a very different, though in its way even more disturbing vein, Anselm Kiefer writes of his desire to exploit the titular "connotations" of the German history he negotiates in his controversially celebrated paintings. The "German stories" lying behind his images are claimed to:

> exist more for their connotations than their readability. I want those connotations to go against the material of the painting. For example, "Deutschlands Geistenshelden" is nonsense. The title is in contradic-

tion to the material of the work. An irony is established. A precise distance is created. This obscures the work, keeping it from immediate consumption, easy familiarity. I don't mind if my titles lead to misunderstanding, because misunderstanding creates distance. The title is like the book the lecturer puts between himself and his public. The lecture is not about the book; it creates an ironic distance between the lecturer and the public.[25]

The ironic disjunction enabled by this system of misrecognitions and deliberate ambiguities is, finally, likened to the artist's "gnosticism," the ineffable return of meanings to the "materials" of light and darkness. What was in Surrealism a poetic misprision, an absurdist or decorative association, has been made over by Kiefer into something much more dangerous: a historical risk. If Kiefer's titles assist in the ironic sublimation of a German history they only thinly, or disingenuously, circumscribe, then where does that leave the history itself? We must respond here as we did similarly to Stella's Nazi titles: that they have been suspended in allusion. The title here is a detour into the void of a para-history.

For other Neo-Expressionists the stakes of the title are knowingly lowered – often so far that their critical or curatorial retrieval produces only a banal replay of the weaker instincts of titular connotation.[26] Thus the names given by Enzo Cucchi to works exhibited at the Guggenheim Museum in New York in 1986 are accounted for in terms that, quite literally, appeal to the lowest common denominator of "allusion": "When the drawings are given titles, these titles, like those of the paintings, add levels of complexity to their subjects. The drawings and writings are linked in the way they capture the feeling of their themes through symbol and allusion."[27] When such works are shown in the context of the gallery, its space is viewed as an "organic" receptacle for work that is "itself organic." These are the co-productions of the "the painter as seer, both demon and saint, possessor and possessed . . . at once the creator and subject of his tale."[28] Elsewhere Cucchi uses multiple post-factum titles to solicit "miraculous" effects from his painting of "surprise" and "astonishment": "I give a painting five or six titles, and they become a little story around it."[29] The title is an individual "legend" within the greater fabulism of the image-making process. It is in Cucchi's terms a little scent within the legendary "smell of . . . events."[30]

Like those of the other Neo-Expressionists, Francesco Clemente's titles – sometimes "very commonplace," sometimes "very literary"[31] – evolve in a fashion that insists on the spontaneity of the image:

I often start from commonplaces, and commonplaces are often ready-made phrases. The title doesn't always correspond . . . I might start

from a commonplace, from a readymade phrase and arrive at another one at the end of the painting. And in the last few years I've chosen to paint in oil especially because . . . I need to know less, I need there to be a possibility in the course of the work for more unforeseen events, for more surprises and for things I'm not aware of to happen. At this point the title is always added at the end with a view to conditioning the painting as little as possible.[32]

Clemente's discussion of his titling practice is the most restrained of the several examples discussed here. But it offers the most complete account of the relays to which the Neo-Expressionist title is subject. Clemente insists on two main ideas in the formation of a title. One is the "readymade" nature of the painting's name; the other is its subordination to the "finalness" of the image, which must be seen to govern and control it – even to the extent of fading away from its visual allures. The titular word, then, is doubly subordinate to the image. Unlike the precious painted surface, it originates in the world of "commonplaces" and found phrases. Then, again, it must always defer to the mastery of the pictorial, at all points "making space" for the cultivation of vision-dominated "surprise." For if in Neo-Expressionism "everything is bracketed in quotation marks," if lines and colors that supposedly signify "spontaneously" are nothing more than *signs* of spontaneity, then the title – which is already within those quotation marks – becomes a citation within a citation.

Neo-Expressionism gives rise to a second postmodern refashioning of the paradigms of the avant-garde title. While Morris and Smithson, and Conceptual artists such as Kosuth, opened up new spaces in the descriptive title, questioning the idea of description itself, and exploding the denotative contingencies of the label, Neo-Expressionist mystification and seerlike, poetic deferral take their place as a reductive spin on the received history of the allusive, connotative title we have traced from Symbolism to Surrealism and into aspects of 1960s abstraction. The Neo-Expressionist title functions as a bracket on which is hung that "externalization of instinct" and its "projection onto the Other" – whether the other is gendered, colonized, or historical – that Owens describes as characteristic of the expressionist impulse in art.[33]

III "On the Other Side of the Proper Name": Untitling, Anonymity, Gender, and Power

> all here is sin, you don't know why, you don't know whose,
> you don't know against whom, someone says you, it's the
> fault of the pronouns, there is no name for me, no pronoun
> for me . . .
>
> — Samuel Beckett, *The Unnameable*[34]

There remains the task of outlining the third postmodern "return" — that of the un-named, untitled work, which finds one of its most significant and problematic destinies in the photography and photo-text work of a generation of women artists who rose to prominence in the later 1970s. In addition to a number of male artists, including Robert Longo, Matt Mullican, and James Welling, who also left their works exclusively, or predominantly, untitled, three of the most successful contemporary women artists — Barbara Kruger, Cindy Sherman, and Sherrie Levine — have made the "Untitled" photographic image into something of a trademark. Not all postmodern photographies are produced and displayed with minimal or absent names (and some have actively cultivated the opposite),[35] but this cluster of practices is significant enough to constitute a tendency for entitling after the late 1970s that merits analysis. As a parenthetical subtitle is usually added to Kruger's works, reiterating her texted captions, and while Levine, in her signature work, used the designation "After" coupled with an authorial name, we can reasonably claim that such refusal to designate is most absolute in Sherman. Her earlier work, made between 1977 and 1980, carries the qualification "Film Still" followed by a number and the year of production, while works in various thematic series — the "Rear Screen Projections" (1980), "Centerfolds" (1981), "Pink Robes" and "Color Tests" (1982), "Fashion" (1983–84), "Disasters" and "Fairy Tales" (1985–89), "History Portraits" (1988–90), "Civil War" (1991), and "Sex Pictures" (1992) — are all called "Untitled," then numbered and dated.[36] The stakes of the "silence" that issues from this litany of unspecified images have been questioned by a number of feminist critics. Their concerns are central to the social signification of all practices of untitling.

Rosalind Krauss summarizes this critique of Sherman, which sees "her not as deconstructing the eroticized fetish but as merely reinstalling it — 'Her images are successful partly because they do not threaten phallocracy, they reiterate and confirm it.'" Such criticism "has focused on Sherman's silence. By calling every one of her works "untitled," they

argue, Sherman has taken refuge in a stolid muteness, refusing to speak out on the subject of her art's relation to the issues of domination and submission central to feminism. Avoiding interviews as well, it is maintained, Sherman further refuses to take responsibility for the interpretation of her work."[37] As seems to be imagined in the caption to one of Kruger's untitled works, titular restraint becomes denial or evasion: *Your Comfort Is My Silence*. Such false comfort can take the form of a tactical silence or disengagement. It might also open up the work to a form of critical co-production founded on biographism and other "readings-in" contradictory to the contextual radicalism argued (or hoped) for by Krauss. One commentator, for example, sees Sherman's images as post-factum symptoms of a recovering bulimic.[38]

Krauss's response to Sherman's textual refusals, in a text significantly entitled "Cindy Sherman: Untitled," is to point out a key intertext to which her later work at least is held to refer. This is the photographic work of Hans Bellmer, serially titled "La Poupée" ("The Doll"). Yet neither this point of reference or deferral, nor the positioning of Sherman within the vectors of the New York critics with whom she has associated, is sufficient to speak to the real issue of authorial withdrawal. Earlier in her monograph, Krauss cites Crimp, discussing Degas's photography, to the effect that "the referents of our descriptive language are dissolved. We are left with a language germane only to the photographic, in which the manipulation of the light generates its own, exclusive logic."[39] These are surely the grounds on which the risk of silence might undermine the criticality of restraint. The photograph, produced and consumed as a function of its own material and "language," is one of the necessary risks (or negotiations) that the un-named image must endure. Yet, the question remains as to what kinds of investment can be made in the spaces of nominal withdrawal: pleasures, fetishizations, voyeurisms, social actions, formal consumptions, even violences? Krauss herself would probably concede that the answer must be "all of the above," though not necessarily with the same relevance, plausibility, or appropriateness.

Other responses to Sherman have found that the serial masquerades of her images actually reverse the restraint of the titles. Stephen Melville, for example, conceives of them as an "allegorical portraiture" made up of "speaking pictures."[40] Melville, in fact, defends Sherman's photographic strategies (with reference to Lessing) on the grounds that their allegorical insistence is separable from textual discourse. It is Owens, however, who insists that the artist's silence is problematic only if her images are consumed individually. In fact Sherman's "permutations of identity from one photo to the next" reimagine the aesthetic, title-assisted seriality of Monet's work in the 1880s and 1890s as a media-driven sequence of

confected moments of sublimated identity.[41] In the sense that the viewer is propelled through their diversity, the silence that invades the unitary image is dissolved into the competitive speech of a field of differences.

The titles chosen by Levine for her "re-photographic images" – *After Walker Evans* (1981); *After Kasimir Malevich* (1984), *After Egon Schiele*, etc. – have two main functions. First, they inscribe the art-historical information–caption used to describe the imitative system of representation in pre-modern representation directly into the title of the image. In this way the "after" qualifying the unspecified "untitled" becomes the new "in" of the photograph.[42] Second, her titles incorporate, displace, and parody the structure of imitative Oedipal desire that controlled the intertextual unfolding of the Western European pictorial (and photographic) traditions. Re-imaging the image, re-photographing the painting, appropriating or re-duplicating the photograph – these gestures force attention from the material site of the image to the conditions of its representation, including the site of the title.[43]

Yet the "face-value" of Levine's titles in the first of these functions has been disputed by some critics. In one of the most thorough discussions of the artist's work, Howard Singerman takes as a point of departure the *imagined* or expected absence of originality or of a historical photographic practice signaled in the title: "What I had expected to see in Levine's 'After Walker Evans' was what I thought her title had promised: the photograph's absence, its historical supersession or its critical irrelevance."[44] It is the provisionality of the titular promise that funds this expectation. But Singerman will argue against the inevitable absence of the image, and against the critical reception of Levine that has been predicated on this lack. It is instead the function of the title as a *name*, according to the second function, that comes forward in a more powerful order of critical attention. For the title carries with it the latent authority of the masculine artistic tradition. Born in the prepositional "after" is a specific regendering as well as an appropriation of the image. As other critics have noted, and as Singerman makes clear, "[n]o longer pinned to the name of the father at either site, both images [the Levine and the "original"] become copies, both are found wanting: desire becomes a continuous circuit."[45] In this reading the title offers a kind of "admission" of the duplicated, simulated nature of the image so that "through the washed-out surfaces of Levine's photographs, we see, if only dimly, a 'genuine' picture that has been reduced to a picture of itself, a representation of itself as something – as the sign for another, more proper name." Working "[o]n the other side of the proper name, outside paternal authority, or going beyond it," Levine is held to enter into gestures of exchange "without identifiable terms . . . pleasure without possession."[46]

Neither exactly un-named ("Untitled") nor subject only to the Proper Name, Levine's photographs operate in the space between the history of masculinist inscriptions and the paralyzed un-history of the deferred title. Neither a ("transvestite") name-swapper, "stealing a position along with a name," nor (necessarily) engaged in simply "making a name for herself," Levine's re-photographs are founded on a kind of supra-nomination, or "over-naming," that cuts across the drift of all the names of the image-fatherers.[47]

Such concerns are also central to Kruger's works (see fig. 83), but her intervention in the gendered politics of the production and reception of images is founded on a very different negotiation between text, image, and sociality. Kruger's titles take the form of a refusal to name (their "untitled" preliminary) coupled with a recapitulation of the caption-texts laid across, and finally merged with, the image. While her titles deliver a collocation of text and silence, the works themselves have become the most recognizable and sanctioned form of postmodern photo-text. By incorporating the title in the image, or the image in the title, Kruger insists on the profound imbrication of the visual and textual sign. The little text of the title is doubled with the text of the caption and doubled again across the space of the image which it both formally interrupts and allusively controls, in such a way that its stereotypical brevity is first affirmed and then displaced. Her captions are the most forceful indices of what Kruger terms "the cool hum of power [that resides] not in hot expulsions of verbiage, but in the elegantly mute thrall of sign language."[48]

The title, of course, has always been caught up in the inevitability of its shortness and redundancy (description, denotation, repetition, or truism). In these conditions its significations have often merged with those of the stereotype or the commonplace. Alternatively, it has militated against their scenes of reduction, aspiring to a new signifying freedom in the domain of "poetic" or mystificatory allusion. Kruger reanimates these titular effacements or minimizations in several ways. First, as we have noted, she folds the title-caption into the space of the image. An important compositional reversal results from this gesture, for the text is typically laid over the appropriated photograph, becoming, in effect, a "figure" that stands out against the "ground" of the image. Second, Kruger gives back to the title-caption a form of language to which it has never (or very rarely) been given access. This is the language of pronominal indeterminacy – the "we," "you," and other "shifters" – whose critical dislocation has been noted by several writers.[49] Producing the caption as a form of address or announcement, an invocation or exhortation, and alluding in the process to the address-forms typical of

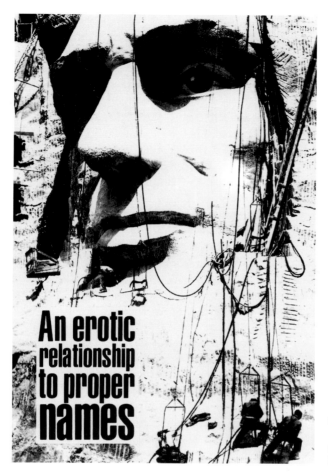

83 Barbara Kruger,
*"Untitled" (An erotic relationship
to proper names)*, 1988.
Photograph, 182.9 × 121.9.

commodity culture, Kruger lends her text an active voice in fundamental dispute with the titular passivity and subordination residual even in the lineage of poetic reverie cultivated for the title by artists from Symbolism to Surrealism and beyond. These are title-captions that require completion or interpellation by the subject positions that read them. The image-(maker) has grappled with the physical space and productive scene of the title, reworked the grounds of its entitlement, and brought into indeterminate foreclosure the uncertain empowerments and paradoxical exclusions of the stereotype. Thus, what Owens reads as Kruger's contestatory – though non-moralistic – doubling of the stereotype, can equally be seen as a deconstruction of everything that is summed up in the caption. The

subordination of the title – its life in that which is unchallenged, scarcely "visible," always marginalized, though socially reproductive – is radically relinquished in a process that here goes so far as to throw its writing (its social inscription) back onto the viewer who reads it. In a 1987 exhibition of Kruger's work in New York, the force of this inscription was ironically supported by a catalogue essay titled "Untitled."[50]

In the work of Jenny Holzer text itself comes forward against a vestigial "ground" of miscellaneous material supports – posters, plaques, LED displays, the Times Square Spectacolor Board, even plastic cups and T-shirts. An important point of origin for Holzer's use of language points to her early years in Gallipolis, Ohio, and the language of common-sense and expeditiousness that prevailed there. The "Truisms" that the artist developed some while later are in this sense the ultimate denotative "images," for a truism is statement that foregrounds its own self-evidence. In a 1986 interview Holzer relates that in art school she was fascinated by diagrams, and went to dozens of science libraries to collect them. Her compulsion arose from the fact that diagrams were "the most reduced, the truest way of visual representation." Such a preoccupation with diagrammatic reduction reveals how the artist worked herself through a tradition of abstract painting and the aesthetics of high Minimalism. In the same interview, she notes that she "finally wound up being more interested in the captions than the drawings. The captions told you everything in a clean, pure way. This was the beginning – or one of the beginnings – of my writing."[51] So, if Sherman refused the title, if Levine deployed it as a site for the postponement and re-routing of visualist authority, and if Kruger made it over as a parenthetical iteration of the slogans within her images, merging the title with the image on somewhat equal terms, Holzer effectively collapses the *work* into the expanded field of the caption. By giving her series framing titles – such as the "Survival Series," "Truisms," "Inflammatory Essays," etc. – Holzer is also participating in the meta-titling that characterizes other kinds of postmodern practice, including, as we have seen, the titled titles of Kosuth, and the titles "in-quotes" of the Neo-Expressionists. But Holzer's work is not simply poised "between literature and visual art"[52]; it actually fulfills what Barthes and Benjamin saw as the destiny of the modern caption, allowing it not only to invade but finally to displace the image-space – leaving the image itself to be conjured as an imaginary figure of reading.

Holzer takes the "enlargement" of the caption beyond the graphic imagination of the text-image. Her siting of work in public space, especially her work with plaques and signs, takes on the project of *re-naming* architectures and corporations grounded in social consciousness. If Baumgarten was concerned with the over-writing, or erasure, of the

names of indigenous peoples by colonial culture, then Holzer focuses on the related reverse of this question, the over-writing, or hyper-visibility, of the nomenclatures of corporate culture: "Use what is dominant in a culture to change it." To rename and relabel these gigantic spaces of exchange in their own materials and according to their sanctioned "style," but in a different *idiom*, is to offer a powerful new social destiny for the public encoding of the title. The imaginary transformation of the symbolic Name takes place in an arena where the interior visual purity of the white cube is made over into the exterior textual interference of brown built space.

The stringent un-naming and relative interpretative silence of Sherman, the untitled afterness of Levine, and the doubled title-captions of Kruger might be contrasted with works by Miriam Schapiro produced in the same years these artists were beginning their exhibition careers, and with her activism in "lecturing, teaching, organizing, and publishing."[53] The contrast, however, is not an easy one to make, and must not be allowed to collapse into false polarizations between types of critique, generations of women, historical redemption and contemporary delirium, activism and passivism, etc. In a series of etchings called *Anonymous Was a Woman* (fig. 84) Schapiro explicitly engages with the historical writing-out of the names of women and of the critical disparagement of their practice as "decoration" or mere "craft." Her folding of the question of the "not-known" into the cultural relegations associated with anonymity and denial offers a direct confrontation with the gender coding of the "name" operative in the history of art. The etchings are subdued reworkings of "individual" gestures of embroidery and needlework and their sites on and around the objects of everyday life – as in the panel "bread" in *Anonymous was a Woman: Bread* (1977), and the patterned collar in *Anonymous was a Woman: Collar* (1977).

While it is clearly part of Sherman's strategy to refuse to name or otherwise precondition the reception of the gallery of masquerades that emerges from the sequence of her untitled film stills and later works, such an assertion of the presentational aspects of the photograph countenances the risks of renaming and mis-taking that necessarily attend any reading of the images. Perhaps the existence of this risk is a measure of the separation of the gallery-sanctioned, avant-garde Sherman from the less lionized Schapiro. For caught up in the refusal of the name, and the refusal to impart an interpretative purchase on the work (in the form of a title, statement, or a clear sense of the relation it might have with recent feminisms, both American and European) is a signifying arena which differs markedly from that taken on by Schapiro. The interpretation of Sherman's work is driven by a forced negotiation with the interstices of

84 Miriam Schapiro, *Anonymous was a Woman: Collar*, 1977. Collotype in red–brown on Arches paper. National Gallery of Art, Washington, D.C. Gift of the Artist

implicit and withheld meanings – an eventuality that allows the avant-garde critic an equal opportunity to name and fashion the work in accordance with a house style of sanctioned radicalism. As so often in the history of visual modernity, the deferral of the title is an invitation to a critical "appropriation" that reinvents the work under its own labels and categories. While such strategies have been associated historically with formalism and abstraction, we have seen that the switch systems of the 1960s reversed the flow of associative meanings, flooding the spare, reduced paintings made in that decade with an empty metaphoricity, and freeing up the untitled designation for the counter-formalists of the next generations. It must be remembered that the language of provisionality, deferral, ambiguity, and ahistoricity that has often (if by no means always) marked the reception of Sherman's work is, among other things, a reworking of the critical strategies associated with formalist "readings-into" the recalcitrant abstractions of the last modernist generation. If I insist on this aspect of the production and critical reception of Sherman, it is only because other (I think equally plausible) readings have domi-

nated in contemporary art journals and catalogues. These see Sherman as leading an important reaction against the instrumentality and labeled directness of the feminist art and theory of the later 1960s and 1970s, though often without naming her "critique" as such.

In a sense, however, the projects of Sherman and Schapiro are not antagonistic, or, rather, they are conceived only in unbroachable opposition by those with agendas directly tied to the discourses they contend are epitomized on either side of the opposition. It is surely the case that Schapiro and Sherman offer two visions of the production, the effects, and the consequences of the non-naming or anonymity of women. Stranded outside of representational discourse save for that of production itself, the unnamed makers alluded to by Schapiro have a very different position in the history of imaging than the overloaded image-repertoire of the photographer-self imagined and "taken" by Sherman. The innumerable subject-positions of Sherman's women-selves include fantasies, violences, surrogates, dreams, vulnerabilities, magazine or filmic mesmerism, and so on. Not only are these positions defiantly plural, but they also merge, overlap, and evaporate with such frequency that to name them might itself be a violence. This may be to understand the space of the name as already on the side of masculinist appropriation, as suggested in the writing of Luce Irigaray and other French feminists.

If Schapiro offers a counter-position to the silence of Sherman, she also attempts another mode of relation to the works of the past not predicated on what the art world began calling "appropriation" in the later 1970s. Discussion of Schapiro has already emphasized how her understanding of "collaboration," especially in her "Collaboration Series" (e.g., *Me and Mary Cassatt* [1976]), might be set apart from the satirical and irreverent attitude to the past of the historical avant-garde, as, for example, in "the mocking, and ultimately competitive, nihilism with which Marcel Duchamp approached his 'collaboration' with Leonardo da Vinci."[54] But this work must also be seen against the appropriative gestures of artists such as Levine who were offering a jived-down version of a historical avant-garde device that was always (or usually) associated more with humor than with either vituperation or solemn critique. The distance measured between the dialogic engagement (what Norma Broude terms "joyous collaboration") of Schapiro and the silent, quizzical, cut-out reframings of Levine is the necessary space that must be taken on in any historical reckoning with the destiny of "collaboration"/"appropriation" – the co-production or taking over of names and practices from the past.

Similarly, the visual opacities and textual indeterminacy of Kruger constitute a powerful retort to the historical emptiness of the formally or metaphysically untitled work. As Donna Haraway suggests (though not in

the course of a reading of Kruger's work), the final indeterminacy negotiated here is that of *nature* itself, the nature invented as the categorical home for women, but also the nature appealed to by "versions of Euro-American feminist humanism" that have been challenged in recent theory and practice:

> "Our" relations with "nature" might be imagined as a social engagement with a being who is neither "it," "you," "thou," "he," "she," nor "they" in relation to "us." The pronouns embedded in sentences about contestations for what might count as nature are themselves political tools, expressing hopes, fears and contradictory histories. Grammar is politics by other means.[55]

The political grammars of the title are the ultimate grounds according to which the "natural" order of relationality between an image and its textual "governance" are disputed. The shifting identities of Sherman, the shifting captions of Kruger, and the shifting fathers of Levine subject the (un)title to a final dissolve that shatters not just its mode of address, but all the pretense of neutrality or ineffability invested in it during a century of silences and modern metaphysics.

"A Museum of Language in the Vicinity of Art"

. . . the public sphere in all its aspects – speech, the printed word, the open exhibition . . .

> – Thomas Crow, *Painters and Public Life in Eighteenth-Century Paris* (1985)[1]

Jarry and Satie, as well as Henri Monnier and Alphonse Allais, were predecessors in this line of perpetrators of hoaxes who took their own antics seriously. The Chat Noir and the Lapin Agile were truly the *salons* of the new art.

> – Roger Shattuck, *The Banquet Years* (1958)[2]

In the ["Museum of Leftover Ideologies," run by the robots of the Establishment] one can find deposits of rust labeled "Philosophy," and in glass cases unknown lumps of something labeled "Aesthetics." . . . On a cracking wall is a list of "ideals" that killed millions. The "Room of Great Artists" presents a panorama that goes from "the grand" to "the horrible." A continuous film, always being shown in a dark chamber, depicts "the artist alienated from society." It is made in "serial" sections under the titles: "Suffering, discovery, fame, and decline."

> – Robert Smithson, "The Establishment" (1968)[3]

We have already encountered important instances of the interaction of titles and names with the spaces of exhibition. I want now to bring these occurrences into a more continuous line by considering a number of key moments in the formation and demise of visual modernism during which the reciprocal dialogue between the title and institutions was opened up (or closed down) most significantly. I will look to a decisive moment of nominal dissonance in the nineteenth-century Salon; to two important,

but oppositely predicated, exhibitions that represented the late nine-
teenth- and early twentieth-century avant-gardes (the Armory Show in
1913 and the Degenerate Art exhibition of 1937); to an influential
account of the constitution of modernist exhibition space; and, finally, to
a visionary contestation of the museum-as-composition.

The "invention" of the Salon exhibition in the eighteenth century,
which became a fixture from 1737, was "the first regularly repeated,
open, and free display of contemporary art in Europe to be offered in a
completely secular setting and for the purpose of encouraging a primarily
aesthetic response in large numbers of people."[4] From the outset, the
Salon was attended by an acceleration in the provision of textual supple-
ments to the image. These emerged and were developed in several
manifestations, the most significant of which were the catalogue or
pamphlet (the *livret*), with its descriptions, "names" and caption-titles, and
the beginnings of a critical discourse, official and unofficial, that offered
opinions, longer descriptions, judgments, and miscellaneous contexts for
the exhibited works. The *livret* and its words, which first appeared in
1671 as a "handlist offered for public sale"; criticism and its paragraphs;
and the ineffable circulation of gossip and debate were three crucial
agencies bound up in the contested emergence of a "new public space."
They were the major combatants in the eighteenth-century "war of
words" pointed to by Thomas Crow: that "struggle over representation,
over language and symbols and who had the right to use them."[5]

Throughout the nineteenth century such supplements became increas-
ingly significant parts of the message-bearing apparatus of an exhibition.
We have seen that they were important elements in the caricatures and
satires of Daumier. Such textual addenda also feature prominently in the
Salon "reviews" written by numerous lesser-known writers, and more
famously by the Goncourts, Théophile Gautier, and Baudelaire.
Baudelaire, in particular, used the entries in the *livret* as a loose structure
for his criticism. His "Salon of 1845" is organized as an assemblage of
comments divided first by genre and then written against a list of artist's
names ("ACHILLE DEVÉRIA. And now a fair name . . .")[6] and titles. In this
"Salon," as in those of 1846 and 1859, the display and reception of genre
paintings give rise to the critic's most direct and elaborate reading of the
catalogue's title-texts. These paintings, which introduced into the closed
forum of the exhibition space the most sustained glimpse of the outside
contemporary world, inspired Baudelaire to inveigh against the contami-
nating metaphoricity of the title-assisted image. In 1845 he described
Guillemin's anti-pictorial tendencies as "the cause of *wit in painting*." This,
he explained, was a case of "providing the catalogue-printer with captions
aimed at the Sunday public."[7] Baudelaire exacts his critical revenge on

such literary witticism by ironizing it in its own terms, rounding out the fourth section of the 1846 "Salon," devoted to "Genre-Paintings," with a whimsical finale predicated on the unseductive riddling of a title by Joseph Hornung, *Le Plus Têtu des Trois n'est pas celui qu'on Pense (The Most Stubborn of the Three is not the One You Think)*. The painting referred to here represented a boy and a girl sitting on a donkey. Baudelaire effectively scuttles the aphoristic cuteness of the image by relaying the signification of the unitary picture-title into his critical gloss on a trio of unsubstantial genre painters, including Hornung. Against the names J.-A. Bard and E.-A.-F. Geffroy, which are listed immediately after that of Hornung, he wrote: "See above," thus deflecting the mild irony of the vacuous maxim back against the unpredictable textual frivolity of genre painting itself.

As I discussed in chapter 1, Baudelaire's "Salons" of 1846 and 1859 develop his attacks against genre painting (practiced by the "apes of sentiment") and other textual interferences with the visual specificity of the painted image. One of the most egregious of these tendencies is what he terms the "Neo-Greek" school of the mid-nineteenth century, whose "epigrammatic wit" and "element of pedantry" are founded on three "irritations": "the proverb, the rebus and the neo-archaism."[8] The rebus is Baudelaire's term for the specious energies coiled around the title, especially in its solicitation of abstract ideas and sentiments. There are sculptural as well as pictorial versions of this cross-eyed referentiality, as, for example, in what Baudelaire describes as the "riddling title"[9] of Emile Hébert's *Jamais et toujours (Never and Always)*.

The catalogue and the caption-title were caught up in the rhetoric of the avant-garde from its earliest moments. It was a critical tour of the first Impressionist exhibition by Louis Leroy and his fictitious academic interlocutor, M. Vincent, that structured the most elaborate of the reviews of this formative moment of visual modernity. Leroy deliberately organizes his text as a series of transgressive encounters between the descriptive and "effectual" titles of the exhibited paintings and their aberrant, contrarealist styles. The reiterated scenes of mismatch and misconstruction constitute the denouement of the traditional descriptive title.

Yet before this crucial moment of avant-garde formation, the critical reception of vangarde work exhibited in Paris uses the title of the image as a convenient springboard to point up the absurdity or outrageousness of a painting's form and/or subject matter. Thus, even one-word titles, such as Manet's *Olympia* (1863),[10] are subject to numerous caricatural distortions and satirical renominations (see fig. 85). A wood engraving by Bertall, published in *Le Journal amusant* (27 May 1865) restyles the painting over a new double title, *Manette, ou la femme de l'ébéniste (Manette* [the

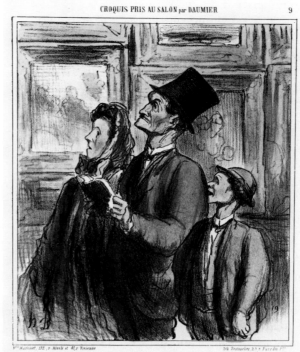

feminine of Manet], *or the Cabinet-Maker's Wife*);[11] and the critic Merson
offers the shocking renomination, "l'enseigne de la *Femme à barbe*" (*The
Bearded-Lady's Shop Sign*).[12] Much of the criticism of the image was
invested in the social identity of the Olympia represented, her class
origination, her sexual proclivity – in short, in the *location* of her *name*. In
addition, as with so many moments of intensity in the nomenclature of
the visual avant-garde, Olympia is also associated with the dissolution of
form – with the formal "decomposition" of the image, and the physical
"decomposition" of the dying and dead body.[13]

The name and title "Olympia" stand, then, at the intersection of avant-
garde experiment, public exhibition space, and critical censure. Olympia
focuses the controversial emergence of modern sexuality, becoming a
measure of how the "category" of the *courtisane* "no longer quite covered
or displaced those of *insoumise* and *petite faubourienne*, and the whole

untidy place those words suggested of the prostitute in class society." For, as T. J. Clark points out, the courtisan existed under a plurality of names: "the *joueuse*, the *lionne*, the *impure*, the *amazone*, the *fille de marbre*, the *mangeuse d'hommes*, the *demi-mondaine*, or the *horizontale* – her names were legion, but they all meant much the same thing."[14]

Ambiguously poised between classical and contemporary histories, between explicit eroticism and attenuated allegorization, the body-name Olympia stands in for the transgressive edge of sexuality, and for the "disarray" of the generic representation of the nude. It is written on the borderlines between pictorial expression and display, between spectatorial displacement and the commodifications of art and the body. Clark summarizes the disturbing generic negotiation of the *Olympia* as follows: "Olympia is depicted as nude and *courtisane*, but also as naked and *insoumise*; the one identity is the form of the other, but the two are put together in such a way as to make each contingent and unfinished." *Olympia* therefore emblematizes the formation for the female subject of "a particular sexuality as opposed to a general one."[15] We are confronted here with an image-title that manages to defeat the logic of denotative inscription – whether in the domain of the subject, of sexuality or of the proper name. For the complex "particularity" of the *Olympia* is achieved through a plurality of ambiguously competitive somatic signs that dispute the objectification and singularity of the unitary name, while at the same time masquerading under its nominal codes and disguises.[16]

The clusters of disputes and ambiguities that circulate around the title, the body, and its *exhibition* in *Olympia* represent one of the greatest concentrations of connotative excess in the pictorial proper name. My earlier discussion of the Symbolists and their affiliates, especially Whistler, Redon, Gauguin, and Signac, revealed that the conjunction of commercial and alternative public exhibition and critical scandal found a special purchase in the new regimes of titling developed by each of these artists. For Whistler, in particular, the title was a talisman whose charms were threaded through the subject matter and form of the image, the frame, the catalogue, and the physical space of the gallery. It was a summation of the organizational principle, or greater "composition," that united all these registers into a consolidated hyperform.

The most parodic of all the exhibitional tendencies of the nineteenth century, the several "Exhibitions of Incoherent Art," used the title and the catalogue as one of its chief agents of critical provocation, conjuring a field full of absurdity, conundrums, and arcane redundancies that would scarcely be matched, even by the disparate titular ebullience of the Dada artists thirty years later. As with the official and unofficial sites of exhibiting "shock" in the later nineteenth century, the public appearance of

avant-garde work in the first decades of the twentieth century continued to elicit critical responses that hit on the title and the catalogue for useful – even necessary – purchase on the content of the outrage they so vociferously contested.

The Armory Show is one of the most interesting of these sites, not least because it brokered the United States's first sustained encounter with the European visual avant-garde. The exhibition was presented in New York, Chicago, and Boston in 1913 under the auspices of the Association of American Painters and Sculptors, which demised shortly after the event. According to John Quinn, who formally opened the New York showing on 17 February 1913, the institutional affiliations of the event were notably provisional: "This association," he underlined, "has had no official, municipal, academic or other public backing."[17] At the Armory Show the ensemble of innovative visual practices developed between the last years of the nineteenth century and the early 1910s – from Redon, who, as so often in the major exhibitions of this time, was especially well represented, to Rouault – was laid out to be negotiated and struck down by an art world that had scarcely come to terms with the work of the Impressionists. In the swirl of hostile, incredulous notices that followed the opening, the title was once again elevated as a leading indicator of the obfuscation of experimental modernism and a leading cause of the incessant disapprobation leveled against it.

Most of the critical invective was directed at the Cubist Room, which contained the most controversial work in the exhibition, Duchamp's *Nude Descending a Staircase No. 2*. This space was given its own nickname – the "Chamber of Horrors" – and the purportedly bizarre work it housed gave rise to numerous jokes, cartoons, doggerel verse, and parodic renominations. One of the most enduring of these is a cartoon by J. F. Griswold for the *Evening Sun*, which was captioned "The Rude Descending a Staircase (Rush hour at the subway)." Other examples of this recast pseudo-description took on the proportions and look of its official title. These included "staircase descending a nude," "explosion in a shingle factory," and "dynamited suit of Japanese armor."[18] Such titular take-offs were mainly directed towards a satirization of the identity of the image and were funded by the discrepancy between what the title announced and the form and perceived content of the painting itself. The critic Royal Cortissoz posed the question of this identity in terms that understand the image as a rebus that unsuccessfully mediates between line, color, and "human life":

[The Cubist] paints you his riddle of line and color, and then, as in the case of M. Duchamp, calls it "Nude Descending a Staircase." In other words, he has the effrontery to assert that his picture bears some relation to human life.[19]

The recourse of the stupefied critics to a kind of generic warfare with Duchamp's painting and its title was almost endless. One of the most popular ripostes was meted out in the form of hack versification. Many of these efforts, such as the following lines by Maurice L. Ahern, called "A Post Impression," which appeared in the *Sun* on 8 March, simply underscored the mimetic, stylistic, and aesthetic shortcomings of the work:

> Awful lack of technique
> Awful lot of paint
> Makes a Cubist picture
> Look like what it ain't.

Others, including a contribution to the Chicago *Tribune* on 8 February, specifically link the mooted illegibility of the image with the seeming transparency of the title – in this case throwing in a reference to the convolutions of the avant-garde activist, and titular deviant, Gertrude Stein:

> I called the canvas *Cow with cud*
> And hung it on the line,
> Altho' to me 'twas clear as mud,
> 'Twas clear to Gertrude Stein.[20]

But, the mock titles and the jeering, gleeful misconstructions of a philistine press are not crucial to my argument in their own right. They become so only when seen in relation to several other modes of critical satire and disabuse, which also focus on the *textual* appendages of the exhibited works and on the nominal conditions of *exhibition* itself. First, the absurdity of the inscription of text in several of the exhibited Cubist paintings occasioned the circulation of jokes and put downs at the expense of such intrusive language. One is directed at the lettering included in Braque's *Violin*, on which the words "Kubelik" and "Mozart" are inscribed:

> Two men were looking at the painting and one said,
> "Braque is the painter who put cube in Kubelik."
> "No," said the other, "he put the art in Mozart."[21]

Second, and more remarkably, the Armory show gave rise to a series of lampoon exhibitions, mounted even while it was still on view. Unlike the avant-gardist origination of the Incohérents, and unlike the non-official, non-"academic" status of the Armory show itself, these boisterous parody-events were invented by some of the most traditional institutions in town, including the Architectural League, which presented an event

on 11 March, and "Les Anciens de l'Académie Julian," whose affiliates
got together at the old Brevoort House on 17 March. On another
occasion a group of satiric, mock-modernist works was assembled at the
"Lighthouse for the Blind," where it was subject to the pseudo-academic
ritual of prizes and medals. There was also a "First Annual Varnishing
Day" of the "Academy of Misapplied Arts," announced in the news-
papers as "for the benefit of the Lighthouse of the New York Association
for the Blind," on 22 March. Advertised as the "Post Mortem Impres-
sionist Exhibition," it featured the "'most distinguished artists of the
Cubistic, Post-Impressionist, Futuristic, Neurotic, Psychotic, and Paretic
Schools' including 'Ten Mattewan Muralists and other nutty groups.'"
This kaleidoscope of frantic, absurdist re-nominations was turned unceas-
ingly by critics and artists during the weeks of the exhibition. There were
other burlesques in Philadelphia, Hartford, and from the publishers G. P.
Putnam's Sons, which published a children's book entitled *The Cubies'*
ABC by Mary and Earl Lyall.[22] Show-names, institutional-names, move-
ment-names, and painting-names were all facetiously corrupted. One
artist even titled his submission to the "Post Mortem Impressionist Exhi-
bition" with a frenzy of repetitions, *Cubist Painting, Cubist Painting, Cubist*
Painting. When parody ran out, iteration was enough in its own right to
continue the line of debunkings.

There was, of course, a more serious side to these harangues, which
affected even the most frivolous of the squibs. Much like insanity and
delirium, the perversions of Duchamp and company were held to
threaten the social fabric. One critic described the show as a "pathological
museum," another dubbed it a "temporary lunatic asylum" filled with
"blear-eyed daubs and phantasmagorias of the insane." The exhibition
was the product of a "miasma of morbid hallucination." The New York
Review of 22 March upbraided the avant-garde as the "degenerates of art"
and attacked the "propaganda" of Cubism and Futurism, which was
judged "a grave danger to public morals." In the same vein, the article
took a would-be technical turn, claiming that such work could only be
the product of "minds which, according to the eminent psychiatrist
Krafft-Ebing, would be classed as hopelessly diseased," the "wildest
imaginings of the victims of Sadism . . . are not more viciously
degenerate."[23]

These accusations of chaos, barbarism, and the empty gestures of
"anarchic hordes" and "paranoia" quite precisely anticipate the charges
that would be leveled by the National Socialists in Germany against the
"degeneracy" of modern art two decades later. The Nazis gathered up the
history of abuse directed at avant-garde painting and sculpture and
deployed it as the title of the "Entartete Kunst" ("Degenerate Art")

86 Partial view of south wall, Room 3, in the exhibition "Entartete Kunst" ("Degenerate Art"), Munich, 1937.

exhibition that opened in Munich in 1937 near the sanctioned, sanitized official "Grosse Deutsche Kunstausstellung" ("Great German Art Exhibition." This exhibition was "an obscurantist perversion" of more than a hundred and fifty years of public exhibition and can be said to mark the climax and end of an Enlightenment dream. Like the Armory Show, and key moments of exhibitional history in the nineteenth century, the assumptions and control-environment of "Degenerate Art" were predicated on a negotiation with textuality that found a focus in the title, the label, and the caption.

In his opening address to the "Great German Art Exhibition" on 19 July 1937, Adolf Hitler clearly signaled a break from what he viewed as the corrupted tradition of textual additives to the receptive context of visual art:

"Works of art" that are not capable of being understood in themselves but need some pretentious instruction book to justify their existence – until at long last they find someone sufficiently browbeaten to endure

such stupid or impudent twaddle with patience – will never again find
their way to the German people![24]

Despite this protest, the some 650 "degenerate" works featured in the
exhibition were efficiently wrapped in the textuality of Fascist propa-
ganda. They were accompanied by a brief, polemical pamphlet – which
functioned as a kind of anti-catalogue, brimming with "murky, vitupera-
tive text"[25] – as well as by an extensive series of wall captions, labels, and
appendages containing diatribes, information on the "outrageous" public
cost of the works (Emile Nolde's *Christ and the Woman Taken in Adultery*,
25,000 Marks), random accusations of immorality, and racialist slurs.
Some captions allegorized the corruption and decadence of the works
they subtended with far-fetched, but powerfully corrosive, references to
contemporary blacklists and Nazi bêtes noires, including the Catholic
church. Max Ernst's work *La Belle Jardinière* (*The Beautiful Gardener*,
1924), purchased by the Düsseldorf Kunsthalle, was "abducted" for the
exhibition, where it was honored with a caption reading "[a] slur on
German womanhood," "and then disappeared."[26]

Described by eyewitnesses, the design of the exhibition has been
researched by several art historians (see fig. 86). Densely clustered bands
of paintings were hung on burlap-encased "trelliswork structures." The
burlap itself constituted a "ground" for the deployment of "numerous
inscriptions," slogans, commentaries, and occasionally (as on the Dada
wall in room three) of graphic marks that parodically "diagram" an
individual work – in this case Kandinsky's *Die schwarze Fleck* (*The Black
Spot*, 1921). Further textual commentaries, called "guiding principles" in
one account, were "written up in large letters in the individual rooms, or
on sections of the wall."

Thus, in addition to the propaganda broadsheet, each of the exhibition
rooms was labeled with an elaborate "title" specifying a particular theme
(in effect a counter-genre) in the litany of "degenerate" abuses perpetu-
ated by the German avant-gardes. One wall of the third room, for
example, was signed: "Degradation of the German Woman. . . ."
Another wall text in the same room associated works by Otto Dix – *Die
Kriegskrüppel* (*mit Selbstbildnis*) (*The War Cripples [with Self-Portrait]*, 1920)
and *Der Krieg (Der Schützengraben)* (*War [The Trench]*, 1920–30) – with a
"[d]eliberate sabotage of National Defense."[27] "The guiding principle in
the first room . . . reads, 'Insolent mockery of the Divine under Centrist
rule,'" while room two was headed, "Revelation of the Jewish racial
soul."

This panoply of textual supplements exploded traditional notions of the
catalogue and the title into an overbearing propagandistic network of

insemination and superscription. Yet, there was still more, as Christoph
Zuschlag notes:

> The installation was completed by "explanatory" or "helpful" remarks
> by Hitler, Goebbels, and Rosenberg, and by comments and statements
> by artists and art critics who, when their words were taken out of
> context, seemed to indict themselves and the artists about whom they
> wrote. This extensive use of extraneous texts represented a departure
> from the organizational praxis of such exhibitions. A further important
> feature was the quotation of passages from Willrich's antimodernist
> book *Säuberung des Kunsttempels* (Cleansing of the temple of art).[28]

In a manner that offers a perverse reprise of the structure of Leroy's
satirical review of the First Impressionist Exhibition, the highest form of
disabuse was reserved for the conjugation of physical disability, dementia,
and insanity with Expressionist style, as evidenced in particular by several
self-portraits, and, more forcefully still, with the abstract paintings hung in
room six. Having just identified the municipal guard as an Impressionist
"portrait," in the process transferring the Impressionist designation onto
himself, the academician, M. Vincent, we recall, tottered out of the
Impressionist Exhibition enveloped in an ironic fog of delusion and
insanity. Yet what was an audaciously conceived critical fiction in the
1870s had become a political reality sixty years later, as the art masters of
1937 attribute the promulgation of insanity to both the producers of the
images and to their infectious consequences in the viewer. In a more
ferocious replay of the association of visual modernity with madness,
the pamphlet for "Degenerate Art" noted of the area devoted to
"abstract" art that "[t]his section can only be entitled '*Sheer Insanity*.'"[29]
Willibald Sauerländer describes this association under the term "aesthetic
eugenics," which saw expressionist "distortion," and the counter-
naturalism of "abstract" painting in general, as clear, morbid symptoms of
what Hitler himself termed an advanced "congenital" sickness whose
"hereditary transmission" ought to be "forestalled."[30]

The "Degenerate Art" exhibition was a hideous, distorted political
assemblage driven by a theory and practice of exhibition-making that
paradoxically attested to the centrality of titular and associated texts in the
field of public display. It marked, first of all, the apogee of state interfer-
ence and control in the production of visual cultural knowledge – a
control, of course, invested in one of the most vigorous textualist infer-
ences with the exhibitional arena in modern history. Yet, as we have
seen, one of the key predicates of the show was the "healthy," denotative
transparency of artworks. Its organizers, and the more powerful control-
systems beyond them, up to and including the Führer, defended a set of

pseudo-modernist assumptions about the dangers of textual supplementa-
tion, proposing that the content of artworks should be publicly "self-
evident." While seemingly close to the modernist *theory* of textual
reduction, though putting such ideas at the service of ideology and not of
form, "Degenerate Art" is, at the same time, the exhibitional antithesis to
the modernist theory of the "white cube," discussed below.

The historical space between these two extremes, between the political
hypertext and its totalitarian and other destinies, and the contra-textualist
white-out of high modernism, is full of nuances and aporias. The most
significant of these is the double retreat of the neo-avant-garde from form
and institutionality, some of the consequences of which were discussed in
previous chapters. One of the limit terms of these tendencies was the final
implosion of institutional space. I will conclude with some remarks on
what seem to me the most suggestive of these theory-events, noting first
that there were many other challenges to the relation between textuality
and the exhibition space.

Consider, for example, Joseph Beuys.[31] Professor at the Düsseldorf
Kunstakademie from 1961–72, he was, in name at least, a man of the
Academy. Dedicated to a kind of art-as-charisma, to a personal vision of
democracy and an academically administered counter-hierarchy, Beuys
attempted to define and then defend one of the twentieth century's last
utopias. If Kaprow stands for the experiential framer as a light magus – a
sort of "practice," or art-world, variant of what Gianni Vattimo described
as "weak theory"[32] – then Beuys, as a parallel master-of-the-frame, is a
rigid designator, and heavy shaman.

Symptomatic of Beuys's artistic ergonomics, and quite opposite to the
rhetorical self-effacement of Kaprow, is his famous self-designation as (an)
"Academy": "wherever I am, Academy is." Precipitating a gesture that
we might term the anticipatory inverse of what is later named as institu-
tional critique, Beuys returns a prophetic authoritarianism blended with a
visionary image of "Social Sculpture" and an "Expanded Concept of
Art." Social Sculpture, it has been claimed, "moved beyond Marcel
Duchamp's Readymade. His [Beuys's] concern was no longer with the
museological but with the anthropological context of art."[33]

Beuys is more instrumental and designatory than Kaprow, claiming that
"regeneration will . . . come from the expanded concept of art."[34] Such
propositions are framed as redemptive and allegorical, and it is in this
sense that he attempts to emulate the social warmth of the bees. For
Beuys the world is a function of all-form, and "formation" is the key
human question, one that will eventually issue in "the totalized concept
of art." Parodied as the "Jesus [of] kitsch" by Norbert Kricke, who
claimed that "museum dust and museum smell [cling] to every object as

soon as it is made,"[35] Beuys seemed to aspire to the condition of a one-person, postmodern Bauhaus, with his designations and blackboards as the scripture of the new utopia. Everything from thought to political parties (both his own) were legitimate moments in the unframed new-time of art. The limits of the all-frame, religio-mythic preciosity of Beuys and the boundless, spiritual self-effacement of Kaprow, might be measured in relation to the adoption of contra-heroic personas by women perform-ance artists such as Eleanor Antin and Hannah Wilke in the late 1960s and 1970s. In the end, Beuys-the-Academy is a maker of speech meted out as a succession of titles whose frames are the institution he personifies. This is one of the final reaches of the progressive expansion of language in relation to the visual, and of the counter-institutionalism that articu-lated the historical avant-garde. Beuys's words are titles-as-works exhib-ited in himself-as-institution.

We have discussed the insinuation of the title in the scene of the public, and private, reception of modern images. Within and across these terms I have also pointed to a special relational site in the signifying exchange between the *modernist* work and its name. I want to bring these two concerns together and add them to the two antitheses to the counter-textuality of modernism we have encountered in the state-written exhibition and the art-shaman whose self-definition merges title, work, and institution. By closely reading one of the key texts offering, loosely, to deconstruct the signifying space of modernist display, I hope to show how the title plays important, occasionally contradictory roles (sometimes counter-insurgent, sometimes devotional) in the ritual visibil-ity of formalism, but also how the operationality of that role is foreclosed by the terms of the discussion – terms that can be said to stand in for the general critical occlusion of the titular activity.

This text is the well-known, two-part article "Inside the White Cube," by Brian O'Doherty, published in *Artforum* in March and April 1976.[36] The first part of the article situates itself as an essayistic critique of the "evenly lighted 'cell'" crucial to the otherwise prolix operationality of the modernist tradition. If O'Doherty was concerned in the mid-1970s to reclaim the history, emergence, and contemporaneity of the gallery space as a decisive frame for visual modernism, we can extend that claim here so that the nominal conditions of the exhibited art object are likewise given back their signifying territory, both within the confines of the exhibition space, but also, and importantly, as a filament of signification that is always borne away, that circulates equally in the spaces of memory, publications, reproductions, and popular knowledge.

The "isolated" "subtractive" space of the "ideal gallery," the white cube itself, is flooded with the conditions of semantic minimization. It is

the zero-economy of the space of display. The art object enclosed in this purportedly neutral space would thus seem to be delivered as a function of its own interiority. Yet O'Doherty is right to insist on the ideological value of this studied neutrality, that it resembles other conventional social spaces written-through by a "repetitive" "closed system" of values: "Some of the sanctity of the church, the formality of the courtroom, the mystique of the experimental laboratory joins with chic design to produce a unique chamber of esthetics."[37]

Before sketching a mini-history of the Salon and post-Salon context for art display, O'Doherty observes two things about modernism. The first is that as it "gets older, context becomes content. In a peculiar reversal, the object introduced into the gallery 'frames' the gallery and its laws." Second, "one of modernism's fatal diseases" is described as a "transposition of perception from life to formal values."[38] O'Doherty writes of the pristine aesthetic of the white cube, noting the "ungrubby surfaces," the absence of almost all interferences with the visual integrity of the space (except, in the commercial gallery, for a "discreet desk" or totemized ashtray), and the disembodied viewing experience perpetuated by a kind of "eternity of display."

As with Greenberg's critical formalism, the title is a key absent term in O'Doherty's discussion – so much so, that we can suggest its absence is a kind of necessary predicate without which the mythology and its ironic counter-mythology of modernism could not flourish in this writing. The title is the only element smuggled into the uncontaminated zone of modernist contemplation. It is the only interruption and irritant in a pure system. In this sense the title functioned as a kind of sanctioned intrusion. It was a necessary moment of textual supplementation that took on many forms of co-signification with the image or object in whose vicinity it was stationed. In O'Doherty's terms we are implicitly led to believe that the titles best respecting the high modernist space that occasions his article might be the most reduced and attenuated of their kind, thus blending in with the conditions of purity and restraint encoded in their context. There are certainly practices of titling – such as the designation "untitled" or the development of numerical or other pointers of semantic absence – that answer in like terms to O'Doherty's evacuated cube. We are all familiar with those curatorial (or mercantile-designer) gestures of titular restraint according to which the labels and captions "belonging" to particular works are minimized, miniaturized, and relocated at a safe distance from the auratic self-presentation of the image-object – and sometimes, though quite rarely, dispensed with altogether.

Yet these gestures are the exceptions and not the rule, even in the most sacred zones of blanched modernism. It is O'Doherty's concentration on

the undoubted significance of the wall and the frame in the construction of modernist aesthetic space that allows him to neglect the title. He offers instead a version of the modernist story according to which invincible pressures are brought to bear on the "portable window" of conventional, framed-off, academic space. The result is that "formal composition" is disrupted, and the frame rendered "equivocal" and "parenthetical" by the "edge-to-edge" horizons, and "ambiguous surfaces" of pictures by Courbet, Caspar David Friedrich, and Whistler, among others. In this account Monet is decisive ("the great inventor"), but exclusively on account of his "doubled and somewhat opposing stress on the edge," which is claimed as "the prelude to the definition of the painting as a self-sufficient object."[39] The "technology" and teleology of flatness literalized in the picture plane and the infinite parables of its modernist afterlife are outlined – and ironized – in this account, but the opportunity of reading differently through the privileged genealogies of flatness-modernism is refused. My point is that there was a place for the redisposition of the (necessary) irony that veins O'Doherty's account, and its conversion into a counter-analysis. That place is the title.

I have considered O'Doherty's article at some length, not just because it offers a useful and influentially succinct account of the contextual parameters of visual modernism, but also because it several times threatens to give access to a critical narrative of modern art that runs parallel to (and is entwined in) conventional reckonings with the modernist trajectory. The present study attempts just such a critical narrative. In one place, for example, O'Doherty notes that "from Courbet on, conventions of hanging are an unrecovered history." Yet the editorial functions and interpretative value of a history of hanging are claimed as "unconsciously influenced by taste and fashion" and held to take their place as "subliminal cues" for "audience deportment."[40] In thinking Courbet as "the first modernist" who undertook for the first time, in his Pavilion of Realism erected outside the Exposition of 1855, "to construct the context of his work and therefore editorialize about its values," and in briefly pointing to the clustered, still-traditional, display context of the First Impressionist Exhibition of 1874, O'Doherty anticipates a much-needed history. But the key to this narrative can be found in a discourse of "editorialization" that was clearly less subliminal, and considerably more complex, than the conventions of hanging.

O'Doherty, of course, was not the first observer to write of the critical and institutional limitations of the modernist gallery space, and of its important refusals of textuality and grudging inclusion of names. In the introductory text of his *Assemblage, Environments, and Happenings*, Kaprow discusses the difficulties of accommodating the counter-compositional

work he describes in the "world unto itself" of the "flat wall and the cubic enframement of the room":[41]

> For as each new exhibition of this recent work has proven, it is becoming harder and harder to arrange a show without compromising present needs with older methods. The work never looks right; it fits uncomfortably within the glaring geometry of the gallery box, and some artists have already tried camouflage of various kinds in an attempt to obliterate this discrepancy.[42]

The uncomfortableness of the "ruled enframement" of the gallery gave rise to a dispute with painting that was simultaneously a dispute with the exhibition arena. New names were needed for the doubly new "environments" that ensued. And it is this sense that Kaprow describes the "large body of diverse compositions referred to as Combines (Robert Rauschenberg's name for his own work), Neo-Dada, or Assemblage."[43] Just as the gallery had been an expression of the images it subtended – "*the room has always been a frame or format too*" – so, the new art of assemblage had to be scored and renominated in its own textual and environmental field.

There are two other instructive approaches – and near-misses – to a history of titles in part one of O'Doherty's article. The first arrives in the context of his brief discussion of "the ultimate capitalist art" of Color-Field and other "late modernist painting." In describing the "strategies" of reconstitution of the picture-plane by artists such as Johns, Twombly, and Arakawa, O'Doherty posits that their energy is predicated on "simile (pretending), not metaphor (believing): saying the picture plane is 'like a ––––––.'"[44] The space represented here, of course, stands for the arrival of an analogue in the form of a caption – a gesture that precisely dispenses the rhetorical effects of the title. As we have seen, what he describes as a series of overly-literalist similitudes was in fact made up of a rich, occasionally provocative textual domain within which are inscribed not only similes, but also metaphors, descriptors, and named absences. This domain, the peculiar signifying field of the late modernist title, carries with it much that can tease out and challenge the overbearing theorizations of Greenbergian and post-Greenbergian formalism. The white cube encloses further defamation of the avant-garde project. Its placelessness and para-contextuality subsume and domesticate the territorial disputes of the avant-garde, rendering them static and etherialized on the wall.

"Inside the White Cube" makes a final drive-by of the title that draws even closer to the spaces of its operationality, yet still fails to speak to the titular inscription. Several of the illustrations selected to accompany the

first part of the article feature installations by the very artists (including Noland, Helen Frankenthaeler, and Stella) whose titular ebullience is strikingly at odds with the closed circuit of formalist enclosure. Pre-eminent among these, and privileged in the text with the only extended commentary, are Stella's works (the article discusses the striped U-, T- and L-shaped canvases exhibited at the Leo Castelli Gallery in 1960, while the illustration reproduces an installation photograph of Stella's Castelli show in 1964). In outlining the "unprecedented" "dialogue" conceived as in process in Stella's shaped-canvas works, the critic finds no place for the title. The exchange is entirely a function of formal values and the aestheticization of the wall: "flatness, edge, format and wall had an unprecedented dialogue in that small uptown Castelli space."[45] There are only (metaphorical) dialogues of form and vision. The real dialogue between the title and the work is simply overlooked.

O'Doherty has collapsed the critique of modernist space, the ideology of its contextless extension and the ever more faintly registered absurdities of its self-reflexivity into a counter-textualist shadow play. In his conclud-ing paragraph, even "wit and cogency" are held over as a function of "surface, mural and wall." "Written clarifications" (perhaps criticism, or artists' statements, but also titles and names) are simply vanquished in this process by the guarantees of formal intelligence. The gallery becomes a "readymade" installation; the wall, a screen memory of the unconscious of modernism; and modernist theory emerges as the victor in a mock battle over its own ironization.

How can we come to a conclusion concerning the institution and the name? Could there be a conjunction between the zero-economy, with which I introduced this study, and the museum, the exhibition, and the title, with which I am ending it? Such a conjunction would have to move beyond the ineffable transcendence courted by Abstract Expressionism, beyond the inexorable nihilism of Reinhardt that parodied it, and beyond the gestalt reductionism of the Minimalists. As perhaps only Malevich did before, it would have to use the zero as a material and as a strategy.

There is one location among the heady reformations of visual practice in the late 1960s and early 1970s that attempts such a negotiation. In his dialogue with Kaprow concerning the question "What is a Museum?," Robert Smithson speaks of "the nullity implied in the museum" and of his "interest" "for the most part in what's not happening, that area between events which could be called the gap. This gap exists in the blank and void regions or settings that we never look at. A museum devoted to different kinds of emptiness could be developed. The empti-ness could be defined by the actual installation of art. Installations should

empty rooms, not fill them."[46] Here, Kaprow's commitment to alternative sites for the cultivation of semi-matrixed action, and the re-negotiation of "composition" it entails, is shouted down by the decompositional emptying-out of form, material, ideas, and, finally, the museum, or space, itself. The negative effects of institutional decomposing are pressed further, though more literally, in Dennis Oppenheim's *Gallery Decomposition* (1968), a kind of anti-installation of wood, cement, and plaster, whose "construction materials consist of a substance (i.e., plaster) and a catalyst (i.e., water) that are combined to form an architecture. Here the gallery is de-architecturized in the sense that the materials used in the construction are shown without the catalyst (i.e., water)."[47] But the real guiding principles for such evacuations are found in Smithson's catalogue of "minuses," the "Minus Twelve" that embraces Uselessness, Entropy, Absence, Inaccessibility, Emptiness, Inertia, Futility, Blindness, Stillness, Equivalence, Dislocation, and Forgetfulness (each of which preside over four further considerations).[48]

Beginning with emptiness, though going much further as we will shortly see, Smithson's void-museum turns the traditional space of exhibition inside out. The pressure of the museum-machine which represents culture by transforming its "materials into art objects"[49] is redirected onto the institution itself. The maintenance of generic order between "objects" labeled for display, the space between those objects (real and imaginary), and the space that encloses them is refused as the insides and the outsides of the museological chamber are exchanged or otherwise disrupted.

This is clear warning that the thought that might join the spaces of the zero-museum and the name would have to be an apocalyptic vision – one in which the European (compositional) tradition implodes into silence, where pictures are surrogate windows opening onto nothing more than blanks. In this scene the viewer would be blind and senseless. Perception itself would be lost to a crisis precipitated by the excuses of abstraction. The museum would be a crypt in which the lost residues of painting, sculpture, and architecture are interred. The silence of the gallery would triumph over its whiteness, which would be lost under an unending aura of bright colors. Solids and space itself would be undifferentiated, subject to inexorable flatness and fade-out. The museum melts down, becoming a ubiquitous surface that substitutes for all the old surfaces it once contained. Finally, it is transformed into "an untitled collection of generalizations that immobilize the eye." How could all this be imagined? Robert Smithson provides the only way out:

> Visiting a museum is a matter of going from void to void. Hallways
> lead the viewer to things once called "pictures" and "statues." Anach-

ronisms hang and protrude from every angle. Themes without meaning press on the eye. Multifarious nothings permute into false windows (frames) that open up onto a verity of blanks. Stale images cancel one's perception and deviate one's motivation. Blind and senseless, one continues wandering around the remains of Europe. . . . Many try to hide this perceptual falling out by calling it abstract. Abstraction is everybody's zero but nobody's nought. Museums are tombs, and it looks like everything is turning into a museum. Painting, sculpture and architecture are finished, but the art habit continues. Art settles into a stupendous inertia. Silence supplies the dominant chord. Bright colors conceal the abyss that holds the museum together. Every solid is a bit of clogged air or space. Things flatten and fade. The museum spreads its surfaces everywhere, and becomes an untitled collection of generalizations that immobilize the eye.[50]

The title is fading out as a blank label in an imploding museum. But behind it lies a field of secretive bright colors, that, brought together, as in the spectrum of light, make up its total whiteness. The titles we have encountered here have been as multiple as the infinite colored parts of this rainbow and the rhetoric of their names. Smithson may have momentarily fused them together in the imaginary context of a monstrous, all-devouring, white cube, but I must conclude by revealing their profuse invisibility one last time. We should remember the thousand faces of the modern title: a description, a label, an i.d., a name, a sound or a music, an invocation, a person, a moralism, an anecdote, a number, a metaphor, a poem, a letter, a topography, a composition, a zero, a repetition, a philosophical question, a conundrum, an impression, an equation, a maxim, a quotation, a paradox, a pun, a textual *cadavre exquis*, a gift-of-words, an admonition, an expletive, a tautology, an inscription, a negation (of painting, but also of the title itself, "untitled"), a supplement, a varnish . . . an invisible color.

Notes

(

Introduction

1 Walter Benjamin, *Moscow Diary*, ed. Gary Smith and trans. Richard Sieburth (Cambridge: Harvard University Press, 1986), p. 23.

2 Following Jean-François Lyotard, *Discours, figure* (Paris: Klincksieck, 1974), Norman Bryson develops an analysis of the interrelation between the visual sign and its textual referents in *Vision and Painting: The Logic of the Gaze* (London: Macmillan, 1983), esp. pp. 37–66.

3 Julia Kristeva, for example, examines the "supplementary" role of color in her essay "Giotto's Joy," in *Desire in Language: A Semiotic Approach to Literature and Art*, ed. Leon S. Roudiez and trans. Thomas Gora, Alice Jardine, and Roudiez (New York: Columbia University Press, 1980), pp. 210–236.

4 Sir Joshua Reynolds, "Discourse IV," in *Nineteenth-Century Theories of Art*, ed. Joshua C. Taylor (Berkeley: University of California Press, 1987), p. 15.

5 Charles Baudelaire, "Salon de 1846," in *Oeuvres Complètes*, ed. Claude Pichois, vol. 2 (Paris: Gallimard, 1976), p. 476.

6 *Baudelaire: Selected Writings on Art and Artists*, trans. P. E. Charvet (Harmondsworth: Penguin, 1972), p. 93.

7 Charles Baudelaire, "The Salon of 1846," in *Art and Paris 1845–1862: Salons and Other Exhibitions Reviewed by Charles Baudelaire*, trans. and ed. Jonathan Mayne (Oxford: Phaidon, 1965), p. 96.

8 Ibid., p. 92.

9 Ibid., p. 96.

10 Ibid., p. 97.

11 Ibid., pp. 99–100.

12 Ibid., p. 100.

13 From his first art criticism to his last, the overindulgence in the *livret* and the title symbolized a refusal of painting that echoed as a disagreeable refrain in Baudelaire's writing. Thus, discussing the genre painters at the Salon of 1845, he records against the name "Guillemin": "Though his execution certainly has merit, M. Guillemin wastes too much talent supporting a bad cause – the cause of *wit in painting*. By this I mean providing the catalogue-printer with captions aimed at the Sunday public," ibid., p. 21. Fourteen years later, assessing the sculpture in the Salon of 1859, he speculates on the meaning of Frémiet's *Cheval de saltimbanque* with his *livret* shut: "But I find the owl perched upon his back just a little disturbing for I suppose I have not read the catalogue." The humorous symbolic overinvestment to which this exercise gives rise leads the writer to imagine a new title for the work: "Obviously this work should have been entitled *A tumbler's horse in the absence of the tumbler, who has gone off to have a game of cards and a drink in a neighbouring*

tavern! That is the real title!" (p. 210). Just one paragraph later, he is speculating on the precise signification of the abstract antithesis in the title *Jamais et toujours*: "Can it be a last resort, or a motiveless whim, like *Rouge et Noir*?" (p. 211).

14 Ibid., pp. 100–101.

15 Charles Baudelaire, "The Salon of 1846," in *A Documentary History of Art*, ed. Elizabeth Gilmore Holt, vol. 3: *From the Classicists to the Impressionists: Art and Architecture in the Nineteenth Century* (New Haven: Yale University Press, 1986), pp. 186–188. At the asterisk is a footnote by the translator: "They [the legends] were mostly invented by Philipon."

16 Walter Benjamin, "The Work of Art in the Age of Mechanical Reproduction" (1936), in *Illuminations*, ed. Hannah Arendt and trans. Harry Zohn (New York: Schocken Books, 1969), p. 226. In his book *Illustration* (Cambridge: Harvard University Press, 1992), p. 62, J. Hillis Miller points to Benjamin's essay, but also to a passage from chapter 44 of Mark Twain's *Life on the Mississippi*, which, considered together, are claimed as the focus of his "investigation." Claiming as it does a key strategic importance for the caption, especially in relation to "historical" painting, the Twain is worth citing in full:

> In this building [the Washington Artillery Building in New Orleans] we saw many interesting relics of the war. Also a fine oil painting representing Stonewall Jackson's last interview with General Lee. Both men are on horseback. Jackson has just ridden up and is accosting Lee. The picture is very valuable, on account of the portraits, which are authentic. But, like many another historical picture, it means nothing without its label. And one label will fit it as well as another.
>
> First Interview Between Lee and Jackson.
> Last Interview Between Lee and Jackson.
> Jackson Introducing Himself to Lee.
> Jackson Accepting Lee's Invitation to Dinner.
> Jackson Declining Lee's Invitation to Dinner – With Thanks.
> Jackson Apologizing for a Heavy Defeat.
> Jackson Reporting a Great Victory.
> Jackson Asking Lee for a Match.
>
> It tells one story, and a sufficient one; for it says quite plainly and satisfactorily, "Here are Lee and Jackson together." The artist would have made it tell that this was Lee and Jackson's last interview, if he could have done it. But he couldn't, for there wasn't any way to do it. A good legible label is usually worth, for information, a ton of significant attitude and expression in a historical picture. In Rome, people with fine sympathetic natures stand up and weep in front of the celebrated "Beatrice Cenci the Day Before her Execution." It shows what a label can do. If they did not know the picture, they would inspect it unmoved, and say, "Young Girl with Hay Fever"; "Young Girl with her Head in a Bag."

17 Roland Barthes, "The Photographic Message," in *Image–Music–Text*, ed. and trans. Stephen Heath (New York: Hill and Wang, 1977), p. 16.

18 Steve Baker, "The Hell of Connotation," *Word & Image* 1, no. 2 (April–June 1985), pp. 164–175. The title of the article derives from Jean Baudrillard's discussion of Bauhaus design in *For a Critique of the Political Economy of the Sign*, trans. Charles Levin (St. Louis: Telos Press, 1981), p. 196.

19 Ibid., p. 165.

20 Roland Barthes, "Rhetoric of the Image," trans. Brian Trench, *Working Papers in Cultural Studies* (Spring 1981), pp. 37–50.

21 Roland Barthes, "Myth Today," in *Mythologies*, trans. Annette Lavers (New York: Hill and Wang, 1973), pp. 109–159.

22 Roland Barthes, *S/Z*, trans. Richard Miller (New York: Hill and Wang, 1974), p. 8.

23 Bryson, pp. 60–61, cited by Baker, p. 164.

24 Baudrillard, p. 196.

25 I develop a brief history of the visual troping of silence in the Western modernist tradition in relation to a very different negotiation of secrecy and restraint operative in the visual-social representational system of Australian Aboriginal culture, particularly Western Desert acrylics, in my "Three Notes on Western Cultural Politics and Aboriginal Representation," in *Modernism Relocated: Towards a Cultural Studies of Visual Modernity* (Sydney: Allen and Unwin, 1995), pp. 249–260.

26 Susan Sontag, "The Aesthetics of Silence" (1967), in *A Susan Sontag Reader* (New York: Farrar, Straus, and Giroux, 1982), p. 187.

27 Ibid., pp. 188–189.

28 Ibid., pp. 197, 198.

29 A partial exception is offered in Richard Brilliant, *Portraiture* (Cambridge: Harvard University Press, 1991), in which the author questions the denotative designation and other nominal structures associated with portrait representations. See esp. pp. 45–49.

30 Saul Kripke, "Naming and Necessity," in *Semantics of Natural Language*, eds. Donald Davidson and Gilbert Harman (Dordrecht: D. Reidel, 1972), pp. 253–355. Other discussions of the name include Ludwig Wittgenstein, *Tractatus Logico-Philosophicus* (1921), trans. D. F. Pears and B. F. McGuiness (London: PUB TK, 1961), sec. 3; and Bernard Harrison, "Description and Identification," *Mind* 91, no. 362 (July 1982), pp. 321–338.

31 "I will hold that names are always rigid designators," Kripke p. 277.

32 See Jean-François Lyotard, "The Referent, The Name," in *The Differend: Phrases in Dispute*, trans. Georges Van Den Abbeele (Minneapolis: University of Minnesota Press, 1988), pp. 32–58.

33 See Paul Ziff, "About Proper Names," *Mind* 86, no. 343 (July 1977), pp. 319–332.

34 John Fisher, "Entitling," *Critical Inquiry* 11, no. 2 (December 1984), pp. 286–298.

35 Ibid., p. 287.

36 Ibid., pp. 291–292.

37 Ibid., p. 291.

38 See William Rubin, "The Genesis of *Les Demoiselles d'Avignon*," in Rubin, Hélène Seckel, and Judith Collins, *Les Demoiselles d'Avignon* (New York: Museum of Modern Art, 1994), 13–144, and my discussion of the painting in chap. 6.

39 E. H. Gombrich, "Image and Word in Twentieth-Century Art," *Word & Image* 1, no. 3 (July–September 1985), pp. 213–241; Stephen Bann, "The Mythical Conception Is the Name: Titles and Names in Modern and Post-Modern Painting," *Word & Image* 1, no. 2 (April–June 1985), pp. 176–190.

 Both articles originated as lectures. Gombrich's was delivered at the Solomon R. Guggenheim Museum in New York in October 1980 as the first annual Hilla Rebay Lecture, and a first draft of Bann's was presented at the conference "British Literature and the Visual Arts," organized by the Department of English, Leiden University, in September 1983.

 In "Picasso: Image Writing in Process," *October*, no. 65 (Summer 1993), pp. 89–105, Louis Marin describes *Word & Image* as a journal "whose very title institutionalizes this problematic [of visuality and textuality] as a veritable discipline in the history and theory of art" (p. 92). During research for this book, I have come across several other articles and extended historical references to the problem of the title. None advances (or permits the possibility of advancing) the historical or theoretical discussion of the subject as significantly as the discussions analyzed in the present

chapter. For example, in "Confronting the Signs: Words, Images, and the Reader-Spectator," *Dada/Surrealism*, no. 13 (1984), pp. 83–95, Laurie Edson discusses five works: Marcel Duchamp's *Nude Descending a Staircase* (1912) and *Fresh Widow* (1920); Joan Miró's *Un Oiseau poursuit une abeille et la baisse* (1926) and *Le Bel Oiseau déchiffrant l'inconnu au couple d'amoureux* (*The Beautiful Bird Revealing the Unknown to a Pair of Lovers*, 1941); and René Magritte's *La Trahison des images* (*The Treason of Images*, 1928–29). Edson raises some of the relevant questions and sites in relation to Dada and Surrealist nomination – including the Duchampian titular pun and "provocative inscriptions"; numbering; Miró's "poetic titles" and "picture-poems"; and the "blatant contradictions" of Magritte. But she does not advance significantly beyond her somewhat reductive premise (derived from an even more reductive assertion by Michel Butor about the "dangerous misnaming" of some works of art) that the spectator necessarily responds to, "makes sense" of, and otherwise "interprets" an image.

40 Gombrich, "Image and Word," p. 213.
41 Ibid., p. 216.
42 Ibid., p. 220.
43 Ibid., p. 221.
44 Ibid., p. 222.
45 E. H. Gombrich, *Art and Illusion: A Study in the Psychology of Pictorial Representation* (London: Phaidon, 1960). See Bryson for an extended critique of Gombrich's perceptualism.
46 Gombrich, "Image and Word," p. 222.
47 Ibid., p. 223.
48 Had Gombrich made reference to Turnbull's own ideas about the making, titling, and reception of his *Head* pieces, his reference to psychological experiment might have been more convincing. Writing of his work in the mid-1950s, including the free-standing *Heads* made between 1953–57, in *Uppercase* no. 4 (1960) (cited in Richard Morphet, *William Turnbull: Sculpture and Painting*, exh. cat. [London: Tate Gallery, 1973], p. 33), Turnbull states:

> From about 50–56 I titled a number of paintings and sculptures "HEAD." The word meant for me what I imagined the word "Landscape" had meant for some painters – a format that could carry different loadings.
> Almost anything could be a head – and a head almost anything – given the slightest clue to the decoding . . .
> The sort of thing that interested me was –
> how little will suggest a head
> how much load will the shape take and still read head
> head as a colony
> head as a landscape
> head as mask
> head as ideogram
> head as sign, etc. . . .

In the same years that he was titling both sculptures and painting with the generalized term "head," Turnbull also added qualifiers such as *Drumhead* (1955), *Head Object 1*, and *Head (Calligraphic)* (1956). From around 1958–59, with the de-velopment of what Morphet terms his "all-over painterly abstraction" (p. 44), Turnbull began titling his paintings by number and year, as in *7-1959* or *3-1960*. Some sculptures bear similar designations (e.g., *No. 1*, 1963), but they more often carry lightly metaphoric or descriptive names, following the international

abstractionist model, such as *Ripple* (1966), *Double Red* (1966), *Coltrane* (1966), or *Butt* (1966).

49 Bryson, p. 32. Bryson details what he terms "the most negative consequence of [Gombrich's] perceptualism" – "its bracketing-out of the constitutive role of the social formation in producing the codes of recognition which the image activates" – in a discussion of Gombrich's analysis of Constable's *Wivenhoe Park* in *Art and Illusion* (p. 43).

50 Gombrich, "Image and Word," p. 232.

51 Ibid., p. 226.

52 As with Turnbull's *Head*, there is more at stake in the title of Marc's painting than Gombrich allows. For, as with many artists active in the 1910s, it is not just color and its effects that elicit commentary, but also the circumstances and implications of its naming. In a letter of 22 May 1913 to Auguste Macke, Marc writes: "I have, at the present time, painted nothing but utterly divergent pictures. You are about to learn the titles. They reveal nothing but perhaps they will amuse you." Cited in Fredrick S. Levine, *The Apocalyptic Vision: The Art of Franz Marc as German Expressionism* (New York: Harper and Row, 1979), p. 76. Despite his disavowal of their importance, Marc's ensuing list of titles was quite particular. It included *The Tower of Blue Horses*, *The First Animals*, *The Poor Land Tirol*, *The Trees Show Their Rings, The Animals Their Veins* (retitled *Fate of the Animals*), *The World Cow*, and *Wolves* (subtitled *Balkan War*). Levine notes that the titles indicate "visions of doom," "imminent catastrophe," and "visions of genius or rebirth." Further, *The Trees Show Their Rings, The Animals Their Veins*, renamed *Fate of the Animals* for an exhibition in Berlin in autumn 1913, bears the inscription, "And all being is Flaming Suffering" on the back, "designed apparently as the work's subtitle" (p. 77).

53 Gombrich, "Image and Word," p. 232.

54 Ibid., pp. 234, 236.

55 In ibid., p. 237, Gombrich cites Virginia Spate, *Orphism: The Evolution of Non-Figurative Painting in Paris 1910–1914* (Oxford: Clarendon Press, 1979), p. 26.

56 Gombrich, "Image and Word," p. 239.

57 Bann, p. 176.

58 Ibid., pp. 176–177.

59 Ibid., p. 177.

60 "That which it [the *parergon*] puts in place – the instances of the frame, the title, the signature, the legend, etc. – does not stop disturbing the *internal* order of discourse on painting, its works, its commerce, its evaluations, its surplus-values, its speculation, its law, and its hierarchies." Jacques Derrida, *The Truth in Painting*, trans. Geoff Bennington and Ian McLeod (Chicago: University of Chicago Press, 1987), p. 9.

61 The term "arborescent" is used by Gilles Deleuze and Félix Guattari, *A Thousand Plateaus: Capitalism and Schizophrenia*, trans. Brian Massumi (Minneapolis: University of Minnesota Press, 1988), pp. 505–506, where it is defined in opposition to the "rhizome."

62 Bann, p. 183.

63 Hubert Damisch, "Equals Infinity," *20th. Century Studies* 15/16 (December 1976), pp. 56–81.

64 Bann, pp. 186, 189.

Chapter 1

1 Jacques Derrida, *The Truth in Painting*, trans. Geoff Bennington and Ian McLeod (Chicago: University of Chicago Press, 1987), p. 24.

2 Roland Barthes, "Proust and Names" (1967), in *New Critical Essays*, trans. Richard Howard (New York: Hill and Wang, 1980), p. 67.

3 Ibid., p. 59.

4 Ibid., p. 60.

5 Ibid., p. 61.

6 Ibid., pp. 66–67.

7 Peter Szondi, "Walter Benjamin's City Portraits" (1962), trans. Harvey Mendelsohn, in *On Walter Benjamin: Critical Essays and Recollections*, ed. Gary Smith (Cambridge: MIT Press, 1988), pp. 27, 26.

8 Walter Benjamin, *Moscow Diary*, ed. Gary Smith and trans. Richard Sieburth (Cambridge: Harvard University Press, 1986), p. 23.

9 Roland Barthes, "Twenty Key Words for Roland Barthes", in *The Grain of the Voice: Interviews 1962–1980*, trans. Linda Coverdale (New York: Hill and Wang, 1985), p. 214. "Names" and "personal pronouns" are among the key words brought forward in this interview. Barthes notes that "[p]sychoanalysis has paid a good deal of attention to [the "mysterious" signification of proper nouns], and we know that the proper noun is, if I may say so, an open road for the subject and desire" (p. 214).

10 Another form of title-text that appears with the image in a relation that at first glance may appear to be singular is the caption-text. In "The Photographic Message," in *Image–Music–Text*, ed. Stephen Heath (New York: Hill and Wang, 1977), pp. 26–27, Roland Barthes notes the renewed problematization of the visual-textual relation with the acceleration of reproductive technologies: "Formerly, the image illustrated the text (made it clearer); today, the text loads the image . . . the text produces (invents) an entirely new signified which is retroactively projected into the image."

11 Barthes, "Proust and Names," p. 68.

12 Paul Carter, *The Road to Botany Bay* (Chicago: University of Chicago Press, 1987), pp. xxiv–xxv. The first chapter of this study, "An Outline of Names," pp. 1–33, takes up this history.

13 Craig Owens, "Improper Names," in *Beyond Recognition: Representation, Power, and Culture*, eds. Scott Bryson, Barbara Kruger, Lynne Tillman, and Jane Weinstock (Berkeley: University of California Press, 1992), p. 285.

14 Ibid., p. 286.

15 Tzvetan Todorov, *The Conquest of America*, trans. Richard Howard (New York: Harper and Row, 1984).

16 Owens, "Improper Names," pp. 290–291. Owens gives two examples of how Baumgarten's captions admit "subjectivity" and "historicity" into the photographic image:

> Subjectivity: "Vashishimi and Hekuna, her blind grandmother, taste the strawberrylike fruit of the kataoto tree, whose sweetness they love so much"; historicity: "The visitors from Tayari stand in the high grass of the Orinoco bank at El Plantanal waiting to be taken across with a canoe. They have come to make peace with their arch-enemies of Mahekodo. Their mutual assaults have gone on for seven years" (p. 291).

17 Barthes, "The Photographic Message," p. 16: "[T]he structure of the photograph is not an isolated structure; it is in communication with at least one other structure, namely the text – title, caption or article – accompanying every press photograph."

18 Owens, "Improper Names," p. 293.

19 Ibid., p. 295.

20 Ludwig Wittgenstein, cited in Donald Kuspit, "Wittgensteinian Aspects of Minimal

Art" (1972), in *The Critic Is Artist: The Intentionality of Art* (Ann Arbor: UMI Research Press, 1984), p. 243.

21 Roland Barthes, *Writing Degree Zero*, trans. Annette Lavers and Colin Smith (New York: Hill and Wang, 1968), p. 48.

22 Robert Smithson, "Some Void Thoughts on Museums," in *The Writings of Robert Smithson*, ed. Nancy Holt (New York: New York University Press, 1979), p. 58.

23 Barthes, *Writing Degree Zero*, p. 48.

24 Brian Rotman, *Signifying Nothing: The Semiotics of Zero* (London: Macmillan, 1987).

25 Ibid., pp. x, 1, 28, 4.

26 Stephen Kern, *The Culture of Time and Space 1880–1918* (Cambridge: Harvard University Press, 1983), p. 177.

27 Ibid., pp. 177, 179.

28 Rotman, pp. 27, 14, 33, 57.

29 Ibid., p. ix.

30 In *Writing Degree Zero*, pp. 48–49, for example, Barthes writes of the reception of the "poetic word" according to "a kind of sacred relish" and of "poetic speech" as "terrible and inhuman": "It initiates a discourse full of gaps and full of lights, filled with absences and over-nourishing signs, without foresight or stability of intention, and thereby so opposed to the social function of language that merely to have recourse to a discontinuous speech is to open the door to all that stands above Nature."

31 This phrase, interestingly enough, is part of a parenthetical remark in Meyer Schapiro's essay "The Introduction of Modern Art in America: The Armory Show" (1952), in *Modern Art: 19th and 20th Centuries, Selected Papers* (New York: Braziller, 1979), p. 146. It convenes under the auspices of the "negative intensity" of the work of Monet, Whistler, and Redon – precisely the artists I claim as instrumental to the development of the titular activity. The full sentence reads: "(At the other end of the spectrum of modern expressiveness is a kind of negative intensity, not always less difficult than the positive kind and no less striking, a search for faint nuances, for an ultimate in delicacy and bareness, that still surprises us; it appeared in Whistler, Monet, and Redon, and more recently in works of Malevich and Klee, among others.)"

32 Kasimir Malevich, "From Cubism and Futurism to Suprematism: The New Painterly Realism" (1915), in *Russian Art of the Avant-Garde: Theory and Criticism 1902–1934*, ed. and trans. John E. Bowlt (New York: Thames and Hudson, 1976), p. 118.

33 Ibid., pp. 122–123.

34 Ibid., pp. 133, 129, 130, 133.

35 Ibid., p. 133.

36 Richard Huelsenbeck, "Dada Lives!" (1936), in *The Dada Painters and Poets: An Anthology*, ed. Robert Motherwell (Cambridge: Belknap Press, 1981), p. 280.

37 Marcel Duchamp, interview with James Johnson Sweeney, in "Eleven Europeans in America," *Museum of Modern Art Bulletin* 13, no. 4–5 (1946), p. 20.

38 Tristan Tzara, "Lecture on Dada" (1922), in Motherwell, p. 246.

39 Barnett Newman, "The Sublime Is Now" (1948), in *Selected Writings and Interviews*, ed. John P. O'Neill (Berkeley: University of California Press, 1992), p. 173.

40 Barnett Newman, "The Plasmic Image" (1945), in ibid., p. 140.

41 Robert Smithson, "Entropy and the New Monuments," in *Writings*, p. 12.

42 Piero Manzoni, "Libera Dimensione" (*Azimuth*, 1960), cited in Ronald Alley, *Catalogue of the Tate Gallery's Collection of Modern Art Other Than Works by British Artists* (London: Tate Gallery, 1981), p. 479.

43 Barbara Rose, "A B C Art," in *Minimal Art: A Critical Anthology*, ed. Gregory Battcock (New York: E. P. Dutton, 1968), pp. 290ff.

44 Maurice Berger, *Labyrinths: Robert Morris, Minimalism, and the 1960s* (New York: Harper and Row, 1989), p. 50. Berger defends the zero-formation of Morris's "more neutral and austere structures" in relation to "David Smith's elegantly burnished *Cubis* [which] appear complex and expressive by contrast" and to Donald Judd's "precious" "use of industrial materials and slickly colored surfaces" (p. 51).

45 The following discussion of Minimalist zero-compositionality draws on my essay, "In and Around the 'Second Frame,'" in *The Rhetoric of the Frame*, ed. Paul Duro (Cambridge University Press, 1996).

46 Agnes Martin, typescript, Willard Gallery, cited in and used to title Lawrence Alloway's essay, "*Formlessness breaking down form*: the paintings of Agnes Martin," *Studio International* 185, no. 952 (February 1973), p. 62.

47 Mel Bochner, "Primary Structures: A Declaration of a New Attitude as Revealed by an Important Current Exhibition," *Arts Magazine* 40, no. 8 (June 1966), p. 34.

48 Alloway, p. 61.

49 In the review section of *Arts Magazine* 37, no. 6 (March 1963), pp. 61–62, Sidney Tillim is one of a number of contemporary critics who pointed to the basis of a continuity between the Minimalists, the "reverse illusionism" of the "popped art" of Jim Dine (and others), and Happenings. Both the "'new' object art" and Dine's object-infiltrated version of Pop exploit the irruptive, frame-transgressive, presencing of material. Thus Judd's "thrusting textured mass into space is related to Dine's poltergeist art, but is completely, militantly, pure" (p. 62). By contrast George Segal's "plaster cast of a man and a woman embracing on a bed" (with real linens) is described as "a 'painting' in three virtual dimensions and has for its frame the gallery. Segal has accomplished what Dine cannot do because the picture plane stops him – putting effigies of humans *behind* the frame where illusions of them once were. This work can be spoken of as 'framed,' even as 'painterly,' because it occupies a bulk space rather than a sculpted one" (ibid.). And while Segal goes "one better" than Dine, his work can only be rescued from its "mummification" by a Pygmalion-like modulation into "life," as in "those performances known as 'Happenings,'" which engage "a sort of space-time Surrealism."

50 Museum catalogues and catalogues raisonnés are paying increasingly careful attention to the titular history of individual works and series. To cite just one example – admittedly from a source notorious for its contextual sleuthing – the entry for John Chamberlain's *Koko-Nor II* (1967) in Alley, p. 116, notes:

> It was known at first simply as "Untitled," but James Jay Jacobs II, Chamberlain's assistant, says that the title is "Koko-Nor II." Like the titles of some of the other urethane sculptures, this is a Chinese geographical point, Koko-Nor being the name of both a province and a lake in northern China. The name was chosen more or less at random, and although there happens to be a slight similarity between the form of the scultpure, when viewed from certain angles, and the shape of the lake, this was purely coincidental.

A later entry for Kandinsky's *Cossacks* (1910–11) outlines the complex titling history of the work, concluding that "the painting has been variously known as 'Cossacks,' 'Improvisation 17,' 'Battle,' 'Fragment for Composition 4,' and 'Composition 4 (Fragment).' The title 'Cossacks' has been adopted here because it is the one Kandinsky seems to have preferred at the time of its acquisition" (p. 381).

51 See William Rubin, "Pollock as Jungian Illustrator: The Limits of Psychological Criticism," *Art in America* 67, no. 7 (November 1979), pp. 104–123, and 67,

no. 8 (December 1979), pp. 72–91. The opening section of the second part is called "Titles."

52 *Diane Arbus: An Aperture Monograph* (Millerton, New York: Aperture, 1979).
53 Carol Armstrong, "Biology, Destiny, Photography: Difference According to Diane Arbus," *October*, no. 66 (Fall 1993), pp. 35–36.
54 Ibid., pp. 46–47.
55 For a theory of literary and social "minority" see Gilles Deleuze and Félix Guattari, "What is a Minor Literature?," trans. Dana Polan, in *Out There: Marginalization and Contemporary Cultures*, eds. Russell Ferguson, Martha Gever, Trinh T. Minh-ha, and Cornel West (New York: New Museum of Contemporary Art and Cambridge: MIT Press, 1990), pp. 59–69.
56 Craig Owens, "Detachment from the *Parergon*," *October*, no. 9 (Summer 1979), p. 49.
57 See Immanuel Kant, *The Critique of Judgement*, trans. J. C. Meredith (Oxford: Oxford University Press, 1952).
58 Owens, "Detachment," p. 43.
59 Michel Foucault, *The Order of Things: An Archaeology of the Human Sciences* (New York: Vintage Books, 1973), p. 117.
60 Svetlana Alpers, *The Art of Describing: Dutch Art in the Seventeenth Century* (Chicago: University of Chicago Press, 1983), p. xxi.
61 Louis Marin, "In Praise of Appearance," *October*, no. 37 (Summer 1986), p. 108.
62 Ibid., p. 111.
63 Ibid., p. 109.
64 *Important Old Master Paintings* (New York: Sotheby's, 19 May 1994), unpag., lot 85. A detail of *Plaster Medallion* appears on the cover of this catalogue. The estimate ($100,000–150,000) for the pair of paintings is both higher than might have been expected for the work of an unknown artist of this period, and also more widely spread than is customary – reflecting some uncertainty as to its worth. It is possible that this appraisal is related to the citation of a precedent for *trompe-l'oeil* paintings of the back of framed pictures from Norman Bryson, *Looking at the Overlooked: Four Essays in Still Life Painting* (Cambridge: Harvard University Press, 1990), p. 143, fig. 54, in which the author discusses *The Back of a Picture* by Cornelius Norbertus Gijsbrechts, now in the Statens Museum for Kunst, Copenhagen. The catalogue entry also makes reference to Laurence Sterne's proto-postmodern *Tristam Shandy*, in which one-and-a-half pages are left black in chapter 38 to permit the free "fancy" of readers to imagine as they will the visual form and content of the widow Waldman. These revisionist and literary supports for the paintings on sale may indicate a new interest, and a new value, for non-canonical, non-"mastered" images – a new commercial and aesthetic value, in effect, for what have traditionally been viewed as only *supplementary* effects of the image: the frame, the title, the label, the catalogue number, etc. Such market validation for supplemental effects is crucial evidence for the revisionist attempt of the present study. As Whistler was to remark more than a century after Hiernault painted his provocative still lifes, "without baptism, there is no . . . market!" We will encounter aspects of the destiny of this conjugation of value and the discourse of the name, including its conscious cultivation by Whistler, in each of the chapters that follow.
65 *Important Old Master Paintings*, unpag.

Chapter 2

1 Roger Shattuck, *The Banquet Years: The Origins of the Avant-Garde in France 1885 to World War I* (New York: Vintage, 1968), p. 25.

2 Marcel Duchamp, *Duchamp du signe: Ecrits*, ed. Michel Sanouillet (Paris: Flammarion, 1975), p. 109, note 41.

3 Philip Hofer, introduction to Francisco Goya, *Los Caprichos* (New York: Dover, 1969), p. 3.

4 John Fisher, "Entitling," *Critical Inquiry* 11, no. 2 (December 1984), p. 286.

5 Griselda Pollock, "Woman as Sign: Psychoanalytic Readings: Are Rossetti's Paintings Meaningless?," in *Vision and Difference: Femininity, Feminism, and the Histories of Art* (London: Routledge, 1988), p. 148.

6 See Maryan Wynn Ainsworth, *Dante Gabriel Rossetti and the Double Work of Art*, exh. cat. (New Haven: Yale University Art Gallery, 1976), p. 3. In this letter to Charlotte L. Polidori, Rossetti lists four possible titular inscriptions, including "(1) Christ sprang from David Shepherd, and even so" – the only work I have found that anticipates the dislocated final word of Duchamp's *Large Glass* (1915–23). He also asks, "Do you think this will help the spectator?" Ainsworth suggests that the first of Rossetti's actualized "sonnets for pictures" was part 2 of "Mary's Girlhood," inscribed on *The Girlhood of Mary Virgin* "and never published otherwise" (p. 6). Many of the "sonnets for pictures," especially common in the last ten years of the artist's career, were published in the short-lived Pre-Raphaelite journal *The Germ*.

7 William M. Rossetti, ed., *The Works of Dante Gabriel* (1886), cited in ibid., p. 7.

8 Cited in Graham Reynolds, *Victorian Painting* (London: Herbert Press, 1987), p. 27.

9 See Francis Greenacre, *Francis Danby 1793–1861*, exh. cat. (London: Tate Gallery, 1988), p. 123.

10 Ibid., p. 110.

11 Reynolds, p. 25.

12 *Art Journal* (1893), cited in Lindsay Errington, *Sir William Quiller Orchardson, 1832–1910*, exh. cat. (Edinburgh: National Gallery of Scotland, 1980), p. 4.

13 Cited in ibid.

14 Gustave Courbet, "Exhibition and Sale of Forty Pictures and Four Drawings of the Work of Gustave Courbet," in *A Documentary History of Art*, ed. Elizabeth Gilmore Holt, vol. 3: *From the Classicists to the Impressionists: Art and Architecture in the Nineteenth Century* (New Haven: Yale University Press, 1986), p. 348.

15 There are several studies on the importance of the naming of movements in the nineteenth century: e.g., Stephen F. Eisenman, "The Intransigent Artist *or* How the Impressionists Got Their Name," in *The New Painting: Impressionism 1874–1886*, exh. cat. (San Francisco: Fine Arts Museums of San Francisco, with Washington, D.C.: National Gallery of Art and Geneva: Richard Burton SA, 1986), pp. 51–59, and Geoffrey Batchen, "The Naming of Photography: 'A Mass of Metaphor,'" *History of Photography* 17, no. 1 (Spring 1993), pp. 22–32. There are, of course, different debates around the naming of the Fauvist and Cubist movements.

16 Cited in Linda Nochlin, *Realism* (London: Penguin, 1971), p. 23.

17 Claude Monet to Alice Monet, 6 February 1901, in Daniel Wildenstein, *Claude Monet: Biographie et catalogue raisonné*, vol. 4 (Paris/Lausanne: La Bibliothèque des Arts, 1974), p. 352.

18 Daniel Wildenstein, "Avant-propos," in Wildenstein, vol. 1, unpag.: "Le titre d'origine tel qu'il est fourni par les carnets de comptes du peintre ou par les livres de la maison Durand-Ruel, ou encore par une exposition très ancienne."

19 Wildenstein, vol. 1, p. 156.

20 Ibid., p. 444.

21 John House, *Monet: Nature into Art* (New Haven: Yale University Press, 1986), p. 18.

22 See Charles Baudelaire, "The Painter of Modern Life," in *The Painter of Modern Life and Other Essays* (New York: Da Capo Press, 1964), pp. 1–40.

23 House, p. 19.
24 Wildenstein, vol. 1, p. 69, note 493: "Le titre *Impression, soleil levant* du catalogue de l'exposition d'avril 1874 a certainement reçu l'approbation de Monet qui n'a jamais émis la moindre critique à ce sujet."
25 John Rewald, *The History of Impressionism* (New York: Museum of Modern Art, 1973), p. 318.
26 Steven Z. Levine, *Monet and His Critics* (New York: Garland, 1976), pp. 16–17.
27 House, pp. 158–162. For further discussion of the term *"impression"* see Richard Shiff, *Cézanne and the End of Impressionism* (Chicago: University of Chicago Press, 1984), pp. 14–20; and Eisenman, "Intransigent Artist," which summarizes the received account of the naming of the Impressionist movement after the April 1874 exhibition at the Paris studios of the photographer Nadar (*Première Exposition* of the *Société Anonyme des Artistes, Peintres, Sculpteurs, Graveurs, Etc.*), and notes that the debate over the naming of the Impressionists is signally related to "the ongoing debate over Modernism itself" (p. 51). He also asserts that "Impressionism in 1874 thus connoted a vaguely defined *technique* of painting and an *attitude* of individualism shared by an assortment of young and middle-aged artists unofficially led by Manet," and that it offered a "combination of painterly daring and political discretion" (p. 52), especially when it finally won out as the preferred designation of the movement in 1877 after competition with the far more politically loaded term *Intransigents* – used by Stéphane Mallarmé, among others. In citing Mallarmé on the function of the frame in excluding "all that is non-pictorial," Ambrose Vollard on the "elimination of literature," and Clement Greenberg on "medium purity" (p. 54), Eisenman sets up a case for the effective negotiation of Impressionist/Intransigent art from 1874–77 between the future excesses and withdrawals of art-world appropriation and political quiescence. The evidence that this incubation period of modernism was actually conscious of its resistance to either political annexation or to self-referential redundancy is supplied by Renoir's approval of the neutral title "Société Anonyme" in 1874 ("the refusal of a proper name," p. 55), and by reference to T. J. Clark's interpretation of the "flatness" of Manet's paintings as a calculated reflection of social flatness. The transition from "Intransigent" to "Impressionist" is put forward as a paradigm for the progressive (inevitable) compromises of visual modernism with the social and political status quo – compromises that must be counted as constitutive of the primary social history of the modern movement.
28 Jules-Antoine Castagnary, "Exposition du boulevard des Capucines: Les Impressionistes" (*Le Siècle*, 29 April 1874), cited in Levine, p. 17: "romantisme sans frein, où la nature n'est plus qu'un prétexte à rêveries et où l'imagination devient impuissante à formuler autre chose que des fantasies personelles, subjectives, sans écho dans la raison générale."
29 Sir Joshua Reynolds, "Discourse IV," in *Sir Joshua Reynolds: Discourses on Art*, ed. Robert R. Wark (San Marino, California: Huntington Library, 1959), p. 73.
30 Joris-Karl Huysmans, "L'Art moderne" (1883), cited in Levine, p. 49: "certainement l'homme qui a le plus contribué à persuader le public que le mot 'impressionisme' désignait exclusivement une peinture demeurée à l'état de confus rudiment, de vague ébauche."
31 See Rewald, pp. 318–324, which includes a full translation of the review. This has properly become the standard English-language reference, and is the version used for the citations made here. The review was first published as "L'Exposition des Impressionistes," *Le Charivari* (25 April 1874).
32 See Norman Bryson, *Word and Image: French Painting of the Ancien Régime* (Cambridge: Cambridge University Press, 1981), p. 32.

33 The term "territorialization" is adopted from Gilles Deleuze and Félix Guattari's discussion of the processes of "deterritorialization" and "reterritorialization" in "Conclusion: Concrete Rules and Abstract Machines," in *A Thousand Plateaus: Capitalism and Schizophrenia*, trans. Brian Massumi (Minneapolis: University of Minnesota Press, 1987), pp. 501–514. See esp. pp. 508–510: "The function of deterritorialization: D is the movement by which 'one' leaves the territory. It is the operation of the line of flight. . . . [T]he territory itself is inseparable from vectors of deterritorialization working it from within. . . . D is never simple, but always multiple and composite."

34 See "BORDERING-ON I," in my *Modernism Relocated: Towards a Cultural Studies of Visual Modernity* (Sydney: Allen and Unwin, 1995), pp. 38–59. The following discussion of the Leroy review draws on this material.

35 For a discussion of interdiscursivity in relation to Dada and Surrealist practice, see my "After the Wagnerian Bouillabaisse: Critical Theory and the Dada and Surrealist Word-Image," in Judi Freeman, *The Dada and Surrealist Word-Image*, exh. cat. (Los Angeles: Los Angeles County Museum of Art and Cambridge: MIT Press, 1989), pp. 57–96; revised version reprinted in *Modernism Relocated*, pp. 60–102.

36 Louis Leroy, cited in Rewald, p. 323.

37 See especially Joseph Kosuth's three-part article, "Art after Philosophy" (*Studio International*, October-December 1969), in *Art after Philosophy and After: Collected Writings, 1966–1990*, ed. Gabriele Guercio (Cambridge: MIT Press, 1991), pp. 13–32.

38 See the listing of Daumier's *Intemperies* in Louis Provost, *Honoré Daumier: A Thematic Guide to the Oeuvre*, ed. Elizabeth Childs (New York: Garland, 1989), p. 111.

39 Exceptions to this in Monet's oeuvre are discussed above.

40 See House, pp. 193ff. The author cites P. H. Valenciennes, *Eléments de perspective pratique* (1800): "It is good to paint the same view at different hours of the day, to study the differences which light makes on forms." He also supplies brief references to Turner, Jongkind (in the 1860s), Japanese prints, and Courbet's 1867 exhibition at which thirteen "Paysages de mer" painted in Normandy were shown together.

41 Levine, p. 136.

42 Wildenstein, vol. 3, pp. 136–144.

43 Octave Mirbeau, "Claude Monet: Vues de la Tamise à Londres" (1904), cited in Levine, p. 271: "le drame multiple, infiniment changeant et nuancé."

44 Levine, p. 271.

45 Robert Goldwater, *Symbolism* (New York: Harper and Row, 1979), pp. 1–2.

46 Ibid.

47 This exchange is quoted by Ann Bermingham, in *Landscape and Ideology: The English Rustic Tradition, 1740–1860* (Berkeley: University of California Press, 1986), p. 148.

48 Ibid.

49 Ibid., p. 154.

50 Claude Monet to Alice Monet, 5 March 1891, in Wildenstein, vol. 4, p. 355: "Il est 6 heures, et depuis 1 heure il a fait un soleil superbe."

51 Ibid., 6 February 1901, in ibid., p. 352: "Il y avait bien un peu trop de brouillard le matin, mais le joli ballon rouge n'a pas été long à se montrer et avec lui une succession d'effets étonnants."

52 Ibid., 14 February 1901, in ibid., p. 353: "Hélas! Le brouillard persiste, de brun foncé il devient vert olive, mais toujours aussi sombre et impénétrable. . . . A partir de 10 heures, le soleil s'est montré un peu voilé par moments, mais des effets de brillants sur l'eau admirables."

53 Ibid., 16 February 1901, in ibid.: "[c]'est le temps seul qui en décidera, faisant tous mes efforts."

54 Ibid., 18 February 1901, in ibid.
55 Ibid., 28 February 1901, in ibid., p. 354: "[I]l y avait du soleil, mais que de changements, que de transformations."
56 The identification of three major sign-types – icon, symbol and index – was first achieved by the semiologist Charles S. Peirce, e.g., in "Logic as Semiotic: The Theory of Signs," *The Philosophy of Peirce: Selected Writings* (London: Routledge & Kegan Paul, 1950), pp. 98–119. The term has been used by recent critics, including Rosalind Krauss, in relation to contemporary visual practice. For a discussion of Krauss's use of indexicality, see "Modernisme à Larousse," in my *Modernism Relocated*, pp. 26–28.
57 Marcel Duchamp, *A L'infinitif: Manuscript Notes of Marcel Duchamp 1912–1920*, trans. and ed. Cleve Gray in collaboration with Duchamp (New York: Cordier and Ekstrom, 1966), unpag.: "Ne pas oublier le tableau de Doumouche: Pharmacie = effet de neige, ciel foncé, nuit tombante, et 2 lumières à l'horizon ([r]rose et verte)" (Duchamp, *Duchamp du signe*, p. 109). It does not seem to have been noticed, and is not made clear either in the French transcription or in the English translation and notes to this edition, that the first word of the parenthetical "(rose et verte)" ("(pink and green)") is actually written as "rrose," thus alluding to Duchamp's *alter persona*, "Rrose Selavy."
58 Ibid.
59 Arturo Schwarz cites the caption and translation (and adds an explanation of the pun) in *The Complete Works of Marcel Duchamp* (New York: Abrams, n.d.), p. 399: "Flirt–/Elle–Voulez vous que je vous joue 'Sur les Flots Bleus'; Vous verrez comme ce piano rend bien l'impression qui se dégage du titre?/Lui (spirituel) – Ça n'a rien d'étonnant Mademoiselle, c'est un piano . . . aqueux."

Chapter 3

1 MaryAnne Stevens, "Innovation and Consolidation in French Painting," in *Post-Impressionism: Cross-Currents in European Painting*, eds. John House and MaryAnne Stevens, exh. cat. (London: Royal Academy of Arts and New York: Harper and Row, 1979), p. 19.
2 Théodore Duret, *Whistler*, trans. Frank Rutter (Philadelphia: J. B. Lippincott, 1917), p. 100. "Une transformation radicale s'était en même temps accomplie dans le régime des Salons et des récompenses à y décerner. L'État se dessaisissait, en 1881, de ses droits traditionnels sur les Salons, pour les remettre aux artistes eux-mêmes, constituant une société légalement reconnue," Duret, *Histoire de James Mc. N. Whistler et son oeuvre* (Paris: H. Floury, 1901), p. 110.
3 Stevens, p. 23.
4 Maurice Denis, "A Definition of Neo-Traditionism," in *Impressionism and Post-Impressionism 1874–1904: Sources and Documents*, ed. Linda Nochlin (Englewood Cliffs, New Jersey: Prentice-Hall, 1966), p. 189. "Ce temps est littéraire jusqu'aux moelles . . . Dans toutes les décadences, les arts plastiques s'effeuillent en affectations littéraires, et en négations naturalistes," Denis, "Définition du Néo-Traditionnisme," in *Théories: Du Symbolisme et de Gauguin vers un nouvel ordre classique* (Paris: L. Rouart and J. Watlin, 1920), pp. 8–10. Section XVIII of this essay was originally published under the pseudonym Pierre Louis in *Art et critique* (August 1890).
5 Stephen F. Eisenman, *The Temptation of Saint Redon: Biography, Ideology, and Style in the Noirs of Odilon Redon* (Chicago: University of Chicago Press, 1992), p. 58.
6 Ibid., p. 146.

7 Ibid., pp. 76, 177.

8 Ibid., p. 76.

9 Ibid., pp. 115, 145.

10 Clement Greenberg, "What the Artist Writes About: Review of *Artists on Art: From the XIV to the XX Century*, edited by Robert Goldwater and Marco Treves" (*The Nation*, 20 April 1946), in *The Collected Essays and Criticism*, ed. John O'Brian, vol. 2: *Arrogant Purpose, 1945–1949* (Chicago: University of Chicago Press, 1986), p. 76.

11 Eisenman brings several of these activities together in his study (p. 66), noting that Redon was undecided as late as 1869 whether to pursue a career as a writer or an artist, and that the role of the "poet-artist" had a "social function" (p. 67).

12 Odilon Redon, *To Myself: Notes on Life, Art, and Artists*, trans. Mira Jacob and Jeanne L. Wasserman (New York: George Braziller, 1986), pp. 31–32. "Ecrire et publier est le travail le plus noble, le plus délicat que puisse faire un homme. . . . Ecrire est le plus grand art. Il traverse le temps et l'espace, supériorité manifeste qu'il a sur les autres comme sur la musique" (August 1869), Redon, *A Soi-même: Journal (1867–1915): Notes sur la vie, l'art, et les artistes* (Paris: Librairie José Corti, 1979), pp. 38–39.

13 Redon, *To Myself*, p. 87. "[L]es savoureux écrits de nos prosateurs, le tour de leurs pensées, le rythme de leur style, le souffle de leur effusion, le jet concis ou abandonné de leur esprit, leurs nuances?" (June 1903), Redon, *A Soi-même*, p. 104.

14 Redon, *To Myself*, pp. 67–68. For the original French, see Redon, *A Soi-même*, pp. 81–82:

> Où est la limite de l'idée littéraire en peinture?
>
> Où s'entend? Il y a une idée littéraire toutes les fois qu'il n'y a pas invention plastique.
>
> Cela n'exclut pas de l'invention, mais une idée quel-conque que pourront exprimer les mots, mais alors elle est subordonnée à l'impression produite par les tâches purement pittoresques, et n'y paraît qu'à titre d'accessoire et, en quelque sorte, de superflu. Un tableau ainsi conçu laissera dans l'esprit une impression durable que la parole ne pourra reproduire, à la seule exception d'une parole sous forme d'art, un poème par exemple. (5 August 1879)

15 Walter Benjamin, "The Work of Art in the Age of Mechanical Reproduction" (1936), in *Illuminations*, ed. Hannah Arendt and trans. Harry Zohn (New York: Schocken Books, 1969), pp. 217–251.

16 Redon, *To Myself*, p. 45. "Imaginez les musées reproduits ainsi [by photographic reproduction]. L'esprit se refuse à calculer l'importance que prendrait soudain la peinture ainsi placée sur le terrain de la puissance littéraire (puissance de multiplication) et de sa sécurité nouvelle assurée dans le temps" (1876), Redon, *A Soi-même*, p. 55.

17 Redon, *To Myself*, p. 29. "'A côté d'une incertitude, mettez une certitude,' m'a dit Corot. Et il me fit voir des études à la plume" (May 1868), Redon, *A Soi-même*, p. 36.

18 Max Waller, reviewing the 1887 exhibition of Les XX, cited in Eisenman, p. 209.

19 Cited by Ted Gott, in *The Enchanted Stone: The Graphic Worlds of Odilon Redon*, exh. cat. (Melbourne: National Gallery of Victoria, 1990), p. 14.

20 "There is no doubt that his [Redon's] works, interpreted by the brief texts which accompany them, violently trouble the spectator," Edmond Picard, "Odilon Redon," *Art Moderne* 6, no. 12 (21 March 1886), p. 92.

21 Eisenman, p. 2.

22 Gott, p. 66.

23 E. H. Gombrich, *Art and Illusion: A Study in the Psychology of Pictorial Representation* (London: Phaidon Press, 1960), p. 286.

24 Eisenman, p. 139.

25 Ibid., p. 136.

26 Eisenman usefully points to a double context (and destiny) for *The Gambler* (and other references to dice in Redon). The first is related to "an important literary tradition exemplified by Balzac's *Un Peau de chagrin* and *Illusions perdues*, Dostoevsky's *The Gambler*, Pushkin's *Queen of Hearts*, and Baudelaire's poem "Le Jeu" from *Fleurs du mal*" (p. 189); the economic conditions that lay behind it in the lottery of emergent nineteenth-century capitalism; and the social theory of "chance," in its many contemporary formulations. A more immediate reference is found in Mallarmé's *Un Coup de dés* (1897), which Eisenman speculates, may have been "conceived in collaboration with Redon" (p. 192).

27 Ibid., p. 106.

28 Redon, *To Myself*, p. 22. For the original French, see Redon, *A Soi-même*, pp. 26–27:

> La désignation par un titre mis à mes dessins est quelquefois de trop, pour ainsi dire. Le titre n'y est justifié que lorsqu'il est vague, indéterminé, et visant même confusément à l'équivoque. Mes dessins *inspirent* et ne se définissent pas. Ils ne déterminent rien. Ils nous placent, ainsi que la musique, dans le monde ambigu de l'indéterminé.
>
> Ils sont une sorte de *métaphore*, a dit Remy de Gourmont, en les situant à part, loin de tout art géométrique.

29 Gott rehearses the history of the titling of *The Origins*, p. 67.

30 "Je fis après coup, pour un amateur qui le désirait, quelques suscriptions appuyant la grande hypothèse du transformisme," copy of letter of 21 July 1898 to André Mellerio and directed to André Bonger, cited by Dario Gamboni, in *La Plume et le pinceau: Odilon Redon et la littérature* (Paris: Editions de Minuit, 1989), p. 308, and by ibid.

31 Eisenman, pp. 150, 153.

32 Redon, *To Myself*, p. 28. "Les jurés officiels de peinture vous recommandent officieusement de présenter au Salon des oeuvres *importantes*. Qu'entendent-ils par ce mot-là? Un ouvrage d'art est important par la dimension, l'exécution, le choix du sujet, le sentiment, ou par la pensée" (15 October 1867), Redon, *A Soi-même*, p. 34.

33 For a fuller discussion of the implications of the notion of *poésie* in visual modernism, especially in Dada and Surrealism, see my "After the Wagnerian Bouillabaisse: Critical Theory and the Dada and Surrealist Word-Image," in Judi Freeman, *The Dada and Surrealist Word-Image*, exh. cat. (Los Angeles: Los Angeles County Museum of Art and Cambridge: MIT Press, 1989), pp. 57–95.

34 Cited by Eisenman, p. 206.

35 Cited in Carolyn Keay, *Odilon Redon* (New York: Rizzoli, 1977), p. 5.

36 See Julia Kristeva, *Revolution in Poetic Language*, trans. Margaret Waller (New York: Columbia University Press, 1984), pp. 223–225.

37 Paul Gauguin, letter to André Fontainas, in response to his review published in *Mercure de France* (January–March 1899), in John Rewald, *Paul Gauguin*, pp. 21–24. For the original French, see Gauguin, *Lettres de Gauguin à sa femme et à ses amis*, ed. Maurice Malingue (Paris: Grasset, 1949), p. 289, no. 170:

> Au réveil, mon oeuvre terminée, *je me dis:* d'où venons-nous, que sommes-nous, où allons-nous? Réflexion qui ne fait plus partie de la toile, mise alors en langage parlé tout à fait à part sur la muraille qui encadre, non un titre mais une signature.

> Voyez-vous, j'ai beau comprendre la valeur des mots – abstrait ou concret – dans le dictionnaire, je ne les saisis plus en peinture. J'ai essayé dans un décor suggestif de traduire mon rêve sans aucun recours à des moyens littéraires, avec toute la simplicité possible de métier, labeur difficile.

38 Paul Gauguin, letter to Daniel de Monfreid, February 1898, in *Paul Gauguin: Letters from Brittany and the South Seas: The Search for Paradise*, ed. Bernard Denvir (New York: Clarkson Potter, 1992), p. 123.

39 Ibid.

40 Paul Gauguin, letter to Dr. Gouzer, 15 March 1898, in ibid., p. 127.

41 Paul Gauguin, *Intimate Journals*, trans. Van Wyck Brooks (New York: Crown, 1936), p. 109. "En Océanie une femme dit: 'Je ne peux savoir si je l'aime puisque je n'ai pas encore couché avec lui.' La possession vaut titre," Gauguin, *Avant et après* (Paris: Editions G. Crès, 1923), p. 94.

42 Gauguin, *Intimate Journals*, p. 17. "Je voudrais écrire comme je fais mes tableaux, c'est à dire à ma fantaisie, selon la lune, et trouver le titre longtemps après," Gauguin, *Avant et après*, p. 2.

43 Gauguin, *Lettres de Gauguin*, p. 288.

44 Paul Gauguin, letter to Charles Morice, July 1901, in *Paul Gauguin: Letters from Brittany*, pp. 136–137 (the translation below has been slightly modified). For the original French, see Gauguin, *Lettres de Gauguin*, pp. 300–302:

> Puvis explique son idée, oui, mais il ne la peint pas. Il est grec tandis que mois je suis un sauvage, un loup dans le bois sans collier. Puvis intitulera un tableau *Pureté* et pour l'expliquer peindra une jeune vierge avec un lys à la main – Symbole connu; donc on le comprehend. Gauguin au titre *Pureté* peindra un paysage aux eaux limpides; aucune souillure de l'homme civilisé, peut-être un personnage.
>
> Sans rentrer dans des détails il y a tout un monde entre Puvis et moi. Puvis comme peintre est un lettré et non un homme de lettres tandis que moi je ne suis pas un lettré mais peut-être un homme de lettres. . . .
> *Où allons-nous?*
> Près de la mort d'une vieille femme.
> Un oiseau étrange stupide conclut.
> *Que sommes-nous?*
> Existence journalière.
> L'homme d'instinct se demande ce que tout cela veut dire.
> *D'où venons-nous?*
> Source.
> Enfant.
> La vie commune.
> L'oiseau conclut le poème en comparaison de l'être inférieur vis-à-vis de l'être intelligent dans ce grand tout qui est le problème annoncé par le titre. Derrière un arbre deux figures sinistres, enveloppées de vêtements de couleur triste, mettent près de l'arbre de la science leur note de douleur causée par cette science même en comparaison avec des êtres simples dans une nature vierge qui pourrait être un paradis de conception humaine, se laissent aller au bonheur de vivre.
> Des attributs explicatifs – symboles connus – figeraient la toile dans une triste réalité, et le problème annoncé ne serait plus un poème.
> En peu de mots je t'explique le tableau.

45 In a letter to August Strindberg, 5 February 1895, in *Impressionism and Post-Impressionism 1874–1904: Sources and Documents*, ed. Linda Nochlin (Englewood Cliffs, New Jersey: Prentice-Hall, 1966), p. 173, Gauguin discusses at some length

4

the contrast between the "bare and primordial" languages of Oceania and the "inflected" languages of Europe. In *Paradise Reviewed: An Interpretation of Gauguin's Polynesian Symbolism* (Ann Arbor: UMI Research Press, 1983), pp. 29–30, Jehanne Teilhet-Fisk writes about Gauguin's "pidgin-Tahitian":

> Gauguin needed his pidgin-Tahitian as a practical matter, to communicate with the rural inhabitants. Learning the language probably also enhanced his feeling that he was becoming a fellow "sauvage," for using the language of a group always intensifies one's sense of identification with the group. In addition, the use of the Tahitian language in his titles heightens the Symbolist's use of musicality and mystery. When written, the Tahitian language, like all syllabic languages, has a rhythmic, musical quality, because every consonant is followed by a vowel. The combination of sounds appears to heighten the expressive quality of the language. Gauguin's interest in the musicality of language led him to combine sounds or words in his titles, in a way Tahitians would rarely do, but which is highly expressive of the visual metaphors in his paintings. For example, the title *Nave Nave Fenua* translates both as *Land of Sensuous Pleasure* or *Delightful Land*; in a Western context it stands as a metaphor for the Garden of Eden or Paradise. But *nave nave* means "sensuous pleasure, pleasure of song, pleasure that parents receive from their children," and *fenua* means "land, the land where you farm." A Tahitian would not juxtapose the two words, Gauguin has taken liberties with the Tahitian language, which might as easily be ascribed to poetic intent as to ignorance. Gauguin's Tahitian titles are an important aspect of his works; they are lyrical tone poems which are deliberately thought out, in such a way that the painting or sculpture becomes the formal element of the title. The titles form disjunctive situations, where form and meaning separate and rejoin in different combinations.

46 Gauguin, to his wife (Mette), 8 December 1892, in *Lettres de Gauguin*, ed. Maurice Malingue, pp. 236–237.
47 In "Gauguin's Tahitian Titles," *Burlington Magazine* 109, no. 769 (April 1967), pp. 228–233, Bengt Danielsson challenges the often sloppy translations rendered in Western accounts of eighty-four of Gauguin's Pacific works accompanied by titles in Tahitian. He castigates in particular the more recent of two articles that discuss the titles: L.-J. Bouge, "Traduction et interprétation des titres en langue tahitienne inscrits sur les oeuvres océaniennes de Paul Gauguin," *Gazette des Beaux-Arts* 47 (January–April 1956), pp. 161–164, many of whose "wild guesses" were incorporated into the Gauguin catalogue raisonné prepared by Georges Wildenstein and Raymond Cogniat.
48 House, in *Post-Impressionism: Cross-Currents*, pp. 138–139.
49 Cited in Joan Ungersma Halperin, *Félix Fénéon: Aesthete and Anarchist in Fin-de-Siècle Paris* (New Haven: Yale University Press, 1988), p. 143.
50 Cited in ibid.
51 Clement Greenberg, "Introduction to an Exhibition of Morris Louis, Kenneth Noland, and Jules Olitski (*Three New American Painters: Louis, Noland, Olitski*, Norman Mackenzie Art Gallery, Regina, Saskatchewan, January–February 1963)," in *The Collected Essays and Criticism*, ed. John O'Brian, vol. 4: *Modernism with a Vengeance, 1957–1969* (Chicago: University of Chicago Press, 1993), p. 153.
52 "Sous ce titre suave: *Première communion de jeunes filles chlorotiques par un temps de neige,* M. Alphonse Allais a collé au mur une feuille de bristol absolument blanche," Félix Fénéon, "Les Arts Incohérents" (*La Libre Revue*, 1 November 1883), in *Oeuvres* (Paris: Gallimard, 1948), p. 98. According to Stevens, in *Post-Impressionism: Cross-Currents*, p. 26, Alphonse Allais's "appearance in the Exposition des Arts Incohérents of 1883 and 1884 is the only evidence to date of his activity as an

artist." In "L'Avant-garde à environs cent ans," in *Supplément culturel d'un journal qui n'existe pas* (Paris: F.I.A.C., 21 October 1988), Catherine Charpin provides further details concerning the seven "Incohérents" exhibitions from 1882–1893. The following passages are translated and revised from the above in Charpin (with Sarah Wilson), "One Hundred Years Ago: The 'Incohérents,'" *Art Monthly*, no. 128 (July–August 1989), pp. 7–9:

> Originally conceived as a private exhibition for a coterie of art-students, poets and actors, it was advertised in *Le Chat Noir* of October 1882, whereupon two thousand people invaded Lévy's atelier. . . . Catalogues and posters were designed according to art-world norms, but with an extraordinary liberty. . . . The participants, named Dada, Zipette, or Troulala, included some celebrated signatures behind the extravagant pseudonyms, such as Toulouse-Lautrec, Caran d'Ache or Alphonse Allais. . . . punning titles were given form: *Porctrait par Van Dyck* represented a sow being milked next to the back view of the artist painting; there were literal translations: *Wrath* or *Mustard's going up my nose*; mirrors were exhibited as *Portrait of Everybody*. . . . Unusual formats and supports were used: a shirt, a cream-skimmer, shammy leather. A live horse painted red, white and blue was exhibited in 1889 in honour of the centenary of the French Revolution. . . . [There were] "natures cuites," pictures made of bread or peas, sculptures in Gruyère cheese.

53 In "The Mythical Conception Is the Name: Titles and Names in Modern and Post-Modern Painting," *Word & Image* 1, no. 2 (April–June 1985), pp. 181–182, Stephen Bann describes the Incohérents in similar terms, though he calls it a "salon" not an "exposition."

54 For a fuller discussion of these issues, see Denys Riout, *La Peinture monochrome* (Paris: Éditions Jacqueline Chambon, 1996); and a discussion between Riout and Catherine Millet in *Art Press* (Paris), no. 211 (March 1996), pp. 19–23.

55 Stevens, in *Post-Impressionism: Cross-Currents*, p. 26. Phillip Dennis Cate offers a useful, illustrated, outline of the Incohérents in Phillip Dennis Cate and Mary Shaw, eds., *The Spirit of Monmartre: Cabarets, Humor, and the Avant-Garde, 1875–1905* (New Brunswick: Jane Voorhees Zimmerli Art Museum, 1996), pp. 40–52. See also Catherine Charapin *Les Arts incohérents (1882–1893)* (Paris: Syros Alternatives, Collection "Zigzag," 1990).

56 Fénéon, "Arts Incohérents," in *Oeuvres*, p. 97: "M. Jules Lévy vient de réunir, Galeries Vivienne, tout ce que les calembours les plus audacieux et les méthodes d'éxécution les plus imprévues peuvent faire enfanter d'oeuvres follement hybrides à la peinture et à la sculpture ahuries."

57 Ibid: "élucubrations épileptiques et exhilarantes;" "Quant aux facéties dont est criblé le catalogue de l'exposition – trop souvent empruntées aux recueils de bons mots que vendent les pitres forains – elles échouent dans le rabâchage."

58 A copy of the *Arts Incohérents* catalogue from the *Le Chat noir* of 1 October 1882 was kindly sent to me by Phillip Dennis Cate, Director of the Jane Voorhees Zimmerli Art Museum, Rutgers, The State University of New Jersey. The following citations are from this source.

59 Fénéon, "Arts Incohérents," in *Oeuvres*, pp. 97–99.

60 Ibid.

61 Constant Chanouard (the surname puns on Chat Noir), "Les Arts incohérents," *Le Chat noir*, 8 October 1882.

62 House, in *Post-Impressionism: Cross-Currents*, p. 139.

63 See Françoise Cachin, *Paul Signac* (Paris: Bibliothèque des Arts, 1972), pp. 103ff.

64 See Floyd Ratliff, *Paul Signac and Color in Neo-Impressionism* (New York: Rockefeller University Press, 1992), p. 13. Ratliff and other historians have noted that Fénéon was implicated in the assassination of the President of France, M. Marie

François Sadi Carnot, in 1894: "Much later, in his old age, Fénéon confessed to a friend that it was he who had set the bomb that exploded in the restaurant of the Hotel Foyot" (ibid).

65 Félix Fénéon, cited in Françoise Cachin, *Paul Signac*, p. 42.

66 House, in *Post-Impressionism: Cross-Currents*, p. 136.

67 Ibid.

68 Félix Fénéon, "Les Expositions artistiques à Paris" (*La Libre revue*, 16 February 1884) in *Au-delà de l'Impressionisme*, ed. Françoise Cachin (Paris: Hermann, 1966), pp. 42–43:

> Dans le catalogue de l'exposition – imprimé en rouge et envahi par un ridicule poème de M. Paul Roinard – je copie textuellement quelques titres de tableaux: "*La foi s'en va! Un derviche harangue les gens du peuple qui rient.*" – "*Fille du Nord après bain. La contraction des muscles et la congestion des extrémités indiquent la sensation du froid.*" – *Le Taureau et le Chien. Allégorie de la France et de la Prusse.*" – "*La Guerre fait les idiots, les estropiés, les mères de quatorze ans et les mendiants.*" De la peinture de Saint-Cyrien philanthrope! . . .

69 Félix Fénéon, "V exposition internationale chez Georges Petit" (*La Vogue*, 28 June 1886), in ibid., p. 69.

70 Félix Fénéon, "L'Impressionisme" (*L'Emancipation sociale*, 3 April 1887), in ibid., p. 83.

71 Félix Fénéon, "Le Néo-Impressionisme aux Indépendants" (*L'Art moderne*, 15 April 1888), in ibid., p. 100:

> Tandis que les autres salles des Indépendants sont tendues de rouge, celle où il expose se revêt toute de papier gris; mais M. Signac estime insuffisante cette précaution: il enlève donc, les jugeant une cause de trouble, les index de carton que la main des organisateurs insère entre la toile et le cadre; sa signature affecte la teinte dominante de la région où il la place; et, comme M. Alma-Tadema, il numérote au pinceau chacune de ses toiles (Alma-Tadema en chiffres romains, Signac en chiffres arabes).

72 Félix Fénéon, "Paul Signac" (*Les Hommes d'aujourd'hui*, 1890), in ibid., p. 118:

> Bien qu'il sût les dénommer agréablement (*Un peu de soleil au pont d'Austerlitz* ou *Bonne brise de N 1/4 NO*), M. Signac renonce à mettre de la littérature sous ses tableaux. Il les numérote. Signature, millésime et numéro sont harmoniés aux fonds, – harmonies de semblables pour un fond clair, de contraires pour un fond sombre. Comme décor: le cadre blanc à quatre étroites raies d'or en bordure extérieure.

73 Vern G. Swanson, *The Biography and Catalogue Raisonné of the Paintings of Sir Lawrence Alma-Tadema* (London: Garton, 1990), p. 42.

74 Ibid.

75 Vern G. Swanson, *Alma-Tadema: The Painter of the Victorian Vision of the Ancient World* (New York: Scribner's, 1977), p. 42. In *Biography*, p. 90, Swanson also notes that in 1907 Alma-Tadema contributed money toward an unrealized sculpture of Whistler to be made by Rodin for a site in Chelsea.

76 Helen Zimmern, cited in Swanson, *Victorian Vision*, pp. 42–43.

77 Cited in Swanson, *Biography*, p. 47.

78 Swanson, *Victorian Vision*, p. 21.

79 Cited in Swanson, *Biography*, p. 66. Another visitor described the Grove End Road house as "like nothing on earth, because to enter any of its rooms was apparently to walk into a picture. Lady Tadema's studio, for instance, might have been a perfect Dutch interior by Vermeer or de Hooch."

80 Ibid., p. 87. Archeology, decoration, Japanese art, the domestic environment, and
 the coordinated sequence of his pictures are joined by Alma-Tadema's interest in
 costume, design, and furniture. Swanson notes that (again like Whistler) he made
 frames for paintings; that he designed a piano and a couch; and that "[s]atin dresses
 made by Liberty of London 'alla Tadema' were very popular, and wealthy
 American women idled in Tadema tunics."
81 Ibid., p. 43.
82 Ibid., p. 204.
83 Ibid., p. 219.

Chapter 4

1 James McNeill Whistler, *Whistler v. Ruskin* (1878), cited in Stanley Weintraub,
 Whistler: A Biography (New York: E. P. Dutton, 1974), p. 201. In *The Gentle
 Art of Making Enemies* (London: William Heinemann, 1892; reprint, New York:
 Dover, 1967), Whistler selects from and redramatizes the courtroom exchange. The
 best sources for this material are the Weintraub biography and Joseph Pennell and
 Elizabeth Pennell, *The Life of James McNeill Whistler*, 2 vols. (Philadelphia: J. B.
 Lippincott, 1909). The Pennells' sources and documents now constitute the Pennell
 Collection at the Library of Congress, Washington, D.C. Much of the discussion
 that follows is built on a deconstructive reading of these and other key historical,
 critical, and autobiographical texts on Whistler's life, work, and context. My aim is
 to demonstrate the formative importance of the artist's titular logic to the develop-
 ment of his "environmental formalism."
 2 *Ten O'Clock: A Lecture by James A. McNeill Whistler* (Portland, Maine: Thomas Bird
 Mosher, 1916), p. 16.
 3 Ibid., p. 17.
 4 "Mr. Whistler's Cheyne Walk," *The World* (22 May 1878), in ibid., p. 34.
 5 Ibid., pp. 33–34.
 6 In Pennell, vol. 1, p. 167. The authors note: "Lord Redesdale told us that it was
 he who suggested this title [*Trotty Veck*], gaily. Whistler assured another friend that
 he had only to write 'Father, dear Father, come home with me now' on the
 painting for it to become 'the picture of the year.'"
 7 One of the fullest treatments of the analogy between music and painting, Edward
 Lockspeiser's *Music and Painting: A Study in Comparative Ideas from Turner to Schoenberg*
 (New York: Harper and Row, 1973) is a case in point. Perhaps inevitably, given
 its historical scope, the text reads more as a compendium of instances of the analogy
 (in Redon, Valéry, Baudelaire, Turner, Huysmans, Laforgue, Wagner, Gauguin,
 Denis, Aurier, Rilke, Berlioz, Delacroix, etc.), than as a comparative study.
 8 Sir Joshua Reynolds, "Discourse IV," in *Discourses on Art*, ed. Robert R. Wark (San
 Marino, California: Huntington Library, 1959), p. 68.
 9 Charles Baudelaire, *Art in Paris 1845–1862: Salons and Exhibitions Reviewed by
 Charles Baudelaire*, trans. and ed. Jonathan Mayne (Oxford: Phaidon, 1965), p. 56.
10 Théodore Duret, *Whistler*, trans. Frank Rutter (Philadelphia: J. B. Lippincott,
 1917), pp. 37–38. For the original French, see Duret, *Histoire de James Mc. N.
 Whistler et son oeuvre* (Paris: H. Floury, 1914), p. 46:

 Ses oeuvres comportaient donc bien réellement deux titres. Dans un portrait, par
 exemple, il y avait tout naturellement à désigner le modèle peint et alors le
 tableau s'appelait: *Portrait de Carlyle, Portrait de Miss Alexander*, mais comme
 Carlyle et Miss Alexander avaient été peints à l'aide d'une combinaison de
 coloris, qui valait par elle-même et en elle-même était faite pour séduire, il
 ajoutait au nom du modèle un titre désignant la combinaison réalisée et disait:

*Portrait de Carlyle, arrangement en gris et noir, Portrait de Miss Alexander, harmonie en
gris et vert.* Dans un tableau de Whistler, outre le sujet proprement dit, il y a donc
un arrangement ou combinaison de coloris qu'on peut appeler décoratif, en
prennant le mot dans son sens élevé et à la manière dont les artistes de l'Extrème-
Orient l'ont compris.

11 Duret, *Whistler*, p. 38.
12 Ibid.
13 Pennell, vol. 1, p. 97.
14 Ibid.
15 Ibid., p. 156.
16 Ibid., p. 103.
17 Ibid., p. 139.
18 Ibid., p. 44.
19 Ibid., p. 157.
20 Henry Blackburn, "A 'Symphony' in Pall Mall" (*The Pictorial World*, 13 June 1874),
 in Robin Spencer, ed., *Whistler: A Retrospective* (New York: Hugh Lauter Levin,
 1989), p. 109.
21 Ibid.
22 Pennell, vol. 1, pp. 159–160. Whistler himself repeatedly changed his titles, some-
 times putting them to work on several different paintings at once. Walter Sickert
 interpreted this as follows: "Although he altered his titles himself, nothing offended
 him more than when others tampered with them or imitated them. . . . He resented
 it when people urged literary titles for them," cited in ibid., p. 166. Albert Moore,
 among others, also "borrowed Whistler's titles," including *Harmony of Orange and
 Pale Yellow*, and *Variation of Blue and Gold* (p. 145).
23 Monet occasionally painted the "effects of the night," as in his early *Marine, effet de
 nuit* (1864).
24 Val Prinsep (*Art Journal*, August 1892), cited in Pennell, vol. 1, p. 166.
25 Duret, *Whistler*, p. 45.
26 Ibid., p. 55.
27 Ibid., p. 62.
28 Katharine A. Lochnan, *The Etchings of James McNeill Whistler* (New Haven: Yale
 University Press, 1984), p. 229.
29 Whistler, *Gentle Art*, p. 203.
30 There is a large body of evidence for Whistler's desire to look beyond the motif to
 the decorative configuration of the image, and to correlate this back into the
 context of display. Of his early japoniste pictures, painted in 1863, the Pennells note
 that "[i]t was not Japan he wanted to paint, but the beautiful colour and form of
 Japanese detail, as the titles he afterwards found for the pictures explain: *Purple and
 Rose, Caprice in Purple and Gold, Harmony in Flesh Colour and Green, Rose and Silver*,"
 Pennell, vol. 1, p. 122.
31 Another of Whistler's alternative shows, at no. 48 Pall Mall, offered a scrupulous
 choreography of paintings and prints, grey walls, and interior decoration. Whistler
 supervised the "arrangement" of "palms and flowers, blue pots and bronzes," and
 designed the invitation card. Yet, as the Pennells note, "even the pictures could
 have been forgiven more easily than the titles," ibid., pp. 179–180.
32 Lochnan, p. 229. Lochnan gives further useful information about the catalogue:

> The notoriety attached to both colour scheme and catalogue attracted great
> crowds, including the Prince and Princess of Wales, who went around the gallery
> looking at everything, "the Prince chuckling at the catalogue." The general
> response of the critics was to dismiss the exhibition as a huge joke, and to portray
> Whistler as the "artistic Barnum" Leyland had once accused him of being. But
> Whistler was elated. He wrote to Storey saying: "The Critics simply slaughtered

and lying around in masses! The people divided into opposite bodies, for and against – but all violent! – and the Gallery full! – and above all the catalogue selling like mad! . . . In short it is amazing.

33 Whistler, *Gentle Art*, p. 97.
34 Ibid., p. 106.
35 Ibid., pp. 97, 98, 100.
36 Ibid., p. 299.
37 Ibid., p. 314.
38 Ibid., pp. 301–302.
39 Ibid., p. 309. The [*sic!*] interpolation is Whistler's.
40 Cited in Pennell, vol. 1, pp. 80, 81.
41 Ibid., p. 76.
42 These details are described in a letter to the Pennells from Mr. J. E. Christie, who attended a life class with Whistler and the Greaves brothers in 1863, in ibid., p. 108: "[Whistler] never entered into the conversation, which was unceasing, but occasionally rolled a cigarette and had a few whiffs, the Greaves brothers always requiring their whiffs at the same moment."
43 Ibid., pp. 193–194.
44 Ibid., p. 116.
45 Ibid., p. 125.
46 Ibid., p. 126.
47 Ibid. There were other artists, of course, who experimented with specially formed or painted frames. In 1887, having written a letter to Signac in the summer of 1886 about the effects of painted borders on canvas, Seurat, for example, added a painted frame to his *Honfleur, un soir, embouchure de la Seine* (*Evening, Honfleur, Mouth of the Seine*, 1886). As Robert L. Herbert states in *Neo-Impressionism*, exh. cat. (New York: Solomon R. Guggenheim Museum, 1968), p. 115, "Pissarro and Whistler had painted their frames earlier, both in contrasting and in harmonizing tones, but with none of the complexity of Seurat's."
48 Pennell, vol. 1, p. 128.
49 Ibid., vol. 2, p. 66.
50 Whistler, *Gentle Art*, pp. 311–312.
51 The importance of the dictionary as a model and metaphor for the visual and literary avant-garde is discussed in "Modernisme à Larousse," in my *Modernism Relocated*, pp. 1–36.
52 In "Image and Word in Twentieth-Century Art," *Word & Image* 1, no. 3 (July–September 1985), p. 229, E. H. Gombrich discusses the influence of the poet Christian Morgenstern's "nonsense verse," *Galgenlieder*, "which might roughly be translated as Whistles in the dark," on the poeticizing titular activity of Paul Klee.
53 Whistler, *Gentle Art*, p. 223.
54 Ibid., p. 224.

Chapter 5

1 Jacques Derrida, "Living On•BORDER LINES," trans. James Hulbert, in *Deconstruction and Criticism* (New York: Continuum, 1979), p. 81.
2 There are many unresolved archival problems surrounding the titles of Cézanne's works. In *Paul Cézanne: The Bathers*, exh. cat. (Basel: Museum of Fine Arts, 1989), p. 254, note 1, Mary Louise Krumrine notes: "Titles for paintings and drawings are problematic, and with the exception of the most famous works, are changed at random by many authors. Indeed we do not know if Cézanne gave his works titles at all." She cites the naming of a work by Antoine Guillemet from Rewald's biography (discussed below). I would suggest that while their precise historical

origins are deeply problematic, the titling procedures of Cézanne and his circle
nevertheless reveal important information about the work and the "anxieties" of the
painter.

3 Meyer Schapiro, *Paul Cézanne* (New York: Abrams, 1952).
4 See John Rewald, *Cézanne: A Biography* (New York: Abrams, 1986).
5 Emile Zola, cited in ibid., pp. 12, 30, 32.
6 Ibid., p. 26.
7 Ibid.
8 See Jacques Derrida, *The Truth in Painting*, trans. Geoff Bennington and Ian
 McLeod (Chicago: University of Chicago Press, 1987), pp. 2–9.
9 Recently, feminist art historians have compared Cézanne's representation of women
 to that of Renoir, Degas, and other contemporary artists, opposing it to the images
 offered by such women artists as Berthe Morisot and Mary Cassatt. See Anne
 Higonnet, *Berthe Morisot's Images of Women* (Cambridge: Harvard University Press,
 1992).
10 Cited in Rewald, p. 18.
11 Ibid., p. 35.
12 Zola, cited in ibid., p. 46.
13 Ibid., p. 62.
14 Ibid., p. 78.
15 Rewald, p. 45.
16 Ibid., p. 40.
17 Ibid., p. 42.
18 Georges Rivière, writing in *L'Impressioniste*, cited in ibid., p. 112.
19 In *The Complete Paintings of Paul Cézanne* (Harmondsworth: Penguin, 1985), this is
 the last work listed: "The Eternal Feminine (The Golden Calf; The Triumph of
 Woman; 'La Belle Impéria') 1875–187?."
20 Lionello Venturi notes in the Cézanne catalogue raisonné, *Cézanne: Son Art – Son
 Oeuvre*, vol. 1, (Paris, 1936; reprint, San Francisco: Alan Wofsy Fine Arts, 1989), p.
 120, that "l'inspiration appartient au même genre que la Moderne Olympia,
 L'après-midi à Naples, etc., c'est-à-dire qu'elle n'est pas sans ironie. Dite aussi Le
 veau d'or; Le triomphe de la femme; la belle Impéria (à cause de l'évêque)" ("the
 inspiration [for *The Eternal Feminine*] comes from the same source as the *Modern
 Olympia*, *Afternoon in Naples*, etc., which is not without irony. [It is] also called The
 Golden Calf; The Triumph of Woman; The Beautiful Impéria [because of the
 bishop]").
21 The term *différend* is used by Jean-François Lyotard in *Le Différend* (Paris: Editions de
 Minuit, 1983). Lyotard elaborates a theory of the *différend* such that it can stand for
 the complexities of exchange (continual interplay and renegotiation) between two
 objects of discourse. His intention is to demonstrate the continual returns (feedbacks,
 recoils, interpositions) that discursive objects undergo in formation and reception, as
 they are produced and received across social, political, subjective, and linguistic
 systems and positions. The term is used of the particular *positions* and *exchanges* that
 inform the development of Cézanne's oeuvre in preference to Bloom's theorization
 of the "anxiety of influence." While, in the absence of sig-nificant documentary
 evidence, we are reduced to speculation concerning the social and psychological
 relation between the antinomies rehearsed in the text, these are complex shifts that
 must have been mediated by rather powerful drives and external forces.
22 Harold Bloom, *The Anxiety of Influence: A Theory of Poetry* (New York: Oxford
 University Press, 1973), p. 30. Writing of the academician Ernest Meissonier
 in "Definition of Neo-Traditionism" (1890), Maurice Denis notes that the first
 factor in the reputation of this artist involves what he describes as the "[d]eformation

of intimate Dutch compositions" (my emphasis). See Herschel B. Chipp, ed., *Theories of Modern Art: A Source Book by Artists and Critics* (Berkeley: University of California Press, 1968), p. 98.

23 Maurice Merleau-Ponty, *Phenomenology of Perception* (London: 1966), p. 325. Merleau-Ponty's *Sense and Non-Sense*, trans. Hubert L. Dreyfus and Patricia Allen Dreyfus (Chicago: North-western University Press, 1964), pp. 9–25, contains his important essay, "Cézanne's Doubt." See also Judith Wechsler, *The Interpretation of Cézanne* (Ann Arbor: UMI Research Press, 1981), for a discussion of Cézanne criticism, including that of Merleau-Ponty and Schapiro.

24 Meyer Schapiro, *Paul Cézanne* (New York: Abrams, 1988), p. 58.

25 Paul Cézanne, letter to Armand, Comte Doria, Paris, 30 June 1889, in *Le Livre des Expositions Universelles 1851–1989* (Paris: Union Central des Arts Décoratifs, 1983), p. 85.

26 The theoretical implications of the Dada and Surrealist movements are discussed in my "After the Wagnerian Bouillabaisse: Critical Theory and the Dada and Surrealist Word-Image," in Judi Freeman, *The Dada and Surrealist Word-Image*, exh. cat. (Los Angeles: Los Angeles County Museum of Art and Cambridge: MIT Press, 1989), pp. 57–95.

27 Alfred H. Barr, *Cubism and Abstract Art*, exh. cat. (New York: Museum of Modern Art, 1936), p. 30.

28 Leo Steinberg, "The Philosophical Brothel, Part 1" *Art News* 71, no. 5 (September 1972), p. 35.

29 John Golding, *Cubism: A History and an Analysis 1907–14* (London: Faber and Faber, 1988), p. 38.

30 Ibid.

31 Ibid., p. 50, note 2.

32 Ibid., p. 38.

33 William Rubin, "The Genesis of *Les Demoiselles d'Avignon*," in Rubin, Hélène Seckel, and Judith Cousins, *Les Demoiselles d'Avignon* (New York: Museum of Modern Art, 1994), pp. 13–144. This book includes Cousins and Seckel, "Chronology of *Les Demoiselles d'Avignon*, 1907 to 1939," pp. 145–205; Etienne-Alain Hubert, "Appendix to the Chronology," pp. 206–212; and Seckel, "Anthology of Early Commentary on *Les Demoiselles d'Avignon*," pp. 213–256. Rubin's essay is a revised version of his contribution to a monograph written for the Musée Picasso, Paris, in 1987.

34 Ibid., p. 23.

35 Ibid., p. 15. All subsequent references, until noted, are to pp. 17–19.

36 See ibid., pp. 112–116, for Rubin's discussion of "The Head of the Crouching Demoiselle."

37 André Breton, letter to Jacques Doucet, 6 November 1923, in Collins and Seckel, "Chronology," p. 177.

38 See Rubin, "Genesis," pp. 98–102, for Rubin's discussion of El Greco.

39 Ibid., p. 96.

40 Ibid., p. 16.

41 Ibid.

42 Clement Greenberg, "The Pasted-Paper Revolution" (*Art News*, September 1958), in *The Collected Essays and Criticism*, ed. John O'Brian, vol. 4: *Modernism with a Vengeance, 1957–1969* (Chicago: University of Chicago Press, 1993), p. 62.

43 The painting is also referred to as *La femme vue de dos à la fenêtre* in Marie Berhaut, *Caillebotte: Sa vie et son oeuvre* (Paris: La Bibliothèque des Arts, 1978), p. 38. The "NT" may be the final letters of "RESTAURANT". Even though a double-page reproduction of a detail of this painting, featuring the letters, the curtain "frame"

and the head and shoulders of the figure on the balcony, is reproduced in a recent monograph on Caillebotte, no mention is made of the word-fragments or of the motif that they "represent" in the accompanying discussion. See Kirk Varnedoe, *Gustave Caillebotte* (New Haven: Yale University Press, 1987), pp. 126–29.

44 Greenberg, p. 61.
45 Frank Jewett Mather, Jr., "Newest Tendencies in Art" (*Independent*, 6 March 1913), cited in Milton W. Brown, *The Story of the Armory Show* (New York: Abbeville, 1988), p. 177.
46 Vladimir Tatlin, discussing a production of Khlebnikov's *Zangezi* in 1923, cited in Christina Lodder, *Russian Constructivism* (New Haven: Yale University Press, 1983), p. 209. Among the seven modes of language deployed by Khlebnikov in his experimental "play," Tatlin lists "word decomposition."
47 John E. Bowlt, in *The Avant-Garde in Russia, 1910–1930: New Perspectives*, eds. Stephanie Barron and Maurice Tuchman, exh. cat. (Los Angeles: Los Angeles County Museum of Art, 1980), p. 180.
48 Ibid., p. 242.
49 Extracts translated by Bowlt in ibid., p. 222.
50 Cited by Bowlt, in "Alexandr Rodchenko as Photographer," in ibid., p. 54.
51 The exhibition and catalogue *The Great Utopia: The Russian and Soviet Avant-Garde, 1915–1932*, exh. cat. (New York: Solomon R. Guggenheim Museum, 1992), from which several of my examples are drawn, was originally to have been titled *Construction and Intuition*, drawing specific attention to the opposition of these coordinates (p. xiii).
52 Christina Lodder, "The Transition to Constructivism," in ibid., pp. 266–281. See also her *Russian Constructivism*, esp. pp. 83–94.
53 Lodder, "Transition," pp. 270–272.
54 Wassily Kandinsky, cited in ibid., p. 271.
55 Kazimir Malevich, letter to Mikhail Matiushin, 25 September 1915, cited by Jane A. Sharp, in "The Critical Reception of the *0.10* Exhibition: Malevich and Benua," in *Great Utopia*, p. 45.
56 Kazimir Malevich, letter to Mikhail Matiushin, September 24, 1915, cited in ibid., p. 46.
57 Mikhail Matiushin, cited in ibid., p. 49.
58 Aleksandra Shatsakikh, "Unovis: Epicenter of a New World," in ibid., p. 53.
59 Ibid., p. 56.
60 I am alluding here to the thesis of Boris Groys set out in his *The Total Art of Stalinism: Avant-Garde, Aesthetic Dictatorship, and Beyond*, trans. Charles Rougle (Princeton: Princeton University Press, 1992). I have summarized elsewhere his central claim concerning the paradoxical complicity of the Soviet avant-garde with the cultural politics of the Stalin era. See my *Modernism Relocated: Towards a Cultural Studies of Visual Modernity* (Sydney: Allen and Unwin, 1995), p. 148.
61 Lodder, *Russian Constructivism*, p. 90.
62 John Milner, *The Exhibition "5 × 5 = 25": Its Significance and Background*, (Budapest: Helikon, 1992), p. 17.

Chapter 6

1 Paul Klee, *On Modern Art*, trans. Paul Findlay (London: Faber and Faber, 1948), p. 43; based on a lecture delivered in Jena, Germany, in 1924.
2 Aristotle, *On the Art of Fiction: "The Poetics"*, trans. L.J. Potts (Cambridge: Cambridge University Press, 1968), p. 27.

3 These are the opening two sentences of part II of "Les Peintres cubistes," which was adapted from "Du Sujet dans la peinture moderne" (*Les Soirées de Paris*, February 1912), in *Theories of Modern Art: A Source Book by Artists and Critics*, ed. Herschel B. Chipp (Berkeley: University of California Press, 1968), p. 221.

4 This is an overly brief summary of the "received" understanding of Mondrian's career, as set out, for example, in Michel Seuphor, *Piet Mondrian: Life and Work* (New York: Abrams, 1956). More recent scholarship, including Carel Blotkamp's *Mondrian: The Art of Destruction* (London: Reaktion Books, 1994), has offered new contextual emphases on the artist's work and its interpretation, including several references to the significance of his titles (see esp. pp. 7, 93, 192ff., 225–226). Blotkamp's caution concerning the accuracy of existing or "received" titles for Mondrian's paintings, and the difficulties that attend the archival retrieval of "original" ones, is echoed in almost all of the scholarly monographs on significant twentieth-century artists: "The titles of Mondrian's abstract compositions have been more or less standardized [in Blotkamp's book]. Mondrian himself was far from consistent in this respect. Entering a painting for an exhibition, he usually added a number or letter to the title but at the next exhibition the same painting might bear a different number or letter, or even a different title. Thus I prefer a descriptive title, e.g. *Composition with Red, Yellow and Blue* to the more haphazard *Composition No. 9* or *Composition B*" (p. 7).

5 Angelica Zander Rudenstine, *The Guggenheim Museum Collection: Paintings 1880–1945*, vol. 2 (New York: Solomon R. Guggenheim Museum, 1976), p. 568. In *The Art of Destruction*, p. 93, Blotkamp underlines this: "From the autumn of 1913 on, his entries were consistently designated *Tableau* or, in German-speaking countries, *Gemälde*, with or without an accompanying number. After 1914 he used the title *Composition*, combined with a letter or a number; in many cases he made use of a different letter or number for each exhibition, to the despair of later art historians." The titling history of one of the last works to depart from the tree motif exemplifies this complexity. Designated as *Tableau IV* in an exhibition in Amsterdam in 1913, it was renamed *Compositie VIII* in the Hague the following year; *Compositie C* in Rotterdam, 1915; *Compositie III in Kleur* in Amsterdam, 1915; *Compositie op boomen* in Amsterdam, 1922; before being further exhibited in Amsterdam, Basel, New York, The Hague, Zurich, Rome, Berlin, Paris, and Tokyo.

6 Rudenstine, p. 571.

7 The Guggenheim's *Composition* (1929), on the other hand, is inscribed with the word "composition" on the reverse; this seems to be the artist's preferred inscriptive designation.

8 Exceptions include *Lozenge with Gray Lines* (1918) and several works still called *Tableau: Tableau I* (1921), *Tableau II* (1921–25), *Tableau II (Composition in Gray and Black)* (1925).

9 In *The Art of Destruction*, p. 93, Blotkamp summarizes this development: "In 1917 he [Mondrian] began giving each *Composition* a more specific designation (*Composition in Line*, *Composition in Colour*, and so on). He continued to use this method, although later the titles became more specific when he included mention of the colours employed (for example, the *Composition with Blue and Yellow*). It was not until well into the 1920s, and again in the 1940s, that certain works were given more suggestive titles." He restricts its significance, however, to the (negative) loss of identifying motifs, rather than the (positive) formation of a new theoretical language.

10 Ibid., p. 106.

11 Ibid., p. 107.

12 Piet Mondrian, "Natural Reality and Abstract Reality" (1919–20), in *The New Art–*

The New Life: The Collected Writings of Piet Mondrian, eds. and trans. Harry Holtzman and Martin S. James (Boston: G. K. Hall, 1986), p. 83.

13 Piet Mondrian, "Neo-Plasticism: The General Principle of Plastic Equivalence" (1920), in ibid., p. 139.

14 Piet Mondrian, "The Manifestation of Neo-Plasticism in Music and the Italian Futurists' *Bruiteurs*" (1921), in ibid., p. 154.

15 The quoted words are those used by Z ("an Abstract-Real Painter," and thus a surrogate for Mondrian himself) in Mondrian, "Natural Reality and Abstract Reality," in ibid., pp. 114–115.

16 Piet Mondrian, "Neo-Plasticism: General Principle," in ibid., p. 143.

17 Entry for Bart Van der Leck's *Study for Compositions No. 3 and No. 4 (Leaving the Factory)*, 1917, in Ronald Alley, *Catalogue of the Tate Gallery's Collection of Modern Art Other Than Works by British Artists* (London: Tate Gallery, 1981), p. 413. In *Art of Destruction*, p. 97, Blotkamp also notes this important stylistic and nominal shift: "The influence of Mondrian is immediately evident in the four paintings that came after Van der Leck's *Port Labour* [1916], and to which the latter gave the telling title *Composition* followed by a number." Blotkamp's interpretation of the mutual influence of Van der Leck and Mondrian suggests an added significance for the title *Composition*. For while Van der Leck clearly appears to have borrowed this designation from his new colleague, Blotkamp is of the opinion that Van der Leck's "rigorous simplification of form and intensification of color" was actually in advance of Mondrian's technique in 1916 – with its "tonality in the colour and a sensitivity in the artist's signature that were, in effect, remnants of nineteenth-century movements, such as Impressionism" (ibid.). The radicalness of textual compositionality was at this moment, then, running somewhat in advance of its pictorial predicates; its signification offered a kind of premium or surplus in the development of non-iconic abstraction.

18 Theo Van Doesburg, cited in Blotkamp, p. 126. In *Mondrian 1872–1944*, exh. cat. (The Hague: Haags Gemeente-museum, Washington D.C.: National Gallery of Art, New York: Museum of Modern Art, and Boston: Bullfinch Press, 1994), p. 190, the relevant passage is translated as follows: "[Mondrian's] most recent works are without composition. The division of the surface is in one measure. That is to say ordinary rectangles of equal size. Contrast is only achieved through color. I think that this conflicts somewhat with his theory of the abolition of position and measure. This is equality of position and measure."

19 Yve-Alain Bois, "The Iconoclast," in *Mondrian 1872–1944*, p. 316.

20 Joost Baljeu, *Theo Van Doesburg* (London: Studio Vista, 1974), p. 66.

21 Ibid., p. 67.

22 Theo Van Doesburg, "What is Dada???????" (*De Stijl*, 1923), cited in ibid., p. 133.

23 See Theo Van Doesburg, "From Nature towards Composition," in *De Hollandsche Revue* (1918); cited in Baljeu, p. 151.

24 Theo Van Doesburg, "Painting: From Composition towards Counter-Composition" (*De Stijl*, 1926), cited in Baljeu, p. 151.

25 Theo Van Doesburg, "Painting and Plastic Art" (*De Stijl*, 1926), in ibid., pp. 156, 158.

26 Ibid., p. 159 (Van Doesburg's emphasis).

27 Ibid., pp. 159, 160.

28 Theo Van Doesburg, "Painting and Plastic Art: Elementarism" (*De Stijl*, 1926–27), cited in Baljeu, p. 164.

29 Mondrian, "Neo-Plasticism: General Principle," in *New Art*, p. 142.

30 Ibid., p. 143.

31 Mondrian, "Manifesto of Neo-Plasticism," in *New Art*, p. 150.

32 Piet Mondrian, "Neo-Plasticism: General Principle," in ibid., p. 142 (first emphasis, mine; second, Mondrian's).

33 Ibid., p. 136 (Mondrian's emphasis).

34 Piet Mondrian, "Down with Traditional Harmony!" (1924), in *New Art*, p. 191.

35 Piet Mondrian, "The New Art–The New Life: The Culture of Pure Relationships" (1931), in ibid., p. 275.

36. Piet Mondrian, cited in *New Art*, p. 198.

37 In "Purism," in *Concepts of Modern Art*, ed. Nikos Stangos (New York: Harper and Row, 1981), p. 84, Christopher Green notes that "it is in the final analysis the Purist approach to the object that demonstrates conclusively Purism's independence from both De Stijl and Cubism."

38 Charles-Edouard Jeanneret and Amadée Ozenfant, "Purism" (*L'Esprit Nouveau*, 1920), in *Modern Artists on Art: Ten Unabridged Essays*, ed. Robert L. Herbert (Englewood Cliffs, New Jersey: Prentice-Hall, 1964), pp. 58–73. My quotations are from pp. 67–72.

39 Piet Mondrian, "Three Notes" (1937), in *New Art*, p. 301.

40 In "Transcending the Visible: The Generation of the Abstract Pioneers," in *The Spiritual in Art: Abstract Painting 1890–1985*, exh. cat. (Los Angeles: Los Angeles County Museum of Art and New York: Abbeville Press, 1986), p. 146, Sixten Ringbom discusses the "systematic" reduction of Mondrian's "dematerialization" in relation to Schoenmaekers's belief, noted in *Beginselen der Beeldene Wiskunde* (*Principles of Visual Mathematics*, 1916) in "a positive, exact, verifiable manner" and not an "oriental-lovable, poetical softness."

41 See, e.g., Blotkamp, who cites the passage from the "trialogue." On p. 141, note 31, he makes reference to Herbert Henkel's original discussion of the composed studio. On p. 144, he also notes that "the front wall of the rue de Coulmiers studio must have given the impression of a carefully balanced composition."

42 Ibid., p. 155. See also pp. 149–158, for a fuller account of both of these activities, and of Mondrian's "spatial" projects. Blotkamp notes that Mondrian's later studios "in Paris until 1938, in London until 1940, and then in New York at two addresses" were also furnished or arranged in Mondrian's "familiar sober style": "In New York we see a more immediate link between the constellations of colored planes on the walls and the sparkling compositions in the paintings done during his final years" (p. 158).

43 John Gage, "The Psychological Background to Early Modern Colour: Kandinsky, Delaunay, and Mondrian," in *Towards a New Art: Essays on the Background to Abstract Art 1910–20* (London: Tate Gallery, 1980), p. 22.

44 Henri Matisse, "Notes of a Painter" (1908), in *Matisse on Art*, ed. Jack Flam (Berkeley: University of California Press, 1995), p. 38. "La composition est l'art d'arranger de manière décorative les divers éléments dont le peintre dispose pour exprimer ses sentiments. . . . La composition, qui doit viser à l'éxpression, se modifie avec la surface à couvrir," Matisse, "Notes d'un peintre," in *Ecrits et propos sur l'art*, ed. Dominique Fourcade (Paris: Hermann, 1972), pp. 42–43.

45 Matisse, "Notes of a Painter," pp. 41–42. "Quand je vois les fresques de Giotto à Padoue, je ne m'inquiète pas de savoir quelle scène de la vie du Christ j'ai devant mes yeux, mais de suite, je comprehends le sentiment qui s'en dégage, car il est dans les lignes, dans la composition, dans la couleur, et le titre ne fera que confirmer mon impression," Matisse, "Notes d'un peintre," pp. 49–50.

46 Matisse comments on all three terms in "Notes of a Painter." The term composition is the subject of the present discussion; Matisse's disregard for the "title" is revealed in the citation that has just been offered; but his remarks on the "impression" are particularly interesting in that, like Kandinsky's analysis of his three titular

types, Matisse reflects on the "word" impressionism itself: "The impressionist painters, especially Monet and Sisley, had delicate sensations, quite close to each other; as a result their canvases all look alike. The word impressionism perfectly characterizes their style, for they register fleeting impressions. It is not an appropriate designation for certain more recent painters who avoid the first impression and consider it almost dishonest." Matisse, "Notes of a Painter," p. 39. "Les peintres impressionistes, Monet et Sisley, en particulier, ont des sensations fines, peu distantes les unes des autres: il en résulte que leurs toiles se ressemblent toutes. Le mot 'impressionnisme' convient parfaitement à leur manière, car ils rendent des impressions fugitives. Il ne peut subsister pour désigner certains peintres plus récents qui évitent la première impression et la regardent presque comme mensongère," Matisse, "Notes d'un peintre," pp. 44–45.

47 See "Modernisme à Larousse," in my *Modernism Relocated: Towards a Cultural Studies of Visual Modernity* (Sydney: Allen and Unwin, 1995), for a discussion of Baudelaire's relation to the effects of "composition."

48 See Julia Kristeva, "Giotto's Joy," in *Desire in Language: A Semiotic Approach to Literature and Art*, ed. Leon S. Roudiez and trans. Thomas Gora, Alice Jardine, and Roudiez (New York: Columbia University Press, 1980), pp. 210–236.

49 This term is cited from an interview Matisse conducted with Clara T. Mac-Chesney in the summer of 1912. The interview – transcribed, translated, and revised for publication in the *New York Times Magazine*, 9 March 1913, on the occasion of the New York Armory Show – "ran under the headline, 'Famous French Artist, Whose Canvases Are One of the Features of the International Exhibition Here, Tells of His Theories and Work.'" It is reprinted in Flam, ed., *Matisse on Art*, pp. 64–69. Flam notes that "[d]espite the (often amusing) inaccuracies and confusions in MacChesney's reportage, her sometimes awkward translations from French, and her evident ignorance of art, the statements by Matisse appear to be authentic and fairly accurate" (p. 65).

50 In the interview with MacChesney cited above, for example, Matisse is reported as "indignantly" replying to a question concerning his recognition of color harmony: "I certainly do think of harmony of color, and of composition, too" (p. 66).

51 Among other French artists active in the 1910s and 1920s, it is worth noting that Fernand Léger names works from his transitional period in the mid-1920s *Abstract Composition* and *Composition (Definitive)* (1925). These compositional titles are thus attached to the most "abstract" works that Léger would produce.

52 Pierre Schneider, *Matisse*, trans. Michael Taylor and Bridget Strevens Romer (New York: Rizzoli, 1984), pp. 263, 267. Schneider writes of *La Joie de vivre* that, "[w]ith the exception of *Luxe, calme et volupté* . . . this is the only literary title in Matisse's oeuvre" (p. 242). A note on titles adds that the metaphoric, or "literary," title of a later work, *Le Silence habité des maisons*, was actually given by Louis Aragon and that "literary titles reappeared with the gouache cut-outs: thus the *Tristesse du Roi* (*Sorrows of the King*)" (p. 273, note 6).

53 Ibid., p. 280. Schneider underlines the centrality of these works elsewhere, claiming that much of Matisse's work can be interpreted as a "series of camouflaged appearances of the Golden Age" (p. 270).

54 Ibid., pp. 197, 242. Schneider refers to Kandinsky as a "radical Matissian disciple" (p. 222).

55 Ibid., p. 404.

56 Kasimir Malevich, "From Cubism and Futurism to Suprematism: The New Painterly Realism" (1915), in *Russian Art of the Avant-garde: Theory and Criticism*, ed. John Bowlt (New York: Thames and Hudson, 1988), p. 135.

57 Ibid., p. 122.

58 Ibid., pp 122–123.

59 Barbara Rose, "Introduction: The Practice, Theory, and Criticism of Art in America," in *Readings in American Art 1900–1975*, ed. Barbara Rose (New York: Praeger, 1975), p. 13.
60 Stanton Macdonald-Wright, in ibid., pp. 78–79.
61 Ibid., p. 79.
62 Wassily Kandinsky, "Reminiscences/Three Pictures" (1913), in *Kandinsky: Complete Writings on Art*, eds. Kenneth C. Lindsay and Peter Vergo, vol. 1: *1901–1921* (Boston: G. K. Hall, 1982), p. 367. This text was first published, with descriptions of Kandinsky's paintings *Komposition 4* (*Composition 4*), *Komposition 6* (*Composition 6*), and *Bild mit weissen Rand* (*Picture with White Edge*), in *Kandinsky, 1901–1913*, October 1913. In *Kandinsky: Compositions*, exh. cat. (New York: Museum of Modern Art, 1995), Magdalena Dabrowski has usefully assembled the surviving compositions (seven of the ten) painted by Kandinsky between 1910 and 1939 in the context of diagrams, sketches, preparatory, and related works. The catalogue text, available to me only after the present chapter was drafted, offers a summary of the importance of these works to Kandinsky's larger project. At the beginning of her text the significance of the title "Composition" is raised: "The descriptive, generic title 'Composition' in itself supports more than one reading. First and foremost, it defines the final, fully executed painting resulting from long and profound considerations of all of its formal elements and sections, relationships, and interplay that led to a harmony of expression. In addition, as Kandinsky's writing demonstrates, the term described the actual process of constructing the work with all of its intricacies, philosophical meanings, and references, as well as its formal complexities" (p. 12).
63 Kandinsky, "Reminiscences," in *Complete Writings*, vol. 1, p. 385. "Auf einigen Skizzen löste ich die körperlichen Formen auf, auf anderen versuchte ich, den Eindruck rein abstrakt zu erreichen. Es ging aber doch nicht. Und das kam nur daher, weil ich dem Ausdruck der Sintflut selbst unterlag, statt dem Ausdruck des *Wortes* "Sintflut" zu gehorchen. Nicht der innere Klang, sondern der äußere Eindruck beherrschte mich." Kandinsky, "Komposition 6," in *Rückblick*, ed. Ludwig Grote (Baden-Baden: Woldemar Klein Verlag, 1955), p. 37.
64 Lindsay and Vergo, "Introduction," in *Complete Writings*, vol. 1, p. 13.
65 Wassily Kandinsky, *On the Spiritual in Art* (1912), in ibid., p. 218. For the original German, see *Über das Geistige in der Kunst: Insbesondere in der Malerei* (Munich: R. Piper Verlag, 1912), pp. 104–105:

Diese Reproduktionen sind Beispiele drei verschiedenen Ursprungsquellen:
1. direkter Eindruck von der "äußeren Natur", welcher in einer zeichnerisch-malerischen Form zum Ausdruck kommt. Diese Bilder nenne ich "Impressionen";
2. hauptsächlich umbewußte, größtenteils plötzlich entstandene Ausdrücke der Vorgänge inneren Charakters, also Eindrücke von der "inneren Natur". Diese Art nenne ich "Improvisationen";
3. auf ähnliche Art (aber ganz besonders langsam) sich in mir bildende Ausdrücke, welche lange und beinahe pedantisch nach den ersten Entwürfen von mir geprüft und ausgearbeitet werden. Diese Art Bilder nenne ich "Komposition". Hier spielt die Vernunft, das Bewußte, das Absichtliche, das Zweckmäßige eine überwiegende Rolle. Nur wird dabei nicht der Berechnung, sondern stets dem Gefühl recht gegeben. See also Will Grohmann, *Wassily Kandinsky: Life and Work* (New York: Abrams, 1958), pp. 81–102.

66 Wassily Kandinsky, cited in Rose-Carol Washton Long, *Kandinsky: The Development of an Abstract Style* (Oxford: Clarendon Press, 1980), p. 122.
67 These terms are used throughout ibid.

68 Ibid., p. 89.
69 Ibid.
70 "Kandinsky drew upon Maeterlinck's theory of words to support his conviction of the expressive potential of hidden objects," ibid., p. 67.
71 Kandinsky, *On the Spiritual in Art*, in *Complete Writings*, vol. 1, p. 169.
72 Ibid., p. 147.
73 Ibid.
74 Will Grohmann discusses Kandinsky's relation to classification and theory in *Wassily Kandinsky: Life and Work* (New York: Abrams, n.d.), pp. 145–59; 179f.
75 Wassily Kandinsky, letter to Will Grohmann, November 1928, cited in ibid., p. 195. Grohmann also notes Kandinsky's "aversion for 'poetic' titles and his predilection for bare characterization," ibid., p. 220.
76 Stephen Bann's essay, "Abstract Art–A Language?," in *Towards a New Art*, pp. 125–145, summarizes the debate over the communicative possibilities of abstract art.

Chapter 7

1 Tristan Tzara, "Dada Manifesto" (1918), in *Seven Dada Manifestoes and Lampisteries*, trans. Barbara Wright (London: John Calder, 1977), pp. 12–13. "En collant des étiquettes, la bataille des philosophes se déchaîna (mercantilisme, balance, mesures méticuleuses, et mesquines)," Tzara, "Manifeste Dada," in *Oeuvres Complètes*, ed. Henri Béhar, vol. 1: *1912–1924* (Paris: Flammarion, 1975), p. 366.
2 John Cage, "26 Statements re Duchamp," *Art and Literature*, no. 3 (Autumn-Winter 1964), p. 10.
3 Werner Spies, ed., *Max Ernst: A Retrospective*, exh. cat. (London: Tate Gallery and Munich: Prestel, 1991), p. 26.
4 "La Peinture au défi" was written as the introduction to the *Exposition de collages* at the Galerie Gohmans, Paris, March 1930.
5 Louis Aragon, "The Challenge to Painting" (1930), in *The Surrealists Look at Art*, ed. Pontus Hulten (Venice, California: Lapis Press, 1990), p. 56.
6 Ibid., pp. 65–66.
7 Clement Greenberg, "'American-Type' Painting" (*Partisan Review*, Spring 1955), in *The Collected Essays and Criticism*, ed. John O'Brian, vol. 3: *Affirmations and Refusals, 1950–1956* (Chicago: University of Chicago Press, 1993), p. 226. It is curious that Greenberg locates what originates as a formalist claim about scale in the context of a pictorial *narrative*. The sentence from which this quoted phrase is taken reads: "That these pictures were big was no cause for surprise: the abstract expressionists were being compelled to do huge canvases by the fact that they had increasingly renounced an illusion of depth within which they could develop pictorial incident without crowding; the flattening surfaces of their canvases compelled them to move along the picture plane laterally and seek in its sheer physical size the space necessary for the telling of their kind of pictorial story."
8 Ernst's account is cited and briefly discussed in William A. Camfield, *Max Ernst: Dada and the Dawn of Surrealism*, exh. cat. (Houston: Menil Collection and Munich: Prestel, 1993), p. 62. The textual "interpretations" he suggests are as follows:

> "Above the clouds midnight passes. Above midnight glides the invisible bird of day. A little higher than the bird the ether spreads and the walls and roofs float." – "At Thunderstone the lovely centrifugal drum hums unconsciously in soundless space." "Carefully poisoned, adolescent girls are put in specimen jars. The little American girl we're promoting this spring gleefully offers her breast to seals and sharks. The human eye is a network of glass tears, salted snow and congealed air."

9 There are several at least partial exceptions to this approach. In "Arcimboldo, or Magician and Rhétoriquer," in *The Responsibility of Forms: Critical Essays on Music, Art, and Representation*, trans. Richard Howard (Berkeley: University of California Press, 1985), Roland Barthes, for example, encounters Ernst's titles in the course of his essay on the artist, entertainer, and stager of performances who produced "composite heads" for twenty-five years at the court of the sixteenth-century German emperors, especially Maximillian. Confronting Arcimboldo's strange vegetal portraits, Barthes finds that his "reading oscillates continually: only the title manages to arrest it, makes the picture the portrait of a *Cook*, because from the dish we metonymically infer the man whose professional utensil it is" (p. 131). As with Ernst, he claims, "baroque representation turns on language and its formulas. Under the picture [Arcimboldo's] hums the vague music of such ready-made phrases as *Le style, c'est l'homme*, or in Max Ernst's case, *The style is the tailor, The work shows the workman, The dish reveals the cook*, etc." (p. 132). Collage (and the collage-like substitutions and juxtapositions of Arcimboldo) functions metonymically in the sense that the imported material has a presence which is not only interruptive, but also self-declarative. Its "part" offers a cover for the "whole."

10 Werner Spies, "An Open-Ended Oeuvre," in Camfield, *Dada and the Dawn of Surrealism*, p. 18.

11 Werner Spies, *Max Ernst Collages: The Invention of the Surrealist Universe*, trans. John William Gabriel (New York: Abrams, 1988), p. 25.

12 Other lists include one of the works in the 1921 exhibition at Au Sens Pareil in Paris: *The Muse's Spring Dress, The Little Tear Gland That Says Tic-Tac*, and others. As Ernst observes in "Biographical Notes: Tissue of Truth, Tissue of Lies," in Spies, *Max Ernst: A Retrospective*, pp. 284–285:

> [T]he first fruits of the frottage technique were collected under the title *Histoire Naturelle*, from "The Sea and the Rain" to "Eve, the Only One Left to Us." (Their titles: The Sea and the Rain – A Glance – Little Tables Around the Earth – Ice-flower Shawl – Earthquake – The Pampas – He Will fall far From Here – False Positions – Confidences – She Guards Her Secret – Whiplashes or Lava Threads – Fields of Honour Flood Seismic Plants – Scarecrows – The Chestnut Tree's Take-off – Scars – The Lime is Docile – The Fascinating Cypress – The Habits of Leaves – The Idol – Caesar's Palette – Shaving the Walls – Come into the Continents – The Vaccinated Bread – Teenage Lightning – Conjugal Diamonds – The Origin of the Clock – In the Stable of the Sphinx – Dead Man's Repast – The Wheel of Light – The Escaped – Solar Money-System – To Forget Everything – Stallion and Bride of the Wind – Eve, the Only One Left to Us.)

13 Max Ernst, "Which Collage Titles Should Every Child Worthy of the Name Know by Heart?," in Spies, *Max Ernst: A Retrospective*, p. 314.

14 See the "Speculations" section of Marcel Duchamp's *A L'infinitif: Manuscript Notes 1912–20*, unpag.; cited in note 57, chapter 2.

15 Cited in Spies, *Max Ernst: A Retrospective*, p. 295.

16 Spies, *Max Ernst Collages*, p. 61.

17 Ibid., p. 62.

18 Ibid.

19 Spies, *Max Ernst: A Retrospective*, p. 26.

20 Ibid., pp. 27, 33.

21 Aragon, p. 70.

22 Ibid., p. 57.

23 Salvador Dalí, "The King and Queen Traversed by Swift Nudes" (*Oui* 2 [6 October 1976]) in Yvonne Shafir, Ph.D. diss., Columbia University, 1995, p. 319.

24 Ulf Linde, "MARiée CELibataire," in *Marcel Duchamp: Ready-Mades, etc. (1913–1964)* (Milan: Galleria Schwarz, 1964), p. 56.
 Concerning the title of this work, Pontus Hulten notes: "It is . . . hard to believe that among the literature on each of the ready mades, no mention was made of the fact that in French this object is also called an *égouttoir*, meaning approximately, a 'de-dropper' (*goutter* in French means 'to drop'), and *goût*, meaning 'taste', has almost the same sound. Hence *égouttoir* could mean 'the removal of taste', good or bad, from art." " 'The Blind Lottery of Reputation' or the Duchamp Effect," in *Marcel Duchamp: Work and Life* (Cambridge: MIT Press, 1993), p. 16.

25 Marcel Duchamp, in "The Richard Mutt Case" (*The Blind Man P.B.T.*, May 1917), cited in Arturo Schwarz, *The Complete Works of Marcel Duchamp* (New York: Abrams, n.d.), pp. 466–467.

26 William Camfield, *Fountain*, exh. cat. (Houston: Menil Collection and Fine Art Press, 1989), p. 22. On p. 53, he adds, "There is irony, too, in the function of this object, transformed by its new title from a receptacle for waste fluids to a dispenser of life-giving water, transfigured from a fixture serving the dirty, biological needs of men to a form suggestive of a serene seated buddha or a chaste, veiled madonna. Even the signature participates – scruffy in form in contrast to the pristine elegance of the urinal, and evocative not of buddhas and madonnas but of the popular cartoon characters Mutt and Jeff."

27 Linde, p. 62.

28 Schwarz, *Complete Works*, p. 456.

29 Robert Lebel, *Marcel Duchamp* (New York: Grove Press, 1959), p. 39.

30 Arturo Schwartz, "Contributions to a Poetic of the Ready-Made," in Walter Hopps, Arturo Schwartz, (Ulf Linde), *Marcel Duchamp: Ready-Mades, etc. (1913–1964)* (Milan: Galleria Schwarz, 1964), p. 36.

31 Schwarz, *Complete Works*, p. 526.

32 Robert Lebel, "Marcel Duchamp: Whiskers and Kicks of All Kinds," in *Marcel Duchamp*, trans. George Heard Hamilton (New York: Paragraphic Books, 1959), p. 96.

33 "Apropos of 'Readymades,' " in *Salt Seller (Marchand du Sel): The Writings of Marcel Duchamp*, eds. Michel Sanouillet and Elmer Peterson (New York: Oxford University Press, 1973), p. 141.

34 Schwarz, *Complete Works*, p. 449.

35 Ibid., p. 442.

36 Ibid.

37 Ibid.

38 Ibid., p. 587. This point is made in the context of Duchamp's "refusal to co-operate with the Paris organizers of the Salon Dada" in 1921. Sanouillet and Schwarz also cite one of the reasons for his reluctance, given by the artist in a letter to the Paris organizers: "[T]he word exhibit [*exposer*, in French] resembles the word to marry [*épouser*, in French]."

39 Amelia Jones makes this suggestion in *Postmodernism and the En-Gendering of Marcel Duchamp* (Cambridge: Cambridge University Press, 1994). She writes of Duchamp's inscriptions and "readymade text-object systems":

> Because these titles and texts rarely explicitly refer to the object, their visual and material signification is shifted to other levels through wordplay, both leading the viewer/reader away from the signatory to other regions of association and also, inevitably, compelling her or him to attempt to reconstruct an explanatory *sujet de l'énonciation* to verify or clarify elusive linguistic reference (pp. 137–138).

Her discussion of the relation between subjects, names, and signatures makes use of

several important contributions in this area: Peggy Kamuf, *Signature Pieces: On the Institution of Authorship* (Ithaca: Cornell University Press, 1988); René Major, "Names: Proper and Improper," trans. John Forrester, in *Postmodernism: ICA Documents*, ed. Lisa Appignanesi (London: Institute of Contemporary Art, 1986), pp. 185–197; and Thierry de Duve, ed., *The Definitively Unfinished Marcel Duchamp* (Halifax: Nova Scotia College of Art and Design, and Cambridge: MIT Press, 1991), pp. 301–302.

40 I discuss the relation between Freud's famous description of the dream work in chapter 6 of *The Interpretation of Dreams* and the strategies of the avant-garde, in "Translation/(Procession)/Transference: Freud, Kosuth and the Scene/Seen of Writing," in my *Modernism Relocated*, pp. 114–145.

41 Marcel Duchamp, in interview with James Johnson Sweeney, in "Eleven Europeans in America," *Bulletin of the Museum of Modern Art* 13, no. 4–5 (1946), pp. 19–21.

42 Schwarz, *Complete Works*, p. 28.

43 Ibid. Schwarz refers to an interview between Duchamp and himself in which the function of the title as a non-visible color was discussed.

44 This phrase is reported by Schwarz in his own "conversations" with Duchamp. See ibid., p. 29.

45 Cited in Arturo Schwarz, "Contributions to a Poetic of the Ready-Made," in *Marcel Duchamp: Ready-Mades*, p. 19, note 4, and in *Complete Works*, p. 31 (in a slightly different translation).

46 Lawrence D. Steefel, Jr., *The Position of Duchamp's Glass in the Development of His Art* (New York: Garland, 1977), p. 48.

47 André Breton, "Les Mots sans rides" ("Words without Wrinkles), *Littérature*, 1 December 1922), cited in Schwarz, *Complete Works*, pp. 508–509.

48 Ibid.

49 Schwarz, *Complete Works*, p. 461.

50 Ibid., p. 487.

51 Cited in ibid.

52 See ibid., p. 457.

53 Marcel Duchamp, cited in Steefel, p. 26.

54 Schwarz, *Complete Works*, p. 405.

55 Molly Nesbit, "Ready-Made Originals: The Duchamp Model," *October*, no. 37 (Summer 1986), pp. 61–62.

56 Ibid., p. 60.

57 Ibid., p. 64.

58 See Donald Kuspit, "Duchamp, Matisse, and Psychological Originality: The End of the Creative Imagination," *New Art Examiner* 20, no. 9 (May 1993), p. 17.

59 I explore this relation as it is staged in the visual, literary, and theoretical trope of the "dictionary" from the mid-nineteenth to the late twentieth century. See "Modernisme à Larousse," in my *Modernism Relocated*.

60 Lebel, *Marcel Duchamp*, p. 46.

61 The phrase is Duchamp's (from the "Notes"), but it has been used as the title of what is to date the fullest, and most theoretically provocative, account of Duchamp's investigation of the relation between names, words, objects, colors, and painting. See Thierry de Duve, *Pictorial Nominalism: On Marcel Duchamp's Passage from Painting to the Readymade*, trans. Dana Polan with the author (Minneapolis: University of Minnesota Press, 1991). De Duve sets Duchamp's work in a "field of resonance[s]" between industrial mass production, psychoanalysis, "abstract" painting (especially Kandinsky's essentialist understanding of the signification of color), and the symbolic and nominal functions of words. He makes several remarks about Duchamp's titles, including the speculation that "literally outside of time, the

irruption of the phallus would return with a metonymic regularity, as a sort of punctuation, in Duchamp's work: the apostrophe of *Tu m'*, the comma in the *Large Glass*, the colon in *Etant Donnés*" (p. 41). De Duve's discussion of the signification of color within the "metaphoric ontology" of visual modernism is especially useful. He considers the work of Duchamp and Kandinsky as operating on a hinge or switch system around the crucial year of 1912, when Duchamp (the nominalist) resigned from painting and Kandinsky (the essentialist) was consolidating the non-iconic image: "The issue at stake in the relationship between color and its name in Kandinsky . . . was nothing less than the production of a foundational ideologeme, not only in Kandinsky's painting but also in the whole of abstract painting. . . . Color, which with form – and before it – is the semiotic *element* of the painter, manifests an essential solidarity with the word that names it" (p. 124).

62 This work is commonly titled *Dances at the Well I*, and corresponds to number 415 in the Armory Show catalogue.

63 Maria Lluïsa Borràs, *Picabia* (New York: Rizzoli, 1985), p. 106.

64 The development of "musical" theories of painting had many origins and destinies. In Picabia's immediate circle, members of the Puteaux group and Apollinaire made frequent reference to the musical analogy – one of the chief theoretical underpinnings for the international development of non-iconic abstraction in these years. Borràs points to *Tarantella* (1912) ("the very title of which alludes to a melody"), exhibited at the Salon de Juin in Rouen in 1912, as one of the first of Picabia's images almost completely given over to the musical play of color and form. Predictably, the local reviewers expressed their perplexity at this new confection by offering speculative titles for works at the Salon: "'A motor accident,' 'A Persian carpet,' 'A volcano in eruption,' 'The Earth in formation.'. . . And what is most curious of all is that all of them were perfectly right, though the canvas actually bore the title *Landscape*!," cited in ibid., p. 92.

65 I develop a fuller discussion of Picabia's machinic-portraits and their relation to what Gilles Deleuze and Félix Guattari term "diagrammicity" in "After the Wagnerian Bouillabaisse: Critical Theory and the Dada and Surrealist Word-Image," in Judi Freeman, *The Dada and Surrealist Word-Image*, exh. cat. (Los Angeles: Los Angeles County Museum of Art and Cambridge: MIT Press, 1989), pp. 57–96, a version of which is published in my *Modernism Relocated*. Parts of my discussion here draw on this earlier text.

66 See Charles Baudelaire, "The Salon of 1845," in *Art in Paris 1845–1862: Salons and Other Exhibitions Reviewed by Charles Baudelaire* (Oxford: Phaidon, 1965), p. 20.

67 Cited in Borràs, p. 100.

68 As noted in ibid., p. 113, note 91, Picabia revealed these origins in an interview with Paul Guth, published in *La Gazette des lettres* (28 June 1947 [date given as "June 1948" on p. 100]).

69 John House, in *Post-Impressionism: Cross Currents in European Painting*, exh. cat., eds. House and MaryAnne Stevens (London: Royal Academy of Arts and New York: Harper and Row, 1979), p. 139.

70 "Expression, for me, does not reside in passion bursting forth from a human face or manifested by violent movement. The entire arrangement of my picture is expressive," Henri Matisse, "Notes of a Painter" (1908), in *Matisse on Art*, ed. Jack Flam (Berkeley: University of California Press, 1995), p. 38.

71 William Camfield, "Jean Crotti and Suzanne Duchamp," in *Tabu Dada: Suzanne Duchamp and Jean Crotti 1915–1922*, eds. Camfield and Jean-Hubert Martin (Bern: Kunsthalle, 1983), p. 10.

72 In *Dada: Performance, Poetry, and Art* (Boston: Twayne Publishers, 1984), p. 21, John D. Erickson sees these images as "parody-machines through which he (Picabia) sought to attain 'the summit of symbolism.'" The phrase "the summit of sym-

bolism" is cited from Picabia's interview, "French Artists Spur on American Art," *New York Tribune*, 24 October 1915, sec. 4, p. 2.

73 As discussed with respect to Duchamp in the previous section, Molly Nesbit has explored the relevance of curricula reforms in France in the 1880s that promoted technical drawing by rote and drill and thus constituted a "grammar of the commodity," "ratifying industrial production." See Nesbit, pp. 53–64.

74 Francis Picabia, cited in William Camfield, *Francis Picabia: His Art, Life, and Times* (Princeton: Princeton University Press, 1979), p. 82.

75 Francis Picabia, cited by M. B. [Marcel Boulanger?], in "Le Dadaisme n'est qu'une farce inconsistante" (*L'Action française*, 14 February 1920), cited in Camfield and Martin, *Tabu Dada*, p. 20, 37.

76 Jacqueline Feldman, *La Sexualité du Petit Larousse; Ou, Le Jeu du dictionnaire* (Paris: Editions Tierce, 1980), p. 5.

77 See Borràs, p. 159, note 5:

> [I]t was to become customary with Picabia to hunt for phrases in the pink pages of the *Petit Larousse*. "Fille née sans mère" is a modified *ready-made*, since the translation given by this dictionary of *Prolem sine matrem creatam* (verse 553 of Ovid's 2nd *Metamorphosis*, quoted by Montesquieu in *L'Esprit des lois*) is "enfant né sans mère."
>
> Picabia's enigmatic phrases had puzzled me exceedingly and were constantly in my mind, so that it was very simple for me to connect them with the pink pages in the *Petit Larousse* when I was going through these one day in search of something that had nothing to do with Picabia. This occurred early in 1975. I at once looked up the first edition of the dictionary (which dates from 1906) in the Bibliothèque Nationale in Paris and was able to confirm that it already contained the same pink pages devoted to Latin and foreign expressions.

Subsequent notes reveal other titular origins from the *Larousse*, including the exclamation *De Zayas! De Zayas!*, which may derive from "*Thalassa! Thalassa!* Exclamation of joy uttered by the ten thousand Greeks . . . when . . . they perceived the shores of the Hellespont" (p. 159, note 10); see also p. 159, notes 22 and 23.

78 Gabrielle Buffet, cited in ibid., pp. 155–156.

79 Cited by Borràs, p. 175.

80 Ibid., pp. 197–198.

81 See ibid., p. 201.

82 Ibid., p. 236. Borràs notes that while their colors and geometric forms were "simplified" and "elemental," these works also evidence "several attempts at diversification": "[T]here are titles alluding to instruments, apparatuses, tools, etc. . . . But there are other pieces that show a striking similarity to the works El Lissitzky was producing at the same time" (pp. 236–237).

83 "L'image peinte et le mot/sont le cercle des dialectiques de la création./Ce qu'un mot déterre des profondeurs de l'esprit,/l'image le rend,/ce fruit magique/sans lequel la conscience ne saurait construire./C'est par des images de l'objet en perspective/que notre conscience a découvert leur physique," Roberto Matta, "La Terre est un homme," ("The Earth Is a Man"), in G. Ferrari, ed. *Matta: Entretiens morphologiques, Notebook No. 1, 1936–1944* (London: Sistan, 1987), p. 91.

84 See Hal Foster, *Compulsive Beauty* (Cambridge: MIT Press, 1993), pp. 93–95.

85 See my "After the Wagnerian Bouillabaisse." My discussion of "pensée-poésie" in Magritte and Miró draws material from this source.

86 Baudelaire, "Salon of 1845," p. 32.

87 Tristan Tzara, "Réponse à une enquête," in *Oeuvres complètes*, vol. 1, p. 417. See note on p. 712 for the provenance of this autographed letter.

88 Tristan Tzara, "Manifeste Dada" (1918), in *Oeuvres Complètes*, vol. 1, p. 363.

89 Hans Bellmer, "La Petite Anatomie de l'image," cited in Renée Riese Hubert, *Surrealism and the Book* (Berkeley: University of California Press, 1988), p. 153.

90 J. H. Matthews, *Languages of Surrealism* (Columbia: University of Missouri Press, 1986), p. 21.

91 Patrick Waldberg, *Max Ernst* (Paris: Jean-Jacques Pauvert, 1958), p. 136. In *Theory of the Avant-Garde*, trans. Michael Shaw (Minneapolis: University of Minnesota Press, 1984), p. 53, it is across these terms that Peter Bürger understands and defends André Breton's iterated injunction to *poeticize*:

> The automatic texts [of Surrealism] also should be read as guides to individual production. But such production is not to be understood as artistic production, but as part of a liberating life praxis. This is what is meant by Breton's demand that poetry be practiced (*pratiquer la poesie*). Beyond the coincidence of producer and recipient that this demand implies, there is the fact that these concepts lose their meaning: producers and recipients no longer exist. All that remains is the individual who uses poetry as an instrument for living one's life as best one can.

Bürger does, however, go on to admit the problem of "solipsism" that might arise in this enterprise of poeticization.

92 In addition to the texts from the later 1950s already cited, see "L'Inspiration," first published in *Magritte: Paintings, Gouaches, Collages*, exh. cat. (New York: Iolas Gallery, 1962), in René Magritte, *Écrits Complets*, ed. André Blavier (Paris: Flammarion, 1979), p. 557.

93 In *"Peinture-Poésie*, Its Logic and Logistics," in *Joan Miró*, exh. cat. (New York: Museum of Modern Art, 1993), pp. 15–82, Carolyn Lanchner offers a detailed account of the development of Miró's "peinture-poésie." Some of these concerns are discussed in relation to Miró's titles, below.

94 René Magritte, letter to M. Hornik, 1959, in Magritte, *Écrits Complets*, p. 379 (Magritte's emphasis).

95 René Magritte, "Jan Walravens: Rencontre avec Magritte" ("Ontmoeting met René Magritte," *De Vlaamse Gida*, November 1962), in ibid., p. 537.

96 René Magritte, letter to Aliqué, 11 June 1959, in ibid., p. 448, note 2.

97 Magritte, "Jan Walravens," p. 539.

98 Magritte, letter to Hornik, May 8, 1959, in *Écrits Complets*, p. 379.

99 René Magritte, "Sur les titres," in ibid., p. 263.

100 "Le titre entretient avec les figures peintes le même rapport que ces figures entre elles. Les figures sont réunies dans un ordre qui évoque le mystère. Le titre est réuni à l'image peinte selon le même ordre. Par exemple, le tableau "La Mémoire" montre une figure de plâtre sur laquelle s'étale une tache de sang. Lorsque j'ai donné ce titre à ce tableau, j'ai senti que les deux allaient bien ensemble. On peut parler d'un tableau et de son titre. . . . [L]e tableau n'est pas l'illustration des idées suivantes," Magritte, "Jan Walravens," pp. 537–538.

101 In "This Is Not René Magritte," *Artforum* 5, no. 1 (September 1966), p. 33, Roger Shattuck, discussing Magritte's refutation of "dictionary convention," notes, apropos the painting *L'Ame des bandits* (*The Soul of Bandits*, 1960), that "the page [with the entry "violin"] in the 1950 Larousse . . . may have been at Magritte's elbow" as this work was produced.

102 Ronald Alley, *Catalogue of the Tate Gallery's Collection of Modern Art Other Than Works by British Artists* (London: Tate Gallery, 1981), p. 464.

103 See Laurie Edson, "Confronting the Signs: Words, Images, and the Reader-Spectator," *Dada and Surrealism* no. 13 (1984), pp. 90–91.

104 Michel Foucault, *This Is Not a Pipe, with Illustrations and Letters by René Magritte*, trans. and ed. James Harkness (Berkeley: University of California Press, 1983). An

early version of the essay was published in *Les Cahiers de chemins*, 1968. An expanded version was published as *Ceci n'est pas une pipe* (Montpellier: Editions Fata Morgana, 1973).

105 Foucault, *This Is Not a Pipe*, p. 27.

106 Ibid., p. 19.

107 Ibid., p. 116.

108 See Rosalind E. Krauss and Margit Rowell, *Joan Miró: Magnetic Fields*, exh. cat. (New York: Solomon R. Guggenheim Museum, 1972), and Sidra Stich, *Joan Miró: The Development of a Sign Language*, exh. cat. (St. Louis: Washington University Gallery of Art, 1980).

109 Joan Miró, cited in David Burnett, "The Poetics of the Paintings of Miró," *Artscanada*, no. 238–239 (December–January 1980–81), p. 6.

110 Stich, p. 8.

111 Lanchner, p. 54.

112 Angelica Zander Rudenstine, *The Guggenheim Museum Collection: Paintings 1880–1945*, vol. 2 (New York: Solomon R. Guggenheim Museum, 1976), p. 520, notes: "The anthropomorphic designation '*Personnage*' is Miró's own. In correspondence with the Museum (February 1967), he specifically rejected the vagueness of *Composition* and substituted the more suggestive '*Personnage*' ('*Le titre marqué de Composition me semble gratuit, j'aimerais que vous mettiez Personnage*')." The painting was known as *Personnage* as early as 1937, when it was exhibited as no. 117 under that title at the Musée du Jeu de Paume (*Origines et développement de l'art international indépendant*, 30 July–31 October 1937). In *Joan Miró: Life and Work* (New York, 1962), J. Dupin emphasizes that like so many works from the mid-1920s, *Personage* (which he called *Painting*), was not explicitly titled when it was painted; and that Miró often "strenuously objected" "to the misleading (and sometimes vulgarizing) titles currently attached to some of the works" (summarized by Rudenstine).

113 Cited in Camfield, *Dada and the Dawn of Surrealism*, p. 95.

114 "[J]'ai fait des personnages pour *monter* sur le train de vision des autres." In Edouard Glissant, "Terres Nouvelles" ("Matta in New Worlds"), Galerie de Dragon, Paris, 1956.

115 Joan Miró, letter to Pierre Matisse, Barcelona, Pasaje Credito 4, 7 Februrary 1934; in *Joan Miró: Selected Writings and Interviews* ed. Margit Rowell (New York: Da Capo Press, 1992), p. 124.

116 Joan Miró, letter to Pierre Matisse, Montroig, 12 October 1934; in ibid., p. 124.

117 Joan Miró, letter to Pierre Matisse, Barcelona, Pasaje Credito 4, 19 February 1936; in ibid., p. 125.

118 Joan Miró, letter to Pierre Matisse, Barcelona, Pasaje Credito 4, 17 December 1934; in ibid., p. 125.

119 Ibid.

120 Stich, *The Development of a Sign Language*, pp. 39, 45.

121 See Jennifer Mundy, "Tanguy, Titles, and Mediums," *Art History* 6, no. 2 (June 1983), pp. 199–200. This article catalogues numerous examples of the cultivation by Tanguy, often with the contrivance of other Surrealists, of enigma and mysteriousness.

122 Ibid., p. 201.

123 Yves Tanguy, interview with Sweeney, "Eleven Europeans," p. 23, cited in ibid.

124 André Breton, "The Pearl Is Moved, in My Eyes," in *Matta Coïgitum*, exh. cat. (London: Hayward Gallery, 1977), p. 23.

125 André Breton, "Three Years Ago," in ibid., p. 48.

126 Matta, "Sensitive Mathematics' Architecture of Time," *Minotaure*, no. 11 (1938).

127 Gordon Onslow-Ford, "Notes on Matta and Painting (1937–1941)," in Ferrari, ed., p. 24.
128 Julien Levy, *Memoir of an Art Gallery* (New York: G. P. Putnam's Sons, 1977), in Ferrari, ed., p. 247.
129 Lionel Abel, *The Intellectual Follies: A Memoir of the Literary Venture in New York and Paris, 1929–1979* (New York: W. W. Norton, 1984), p. 101.
130 Ibid., pp. 101–102.
131 Cited by Sidney Janis, in "The School of Paris Comes to the U.S.," *Decision II*, no. 5–6 (November–December 1944).
132 Matta, "Inscape," in Ferrari, ed., p. 219.
133 Matta, in ibid., p. 227.
134 Matta, "Matta Physics," in ibid., p. 226.
135 Matta, "The Automatic Descriptions," in ibid., p. 229.
136 Matta, "The Disaster of Mysticism," in ibid.
137 In "The Roses' Green Stalks," in ibid., p. 239, Matta wrote an account of his punning title *Le Vertige d'Eros*: "The title came to me gradually. There was a great deal of green and red: *The roses' green stalks* slowly turned into *Le vertige d'Eros*. Is it the expansion of the labyrinth, not just in its spatial meaning, that shows up as much in the significant as in desire? Falling, rising, in an element that is neither air nor liquid."
138 Matta, "Letters to Charles," in ibid., p. 235.
139 These are the titles of the works listed as nos. 9 and 12 in the pamphlet for "Matta," an exhibition presented at the Institute of Contemporary Arts in London, 16 January–15 February 1951.
140 Matta, in ibid.
141 This is the title of a painting of 1952–53 in the Peggy Guggenheim Collection, Venice.

Chapter 8

1 Stéphane Mallarmé, *Oeuvres Complètes*, eds. H. Mondor and G. Jean-Aubry (Paris: Gallimard, 1945), p. 872.
2 Emile Hennequin, cited by Stephen F. Eisenman, in *The Temptation of Saint Redon: Biography, Ideology, and Style in the* Noirs *of Odilon Redon* (Chicago: University of Chicago Press, 1992), p. 203. Other phrases from Hennequin's discussion reinforce the cut-out, constructed nature of the Flaubert text. He writes of its "synthesis of the particular in the general," its "dissection," its "composition of discrete and analytical phrases," its "adversary alliances," and its "ideal contradictions." This is a vocabulary that remarkably anticipates (right down to the identification of "analytic" and "synthetic" moments) the language of constructed form that accompanied the Cubist counter-compositional revolution.
3 Yve-Alain Bois, "The Limit of Almost," in *Ad Reinhardt*, exh. cat. (New York: Museum of Modern Art and Rizzoli, 1991), p. 19.
4 Meyer Schapiro, "On Perfection, Coherence, and Unity of Form and Content" (1966) in *Theory and Philosophy of Art: Style, Artist, and Society, Selected Papers*, vol. 4 (New York: Braziller, 1994), p. 49. See also "The Great Outsider," Willibald Sauerländer's review of this collection of Schapiro's essays, in *New York Review of Books*, 2 February 1995, pp. 28–32: "Schapiro's principal difference from Panofsky lay in his stress on the limitations of 'our perception of such complex wholes as works of art.' He pointed out that rather than seeing a work as a unified whole, we frequently focus on only a few selected aspects of it and view it in the light of past

experience. Qualities such as the perfection and coherence of the whole thus appear to us not as an immediate certitude but as a hypothetical judgment, which each viewer modifies through fresh observations and interpretations" (p. 28).

5 Francis Valentine O'Connor and Eugene Victor Thaw, eds., *Jackson Pollock: A Catalogue Raisonné of Paintings, Drawings, and Other Works*, vol. 1: *Paintings, 1930–1947* (New Haven: Yale University Press, 1978), p. xviii.

6 Donald Kuspit, "Symbolic Pregnance in Mark Rothko and Clyfford Still" (1978), in *The Critic Is Artist: The Intentionality of Art* (Ann Arbor: UMI Research Press, 1984), p. 199.

7 William Rubin, "Pollock as Jungian Illustrator: The Limits of Psychological Criticism," *Art in America* 67, no. 7 (November 1979), pp. 104–123, and 67, no. 8 (December 1979), pp. 72–91.

8 Rubin, "Pollock," *Art in America* 67, no. 8, p. 72. The randomness and indeterminacy of Pollock's titling methods are attested by other writers. Claude Cernuschi cites from an account by B. H. Friedman, *Jackson Pollock: Energy Made Visible* (New York: McGraw-Hill, 1972), who notes that "Pollock frequently encouraged the people close to him, whose sensitivity he trusted, to free associate verbally around the completed work. From their responses, from key words and phrases, he often, though not always, chose his titles – typically vague, metaphorical, or poetic." Cited in *Jackson Pollock: Meaning and Significance* (New York: Icon, 1992), p. 155.

9 Willem de Kooning, "What Abstract Art Means to Me," *Museum of Modern Art Bulletin* 18, no. 3 (Spring 1951), in *Readings in American Art 1900–1975*, ed. Barbara Rose (New York: Praeger, 1975), pp. 125–127.

10 Ibid., p. 126.

11 Ibid., pp. 126, 127.

12 Willem de Kooning, interview by David Sylvester, 30 December 1969 (first published in "Content is a Glimpse," *Location*, Spring 1963), in Rose, p. 127.

13 Vivian Endicott Barnett, *Handbook: The Guggenheim Museum Collection 1900–1980* (New York: Solomon R. Guggenheim Museum, 1980), p. 418.

14 Clement Greenberg, "After Abstract Expressionism" (*Art International*, 25 October 1962), in *The Collected Essays and Criticism*, ed. John O'Brian, vol. 4: *Modernism with a Vengeance, 1957–1969* (Chicago: University of Chicago Press, 1993), p. 124.

15 Franz Kline, interview with David Sylvester (*Living Arts*, Spring 1963), in Rose, p. 133.

16 Barnett Newman, "The Sublime Is Now" (*Tiger's Eye*, December 1948), in *Selected Writings and Interviews*, ed. John P. O'Neill (New York: Knopf, 1990), pp. 172, 173.

17 Cited in Rose, pp. 134–135.

18 Clyfford Still, in Ronald Alley, *Catalogue of the Tate Gallery's Collection of Modern Art Other Than Works by British Artists* (London: Tate Gallery, 1981), p. 710.

19 Clyfford Still, in *Clyfford Still: Paintings in the Albright-Knox Art Gallery* (1966), in Rose, pp. 139–140.

20 Ibid., pp. 140, 142.

21 Robert Rauschenberg, in *Sixteen Americans* (1959), in Rose, p. 149.

22 Ibid., p. 150.

23 Rosalind E. Krauss, *The Optical Unconscious* (Cambridge: MIT Press, 1993), p. 21. For a review of this publication and Peter Wollen, *Raiding the Icebox: Reflections on Twentieth-Century Culture* (Indianapolis: Indiana University Press, 1993), see my "Modernism across the Board," *Art and Text*, no. 47 (January 1994), pp. 66–68.

24 Krauss, *Optical Unconscious*, pp. 16, 149, 151, 152, 154, 156, 157.

25 Allan Kaprow, *Essays on the Blurring of Art and Life*, ed. Jeff Kelley (Berkeley: University of California Press, 1993), p. 3.

26 Allan Kaprow, "Assemblage, Environments, and Happenings," in *Assemblage, Envi-*

ronments, and Happenings (New York: Abrams, 1966), p. 159.

27 Ibid., p. 161.

28 Ibid., pp. 161–162.

29 Ibid., p. 164.

30 Ibid., pp. 165, 169.

31 Ibid., pp. 176, 178.

32 Ibid., p. 181.

33 Michael Kirby, *Happenings: An Illustrated Anthology* (New York: Dutton, 1965), p. 21.

34 Kaprow, *Assemblage*, p. 184, note.

35 Ibid., pp. 184, 186, 187, 188.

36 Ibid., p. 198.

37 Ibid.

38 Ibid., pp. 198, 202, 206, 207.

39 Ibid., pp. 203–204.

40 The paradoxical refurbishment and denial of compositionality by the neo-avant-garde is not restricted to Kaprow. In 1958 John Cage taught an "experimental composition" course at the New School for Social Research, which was attended by Kaprow, Dick Higgins, and others who would be prominent in the art scene during the next decade. The Fluxus movement offered another moment in which the contradictions of the drive for composition and the perceived need radically to reconstitute it were caught up in a spiral of debate and definitional anxiety. As was often the case in the postwar period, some of this discussion is predicated on the title, as the following exchange printed on the front cover of *In the Spirit of Fluxus*, exh. cat. (Minneapolis: Walker Art Center, 1993), suggests:

> LM: A publication called . . .
> GM: FLUXUS, and that's it, that was going to be like a book, with a title, that's all.

The credits-page of this "publication" contains a "caveat lector" that begins: "Attributing dates, dimensions, titles, even authorship to Fluxus works is often a tricky affair." Each of the identifying coordinates associated with the catalogue, and with compositional order, are questioned in the documentary retrieval of Fluxus. Yet, at the same time, Fluxus as a movement was predicated on a kind of pseudo-encyclopedism that flourished in the context of dictionary-like self-reinventions, and compositional divisions. I develop a discussion of the relation of Fluxus to a long tradition of flirtation by the visual avant-garde with dictionary knowledge in "Modernisme à Larousse," in my *Modernism Relocated*, pp. 1–36.

41 Susan Sontag, "Non-Writing and the Art Scene" (*New York Herald Tribune*, 25 July 1965), in *The New Art: A Critical Anthology*, ed. Gregory Battcock (New York: E. P. Dutton, 1966), pp. 152–160.

42 For a critical discussion of this and related positions, see Sohnya Sayres, *Susan Sontag: The Elegiac Modernist* (New York: Routledge, 1990).

43 The genealogy of this position and the inflections it has taken in both art history and criticism are legion. Lawrence Gowing gives us access to a version of this mythology with reference to the seventeenth century: "Vermeer seems almost not to care, or even to know, what it is that he is painting. What do men call this wedge of light? A nose? A finger? What do we know of its shape? To Vermeer none of this matters, the conceptual world of names and knowledge is forgotten, nothing concerns him but what is visible, the tone, the wedge of light," *Vermeer* (London: Faber and Faber, 1952), p. 1, cited in Svetlana Alpers *The Art of Describing: Dutch Art in the Seventeenth Century* (Chicago: University of Chicago Press, 1983), p. 37.

44 Douglas Crimp, with Adam Rolston, *AIDS Demo Graphics* (Seattle: Bay Press, 1990), pp. 13–14:

> That simple graphic emblem – SILENCE = DEATH printed in white Gill sanserif underneath a pink triangle on a black ground – has come to signify AIDS activism to an entire community of people confronting the epidemic. . . . SILENCE = DEATH does its work with a metaphorical subtlety that is unique, among political symbols and slogans, to AIDS activism. Our emblem's significance depends on foreknowledge of the use of the pink triangle as the marker of gay men in Nazi concentration camps, its appropriation by the gay movement to remember a suppressed history of our oppression, and now, an inversion of its positioning (men in the death camps wore triangles that pointed down; SILENCE = DEATH's points up). SILENCE = DEATH declares that silence about the suppression and annihilation of gay people, *then and now*, must be broken as a matter of our survival.

45 Clement Greenberg, "Modernist Painting" (*Arts Yearbook*, 1961), in *Collected Essays*, vol. 4, pp. 85, 87.
46 Smith himself notes that "Zig" was "an affectionate term for Ziggurat – Ziggurat is too big a word and – I don't know – it [Zig] seems more intimate, and it doesn't have to be as high as the towers of Babylon," in Gene Baro, "Some Late Words from David Smith," *Art International* 9, no. 7 (20 October 1965), p. 49.
47 Clement Greenberg, "David Smith: Comments on His Latest Works," (*Art in America*, January–February 1966), in *Collected Essays*, vol. 4, pp. 222–228.
48 Clement Greenberg, "Review of Exhibitions of David Smith, David Hare, and Mirko" (*The Nation*, 19 April 1947), in *The Collected Essays and Criticism*, ed. John O'Brian, vol. 2: *Arrogant Purpose, 1945–1949* (Chicago: University of Chicago Press, 1993), p. 141.
49 These terms are from the paragraph that precedes that cited in the previous note.
50 Clement Greenberg, "David Smith" (*Art in America*, Winter 1956–1957), in *The Collected Essays and Criticism*, ed. John O'Brian, vol. 3: *Affirmations and Refusals, 1950–1956* (Chicago: University of Chicago Press, 1993), p. 279.
51 Clement Greenberg, "Review of the Exhibition *American Sculpture of Our Time*" (*The Nation*, 23 January 1943), in *The Collected Essays and Criticism*, ed. John O'Brian, vol. 1: *Perceptions and Judgements, 1939–1944* (Chicago: University of Chicago Press, 1993), p. 139.
52 Clement Greenberg, "How Art Writing Earns Its Bad Name" (first published in *The Second Coming Magazine*, March 1962, and *Encounter*, December 1962), in *Collected Essays*, vol. 4, p. 136.
53 Harold Rosenberg, "The American Action Painters," *Art News* 51, no. 8 (December 1952), pp. 22–23. The mistake and correction (and its introduction of some "confusion" into the Rosenberg oeuvre) are noted in a footnote by O'Brian in *Collected Essays*.
54 The notion of "Naming the Name," as Greenberg puts it, had been debated in the generation before the 1960s abstractionists he celebrated. The second issue of *The Tiger's Eye*, published in December 1947, for example, dedicated an entire editorial page to "The First Use of a Name." Greenberg notes that while Rosenberg may not have directly called the names of artists he indirectly referenced, there was no doubt about the individuals he intended, nor was there doubt concerning the embodiment of particular ideas, sensitivities, and expressions in the personalities and names. Most of the artists and critics associated with the Abstract Expressionists defended the value of the name. Yet the editorial page of *The Tiger's Eye* is poised between the values of Abstract Expressionism and those of the New Criticism that

was so powerful in the contemporary literary world. While asserting the "placing of a name with a statement adds force and meaning to the words, for the actuality of the person is the reason for reading the statement", "a work of art is not a statement . . . it is a creation, a subtlety beyond direct description, with an entity of its own, and any intrusion of personality, even of the creator, is distracting."

55 Greenberg, "Art Writing," p. 136.
56 Ibid., pp. 136, 137, 138.
57 Stephen Melville examines some of the filiations and separations between the projects of Derrida and Greenberg in *Philosophy Beside Itself: On Deconstruction and Modernism* (Minneapolis: University of Minnesota Press, 1986), esp. pp. 3–33.
58 Greenberg, "Art Writing," p. 137.
59 Ibid., p. 138.
60 Ibid., pp. 140, 141.
61 Ibid., p. 142.
62 Ibid., p. 143.
63 Ibid., p. 144.
64 Ibid.
65 Clement Greenberg, "Avant-Garde Attitudes: New Art in the Sixties" (1969), in *Collected Essays*, vol. 4, p. 301.
66 Ibid., pp. 300, 301.
67 T. J. Clark, "Clement Greenberg's Theory of Art," *Critical Inquiry* 9, no. 1 (September 1982), pp. 153–154. The first paragraph of this discussion contains material first developed in "In and Around the 'Second Frame,'" my contribution to *The Rhetoric of the Frame*, ed. Paul Duro (Cambridge: Cambridge University Press, 1996).
68 Clark, p. 147.
69 Bois, "Limits," p. 27.
70 Leo Steinberg, "Paul Brach," in *Toward a New Abstraction*, exh. cat. (New York: Jewish Museum, 1963), p. 12. The exhibition featured work by Paul Brach (essay by Leo Steinberg), Al Held (Irving Sandler), Ellsworth Kelly (Henry Geldzahler), Morris Louis (Robert Rosenblum), Kenneth Noland (Alan R. Solomon), George Ortman (Herman Cherry), Raymond Parker (Ulfert Wilke), Miriam Schapiro (Dore Ashton), and Frank Stella (Michael Fried).
71 Alley, p. 456.
72 Ibid.
73 Diane Upright, *Morris Louis: The Complete Paintings* (New York: Abrams, 1985), p. 36. Rubin is cited from his letter to the editor, in *Artforum* 9, no. 7 (March 1971), p. 8.
74 Ibid.
75 Ibid., p. 37.
76 Ibid., p. 208.
77 Cited in ibid., p. 38.
78 Ibid.
79 Ibid., p. 210.
80 Alley, pp. 546, 564, 620.
81 Ibid., p. 622.
82 Robert Rosenblum, "Frank Stella: Five Years of Variations on an 'Irreducible' Theme," *Artforum* 3, no. 6 (March 1965), pp. 22, 23.
83 Brenda Richardson, "Titles," in *Frank Stella: The Black Paintings*, exh. cat. (Baltimore: Baltimore Museum of Art, 1976), p. 4.
84 Ibid., p. 3.
85 Ibid., p. 11.
86 Ibid., p. 6.

87 Ibid., p. 46.

88 In her entry for *Die Fahne Hoch!* Richardson notes that "there is no question that the title relates formally to the proportions and to the cruciform pattern of the painting. But there also seems little doubt that the title additionally relates to the 'black' history of the Third Reich and the Holocaust," ibid., p. 39.

89 Ibid., pp. 3–4. Less than ten years after Stella's "Black Paintings," Joseph Kosuth took up the dictionary definition of "Black" quite literally, producing a work in his "Art as Idea as Idea" series that consists, solely, of a photostat of the definition of "black."

90 Ibid., p. 4.

91 William Rubin, *Frank Stella, 1970–1987*, exh. cat. (New York: Museum of Modern Art, 1987), pp. 7, 35, 77.

92 Ibid., p. 18.

93 Ibid., p. 20.

94 Ibid., p. 56.

95 Ibid., p. 142.

96 Ibid., pp. 77, 83.

97 Ibid., p. 120.

98 Kirk Varnedoe, *Cy Twombly: A Retrospective*, exh. cat. (New York: Museum of Modern Art, 1994), p. 23.

99 Cy Twombly, in *L'Esperienza moderna* (August-September 1959), cited in ibid., p. 27.

100 Varnedoe, p. 27.

101 Ibid., p. 30.

102 Ibid., pp. 40, 45.

103 Ibid., pp. 28–29.

104 Writing of Twombly's paintings made in 1960, Varnedoe notes that they "were often titled with florid evocations *(Crimes of Passion)* or homages to art and artists: *to Leonardo; Woodland Glade: (to Poussin); Garden of Sudden Delight (to Hieronymous Bosch); Study for School of Athens.*" Varnedoe continues with a description of Twombly's titling method at this time that quite closely resembles the strategies of Stella. Both were not pre-eminently concerned with "visual correlations"; both cultivated "irony"; and both produced titles that purportedly shed more light on their working contexts and milieux than their artistic theories or credos. Varnedoe believes these works to be somewhat exceptional in Twombly's career, and actually describes them as "clinically diagrammatic," thus linking their formal values as well as their titles to Stella's much more ordered, even formulaic, abstraction: "Such christenings almost never indicate visual correlations, and can easily be overinterpreted. . . . [T]he gestures had some knowing element of irony. . . . The titles are more useful in the general sense of showing how far the artist had moved – not just from Lower Manhattan loft life but also from his original territory of the prehistoric and tribal – into the halls of high European culture. . . . Yet . . . [a]n air of grand rhetoric and formality thus replaced the hot crustiness of works such as *View.*" Varnedoe's discomfort with the "grand rhetoric and formality" of the 1960 images is a measure of a more general discomfort with the gratuitously non-commensural relations between a work and its over-allusive title (ibid., p. 33).

There are further similarities between Twombly's choice of titles and other titular activities discussed here. First, works made in 1953 following a trip to North Africa are titled with the names of Moroccan cities. Lawrence Campbell states that Twombly "identifies his works by the name of Moroccan cities because he likes the sound of the words and not because they are descriptive" ("Rauschenberg and Twombly," *Art News* 52, no. 5 [September 1953]). As noted above, this kind of

formal choice was cited by Rubin as an explanation for many of Stella's titles, especially for his later works.

 Second, Varnedoe offers a specific discussion of Twombly's *Night Watch*, arguing (as did Richardson for Stella's "Black Paintings") that the title choice was governed not by any "paraphrase on, or homage to, the huge Rembrandt canvas in the Rijksmuseum in Amsterdam," but "solely for its poetic quality in relation to the dark space of the canvas" (ibid., p. 63, note 159). Third, Twombly made a number of works in the 1950s whose titles – such as *The Slaughter* and *Attacking* – recall the violence of Cézanne's early paintings.

105 Varnedoe concludes his study by claiming that Twombly's work engages with the "primal electricity of communication, in his apparently simplest acts of naming, marking, and painting," ibid., p. 51.

106 See "The Paintings of Leon Polk Smith: A Conversation between Leon Polk Smith and d'Arcy Hayman," *Art and Literature*, no. 3 (Autumn–Winter 1964), pp. 82, 85.

107 These terms are cited from just two pages in Terry Fenton, *Anthony Caro* (New York: Rizzoli, 1986), pp. 10, 11.

108 Ibid.

109 Michael Fried, "Anthony Caro and Kenneth Noland: Some Notes on Not Composing," *Lugano Review* 1, no. 3–4 (Summer 1965), p. 198.

110 Fried develops a theory of deductive structure for Noland in his essay for the exhibition "Three American Painters" at the Fogg Art Museum in Cambridge in 1965, and in the Noland retrospective at the Jewish Museum in New York in 1965.

111 Fried, p. 203.

112 Interview with Lawrence Alloway in the first edition of *Gazette* (1961).

113 Fried, p. 205.

114 Rosalind E. Krauss, "On Anthony Caro's Latest Work," *Art International* 11, no. 1 (20 January 1967), pp. 26–27.

115 Donald Kuspit, "Authoritarian Abstraction," *Journal of Aesthetics and Art Criticism* 36, no. 1 (Fall 1977), p. 29.

116 Yve-Alain Bois, "Ellsworth Kelly in France: Anti-Composition in Its Many Guises," in *Ellsworth Kelly: The Years in France, 1948–1954*, exh. cat. (Washington, D.C.: National Gallery of Art, 1992), pp. 16, 22, 23, 26, 31.

117 Jasper Johns, "Sketchbook Notes," *Art and Literature*, no. 4 (Spring 1964), p. 185.

118 James Rosenquist, "What Is Pop Art?," in Rose, p. 157.

119 Roy Lichtenstein, "Talking with Roy Lichtenstein" (*Artforum*, May 1967), in Rose, p. 153.

120 The "minimally edited transcript" of this text ("A Duologue"), from a BBC radio broadcast in March 1967, is reprinted in *Robert Morris*, exh. cat. (London: Tate Gallery, 1971), pp. 13–20. The present citation is from p. 19.

121 Donald Judd, "Specific Objects" (*Arts Yearbook*, 1965), in *Complete Writings 1959–1975: Gallery Reviews, Book Reviews, Articles, Letters to the Editor, Reports, Statements, Complaints* (Halifax: Press of the Nova Scotia College of Art and Design, and New York: New York University Press, 1975).

122 Donald Judd, "New Nihilism or New Art?" (interview by Bruce Glaser with Frank Stella and Donald Judd, broadcast on WBAI-FM, New York, February 1964, and published as "Questions to Stella and Judd: Interview by Bruce Glaser. Edited by Lucy R. Lippard," *Art News*, September 1966), in *Minimal Art: A Critical Anthology*, ed. Gregory Battcock (New York: E. P. Dutton, 1968), pp. 154, 155.

123 Benjamin H. D. Buchloh, "Gerhard Richter: Legacies of Painting," in *Artwords 2: Discourse on the Early 80s*, ed. Jeanne Siegel (Ann Arbor: UMI Research Press, 1988), p. 115.

124 See Susan Stewart, *On Longing: Narratives of the Miniature, the Gigantic, the Souvenir, the Collection* (Chapel Hill: Duke University Press, 1993), pp. 70ff.

125 Paul Virilio, *The Aesthetics of Disappearance*, trans. Philip Beitchman (New York: Semiotext(e), 1991), p. 105.

126 Paul Virilio, *The Lost Dimension*, trans. Daniel Moshenberg (New York: Semiotext(e), 1991), pp. 84–85.

127 Alphonso Lingis, *Libido: The French Existential Theories* (Indianapolis: Indiana University Press, 1985), pp. 104–105.

128 Ibid., p. 117.

Chapter 9

1 Robert Morris, dream-journal entry (1990?), cited in W. J. T. Mitchell, "Word, Image, and Object: Wall Labels for Robert Morris," in *Picture Theory: Essays on Verbal and Visual Representation* (Chicago: University of Chicago Press, 1994), p. 266.

2 Eric Michaels, "Postscript: My Essay on Postmodernism," in *Bad Aboriginal Art: Tradition, Media, and Technological Horizons* (Minneapolis: University of Minnesota Press, 1994), p. 179.

3 Guy Debord and Gil J. Wolman, "Methods of Detournement" (first published in *Les Lèvres nues*, May 1956), in *Situationist International Anthology*, ed. and trans. Ken Knabb (Berkeley: Bureau of Public Secrets, 1981), p. 9.

4 Ibid.

5 Ibid., pp. 11–12.

6 Ibid., p. 13.

7 Ibid., p. 12.

8 Ibid., p. 9.

9 Robert Smithson, interview with Paul Cummings, in *Artists in Their Own Words* (New York: St. Martin's Press, 1979), pp. 227–228.

10 Craig Owens, "Earthwords," in *Beyond Recognition: Representation, Power and Culture*, eds. Scott Bryson, Barbara Kruger, Lynne Tillman, and Jane Weinstock (Berkeley: University of California Press, 1992), pp. 40–51.

11 Smithson, in *Artists in Their Own Words*, p. 230.

12 Ibid, p. 232.

13 Ibid., p. 235.

14 Charles Harrison, *Essays on Art & Language* (Oxford: Basil Blackwell, 1991), p. 56.

15 Ibid., p. 129.

16 George Dickie, *Art and the Aesthetic* (Ithaca: Cornell University Press, 1974), p. 39.

17 Morris, dream-journal entry (1990?), cited in Mitchell, p. 249.

18 Mitchell, p. 242.

19 Ibid., p. 249.

20 Ibid., pp. 259–260.

21 Ibid., pp. 246–247.

22 Ibid., p. 254.

23 Michael Baxandall, "Exhibiting Intention: Some Preconditions of the Visual Display of Culturally Purposeful Objects," in *Exhibiting Cultures: The Poetics and Politics of Museum Display*, eds. Ivan Karp and Steven D. Lavine (Washington, D. C.: Smithsonian Institution Press, 1991), p. 36.

24 Douglas Crimp, "The Art of Exhibition," *October*, no. 30 (Fall 1984), p. 60.

25 Anselm Kiefer, interview with Donald Kuspit, in *Artwords 2: Discourse on the Early 80s*, ed. Jeanne Siegel (Ann Arbor: UMI Research Press, 1988), p. 90.

26 Something of this "lowering," and the collaborative exhaustion associated with it, can be glimpsed in Georg Baselitz's remark: "A year ago, Penck and Lüpertz and Immendorff and I sat together, and we discussed whether to do something collectively – one should definitely do *something*, we thought, an exhibition or a journal – and we could not even come up with a title for the whole thing!" (interview with Henry Geldzahler, in ibid. p. 99).

27 Diane Waldman, *Enzo Cucchi*, exh. cat. (New York: Solomon R. Guggenheim Museum, 1986), p. 27.

28 Ibid.

29 Enzo Cucchi, in interview with Giancarlo Politi and Helena Kontova, in Siegel, p. 142.

30 Ibid., p. 149.

31 Franceso Clemente, in interview with Giancarlo Politi and Helena Kontova, in ibid., p. 135.

32 Ibid.

33 Craig Owens, "Sherrie Levine at A&M Artworks," in *Beyond Recognition*, p. 115.

34 Samuel Beckett, *The Unnameable* (New York: Grove Press, 1958), p. 164.

35 A case in point was discussed in a recent review of a New York exhibition, "Interventions: Four Approaches to Contemporary Photography," by Vicki Goldberg. Discussing the work of Paul Laster, who borrows black-and-white reproductions and overlays them with cut-out colored papers from the Sunday *New York Times*, she notes: "The titles are borrowed, too, from other artists with no connection to either the image or the style. This little game of quoting makes an inadvertent comment on the fatuity of excessive quotation." See Goldberg, "Lessons in High Seriousness, Low Parody and Borrowing," *New York Times*, 28 January 1995, sec. 2, p. 30.

36 I am following the thematic indicators given in Rosalind E. Krauss, *Cindy Sherman 1975–1993* (New York: Rizzoli, 1993).

37 Ibid., p. 207.

38 See Ken Johnson, "Cindy Sherman and the Anti-Self: An Interpretation of Her Imagery," *Arts Magazine* 62, no. 3 (November 1987), pp. 47–53: "Sherman opens herself up to a certain potential that, we can safely guess, she probably lived through as a teenager and later did her best to leave behind" (p. 51). Marjorie Welish voices a concern about the lack of specificity in Jenny Holzer's work, which is one chord in a minor chorus of criticisms lodged against the "silence" and lack of specificity held to characterize work by many artists of the 1980s. See "Who's Afraid of Verbs, Nouns, and Adjectives," *Arts Magazine* 64, no. 8 (April 1990), pp. 79–84. In the same vein, in "Crowding the Picture: Notes on American Activist Art Today," *Artforum* 26, no. 9 (May 1988), pp. 111–117, Donald Kuspit criticizes Holzer's installation for the "Skulptur Projeckte" exhibition in Munster in 1987 for its one-dimensional critique and cautions that Kruger's image-texts fail to be "transformative" because they look too much like the work they appropriate.

39 Douglas Crimp, "A Note on Degas's Photographs," *October*, no. 5 (Summer 1978), p. 99, cited in Krauss, "Cindy Sherman: Untitled," in *Cindy Sherman 1975–1993*, p. 61.

40 See Stephen Melville, "The Time of Exposure: Allegorical Self-Portraiture in Cindy Sherman," *Arts Magazine* 60, no. 5 (January 1986), pp. 17–21.

41 Craig Owens, "Allan McCollum: Repetition and Difference," in *Beyond Recognition*, p. 119. Owens also notes the three phases of serial repetition brought forward in the present study: Monet's "Rouen Cathedrals" and "Wheatstacks," Mondrian's repetitive grids, and the reiterative tendencies in contemporary art, including those

of McCollum. He argues that "while, in impressionism, the series works to claim the absolute uniqueness of each single moment of perception, and while, in modernism, it represents an evolutionary or developmental process, in contemporary art it is used to deny both uniqueness and development" (p. 121, note 3). We have found that Monet's cult of experiential temporality was indeed predicated on the assertion of the "moment," but that Mondrian's "compositional" repetition is less evolutionary than utopian, less concerned with the idea of taking cumulative steps, than with the articulation of environmental part-objects each of which stands in a synecdocal relation to the wished-for visual-social whole.

42 In an interview with Sherrie Levine in *Artwords 2*, p. 248, Siegel observes, "In titling your works *After Kasimir Malevich* or *After Egon Schiele* you are alluding to an accepted earlier convention in art – one which flowered in the Baroque period and continued into the nineteenth century."

43 In "Sherrie Levine: Rules of the Game," in *Sherrie Levine*, exh. cat. (Zurich: Kunsthalle, 1991), pp. 8–10, David Deitcher, writing of the "22 photographs . . . copied, framed, and put on view as her own" in the artist's *After Walker Evans* exhibition at Metro Pictures in New York in 1981, suggests that "[t]he 'after' in these works denotes more than the condition of derivation or indebtedness. It is also the temporal and historical 'after' as in: 'Our world comes *after* Walker Evans's.' The 'after' that has proliferated like a Leitmotif in Levine's titles joins the immovable billiard balls in *La Fortune (After Man Ray)* to propose that chance and history – personal and social – deal one a hand that determines one's perspective on life, limits one's sense of entitlement, and challenges one's ability to act."

44 Howard Singerman, "Seeing Sherrie Levine" *October*, no. 67 (Winter 1994), p. 80.

45 Ibid., p. 85. Craig Owens was among the first to point to the "refusal . . . of the paternal rights assigned to the author by law," in "The Discourse of Others: Feminists and Postmodernism," in *The Anti-Aesthetic: Essays on Postmodern Culture*, ed. Hal Foster (Seattle: Bay Press, 1983), p. 73.

46 Singerman, pp. 87, 95. Both Owens and Singerman borrow terms from Luce Irigaray to describe a female exchange "value" that might be opposed to male commodity-economy. Discussing Walker Evans's photograph of the fireplace of the Burroughs's home in Hale County, Alabama, Singerman also cites James Agee from *Let Us Now Praise Famous Men*, drawing out a complex relationship between the photograph, the title it contains, and a double signature which appropriates it: "'The title is Cherie . . . and written twice, in pencil, in a schoolchild's hand: 'Louise, Louise.' Signing the picture twice, ten-year-old Louise Burroughs claimed it not only as hers, but as herself; she has signed it not only as its author, as though it was her object, but as its subject, as though it was her being. Louise's double signature marks her closeness to the image, her place within its story; in that, it doubles Levine's own" (p. 91).

47 Ibid., pp. 99–100.

48 Barbara Kruger, cited in Kate Linker, *Love for Sale: The Words and Pictures of Barbara Kruger* (New York: Abrams, 1990), p. 29.

49 See Craig Owens, "The Medusa Effect, or, the Specular Ruse," in *Beyond Recognition*, esp. pp. 192–193.

50 Jean Baudrillard, "Untitled," *Barbara Kruger*, exh. cat. (New York: Mary Boone Gallery, 1987), unpag. Baudrillard thinks the difference between Surrealist and postmodern irony: "[w]e no longer have to do what the surrealists did: juxtapose objects with the absurdity of their functions, in a poetic unreality." In this sense Kruger's images and captions, which "designate each other ironically," are seen as manifestations of the obscene visibility of the corporate-technological "scripting" of

the world – "[a]n ingenious scriptwriter (perhaps capital itself) has pulled the world into a phantasmagoria, and we are all its spellbound victims."

51 Bruce Ferguson, "Wordsmith: An Interview With Jenny Holzer," *Art in America* 74, no. 12 (December 1986), p. 111.
52 See Jeanne Siegel, "Jenny Holzer's Language Games," *Arts Magazine* 60, no. 4 (December 1985), p. 64.
53 Miriam Schapiro, "Notes from a Conversation on Art, Feminism, and Work," in *Working It Out: Twenty-Three Women Writers, Artists, Scientists, and Scholars Talk about Their Lives and Work*, eds. Sara Ruddick and Pamela Daniels (New York: Pantheon, 1977), p. 300.
54 Norma Broude, "Miriam Schapiro and 'Femmage': Reflections on the Conflict between Decoration and Abstraction in Twentieth-Century Art," in *Feminism and Art History: Questioning the Litany*, eds. Broude and Mary D. Garrard (New York: Harper and Row, 1982), p. 322.
55 Donna Haraway, "Introduction," *Simians, Cyborgs, and Women: The Reinvention of Nature* (New York: Routledge, 1991), p. 3.

Epilogue

1 Thomas E. Crow, *Painters and Public Life in Eighteenth-Century Paris* (New Haven: Yale University Press, 1985), p. 40.
2 Roger Shattuck, *The Banquet Years: The Origins of the Avant-garde in France 1885 to World War I* (New York: Vintage, 1968), p. 283.
3 Robert Smithson, "The Establishment," in *The Writings of Robert Smithson*, ed. Nancy Holt (New York: New York University Press, 1979), pp. 79, 80.
4 Crow, p. 3.
5 Ibid., p. 5. Following the lead of the "writer often cited as the first modern art critic, one La Font de Saint-Yenne," who wrote a controversial pamphlet in 1747, Crow notes that "the volume of published comment on the exhibitions and the public functions of art expanded rapidly. Substantial numbers of critiques appeared during and after subsequent Salons, as well as more far-ranging treatises on painting intended for a general literate public. . . . A waiting readership seemed to exist; each year the Academy had to print increasing numbers of its Salon guide and catalogue (the *livret*), and soon was selling them in the thousands. The official handbook was supplemented by more and more critical pamphlets, many of them illegal and anonymous, sold in the streets, cafés, and printshops of the city during the run of each exhibition. To judge from their numbers and variety, these constituted a small industry in themselves" (p. 6).
 An occasional history of the catalogue is written into Crow's book, and can be unfolded here: Following its appearance in 1671, the *livret* was used in 1699 and more expansively in 1704, to develop "an explicit statement of [the Salon's] educational and discursive intentions" (p. 37). Crow observes of these early efforts at catalogue criticism and description that the "text begins by carefully laying out the architectural setting and supporting décor; the works of art are initially located and identified for the visitor as part of that décor, and the name of the artist is only supplied after the location and subject matter of each work have been firmly established. . . . The striking part of this mode of presentation is what is not given stress: the identity and academic rank of the individual artist, the didactic significance of the hierarchy of genres, some relative order of importance among the works submitted by each artist. These considerations would determine the arrangement of later *livrets* – they stand after all for the Academy's own distinct orders –

but at this stage are presented as secondary points of reference" (p. 38).

Later, in 1727 "Dubois de St. Gelais, historiographer of the Academy, produced a detailed catalogue of the Palais Royal collection, and unlike the other handlists examined above, it was organized according to fairly modern critical principles. The entries are not ordered by the arrangement of pictures on the walls, but alphabetically by artist's name. Dubois then attempts to describe for each 'his character as a painter in order that he might be easier to recognize'" (p. 41). "[T]he emphasis on the physical arrangement of the pictures diminished year by year until 1740 when it assumes the form it will retain permanently: the pictures and works of sculpture are now grouped and numbered by artist in order of academic rank; the viewer is assumed to be able to sort out the hanging without help. The preface of the 1741 *livret* specifies the contribution of the assembled public and the utility of exhibitions in more egalitarian terms than any previous document. . . . [T]his is . . . in comparison to earlier *livrets*, a ringing vote of confidence in the enlightened *amateur*. These changes suggest that the heretofore empty notion of an active, challenging public audience had taken on some substance. And it would be only a few years until the dramatic emergence of art criticism and debate from the *conférence* into the streets" (p. 82).

6 Charles Baudelaire, "The Salon of 1845," in *Art in Paris 1845–1862: Salons and Other Exhibitions Reviewed by Charles Baudelaire*, trans. and ed. Jonathan Mayne (Oxford: Phaidon, 1965) p. 11.

7 Ibid., p. 21.

8 Charles Baudelaire, "The Salon of 1859," in ibid., pp. 172–188. My citations are from pp. 172, 174.

9 Ibid., p. 211.

10 *Olympia* was not quite so simply titled. In *The Painting of Modern Life: Paris in the Art of Manet and his Followers* (New York: Knopf, 1984), p. 83., T. J. Clark, whose exemplary account of the critical reception and historical contexts of *Olympia* I follow here, writes thus about Manet's two works in the 1865 Salon: "Manet put the simple title *Jésus insulté par les soldats* in the salon catalogue, but underneath *Olympia* he added five lines of unforgivable verse by Zacharie Astruc." Supplementing this addition, Jean Ravenal, the only critic who offered something approaching a considered discussion of the painting, suggests the substitution of lines from Baudelaire's "Les Phares" for the "epigraph" from Astruc (pp. 139–40).

Clark also offers a close discussion of the name *Olympia*, noting that it was "Astruc's choice of title," and that "it was on the face of it a dignified name." It was also "a pseudonym favoured by prostitutes: it figured in the classic list of names drawn up in 1836 by the trade's first great investigator, Parent-Duchâtelet. . . . For readers in 1865 the name Olympia probably also conjured up, as Gautier put it in his *Salon*, 'the memory of that great Roman courtesan on whom the Renaissance doted,' by whom he meant La Dona Olympia, villainous heroine of a popular novel by Etienne Delécluze; sister-in-law, mistress, and manipulator of Pope Innocent X." Clark notes, however, that "Manet's young woman had taken nothing but her predecessor's name, and in that she was one of many. Her title was bogus; and as for Astruc's 'August jeune fille'! It [sic] appeared to the critics a euphemism coined with the same cynical aplomb." And of the critical response that focuses on her name, he cites one writer who asked "'What is this odalisque with a yellow belly . . . , ignoble model picked up who knows where, who represents Olympia? Olympia? What Olympia? A courtesan, no doubt'" (pp. 85–86).

There is much more that could be said on the subject of the title-text-name *Olympia*. In a footnote Clark points to one of these sites of discussion, Georges Bataille's *Manet: Etude biographique et critique*, where he disputes an interpretation of

the painter's work put forward by Valéry. To Valéry's contention that the Olympia was a representation of "impurity," "ritual animality," and "absolute nudity," he retorts that while "in a sense this was initially the *text* of *Olympia* . . . this text is a separate matter from the woman . . . the text is *effaced* by the picture. *And what the picture signifies is not the text, but the effacement*" (pp. 137–138).

11 Reproduced in ibid., p. 97.
12 Ibid., p. 98.
13 Clark records numerous critical epithets that speak to *Olympia*'s de-composition and "undecipherability." Not only was she "informe," but one account stated that "I . . . do not know if the dictionary of French aesthetics contains expressions to characterize her," cited in ibid., p. 92. He later claims that the compositionality relinquished in the form and style of the painting is reconvened in the peculiar force of the *Olympia*'s *look*: "[I]t is *her* look, her action upon us, her composition of herself" (p. 133).
14 Ibid., pp. 117, 109.
15 Ibid., pp. 131–132.
16 This discussion could be widened to include other named and non-named female protagonists that feature in Manet's work. Consider the difference marked, for example, between the named *Nana* (1877), represented in her Parisian demi-monde interior under the gaze of "the *soigné* figure of the admirer to the right who is permitted only quarter presence, his physical incompleteness emphasizing the more central importance of the mirror in the imagery of provocative narcissism" (Linda Nochlin, *Realism* [London: Penguin, 1971], p. 164), and the un-named *Street Singer* (1862), caught in a snapshot-like moment as she distractedly emerges from a bar into the street.
17 John Quinn, cited in Milton W. Brown, *The Story of the Armory Show* (New York: Abbeville, 1988), p. 44.
18 Cited in ibid., p. 137.
19 Royal Cortissoz, cited in ibid., p. 174.
20 Cited in ibid., p. 138.
21 Cited in ibid., p. 139.
22 These events are described in ibid., pp. 141–142.
23 Ibid., pp. 163, 165.
24 Adolf Hitler, opening address to the first official "Great German Art Exhibition," 19 July 1937, cited in Willibald Sauerländer, "Un-German Activities" *New York Review of Books*, 7 April 1994, p. 9. Sauerländer also cites Hitler's assertion (from the same address) that "to be German means to be straightforward" (p. 11). There is little need to point to contradictions in the cultural logic of the National Socialists, but it is worth observing with respect to Hitler's blanket disavowal of the textual supplement that many approved Nazi paintings bore allegorizing or moralizing title-captions, whose "symbolic profundity" has been noted by several commentators. See Berthold Hinz, *Art in the Third Reich* (New York: Pantheon, 1979), pp. 81, 103.
25 Ibid., p. 11.
26 Werner Spies, *Max Ernst: A Retrospective*, exh. cat. (London: Tate Gallery and Munich: Prestel, 1991), p. 299.
27 Stephanie Barron, "1937: Modern Art and Politics in Prewar Germany," in Barron, *"Degenerate Art": The Fate of the Avant-Garde in Nazi Germany*, exh. cat. (Los Angeles: Los Angeles County Museum of Art, 1991), p. 12.
28 Christoph Zuschlag, "An 'Educational Exhibition': The Precursors of *Entartete Kunst* and Its Individual Venues," in ibid., p. 89.
29 *"Degenerate Art,"* p. 380.

30 Sauerländer, "Un-German Activities," pp. 9–10.
31 The discussion of Beuys here draws on my "In and Around the 'Second Frame,'" in *The Rhetoric of the Frame*, ed. Paul Duro (Cambridge: Cambridge University Press, 1996).
32 See, e.g., Gianni Vattimo *The End of Modernity*, trans. Jon R. Snyder (Baltimore: Johns Hopkins University Press, 1988). In defining Heidegger's "weak ontology" in "Ornament/Monument," Vattimo notes that "Heideggerian aesthetics" [in this sense unlike Kaprow's] "does not induce interest in the small vibrations at the edges of experience, but rather – and in spite of everything – maintains a monumental vision of the work of art." Heidegger, Vattimo states, argues for the "endurance" of art "not because of its force . . . , but because of its weakness." Kaprow, it would seem, (strongly) argues for the endurance of art by virtue of its weakness *and* its non-monumentality.
33 See Heiner Stachelhaus, *Joseph Beuys*, trans. David Britt (New York: Abbeville, 1991), p. 64. Beuys specifically took issue with Duchamp in his "Action," *The Silence of Marcel Duchamp Is Overrated* (November 1964), in which he commented on the narrowness of Duchamp's conjugation of anti-art, chess, and "literature."
34 Joseph Beuys, cited in ibid., p. 68.
35 Norbert Kricke, cited in ibid., pp. 94–95.
36 Brian O'Doherty, "Inside the White Cube: Notes on the Gallery Space, Part I," *Artforum* 14, no. 7 (March 1976), pp. 24–30, and "Inside the White Cube, Part II: The Eye and the Spectator," *Artforum* 14, no. 8 (April 1976), pp. 26–34.
37 O'Doherty, "Part I," p. 24.
38 Ibid., p. 25.
39 Ibid., p. 27.
40 Ibid., p. 28.
41 Allan Kaprow, *Assemblage, Environments, and Happenings* (New York: Abrams, 1966), p. 152.
42 Ibid., p. 153.
43 Ibid., p. 154.
44 Ibid., p. 29.
45 Ibid., p. 30.
46 Robert Smithson, "What is a Museum?: A Dialogue between Allan Kaprow and Robert Smithson," in *Writings*, p. 60.
47 Alanna Heiss, ed., *Dennis Oppenheim: Selected Works 1967–90*, exh. cat. (New York: Institute for Contemporary Art, P. S. 1 Museum and Abrams, 1992), pp. 14–15.
48 Robert Smithson, "Minus Twelve," in *Writings*, p. 81. This text was first published as the final contribution to *Minimal Art: A Critical Anthology*, ed. Gregory Battcock (New York: E. P. Dutton, 1968), pp. 402–406.
49 Svetlana Alpers, "The Museum as a Way of Seeing," in *Exhibiting Cultures: The Poetics and Politics of Museum Display*, eds. Ivan Karp and Steven D. Lavine (Washington D. C.: Smithsonian Institution Press, 1991), p. 31.
50 Robert Smithson, "Some Void Thoughts on Museums," in *Writings*, p. 58.

Index

Photograph Credits

In most cases, illustrations have been made from photographs kindly provided by the owners or custodians of the works. Those plates for which further credit is due are listed below:

Copyright Paolo Mussat Sartor: 1, 7; © Photo RMN: 13, 33; © President and Fellows, Harvard College, Harvard University Art Museums: 14; Giraudon, Paris: 15; Photograph © 1996, The Art Institute of Chicago, All Rights Reserved: 20, 21, 42, 66; Photograph © 1996 The Museum of Modern Art, New York: 23, 35, 44, 54, 76; © 1994 Museum of Fine Arts, Boston. All rights reserved: 24; Photo Jack Abraham: 26a, 26b; © Succession H. Matisse/DACS 1996: 46 (© Photo RMN), 47, 48; © ADAGP, Paris and DACS, London 1996 (Photo Javier Campano): 50; © ADAGP, Paris and DACS, London 1997, and © The Solomon R. Guggenheim Foundation, New York: 51 (photograph Robert E. Mates), 52 (photograph Carmelo Guadagno), 59, 63 (photographs Robert E. Mates); © ADAGP, Paris and DACS, London 1996 and © President and Fellows, Harvard College, Harvard University Art Museums: 53; © DACS 1997, and photograph © 1996 The Museum of Modern Art, New York: 55; © ADAGP, Paris and DACS, London 1997: 56, 57 (photograph Eric Pollitzer), 58, 63, 64 (photograph Eric Pollitzer); © ADAGP, Paris and DACS, London 1997, and photograph © 1996, The Art Institute of Chicago, All Rights Reserves: 60; © ADAGP, Paris and DACS, London 1997, and copyright © 1993 Museum Associates, Los Angeles County Museum of Art. All Rights Reserved: 61; © ADAGP, Paris and DACS, London 1997: 62; © ARS, NY and DACS, London 1997, and photograph © 1996 The Museum of Modern Art, New York: 65; © Roy Lichtenstein/DACS 1997: 69; © The Solomon R. Guggenheim Foundation, Venice: 67; © ARS, NY and DACS, London 1996: 70, 76; © ARS, NY and DACS, London 1996 and © the Solomon R. Guggenheim Foundation, New York: 71 (photograph Robert E. Mates); Photo Robert McElroy: 73; © Estate of David Smith/DACS, London/VAGA, New York 1996: 74 (photograph Joseph Szaszfai); Photograph: Rudolph Burkhardt: 82

DUE DATE

	201-6503		Printed in USA